VERMEER AND HIS MILIEU

VERMEER

AND HIS MILIEU

A WEB OF SOCIAL
HISTORY

JOHN MICHAEL MONTIAS

PRINCETON UNIVERSITY PRESS

PRINCETON, NEW JERSEY

Copyright © 1989 by Princeton University Press
Published by Princeton University Press, 41 William Street,
Princeton, New Jersey 08540
In the United Kingdom: Princeton University Press,
Chichester, West Sussex

Second printing, 1989

Library of Congress Cataloging-in-Publication Data

Montias, John Michael, 1928-
Vermeer and his milieu.
Bibliography: p.
Includes index.
1. Vermeer, Johannes, 1632-1675. 2. Painters—
Netherlands—Biography. I. Title.
NB653.V45M66 1988 759.9492 88-30685
ISBN 0-691-04051 (alk. paper)

Publication of this book has been aided by a grant from the
Johannes Vermeer Stichting, Amsterdam

This book has been composed in Linotron Sabon

Princeton University Press books are printed
on acid-free paper and meet the guidelines for
permanence and durability of the Committee on
Production Guidelines for Book Longevity
of the Council on Library Resources

Printed in the United States of America by
Princeton Academic Press

7 9 10 8 6

TO THE DUTCH PEOPLE,
THEN AND NOW

CONTENTS

LIST OF ILLUSTRATIONS

ACKNOWLEDGMENTS

It is a pleasure to recall the names of all those who helped me in writing this book and to express my gratitude to them.

In the research itself, H. W. van Leeuwen and Sebastian van der Wulp of the Delft Municipal Archive, A. J. Busch of the Gorinchem Municipal Archive, Isabella van Eeghen and S.A.C. Dudok van Heel of the Amsterdam Municipal Archive, and J. Fox of the Algemeen Rijksarchief were most helpful to me. In tracing the lineage of individuals in Gouda, Utrecht, and elsewhere who played a role in my story, C. J. Matthijs and A. M. Wijburg lent me crucial assistance. J. A van Hoesel detected some errors in my earlier essay on Vermeer in G. Aillaud, A. Blankert, and J. M. Montias, *Vermeer* (Paris: Hazan, 1986). My old friend Rob Ruurs did research in Gouda on my behalf: the fruits of his research are published here for the first time.

A number of my friends read the manuscript of this book in whole or in part and made comments for which I am most grateful. Svetlana Alpers and Jakub Smit read the book at the request of Princeton University Press; Egbert Haverkamp-Begemann, Albert Blankert, Hanna Demetz, Andrew Forge, John Hollander, Claude Lopez, and Otto Naumann did so as a favor to me. I have to single out Professor Smit's contribution because, in the absence of his very careful reading and criticisms of two earlier drafts, I should never have been able to get straight various details on the complex history of the Netherlands, nor would I ever have understood the confederate political structure of the United Provinces. The encouragement and the intellectual stimulation I received over many years from Albert Blankert and Egbert Haverkamp-Begemann helped bring this project to fruition. Leon Lipson also gave me the benefit of his wide knowledge of civil law. Remaining errors are of course mine.

I owe a special debt to Marten J. Bok and Kitty Kilian for a careful reading of the manuscript for errors and inconsistencies (especially in the spelling of Dutch words and names).

My wife Marie Agnes carried out the arduous and painstaking task of transforming thousands of draft pages written in longhand into clear typescript "7 ofte 8 uur ja noch meer in de tag ende oock in de nagt zonder dagloon noch salarie," as a Dutchman might have written in the seventeenth century.

I am grateful to Elizabeth Gretz for her very careful editing of the manuscript and to Ann Dutlinger for drawing the complicated family trees reproduced in Appendix C. Eric Van Tassel, the Fine Arts Editor of

Princeton University Press, took an interest in the project that went beyond his normal responsibility for seeing a book brought to fruition.

The editor of *The Art Bulletin* kindly gave me permission to reproduce my article "Vermeer's Patrons and Clients," with minor changes, as Chapter 13 of this book.

Among the institutions to which I am indebted, I should mention the National Endowment for the Humanities for fellowship support in 1985–1986 and the Johannes Vermeer Foundation of the Netherlands for a publication subsidy which I deeply appreciate. The Institution for Social and Political Studies of Yale University, with which I am affiliated, provided me with secretarial and other assistance over the long gestation of this manuscript.

INTRODUCTION

This book is in part about the painter Vermeer and his extended family. It is also a detailed account of the lives of many ordinary persons in seventeenth-century Holland who in one way or another intersected with Vermeer and his relatives. The individuals I deal with, most of whom lived in Delft, a city that numbered only about 25,000 inhabitants around 1650, knew and frequented each other; they lent each other money; they witnessed the acts their relatives and friends passed before notaries. This little world formed a web of relationships that is the principal subject of the present study.

In spite of all my efforts and of those who preceded me in combing through Delft's archives, less documentary evidence has survived regarding Vermeer himself than regarding his grandparents, his uncles and aunts, and especially his in-laws: Maria Thins, the formidable mother of his wife Catharina, and Catharina's irascible brother Willem. Vermeer seems to have been exclusively devoted to his art. He left few traces in the notarial archives and none in the judicial records of his time. There is little to go on to reconstruct his personality, beyond his ability to get along with a very domineering and contentious mother-in-law. I was able to trace the outline of his character only by using the more abundant information available about the people with whom he lived and interacted.

Our documentary sources constrain, shape, and frequently distort our idea of what people were like three and a half centuries ago, especially if they were little known in their time. The material evidence for seventeenth-century Dutch artists consists chiefly of depositions, business transactions, and other documents drawn up by notaries and municipal clerks that force us to consider a person's life from a particular angle, closer to his adversarial than to his amicable relations with his fellow men. We are more likely to know that a painter had a knife fight with somebody in an inn than that he admired or befriended another artist. That one individual was friendly with another may have to be inferred from the fact that they were both witnesses to a christening or that one lent the other money. Since the inference is then merely plausible rather than certain, it cannot quite offset the bias in the information we are able to collect about our subject. Imagine the picture that would emerge of Edward Hopper or Jackson Pollock if all that we could find out about them was dredged out of civil or legal records.

Notarial depositions give us a partial view of individual personalities not only because they give excessive emphasis to the controversial side of their activities but because they are by and large woefully one-sided and incomplete. Very few depositions have survived that were originally

drawn up by the two sides to a controversy. The problem is not very different from that confronted by historians who have tried to reconstruct the views of heretics and witches from the trials conducted by the Inquisition.[1] Still, these notarial depositions, which the notary painstakingly corrected as witnesses struggled to give the most precise version of the events they claimed to have experienced, generally have the ring of truth. The accumulation of vivid details contributes to the Dickensian quality of these stories. The language is the language the witnesses spoke, unadorned. Even the aristocratic Maria Thins—Vermeer's mother-in-law—did not hesitate to say that her son Willem had bragged he had "turned his arse toward her."

The life stories of the people who form the subject of this book were pieced together from archival documents that started resurfacing over a century ago. The history of the search is itself instructive. It begins in the 1870s when J. Soutendam, the first keeper of Delft's archives, and Henry Havard, a French érudit, looked for information about Vermeer and his family in the birth and death registers of the Old Church and the New Church (both Reformed), which were later incorporated into the municipal archives. However, the first systematic search was done by the Dutch art historian Abraham Bredius, who read his way through most of Delft's notarial archives between 1880 and the 1920s. Bredius, the scion of a wealthy Dutch family that was already well known in the seventeenth century, worked under special circumstances. The archives of his day were mostly uncatalogued and unclassified; on the other hand, owing to his prominence as a historian and to his high social status, he was given every facility for his work, including permission to take the material to his hotel room or to his home. He did not scruple to underline in blue pencil the passages in manuscript documents that he found significant. Today researchers are lucky if they are not obliged to work with a microfilm of the original. If the volume holding a document in which one is interested is too thick, permission will not be given to photocopy the needed pages, because this is liable to break the book's spine. Yet if I had not had photocopies of documents to work with in the initial stages of my project, I do not think I should ever have completed it. Many volumes of notarial records that I consulted a few years ago have since been withdrawn from circulation because of their poor condition.

Little new material surfaced about Vermeer's family between the two world wars. One exception of decisive importance was the recognition by L.G.N. Bouricius in 1925 that the man who had registered as an art dealer in the Guild of St. Luke in 1631 under the name "Reijnier Vos or

[1] See, for example, Carlo Ginzburg, *The Cheese and the Worms: The Cosmos of a Sixteenth-Century Miller* (Baltimore: Johns Hopkins University Press, 1980).

Reijnier van der Minne" was none other than Vermeer's father. Later many documents turned up that were signed by Vermeer's father with his alias Vos.

In 1950 P.T.A. Swillens published a book on Vermeer that contained a good deal of useful speculation on the relation between the artist's works and his physical surroundings. It also incorporated new material on his wife's family in Gouda. Beginning in the early postwar period, a Dutch primary school teacher, A.J.J.M. van Peer, devoted nearly thirty years of his spare time to archival research on Vermeer. Most but by no means all of his findings, important chiefly for the light they threw on the painter's Roman Catholic milieu after he joined the household of his mother-in-law, have been published. Four years before his death in 1981 he kindly allowed me to use a forty-nine-page typescript he had written on the Vermeer family.

When I began the research for my study of the Guild of St. Luke in Delft in 1975,[2] I greatly admired Vermeer as an artist, but I had no special interest in his life. He was only one of the 250-odd painters in my card file. I was more concerned with assigning a place to the lesser lights in Delft's artistic community than I was with raking over familiar ground about its best-known member. I was so convinced that all the information regarding Vermeer had been extracted by previous investigators that I initially made no effort to make a contribution to his life. However, early in the course of my investigation, while browsing in the stacks of the Delft Municipal Archives, I found a set of documents that had never been scrutinized by previous researchers—uncatalogued records of real-estate transactions kept by Delft's Camer van Charitate. One of these contained a notice of the purchase by Vermeer's father of the inn "Mechelen" on Delft's Great Market Square, in which the artist spent his late childhood and adolescence. This find convinced me that the Delft archives had not been exhausted on the subject of Vermeer. I went on to search the other records of the Camer van Charitate for material on Delft's most famous artist. I soon discovered in a register of death donations a notice of his burial, indicating that the chest ordinarily sent to the house of the defunct to collect his best outer garment or an equivalent donation for the city's poor was not supposed to be sent to Vermeer's house because there was "nothing to get" there. After this, when I was able to read seventeenth-century handwriting well enough to tackle the "protocols" or records of individual notaries, I began to look more systematically, as a side-product of my research on the guild and its members, for documents relating to the artist and to his family.

[2] Eventually published as *Artists and Artisans in Delft: A Socio-Economic Study of the Seventeenth Century* (Princeton: Princeton University Press, 1982).

My next find was the inventory of Vermeer's father's possessions in 1623, which recorded the subjects of a number of his paintings, unfortunately all unattributed. This inventory was made in connection with a debt recognition in favor of his father-in-law Balthasar Claes Gerrits (Vermeer's grandfather), who had been implicated in a counterfeiting scheme in The Hague but had apparently recently moved to the small town of Gorinchem. Soon after, I found two depositions of 1653—one signed by the artist, one by his mother, along with two prominent Delft painters—relating to the activities of Vermeer's uncle, Reynier Balthens, a military contractor whose existence was hitherto unknown. This led me first to correspondence with the Gorinchem archive and later to actual research there, which produced a good deal of information about the activities of Grandfather Balthasar and Uncle Reynier in that city and in other parts of Holland. The importance of this maternal side of the artist's family, as it turned out, lay in the close contacts that they maintained with Vermeer's parents in Delft, who became involved in helping to get the military contractor out of jail in 1652. Some of the details in the civil suits and judicial processes regarding Reynier Balthens's case I found in the Rijksarchief in The Hague. Reynier Balthens's financial collapse seems to have contributed to the money troubles Vermeer and his mother experienced in the months following his father's death in October 1652.

After this exploration of the maternal side of the family, I decided to look more closely into the paternal side. This led me to the discovery of a key document, dated October 1620, in which Vermeer's grandmother, Neeltge Goris, asked her children and their spouses, all listed by name, to acknowledge that they had duly received the portions due to them out of the inheritance of her second husband, Claes Corstiaensz. Once I had these family links figured out, I had no trouble locating a number of other documents about the previously unknown Neeltge Goris and her three husbands, one of whom was Vermeer's paternal grandfather, as well as about her sons, daughters, and in-laws. One lengthy document, translated in full in Chapter 3, linked Neeltge Goris with Balthasar and his son, the future military contractor, at the time when the two men were engaged in the counterfeiting operation already noted. I then pursued this lead into the Amsterdam archives, which contained a comprehensive record of the interrogation of the main culprits in the affair and of their confrontation with Balthasar. Because Grandfather Balthasar had business dealings with founding members of the United East India Company and several very high personages were implicated in the counterfeiting affair, my account of his life in Chapter 2 is more closely interwoven with the history of seventeenth-century Holland than any other part of the book.

After I had more or less exhausted these records, which also yielded a

great deal of information about other artists and artisans active in the first quarter of the seventeenth century, I worked my way back to the notarial records of the 1640s, where I found a number of references to Vermeer's father's activities as an innkeeper and art dealer. His contacts with several major Delft artists of his generation had not previously been known. I then made a determined, and largely unsuccessful, effort to find out more about Johannes Vermeer's apprenticeship. My only significant finding for the critical period of 1652–1653 was a document that had been witnessed by both Vermeer and the genre painter Geraerd ter Borch.

The Delft archivist H. W. van Leeuwen, in 1977 or thereabouts, found a notice in the book of baptisms concerning the burial of a child of Vermeer in 1660 that had not been transcribed in the card files under his name. The entry in the book stated that Johannes Vermeer resided on the Oude Langendijck, thus in the house of his mother-in-law Maria Thins, when it had been thought that Vermeer was still living in his parents' inn. I thereupon decided to concentrate on the artist's life in the Roman Catholic milieu of the "Papists' Corner" in which the house was located. I was able to round out the work of Van Peer on the Vermeers' family life on the Oude Langendijck with the discovery of some new documents regarding the violent quarrels that pitted Vermeer's brother-in-law Willem against his mother Maria Thins and Catharina herself. In one episode, cited in Chapter 9, Catharina was assaulted by her brother when she was far along in pregnancy. My next-to-last round of research was in the Gouda archives in 1982 where again I followed the steps of Van Peer, J. C. Hebbers, and Rob Ruurs, who had also found a number of documents concerning Maria Thins, her husband Reynier Bolnes, and their respective families.

The principal fruit of this expedition came from a chance encounter with C. J. Matthijs. This gentleman, a secondary school teacher in Gouda, had formerly done considerable research on the Van Hensbeeck family, the ancestors of Vermeer's wife on her mother's side. In the course of his research he had found some petitions to the Orphan Chamber of Gouda by Maria Thins and Catharina Bolnes (by then the artist's widow), in which they described in fascinating detail the circumstances of Vermeer's death and the financial distress in which Catharina "had been left sitting with ten children under age." Perhaps because these petitions resembled in their contents similar but less detailed Delft-based documents, it had not been realized that they were new findings. They were in part published by Matthijs in 1978 in a booklet on the genealogy of the Van Hensbeeck family, which escaped the attention of historians working on Vermeer. The information the Gouda documents contain is supplied and analyzed in Chapter 12. My last foray outside Delft took me to Utrecht where I investigated, with the help of the genealogist W. A. Wijburg, the

links between Vermeer's in-laws and various patrician families that had also remained faithful to the Catholic Church.

Finally, in 1985, I discovered new documents on Pieter Claesz. van Ruijven, Jacobus Dissius, and Hendrick van Buijten, the principal collectors of Vermeer's paintings. These findings are incorporated into Chapter 13.

If nothing else, the reader should be impressed by the diversity of contributions, by amateurs and professional scholars alike, that served as building blocks for this study. The variety of sources uncovered in the course of the last century is also impressive. Documents about members of Vermeer's extended family have been found scattered through seventeen archives located in fifteen Dutch and Belgian cities: Amsterdam, Bruges (Municipal and State Archives), Delft, Gouda, The Hague (Municipal Archive and Algemeen Rijksarchief), Gorinchem, Brussels, Antwerp, Dordrecht, Schiedam, Rotterdam, Groningen, Utrecht, Breda, and Leyden.

The research I conducted intermittently from 1975 to 1986 differs from that of my predecessors in one important respect: I paid at least as much attention to the milieu in which Vermeer and members of his family lived and worked as I did to details concerning them directly. My work on the artists and artisans who belonged to the Guild of St. Luke, on inventories of paintings recorded in seventeenth-century Delft, on the art market in Delft, on real estate transactions, on the system of borrowing and lending through notaries, and on many other aspects of business and social life in the Holland of that time helped me set a coherent frame for my biographies.

This book is also aimed at placing Vermeer's art in perspective. It is concerned with his milieu and his relationship to his own family and to that of his wife not only for their own sake but also to trace possible connections between his environment and the contents of his known paintings (see Chapters 8 and 10). Although I am not a professional art historian, I have not hesitated to introduce aesthetic considerations in writing about the artist's works. Here I profited greatly from previous analyses of Vermeer's art, especially those of Albert Blankert, Lawrence Gowing, Andrew Forge, John Walsh, and Arthur Wheelock.

Institution for Social and Policy Studies,
Yale University
New Haven, Connecticut
October 3, 1987

COINS AND THEIR
EQUIVALENTS

Doit (Dutch "duit") – one-eighth of a stuiver
Ducatoon (Dutch "dukaton") – 3.15 guilders
Flemish pound – six guilders
Guilder (Dutch "gulden," abbreviated "f.") – twenty stuivers
Penny (Dutch "penning") – one-sixteenth of a stuiver
Rijksdaelder – two and a half guilders
Schelling – six stuivers

VERMEER AND HIS MILIEU

· 1 ·

BY THE SIDE OF THE
SMALL-CATTLE
MARKET

The modern history of Delft begins with the Great Fire of 1536, which destroyed the western quarters of the city. Of the two large churches that dominated the landscape, the Old Church, built in the thirteenth century, was spared; but the New Church on the Great Market Square, then already about a century old, burnt halfway to the ground. Few of the wooden houses that gave the town its medieval character withstood the fire. In the next forty years, the reconstruction of the New Church and the building of scores of houses in brick and mortar to replace the old wooden ones absorbed the energies of citizens and drained their resources.

In the 1540s and 1550s, stately houses went up around the Great Market Square near the New Church, along the Old Delft Canal, and in other neighborhoods where so many old dwellings had burned down (Fig. 2). These were the new houses, built along tree-lined canals, where rich burghers lived, who, as common people said, "sat on cushions and ruled the city."

The Franciscan Convent, southeast of the New Church, had only been singed by the fire. In the adjoining streets, a few decrepit wooden houses still stood, interspersed among brick houses with crenelated gables of various ages. This quarter was occupied chiefly by artisans, craftsmen, and laborers. Here coopers made barrels for the breweries for which the town was famous; potters turned the crude lead-glazed pots that most people cooked and ate in; carpenters, joiners, and masons worked on rebuilding the town; and a host of bakers, tailors, and shoemakers fed, clothed, and shod the citizens of Delft. All these tradesmen catered to rural dwellers of surrounding areas who came to town on market days to do their shopping. Delfland, the administrative region of which Delft was the principal city and the port of Delfshaven on the lower Maas River was the outlet to the sea, had been covered with marshes up to the thirteenth century (Fig. 1). The Counts of Holland had ordered the marshes drained and the land divided into polders lined with water-filled ditches. In the course of the next three centuries, these had become fertile croplands and meadows on which cattle grazed. In the villages strung along the river Schie, which runs southeast of Delft toward Schiedam and Delfshaven, there lived many rich farmers who were avid consumers of the confectionaries, cloth, and leather goods that the city's merchants offered for sale.

The masters in the crafts all belonged to guilds. Each guild, when Delft was still a Catholic city under the ecclesiastic dominance of the Archbishop of Utrecht, had its own chapel and altar in the Old Church or in the New Church. After the New Church had been nearly destroyed by the fire of 1536, it was reconstructed with the financial assistance of the guilds, which were only exempted from turning over half their incomes to the Church if they undertook to pay for the costs of refurbishing their own chapel.[1] Several times a year all the guild members walked in the Market Square (as the Great Market Square was more simply known) holding torches and candles in colorful religious processions.

The spiritual life of the city, from the time of the fire, was racked by religious struggles as an increasing portion of the inhabitants fell under the sway of Lutheran and Anabaptist doctrines. From the 1550s on, the well-organized disciples of Jean Calvin, who preached secretly in open fields and barns, made more converts than any other sect. The new creed was especially popular among the apprentices, laborers, and common textile and brewery workers, the polloi of the city. It was from among the most radical members of the Calvinist sect that the destroyers of graven images, the iconoclasts, were recruited. In October 1566, they converged on the reconstructed New Church from the populous quarters in the eastern half of the city. With hammer and tongs, they climbed on ladders, defaced the sculptures, destroyed the altars, and hacked to pieces the objects of worship wrought in the image of man that their pastors condemned as idols.[2] They also broke the beautiful colored-glass windows that had replaced those burnt in the fire of 1536. The syndics of the Guild of St. Luke (to which the painters, glassmakers, and other practitioners of artistic handicrafts belonged) were barely able to salvage the altarpiece painted by Master Maerten van Heemskerck of Haarlem, which they had helped to pay for with the accumulated funds of the guild just fifteen years before the assault on the church.[3]

At this time, Delft was still ruled by burgomasters, aldermen, and sheriffs who owed their allegiance to the King of Spain, Philip the Second. The Delft patriciate was said to be particularly resistant to the new faith. The authorities did not hesitate to comply with the directives issued by the Governor General, Philip's representative in Brussels, to check the spread of heresy and civil disorder. On All Saints' Day, 1567, a special church procession took place in Delft around the New Church and on the Market Square, to celebrate the Spanish victory against the Protestants at

[1] John Michael Montias, *Artists and Artisans in Delft: A Socio-Economic Study of the Seventeenth Century* (Princeton: Princeton University Press, 1982), pp. 16–25.
[2] H. J. Jaanus, *Hervormd Delft ten tijde Arent Cornelisz. 1573–1605* (Amsterdam: Nordemann's uitgevers maatschappij n.v., 1950), pp. 19–20.
[3] Montias, *Artists and Artisans*, p. 28.

Valenciennes. The masters in the guilds were compelled to contribute money to buy candles for the march. The rebellion was given renewed vigor in 1568 when Willem of Orange, who was legally the Stadhouder or lieutenant of the King in the provinces of Holland, Zeeland, and Utrecht, raised an army in Protestant Germany to fight the Duke of Alva, newly arrived from Spain to restore order by force. Willem was unsuccessful at this time and had to retreat to Germany, but his leadership of the rebellion braced popular resistance to Alva's despotism.

On July 25, 1570, the infamous Duke of Alva issued a general pardon to all repentant rebels. Once again the members of the various guilds of Delft walked around the Market Square to celebrate the pardon, which the Protestants regarded as a sham. On the same occasion the authorities ordered all citizens to go to church for the next few Sundays "to pray for the unity of the Mother Church."[4] These collaborationist decisions on the part of the city were bitterly resented by the Reformed preachers. They and their proselytes abhorred and feared the Inquisition that had been let loose on the heretics by the Duke of Alva. They watched silently, with hatred in their hearts, when the book printer Herman Schinkel was beheaded in Delft's Great Market Square on July 13, 1568, for having published Protestant tracts. But Catholics and Protestants alike were also alienated by the heavy contributions they had to pay to help suppress the rebellion. The "tenth-penny" tax levied on the burghers may have had as much to do with the revolt of the Northern Provinces as did religious opposition.

In early 1572, it seemed as if the Duke of Alva had secured Spanish control over both the Southern and the Northern Provinces of the Netherlands. Prince Willem of Orange's army was still confined to German territory under friendly Protestant rule. The sea-rovers commissioned by Willem to act as privateers had seized a few Spanish ships and made occasional forays on the coast of Holland and Friesland, but they were not considered a significant menace to the Spanish crown.

The situation turned around after the sea-rovers captured the port of Briell (Den Briel) on the Maas River on April 1, 1572 (Fig. 1). In the next few months, one city of Holland after another rallied to Willem's cause, in part for economic reasons, because their commerce required free access to the sea.

In July 1572, a majority of the ruling oligarchy of Delft voted to transfer the allegiance of the city to the Prince of Orange.[5] This great "Alteration," as the inhabitants called it, marked the shift from Catholic to Protestant rule. From this time on Delft played a major role in the league of

[4] Ibid.
[5] Jaanus, *Hervormd Delft*, p. 25.

Protestant cities in the northern provinces struggling against Spanish domination.

One of the first decrees issued by Willem the Silent, who elected to move his court to Delft shortly after the Alteration, banned all public processions. The candlelit marches around the Market Square and the New Church were never to be revived.

On August 3, 1572, the New Church was given over to the Calvinists. Even though they had won political control of the city, Calvinists could claim only 180 registered members, along with an unknown (but clearly much larger) number of sympathizers. The Old Church was left to the Catholics.[6]

Prince Willem's hopes that Protestants and Catholics would live in good harmony were soon disappointed. The highly revered Catholic Pater Musius, who was preaching in the St. Agatha Convent, was killed by Protestant troops in December 1572. The following year a new onslaught of the iconoclasts on the Old Church destroyed the idolatrous ornaments that had replaced those destroyed in the 1566 onslaught. The Calvinists kept the church. After the nuns were evicted from the Convent of St. Clara a few months later, no more Catholic services were held in public in Delft.[7]

Both the Old Church and the New Church were stripped of what was left of their "pagan" decoration. Clear-glass windows, which let in enough light for the faithful to follow the divine service in their prayer books, were set in the spaces that had once been adorned with grandiose compositions of colored glass. Ecclesiastic patronage for works of art virtually ceased. Henceforth, the painters and the other members of the Guild of St. Luke relied almost exclusively on a private clientele.

Calvinist control of ecclesiastic and civil institutions does not of course imply Calvinist dominance over the hearts and minds of the population. Many people, especially among the bourgeoisie, were influenced by the writings of Erasmus and supported his call for humanism and tolerance. Some of these were Protestant, others remained Catholic. Fanatic adherents to the doctrine of Calvinism were apparently to be found mainly among semi-literate artisans and similarly situated folk.

In any case there were too many Catholics left in Delft to ban the exercise of their religion altogether. Catholic services were still tolerated if they were discreetly held in "hidden churches." Adherents to the old faith suffered mainly official discrimination. They were denied access to all municipal functions. They could no longer become burgomasters, aldermen, or sheriffs. Yet they retained influence in some of the guilds, includ-

[6] Ibid., p. 33.
[7] Ibid., pp. 34–35.

ing the Guild of St. Luke. In 1582 Calvinists complained to the city administration that "the guilds continued to ring the bells on the days when the papists used to honor their patron saints."[8] With such timid exceptions, the guilds, which for centuries had clung to the bosom of the Church, abandoned their "papist" practices and became entirely secular.

The monasteries had now lost their raison d'être: they were either destroyed or put to other uses. The Franciscan Convent, which had withstood the fire of 1536, could not resist the attacks of Calvinist militants who, rightly or wrongly, suspected the monks of having kept lists of heretics before the Alteration.[9] The monks were chased out in 1572. Four years later the convent was turned over to the Calvinist church fathers, who had it demolished in 1595. Once the site on which it stood had been cleared of rubble, it was turned into the town's Small-Cattle Market, where pigs and goats were sold.[10] Only the name of the street that lined the north side of the Small-Cattle Market, called Broerhuyssteegh (the Brothers' House alley), recalled the old convent. This was the street where the family of Vermeer, on his father's side, lived toward the end of the 1590s and in the first quarter of the new century (Fig. 3).

The war with Spain waxed and waned until the Truce of 1609. In the early 1580s Prince Willem held his court in Delft in the old St. Agatha Convent, now called the Prinsenhof. He was still Stadhouder, by virtue of which title he ruled "in place of the king" against whom he was heading the rebellion. In July 1584 he was assassinated in the Prinsenhof by Balthasar Geerards, a Catholic fanatic in the pay of King Philip. His son Maurits succeeded him as Stadhouder. From the 1580s on, thousands of people of various denominations fleeing Catholic rule in the south migrated to Holland. Some emigrants left their homes because their towns had been ravaged or sacked, others because there was no work left in their devastated provinces.

The blocking of the Scheldt River by rebel ships had closed Antwerp's outlet to the sea. This loss had dealt the commercial capital of the south a blow from which it was not soon to recover. Many of its most eminent businessmen moved to Amsterdam and other Dutch cities. The number of refugees in Delft would have been greater still had not the city authorities elected to bar impoverished textile workers. Many of the refugees who were admitted stayed only a year or two and then made their way north to Leyden, Haarlem, or Amsterdam. Yet hundreds of families suc-

[8] Ibid., p. 73.
[9] Ibid., p. 19.
[10] H. C. Brouwer, "De verdwenen kloosters uit de Delftse binnenstad," in *De Stad Delft: Cultuur en maatschappij tot 1572*, exhibition catalogue (Delft: Stedelijk Museum Het Prinsenhof, 1979), pp. 56–57; P. C. Visser, "Waar de beesten te markt komen," *Delftse Courant*, 10 April 1948.

ceeded in settling in Delft, which had a population of about 15,000 in-
habitants at the close of the century. The colorful clothing and extrava-
gant taste for luxuries displayed by the new arrivals scandalized the more
sober and puritanical northerners. But the sermons of the Calvinist
preachers who castigated the self-indulgence and profligacy of the Flem-
ish and Brabanders were to no avail. By the end of the century the city
pulsed with new life as artists and skilled craftsmen who had immigrated
from Antwerp, Brussels, Ghent, and Mechelen strove to meet the in-
creased demand for luxuries. Many of these craftsmen prospered. The
city administration assisted a few of the more important southern masters
in establishing themselves. Foremost among them, Master Franchoys Spi-
erinx, the great tapestry maker from Antwerp, received spacious quarters
in the old St. Agnes Convent in the East End to set up his looms. His
tapestries were soon bought by the States General of the United Provinces
as gifts to foreign potentates with whom the new Republic wished to en-
tertain good relations.

Landscape and still-life artists from the southern provinces added range
and variety to Delft painting, which had hitherto distinguished itself
chiefly in portraiture and, to a much lesser extent, in religious composi-
tions. The intermingling of southern and local talents added variety to the
artistic life of the city. Young men who had come from Flanders and Bra-
bant learned painting from Michiel van Miereveld, Delft's most accom-
plished portraitist, whose work was renowned in the princely courts of
northern Europe.[11]

The new artistic currents from the south enlivened the city. Yet as a
whole Delft remained stately, conservative, and aristocratic. In a country
known for its cleanliness, it was reputed to be the cleanest town. The
Calvinist preachers exhorted their flocks to keep their souls as immacu-
late as their houses. Cleanliness was not only a matter of godliness: it was
also good for the beer business. Since the Middle Ages, ordinances had
been in effect that prohibited throwing rubbish and feces in the canals, to
keep the water pure for the breweries.

TOWARD the end of the century, Vermeer's grandfather, a tailor named
Jan, lived with his wife and three children in a house called Nassau, abut-
ting the Small-Cattle Market. In those days common people had no last
names. Both men and women were identified by their fathers' Christian
names. Jan was known accordingly as "the son of Reyer" (in Dutch, Re-
yerszoon, abbreviated Reyersz.). Vermeer's grandmother Cornelia was
the daughter of a man named Gregory. She was called Neeltge (little Nel)
for short. Neeltge's patronymic was familiarly condensed from Gregoris-

[11] Montias, *Artists and Artisans*, pp. 47–49.

dochter to Gorisdochter or just plain Goris, and she was known to one and all as Neeltge Goris.

When the first son of Jan and Neeltge was born in 1591, they christened him Reynier, a variant of his grandfather's name.[12] He became known as Reynier Janszoon (or Jansz.). Forty years later when Reynier had a son—the future painter—he baptized him Joannis after the child's grandfather, the tailor Jan. By the time Johannes (to use the more common spelling of his Christian name) was growing up in the 1630s, most self-respecting burghers of Delft had taken last names. Reynier Jansz. first called himself Vos (fox), later Vermeer. The painter himself always signed his Christian name plus Vermeer, omitting his patronymic, Reynierszoon, or Reyniersz.

Tailor Jan and Neeltge had two other children besides Reynier Jansz.: a daughter named Maertge (little Maria) and a son, Anthony. Maertge, Vermeer's aunt, was born about 1594. She lived until 1661, the year her nephew became a headman of the Guild of St. Luke. Anthony came into the world sometime between 1592 and 1597.[13]

Most of the people living around the Small-Cattle Market were illiterate. Only major events in their lives—their baptism, marriage, and burial—were recorded in the vellum-bound registers of the Old or the New Church. From time to time they went to a neighborhood notary to transfer property, borrow money, or testify to some event they had seen or heard. Some of the notarial papers from this early period have come down to us, but most are irretrievably lost.

The earliest document about the Vermeer family that survived the ravages of time is a "notarial protocol" dated January 11, 1597.[14] It is typical of those laconic depositions from which entire lives must sometimes be reconstructed. On this occasion the tailor Jan Reyersz. appeared before the family's notary, Van Overgaeu, and transferred to a merchant an interest-bearing obligation issued in 1591 for forty-eight guilders in exchange for the cash value of the obligation. The transfer was witnessed by two neighbors: a tailor named Claes Corstiaensz. and an ironsmith.

[12] The date of birth of Reynier Jansz. can be inferred from five documents reporting his age: He was said to be 24 years old on 27 June 1615 (doc. no. 17), 43 on 27 January 1635 (doc. no. 143), 49 on 6 September 1640 (doc. no. 156), 53 on 11 February 1645 (doc. no. 181), and 58 on 24 June 1650 (doc. no. 229). For all these dates to be consistent he would have to have been born between June 25 and June 27, 1591. It is more probable, however, that he exaggerated his age by a few months at the time of his marriage and that he was born sometime between late June and early September 1591. Document numbers cited in the notes refer to Appendix B.

[13] Maertge Jansdr. was said to be 55 years old on 27 May 1649 (doc. no. 215). I infer from the fact that Reynier Jansz.'s name was listed before Anthony Jansz.'s when they both appeared as witnesses that Reynier was older than Anthony (doc. no. 103, 2 January 1625). It was customary (although exceptions can be found) to list witnesses by order of age.

[14] Doc. no. 2, 11 January 1597.

This is the only notarial document we have that bears the name of Jan Reyersz.[15] Since it is an unsigned notary's copy of a lost original, we shall probably never know whether the tailor living in the House of Nassau was literate (which he most probably was not).

Jan Reyersz. was perhaps ill and in need of money when he cashed the obligation. Less than five months later, on May 2, 1597, he was buried in the New Church.[16]

Neeltge, who was thirty years old when her husband died, did not wait long to remarry. On October 19 of the year 1597 she was joined in holy matrimony with the same Claes Corstiaensz. who had witnessed the debt transfer nine months earlier.[17] Both the bride and groom were said to be living in the Broerhuyssteegh. Neeltge's second husband owned a house on this street. A board representing three hammers hung from the side of the house facing the market. The house called "The Three Hammers" still exists. It bore the old name until a few years ago.

Neeltge's new husband was the grandson of Aert van der Minne, who was born around 1480. His father, Corstiaen Aertszoon, born about 1515, had migrated to Delft, probably from Flanders, sometime before 1553, when he is referred to as "Master Corstiaen, cantor" ("zanger") in one of the city's official books. He became a citizen of Delft in 1559. In 1566 he was said to exercise the trade of barber. His son Niclaes, usually referred to as Claes Corstiaensz., was born about 1548. He was first married to Ariaentge Dircksdr. van Zeijl, with whom he had two children, a son named Dirck, baptized on November 6, 1582, and a daughter Grietge who died young. Dirck was about fifteen years of age when Claes Corstiaensz. married Neeltge after the death of his first wife. He was nine years older than Vermeer's father, Reynier Jansz.[18] In 1599, Claes Corstiaensz. and Neeltge Goris produced a daughter whom they named Adriana or Adriaentge (little Adriana) after Claes's first wife, Ariaentge Dircksdr. By then there were five children living in The Three Hammers, three from Neeltge's first marriage with Jan Reyersz. (Reynier, Anthony, and Maertge), one from Claes Corstiaensz.'s previous marriage (Dirck), and one from the newly married couple (Adriaentge). A quarter of a cen-

[15] It is quite possible that "Jan Reyersz. cleermacker," living on the Marcktvelt, who acted as surety for Jan Ariensz. van den Ouden Bosch (in Brabant) when he acquired the citizenship of Delft on 1 April 1592, was the artist's grandfather ("Poorter regyster," fol. 69ᵛ).

[16] Doc. no. 3.

[17] Doc. no. 4. Neeltge Goris was said to be 56 years old on 2 October 1623 (doc. no. 92). The marriage is recorded in doc. no. 4.

[18] The genealogy of Claes Corstiaensz. was first published by A. van der Minne (one of his descendants) in *Genealogie van de familie Van der Minne* (Utrecht: Familie uitgave, 1937). The author claims without much supporting evidence that Claes was descended from the minstrel Pieter van der Minnen, who flourished in the 1380s. The links he traces between Claes Corstiaensz., Neeltge Goris, and Adriaentge Claes confirm my independent findings in "New Documents on Vermeer and His Family," *Oud Holland* 91 (1977): 270.

tury later Anthony called himself Vermeer; Dirck and Adriaentge, van der Minne, which was apparently the ancestral name of Claes Corstiaensz. No one knows whether Vermeer's grandfather, the tailor Jan Reyersz., ever used the name Vermeer.

The artist's father, Reynier Jansz., made the confusion worse by first calling himself Reynier Vos, then registering in the Guild of St. Luke as an art dealer under the name of "Reijnier Vos or Reijnier van der Minne," and ending his life as Reynier Vermeer. This variability of names was common in a period of transition from people having no surnames at all to having permanent ones. In 1600, The Three Hammers was used as a tavern and Claes was referred to as a tapster or tavern keeper. He probably ran a small-scale establishment that catered chiefly to neighboring craftsmen and artisans. Claes's neighbors at the time, we learn from a register of the taxes on hearth,[19] included a cooper, a smith, a joiner, and a surgeon (who shaved beards, bled arms, and set bones). Another neighbor on the Broerhuyssteegh was a man named Jan Janszoon who worked for one of the new faience manufacturers that had sprung up near the Oosteynde Canal, a couple of blocks to the east of the Small-Cattle Market. The makers of tin-glazed dishes and tiles, which became known all over the world as Delftware, were soon to bring fame and wealth to the city. All the neighboring artisans whose names were recorded in the tax book at least owned their houses. There were also many humble families who rented a room or two from those established citizens.

The first indication we have that the family in The Three Hammers was Protestant is the registration of Maertge as a member of the Reformed Community in August 1604. She was then about ten years old, about the age at which members of the community were confirmed.[20]

In the next few years, the Vermeer family began to rise in the world, just as Delft itself swelled and prospered. The first step was symbolic: from about 1611 on, Neeltge's new husband Claes Corstiaensz. is referred to in numerous documents as a musician, an occupation that recalls his own father's vocation (or avocation) of "cantor." Hereafter he was called Master Claes Corstiaensz., musician (in Dutch, "speelman").[21] We might never have known what sort of musician or player Master Claes was if his son Dirck Claesz. had not left a small collection of musical instruments at his death in 1657.[22] Since Dirck himself was a master felt worker and hat merchant with no known professional connection with music making, it is very likely that the instruments had been left to him by his father. There were six instruments in all: a lute, a trombone, a

[19] Delft Gemeente Archief (hereafter G.A.), "Haardsteden register" 1600.
[20] Doc. no. 5, August 1604.
[21] Doc. no. 11, 17 May 1611.
[22] Doc. no. 270, 20 July 1657.

shawm (a wooden pipe shaped like an oboe), two viols, and a cornet.
Two of the five paintings in Dirck Claesz.'s estate represented musicians.
When a notarial inventory was taken of Reynier Jansz.'s possessions in
1623, the first item listed was a painting of an "Italian piper." The
wooden flute in the family collection was perhaps the instrument Ver-
meer's father played on. Master Claes probably played one of the viols
(the word "speelman" also means "fiddler"). Five years after the death of
his stepfather, Reynier Jansz. witnessed a notarial deposition for another
musician with whom he was almost certainly acquainted.[23] This man re-
lated how he had gone to play for a wedding in a village near Delft and
how over a hundred people danced far into the night. Master Claes and
his little family orchestra in all likelihood played in inns and brothels
(which were often one and the same), and at the more elegant weddings
in town as well as at simple country dances.

Music making was another worldly activity that the Reformed clergy
deplored but could not stop. Their representatives in the early church syn-
ods had succeeded in banning organ music from services but had failed in
their attempts to have the organs (built in pre-Reformation times) re-
moved from the churches. The preachers did not have sufficient power in
the community to prohibit the secular music that Master Claes played,
but they did their best to deter the faithful from such vanities.

For reasons that are no longer apparent, Claes Corstiaensz. borrowed
money frequently. From 1608 on, the family notary Van Overgaeu lent
him money at interest on various occasions. Eventually, the loans totaled
slightly over six hundred guilders, equivalent to about two and a half
years' pay for an ordinary worker at the time. These debts remained a
heavy burden on the family after Master Claes's death.[24]

We get a first faint glimmer of Neeltge's character in a testament drawn
up and signed in Claes Corstiaensz.'s house on the Broerhuyssteegh in
December 1610.[25] The testator, who was the son of a broommaker, left a
certain woman named Annitge Bouwens the sum of eighteen guilders to
buy a silver chain on condition that Annitge remain single until his death.
If she were to marry or to die before his death, the money would go to
Neeltge Goris, the wife of Claes Corstiaensz., also for the purpose of buy-
ing a silver chain, which would be given after her death to her children
and children's children. Why the broommaker's son wanted Annitge Bou-
wens to remain single we do not know. Wills and depositions rarely ex-
plained circumstances that were presumably familiar to those present.
That the conditional gift should have been made out to Neeltge Goris is

[23] Deposition of 20 September 1622 by Cornelis Cornelisz. (Delft G.A., records of Notary
H. Vockestaert, no. 1587).
[24] Doc. no. 15, 19 January 1613; no. 16, 29 May 1615; no. 31, 11 February 1619.
[25] Doc. no. 10, 17 December 1610.

not so mysterious, given what we know of her personality as it emerges from episodes that will subsequently be described. She was capable of talking an acquaintance into doing something like this.

Claes Corstiaensz. made his mark in lieu of his signature as a witness to the will. He was illiterate, as were most craftspeople of his generation. After the Alteration many more children went to school to learn to read the Holy Scriptures. Dirck Claesz., the musician's son, who was twenty years old at the time, signed the will. There is little doubt in view of the clear and firm signatures on this and other documents that the three boys—Dirck, Reynier, and Anthony—had all gone to school. The girls— Maertge Jans and Adriaentge Claes—could sign their names but not very well or fluently, and it is doubtful whether they attended school for long (if they attended it at all). Women in those days were considered sufficiently educated if they could follow the church service in their prayer books.

The next year, which was 1611, Reynier Jansz., now twenty years old, was sent to Amsterdam to learn the trade of caffa worker. Caffa was an expensive silk-satin fabric, generally mixed with cotton or wool, that the Flemish immigrants had helped to make popular in the north. Since the 1590s a few masters, apparently of southern birth, had been weaving caffa in Delft. One of them was said to have learned drawing before 1600 with "Master Jacob." This no doubt was Jacob Willemsz. Delff, the best painter of religious scenes in town. Drawing was helpful in weaving the fine patterns in the damasked cloth. Apprenticeship in this skilled occupation normally lasted four years, two years less than for artist-painters who were bound to one or more masters for six years before they could join the guilds.[26]

Reynier began his apprenticeship rather late. Most boys were apprenticed to master weavers, in caffa or other fabrics, when they were in their teens. Could it be that Reynier had failed to become an accomplished musician, or had he been loath to succeed his stepfather? It is also probably significant that Master Claes apprenticed his stepson in Amsterdam where the caffa-weaving craft had been brought to a higher degree of perfection than in the more provincial city to the south.

When Reynier was twenty-four years old and had completed his four-year apprenticeship, he was betrothed in Amsterdam on June 27, 1615, to a girl born in Antwerp named "Digna Balthazars," said to be twenty

[26] Montias, *Artists and Artisans*, p. 45. A contract for the four-year apprenticeship of a nineteen-year-old *caffawercker*, dated 29 March 1628, has been preserved (Delft G.A., records of Notary A. van Twelle, no. 1654). The young man was expected to work from 6 A.M. in the summer and from sunrise in the winter until 8 P.M. After completing his apprenticeship he would be able to make "woolground" ("wollegront") and satin. He was to be fed and lodged by his master, who was to pay him in addition ten stuivers (a half-guilder) a week.

years old.[27] Digna was accompanied by her father "Balthazar Geerars-zoon," more commonly known as Balthasar or Balten Gerrits. (Digna normally used the familiar form of her father's name as a patronymic and called herself Digna Baltens.) The municipal document stipulated that before the marriage could take place the consent of the young man's father would have to be obtained. A marginal notation shows that Reynier brought in an attestation, signed by Johannes Taurinus, pastor of the New Church in Delft, along with his stepfather's consent. The marriage took place on July 19 before Jacobus Triglandius, a famous Calvinist preacher, one of the leaders of the strictly orthodox Gomarist party in the Reformed Church. The attestation of Taurinus and the consecration of the marriage by Triglandius prove that both birde and bridegroom were Reformed. We know from other evidence that Reynier Jansz.'s mother Neeltge Goris, his sister Maertge, and his paternal uncle Reynier Balthens were all members of the Reformed Community, the official designation for the Calvinist Church. Both families thus belonged to the dominant Protestant religion.

The newly betrothed were expected to sign a statement in the register to the effect that they were unmarried persons and free of blood ties. The future bridegroom signed neatly "Reijnier Jansz.," while Digna made a cross. She later learned to sign her name, as many illiterate people did. That she had not gone to school is further proof of her father's impecunious circumstances in the early 1600s. Her brother Reynier Balthens, if we may judge by his fairly fluent signature, probably did attend school long enough to learn to read and write.

A few weeks before the wedding took place, Neeltge's second husband, Claes Corstiaeansz., borrowed two hundred guilders, perhaps to pay for the wedding or to provide the young couple with a little money to start their household.[28] Claes Corstiaensz.'s son, Dirck Claesz. van der Minne, and Jan Heymenszoon, baker, were "co-principals and guarantors" of the loan, responsible for repayment if it fell in default (as it eventually did). This Jan Heymensz. was Reynier Jansz.'s brother-in-law, having married his sister Maertge about this time. The master baker—Vermeer's uncle by marriage—would entertain long and close relations with the artist's family.

Reynier Jansz. and his bride seem to have returned to Delft soon after the marriage to live with Reynier's parents in The Three Hammers. In December 1616, Digna Baltens was present at the christening of Jan Jansz., son of baker Jan Heymensz. and Maertge Jans. Neeltge, the boy's grandmother, was another witness.[29]

[27] Doc. no. 17, 27 June 1615.
[28] Doc. no. 16, 29 May 1615.
[29] Doc. no. 18, 23 December 1616.

Anthony Jansz., Reynier's younger brother, was apprenticed to a stone-cutter. We have no idea whether he learned the trade from a bona fide sculptor or from a common stonecutter, since both crafts were designated only as "steenhower." In any case, he never became a master in the Guild of St. Luke, to which sculptors belonged.

Sometime before Master Claes's death in October 1617, Anthony married a young woman named Catharina (or Tryntje) Isbrandts. Two weeks before Claes was buried,[30] Anthony's first child Neeltge (named after her grandmother) was christened in the New Church.[31] The custom was to baptize children one or two weeks after their birth at a noontime service immediately after the sermon. For Protestants, it was not urgent to baptize a child within a day or two after birth because, if it died before the ceremony took place, it was not fated to go to limbo as Catholics believed it would.

After Master Claes's death, Neeltge Goris and her family (including her daughter Maertge and her son-in-law Jan Heymensz., who had a house and bakery next to The Three Hammers), continued to dwell on the Broerhuyssteegh, by the side of the Small-Cattle Market. The market was held every week. We can imagine the long-haired pigs, their front and hind legs tied with osier stems, lying on their sides as they waited for buyers. The shouts of the crowd mingled with the squeals of the hogs and the bleats of the sheep and goats; the stench of manure wafted from the square to the eaves of surrounding houses. Not all the inhabitants of the quarter were happy over the transformation of their neighborhood. Some older residents no doubt missed the soft peals of the old convent's chapel bells, which had given way to the strident sounds of the market. Others remembered the flowers in the monks' inner yard, which smelled sweeter than the pigs and goats.

On market days the butchers and the ordinary citizens who came to buy a hog or two for fattening or slaughter met the farmers who had brought their livestock for sale. One master butcher originally from Rotterdam, Anthony Jansz. Back (about sixty years old in 1617), had a son, Jan Thonisz., who came with him when he bought sheep and hogs and then helped to slaughter and dress them. Adriaentge, the daughter of Claes and Neeltge, probably became acquainted with the young butcher in the market-place. He was a good match for her. The number of master butchers in Delft had been limited from time immemorial to thirty-two, and Jan Thonisz. would inherit his father's butcher stall on the Great Market Square, in front of the New Church, when the old man died. They were married in the beginning of August 1618, just ten months after Mas-

[30] Doc. no. 21, 9 October 1617.
[31] Doc. no. 20, 20 September 1617.

ter Claes's death.[32] Adriaentge left home and went to live with her hus-
band and father-in-law on the Vlamingstraat, a few blocks to the north-
east. The young couple retained close links to their family on the
Broerhuyssteegh for many years to come.

Except for Master Claes's musicianship, there was little to distinguish
the family of Vermeer's father, Reynier Jansz., from the milieu of crafts-
men and artisans established around the Small-Cattle Market.[33] To be
sure, Reynier, his stepbrother the hatmaker Dirck, and his brother-in-law
the baker Jan were all masters in their trades. They were better off than
the great majority of the apprentices and journeymen in their neighbor-
hood. Yet their economic and social status hardly rose above the lower
middle class of Delft citizens. They owned their houses and lived in mod-
erately comfortable circumstances, but they did not have a sufficient
cushion of wealth to save them from financial ruin when the winds of
chance began to blow against them. The financial collapse of Neeltge
Goris and of the butcher Jan Thonisz. will be related after the curious
story of Balthasar Gerrits (Vermeer's maternal grandfather), the subject
of the next chapter.

[32] Doc. no. 24, 21 July and 5 August 1618.
[33] On the neighbors of Claes Corstiaensz. in 1620, see the "Verponding boek" of 1620
(Delft G.A., fol. 215). On one side of the house there lived Michiel Joosten, cooper; on the
other Adriaen Pietersz., surgeon. Jan Heymensz., baker, the brother-in-law of Reynier Jansz.,
lived three houses down, and Jeroen Fransz., joiner, another two houses away from Claes
Corstiaensz.'s home. Jan Jansz., faiencier ("plateelbacker"), also lived in the neighborhood.
The house of "the widow of Claes Corstiaensz." (Neeltge Goris) paid a tax of six guilders,
which was above average for the neighborhood (Jan Heymensz. paid only four guilders).

· 2 ·

GRANDFATHER BALTHASAR,
COUNTERFEITER

Balthasar Gerrits, the father of Digna Baltens (the artist's mother), was born in Antwerp in or about 1573, some three years before the Spanish ransacked the town.[1] He was twelve years old when the resistance finally succumbed to the onslaughts of the Duke of Parma besieging the city. The citizens of Antwerp had to knuckle under to Spanish-Catholic rule or choose exile. Balthasar, when he was old enough, chose exile. He was still in Antwerp when he married Beatrix van Buy on the fourth day of January, 1596,[2] if he is identical with the "Balten Geerts" who appears on the register of marriage of the St. Jacob's parish in Antwerp on that date (as I think is quite probable).

Balthasar was the son of Claes Gerritszoon (or, more formally, Geerardszoon). He probably used his father's patronymic as a last name, as was frequently done in Antwerp. Thus he could call himself Balthasar Gerrits or Geerts or, as he did after he had gone to live in Gorinchem, Balthasar Claeszoon or Claesz. He generally signed Balten Claes Geersen,[3] which comes close to his putative name on the marriage register of St. Jacob's. I shall refer to him as Balthasar Gerrits, the most commonly used form of his name.

When Balthasar's daughter Digna was married in 1615, she claimed to be twenty years old. She may have exaggerated her age by a year or so, if she was born after her parents were married. At the time of her marriage in Amsterdam she was said to be "from Antwerp," which meant that she had been born there. Balthasar and his wife must have left Antwerp soon after 1596, since their son Reynier, who was only a few years younger than his sister, came into the world in Amsterdam.[4] There was also apparently a daughter Tanneken, still living in 1623, but nothing is known about her birthplace.[5]

[1] Balthasar's age was stated to be 38 in a deposition dated 13 September 1611 (doc. no. 12).

[2] Doc. no. 1, 4 January 1596.

[3] As in doc. no. 12 of 13 September 1611. In doc. no. 82 of 18 June 1622, Balthasar is called Balten Gersz.

[4] Doc. no. 17, 27 June 1615. When Reynier Balthens remarried in Gorinchem in 1637, he was said to be "from Amsterdam," by which was meant that he was born there (doc. no. 147, 14 January 1637). Since he could not have been much less than 18 years old when his putative child was baptized on 21 December 1618 (doc. no. 30), he must have been born between 1596–1597 and 1600.

[5] In doc. no. 93 of 15 October 1623, "Tanneken Balthus" appears as a witness at the

When Balthasar arrived in Amsterdam, the port city on the IJssel River was in the midst of a vigorous expansion.[6] After Antwerp, the great commodity market of the Lowlands, had been retaken by the Spanish in 1585, the insurgent northerners of Holland and Zeeland blocked the Scheldt River and cut the city off from its outlet to the sea. Antwerp's trade was soon displaced to Amsterdam, the best protected port in the north. Even before this windfall, Amsterdam had been a prosperous shipping center. But only after the fall of the city on the Scheldt did it develop as a trading forum, a place where finance, credit, and insurance were available on an unsurpassed scale, an entrepôt for stocking the staples of the world. Its population of thirty thousand in 1560 (only twice as large as Delft's) had already doubled by 1600. By this date, it had forged ahead of Haarlem and Leyden as the foremost commercial city of Holland. Amsterdam was far less constrained by tradition and more open to new currents than its old, established competitors. Here was a place of opportunity where individuals of talent, both honest men and hustlers, could improve their lot. More Flemish immigrants lavished their beneficial influence and settled here than in Dordrecht, Rotterdam, Delft, The Hague, Leyden, or Haarlem, the largest towns they had crossed on their northern trek.

Owing to the initiative of the city's successful merchants, many of whom were immigrants from the south, new institutions to facilitate business were created in Amsterdam around the turn of the century. The Chamber of Assurance, founded in 1598, and the United East India Company, chartered in 1602, preceded by only a few years the launching of the Stock Exchange, the Exchange Bank, and the Bank for Lending. Together they created a vastly improved framework for conducting trade. Balthasar Gerrits, who was a witness to these developments, played a modest part in a scandal that arose over speculation in the shares of the East India Company, only seven years after the Company's founding.

We first find Balthasar Gerrits mentioned in January 1606 when he bought a house, situated just beyond the city walls of Amsterdam, for one thousand guilders.[7] In the city record of the transaction, he is called "lichterman," an individual unloading cargo from ocean-going vessels into flat-bottomed boats called lighters. This was perhaps the best work he could find upon immigrating to Amsterdam. But he may already have

christening of Niclaas, son of Reynier Balthensz. in Gorinchem. I surmise that she was Reynier's sister.

[6] On Amsterdam's expansion after 1600, see Violet Barbour, *Capitalism in Amsterdam in the 17th Century* (Ann Arbor: University of Michigan Press, 1963).

[7] The evidence on Balthasar Gerrits's role as a real estate broker is contained in Amsterdam, Gemeente Archief, R.A. 5061, inv. nr. 2764, fol. 52; R.A. 5073 Weeskamer, inv. nr. 922, fol. 31–32; R.A. 5068, "Willige verkopingen," fol. 114ᵛ. These documents were kindly communicated to me by S.A.C. Dudok van Heel and Marten J. Bok. On his role as a broker in East India Company shares, see doc. no. 6 of 15 August 1609.

abandoned this low-status occupation by this date to become a broker in real estate and other assets. Speculation in real estate was rife at a time when population pressure was causing Amsterdam to burst at the seams. The city government was forced to tolerate the building of houses on the Nieuwezijds Achterburgwal, where Balthasar's lot was located, virtually without municipal supervision. He resold the house in 1609 at a 10 percent profit. In 1608 he is called a merchant's servant ("koopmansdienaar") when he buys another lot with a house, this time for 1,450 guilders, in the Plempenpad, also beyond the city walls. Two years later he claimed to the city authorities that he had resold the house without profit and was therefore not obligated to pay taxes on the transaction. This may not have been the truth: he had in fact parcelled out the ground into several lots which he had sold at auction separately, presumably at a profit. It is not known whether he was acting on his own or as a broker on behalf of other parties in either the transaction of 1606 or that of 1608.

In a notarial deposition of August 1609 Balthasar first appears as a broker (in Dutch "makelaer") in a transaction in East India Company shares. Normally such brokers were registered with the city, which he was not. It is extremely probable that he could not act as a broker unless he was literate, although there is one document that can be interpreted to mean that he was not.[8]

The affair began in February 1609 when a group of ten Amsterdam businessmen, most of them of Flemish origin, formed a "Groot Compagnie" (Great Company) to speculate in shares of the East India Company.[9]

[8] Doc. no. 6, 15 August 1609. The only evidence that he was illiterate stems from the following quotation extracted from the interrogation of the prisoner Hendrick Sticke when he was confronted by Balthasar Gerrits (his former employee in the counterfeiting operation). Sticke was asked whether it was true that: "hij in den brieff aen sijn moeder op Craijenburch geschreven die was gaende neffens den brief aen hem declarant ende bij hem (door dien hy niet lesen en conde) onverroerts geopent ende van een ander voorgelesen was, heeft gestelt in effecte dese woorden: weet beminde moeder dat de bringer dieses sal mijn dienaer sijn. . . ." This may be literally translated as follows: "He [Sticke] had written in the letter to his mother in Crayenburch, which went along with the other letter to the declarant [Balthasar Gerrits] and which had been opened by him unexpectedly (seeing that he could not read) and had been read aloud by another, in effect the following words: 'Be advised, dear mother, that the bringer of this will be my servant.' " Sticke denied only that the letter said that the bringer of the letter would be his servant (doc. no. 35, R.A. 293, fol. 22). If Balthasar Gerrits could not make out to whom the letter was addressed or read the letter itself because he had no glasses (or for some reason other than his illiteracy), the scribe should have written that "he could not read *it* [the letter]." It is also possible that Balthasar pretended that he could not read the letter. On balance, I am inclined to believe that these alternative explanations are more probable than that Balthasar could have operated as a broker and represented a merchant in a suit (doc. no. 7, 13 March 1610) without being able to read and write. On the other hand, it must be conceded that the signatures of Balthasar Gerrits in documents nos. 9 and 94 betray a low level of literacy, compared—for example— with the fluent signature of Vermeer's father.

[9] The following account is based on J. G. van Dillen, "Isaac Le Maire en de handel in

The most important of the participants was the rich merchant Isaac Le Maire, one of the original subscribers to the East India Company. For some time he had been engaged in secret negotiations with King Henry IV of France to launch a new enterprise under French aegis that would have competed with the Dutch trading monopoly. When Isaac Le Maire's association was formed, the shares of the East India Company were trading at 49 percent above parity. The profits of the company were to be distributed to share owners on the tenth anniversary of the founding of the Company, which fell in 1612, at which time the initial capital was to be completely liquidated. The associates in the Groot Compagnie, in the expectation of a decline in the value of the shares, which would almost certainly have occurred if Isaac Le Maire had succeeded in his devious scheme to set up a competing enterprise under French sponsorship, sold shares that they did not own for delivery one to two years hence. Such "short" or "blanco" sales were on the fringe of legality at the time. In August 1609, when the shares stood at 141, Balthasar Gerrits had acted as broker in a sale to one member of the Groot Compagnie, who was perhaps "covering" a short sale after making a moderate profit. The controversy that had arisen over this particular transaction was whether the seller had really disposed of the shares or whether he was equivocating so that he could claim the shares were still his in case their value rose again. (The buyer had sent Balthasar to the seller's house on several occasions to entreat him to deliver the sale contract but without success.)

Prices of shares kept slowly declining throughout 1609, reaching a low of 131 in January 1610. There was talk of a conspiracy to depress prices. Shareholders accused Le Maire and his confederates of sowing unwarranted rumors about East India Company reverses to precipitate sales. In February 1610, the States General issued an edict forbidding "blanco" sales. But, by then, favorable reports were reaching Amsterdam about successful campaigns of the Company in the East Indies and the expected return of ships laden with spices. In April 1610, Henry IV was assassinated, and Le Maire's hopes of making a deal with the French evaporated. The shares began rising. In August they stood at 152 to 156 percent of parity; in 1611 they climbed to 200 percent. Several of the speculators were wiped out. Two members of the association, Pieter Loos and Hans Bouwer, were declared bankrupt. Le Maire, who had lost a very large sum of money in these speculations, spent the rest of his life in lawsuits, waged by or against him, in consequence of the affair.

On September 13, 1611, Balthasar Gerrits, thirty-eight years old, merchant's clerk or servant, appeared before an Amsterdam notary to testify

actiën der Oost-Indische Compagnie," *Economisch-historisch Jaarboek* 16 (1930): 46, 107-111.

at the request of Hans Bouwer.[10] Balthasar declared that Pieter Loos and Hans Bouwer had signed a contract in April 1610 whereby Bouwer undertook to pay a bill of three thousand guilders that Loos owed to an Antwerp merchant. Bouwer's representative in Antwerp had delivered the money, but Loos had not paid Bouwer back. Both Bouwer and Loos, as we know, were already bankrupt by this time. In October 1610 Bouwer had been summoned by the sheriffs to answer complaints of fraud, not just for selling "short" but for flagrantly illicit manipulations. In April 1611, five months before the attestation had been made, he was arrested and set in irons at the Town Hall. He was still (or again) in prison in May 1615. A year earlier Loos had also been arrested for fraudulent dealings in The Hague but had been released soon afterward. Balthasar Gerrits's role as an intermediary in transactions effected by three members of the Groot Compagnie, whose operations caused the greatest scandal to hit the stock exchange in its first decade of operation, was not necessarily reprehensible; but it certainly raises the suspicion that he must have known about the shady affairs of his clients. His subsequent career suggests that he did not keep bad company in all innocence.

We do not know when Balthasar's first wife, Beatrix van Buy—Vermeer's grandmother on his mother's side—died. It was probably not long before the counterfeiting venture that Balthasar married, or began to live with, his second wife, Beatrix Gerrits, who was twelve years younger than he was. The second Beatrix, the daughter of a military man named Gerrit Vouck, had served twelve years as one of Amsterdam's city-appointed midwives when her first husband was still alive.[11] She survived until the mid-1650s, long after Balthasar's death, the last link between Vermeer's generation and that of his grandparents.

In 1610 and 1611 Balthasar Gerrits is cited several times in the records of Amsterdam notaries. The first mention is not specific enough to be sure that we are dealing with Balthasar Claes Gerritsz., although the identification seems probable. This Balthasar Gerrits, representing a merchant in Dieppe who had lost a suit against an Amsterdam woman, had a notary formally notify her that the merchant was appealing his suit.[12] Another document, because it mentions Balthasar's age (which is consistent with that given a year later in a signed document that can be attributed to him with certainty), doubtlessly refers to him. Here he appears as a witness to a conversation he had heard in an inn in Leyden. One of the two goldsmiths who were with him on this occasion (and with whom he may have

[10] Doc. no. 12, 13 September 1611.
[11] Document no. 121, 27 January 1628; and no. 134, 17 April 1632.
[12] Doc. no. 7, 13 March 1610.

been conducting business) was closely associated with the uncle and
guardian of the painter Frans van Mieris.[13]

In June 1610 Balthasar Gerritsz., merchant's clerk, bought a small
house for only four hundred guilders, for which sum he had to acknowl-
edge a mortgage debt before the two aldermen of the city. The house was
located in a passage called "in't hol" in a poor section of Amsterdam.[14]
He may have been forced to move into these modest quarters after he had
lost money in the debacle of the Groot Compagnie, which had occurred
a couple of months before he purchased the small house.

Two years later the house Balthasar had acquired was sold by order of
the city authorities, presumably because he had not been able to keep up
his mortgage.[15] In 1615, when his daughter Digna married Reynier
Jansz., she was said to be living "in the Dyeworks" (De Ververij), where
her father was perhaps employed. The traces left by Vermeer's grand-
father in these notarial documents give the impression of a man hobnob-
bing with people richer or better established than he was, but also a man
who was not able at this time to secure for himself a solid place in society.
This guess is no doubt colored by our knowledge of the man's subsequent
tribulations.

In the middle of 1618, Reynier Balthens (Balthasar's son and Johannes
Vermeer's maternal uncle) turned up in Delft where he was apprenticed
to a joiner living next door to Neeltge Goris and her family on the Broer-
huyssteegh.[16] He must have come to Delft, after getting his earlier training
in Amsterdam or The Hague, to learn the finishing end of the construc-
tion trade—to make doors, windows, stairs, and other components of
houses.

On December 21, 1618, a man designated simply as "Reynier" bap-
tized his daughter Tanneken in the New Church in Delft. The mother's
name was omitted from the church register, possibly because she was no
longer alive. The witnesses were Neeltge Goris and her son Reynier Jansz.
(Vermeer's father).[17] The only other man named Reynier who lived in
Neeltge's neighborhood or belonged to her extended family was young
Balthens. The fact that his own sister was named Tanneken also lends
weight to the supposition that Balthens was the father of the child. It is
probable that the child was illegitimate since, when Reynier Balthens
married three years later, the record indicated that he was still a "young
man," by which was meant that he was previously unmarried. It was
characteristic of the cohesiveness of the family his sister Digna had mar-

[13] Doc. no. 9, 17 July 1610.
[14] Doc. no. 8, 22 June 1610.
[15] Doc. no. 13, 20 January 1612.
[16] Doc. no. 33, 16 October 1619.
[17] Doc. no. 30, 21 December 1618.

ried into that her in-laws gave Balthens the moral support of their presence in church on this solemn and delicate occasion. They stood by him again when much more serious trouble befell him the next year.

On October 16, 1619, Neeltge Goris, accompanied by her son Reynier Jansz. and her son-in-law, the baker Jan Heymensz., went to visit the family notary who lived a few doors away on the Small-Cattle Market. Neeltge also brought along four neighbors—a surgeon, a straw-hat maker, the apprentice faiencier Jan Jansz., and the master joiner with whom Reynier Balthens had been apprenticed—as character witnesses for young Reynier Balthens. They declared at her request that Balthens, presently a prisoner in The Hague, had behaved like an honest young man at the time he was apprenticed in Delft. The joiner confirmed that Balthens had spent one year learning the trade with him, from August 1618 to August 1619, sleeping in the house of the faiencier, a couple of doors from Neeltge's house. He testified that young Balthens had conducted himself quite properly during his apprenticeship. Reynier Jansz., caffa worker, and Jan Heymensz., the baker, signed the deposition as witnesses.[18]

What had happened was that Balthens had been arrested a few days earlier in a counterfeiter's workshop located on the north side of The Hague. His father, Balthasar Gerrits, had escaped arrest by fleeing to Delft. Neeltge Goris collected the certificates of good conduct to secure Balthens's release, but she was unsuccessful in her efforts at this time.

Since the records of the judicial interrogation of Balthasar's senior partners in the operation have survived, the main lines of this fascinating affair can easily be reconstructed, although some points were never brought to light in the investigation and remain obscure to this day.

Before summarizing the records of the interrogations, I must convince the reader that there is no possible error in identifying the counterfeiters Balthasar Gerrits and Reynier Balthens with the father of Digna Baltens and with her brother. Not only do we have the deposition of October 1619 described above in which Neeltge Goris sought to release "the brother of her daughter-in-law," thus Reynier Balthens, but we also can rely on the lengthy statement of Rogier Laurens of June 18, 1622, translated in full in the next chapter. There the merchant stated that he had inquired, upon his arrival in Delft just before Easter, 1620, about "Balten Gersz., the father of her [Neeltge Goris's] son's wife," who could be no one else but Balthasar Gerrits. He had been told by Neeltge that "he [Balthasar] was in flight from these lands by reason of some coins or monies that he had made in The Hague, whereupon another man and her son's wife's

brother [Reynier Balthens] had been put in prison in The Hague."[19] The "other man," mentioned numerous times in the interrogation, was a young fellow named Andries Hendricxz. who was apparently a helper, along with Reynier Balthens, in the actual forging of the coins under Balthasar Gerrits's direction.

If we needed more evidence, we could invoke the frequent mention in the judicial record of Beatrix Gerrits, "the wife or mistress"[20] of Balthasar Gerrits, and in one instance, of her brother Claes Gerritsz. Vouck, who are both cited in subsesquent documents. As we have seen, Beatrix plied her midwife trade in Amsterdam from approximately 1613 to 1623. When she married Balthasar, which must have been some time after the events I am about to narrate, she was said to be a widow. She was about thirty-five years old in 1620.[21] We can be almost sure that "Reynier from Delft" who also makes a brief appearance in the lengthy record of the interrogation was Vermeer's father. Finally it is very likely that the mysterious unnamed woman who tried to free Reynier Balthens from jail shortly after Easter in 1620 was Neeltge Goris herself. Thus almost everyone in the immediate family of Vermeer's mother—her father, stepmother, mother-in-law, brother, stepbrother, and husband—seems to have been embroiled in this affair.[22]

The reader may wonder what Balthasar Gerrits, the former broker and merchant's servant, could have been doing cutting dies and forging coins. Where had he acquired these skills? Ten years later we shall find him referred to as a "clockmaker" and "engineer," a man with an interest in the business of making steel from iron. It is likely that he had been trained in some metal trade or other—perhaps as a clockmaker or even as a goldsmith—but that he had found it more rewarding to work as an unregistered broker or merchant's clerk in Amsterdam in the early years of the century.

Since the interrogators of Balthasar's partners knew only a part of the

[19] Doc. no. 82, 18 June 1622.
[20] In the course of the interrogation of one of the counterfeiters, Beatrix Gerrits is called "huysvrouw ofte bijbesith" (wife or concubine) of Balthasar Gerrits (doc. no. 35, R.A. 533, fol. 157).
[21] Claes Vouck's name appears only once in the judicial record. In the interrogation of Gerrit de Bury of 26 May 1620 (doc. no. 35, R.A. 533, fol. 167v), the prisoner is asked whether Vouck did not transmit a letter he had received from Resident Sticke. De Bury acknowledges that Vouck had brought him a letter, but from Balthasar Gerrits rather than from Sticke. Beatrix Gerrits is mentioned in doc. no. 121 of 27 January 1628 and doc. no. 134 of 17 April 1632. In this latter document, Beatrix declared that she was the widow of Balthasar Claesz. [Gerrits]. On 5 July 1642, Beatrix Gerits Vouck was said to be fifty-seven years old (doc. no. 173).
[22] The identification of the counterfeiter Balten Gerrits with the intermediary in various financial transactions in Amsterdam that have already been described is also supported by the prisoner Gerrit de Bury's reference to him as broker ("mackelaer") in his first interrogation (doc. no. 35, R.A. 533, fol. 152).

truth, their questions meandered as they explored one possible lead after another. To avoid confusing the reader, at the risk of breaking the suspense, I will first introduce the dramatis personae and then outline the bare bones of the counterfeiting plot as it can be reconstructed from the entire series of interrogations which lasted, with intermissions, from April 28 to July 2, 1620.[23]

Gerrit de Bury from Antwerp, forty-four years old, was the first person arrested and interrogated on April 28, 1620. (The reader will recall that Balthasar Gerrits was also from Antwerp, as were his chief associates in the transactions in East India Company shares.) The crime of which the prisoner was accused is not specified in the document, but the lines of questioning made it clear that he was implicated in two distinct affairs, one involving the counterfeiting of currency, the other the violation of the trade monopoly of the East India Company. The affairs in question were linked through the names of several prominent persons whose possible criminal involvement was of great interest to the investigators.

These prominent persons were Christoffel Sticke, Knight and Lord of Brems, son of Dirck Sticke, Burgomaster of Deventer; his brother the Resident Hendrick Sticke, representative in The Hague of the Prince Elector of Brandenburg; and Pieter Hoeffijser, Receiver-General of the Amsterdam Admiralty. Hendrick Sticke was arrested a month after De Bury.

The police suspected that the counterfeiting plot might have been connected with the "Hoeffijser debt."[24] In November 1614, the Elector of Brandenburg, Johann Sigismund, had acquired the Duchy of Cleves by the Treaty of Xanten. By this acquisition the Elector had become a neighbor to the east of the United Provinces. The United Provinces welcomed the Protestant prince as the ruler of contiguous territory, especially in view of his conversion the year before from the Lutheran to the Calvinist faith, dominant in the Netherlands. To help settle the great expenses the Elector had incurred in acquiring the Duchy of Cleves and to assist him in ridding the Duchy of Spanish occupation, the States, a month after the treaty, had agreed to raise 100,000 guilders "from various merchants and other persons in these lands" for the purpose of lending them to the Elector.

In May 1615, Pieter Hoeffijser, together with Burgomaster Dirck Sticke and his two sons Christoffel and Hendrick, borrowed 8,500 guilders on behalf of the Elector. Less than a year later, the States General resolved to raise a new loan of 100,000 rijksdaelders or 248,000 guilders—a prodigious sum at the time—for the Elector. They allowed Hoeffijser to guarantee the loan with the receipts from the taxes on imports and exports

[23] Document nos. 35, 37, 39–43, 45–60, and 64.
[24] W. F. Oldewelt, "De hoeffijserse schuld (1616–1681)," *Jaarboek Amstelodamum* 51 (1959): 43–45.

into Amsterdam, called "Convoys and Licenses," which as Receiver-General of the Admiralty he was responsible for administering. Resident Hendrick Sticke, who was well regarded in official circles in The Hague, was a pivotal person in the negotiations between Brandenburg and the States General. Neither the Elector, who died in December 1619, nor his successor was able to repay the loan, now known as the Hoeffijser debt. Not even the promise to turn over to the States half the revenue from the Duchy of Cleves and of the Land of Gulick or Julich (in present-day Germany), which belonged to the Elector, sufficed to meet the payments that soon fell due. By 1640, as a result of cumulative interest charges, the Hoeffijser debt had swelled to over a million guilders. It was not until many years later that the debt was finally written off in exchange for a territorial concession by the Great Elector Friedrich Wilhelm, the grandson of the original debtor. In the meantime, the Hoeffijser debt had become an internal affair of the House of Nassau ever since Friedrich Wilhelm had married Louise Henrietta, daughter of the Stadhouder Frederik Hendrik, the younger son of Willem the Silent.

In view of the allegation later made in the interrogation of De Bury and Hendrick Sticke that Frederik Hendrik's predecessor, the Stadhouder Maurits, was willing to pardon the counterfeiters who had been arrested in 1619 and that he would also pardon Balthasar Gerrits if he were arrested, the possibility arises that Maurits had secretly given his blessing to the scheme in order to help his Brandenburg ally. If so, it would be easy to understand why the investigation had to be kept secret: a public airing of the affair might have resulted in an open conflict between the Stadhouder and the States of Holland and West Friesland, which dominated the federation. Such a conflict would have been highly detrimental to both parties at a time when the political stability of the new Republic was still so fragile.

De Bury, on April 28, 1620, was first questioned about a petition to the States General contained in a letter that Christoffel Sticke, Knight and Lord of Brems, the very prominent brother of Resident Hendrick Sticke, had written to the prisoner. He explained that the petition requested a pardon for Dutch sailors on a ship who might have violated orders issued by the States and thereby harmed certain interests, which he did not specify. Asked who had outfitted the ship, he answered that he himself had put up most of the money but that Daniel and Jan van Geel had contributed three thousand guilders each. The ship, De Bury added, had sailed on April 12, 1619 from Texel, an island in the north of Holland, to the Cape of Good Hope to catch seals and trade in oxhides and elephant ivory. According to the minutes of the delegates to the States General, Gerrit de Bury, merchant in Amsterdam, had applied in September 1618 to send one or two ships and a yacht around the Cape of Good Hope up

to the coast of Mozambique, 15 degrees south of the equator, to engage in trade. He had proposed to pay 10 percent over and above the usual rights accruing to the States for the privilege. The deputed councillors referred the matter to the Dutch East Indies Company, which either rejected the application or at least failed to approve it. De Bury had gone ahead with the venture regardless. He was technically guilty of having violated the monopoly rights of the East Indies Company. But this was only a peccadillo. De Bury was happy to linger over this affair in the hope that his more serious crime would not be discovered.

On May 2, 1620, De Bury was interrogated about the means that had been employed in the attempts to free Reynier Balthens and his co-worker Andries Hendricxz. after their arrest in October 1619. He denied having made any such attempt himself. He did acknowledge having heard that Prince Maurits was ready to grant them pardon but that 72 Flemish pounds, or 432 guilders, had been needed to "cover the costs of soliciting the pardon." He denied that a visitor had come from Amsterdam to ask him for this sum and that he had given the money to Balthasar's wife. Wasn't it true, De Bury was asked, that on hearing that most of the money had gone to pay the bailiff, he had said, "if the prisoners had been in Amsterdam, I could have got them free for one pound"? This also De Bury denied. Had he not said that he would be willing to give 200 guilders to set Balthens free? He had neither thought or said this. Had he not received a letter from Reynier Balthens last Easter and what did the letter contain? The answer to this was again "no." Had he not said to the man who had visited him from Amsterdam, after the letter had been delivered, "I like the project but I don't know whether the maiden can be trusted," and had not the man answered, "As to the maiden, there is no doubt about her since Balthens is betrothed to her. She won't bring her lover into trouble or anyone else acting on his behalf"? This maiden, as it turned out, was the jailer's daughter.

The interrogator's information was undoubtedly correct. The birth of Balthens's daughter Tanneken, less than a year before the events about which De Bury was questioned had taken place, had not stilled the young man's ardors. And what better way to get out of jail than to seduce the jailer's daughter. (John Gay resorted to the device a century later in his *Beggar's Opera*.) As to the visitor from Amsterdam who had asked De Bury for money to help free Balthens, he was almost certainly identical with the merchant Rogier Laurens, who was well acquainted with both Neeltge Goris and Balthasar Gerrits.

In a further interrogation De Bury admitted that he had given the "wife or concubine" of Balthasar Gerrits, "out of sheer compassion," twelve pounds, worth six guilders each, to travel or to do whatever she wished to do with them. This was of course the former Amsterdam midwife Bea-

trix Gerrits, whom Balthasar had married or taken up with not long before these events.

When the question of the letter addressed to him by Reynier Balthens came up again, De Bury conceded that "a certain woman" (probably Neeltge Goris) had brought him such a letter around Easter of the current year. The letter, De Bury admitted, requested money over and above the one hundred guilders that had already been received to assist Reynier Balthens in getting out of jail with the help of the jailer's daughter. But he thought "it" (the claim? the letter?) had been "fabricated" and he dismissed the woman, promising, however, to come to Antwerp. He did recall that the woman had said, "The young man will go away with the maiden." De Bury also acknowledged he had written a letter the previous winter—that is, a month or two after Balthens and Andries Hendricxz. had been arrested—to a "certain Reynier from Delft," within which was enclosed a letter to Balthasar Gerrits. He had disguised his handwriting and left both letters unsigned. This "Reynier from Delft" could only have been Reynier Jansz., the artist's father. De Bury now confessed that he had planned to secure the release of the two young men and to help them reach Antwerp, as the interrogators suspected, but he insisted that the initiative had come from his female visitor and not from him.

The interrogation subsequently turned to De Bury's meetings with "Reynier from Delft," the man I have identified as Reynier Jansz., the son of Neeltge Goris. These meetings had occurred a few days after Easter, which in 1620 fell on April 19. This was shortly before De Bury's apprehension, and hence about six months after the arrest of the two young counterfeiters. Reynier Balthens by then was perhaps about to be released or to escape. What conversation had De Bury had with Reynier from Delft in the New Church in Amsterdam? Reynier had first gone to his house and asked him for some money. They had then agreed to meet in the New Church at one or two o'clock in the afternoon. Reynier had complained that he had stripped himself bare for the sake of Reynier Balthens, to the point of having sold his bed for him. De Bury then told him, "If Balthasar Gerrits wants to follow my advice he can repay both you and me," meaning, the prisoner now alleged, to set him up in an official mint. Evidently the money Reynier Jansz. and his mother had spent to secure Reynier Balthens's release was considered a loan which the young prisoner's father was held responsible for repaying. After this conversation, De Bury and the presumed Reynier Jansz. had gone to the Stock Exchange. Reynier Jansz. had asked De Bury for travel money, and De Bury had given him sixteen stuivers.

When asked by the interrogators whether he had ordered any false coins to be minted, De Bury persisted in his denials.

On this same day, May 5, two burgomasters of Amsterdam, Gerrit de

Witt and Reynier Paeuw, with three city aldermen, resolved to place De Bury in the hands of the sheriff who was instructed to administer torture with a view to inducing the prisoner to tell the truth about the counterfeiting of which he was accused. De Bury was not immediately tortured, however. Before he was set on the rack, he was again asked about the organization of the counterfeiting plot. He still refused to confess that he had leased the premises in the North End of The Hague in which Balthasar had been set to work, that he had ordered the dies made, or that he had given instructions to forge two- or three-stuiver coins. He said he had only accepted some three-stuiver coins as partial payment for the money he had lent to Balthasar.

The prisoner's answers not being considered satisfactory by the sheriff, the commissary, and the aldermen, De Bury was set on the rack with a 200-pound weight attached to his feet. The weight was alternatively lifted and lowered. But he still persisted in his answers and showed himself unwilling to say anything that would further incriminate him.

On May 7, the commissary Franchoys van der Burgh reported to the deputed councillors ("Gecommitteerde Raden") of the States of Holland and West Friesland on the counterfeiting plot.[25] According to the printed resolutions of the province, the councillors, after hearing about the confessions of the prisoner and reading various letters and documents pertaining to the case, urged that the investigation proceed with all possible haste, that the evidence be handed over to the Fiscal Advocate of the province and to the bailiff of The Hague, who would be authorized to introduce new questions for the prisoner. The prisoner should be further interrogated, in the ordinary way or under torture, until the truth was discovered regarding other participants or accomplices that he might have had.

On May 21, 1620, the bailiff of The Hague reported to the councillors of the States of Holland and West Friesland that he had been in Antwerp and had spoken there with Balthasar Gerrits who had made a confession in front of witnesses concerning the affair, which had been set down in writing.[26] After the confession had been read aloud, the gentlemen present decided that the "individual named in it" should be apprehended. They further cautioned that everything be done "under oath and in silence." The individual whose name the printed resolution of the province did not reveal was Hendrick Sticke, the Resident of the Elector of Brandenburg. Even though there was no diplomatic immunity in those days, the arrest of a representative of a friendly state was still a grave matter. On the same day, the councillors of Holland and West Friesland reported

[25] Doc. no. 37, 7 May 1620.
[26] Doc. no. 39, 21 May 1620.

to the States General in The Hague that the Resident Sticke was impli-
cated in the counterfeiting operation of De Bury. A letter was dispatched
to an officer in Zutphen in Gelderland enjoining him to go to Crayen-
burch in the Bishopric of Münster to arrest Sticke if he happened to be
there.[27] On the next day, the States General informed His Excellency
Prince Maurits of their decision regarding Resident Sticke.[28] Resident
Sticke had actually left Deventer on May 22 and had gone to Amsterdam,
where he was duly arrested.[29]

On May 25, Hendrick Sticke from Deventer, thirty-three years old, after
duly protesting against the illegality of his interrogation, answered the
questions put to him by the sheriff of Amsterdam in front of four alder-
men.

The prisoner was interrogated about two letters he had written in Jan-
uary 1620. One had been addressed to his mother in his family manor,
called the House in Crayenburch, and the other to Balthasar Gerrits. The
letter to Balthasar contained directions on how to get to Crayenburch.
The one to his mother informed her that the bearer of the letter (Bal-
thasar) was his servant and requested that she put him up for a few days
in case he, Sticke, had not arrived by then. All this was conceded by
Sticke, except that he denied calling Balthasar his servant in the letter.

Wasn't it true that Balthasar had not gone to Crayenburch immediately
upon receipt of the letter (in January) but only on March 12? Then had
not Sticke gone to the House in Crayenburch himself on March 16 and,
when he arrived, had found Balthasar Gerrits there? All this, in substance,
the prisoner said, was true.

The interrogator then showed Sticke the letter he claimed had been
written by Sticke to De Bury and delivered to him by Balthasar Gerrits.
In this letter he asked De Bury to give Balthasar fifty or sixty guilders or
whatever sum might be necessary to get his (Balthasar's) son released. The
letter also warned De Bury that the prisoners had inculpated him and that
he should "absent himself in order not to land in difficulties."

On further questioning, Sticke declared that De Bury had gone to De-
venter to try to inveigle his brother Christoffel Sticke in the plot but that
he, Hendrick Sticke, had prevented him from doing so. He also declared
that De Bury, to entice him, had claimed that the profits from the opera-
tion would be very large, because it was possible to produce as many
coins with one man by pressing the coins as the (legitimate) masters of
the mints could produce with ten by striking or forging. Furthermore, the
House in Crayenburch would be a quiet, secure, inaccessible place to set
up a mint. De Bury's clinching argument was that if Balthasar Gerrits did

[27] Doc. no. 40, 21 May 1620.
[28] Doc. no. 41, 22 May 1620.
[29] Doc. no. 43, 27 May 1620.

get caught he would have no trouble getting a pardon "since he had already made some artful tools for His Excellency [Prince Maurits]." It was never made clear what was referred to or if De Bury had been telling Sticke the truth on this point, although an echo of the claim resounded twelve years later in the petition Beatrix Gerrits drew up after her husband's death.[30] To De Bury's entreaties, Sticke had finally answered that he would go along with the scheme, even though, he now claimed, this had not been his real intention.

For one month, from May 28 to June 29, the investigation continued without leaving a trace in surviving documents. On the latter date, the deputed councillors of the States of Holland and West Friesland ordered the bailiff of The Hague to go to Amsterdam with Balthasar Gerrits with the purpose of confronting the prisoners Sticke and De Bury and examining them on the points that they still denied.[31] Balthasar Gerrits was to be granted a written safe-conduct that would enable him to travel to Amsterdam with the bailiff and to depart therefrom unhampered and free. The bailiff was also requested to write the authorities in Amsterdam with the charge that, as soon as the truth was uncovered, justice should swiftly be done, as befitted such a grievous crime.

Balthasar Gerrits was presumably still in Antwerp, where he had been interrogated by the bailiff five weeks before, when the States of Holland and West Friesland resolved to grant him a safe-conduct to Amsterdam. He had presumably obtained freedom from prosecution in exchange for the testimony that he was willing to give against his former employers. This freedom allowed him to reside in Holland unmolested and rejoin his son who, by this time, had already been freed or had escaped sometime previously.

On July 2, a week after the resolution was issued, Balthasar turned up in Amsterdam and confronted the prisoners—first, the Resident Sticke and, immediately afterward, his former employer Gerrit de Bury.

After recalling some details of the counterfeiting operation, Balthasar brought up the letter that Sticke had written to his mother in Crayenburch, which had been sent along with the letter addressed to him. Balthasar said that he had opened the first letter by mistake, "seeing that he could not read," and that it had been read aloud to him by another person.[32] It began with the words, "Dear Mother, the bringer of this letter is my servant." Sticke, as he had earlier, denied the letter had said that Balthasar was his servant. (This was of course the point the interrogators wished to ascertain in order to prove Sticke's responsibility as the ultimate backer of the operation.) Balthasar went on to relate how, when

[30] Doc. no. 134, 17 April 1632.
[31] Doc. no. 49, 25 June 1620.
[32] See note 8 above.

Sticke had joined him in Crayenburch, he had proposed that they travel further to the Land of Luyck where they would have instruments made for a mint. This Sticke also denied. Sticke did acknowledge having handed Balthasar a letter addressed to De Bury asking him to give eight or ten Flemish pounds for the release of Balthasar's son from jail. He could not remember, however, having told Balthasar to comply with all the orders De Bury would give him.

Turning to the second prisoner, Balthasar recalled that De Bury had specifically asked him whether pieces of eight, which were normally forged rather than pressed, could also be made. De Bury now insisted that the only coins he had caused to be made were groschen, three-stuiver coins, and schrikenburgers, none of which were in circulation in the United Provinces.

Balthasar then described how De Bury had come daily to supervise the counterfeiting operation in The Hague, complaining that "they" (i.e., Balthasar, his son Balthens and the other assistant in the counterfeiting shop, Andries Hendricxz.) were not working hard enough and suggesting that they use a horse to move the operation along. De Bury conceded that something like this had been said. So much had come to light already, there was little to be gained in refuting details.

As it was, the game was lost. Perhaps it had been lost ever since De Bury's and Sticke's arrests. On August 5, the burgomasters and aldermen of Amsterdam issued their sentence regarding Hendrick Sticke, former Resident of the Elector of Brandenburg. The sentence noted that Sticke had violated various edicts of the States General banning the counterfeiting of "all coin of foreign states, kings, and princes as well as of these lands." He had contributed two-thirds of the sum advanced in the counterfeiting operation; De Bury had contributed one-third. There were no other accomplices. He had also plotted "with one of the masters" (presumably Balthasar Gerrits) to set up a mint in Crayenburch. He had advanced a certain sum of money to get "the son of the master" out of jail and had written De Bury to ask him to advance more money to this end. For all these reasons, he could be considered the "principal culprit" in the case. He was therefore condemned to be executed by the sword.[33]

On August 6, Amsterdam authorities issued their sentence against De Bury, who was said to have leased the house in The Hague where the counterfeiting took place, hired the masters and servants who carried out the work, and advanced money for the operation. He had ordered the master (Balthasar Gerrits) to make dies for the three-stuiver coins and had two hundred of these coins pressed. After the operation had been discovered in The Hague, he had advanced money for the release of the master's

[33] Doc. no. 56, 5 August 1620.

son. He had then gone to Deventer with Hendrick Sticke to see Christoffel Sticke who, he claimed, had suggested that a mint could be set up in the territory of the Count of Bentheim where groschen could be pressed "with the help of the same master he had employed in The Hague." From all this it was concluded that Gerrit de Bury was "also implicated" in the secret counterfeiting plot. He too was to have his head severed by the sword.[34]

The sentences were carried out on August 8, notwithstanding the appeal made by the Elector of Brandenburg to the States General for the extradition of the Resident. The goods of the two men were confiscated for the benefit of the Sovereign States of Holland and West Friesland. Burgomaster Reynier Paeuw looked on as the executioner severed the two heads. A week later the deputed councillors of the States of Holland and West Friesland thanked the delegates from Amsterdam for doing "good justice" in the case of the counterfeiters Hendrick Sticke and Gerrit de Bury.[35]

Christoffel Sticke, Knight and Lord of Brems, had removed sometime earlier from Deventer to the Land of Cleves. The commander of the Nijmegen fortress (not far from the House in Crayenburch), at the behest of the States General and with the concurrence of the Brandenburg authorities, had him taken into custody. The States requested his extradition. Brandenburg officials apologized for not being able to meet their request. They kept him a prisoner for a few months and then released him before the year was over.[36]

Balthasar Gerrits and his son Reynier Balthens, after the execution of their former associates, remained at large. There is no reason to believe that the authorities of the province ever bothered them again for their participation in the counterfeiting affair. By July 1621 at the latest, Reynier was back in Delft.[37] Balthasar did not resurface until December 1623, when he passed through Delft on the way from The Hague to Gorinchem.[38]

Except in Rogier Laurens's formal protest of 1622, no reference was ever made to Balthasar Gerrits's counterfeiting scheme in any subsequent document bearing on Vermeer or his family. Yet Vermeer, who was born shortly after his grandfather's death, must have heard from his parents or relatives about Balthasar's adventure. It was an inescapable part of his own background. He himself became a "counterfeijter," an artist coun-

[34] Doc. no. 57, 6 August 1620.
[35] Doc. no. 59, 13 August 1620.
[36] This information on Christoffel Sticke and Pieter Hoeffijser is culled from Oldewelt, "De hoeffijserse schuld," pp. 43–45.
[37] Doc. no. 68, 24 May 1621.
[38] Doc. no. 94, 8 December 1623.

terfeiting the visible world. One may wonder whether the linguistic co-
incidence ever occurred to him.

Twenty-one years after the execution of Sticke and De Bury, Pieter
Hoeffijser, Receiver-General of the Amsterdam Admiralty, took flight
from his creditors and was declared bankrupt. When an inventory was
taken of his assets on March 31, 1641, the only money found in his office
consisted of thirty-one false rijksdaelders and seventy-five forged three-
stuiver coins of unknown provenance.[39]

[39] Oldewelt, "De hoeffijserse schuld," p. 45.

· 3 ·

GRANDMOTHER NEELTGE GORIS

Delft prospered along with other parts of Holland during the Twelve-Year Truce, which lasted from 1609 to 1621, in the war against Spain. From Delfshaven, the port of Delft on the Maas River, ships sailed to all corners of the world, including Plymouth in North America, where the Pilgrims landed in 1620. Many ships flew the flag of the United East India Company, which had one of its five offices, or "Chambers," in Delft. Beer brewing and cloth weaving crested on a wave of growing demand. Delft businessmen had major interests in the rapidly developing fisheries in the North Sea. Several new producers of Delftware faience, employing fifteen to twenty men each, began firing their kilns in the neighborhood of the East End. In this period of bustling activity, many women seized the opportunities for engaging in business that the new times afforded. Vermeer's paternal grandmother, Neeltge Goris, was one of the more energetic and colorful of these women. Inexperience, lack of initial resources, and plain bad luck may have caused her eventual failure in spite of a favorable environment.

Prosperity gave God-fearing people the leisure to engage in religious controversy. The two warring factions of Dutch Calvinism—the strictly orthodox followers of the theologian Gomarus and the more liberal followers of Arminius—were well represented in Delft, the Gomarists enjoying more support than the Arminians among the poorer classes. Religious controversy was bound up with political and social strife. For reasons of state, Prince Maurits, the Stadhouder, sided with the strict Calvinists. The high bourgeoisie among the Protestants sided with the Arminians, or Remonstrants. The learned jurist Hugo Grotius of Delft and the prominent statesman Joan van Oldenbarnevelt of Amersfoort were among the well-born burghers who supported the more liberal and tolerant Arminian positions. Stadhouder Maurits convened the Synod of Dordrecht in 1618 with a view to crushing the Arminians. In May 1619 the majority of the Synod declared itself in favor of the Gomarists, whose views were henceforth established as the official creed of the Reformed faith. In the political convulsions that followed, Van Oldenbarnevelt was beheaded.

In Delft the controversy flared up on an occasion in 1617, when an Arminian preacher named Henricus Slatius had the temerity to accuse the famous Gomarist pastor Henricus Arnoldus of being a usurer and a liar. The supporters of Arnoldus challenged Slatius to say these things to his face. The landscape painter Pieter Stael testified afterward that Slatius

had backed down and confessed that he had perjured himself. Stael told him he was lucky that the Lord Jesus had not descended upon him and struck him down with apoplexy (which no doubt was what he deserved as a perjurer).[1] A couple of years after the Synod, Slatius—suspected of involvement in a plot to assassinate the Stadhouder—attempted to disguise himself to escape the police, but he was discovered, arrested, and executed.

The famed religious tolerance of the Dutch might apply to the Jews and other outlandish faiths. But it did not extend in those passionate years to fellow Protestants who did not see eye to eye with them on the conditionality of predestination or the possibility of lapsing from grace.

Vermeer's grandmother Neeltge Goris was too busy supporting her family after the death of her husband, the musician Claes Corstiaensz., to worry much about religious or political events. A month after his death in 1617, we find her transferring two obligations worth 250 and 160 guilders to her stepson Dirck Claesz., the hat merchant.[2] But the cash she raised through these transfers did not suffice to maintain her household for long. She had to pay installments on various debts contracted by her late husband amounting to at least one hundred guilders a year.[3]

In 1618, Neeltge started earning money as a secondhand dealer and a seller of bedding. Two years later, when she was dunned for a debt of fifty guilders that she owed to the late Servaes Meesz., she claimed she had delivered a mattress cover made of ticking to one of Meesz.'s heirs as partial payment on her debt.[4] The heir alleged he knew nothing about the mattress cover. The uncontested part of the debt was paid in two installments. Whether Neeltge's assertion was valid or not, it would not have been out of character (as we shall see presently) for her to try to reduce a debt by advancing a spurious claim.

In 1620, her name appears several times in the estate papers of an obscure painter of religious subjects, Pieter den Dorst, for various services she had rendered the estate.[5] She and a certain Tryn Rochus had been hired as secondhand dealers (literally "women carrying out goods," in Dutch "uijtdraegsters") to liquidate the estate. Neeltge received a small sum for selling the expensive clothing of the late painter's wife. Among the garments, which sold for 143 guilders, was a silk worsted dress *à la Turque* that brought 25 guilders. We do not know whether Neeltge had other contacts with painters at the time or whether she participated with Tryn Rochus (whose activities as a secondhand dealer are much better

[1] Montias, *Artists and Artisans*, pp. 154–56.
[2] Doc. no. 22, 11 November 1617.
[3] See doc. nos. 15, 16, and 31.
[4] Doc. no. 38, 13 May 1620.
[5] Doc. no. 65, 18 November 1620.

known) in the liquidation of other estates. Her son Reynier's later career as an art dealer may have had its origin in her occasional jobs clearing estates. In larger cities like Antwerp and Amsterdam, a number of instances have come to light of painters and picture dealers whose parents had their first experience buying or selling art goods as secondhand dealers. The mother of Pieter Lastman, Rembrandt's most important teacher, was herself an uijtdraegster.[6]

The parents of Johannes Vermeer, Reynier Jansz. and his wife Digna, had been living with Neeltge Goris in The Three Hammers since their return from Amsterdam some months after their marriage in 1615. For the first five years of their union the young couple was childless. At last, in March 1620, a daughter was born. They christened her Gertruy. The witnesses at the baptism in the New Church on March 15 were all close relatives of the family: Jan Thonisz., the butcher who had married Reynier Jansz.'s half-sister Adriaentge; Maertge Jans, Reynier Jansz.'s full sister, who lived with her husband, the baker Jan Heymensz., next door to The Three Hammers; and Neeltge Goris herself.[7]

Gertruy was the only sibling of Johannes Vermeer, who was born a full twelve years later. When Reynier Jansz. had gone to talk to Gerrit de Bury in Amsterdam and had complained that he had been forced to sell his bed to raise money to get his brother-in-law Reynier Balthens out of jail, he might have added that he was now also burdened with the necessity of providing for a month-old child. About the time of Gertruy's birth, the baby's uncle was still in jail and her grandfather Balthasar was a refugee from justice in Antwerp.

Shortly before Easter Sunday in 1620 there arrived in Delft, coming from Amsterdam, a merchant named Rogier Laurens, a man in late middle age, who had been selling mirrors, fine fabrics, and other objects of luxury in various cities of Holland for over twenty years.[8] What follows is the story he told two years later about the misdeeds of Neeltge Goris and her partner Tryn Rochus. The notary was expected to deliver copies of the formal notification of this complaint ("insinuatie") into the hands of the two women who Laurens claimed had wronged him.

The lotteries that Laurens describes were profitable affairs. People were eager to buy tickets that gave them a chance to obtain luxury goods they could not otherwise afford. The profits of the operation derived from the fact that the total value of the goods offered as prizes was less than the value of tickets sold. Most participants drew blanks. The merchandise consigned in the lottery that was to take place on Whitsuntide (June 7, 1620) was estimated at 22,735 guilders. This was about the value of

[6] Information kindly supplied by S.A.C. Dudok van Heel.
[7] Doc. no. 34, 15 March 1620.
[8] See Montias, *Artists and Artisans*, pp. 60–62, and doc. no. 14, 18 May 1612.

twenty ordinary houses or nearly one hundred and fifty years of common laborers' wages. Calvinist preachers strongly disapproved of these idle enterprises. The municipal authorities ordinarily permitted them only if part of the proceeds were turned over to charity. Out-of-town entrepreneurs like Laurens had to find one or more native citizens to help them wrangle a permit to hold a lottery from the Delft magistrates. The merchant's tale of woe is reproduced below in his own words, repetitions, ambiguities, and all.[9]

"I, Rogier Laurens, living in Amsterdam, arrived in Delft before Easter at the house of Neeltge Goris. I asked her about Balthasar Gerrits, the father of her son's wife. She said he had fled the country because of certain moneys or coins that he had made in The Hague, as a consequence of which another man [Andries Hendricksz.] and her son's wife's brother [Reynier Balthens] had been put in prison in The Hague. She complained that she now found herself in considerable difficulties owing to all this and that she was suffering grievously from lack of money. If she only had the money to pay the costs, she knew she could get her son's brother-in-law out of jail.

"Even though Balthasar Gerrits still owed me eleven Flemish pounds [66 guilders] for money that I had lent him, I was moved by compassion over her complaints and laments and over the imprisonment of her son's brother-in-law. So I answered her that if it could be done for 100 guilders and one could get him out of jail for that much, I would be willing to put up the money. And in fact I delivered to the attorney Hantschoenwercker in The Hague between 60 and 70 guilders in gold to pay the costs of the prisoner provided he would be freed.

"In the meantime, I had come again to the domicile of Neeltge Goris. She told me she had heard that from time to time I organized lotteries as a business. And, as we happened to be talking about Delft, she mentioned that a number of people in the past had applied for a permit from the magistrates in Delft but none had received consent to set up a lottery. After complaining again of being under a great burden and impoverished, she gave me to understand that, being a citizen of Delft, she had reason to think that if she applied for permission to organize a lottery she would certainly be able to obtain it.

"Whereupon Neeltge Goris asked me how much I was willing to pay if she could get the permit. We finally agreed that I would pay her 1,500 guilders. Neeltge Goris, for greater security, had me set down in writing that I would pay her 1,500 guilders as soon as she would get the permit. I stipulated the condition that she would also guarantee in writing that, if she did get the permit, it would be exclusively for me and that she would

[9] Doc. no. 82, 18 June 1622.

not apply for anyone else. After the agreement had been set down in writing by both parties, I informed her about everything there was to know about lotteries and I gave her instructions, according to the best of my ability, as to how she should apply for the permit from the Delft magistrates. After a few days Neeltge Goris told me that she had found someone to help her, a woman named Tryn Rochus. She said Tryn was very clever, could talk well, and had a smooth tongue. Moreover, Tryn was well acquainted with the Delft magistrates. She conversed with them every day and went around with them. Neeltge Goris hoped that with her help she would all the better be able to achieve her purposes. However, after some troubles had been taken and the request submitted, the magistrates refused to give their consent.

"Neeltge Goris felt very despondent over this failure and complained bitterly about the great humiliation she had suffered as a result. She said she would never have laid out such a great sum of money to obtain the permit if she had known she would not get it and that all the troubles she had taken would be in vain. Then she and her friend Tryn Rochus advised me that they would not let the matter rest there but that they would go and tell the Delft magistrates that if they would not let them set up a lottery in Delft then they would obtain a permit in some other jurisdiction close to Delft and that they [the Delft magistrates] would well have to allow it.

"So the two female persons Neeltge Goris and Tryn Rochus applied to the bailiff of Ryswijck [a small town about three miles from the center of Delft between Delft and The Hague] to allow them to hold a lottery in Ryswijck. Having easily obtained his consent, they asked me how much I was willing to give for a lottery in Ryswijck. I said, 'Ryswijck is no Delft.' Since there was some risk in it and I had no great desire to hold a lottery there, I said I did not dare to give them a sum outright but would like to deal with them conditionally: in case all the lots were drawn without hindrance from anyone, I would give them 1,200 guilders; if only half of the lots were drawn, I would give them 600 guilders, and so on pro rata. They said they were satisfied with this arrangement.

"I expected that the lottery would be held in Ryswijck at the time of the yearly kermess. But, unbeknownst to me, the two women had gone to solicit permission from the bailiff of Rijnsburg and Vrouwenrecht. First they had visited a certain Cornelis Gijsen living in The Wandelinge, an inn on the edge of Delft, and they had found out from him where the bailiff resided. They had also leased from him a stand or platform and contracted with him that he should set up some parrots for people to shoot at [when they came for the lottery]. The women then betook themselves in great haste to the bailiff who lived near Leyden and promised him a gratuity of about 100 guilders for his consent to hold a lottery in

The Wandelinge in his seigniory of Vrouwenrecht. The bailiff wrote out the permit with his own hand to the two women who then came back to me and declared that they had received permission to hold the lottery in a good place at the Feast of the Pentecost, but they did not want to say where until they had ascertained how much I wished to pay. I answered that they had better tell me the place first and we could come to an agreement later. So they named the place and showed me the bailiff's written act of consent and then said that if I were not minded to come to an agreement with them they would find somebody else who would gladly do so. I felt cheated that they had first got a permission from Ryswijck and shown me the act of consent then had threatened to use other persons if I did not want to hold a lottery so close to Delft [as The Wandelinge was]. I worried about the bad luck that would befall me if the two women caused other persons to hold a lottery so unreasonably close to Delft; moreover, it would not do for two lotteries to be staged at the same time or in the same summer so near Delft; one would cause heavy losses and bring ruin on the other. A single lottery would be more than enough. I pointed out to the two women that if a lottery were held in The Wandelinge so close to Delft, especially after an application had been turned down for a permit such a short time ago, the Delft magistrates would think, and not without reason, that this had been done in defiance of their decision. So the thought lay heavy on my mind that the lottery would not take place but would be stopped by the Delft magistrates, and I would suffer heavy losses since I would have to buy 20,000 guilders worth of merchandise that would remain on my hands after the lottery had been stopped. Thereupon the women alleged that they would be willing to risk the losses that would be incurred if the lottery did not go through and, anyway, the authorities in Delft had no say in the matter since they had no jurisdiction or power in the seigniory of Vrouwenrecht. They also said: 'As we are in agreement with you, we'll get you an even stronger act of consent from the bailiff, yes, one backed by the sovereign States of Holland and West Friesland, which will permit the holding of the lottery in Vrouwenrecht without any interference from anyone.' And they indicated that if I did not go forward with the lottery and failed to come to an agreement with them, I should keep in mind there were other persons begging to do business with them.

"So I felt obliged to come to terms, chiefly for fear that they would turn to other persons, in which case my project for a lottery in Ryswijck would also collapse, and all the money and time I had spent, which 200 guilders would not make up for, would go to waste. And I also thought of the damage done to the bailiff of Ryswijck who would miss the fine gratuity that I had promised to pay him for his consent.

"With this new promise to secure a stronger act, a conditional contract

was drawn up, to the two women's satisfaction, that stipulated they would receive 1,200 guilders provided lots worth at least 2,000 guilders were drawn, 600 guilders if half that amount were drawn, and pro rata for less. The women would be obligated to pay for the act of consent and all other costs of setting up the lottery. I undertook to pay them 300 guilders as soon as the lottery got started. To make sure all this would be carried out, they asked that somebody guarantee fulfillment of the contract. So my brother Adriaen Pietersz. living in Rotterdam signed the contract too.

"A few days later I received the act of consent that read in part as follows: 'Joncker Dirck van der Does, bailiff of Rijnsburg and Vrouwenrecht, in the presence and with the advice of the noble lords of Holland and West Friesland, at the request of Neeltge Goris and Tryn Rochus, has consented and agreed that they may hold and set up a draw-lottery in the seigniory of Vrouwenrecht on the stand in the front of the house named The Wandelinge.'

"As I had confidence that the act that had been delivered to me was in order and no reason to believe the contrary, I stirred myself to buy or otherwise obtain on credit or consignment, as quickly as possible, over 20,000 guilders worth of merchandise that would be suitable for raffling off. From Niclaes Brugman [a well-known silversmith in Delft] I obtained gilded and silverware worth 3,000 guilders; from Hans Bouwens in The Hague, gilded and silverware for 2,150 guilders; from Jan Gertsz. Oosterlyck and Bartolomeus Salomonsz., goods worth 5,400 guilders; in Haarlem from Dominicus Fredericsz., goods worth 2,000 guilders; in Amsterdam from Daniel van Horenbecke, mirrors for 500 guilders; from Pieter Jansz. Singel, mirrors for 450 guilders; in Dordrecht from Gilliam Wagenaer, mirrors for 500 guilders; in Amsterdam from Abraham Schimmel, mantles and women's dresses for 1,200 guilders; from Jacob Schimmel, muskets, guns, rapiers, and rifles for 500 guilders; in The Hague from Symon Salomonsz., various costly firearms for 800 guilders; in Rotterdam from Adriaen Pietersz. [Rogier Laurens's brother], various soft goods and hosiery for 1,100 guilders; from me, Rogier, velvets and silk goods for 2,500 guilders; in Utrecht from Niclaes Roijstien, various copperwares for 300 guilders; in Delft from Pouwel Weyts [an important art dealer] and his mother, alabaster works and paintings, for 800 guilders; from Pieter Huygen, silver clockworks for 300 guilders; from Daniel Pietersz., velvets and silk hosiery for 1,235 guilders. The total came to 22,735 guilders.

"In addition my costs included 400 guilders for travel and transportation expenses to bring the goods and 50 guilders to build the lottery stand. Two days before Pentecost, the bailiff with his aldermen and a number of well-born people visited the entire lottery. Considerable ex-

pense was incurred in connection with their visit, amounting to 120 guilders for drinks and food alone, which were paid to Cornelis Gijsen [the innkeeper who was the owner of the stand]. I also had to give out for tickets and blanks 50 guilders, to the bailiff of Delfland and his substitute 80 guilders, to Cornelis Jansz. and two trumpeters 30 guilders, and to the two women as promised 300 guilders, or 1,030 guilders in all. All this before the lottery was even opened.

"And so on the day of Pentecost, in the afternoon, after the sermon, about five o'clock, the lottery stands were opened and the lots began to be drawn. Suddenly Adriaen van der Waes, substitute sheriff of Delfland, arrived from Delft and showed me a letter which he said he had received from the bailiff of Rijnsburg. The letter had been sent to the bailiff on behalf of the delegates of the States of Holland and West Friesland in The Hague instructing him that he should put a stop to the lottery and dismantle the stand. It also informed him that if he failed to do away with the lottery, the order would be carried out by a higher authority.

"It struck me that I had been shamefully treated by the two female persons Neeltge Goris and Tryn Rochus, who not only had given me to understand that the consent for the lottery had been given by the noble lords of Holland and West Friesland but had delivered to me an act of consent that seemed to be in order. Moreover, it looked as if the women might have heard rumors a few days before that the letter from the delegates forbidding the lottery was in the offing, and they still had deceitfully prized the 300 guilders from me and, against all reason and right, kept them from me. When they had seized their prey, they abandoned me in my distress. The damages I suffered exceeded 1,000 guilders, not counting the heavy obligations and interests connected with the goods offered as prizes, some of which I had paid cash for, others that I had received on credit and still others on consignment. These last I was supposed to return to the extent that they had not been raffled off. Since the lottery had not taken place and the merchandise could not be converted into cash, I had to return some of the goods along with a money payment for compensation. But there were also a few persons who did not want their goods back. After they had collected my goods and theirs in Delft at the house of Pouwels Weyts [the art dealer], they had them impounded; then they brought suit on me: the silversmith Dominicus Fredericksz., for 2,000 guilders; Abraham and Jacob Schimmel for over 1,600 guilders; the dealers in mirrors, Gilliam Wagenaer and Pieter Jansz. Singel, for over 500 guilders; and Claes van Roijstien, coppersmith in Utrecht, for over 200 guilders. These individuals caused me great trouble and expenses, and I was condemned by the judges in Delft to pay them for some goods and for others to compensate them for the damages that the goods had suffered. This, as I can prove by the accounts and bills in my possession, cost

me over 400 guilders for repairs for damages, for rent [of Weyts's premises], for food and drink, and for legal costs, not counting the loss of my time and the interest foregone on the goods that I had bought for cash, which remained on my hands and have since become spoiled. So that I can aver it to be the truth that I suffered damages at least equal to 1,500 guilders at the hands of the aforesaid female persons who cheated me in this manner and did not even scruple, even though I owed them nothing, to keep my three hundred guilders. They kept them for some time until they heard that I wanted to speak to them about my rights and they were afraid that I would sue them. They then approached their good friend Adriaen van der Waes, the substitute sheriff of Delfland [the one who had brought the letter from The Hague]. Van der Waes informed me that they were willing to pay two hundred guilders a few months hence to any person I would designate, but as to the three hundred guilders, they had given them to people they were indebted to, and the money was no longer available. The substitute sheriff advised me that I should accept the two hundred guilders, otherwise if I were to go to court, it would take even longer to get my money back. Moreover, he said the women were well known for being contentious persons and of little conscience who would not hesitate to invoke legal pretexts or excuses to delay repayment. So they kept my hundred guilders and they did nothing to compensate me for the heavy losses they had inflicted on me as result of the deceptive act of consent.

"Meanwhile the two female persons were again making me promises and blandishments, claiming they were acquainted with great magnates from whom they hoped to obtain a permit to stage lotteries in some cities. They said that at some suitable time, they would again solicit a permit in Delft and they promised that they would employ me and no one else, provided that I would satisfy their demands and deliver appropriate goods for the lottery. They would thereby compensate me for my great losses.

"But I found I had to do with people who were very crafty, full of guile, and of little scruple, yea, people such that one would be hard put to find any others like them in Delft. Moreover, I was afraid, as the proverb says, to throw good money after bad, so I neglected to bring them to court to force them to compensate me for my losses. But the main thing was that I kept on hoping that the women, some time, some place, would get a permit for me to stage a lottery and then, to make up for my losses, that they would engage me as they had promised. So I fully entrusted myself to them, all the more so that each time I asked them how they were doing in their efforts to obtain the permit, they always replied that they had good expectations to get it soon and they always swore to me that, when they did, it would be for me and for no one else.

"Thus having heard that the two women had firm expectations to obtain the permit for the lottery, I happened to be going by the hog [small-cattle] market near the home of Neeltge Goris, seller of bedding, when I came upon Cornelis Jansz., a resident of Leyden, who also earned a living organizing lotteries. It occurred to me that Cornelis Jansz. must have just walked out of the house of Neeltge Goris and that they probably had transacted some business there. This happened in the beginning of April 1622 [two years after the abortive lottery]. I went to Neeltge Goris's house and I told her, among other things, that I had just met Cornelis Jansz. and I asked her whether he had been to see her. She was surprised and hesitated, but she said no, she had not seen him. So I said I had heard she was soliciting the permit very earnestly, which she acknowledged to be true, adding that she had heard some promising news, and she renewed the promise she had made to me, saying 'you should not have any dark thoughts about it. I can assure you that if the consent is obtained, you and nobody else will be engaged.' To this I answered that if it were not so and if I had mislaid my confidence, this would do me a great wrong and I would feel fearfully cheated, besides the great losses I had suffered outside Delft, as was well known, without being compensated for them. And I was free to solicit the permit myself from somebody else if I could not trust in their promises, whereupon Neeltge Goris asked me to stand still and, with her hand on her breast, she said, 'Cousin, I promise you between God and my conscience; if the consent is obtained, it will be for you and for nobody else. You can rely on it.' This was said with a sanctimonious air as if she held God by the feet. Then she boasted several times that she was a sister and member of the community of the Reformed Church. In consequence I did not believe that she would deceive me one more time and would renege on all her promises.

"Then I heard that the two women had obtained the consent from the magistrates to hold a lottery in Delft. When they still did not call on me, I went to the house of Neeltge Goris with the intention of speaking to her about what we should do next. In point of fact, she received me spitefully and rudely. She acknowledged they had obtained the consent but said outright that it would not be for me. I would have nothing to do with it and they would not engage me. She added that they had applied for a permit some other place and that they had been led to expect a successful outcome, but that it had been refused. By this she meant that if it had been obtained it would have been for me, and they would have fulfilled the promise they had made to me. So we had some harsh words, as I found myself again cheated by the two female persons named Neeltge Goris and Tryn Rochus. I left the house in low spirits, half desperate, and in a very bad mood about my great losses and the great wrongs and unlawful things I had suffered anew at the hands of the two women. It was

intolerable that I should have endured such heavy losses which 2,000 guilders would not make up for. And it had become public knowledge that Neeltge Goris, Tryn Rochus, and Claes Brugman [the well-known silversmith who had contributed 3,000 guilders worth of silverware to the abortive lottery of Easter 1620] had obtained permission to hold a draw-lottery on the 19th of June 1622 [during the Delft kermess] and were able to show the act of consent from the magistrates. And now that the lottery was all set to go, the two women would not employ me in spite of all their promises. They had taken on other persons and had not compensated me in the least for any of my losses.

"Therefore, *mijnheer* the notary, I, Rogier Laurens, request that you go, in the presence of witnesses, and address the two women aforesaid, namely Neeltge Goris and Tryn Rochus, wherever they might be found, in their domicile or elsewhere, and, on my behalf, read aloud to them this declaration and leave a copy with them and inform them that I am still ready to settle our differences amicably, provided that they are willing to fulfill their promises and to employ me in place of somebody else in the lottery and make up for my losses insofar as possible. In that case I would be prepared to give them appropriate satisfaction and to be at their service in all possible ways, as I was at their service outside Delft in The Wandelinge where the lottery was held and where I suffered such great losses. If they are not willing to do this, I would still want my losses, amounting to 2,000 guilders or whatever sum will be judged appropriate, compensated.

"In case they refuse both of these things, then I declare myself to have been the victim of deceit and I protest by the present against the female persons Neeltge Goris and Tryn Rochus and against Tryn Rochus's husband Cornelis Lendertsz. van der IJssel, together and each separately, their heirs and descendants, and I reserve the right to take them to court before a judge or judges of any courts as I might at some time see fit, and I request that, after this notification and protest ("insinuatie") have been made, an answer be sought, a suitable report made, and an act in due form drawn. All of this was done without sham or deceit and was signed by me in recognition of the truth on June 17, 1622."

"I [writes the notary] found and addressed Neeltge Goris, Tryn Rochus, and Cornelis Lendertsz. van der IJssel at the house of Maritgen Aryens, called "The Butter Barrel" on the south side of the Great Market Square, in the presence of the witnesses cited below. After they had been informed of the contents of the insinuatie and, in case of refusal, of the protest, Cornelis Lendertsz. departed from the place without vouchsafing an answer; his housewife followed him, saying on her way out, 'I see, I hear'; and Neeltge Goris answered: 'I have nothing to do with the man.' So I left a duplicate of the insinuatie with Neeltge Goris, requesting that

she communicate the same to Tryn Rochus and Cornelis Lendertsz. I then protested against these persons over the great damages specified in the document. This was done in the same house in the presence of Lodewyck Cornelisz. Sontwyck and my clerk Pieter van Coelycken on June 18th, 1622."

Besides this unusually lengthy and circumstantial "insinuatie," a few other papers relating to the affair have survived. On June 7, 1620, a few days before the lottery in The Wandelinge was to be held, Cornelis Lendertsz. van IJssel, grain merchant, and Neeltge Goris acknowledged a debt of one hundred guilders that they owed to Cornelis Gijsen for having allowed Rogier Laurens the use of his stand for a lottery. Jan Thonisz. Back, the husband of Neeltge's daughter Adriaentge, witnessed the deed.[10] A few months later, in September 1620, Rogier Laurens asked a swordmaker to testify regarding the prices of some sidearms he had bought for the lottery from Jacob Schimmel. He apparently wished to establish that he had bought the weapons at advantageous prices.[11]

In February of the following year, Cornelis Gijsen had a number of witnesses testify about the lottery set up on his wharf from May 28 to June 18, 1620. One of the deponents, an elderly bookkeeper from The Hague, claimed he had kept a record of all the costs incurred by Rogier Laurens "along with his entourage, servants, and trumpeters." An alderman of Vrouwenrecht declared that he had kept in his house the box where the lottery tickets had been deposited and handed it over to "the master of the lottery" (presumably Rogier Laurens) when he and his suite departed on June 18.[12] All this no doubt was to prove that everything had been aboveboard as far as Gijsen was concerned.

A document dated shortly before Rogier Laurens registered his long-winded and passionate protest in 1622 shows that he was not telling the entire truth about having been cut out of Neeltge's lottery project in Delft.[13] The silversmith Claes Cornelisz. Brugman, Tryn Rochus, and Neeltge Goris each had a share of one-third in the lottery scheduled for June 21 of that year (during the Delft kermess), for which they had solicited a permit from the Delft magistrates. The contract stated that, in exchange for two hundred guilders and a pair of Milanese silk hose, Rogier Laurens was entitled to draw all the profits that he could earn from the six thousand guilders worth of silver- and giltwork and jewels that Claes Brugman had put up for the lottery. Laurens also had to assume the expense of one thousand guilders that Claes Brugman had promised would be paid to Delft charities if the permit were granted. These concessions

[10] Doc. no. 44, 7 June 1620.
[11] Doc. no. 61, 25 September 1620.
[12] Doc. no. 67, 28 February 1621.
[13] Doc. no. 78, 25 April 1622.

fell far short of what he claimed Neeltge had promised him as a chief participant in the lottery venture, but it did offer him an opportunity to recoup a part of his losses.

An opportunity, not a certainty, for in fact the project turned sour. By October of the same year, the lottery apparently had not taken place, and Brugman had impounded various goods belonging to Laurens for failure to fulfill the contract.[14] Laurens complained that Brugman had never delivered to him the silver- and giltwork worth six thousand guilders that he had promised. Laurens, in a second "insinuatie," this time addressed to Brugman, declared that he was still prepared to fulfill all the provisions of the contract. The ultimate fate of the protracted controversy over the Delft-based lottery is unknown.[15]

Groningen, in the northeast province of that name, was the "other city" in which Neeltge Goris was trying to obtain permission to stage a lottery, as she had informed Laurens at the time of the altercation they had had in her house. Here she apparently fulfilled her end of the bargain. A few weeks after she received permission to raffle off silverware from the burgomasters of Groningen, she gave power of attorney to Rogier Laurens and an associate in Dordrecht to allow them to organize a lottery in her name. This affair also led to a complicated dispute.[16]

Two years later Rogier Laurens was still organizing lotteries in the province of Zeeland and elsewhere. But he was no longer teamed up with Neeltge Goris. Neeltge was out of the lottery business altogether.

The archives of Delft contain material that sheds light on the background and character of Tryn Rochus, Neeltge's friend and partner—both in the affair of the lottery of June 1620 and in clearing estates. She was more than just a good talker with a smooth tongue, as Neeltge had described her to Laurens. She was a busybody and probably a cheat as well. In 1623 the adult children of the famous tapestry manufacturer Franchoys Spierinx asked several witnesses to make a deposition regarding calumnious statements that Tryn Rochus had made about him and his wife.[17] The witnesses declared this allegation to be totally false and vile, as one witness knew perfectly well because she had been present at the couple's wedding in the church in Scheveningen, at which time Spierinx was a widower and still "quite free" of his bride-to-be.

[14] Doc. no. 85, 15 October 1622.

[15] Brugman must have sued Laurens, considering that the latter, in October 1622, when he was residing in Dordrecht, had named an advocate to represent him before the judges in Delft in this affair (see Dordrecht G.A., records of Gijsbert de Jager, O.N.A. no. 27, documents dated 26 October and 24 November 1622, and Delft G.A., records of Notary H. van der Ceel, no. 1637).

[16] Doc. no. 81, 1 and 3 June 1622; and no. 87, 10 January 1623.

[17] Delft G.A., records of Notary A. Ryshouck, no. 1787, dated 5 May 1623.

Five years earlier, scandal had arisen over Tryn's disposal of an estate.[18] She claimed the deceased had instructed her—just before her death—to take some goods for herself and distribute others to some friends. Even though her husband had cautioned her to behave decently and stick by the law in settling the estate, she had removed many valuables before the inventory was drawn up and had woven a web of lies around her activities. It is not clear how much she had misappropriated for herself and how much she had diverted from the rightful heirs to her friends and acquaintances. In any event most of the goods she had taken were returned before the estate auction took place, and she escaped prosecution. This incident does not seem to have hampered her subsesquent career as a secondhand dealer. When she died at the age of eighty-two in 1643, she was well-to-do. Unlike her friend Neeltge Goris, who died in penury, Tryn never paid for her sins.

Between the abortive lottery of April 1620 and the "insinuatie" drawn up by Rogier Laurens against her in June 1622, Neeltge Goris had acquired and lost a third husband. She had married a man named Jan Michielsz. van der Beck, an illiterate ship's carpenter or shipmaker, from Delfshaven. On the day they were betrothed, October 17, 1620,[19] Neeltge and her entire household went to the notary to settle the succession of her second husband, Claes Corstiaensz.[20] Her son Reynier Jansz. and sons-in-law Jan Heymensz. (the baker who had married her daughter Maertge) and Jan Thonisz. Back (husband of her daughter Adriaentge) declared for themselves and on behalf of Anthony Jansz., stone carver (her second son, presently away in the East Indies), that Neeltge Goris had given them entire satisfaction with respect to all the goods they might have been entitled to in the estate of the late Claes Corstiaensz.

Neeltge's marriage with Jan Michielsz. was celebrated on November first. Less than a year later the ship's carpenter made out his will.[21] Sick in his body, yet in command of his reason and his five senses (as the notary ritually observed), he left all his worldly possessions to his wife Neeltge Goris, except for two donations of one hundred guilders each that were to be given after her death to nephews living in Haarlem. He was buried four days later. As a death donation for her late husband, Neeltge delivered six guilders to Delft's Camer van Charitate, the city's welfare organization, a sum that suggests the ship's carpenter was not without means.[22] Two months after his death she sold a house in Delf-

[18] Delft G.A., records of Notary H. Vockestaert, no. 1582, depositions dated 9, 10, and 12 March 1618.

[19] Doc. no. 62, 17 October 1620.

[20] Doc. no. 63, 17 October 1620.

[21] Doc. no. 70, 24 September 1621.

[22] Doc. no. 71, 28 September 1621.

shaven that had belonged to him for three hundred guilders.[23] The profit-and-loss statement for the twelve months of her third marriage showed a clear surplus.

Yet her inheritance was not large enough to solve her financial problems. The arrears on old debts kept piling up. She had to borrow again and again to keep up her payments on old obligations and to help members of her extended family when they were in need of money. In May 1622, she acknowledged a debt of four hundred guilders to the heirs of the notary Jan Molijn.[24] Later that year, she guaranteed a loan contracted by her son-in-law, the baker Jan Heymensz.[25] In January 1623, her son Anthony was back in Delft from his first voyage to the East Indies. Neeltge borrowed two hundred guilders from a sailor, seventy-five guilders of which were used to outfit Anthony for a second trip to the East.[26]

Back in 1621, another of Neeltge's sons-in-law, the butcher Jan Thonisz., had bought on credit from a man named Govert Coenen one hundred sheep for slaughtering. Neeltge had guaranteed repayment of the debt of 725 guilders.[27] In March 1623, Jan Thonisz. still owed the greater part of the money. He now transferred to Neeltge all his movable goods as collateral for a loan of 965 guilders, of which 540 guilders were to be used for reimbursement of his debt to Coenen.[28]

The butcher's possessions included a small collection of paintings: a picture of Lot and his daughters (valued at four guilders), a landscape with Jesus curing the blind (twelve guilders), a landscape with a pair of oxen (fifteen guilders), a panel representing Charity (six guilders), a winter landscape (seven guilders), and a flower in a vase (eight guilders). There were also several inexpensive paintings on panel, some prints, a large Bible, and a book on Christian ethics by Ursinus, a well-known Protestant theologian. The paintings and prints, together with the furnishings and the clothing, denote a fairly comfortable middle-class status. The transfer was of course only nominal: Jan Thonisz., who was living with his wife Adriaentge Claes on the Vlamingstraat, kept his household goods *in precario*, by which was meant that the creditor was entitled to seize them anytime she had a mind to.

It is puzzling, in view of this loan-cum-transfer, that only a month later, Jan Thonisz., together with Vermeer's father Reynier Jansz., guaranteed

[23] Doc. no. 75, 12 December 1621.
[24] Doc. no. 80, 24 May 1622.
[25] Doc. no. 84, 6 August 1622.
[26] This debt is cited in doc. no. 116, 17 July 1627.
[27] Doc. no. 72, 15 October 1621.
[28] Doc. no. 89, 28 March 1623. On 11 February 1623, one month before transferring his possessions to his mother-in-law, Jan Thonisz. contracted to buy sheep, hogs, oxen, and cows for slaughtering to the extent of two hundred guilders that she had advanced him, for which service he was only to earn eight guilders during this year (doc. no. 88).

a debt of 749 guilders incurred by Neeltge Goris.[29] This time it was for ticking delivered for the old woman's bedding business. The money was owed to the merchant Hans Lemmes. She promised to buy more ticking from him, evidently to make the mattresses, eiderdowns, and pillows she sold for a living. The debt was scheduled to be paid in installments of one hundred guilders a year plus interest "at the penny sixteenth," or a little more than 6 percent a year.

In April 1624 Jan Thonisz. came to the rescue again. This time he took over one-fourth of the guarantees made by his brother-in-law, the baker Jan Heymensz., on Neeltge's debts, except for the obligation secured by The Three Hammers.[30] Since Neeltge was no longer able to keep up with all her payments, such a guarantee was tantamount to shouldering part of her debts. Jan Thonisz.'s commitments hastened the day of his own financial collapse, which occurred at the beginning of the 1630s.

This web of crisscrossing obligations illustrates a characteristic trait of Vermeer's family in those early days: mutual loyalty and cohesiveness. All the men in this extended family—Jan Heymensz., Jan Thonisz., and the brothers Anthony and Reynier Jansz.—helped Neeltge Goris to carry her debts even at the cost of their own financial prospects (just as she and her son Reynier had done their utmost to get Balthens out of jail a few years earlier).

One more incident from the life of Neeltge Goris rounds out her portrait. In October 1623, Neeltge Goris, dealer in bedding on the Small-Cattle Market, being fifty-six years of age, made a deposition concerning a neighbor named Geertge Jacobs, the wife of Willem van Antzen.[31] Van Antzen played a significant role in the history of the Netherlands' colonization of the East Indies. He had first sailed to the Indies in 1614 as a captain under Joris van Spilbergen when this famous explorer was sent by the United East India Company to find a shorter route to India via the Strait of Magellan. He had become governor of Banda in what is now Indonesia in 1618 and a member of the governing council of the East Indies in 1621.[32] Van Antzen left the Indies in September 1622 and arrived in Holland shortly before Neeltge made her appearance before the notary. The person who had requested Neeltge's deposition was Pieter Ghysenburch de Jonge, owner of the brewery "In't heck" ("In the gate").

Vermeer's grandmother declared that, not long ago, she had been with Van Antzen and his wife in an inn named The Dolphin in The Hague and she had seen and heard Geertge Jacobs (her neighbor on the Broerhuys-

[29] Doc. no. 90, 30 April 1623.
[30] Doc. no. 99, 22 April 1624.
[31] Doc. no. 92, 2 October 1623.
[32] W. P. Coolhaas et al, *Jan Pietersz. Coen: Bescheiden omtrent zijn bedrijf in Indië* (The Hague: Martinus Nijhoff, 1952), vol. 7 (by W. Ph. Coolhaas), p. 895.

steegh) list certain debts she had contracted while her husband was away in the Indies. Having noticed that Geertge had omitted to mention a debt to the brewer Pieter Ghysenburch de Jonge (of which she, Neeltge, had knowledge), Neeltge had said: "Geertge, why don't you say anything about the debt you owe to the brewer?" Whereupon Van Antzen asked Neeltge whether there was something he should pay there. She answered, "Yes, there is, about 75 or 80 guilders, so Geertge herself told me. And she also told me about some dress she had pawned."

Van Antzen said he had given Geertge money to pay for the debt to Ghysenburch. When Geertge was asked where she had left the money, Neeltge could not remember what Geertge's answer was. Other documents reveal that Geertge Jacobs had run up a number of debts during her husband's lengthy absence. A judge finally granted Van Antzen's request for the couple's separation.[33] Since Neeltge was not above concealing a debt or two herself, her talebearing has the mark of gratuitous mischief, particularly vis-à-vis a neighbor.

Neeltge's son Anthony Jansz., as we have just seen, was back in Delft in January 1623 when he was "outfitted" for a second voyage to the East Indies at the cost of seventy-five guilders. Actually he had been back from his first trip as early as August 1621, when he witnessed a document for Notary Coeckebakker. On this occasion he declared himself to be a brass caster ("geelgieter").[34] In November of the same year he again acted as witness to a deposition, along with Jan Ariensz., glassmaker. For the second time he added the name of his new brass casting trade to his signature.[35]

This is all very curious because the last mention of his name, after he had died and his widow had remarried in 1629, was followed by the word "steenhower," the name of his original trade as stonecutter or sculptor.[36] Brass casters, who made copper dishes with letters and designs, as well as cannons and other firearms, possessed skills superior to those of ordinary stonecutters. The fact that Anthony Jansz. appeared in 1621 as co-witness with the glassmaker Jan Ariensz., who was a master in the Guild of St. Luke, and again at the beginning of 1625 when the glassmaker's brother sailed for the East Indies,[37] suggests the possibility that he may

[33] A later request to the States General by "Geertgen Jacobsdr., wife of Willem van Ansem," which presumably asked for more funds, was turned down on 24 January 1620 (Rijksgeschiedkundige publicatiën, Grote serie, Resolutiën der Staten-Generaal, nieuwe reeks, part 4, 1619–1620 [The Hague: Martinus Nijhoff 1981], p. 361). On subsequent payments made on her behalf, see the records of Notary A. Ryshouck, no. 1787, for 2 April and 3 July 1624.

[34] Doc. no. 69, 20 August 1621.

[35] Doc. no. 73, 3 November 1621.

[36] Doc. no. 125, 17 March 1629.

[37] Doc. no. 103, 2 January 1625.

have been working with him, perhaps to cast iron or brass forms for
blowing glass receptacles. He may later have gone back to his original
trade, for which there may have been greater demand in the overseas pos-
sessions of the East India Company.

We have only one glimpse of Anthony's existence in the Indies prior to
1621. A year or so before he left for his second voyage, he made a depo-
sition at the request of the wife of a certain Jacob Jansz. van Cortyen.[38] He
related how Jacob Jansz. had died in his arms in East India, in front of
the Fort of Djakarta, and that he had helped to bury him there. This was
during one of the many skirmishes with the troops of native princes who
did not share the view that the United East India Company had a God-
given right to rule their land.

In January 1623, Anthony Jansz. baptized his daughter Anna, with his
brother Reynier Jansz. acting as witness.[39] A year later, he was called
upon to help prop up his mother's crumbling finances. The sum of 749
guilders she had borrowed from Hans Lemmes two years earlier had now
grown to 793 guilders, 18 stuivers, and 9 pennies with the interest due.
Anthony promised to repay the entire sum out of the wages he was slated
to earn on his forthcoming voyage at sea. Hans Lemmes's lien was not to
exceed one-fourth of Anthony's wages on this or on succeeding trips.[40]

At the beginning of 1625, Anthony Jansz. and Vermeer's father Reynier
Jansz. both signed as witnesses to a power of attorney for the brother of
Jan Ariensz., glassmaker, who was ready to sail to the East Indies.[41] The
two brothers never appeared before the notary together on any other oc-
casion that we know of. In April Anthony's daughter Neeltge was bap-
tized in the New Church.[42] This time his mother Digna Baltens and his
sister Maertge Jans were the witnesses. Anthony's first daughter, who had
presumably died some time previously, was also called Neeltge. He evi-
dently felt that there had to be someone in the family to carry on his
mother's name. On the occasion of the christening, he called himself An-
thony Jansz. Vermeer. This was the first time the name Vermeer was used
in any document that has come down to us.

Two years later, in July 1627, Anthony's wife, Tryntje Isbrantsdr. re-
ferred to him as being alive in the East Indies when she bound her posses-
sions and her person to repay the seventy-five guilders his mother had
borrowed on his behalf to outfit him for his voyage.[43] She must have
heard of his death soon afterward, since according to the register of the

[38] Doc. no. 102, 8 December 1624.
[39] Doc. no. 86, 6 January 1623.
[40] Doc. no. 97, 27 January 1624.
[41] Doc. no. 103, 2 January 1625.
[42] Doc. no. 106, 6 April 1625.
[43] Doc. no. 116, 17 July 1627.

citizens of Delft "who have entered the holy state of matrimony," Tryntje Isbrantsdr., widow of Anthony Jansz., stonecutter, was betrothed to Joris Balfort on March 17, 1629.[44]

Anthony's help could only temporarily stave off Neeltge's financial collapse. In December 1623 her son-in-law Jan Heymensz. had already been forced to pay a debt for 140 guilders that she owed to Gerard Welhouck, in compliance with a sentence issued by a court in Delft.[45] Welhouck, a well-known merchant in Delft who later became a burgomaster, sold feathers to Neeltge to fill mattresses and pillows. A document certifying that he had sold and delivered to her 328 pounds of feathers raises the suspicion that she had falsely denied receiving the merchandise.

In March 1624 Neeltge was forced by financial necessity to rent The Three Hammers. Willem Jansz. Meyns, drummer in the guard of His Excellency Prince Maurits, leased the house for one hundred guilders a year for three years.[46] A few months later Neeltge transferred the entire sum owed for the three years' rent to her stepson Dirck Claesz. van der Minne and her son-in-law Jan Heymensz. to compensate them for the previous repayment of one of her debts.[47] She moved to premises on the Cruysstraet, a couple of blocks east of the Small-Cattle Market.[48] In January 1625, a creditor officially notified her that she was in arrears on a debt of 125 guilders, of which she had managed to pay 100 guilders "through the hands of Tryn Rochus." She was taken to court in May 1626 before she paid the debt in full, shortly thereafter.[49]

Less than three months later, on August 12, the heirs of one of her creditors sued to recover 125 guilders still outstanding on the debt guaranteed by Jan Heymensz. and Dirck Claesz. that they had partly repaid two years earlier. The aldermen of Delft ordered her to pay twenty-five guilders by August 12, 1628, and the rest within the two following years. The entire debt, including interest, was remitted before August 10, 1632.[50] It is not clear whether the rental income from The Three Hammers was enough to compensate Jan Heymensz. and Dirck Claesz. for the sums they had been obliged to expend on Neeltge's behalf.

The reason we know so much today about Neeltge's debts is that several of her creditors died in 1624–1625, when the plague raged in Delft, and the amounts she owed were written down in their estate papers.[51] As luck would have it, not a single member of Neeltge's extended family was

[44] Doc. no. 125, 17 March 1629.
[45] Doc. no. 95, 13 December 1623.
[46] Doc. no. 98, 11 March 1624.
[47] Doc. no. 101, 25 September 1624.
[48] Doc. no. 104, 4 January 1625.
[49] Doc. no. 105, 17 Janaury 1625.
[50] Doc. no. 123, 3 November 1628.
[51] See document nos. 104, 105, 107, and 108.

carried off by the illness in those terrible months when the clerk holding the register of burials crowded more and more names on each page. At times he could do no more than note the number of people who had been brought to be buried from the hospice or the pesthouse. Even though more than one-tenth of the city's population died in the twelve months that followed the summer of 1624, social norms did not break down. Delft was governed much as in ordinary years. The machinery for ensuring the repayment of debts was unimpaired. One clerk might die; another would replace him. Nothing was forgotten or forgiven. The fiber of Dutch urban society was tougher than the plague.

In early 1627, when the rental contract with His Excellency's drummer had run out, Neeltge came back to her house on the Small-Cattle Market. She died in the first days of September of that year, at the age of sixty.[52] Two months after her death, the aldermen of Delft, acting upon the request of her creditors, ordered her house and all her movable goods sold to pay her debts.[53]

[52] Doc. no. 117, 6 September 1627.
[53] Doc. no. 118, 5 December 1627.

· 4 ·

REYNIER JANSZ. VOS,
ALIAS VERMEER

In the last months of 1623, Vermeer's grandfather, Balthasar Gerrits, former counterfeiter, reappeared in Delft. Notary Van der Ceel, who lived next door to The Three Hammers by the Small-Cattle Market, noted in the first part of the debt acknowledgment he drafted on this occasion that Balthasar was domiciled in The Hague.[1] In the second part, The Hague was crossed out after his name and the town name Gorinchem written above the erasure. He was doubtless on his way from The Hague to Gorinchem, forty miles to the southeast of Delft, where his son Balthens, after his release from prison, had settled earlier in the same year.

This document began with an inventory of "all such movable goods as Reynier Jansz., caffa worker, had sold and transferred in full ownership to Balthasar Claes Gerrits." Why was Reynier Jansz. impelled to borrow from his father-in-law? One would have thought, rather, that Balthasar owed money to Vermeer's father for his son's release from jail. One explanation that comes to mind is that the older man had actually just repaid the debt he owed Reynier Jansz. but wished to dispel any suspicion friends and neighbors around the Small-Cattle Market might have had about the origin of the money. So he had made it appear as if he were making out a loan to Reynier Jansz. The fact that the amount of the alleged loan was left blank lends weight to this supposition. At this time, Reynier Jansz. might also have needed money to launch his innkeeping venture, which he began sometime in the next five years.

Reynier Jansz. was then thirty-two years old, married, and the father of a three-year-old child. The movable possessions that he had "sold" to his father-in-law were appraised at 693 guilders, which was about two and a half times as much as the average value in a fairly large sample of inventories drawn from the notarial and Orphan Chamber archives of Delft.

The paintings in the inventory were appraised by an artist named Joris van Lier, who supplemented what must have been a poor living as a still-life painter by clerking for Notary Van Ceel. Van Lier, a man of Reynier Jansz.'s generation, had traveled extensively in Italy before settling in his native city not long before this. He later gave up painting to become a collector of excise.

The first item in the inventory was a painting of "an Italian piper in a

[1] Doc. no. 94, 8 December 1623.

gilded frame," appraised at three guilders. This was probably a half-length figure of a flutist or a man playing on a shawm. The adjective "Italian" was often applied to musicians dressed in fancy jackets of varicolored stripes with slit sleeves. Judging by the low price, it was a copy rather than an original by a well-known master. In the first chapter, I speculated that Reynier Jansz. may have owned this painting because he himself played on a pipe or flute in family concerts, with his stepfather, the musician Claes Corstiaensz., and his stepbrother, Dirck Claesz. van der Minne.

The second painting in the inventory was a vase of flowers appraised at six guilders. Next came two portraits at twelve guilders. The only portraits other than those of the reigning Stadhouder's family in the small collection, they are presumed to have been likenesses of the young couple painted at the time of their marriage. If so, they were probably the very pictures that Johannes Vermeer owned throughout his life and that appear in his death inventory in February 1676 ("two portraits of Sr. Vermeer's late father and mother").[2] Three small paintings on alabaster appraised at one guilder a piece and a night scene at three guilders completed this first list of paintings. The inventory, after itemizing other household objects, closed with a second series of paintings: a dish of grapes in a gilded frame appraised at four guilders, portraits of the Prince and Princess (the future Stadhouder Frederik Hendrik and his wife) at eight guilders, portraits of Stadhouder Maurits and his brother Prince Frederik Hendrik at four guilders, a brothel scene ("bordeeltje") at three guilders, a Sacrifice of Abraham at one and a half guilders, a landscape at two guilders, a Story of Lot at two guilders, and two paintings on alabaster for one and a half guilders. Altogether the paintings were valued at fifty-three guilders, or 7 percent of the entire inventory.

What do the paintings tell us about Reynier Jansz. at this stage in his career? The presence of four portraits of the reigning Stadhouder's family in the little collection hints of loyal Protestant support for the House of Nassau. The Old Testament subjects (Sacrifice of Abraham, Story of Lot) are also typical of a Reformed household. On an aesthetic plane, three pictures stand out: the Italian piper, the night scene, and the brothel. Although these three subjects were not the exclusive province of the Utrecht School, they are certainly genres that the school popularized. From the early 1620s on, Terbrugghen and Bloemaert painted musicians dressed in fancy "Italian" garb. There are two pictures of flutists by Terbrugghen, both dated 1621, each with a dark figure against a light background, which are often said to have anticipated the work of Carel Fabritius and Vermeer.

[2] Doc. no. 364, 29 February 1676.

Gerrit van Honthorst, who came back to Utrecht from Italy in 1620, launched a vogue for candlelight scenes that influenced Rembrandt. The night scene in the inventory may have been a copy of one of Honthorst's works. Brothels were frequently painted by Dirck van Baburen, one of whose paintings (representing a procuress offering the services of a whore) later entered the Vermeer household via his mother-in-law, Maria Thins. If I am right in believing that all three pictures were by Utrecht painters or copied from their works, then it is remarkable that they had come into the collection of a common craft master in Delft no later than 1623. These straws in the wind are all the evidence we have of Reynier's discerning taste for the latest trends in the Dutch painting of his time.

Other items in the inventory give us an idea of the young couple's condition. The bed in which Reynier and Digna slept, with all the mattresses, eiderdowns, and pillows that went with it, which had probably been supplied by Neeltge Goris, was appraised at sixty guilders. (Bed and bedding were among the most costly items in seventeenth-century inventories.) The second bed, which must have been their young daughter Gertruy's, cost twenty-four guilders. Among the household items, a few stand out: twenty-two porcelain cups appraised at eight guilders (if they were not Delft faience, spuriously called porcelain), which may have been imported from the Far East, perhaps by Reynier's brother Anthony when he returned from his first trip to the Indies; an ebony mirror at four guilders; eight pairs of sheets at forty-eight guilders; four cushions (probably embroidered) at thirty guilders; two green curtains at six guilders; two rugs used as table covers at twelve guilders; and a half-dozen tablecloths at twenty-four guilders. There was a good deal of tin plate in the inventory, but no silver or gold.

The clothing, as usual in those days, was very expensive. Reynier and his wife Digna each owned eight shirts valued at twenty-four guilders; a mantle priced at thirty-six guilders; Digna's hooded cape at thirty-six guilders; a cloth dress at twenty-two guilders; a silk apron at thirty-six guilders; a satin bodice at twenty guilders; and a few more ordinary items. The real magnitude of these prices may be gauged from the fact that apprentices and journeymen, who made up the bulk of the population, earned on average less than one guilder a day.

Did the inventory contain all the couple's possessions? A few omissions stand out. There was no caffa worker's equipment—looms, tools, raw materials, or finished goods. Six Spanish leather chairs and one small bench were mentioned, but not a single table. There were no books—not even a Bible, a standard item in literate Protestant families. Most suspect, however, is the absence of children's clothing (Gertruy was then three years old).

On balance it is fair to say that the inventory probably contained most,

but not all, of the movable goods Reynier and Digna could call their own. The contents of the inventory were rather luxurious, even for a master craftsman. Reynier Jansz. was living on a higher level than anyone had a right to expect three years after he had "stripped himself bare to the point of selling his bed," as he is said to have told Gerrit de Bury in 1620. Perhaps Reynier (or De Bury) had exaggerated. Or again, Reynier's earnings from weaving caffa in the intervening years may have been sufficient, if the couple lived frugally from day to day, to buy the more expensive objects and clothes that were found among their household goods.

The remaining portion of the document relates how all these goods had been duly sold and transferred by Reynier Jansz. to Balthasar Gerrits, in compensation for an equivalent sum (left blank) that Balthasar had extended to him. The goods had been removed from Reynier's house, placed on the public street, and there had been delivered to Balthasar. However Reynier had earnestly beseeched that the goods be returned to him for his use *in precario* (that is, so long as his father-in-law did not ask to have them back). Balthasar, "moved by fatherly affection," had granted his request. So we are given to understand that the goods were again in Reynier's house. But these were all notarial formulae. The goods probably had never left Reynier's house. Notaries inserted such clauses to firm up loan contracts so that, in case the lender wanted to foreclose on a loan, he could call on the sheriff to confiscate the goods. The loan contract between butcher Jan Thonisz. and Neeltge Goris contained similar clauses.

As far as we know, Reynier Jansz. was only drawn into his mother's financial affairs on one occasion. Eight months before he ostensibly borrowed money from Balthasar Gerrits, he had guaranteed, together with his brother-in-law Jan Thonisz., a debt that she had incurred for nearly 750 guilders from the dealer in bedding, Hans Lemmes.[3] Even then, as we have already seen, he was able to fob off this conditional obligation on his brother Anthony, who agreed to shoulder the greater part of debt with a lien on his future wages in January 1624.[4] Reynier remained solvent throughout the period of Neeltge Goris's final collapse. The financial decline of his brother-in-law Jan Thonisz., in the late 1620s, did not seem to affect Reynier either. We find him in 1626 promptly repaying a debt of seventeen guilders for brandy.[5] In 1629–1630, he owed money to a silk merchant, perhaps for the yarn he wove into caffa.[6] This too was paid. From the looks of it, Reynier Jansz. carefully husbanded his assets to give

[3] Doc. no. 90, 30 April 1623.
[4] Doc. no. 97, 27 January 1624.
[5] Doc. no. 108, 12 July 1625 and 29 September 1626.
[6] Doc. no. 131, 3 June 1631.

himself the best chance of moving up in the world, as he gradually succeeded in doing.

In July 1625, when the plague, which had been raging in Delft for a year, was just about over, the young caffa worker got into a scrape which, in modern times, would have caused him far more trouble with the law than it actually did. What happened was that Reynier Jansz. Vos, together with a fellow caffa worker named Dingeman Cornelisz. van der Plaat and a certain Jacob Jansz., had a fight with Willem van Bylandt, a soldier who was temporarily quartered in Delft.[7] Van Bylandt had been wounded severely in several places.

Digna Baltens and the mothers of the two other assailants appeared before the notary to settle the dispute with the injured soldier. The three men "who all had a hand in causing the wounds" were then in flight. The agreement called upon each woman to hand over six Flemish pounds of six guilders each to Van Bylandt as compensation for his pain and suffering. In addition they would have to pay the surgeon's bills. Van Bylandt declared himself fully satisfied with the arrangement. He abjured all intentions of revenge on his own part or, if he died, on the part of his heirs. In case God Almighty vouchsafed him recovery from his wounds, he promised to invite his assailants to the house of Corporal Hans Pieters, where he would show them his good will by spending five guilders on a treat.

For reasons she did not explain, the mother of the other caffa worker, Dingeman Cornelisz., failed to sign the accord. She perhaps thought that her son bore less responsibility for the soldier's injuries than the other two men.

A week later, Reynier Jansz. and the third assailant, who had both recently returned from their flight, showed up with the notary at Willem van Bylandt's house. The soldier acknowledged having received four Flemish pounds each from the two men, or two-thirds of the money that

[7] Doc. no. 109, 26 July and 4 August 1625. In my summary of this document in *Oud Holland* 91 (1977): 276, I stated that the fight occurred in Mechelen, the inn that Reynier Jansz. purchased sixteen years later. This location of the fight was first proposed and conjectured by P.T.A. Swillens, *Johannes Vermeer, Painter of Delft 1632–1675* (Utrecht and Brussels: Spectrum Publishers, 1950), p. 17; it was then reported as a fact in Albert Blankert, *Vermeer of Delft* (Oxford: Phaidon, 1978), p. 145. But there is no evidence in these or any other documents that the fight ever took place in an inn, let alone in Mechelen. It may be noted that the fellow caffa worker cited in the document, whose full name was Dingeman Cornelisz. van der Plaat, was the brother of the master painter in the Guild of St. Luke, Marinus Cornelisz. van der Plaat. In 1623 their mother, Fitgen Florisdr. van Croonenburch, widow of Cornelis Marinusz. van der Plaat, was accused along with Neeltge Goris's friend and partner Tryn Rochus, of calumny against the master tapestrymaker, Franchoys Spierinx (Delft G.A., records of Notary A. Ryshouck, no. 1787, 5 May 1623). The other assailant, named Jacob Jansz., son of Neeltge Jansdr., the widow of Jan Jacobsz., may have been the tailor of that name with whom Reynier Jansz. appeared as a witness on 12 January 1630 (Delft G.A., records of Notary H. van der Ceel, no. 1641).

had been agreed upon. He declared himself fully satisfied with these payments and said he had no more claims on them or on their descendants.

God Almighty did not vouchsafe the young soldier's recovery. He died of his wounds the following November. Three days after he was buried in the New Church his mother, living in Thiel, gave Corporal Hans Pieters power of attorney to collect four Flemish pounds from Fitge Florisdr., the mother of Dingeman Cornelisz.[8] It is not known whether Dingeman's mother ever paid her son's blood debt.

Once Van Bylandt had died, Reynier and his acolytes could have been accused of manslaughter, if not outright murder. But the language used in the documents raises doubts about the extent of their guilt. The soldier must have started the brawl or somehow been at least partially at fault, for otherwise he would not have been so willing to come to a reconciliation or to accept a lower payment than the agreement stipulated (which already was quite modest). Also it may be argued that if Van Bylandt had been assaulted without provocation, he and his friend Corporal Pieters would have reported the incident to the authorities. In any event, Reynier and his two comrades seem not to have been prosecuted.

In the next three years we find no direct evidence[9] of Reynier Jansz.'s presence in Delft. He perhaps preferred to keep a low profile after the affair with Van Bylandt. He may even have absented himself from his native city for a year or two. He first reappears as a witness for Notary Herman van der Ceel on the Small-Cattle Market in August 1628, some eight months after the family house, The Three Hammers, had been sold by order of the aldermen.[10]

Then on February 9, 1629, he witnesses for the first time a debt acknowledgment for Notary Willem de Langue, whose office was located behind the New Church, a few doors away from the house on the Voldersgracht that we know he was leasing as an inn by January 1635.[11] From the fact that he is called "herbergier" (innkeeper) in this notarial act and from his frequent appearances as a witness for Notary De Langue from 1629 to 1631,[12] I conclude that he had moved to the inn on the Volders-

<hr>

[8] Doc. no. 110, 17 November 1625. Willem van Bylandt, soldier under Captain Baron, was buried in the New Church on 14 November 1625. (Delft G.A., New Church, Burials files).

[9] The repayment of the debt for brandy between July 1625 and September 1626 (doc. no. 108) is the only evidence of Reynier Jansz.'s presence in Delft at this time.

[10] Doc. no. 122, 12 August 1628.

[11] Doc. no. 124, 9 February 1629; and doc. no. 148, 30 December 1637.

[12] From February 1629 to August 1631, Reynier Jansz. signed six acts for Willem de Langue, but only one for H. van der Ceel, the old family notary on the Small-Cattle Market (12 January 1630). If the rental contract of January 1635 (doc. no. 148) was a renewal of the lease, which was to run another five years, as appears likely, and if the previous lease was also for a duration of five years, then Reynier Jansz. may have moved from the Small-Cattle Market to his new premises on the Voldersgracht at the beginning of 1629. This would be consistent with his first known contact with Notary Willem de Langue.

gracht by this time. What had brought him to the Voldersgracht? The inn—assuming it was the same one that he was renting in 1635—was owned by Pieter Corstiaensz. Hopprus (or Oprust), a successful shoe-maker, tanner, and leather merchant who seems to have been a relative by marriage of Reynier Jansz. through one or the other of his brothers-in-law Jan Heymensz. or Jan Thonisz. Back.[13] Even a distant family con-nection would have been a powerful inducement to enter into a business relationship at that time.

The inn was located on the north side of the Voldersgracht, the second house to the east of the Old Men's House (whose chapel was later con-verted to a hall for the Guild of St. Luke).[14] In recent years an elementary school named after Johannes Vermeer has been erected on the site where the Guild Hall stood until 1876. The future artist was most probably born a few steps away from the premises of the guild of which he was to become the most distinguished member, and of the school after which he was to be named.

The inn on the Voldersgracht was called "De Vliegende Vos" (The Flying Fox).[15] The coincidence with Reynier Jansz.'s last name, Vos, was surely not accidental. What is not clear is whether he hung a sign board with an image of a flying fox in front of the inn to announce to the world that he, Vos, was the new boss, or whether he took to calling himself Vos only after he started leasing the inn that was already known by that name. The second alternative would imply that he was already established in the inn as early as January 1625, when he first called himself Vos. This is unlikely, because he was still living on the Small-Cattle Market when he repaid a debt for brandy in September 1626.

It happens also that "Reynier" sounds like "renard," the French word for fox, and that the great compilation of fables that the French call "Le Roman de Renard" became famous in Holland under the title "Reynaerd de Vos." Vos was a natural last name to choose for a man christened Reynier. Not surprisingly, there were many people besides Vermeer's fa-ther who called themselves Reynier Vos or De Vos in Delft. There was

[13] According to doc. no. 203 of 28 January 1648, Pieter Corstiaensz. Opperis (Hopprus), Meynert Meynertsz. Verhan, Jan Heymensz. van der Hoeve, and Gysbrecht Heymensz. van der Hoeve were the closest relatives ("naeste vruden") of Jan Anthonisz., son of Anthonis Jansz., baker. Thonis Jansz. Back, stovemaker, signed the deposition. I have not been able to establish the family relations among these individuals, except of course for the fact that Jan Heymensz. van der Hoeve was Reynier Jansz.'s brother-in-law and that Gysbrecht Hey-mensz. was Jan's brother.
[14] On the location of Hopprus's house, see Delft G.A., "Verponding boek" 1632, fol. 127ᵛ. From west to east there stood the Old Men's House, the house of Cornelis van Schagen, the house of Pieter Corstiaensz., and the house of Willem Anthonisz. van Staveren. The last two houses were sold to the Anabaptist Community on 30 October 1640 (doc. no. 158).
[15] Doc. no. 145, 17 October 1635.

even an illiterate brewery worker named Reynier Jansz. Vos who was also
a client of Notary Willem de Langue. On balance, therefore, it is more
reasonable to assume that Vermeer's father gave his name to the inn De
Vliegende Vos than that he called himself Vos after the inn's name.

The first document in which Reynier Jansz.'s activity as an innkeeper is
mentioned dates back to the summer of 1631.[16] A woman named Beatrix
Hendrix, wife of Gysbrecht van Vianen, had bought several pairs of
wooden clogs and brought them to the house of Reynier Vos, innkeeper,
with the request that he take them to her niece in Amsterdam. The depo-
sition was made, at the request of Van Vianen, by the shoemaker Adriaen
Hendricksz. van Buyten, the father of the master baker Hendrick van
Buyten who many years later became Johannes Vermeer's creditor and
client. Another witness declared that Beatrix had turned up unexpectedly
at her house one day completely drunk, had undressed, and fallen asleep.
The document is presently so damaged by humidity that the connection
between the clogs brought to Reynier's inn and Beatrix's drunken visit
can no longer be made out. It appears that Van Vianen had the deposition
made in order to document his wife's disorderly behavior to obtain a legal
separation, or for some similar purpose.

Notary De Langue, who was about the same age as Reynier, was a
connoisseur of art, a collector of paintings, and a friend of most Delft-
based artists (see Fig. 4). More names of painters show up in his records
than in any of the other notaries'. Among others, the notary handled the
affairs of the painter Leonaert Bramer after he came back to Delft in 1628
from his travels in France and Italy, where he had lived over ten years.
Bramer, a versatile artist who painted landscapes and still lifes in addition
to the religious works and other "histories" that were his main specialty,
enjoyed a shining reputation in his home town in his day. His early night
scenes may have influenced Rembrandt. De Langue also had dealings
with Willem van Vliet and Jacob Delff, who both painted his portrait;
with the landscape artist Moses van Uyttenbroek, a resident of The
Hague but an occasional visitor to his office; with Hans Jordaens who,
until his death in 1631, was the most sought-after painter of religious
scenes in Delft; and with Balthasar van der Ast and Evert van Aelst, who
were both excellent painters of flower and fruit pieces.

That the notary and the innkeeper formed personal as well as business
ties is suggested by De Langue's presence many years later at another
notary's office as a witness on the occasion when Maria Thins, Vermeer's
future mother-in-law, announced that she would put no obstacle in the
way of the marriage of the young artist with her only daughter Catharina
Bolnes.[17]

[16] Doc. no. 132, 12 August 1631.
[17] Doc. no. 249, 5 April 1653.

On October 13, 1631, Reynier Jansz. registered in the Guild of St. Luke as an art dealer.[18] The clerk wrote his name down as "Reijnier Vos or Reijnier van der Minne." Van der Minne was of course the last name of his stepbrother Dirck Claesz. and perhaps that of Dirck's father, Claes Corstiaensz., as well. Art dealers, painters, glassmakers, embroiderers, sculptors, and faienciers had to be registered in the guild if they made their living from any of these trades in Delft.[19] There is also a possibility, discussed in the next chapter, that Vermeer's father joined the guild in order to be allowed to sell the paintings that his wife Digna had inherited from her father Balthasar Gerrits.

Reynier's first recorded contract with a painter dates back to the year of his registration in the guild. The flower painter Jan Baptista van Fornenburgh of The Hague had sent his son Barend to live in Reynier's house while the young man, who had enlisted as a soldier, waited for his ship's departure for the East Indies. Reynier, at Van Fornenburgh's request, had bought a small barrel of brandy for Barend and had sent it aboard the ship 'S Hertogenbosch, on which he was about to sail. The deposition relating these facts was made nine years later, after Barend had been shot and killed in the Indies.[20]

Did Reynier Jansz.'s new activities as innkeeper and picture dealer cause him to abandon his old trade of caffa weaving? About all I can adduce on this subject is that he was called "caffawercker" numerous times in subsequent years and "meester caffawercker" as late as 1645. He also frequented other caffa workers.[21] But, except for one early debt that may possibly have been incurred for silk yarn before July 1629,[22] there is no other evidence that he ever bought raw materials for his craft, in contrast to the various mentions in estate papers of his debts for beer, wine, peat, and other commodities that one would expect an innkeeper to stock.

Almost exactly a year after Reynier's inscription in the guild, a son— the future artist—was born to the couple living on the Voldersgracht, twelve years after the birth of their first child, Gertruy. Digna Baltens was now thirty-seven and Reynier Jansz. forty-one years old. They had been married for seventeen years. The new child was taken to the New Church and christened Joannis on October 31, 1632. The witnessees to the future

[18] Doc. no. 133, 13 October 1631.
[19] Montias, *Artists and Artisans*, pp. 75–76.
[20] Doc. no. 156, 6 September 1640.
[21] See in particular doc. no. 143, 27 January 1635; no. 148, 17 February 1638; and no. 181, 11 February 1645.
[22] In doc. no. 131, 3 June 1631, "Reynier Iansz. caffawercker" is recorded as owing to Franchois Camerling, dealer in silk cloth, a total of 18 guilders, 2 stuivers, 8 penningen for two separate debts "arising from the trade in silk cloth" ("spruytende wte neringe van zijde lakenen"). Franchois Camerling, who died in July 1629, belonged to the Protestant branch of the family, whereas Gerrit Gerritsz. Camerling, the stepfather of Maria Thins, the mother-in-law of Vermeer, belonged to the Catholic one.

painter's baptism were Pieter Brammer, Jan Heijndricxz., and Maertge Jans.[23]

I have not been able to identify securely Pieter Brammer, who may have been the artist's godfather. The only person with this name I could find was a certain Pieter Simmons Bramer, who is recorded in Delft in 1654 (twenty-two years after the christening) as the skipper on Het Witten Een-hoorn (The White Unicorn).[24] He had no known connections with the Vermeer family. As to the second witness, Jan Heijndricxz., I believe that he was identical with "Jan Heyndricksz.," ebony worker and frame-maker, from whom Reynier Jansz. bought frames a few years later.[25] Maertge Jans, the sister of Reynier Jansz. and wife of the baker Jan Hey-mensz., was almost surely the baby's aunt, who had been present at Ger-truy's baptism twelve years earlier. The only female witness, she must have been the baby boy's godmother.

As far as I know, neither Pieter Brammer nor Jan Heijndricxz. were members of Reynier Jansz.'s family—up to and including second cousins. This in itself is remarkable because, in the past, when the children of An-thony, Maertge, and Adriaentge had been baptized, the witnesses had been close family members.[26] The witnesses at Gertruy's christening in 1620 had been part of the family circle too. Neeltge and Anthony were now dead, and the butcher Jan Thonisz. was within a year of his death and perhaps ailing. But Reynier's half sister Adriaentge and his step-brother Dirck Claesz. were very much alive in Delft and could have been invited to take part in the ceremony. With the intrusion of these two alien witnesses, the cocoon in which the extended family of Neeltge Goris had been so snugly wrapped began to unravel.[27]

Even the baptismal name, Joannis, that was given to the child marked a departure from tradition. Jan, the name of the boy's grandfather (the tailor Jan Reyerszoon), was the most common name given to the male

[23] Doc. no. 136, 31 October 1632.
[24] Delft G.A., records of Notary C. van Vliet, January 1654, fol. 58.
[25] Doc. no. 151, 11 December 1639. A furniture maker ("stoeldraijer") named Jan Heyn-dricksz. was a next-door neighbor of Jan Heymensz. on the Cattle Market in 1636 (Delft G.A., records of Notary A. C. Bogaard, no. 1875). If he also made frames, he may have been our witness.
[26] The only exception I could find occurred when the twin daughters of Jan Heymensz. van der Hoeve and Maertge Jans were baptized on 19 June 1626 (doc. no. 112). The last of seven witnesses (an extraordinary number) was a certain Franchoijs Volland, who was cer-tainly not a close family member.
[27] Compared to other members of their extended family, Reynier Jansz. and Digna Bal-tens may have been exceptional in going beyond the family circle to choose two witnesses out of three for their son's baptism. When Jan Thonisz. Back and Adriaentge Claes baptized their last child, Neeltge, on 6 February 1633 (three months after Johannes Vermeer), the only witnesses were Reynier Jansz., Maertge Jans, and Trijntgen Thonisdr. (doc. no. 137). The first two were the baby girl's maternal uncle and aunt; the third is presumed to have been her paternal aunt.

heirs of Delft's good Calvinist folk. Joannis was a Latinized form of Jan
that Roman Catholics and upper-class Protestants favored. Since the fu-
ture artist's parents had baptized him in the established church, it is very
unlikely that they were Catholic at this time. (We have already seen that
Vermeer's grandmother Neeltge and his aunt Maertge were members of
the Reformed Community; the attestation of the pastor of the New
Church shown to the Amsterdam's authorities on the occasion of Reynier
Jansz.'s marriage with Digna Baltens adds to the presumption that Ver-
meer's parents were Reformed.) Perhaps the baby was christened Joannis
because his parents thought it was a more elegant, refined name than
plain old Jan. There was also a humanist flavor to the name. Taurinus,
the pastor of the New Church who probably christened the child, also
called himself Joannis or Johannis. Vermeer himself never used the name
Jan. Nonetheless, most Dutch authors, in the century since his rediscov-
ery, have dubbed him Jan, perhaps unconsciously to bring him closer to
the mainstream of Calvinist culture.

The houses that lined the north side of the Voldersgracht, or Fullers'
Canal, opened on the Great Market Square. Young Vermeer, even as a
toddler, must have played in the square, bounded by the towering New
Church in the east and the richly gilded Town Hall in the west. Reynier
Jansz.'s neighborhood around the Voldersgracht was considerably more
distinguished than the Small-Cattle Market area. A few doors down the
canal, Pastor Taurinus lived with his wife Margaret van der Meer (no
relation of the artist's family). There were richer people in Delft than the
pastor and his wife, but those two stood on the highest rung of the town's
society.

Reynier's immediate neighbor was Cornelis van Schagen, a well-to-do
merchant who sold cloth from the shop in the lower part of his house.
There was also a painter, Cornelis Daemen Rietwijck, living just on the
other side of the Old Men's Home next door to Vermeer's house, who
ran a sort of academy where young people learned how to draw and re-
ceived elementary instruction in mathematics and other subjects. Reynier
Jansz. Vos, alias Vermeer, may not have been as well off as some of his
neighbors; keeping an inn, moreover, was scarcely a prestigious occupa-
tion. But it was much better than weaving caffa by the side of the Small-
Cattle Market.

The baker Jan Heymensz. and his wife Maertge Jans also rose in the
world. His baking business was sufficiently important to warrant his ap-
pointment to the board of headmen of the bakers' guild. His prosperity is
reflected in the purchase and sale of several houses, including one on the
elegant Wijnstraat.[28]

[28] Jan Heymensz. van der Hoeve is cited as one of the headmen of the Bakers' Guild in

Only the butcher Jan Thonisz. was dragged down by Neeltge's bank-
ruptcy and by the weight of his own obligations. When he died in July
1633,[29] he left five children and liabilities exceeding his assets. His widow
Adriaentge, Reynier's half-sister, was allowed by the aldermen of the city
to repudiate the estate.[30] The Orphan Chamber appointed as curator of
the estate Gysbrecht Heymensz. van der Hoeve, the brother of the baker
Jan Heymensz. Gysbrecht earned his living making foot warmers, the lit-
tle wooden boxes in which a receptable filled with hot coals was placed
to keep one's lower parts warm in poorly heated houses or churches.

After her husband's death, Adriaentge became a dealer in pigs' tripe.[31]
She somehow managed to keep her head above water and eventually suc-
ceeded in settling the claims of her late husband's creditors, even though
her social and economic status remained quite low. It does credit to Rey-
nier Jansz.'s character that he became the godfather of Jan Thonisz.
Back's last child, a girl named Neeltge, born in February 1633,[32] in spite
of the Back family's financial collapse. On the other hand, there is no
evidence that he ever did anything for her subsequently.

Vermeer's father appeared many times in Delft notaries' records in the
1630s and 1640s, sometimes as a mere witness, at other times as a depo-
nent, a debtor, or in some other role. Even when he only witnessed a deed,
we often find that he had some connection with the principals involved.
In September 1630, for instance, he signed a deposition in which Gys-
brecht van Zuijlen, brewer "In the Conduit," declared that a certain Pie-
ter Jansz. van Santen had sailed from Delft to the East Indies in 1621 and
returned in 1628.[33] Five years later Reynier acknowledged a debt for beer
that he owed to Gysbrecht's widow, Hester van Bleyswijck.[34] In all like-
lihood he was already buying beer "In the Conduit" in 1630. In July
1632, he witnessed a document in which Cornelius Theunisz., caffa
worker, appeared as principal deponent.[35] Three years later, as we shall
see, the same Cornelius contributed his testimony to a deposition con-
cerning a brawl on ice with Reynier Jansz. In 1634, the innkeeper was a

doc. no. 172 of 3 July 1642; Reynier Jansz. Vos, "caffawercker," signs as witness. On 13
January 1629, Jan Heymensz. van der Hoeve, baker, bought a house on the Butter Bridge
for 2,400 guilders (Delft G.A., records of Notary J. van Roon, no. 1629). The house on the
Wijnstraat is mentioned in the records of Notary Willem van Assendelft (Delft G.A., no.
1857, of 24 March 1632). On 12 February 1636, Jan Heymensz. bought a house on the
north side of the Broerhuys (close to the old family home, The Three Hammers) for 1,400
guilders (Delft G.A., records of Notary A. C. Bogaard, no. 1875).

[29] Doc. no. 140, 17 July 1633.
[30] Doc. no. 141, 12 August 1633.
[31] Doc. no. 242, 22 September 1633.
[32] See note 27 above.
[33] Delft G.A., records of Notary W. de Langue, no. 1688, 12 September 1630.
[34] Doc. no. 145, 17 October 1635.
[35] Doc. no. 135, 15 July 1632.

witness to a contract for the sale of a house on the Small-Cattle Market.[36] The seller was Abraham Willemsz. van Lith, mason, the son of Willem Hendricksz. van der Lidt, straw hat maker, who had testified to the good behavior of Reynier Balthens in 1619.[37] Reynier Jansz. went along with his brother-in-law, Jan Heymensz., in 1642 when Jan testified before De Langue in his capacity as headman of the bakers' guild.[38] These connections give us some idea of Reynier's milieu and entourage. Other documents in which he played a more central role shed a glancing light on his personality.

The first document referring to Reynier Jansz. as caffa worker after he had moved to the Voldersgracht relates an incident that occurred in January 1635, when he was forty-three years old.[39] He had gone on an outing on the ice in the vicinity of the Houttuynen (wood gardens), just outside Delft, with four other caffa workers, including the previously mentioned Cornelis Theunisz. It was a cold January day. Two of Reynier's younger comrades, Theunis Jansz., twenty-three, and Abraham Jeronimusz., eighteen years old, were standing close to Cornelis Jansz. van Noorden, another caffa worker in the group, when they saw a man named Robberecht Post beckon Cornelis to the side. When the two young men looked around, they noticed that Cornelis and Robberecht had pulled out their knives. They then called Reynier Jansz. and one of the other caffa workers to come over.

All witnesses saw Robberecht repeatedly assault Cornelis with a knife in his hand. Cornelis parried the stabs and tried to repel Robberecht with his own knife. The other caffa workers warded off the assailant with clubs that they were carrying. (These clubs, called "kolven" in Dutch, were curved sticks with which the Dutch played a sort of ice hockey.) Someone said, "Cornelis, put away your knife," which he did. But Robberecht, who still had a knife in his hand, again tried to come between the other men, to get at Cornelis and stab him. When he failed to do so, he said to Cornelis, "If I had been able to nab you in an inn, you wouldn't have gotten off so easily, remember that."

When the commotion had quieted down a bit, Reynier Jansz. and his friends went on the ice again. At this point Robberecht attacked Cornelis anew. Cornelis fell on the ice while trying to fend him off. When he stood up again, Robberecht hit him several times on the head. After Cornelis had reached land, he wrapped his mantle around his shoulders and started walking away. Robberecht followed, hurling vile insults at him. Cornelis and his friends only were rid of him when they reached the Nick-

[36] Delft G.A., records of Notary W. van Assendelft, no. 1858, 10 December 1634.
[37] See Chapter 2 at note 18.
[38] See note 28 above.
[39] Doc. no. 143, 27 January 1635.

er's path in town. Reynier Jansz. and the other caffa workers recounted this adventure before the notary at the request of Cornelis Jansz. No one said anything about how the deposition would be used, but it was presumably submitted to a court of justice as a basis for suing or prosecuting Robberecht Post.

The deposition only told one side of the story, or course. But if the facts were anything like the account the witnesses gave, the least that can be said is that Reynier Jansz. and his comrades had tried to keep a lid on the violence.

Who was this alleged assailant, Robberecht Post? From the deposition one might easily make him out to be a young hooligan or at least a person of the same class as the craftsmen with whom he had fought. To my surprise, I found when this book was nearly completed that he was a man of some substance, a captain in the service of the Admiralty. The evidence we have about Captain Post confirms that he was of a querulous nature.[40]

A few months later, in October 1635, Vermeer's father again appeared before a notary, this time in connection with his innkeeping business.[41] Reynier Jansz. Vos, "caffa worker and tapster in The Flying Fox," discharged Hugh Jansz. van Boodegem, brewer "In the Stork," of any liability for the loan that he, Vos, had contracted and that he, Vans Boodegem, had guaranteed. Reynier owed the debt, amounting to 202 guilders 6 stuivers, to Hester van Bleyswijck, the widow of Gysbrecht van Zuijlen, brewer "In the Conduit," who had recently passed away. He also bound himself and his possessions to repay the money he owed Van Boodegem for deliveries of beer according to the brewer's register.

This was not the first or the last time Reynier Jansz. was cited for a debt in a document. It almost seems as if he never paid anything with cash. We find him at various times owing money for beer, wine, peat, and fats.[42]

[40] On 22 March 1630, Captain Robberecht Baerthoutsz. Post, lieutenant of Captain Cornelis Silvergieter, in the service of the Admiralty of the Gecommitterde Raeden, after some bargaining, agreed to pay the sailors that he was engaging eight guilders per month (Delft G.A., records of Notary A. C. Boogert, no. 1873–74). On 31 October 1639, he complained that the captain of a barge on which he had been riding had claimed that he had given him (Post) a bloody nose (Delft G.A., records of Notary C. Brouwer, no. 1659). On 12 March 1640, he "insinuated" a certain Maritge Abrams because she had said his wife was a whore and had otherwise insulted him (Delft G.A., records of Notary C. Brouwer, no. 1659). Captain Post was probably of Delft origin, considering that his brother, the painter-decorator Utterant Baerthoutsz. Post, paid six guilders as his entrance fee when he registered in the Guild of St. Luke in 1640 (Montias, *Artists and Artisans*, Table A.2).

[41] Doc. no. 145, 17 October 1635.

[42] For wine and beer, see, inter allia, doc. no. 240 of 15 June and 10 September 1652 and note 43. The debt for peat is cited in doc. no. 150 of 6 March 1638. In the estate of Warnaert Adamsz. van Sommelman who died on 18 July 1636, a debt of 14 guilders 19 stuivers for animal fats (possibly soap) is owed by Reynier de Vos (doc. no. 183). A debt for beans and oats (possibly for the horses of clients stopping at Mechelen) for 2 guilders 19 stuivers, the remnant of a larger sum, was due by "Dingena who lives on the corner of the Old Man's path" (thus in Mechelen) sometime before 1648. (doc. no. 207).

One debt incurred for beer sometime before 1645 was never paid during his lifetime. (He died in October 1652).[43] The small amount he owed for peat in 1638, the unpaid remainder of a larger bill, was eventually remitted to the son-in-law of the deceased peat merchant who was the beneficiary and trustee of the estate. This man was none other than Anthony Palamedes, the first genre painter in Delft. Palamedes, from the early 1620s on, had begun painting banquets with finely dressed gentlemen and ladies, corps-de-garde scenes, and elegant, if rather vacuous, portraits. He was one of the town's most successful and popular artists.

Another of Reynier's debts, this time for frames, was settled, without the use of cash at all, by offsetting it against a bill that he was owed for food and drinks consumed in his inn.[44] The merchant Gillis Verboom was an importer of ebony wood from the Dutch West Indies Company. The ebony worker Jan Heyndricksz.—the one who is presumed to have been a witness at Johannes Vermeer's christening—had bought some of this wood, for which he owed the estate of the late wife of Gillis Verboom 47 guilders 13 stuivers in December 1639. But Gillis Verboom had consumed food and drink for 45 guilders 5 stuivers "at the house of Reynier Vos." The innkeeper had apparently given Heyndricksz. permission to use the debt that Verboom owed him to extinguish the debt for 47 guilders 13 stuivers that Heyndricksz. owed for ebony. Although this is not stated explicitly in the accounting of the estate, it is clear that Reynier Jansz. must have bought frames from Jan Heyndricksz. for at least the amount of the bill for ebony wood. It may be noted in passing that after the death of Gillis Verboom, which occurred a year later, the trustees of his estate paid Anthony Palamedes 22 guilders for instructing the late merchant's son Adriaen in the art of painting and drawing.[45]

On February 17, 1638, Willem de Langue drafted the last will and testament of Reynier Jansz. Vos, living on the Voldersgracht, and of his wife, Digna Baltens.[46] Reynier was then forty-seven years of age, Digna forty-three. They were both said to be of sound mind and in good health. They declared that the longer-lived of the two would be the sole and unique heir of the other. The survivor would be entitled to dispose of all the goods that they possessed in common, with this exception: the survivor must feed, clothe, and take care of the child or children, who must be sent to school to learn how to read and write, and be taught a suitable trade.

[43] A debt for beer owed by Reynier de Vos for 82 guilders 10 stuivers appeared in the estate of Johan Croeser, brewer in the Swaenhals, who died on 31 July 1645 (doc. no. 185). This debt was still outstanding on 12 November 1660 (doc. no. 278).
[44] Doc. no. 151, 11 December 1639.
[45] Montias, *Artists and Artisans*, pp. 167, 169, 170.
[46] Doc. no. 149, 17 February 1638.

These obligations would last until each child was adult or had entered the married state.

The survivor was also bound to provide a marriage feast according to his or her means. All such expenses would be made in lieu of the legitimate portion of the estate of the first parent deceased to which each child might be entitled. The survivor would be named the guardian of the child or children. The Orphan Chamber was "excluded from the succession." Unless this clause was inserted in a will, the Chamber was automatically entrusted with the administration of the estate after the death of either parent and appointed guardians for the children. The will was read aloud to the testators, who approved it in front of the notary's clerks, who signed as witnesses.

As testaments of this period go, this one was extremely routine. There were no specific bequests or donations. Gertruy, who was eighteen years old at the time, and Johannes, who was not quite six, were mentioned only as "child or children." Sad to say, this indirect reference to Johannes Vermeer is the only one that has come down to us from the day of his baptism to the negotiations over his marriage in 1653, when he was nearly twenty-one years old. Nor was anything more heard about his sister Gertruy until she married in 1647, at the relatively mature age of twenty-seven.

Reynier Jansz. reappeared two years after making his testament when he testified about the death of the son of Jan Baptista van Fornenburgh who had enlisted as soldier to fight in the Indies.[47] The young man had been stationed in Castle Batavia, Fort Nassau, and other places in the East Indies. He had ultimately been shot to death on some expedition. Reynier Jansz.'s deposition was dated September 6, 1640. The next day Van Fornenburgh, who had come to Delft to collect Barend's back pay from the local chamber of the United East Indies, declared having ceded his claims to a purser who had paid him the money his son had coming to him. The deposition on September 6 was signed "Reynier Jansz. Vermeer." This was the first time, to our knowledge, that he used the last name Vermeer, fifteen years after his young brother Anthony had called himself by that name at the baptism of his daughter Neeltge. The witnesses to the deposition were the painters Pieter Groenewegen and Balthasar van der Ast. The receipt for the money on September 7 was signed by Jan Baptista Fornenburgh. The witnesses this time were "Reynier Jansz. Vermeer alias Vos" and the painter Pieter Steenwijck.

Enough is known about the four artists to give a first impression of Reynier's relations in the artists' communities of Delft and The Hague. The most distinguished of the group was Balthasar van der Ast. He was

[47] Doc. no. 156, 6 September 1640.

born in Middelburg in Zeeland around 1590. Middelburg, from the time of the fall of Antwerp in 1585, had become an important refuge for Protestants fleeing Spanish domination. Around the turn of the century the Protestant artist Ambrosius Bosschaert had founded a school of flower painting there that rivaled the achievements of Jan Brueghel and his fellow Catholics who specialized in the genre in Antwerp. Van der Ast, Bosschaert's pupil and brother-in-law, began working in Middelburg around 1610, moved to Utrecht in 1619, and arrived in Delft in 1632. To his teacher's linear precision, he added a more painterly touch. In Boschaert's pieces, each flower, fruit, shell, or insect was a separate entity, the whole composition the sum of its parts. In Van der Ast's later paintings, the parts were subordinated to the whole—the flowers to the bouquet, the fruits to the entire basket. It was during the latter part of his life spent in Delft that he painted ravishing displays of sea shells: even-sized, abstrusely shaped conches, artfully laid out on reddish-brown tablecloths, rendered in subdued pinks, browns, and pearly grays, the whole composition bathed in a diffused light. These, along with his flower pieces, have won him a reputation among connoisseurs in modern times (Fig. 5).

Jan Baptista van Fornenburgh was also an accomplished flower painter. There is a contemplative aspect to his work, especially in his representations of insects, small rodents, and wilting tulips and roses strewn on fissured plinths, recalling the transience of life and the proximity of death, that is rarely found in the more decorative pictures of his colleague Van der Ast (Fig. 6). The death of his soldier son may have inspired these meditations on the vanity of earthly joys.

Pieter Steenwijck, also a still-life painter, was still only in his twenties at this time. When he signed the Van Fornenburgh deposition with Reynier Jansz., he was not yet a member of the guild in Delft, which he finally joined two years later in 1642. Since his brother Herman had become a member in 1638, Pieter, who shared a studio with him, may not have been compelled to register at this early date. Some of the two brothers' skull-centered Vanitas pictures, illuminated by beams of light, recall the light-filled paintings that brought fame to the Delft School of Pieter de Hooch, Gerard Houckgeest, Emanuel de Witte, and Vermeer in the 1650s and 1660s (Fig. 7).

Pieter Groenewegen was about forty years old in 1640. Of the entire group, he was the only one who had been to Italy. In Rome in the early 1620s, he had become a member of the loose association of northern artists called the Bentvueghels, where he was known by the sobriquet "Lion." Groenewegen was primarily a landscape painter (Fig. 8). His importance for Delft lies chiefly in that he was the only Italianizing landscape painter active in the 1630s and early 1640s. Since he spent at least as much time in The Hague as in Delft, it is quite possible that he accom-

panied Jan Baptista when he came from The Hague to collect his late
son's wages. Van Fornenburgh and Groenewegen probably stayed over-
night in The Flying Fox while the soldier's father waited for his son's back
pay after making his deposition on September 6.

A couple of months before Reynier Jansz. had drawn up his testament,
a notary had called on him at his house on the Voldersgracht on behalf of
the Amsterdam merchant Heijndrick van der Burch.[48] In his absence the
notary had shown Digna Baltens the rental contract, dated January 27,
1635, that Reynier had signed with Pieter Corstiaensz. Hopprus, shoe-
maker, leather merchant, and the owner of The Flying Fox. The notary
had asked her whether Reynier Jansz. would be willing to assign the rent
money to Van der Burgh, who held a mortgage on the house. Digna said
she would tell her husband about it. She herself would not make any ac-
commodation unless it was specified in the contract.

Actually Reynier Jansz. was getting ready to move from the inn on the
Voldersgracht to new quarters. In January his landlord Pieter Hopprus
had sent his notary to ask him whether he would be willing to leave the
premises before his contract ran out.[49] It was Hopprus's intention to sell
the house for 2,100 guilders. However, the notary explained, if Reynier
Jansz. wanted to buy the house at that price, Hopprus would give him
preference. To this Reynier Jansz. replied that he did not wish to buy the
house but that he insisted on keeping the house until his contract ran out
in May 1641. On May 15, 1640, Hopprus sold the house anyway with
the provision that the buyer would have to "endure" the lease of the
premises (to Reynier Jansz.) until May 1, 1641. The buyer would be
entitled to subtract the rental money for these twelve months, amounting
to 138 guilders, from the contract price of 2,100 guilders.

A soon as the lease on The Flying Fox had run out, Reynier Jansz., his
wife, and their two children moved into the house they had just acquired
on the Great Market Square. This was the inn called "Mechelen" that the
family was to own throughout Vermeer's life (Fig. 9). Reynier Jansz. had
bought it for 2,700 guilders from Willem Jansz. Slooting and Pieter van
Vliet, rich merchants who were important clients of Notary Willem de
Langue.[50] Mechelen with its six hearths, must have been one of the more
imposing residences on the Great Square. Reynier had succeeded in ac-
quiring it at a very reasonable out-of-pocket cost. He had only given 200
guilders as down payment. For the rest, he had signed two mortgage con-
tracts, one with a Haarlem brewer for 2,100 guilders and the other for
400 guilders with Arent Jorisz. Pynacker in Delft, both at 5 percent. (Pyn-
acker was the brother-in-law of Willem de Langue.) The yearly mortgage

[48] Doc. no. 148, 30 December 1637.
[49] Doc. no. 152, 28 January 1640.
[50] Doc. no. 161, 23 April 1641.

payments, amounting to 125 guilders, came to a little less than the rental on The Flying Fox. Payments on the two mortages were still being made twenty-eight years later when Digna Baltens tried to sell the inn at auction.[51]

By the spring of 1641, Johannes Vermeer was nine and a half years old. He had probably learned how to read and write in a neighborhood school. At this time he was perhaps attending the little academy on the Voldersgracht run by the Catholic painter Cornelis Daemen Rietwijck. Two to three years later, in 1644 or 1645, when Vermeer had reached the age of thirteen or fourteen, he must have begun his six-year apprenticeship.[52]

Although the details and dates of Vermeer's training are all speculative, there is one thing we can be fairly sure of: the "suitable trade" in which he was supposed to be trained, according to his parents' testament of February 1638, cost them a good deal of money. If he was apprenticed to a local master and lived at home for the first couple of years, his father would have had to pay his teacher about fifty guilders a year. If he went away to Amsterdam or Utrecht for his last four years of apprenticeship, as I think he probably did, the cost would have risen to a minimum of a hundred guilders a year, including bed and board.[53] This would have made a sizable dent in the family budget. It probably cost them nearly as much to support the fledgling artist out of town as to carry the mortgage on Mechelen. This presupposes that he was apprenticed with a competent local painter. But if Reynier Jansz. had wanted his son to learn the art of painting from a famous artist like Abraham Bloemaert, one hundred guilders a year would only have bought the lessons; the keep would have been extra.[54]

To his father's out-of-pocket costs for his training should be added the "opportunity cost" of Johannes's foregone earnings in a manual trade, where apprentices began to earn wages from the start of their training. He could also have helped his parents and his sister by serving at the inn.

The sacrifices Reynier Jansz. and Digna had to make to get their son launched in life may help to explain why the innkeeper had trouble paying all his debts after he bought the inn on the Great Market Square.

To study the milieu in which young Vermeer grew up, we must first of all attempt to place Mechelen and its clientele in the social setting of Delft. What sort of customers did Reynier Jansz. have in his inn? Was

[51] Doc. no. 324, 2 January 1669.
[52] Montias, Artists and Artisans, 88.
[53] Ibid., pp. 160–69.
[54] Utrecht G.A., records of Notary H. Ruysch, 20 March 1647. The pupils of Rembrandt paid one hundred guilders a year for lessons alone in the 1640s (Egbert Haverkamp-Begemann, "Rembrandt as a Teacher," in Rembrandt after Three Hundred Years, exhibition catalogue, Art Institute of Chicago, 1969, p. 21).

Mechelen a low-life tavern, next of kin to a brothel, or was it more like a respectable hotel where drinks and meals were served?

Our first document bearing on this question is a deposition of February 1645 made by Reynier Jansz. Vos., master caffa worker.[55] This is the first time to our knowledge that he is referred to as a master in his trade, but also the last time he is called "caffa worker." It may be that his double career as innkeeper and art dealer forced him to give up weaving caffa cloth about this time. The other deponent was a young man from Dordrecht, Gerrit van Slingelandt, who was perhaps staying at the inn.

Reynier Jansz., fifty-three years old, and Van Slingelandt, twenty-two, declared at the request of Cornelis Balbiaen, a medical doctor, that at the time of the Delft kermess in June of the preceding year, in the house of Reynier Jansz., a girl named Sara Pots (who was a daughter by a former marriage of the wife of Cornelis Balbiaen) had confessed to stealing a silver spoon. She had acknowledged the theft, in front of Reynier Jansz. and Van Slingelandt, to her mother and other persons. After stealing the spoon from the house of Maritge Willems van Linschoten, the wife of Adriaen Jacobs Balbiaen, Sara had broken it into pieces and sold it to the widow of the silversmith Frans Verboom "In the Golden Coach." After her confession, Sara had cried bitterly and implored that nothing be said about it. But now that the witnesses had been asked to tell the truth, they had not been able to refuse. They were willing, if the need arose, to swear to the truthfulness of their deposition, and they had consented to consign it in writing.

Doctors of medicine, by and large, were well-educated, prosperous, and respected citizens, much superior in status to ordinary surgeons. The Balbiaens belonged to a high-class family whose members were counted among the elite in Delft. It is revealing of Reynier Jansz.'s character that he was sufficiently compassionate to conceal the girl's minor crime as long as he could prudently do so, but he could not resist telling the truth when he was hard pressed, particularly by an upper-class person.

In August of the same year, 1645, Reynier Jansz. Vos made a declaration regarding a conversation he had heard in his house between the wife of a captain whose ship had just returned from the East Indies and one of the ship's officers.[56] Captain Heyndrick Dircxz. van der Graeff having died on the return journey of the ship *Nieuw Delft* from the Indies, his cabin attendant, a boy of seventeen, had gone to the dead captain's cabin and discovered there a draft of a last will and testament. It contained a bequest to the boy of 100 guilders, one to the junior officer Wybrand van der Cost of a side-musket with a silver hilt, and one to the senior officer

[55] Doc. no. 181, 11 February 1645.
[56] Doc. no. 186, 2 August 1645.

Coenraedt Calrmansz. of 200 guilders, which had been amended in the draft to 250 guilders.

The two officers had told other members of the crew that the draft was legally invalid, but that they would still try to prevent the widow from getting her inheritance. Van der Cost had said to the cabin boy, "Just keep quiet, we'll see to it that you get your hundred guilders." Reynier Jansz. Vos testified that he heard the matter discussed in his own house between Van der Cost and Van der Graeff's widow. Van der Cost had told her about the draft, which he said was not valid. Still, if she was willing to accept it, he would see to it that it was made good. Otherwise, she would have to give up half of the estate, presumably, because her husband would have died intestate. Whereupon Reynier said that the widow had another testament which Van der Cost asked to read. Having done so, Van der Cost averred that it was not valid either, because it did not mention the legitimate shares of the heirs. He then repeated his offer to "give effect" to the draft found in the captain's cabin.

There is not enough information contained in the document to reconstruct the whole affair. The impression we get, though, is that Reynier Jansz. had helped Van der Graeff's widow, who was probably staying in his inn, to secure her inheritance in the face of an unscrupulous attempt by two of the ship's officers to validate a will that would not otherwise stand up in court.

Reynier Jansz. did not lose touch with his old landlord (and presumed relative) Pieter Corstiaensz. Hopprus, shoemaker and leather tanner, after he became owner of Mechelen. In June 1650 we find both men—Reynier is now fifty-eight years old and Hopprus forty-eight—attesting to the good character and piety of a shoemaker and his wife who had left Delft a number of years previously for Haarlem.[57] We do not know precisely why this couple, Frans Andriesz. Le Cock and Jannitgen Franssen van de Water, needed a certificate of good conduct. It is sobering to observe that, although both Hopprus and Reynier Jansz. claimed that they had "known them well, entertained civil conversation, and gone around with them," their names never came up in any of the documents I have collected about Vermeer's father or his family. Our web of social history is not as tightly woven as we should wish.

If all clients who stayed at Mechelen had paid their bills on time, we would never know who they were. One who did not is of considerable interest to us. Reynier van Heuckelom, who owed 126 guilders 17 stuiv-

[57] Doc. no. 229, 24 June 1650. In a companion piece to this deposition, dated the same day, Jannitgen Fransdr. van de Water testified about insults that two Rotterdam women had hurled at the wife of an Amsterdam skipper. It is possible that the two women had also libeled her (Delft G.A., records of Notary G. Rota, no. 1981, fols. 74, 75).

ers for board and other expenses in July 1651,[58] according to Reynier
Jansz.'s register, was apparently a former painter who, together with Pie-
ter Groenewegen, had been one of the first members of the Bentvueghels
in Rome (nicknamed "Wolf"). In the early 1650s he was living in The
Hague, where he became an important collector of paintings. Van Heuck-
elom had extensive dealings with military engineers and masters of forti-
fications in Gorinchem and The Hague.[59] The cosigner of the power of
attorney by which "Reynier van der Meer" sought to collect money that
Van Heuckelom owed him was a contractor named Tobias Bres. This
man, a captain in the States' army, was a friend and partner in various
undertakings of Reynier Jansz.'s brother-in-law, Balthens. Their enter-
prises will be related in the next chapter.

It is reasonable to suppose that contractors and military engineers who
traveled back and forth between Gorinchem and The Hague, many of
whom were friends of Tobias Bres, slept at the inn on the Great Market
Square whenever they sojourned in Delft.[60] Reynier Jansz.'s contacts with
a doctor of medicine and a captain's wife (who probably stayed at his
inn), together with his known and conjectured dealings with contractors,
suggest that he drew his clientele from a solidly middle-class array of cit-
izens.

An inn, it should be noted, was a nodal point in the social life of the
city. Ideally situated on the Great Market Square between the New
Church and the Town Hall, Mechelen was a place where townspeople
and "foreigners" gathered to talk about their affairs, exchange political
news, and discuss the ideas of the day. Given Reynier's interest in painting
and the inn's frequentation by artists and collectors, it is likely also that
many conversations in Mechelen revolved around matters of art.

A citizen of some standing in Delft, named Johan van Santen, was an-
other acquaintance of Reynier Jansz. The innkeeper knew Van Santen
well enough to have him guarantee a loan for 250 guilders that he took

[58] Doc. no. 236, 12 August 1651.

[59] Reynier Hendricksz. van Heuckelom was said to be a "good Catholic," born in Gor-
inchem (Gorinchem G.A., "Rechterlijk Archief," no. 565, 30 December 1650). In a Delft
document dated 29 May 1645, Reynier Heuckelum from Gorinchem was named by Gerrit
Hamel (who was a witness to the christening of one of Reynier Balthens's children) to collect
money due to him and to his late brother Dirck Hamel, for fortifications works carried out
in the service of the country ("het gemeen lant") in Amsterdam and The Hague (Delft G.A.,
records of Notary A. Ryshouck, no. 1823). Although it appears probable that the painter
and the man who had close contacts with contractors in Gorinchem are one and the same
person, the link could not be definitely established.

[60] In January 1645, the workmaster Hendrick Claesz. van Neercassel and the Delft con-
tractor Jan de Vos transacted some business with Reynier Balthensz. in the house of Reynier
Jansz. Vermeer, living in Mechelen (doc. no. 184, 19 April 1645). It may be presumed that
Van Neercassel, who was a witness to the christening of one of Reynier Balthens's children
in 1647 (doc. no. 194), stayed in the inn on this occasion.

out on December 5, 1648, the day after he made his testament.[61] (By leaving blank the lender's name on the contract, the notary Simon Mesch indicated that he obligated himself to find a person willing to advance the money.) Johan van Santen, the son of Cornelis van Santen, a prominent member of the Reformed Community and a regent of the Delft Orphanage, and the brother of the military officer and playwright Gerrit van Santen, later became a captain of the Delft militia commanding the orange-pennant shooters ("orange vendel schutters"). He was forty-four years old when he guaranteed the loan. In 1655, three years after the death of Reynier Jansz., Johannes Vermeer and his wife Catharine Bolnes discharged Captain Johan van Santen of his guarantee and undertook to repay the loan themselves. If Reynier Jansz. had access, via Johan van Santen, to the milieu of Johan's brother Gerrit, this might have been very valuable to him in his art-dealing activity. The playwright, who died in 1656, was friendly to some of the most eminent collectors and art lovers of Delft. In the 1620s, he dedicated one of his plays to Boudewijn de Man, who owned what was perhaps the finest collection of paintings in Delft, and another to Maria van Bleiswijck, who belonged to one of the two or three most eminent "regenten" families in Delft and appears to have been a patroness of the arts. It is also possible that Johan van Santen introduced Vermeer into this artistic circle.[62]

One document that has surfaced in recent years bears directly on the innkeepers' picture business. It concerns the still-life painter Evert van Aelst, uncle and teacher of the more famous Willem van Aelst. Sometime in the early 1640s, Evert van Aelst had asked for the return of a painting that he had consigned for sale with Reynier Jansz.[63] The idea originally had been that Reynier Jansz. would be reimbursed from the proceeds of the sale of the painting for a debt that Van Aelst owed him. But the painting remained unsold. On several occasions Van Aelst had sent an ebony framemaker named Gerrit Jansz. with a message to Reynier Jansz., saying that if Van Aelst could have the painting back he would be able to sell it. He had sworn many times to Gerrit Jansz. that he would return the money soon. Finally Reynier Jansz. had let him have the painting. Two years later, Van Aelst's debt still had not been paid. In March 1643, Vermeer's father asked Gerrit Jansz. to testify to those facts so that he could, if necessary, sue Van Aelst for the money.

Evert van Aelst, who was forty-three years old at this time, was well known in Delft (Fig. 10). His rather inexpensive flower paintings and fruit still lifes, in the simplified modern style that was coming into vogue in the

[61] Doc. no. 211, 5 December 1645.
[62] Johannes Vermeer discharged Captain Van Santen of his guarantee on 14 December 1655 (doc. no. 262).
[63] Doc. no. 178, 27 March 1643.

1640s, were to be found in the collections of many middle-class burghers who could not afford the more elaborate, more precisely painted works of Balthasar van der Ast and Jacob Woutersz. Vosmaer, the other prominent followers of the Middelburg School working in Delft. His flower pieces sold for seven to twenty guilders. If the debt Van Aelst owed Reynier was less than the price of the picture, it was hardly worth bothering the notary about, but the price of Van Aelst's painting may have covered only part of the loan.

The son of a successful Delft lawyer, Evert was the teacher of the great painter of church interiors, Emmanuel de Witte, as well as of several other less notable artists. In spite of his ability to sell his paintings, he was not a financial success. When he died in 1656, his nephew Willem van Aelst relinquished his pathetically poor estate to his creditors. Perhaps the reason was that Evert, who lived alone, spent more than he could afford in taverns, where he piled up large debts for drinks.[64]

Gerrit Jansz., the intermediary in Reynier's negotiations with Evert van Aelst, lived with his three sons, also ebony workers, in the Vlamingstraat, to the east of the New Church. Shortly after he died, one of his sons, Anthony Gerritsz. van der Wiel (another man who took on a last name when his father hadn't one), married Johannes's sister, the twenty-seven-year-old Gertruy Vermeer, on July 10, 1647. He was completely illiterate at the time. Later on, as he improved his standing in the world, he learned to sign his name. From Gertruy's fairly fluent signature, it would appear that she could read and write at least at an elementary level. As the only daughter of the keeper of Mechelen, Gertruy must have helped to serve food and drinks, make beds, and fetch provisions. Did she marry late because her parents could not do without her services? Or was it because a young woman growing up in an inn was not considered a good match, perhaps because an innkeeper's daughter was compelled by the necessities of the business, from the first years of adolescence on, to receive the advances of the male clientele of the house with complaisance? Although Gertruy's marriage with Anthony van der Wiel did not enhance her father's standing in the community, it did have its positive side: it was convenient for Reynier Jansz., in his secondary business as picture dealer, to have a hard-working framemaker as a son-in-law.

A couple of weeks before the marriage, Barbara de Meijer, the widow of Gerrit Jansz., bequeathed to her son Anthony van der Wiel all the ebony-working equipment belonging to his late father that he had been using in his shop, in recognition of the "loyal services" Anthony had performed on behalf of the family since his father's death. Reynier Jansz. was

<hr>

[64] On Evert van Aelst, see Montias, *Artists and Artisans*, pp. 130–31, 235–36.

a witness to the transaction.[65] A while later, she sold the family house on the south side of Vlamingstraat to Anthony for 1,000 guilders.[66]

In December 1648, Anthony and Gertruy made out their last will and testament before Willem de Langue.[67] As usual, each named the other his or her universal heir. Special provisions were made in case the couple should be childless when one or the other should die. If Anthony died first, Gertruy would be obligated to pay his widowed mother fifty guilders. If Gertruy predeceased her husband, Anthony would have to pay her parents, Reynier Jansz. and Digna Baltens, fifty guilders in place of her legitimate portion of the goods held in common. These conditional bequests were of very modest size. The economic and social standing of the couple was evidently a cut or two below that of the new owner of Mechelen on the Great Market Square.

An altercation that was reported among neighbors living on the Vlamingstraat in 1650 also throws light on Anthony van der Wiel's milieu. The wife of the caffa worker Cornelis Jansz. van Noorden, who had been assaulted on the ice by the knife-wielding Robberecht Post a few years previously, was a shrew and termagant named Itge Jacobs. For years she had made a nuisance of herself with her insidious gossip and her calumnies.[68] This time Anthony's sister Maria, who was a housemaid in the house of Niclaes van der Horst, asked a young woman named Barbara van Lier (the daughter of the painter Joris van Lier) to testify regarding an allegation that Itge Jacobs had made about Maria.[69] According to Barbara, Itge Jacobs had said that "pieces had fallen out of her," that is, in the colloquial language of the time, that Maria had had an illegitimate child.

There had also been a dispute about one of Maria's brothers (Willem, Jacob, or Anthony, all ebony workers). Itge had accused this unnamed brother of Maria of some unspecified misbehavior. The matter had been brought before the magistrate who, according to Maria, had rejected Itge Jacob's allegations. "Does Maria say this?" asked the indomitable Itge. "Well, folks that's had a piece fall out of them should rather keep quiet." There is no evidence that Maria had had "conversation of the flesh" with anyone. Yet the scandal could not have helped her chances of marriage. She was still a spinster twenty years later.

Reynier Jansz. remained on friendly terms with his daughter and son-in-law after the marriage. In June of the same year (1650) in which Maria

[65] Doc. no. 196, 22 June and 10 July 1647.

[66] Delft G.A., records of Notary W. de Langue, no. 1692, 1 June 1649.

[67] Doc. no. 210, 4 December 1648.

[68] For example, in a deposition of 2 February 1644 (Delft G.A., records of Notary F. Bogaert, fol. 89[r&v]), Itge Jacobs was said to have made many unfounded accusations and created scandals without cause against her neighbors on the Vlamingstraat. One of the deponents was Maritgen Cornelisdr., the wife of the painter Willem van den Bundel.

[69] Doc. no. 232, 14 November 1650.

had her encounter with Itge Jacobs, Anthony and the painter Willem Wil-
lemsz. van den Bundel agreed to exchange houses, both of which were
situated on the south side of the Vlaminstraat. Reynier Jansz. Vos wit-
nessed the deed.[70] Van den Bundel, born in 1575, belonged to the gener-
ation of Flemish immigrants who had arrived in Delft around the turn of
the century. He was a rather humdrum continuer of the Flemish tradition
in landscape painting. In 1650 he was seventy-five years old and no longer
active. It is doubtful whether Reynier Jansz. was buying any of his old-
fashioned pictures for his stock-in-trade.

Anthony van der Wiel must have been a very good ebony framemaker,
otherwise he would not have been sought out by clients in The Hague and
Amsterdam who had plenty of local talent to draw from. It is particularly
impressive that he was able to sell frames to the famous Amsterdam col-
lector and connoisseur, Maerten Kretzer.[71]

In February 1648, we have a record of another contact between Ver-
meer's father and an artist-painter. A deposition was made in Reynier's
house in the presence of Egbert Lievensz. van der Poel, master painter.[72]
Van der Poel, who was twenty-six years old at the time, did not actually
register in Delft's Guild of St. Luke until October 1650. Since he had
already been signing pictures for at least two years, he may have regis-
tered earlier in the guild of some other city—judging by his style, in Rot-
terdam.

One member of his extended family with whom Reynier Jansz. main-
tained cordial relations during the closing years of his life was his old
friend and brother-in-law, the baker Jan Heymensz. van der Hoeve. In
July 1651, "Reynier Jansz. van der Meer" and Jan Heymensz. coguaran-
teed a loan of 250 guilders made out to Herman Gerritsz. Valckenhoven,
the grandson of Herman Pietersz., the founder of Delft's faience indus-
try.[73] Herman Gerritsz., who was also a faience maker, never established
himself on his own but worked most of his life in the workshop of other
Delftware manufacturers.[74] A couple of months later, Reynier Jansz.

[70] Doc. no. 228, 5 June 1650.
[71] See doc. no. 277, 17 September 1660. In a document of 25 October 1671 (Delft G.A.,
records of Notary W. van Assendelft, no. 1853), Van der Wiel named a notary in The Hague
to collect money from Hubert van der Venne and from the heirs of Adriaen van der Venne.
By 1660, when Anthony van der Wiel was dunning Kretzer for ebony frames delivered, the
collection once sung by the poet Lambert van den Bos had long been sold; yet Kretzer re-
mained an important cultural entrepreneur on the Amsterdam scene. For details, see Walter
L. Strauss and Marjon van der Meulen, with the assistance of S.A.C. Dudok van Heel and
P.J.M. de Baar, *The Rembrandt Documents* (New York: Abaris Books, 1979), pp. 282, 293,
305, 321, 397.
[72] Doc. no. 204, 8 February 1648.
[73] Doc. no. 234, 8 July 1651.
[74] Herman Gerritsz. Valckenhoven, who was born around 1598, sold his house to another
employee of a Delftware manufacture for only six hundred guilders in 1657 (Delft G.A.,
records of Notary F. van Hurck, no. 2095, 12 January 1657). Henry Havard also inferred

stood surety for a mortgage loan of one thousand guilders on the house
Jan Heymensz. had just bought on the Nieuwe Straat. The second guar-
antor was Jan Heymensz.'s brother, Gysbrecht (the one who made foot
warmers). The loan was still outstanding in 1668, many years after the
baker and his two relatives had died. In the papers of the individual who
held the obligation in 1668, Reynier Jansz. was called "painter," perhaps
in confusion with his secondary occupation as an art dealer or even in
confusion with his son's métier.[75]

On May 5, 1652, Reynier Jansz. appeared for the last time at the office
of his old friend, the notary Willem de Langue, to witness the sale of a
house.[76] On June 15, the wine merchant Simon Doncker delivered about
fifty liters of French wine and twenty liters of Spanish wine to Mechelen.[77]
The June 15 delivery plus accumulated arrears raised the amount Reynier
owed to 250 guilders, a large but not abnormally high sum for an inn-
keeper of his standing. He died four months later. According to the reg-
isters of the New Church, "Reynier Jansz. Vermeer on the Market
Square" was buried on October 12.[78] No money was given on his behalf
to the Camer van Charitate after his death.

Two final mentions of Vermeer's father, dating from the last months of
his life, add to our knowledge of his art-dealing activities. One is a debt
he owed Cornelis Saftleven in Rotterdam for paintings, according to the
inventory of the artist drawn up after his wife's death in September
1654.[79] The other mention of the name "Reynier Vermeer" is to be found
in a list of eleven collectors and dealers, inscribed on the back of a draw-
ing by Leonaert Bramer in an album containing sketches of paintings in
Delft collections.[80] There is at least tentative evidence that the drawings
were made in 1652, not long before Reynier's death. The drawing in Fig-
ure 11, representing a gypsy reading a young woman's fortune, copied
after a painting by Jan Lievens, may have been in Reynier Jansz.'s stock-
in-trade or collection.[81]

from an inventory of the 1630s (after Herman Gerritsz.'s wife had died), that the faiencier
was of very modest condition (Henry Havard, *La céramique hollandaise: Histoire des fa-
ïences de Delft, Haarlem, Rotterdam, Arnhem, Utrecht, . . .* , 2 vols. [Amsterdam: Compag-
nie Générale d'Editions "Vivat," 1909], 2:35).

[75] The original debt acknowledgment of 10 September 1651 is cited in doc. no. 320, 10
September 1668.

[76] Doc. no. 239, 5 May 1652.

[77] Doc. no. 240, 15 June and 10 September 1652.

[78] Doc. no. 243, 12 October 1652.

[79] Doc. no. 243, 12 October 1652.

[80] Doc. no. 246, 1652–1653. For a solid and extensive discussion of the drawings, see
Michiel C. Plomp, " 'Een Merkwaardige Verzameling Teekeningen' door Leonard Bramer,"
Doctoraal Hoofdvak Scriptie 1983–1984, Kunsthistorisch Instituut der Rijksuniversiteit
van Utrecht, 2 vols.

[81] This hypothesis is based on the following assumptions: (1) the original numbers in-
scribed on the drawings corresponded to the order in which the collectors were listed on the

In addition to Reynier Jansz., there was another picture dealer on the list of owners of paintings after which Bramer had made his drawings. Abraham de Coge, who was also an engraver and an occasional painter, dealt in artwork, clocks, organs, tulip bulbs, and other objects of luxury on a fairly large scale. He frequently traveled for his business to Antwerp, Utrecht, and Amsterdam, where he bought "old masters" as well as paintings by contemporary artists. Rembrandt once testified at De Coge's request about the authenticity of a landscape by the Flemish master Paul Bril that he had sold.[82] A third dealer—not on the list—who was active in Delft from the mid-1640s on (even though he lived chiefly in Amsterdam) was Johannes de Renialme.[83] This man, a close acquaintance of both De Coge and of the notary Willem de Langue, is important because he bought the first painting by Johannes Vermeer of which we have any record. (The picture, discussed in Chapter 8, appeared in the inventory made after De Renialme's death in 1657). Compared to De Coge and De Renialme, who dealt in expensive paintings and drawings and carried on business both in the Netherlands and abroad, Reynier Jansz.'s activities were probably of limited scope. Except for his purchase of one or more paintings from Cornelis Saftleven in Rotterdam, we have no record of his contacts with artists beyond the confines of his native city.

It is noteworthy that in the twenty-one years between his registration in the Guild of St. Luke in 1631 and his death in 1652, Reynier Jansz. was not once called "konstverkoper" (art dealer) in any of the numerous documents that have come down to us in which he appeared as a principal or as a witness. Although there is no denying that he rose in social status from his rather humble beginnings as a caffa worker, he was never associated by the notaries and clerks who drafted these documents with the notables whose name was preceded by a term of deference such as "Monsieur," "signior," or "the respectable so-and-so" ("de eerbare . . .").[84]

back of a drawing by Heyndrick Bramer originally numbered 107 (presumed to be the last drawing in the original album); (2) the drawings originally numbered 85 to 98 belonged to Adam Pick, number 9 in the list of collectors; (3) the drawing numbers 105 to 107 belonged to Leonaert Bramer himself, who was number 11 in the list of collectors. If so, Reynier Vermeer, who was tenth on the list, may have owned the Lievens, which was originally number 103. If Johannes Vermeer saw this "Gypsy Reading a Young Woman's Fortune" in his father's collection or stock-in-trade, the grouping of its three main characters may have influenced his "Procuress" of 1656 (Fig. 20).

[82] Montias, *Artists and Artisans*, pp. 210–14.

[83] Ibid., pp. 214–15.

[84] This social gap is nowhere more evident than in the list of eleven collectors and dealers in back of the Bramer drawing mentioned in doc. no. 246. Reynier Vermeer was the only name on the list beside that of Bramer himself which was not preceded by "de heer," "captain," or "Monsieur." It is interesting that both the dealer Abraham de Coge and the inn-keeper-painter Adam Pick were called "Monsieur" (Plomp, "Een Merkwaardige Verzameling," vol. 1).

Whatever his limitations as an art dealer, Reynier Jansz. certainly provided a favorable artistic background for his gifted son. Reynier had been trained as an artisan, making fine decorative fabrics that generally required drawing skills. He already owned eleven paintings (not counting family portraits or paintings on alabaster) nine years before Johannes's birth. Toward the end of Reynier Jansz.'s life, Bramer had drawn copies of paintings in his collection or business inventory and included them in an album containing works owned by Delft's most distinguished collectors and dealers. Reynier was acquainted and had business with many painters and collectors. His inn was no doubt known to artists in and out of town as a gathering place where they could meet colleagues or potential clients.

These art matters aside, what sort of a man was Vermeer's father? What do the disparate anecdotes in the notarial archives tell us about his character? The impression that emerges from the documents is of a man with a well-balanced and open personality, alert to opportunities, and intelligent. Reynier Jansz. was surely impulsive at times, as in the knife fight he got into with Van Bylandt, or on the occasion when he gave in to Sara Pots's entreaties and concealed her theft—until he was obliged to acknowledge it. But he was more inclined to settle disputes peacefully and to stay on the right side of the law. Neither of the inns he managed is ever cited for failure to pay excise taxes on beer or wine, which happened very frequently to his competitors.

If he did not always pay his debts on time, the fault lies in the nature of his business and in his fragile economic circumstances. He had few assets of his own and had to buy everything on credit, including Mechelen, which was heavily mortgaged. He was too close to the edge of solvency to meet unexpected demands when they arose, as probably happened when his brother-in-law Reynier Balthens landed in the financial difficulties described in the next chapter.

Reynier was a good family man. During his life, he remained friends with his brothers-in-law Jan Heymensz. and Reynier Balthens. Yet he was not so wrapped up in his family as to jeopardize his hard-earned money for the sake of saving his mother from ruin. What strikes us also is his extroverted, confident attitude toward society. No man was to be found more often at the notary, making depositions, witnessing deeds, or guaranteeing loans.

His sanguine temperament is also revealed in the name he apparently chose himself for the inn he rented on the Voldersgracht in the 1630s, The Flying Fox. His qualities—shrewdness, dynamism, an eye for business opportunities—suited him well for his climb up the ladder of success. They might not have availed him had not Holland provided opportunities for those who could seize them in a period of social and economic efferves-

cence, when individuals were emancipated from many of the social and religious constraints that had checked their progress in earlier times. He was not able to succeed well enough to assure himself an easy life or to achieve high social status, but he did transmit to his son Johannes valuable human capital: the costs of an artistic training that the young man's talent transformed into an invaluable asset, if not for himself, at least for art lovers in later centuries.

· 5 ·

REYNIER BALTHENS, MILITARY
CONTRACTOR

On July 16, 1621, a year after Vermeer's uncle, Reynier Balthens, master joiner and former counterfeiter, had been released from prison, he was married in Schiedam, a small town a few miles south of Delft.[1] His bride was a local girl named Susanna Heyndrixdr. Balthens was said to be accompanied by his "mother," Beatrix Gerrits—in reality his stepmother, the second wife of Vermeer's grandfather, Balthasar Gerrits. Balthasar himself was not present at the marriage. He was perhaps still abroad in his native Brabant, enemy territory since the resumption of hostilities with Spain at the beginning of 1621, if he was not already back in the Hague, whence he moved to Gorinchem two years later.

By the end of 1623, the whole family was residing in Gorinchem: Reynier Balthens and his new bride Susanna; Balthasar and his wife Beatrix Gerrits; Tanneken Balthus, the presumed sister of Reynier Balthens; and Niclaes, the baby son of Reynier and Susanna, who had been christened in Gorinchem in October of that year.[2] Reynier Balthens himself registered as a member of the Reformed Community, with an attestation from Rotterdam, on December 23, 1623.[3]

Gorinchem, also known as Gorkum, a town of roughly eight thousand inhabitants at the time, was strategically located on the Merwede River (an arm of the Maas), which separated the free territory of Holland from Spanish-occupied Brabant to the south. In the early 1620s, Gorinchem swarmed with soldiers in the pay of the States General of the United Provinces. Military engineers, known as "pioneers," were building fortifications—half-moons and bulwarks—in the waterways surrounding the town. The States General's plan was to transform Gorinchem into a *place forte*, capable of resisting Spanish attack.[4] The castle of Loewestein, situated at the confluence of the Merwede and Maas rivers a few miles from Gorinchem, was a key military installation in the defense of the region. Here Hugo Grotius, Delft's famous jurist—the "father of international law"—was imprisoned in 1619, after the defeat of the Remonstrant Party

[1] Doc. no. 68, 24 May and 16 July 1621.
[2] Doc. no. 83, 15 October 1623.
[3] Letter from A. J. Busch, archivist in Gorinchem, 4 December 1975.
[4] On these fortifications see Gorinchem G.A., no. 4000. I found sixteen different workmasters ("werck meesteren") first mentioned in the Gorinchem archives in the 1620s, twenty-one in the 1630s, and eight in the 1640s. They traveled all over the United Provinces, where they were engaged in building fortifications for the States' army and for other clients.

and the beheading of the statesman Van Oldenbarnevelt. A year later
Grotius made his sensational escape in a trunk carried out by two acolytes
with his wife's connivance.

In 1627, Balthasar Gerrits left his trace in archival documents in con-
nection with an affair that had its origins in Delft and Amsterdam. Back
in 1616, a certain Jan Rogier, master caffa worker in Delft, had con-
tracted with Laurens van Otteren of Maastricht "to learn the art of mak-
ing steel."[5] On May 16, 1627, Van Otteren drew up an agreement in Am-
sterdam with the same Jan Rogier, said to be his brother-in-law, to form
a company to exploit an invention for making steel out of iron. Rogier,
who now called himself by the distinguished name of Van Rosieren,
promised to do "his utmost best" to find other partners or financial par-
ticipants in the company. Rogier, alias Van Rosieren and now a "mer-
chant in Amsterdam," had already gone to Gorinchem a month before
signing the agreement with a view to recruiting a partner for the new
company. In a deposition made before the aldermen of Gorinchem at his
request, witnesses testified to the financial soundness of Balthasar Ger-
rits.[6] A basketmaker and a joiner declared that Balthasar Claes Gerrits,
presently living in Gorinchem, was an "artful master of clockmaking
and other wonderful inventions." They were aware that he was a person
of means who kept a good house in which there was a remarkable num-
ber of artful paintings, estimated by all who had seen them to be worth
several thousand guilders. He also had as beautiful a library as anyone in
town, worth to all appearances far more than a thousand guilders. They
further claimed that Master Balthasar was a "highly qualified person,"
exempt of any debts. The basketmaker had been to his house several
times and had seen his paintings and other possessions. He had also heard
about these things from Balthasar's good friends. The joiner knew the
paintings because he had made frames for most of them.[7]

No other information has surfaced in the archives about the fate of the
steel venture, let alone about Balthasar's participation in it. The Gorin-
chem deposition makes it appear as if Jan Rogier wanted to establish Bal-
thasar's technical qualifications as well as his financial status, so that he
might have a document to show Van Otteren in Amsterdam. That Bal-
thasar could make clocks and was generally familiar with metalworking
should not surprise us. These skills would have stood him well in forging

[5] Delft G.A., records of Notary C. Coeckebakker, no. 1610, 14 August 1616, fols. 50–
51.

[6] Doc. no. 115, 16 May 1627.

[7] Doc. no. 113, 14 April 1627. Jan Rogier, alias Johannes de Rogieren and Hans van
Rosieren, died in Amsterdam before 6 March 1654. His widow, Gertruit van Otteren, who
was presumably the sister of Laurens van Otteren, survived him. The papers left after his
death make no mention of the steel-making enterprise (Amsterdam G.A., records of notary
C. de Grijp, no. 2604, fol. 459f.).

coins. The rest of the deposition should be taken with a grain of salt. The deponents, Balthasar's friends, were probably asked to exaggerate the value of his possessions. The old counterfeiter may have had some paintings, but it is hard to believe that he had a collection worth thousands of guilders. Very few patricians in a city such as Delft, with three times the population of Gorinchem, had paintings worth as much as that. What we know about the modest status of his son Balthens hardly squares with wealth of this magnitude. As to the library valued at over one thousand guilders, it seems a bit large for a man like Balthasar, whose daughter Digna did not know how to read or write.

How did Jan Rogier formerly of Delft, now of Amsterdam, latch on to Balthasar Gerrits in the small town of Gorinchem? Perhaps through his fellow caffa worker Reynier Jansz., Balthasar's son-in-law. No direct connection between Jan Rogier and Reynier Jansz. can be established; yet if we consider that there were fewer than ten master caffa workers in Delft in the 1620s, it is evident that they must have known each other.

Eight months later, Master Balthasar Claes Gerrits, "engineer living in this city," appeared before the aldermen of Gorinchem to draw up a power of attorney aimed at collecting money due to his wife in Amsterdam.[8] His brother-in-law, Claes Gerrits Vouck, named in the procuration, was able to obtain from the commissioner of the garrison of Amsterdam a portion of the salary earned by Beatrix's father when he served in the garrison.

Balthasar died sometime between January 1628 (the date of this last document) and April 1632, when his widow petitioned the Gorinchem authorities to name her as town midwife.[9] Nothing is known about the size or the disposition of his estate. If he did own paintings, as he probably did in the light of the highly specific reference to his collection in the deposition of 1627, it is likely that some of them were inherited by his daughter Digna in Delft. This raises the interesting possibility that Reynier Jansz. started dealing in paintings from the stock left to his wife. The date of his registration in the Guild of St. Luke as art dealer (October 1631) is at least consistent with this hypothesis.

In the late 1620s and early 1630s, Balthens and his wife Susanna left no traces in the Gorinchem archives except for the baptisms of their children and their testament. Four daughters were born to the couple between 1627 and 1633. In a testament dated April 1629, husband and wife named each other universal heirs.[10] The first information of interest about

[8] Doc. no. 121, 27 January 1628.
[9] Balthasar Gerrits was probably still alive on 16 April 1629, since his wife Beatrix was not referred to as a widow on the occasion of her testimony, in her capacity as a midwife, concerning the father of an illegitimate child (doc. no. 126, 16 April 1629).
[10] The baptisms are recorded in document no. 119, 14 December 1627; no. 128, 4 June

the family that surfaces after Master Balthasar's death is contained in a petition that Beatrix Gerrits (Balthens's stepmother) submitted to the burgomasters of Gorinchem to obtain the position of "town midwife" in April 1632.[11] Women appointed to this post received a fixed yearly salary from the city treasury to deliver the children of indigent mothers.

Beatrix introduced herself as the widow of Master Balthasar Gerrits, alias Mijnheer, of blessed memory. She declared that she had practiced as a town midwife in Amsterdam for twelve years. After her first husband's death, she had married Master Balthasar and had come to live in Gorinchem. In the last six years, she had again engaged in the practice of midwifery, offering her services not only to well-off but also to poor people. She had served the poor (and was still doing so) more than any town midwife. She had been advised earlier by her good friends that she should apply to be admitted as a town midwife so that she could be remunerated by the city, but she had not been able to do so because her husband had used her in trips and travels in secret services for the land.

There is not a shred of evidence to suggest what these secret missions for the Republic might have been. But Beatrix's spectacular assertion faintly echoes the claim she had made in 1620 to Gerrit de Bury, her husband's partner in the counterfeiting operation in The Hague, that Balthasar would be pardoned by His Excellency if he were ever caught counterfeiting by reason of services that he had earlier rendered to the Prince. Both claims could of course have been spurious. If so, it is not apparent why she should have boasted about her husband's alleged services in the petition.

Beatrix went on to declare that she was now prepared to settle down. Since the death of her husband had deprived her of his earnings and since he had left her no means but only debts, she was incapable of maintaining her household on her present earnings. Therefore she implored the burgomasters and aldermen to name her as a sworn town midwife with the attendant emoluments. Her petition was accepted. The treasurer was instructed to pay her the sum of forty-two guilders a year, beginning in May 1632. Treasury payments to Beatrix Gerrits are recorded in the city ledgers until 1656.[12]

The first mention of Reynier Balthens as a "workmaster" or contractor is dated July 1633.[13] With three of his close associates, he declared that a "compagnie" or partnership had been created with two other workmas-

1629; no. 129, 15 September 1630; no. 142, 13 September 1633; and the testament in doc. no. 127, 28 April 1629.

[11] Doc. no. 134, 17 April 1632.

[12] Gorinchem G.A., "Reeckeningen van de Thesaurier, 1611–1660," no. 1431, 1432. The entry for April 1656 (50 guilders) is crossed out, presumably because she died in that year.

[13] Doc. no. 138, 11 July 1633.

ters to build military fortifications in Rhijnberch, a "fortified place" on the Rhine now in Germany. The compagnie had carried out five orders or contracts "between the quarters of Count Johan Maurits of Nassau and the Lord of Brederode." All further works were to be undertaken on separate accounts "for profit or for loss." Four days later the dissolution of the partnership was announced in a second deposition.[14] A debt of eighty-two guilders owed for various work undertaken in Rhijnberch was to be paid to four of the six contractors (including Balthens), who were still in association.

Ever since the Spanish forces had taken Rhijnberch from the States General in 1601, they had used the fort to launch campaigns in the provinces of Gelderland, Overijssel, and Drenthe. Rhijnberch had changed hands so many times in the Eighty Years' War between Spain and the United Provinces that it had become known as the *putaña de la guerra*, the whore of war. In the spring of 1633 it had become the object of a major offensive by Stadhouder Frederik Hendrik. From May 16, when the siege of Rhijnberch began, Balthens and his companions were presumably engaged in fortifying the two trenches that had been dug to gain access to the moat around the fort.[15] The breakup of the compagnie later that summer may have been linked with the money troubles besetting the States General's army at the time. The siege of the fort had been hampered by lack of funds to pay for redoubts, trenches, and batteries. Military contractors for the States' army were paid irregularly. Delays in payment placed a heavy burden on workmasters, who had very limited funds to continue their work while they waited for their money.

We hear next about Balthens when the aldermen of Gorinchem, on April 21, 1635, granted him permission to submit his claim, along with other creditors, against the estate of Pieter van der Griend. This permission was given "after verification of Balthens's invention." Was this perhaps one of his father's "wonderful inventions"? Or did young Balthens continue to make clocks and other admirable contraptions on his own? Archival documents yield no information whatever on this point. It may or may not be significant that Van der Griend, who had died at least as early as 1631, was married to a woman from a village just outside Delft.[16]

By the early 1640s, Balthens had been appointed a lieutenant in the "pioneers," the engineering corps of the States' army for which he was again constructing barracks in Rhijnberch. A wealthy beer brewer in Gorinchem, Anthony Wijardt, had invested 3,700 guilders in the project. Wijardt later complained that the funds that had been lent to Dirck Ha-

[14] Doc. no. 139, 15 July 1633.
[15] Jan Wagenaar, *Vaderlandsche Historie* (Amsterdam: Johannes Albert, 1793), 11: 174–75.
[16] Doc. no. 144, 21 April 1635.

mel (the primary contractor for the project, who had died soon after it had been completed) had never been repaid to him. Balthens himself was apparently only a subcontractor in this affair.[17]

In the spring and summer of 1642, the allied armies of France, several Protestant Principalities of Germany, and the United Provinces of the Netherlands crisscrossed the Maas and Rhine valleys, skirmishing with the Spanish troops under Francisco de Melo. In June, the States' army settled in Bothbergen, a few miles down the river from Rhijnberch. The French camped in Ordiningen, a half hour's march from Bothbergen. The allies confronted De Melo's troops for three months. Little happened beyond a cavalry encounter that resulted in the capture of Rhijngraaf Frederik, one of the leaders of the allied army. Once ransom money had been paid for his release, the Rhijngraaf promptly returned to his quarters. This indecisive maneuvering, according to contemporary accounts, had more serious consequences for the local population, on which the troops of all sides preyed, than on the military contenders themselves.[18]

Balthens found himself in the castle of Loewestein, near Gorinchem, when hostilities resumed near Rhijnberch. He was serving at the time as the lieutenant, or deputy, of Captain Schade, who had dispatched him to Bothbergen at the beginning of May. Captain Schade nine months later asked two of his subordinates to testify that Balthens had "done little or no work in the Rhine campaign."[19] According to the deposition, Balthens had taken his time, marching "eight to ten days" to reach Bothbergen, where he had proceeded "to make his profit" in the Weimar quarter, the part of the camp where the troops of the Elector of Brandenburg were stationed. He had crossed the bridge over the Rhine two or three times to visit the quarters of the States General and then had hastily returned to the Weimar quarter. While he was on the States' side of the Rhine, he had taken out of the States' stores thirty spades and twenty-four shovels in Captain Schade's name, which he had brought back to the Weimar side and left there. Later he had run away, taking the money he had received in cash for his contribution "without completing his work or rendering the least service after this date."

These charges should not be taken too seriously. It is doubtful that Balthens had run away from the battlefield out of cowardice. Captain Schade was perhaps trying to deprecate his contribution to avoid paying Balthens for the sums he would have been entitled to if he had done his job more conscientiously. The document does reveal an interesting aspect of his work as a military engineer: he could hire himself out to do an odd

[17] Document no. 171, 7 May 1642; and Gorinchem G.A., "Rechterlijk Archief," no. 564, 15 November 1649.

[18] Wagenaar, *Vaderlandsche Historie*, 11: 318–20.

[19] Doc. no. 177, 21 March 1643.

job for an allied regiment and obtain cash payment for performing a spe-
cific task, even though he was not nominally serving in that particular
regiment. The pioneers were much more loosely subordinated to their
corps than the engineers in a modern army.

If Balthens had committed a really serious offense he would have been
dismissed from his charge or even court-martialed. As it was, he was still
serving as a lieutenant under Captain Schade a year after this episode. In
the summer of 1644, Balthens, along with his friend, the workmaster
Hendrick Claes van Neercassel,[20] took part in the siege of Sas van Gent
in Flanders. On March 15, 1645, the two men appeared before a notary
in The Hague to collect a large sum of money that the States General
owed them for the construction of the "left gallery," which had played a
crucial role in the siege.[21] They received a little more than five thousand
guilders in cash for the job. "Reynier Jansz. Vos," Vermeer's father,
signed the transfer of the claim and the receipt for the money Balthens
and Van Neercassel obtained.

The Dutch eighteenth-century historian Jan Wagenaar mentions the
gallery that Balthens had worked on.[22] The siege of Sas van Gent, the
most important fortified place in Spanish Flanders, had taken place in
August and in the first days of September 1644. Prince Frederik Hendrik,
who led the States General's forces, had personally ordered galleries built
over the two bridges spanning the canal to shield his attacking troops
from the defenders of the fort as they made their way to the ramparts.
Before the galleries were completed, a great storm and flood tide that
suddenly rose during the night destroyed them both.

The soldiers were greatly dispirited over this mishap. But the next
morning, the Prince—wading through the waters to his knees—roused his
troops to renewed courage. Within four days, the galleries had been re-
paired. Soon after, one of them was again damaged by a cannon shot
from the fortress. The work was made whole in a single day. Once the
galleries were securely in place and access to the ramparts could no longer
be denied, the enemy forces were ready to negotiate their surrender.

On September 5, 1644, the victorious Dutch troops entered the town.
The work of the pioneers had been decisive in the success of the States'
army. The pay order cashed by Bres and Balthens in The Hague, large as
it was, may not have represented the entire amount that the States' army
owed the two men. A few months later Captain Bres, who may also have
been acting on behalf of his fellow pioneer Balthens, and Captain Schade

[20] Hendrick van Neercassel was born about 1610 (doc. no. 184, 19 April 1645). He wit-
nessed the second testament of Reynier Balthens (doc. no. 190, 19 November 1646) and the
christening of Balthens's son Balthasar on 10 March 1647 (doc. no. 194).

[21] Doc. no. 182, 15 March 1645.

[22] Wagenaar, *Vaderlandsche Historie*, 11: 366–70.

requested payment for arrears totaling 12,384 guilders 4 stuivers from the States General.[23]

Reynier Jansz.'s presence in The Hague, by Balthens's side when the two workmasters collected their pay, is easily accounted for. The families entertained close relations. In mid-January 1645, two months before the trip to The Hague, Balthens and Van Neercassel were both staying in the inn Mechelen on Delft's Great Market Square.[24] There, a Delft contractor named Jan de Vos had given Balthens a small sum in partial payment of a debt of eighty guilders that he owed to a Dordrecht workmaster (to whom Balthens had advanced the funds). The three-way transaction had originated in Assendelft in Flanders (near Sas van Gent) at the time the troops of His Highness the Prince of Orange were breaking camp in the autumn 1644.

The last child born to Balthens's wife Susanna had been christened in September 1633.[25] After Susanna's death, which took place sometime in the next three years, Balthens remarried. On January 14, 1637, a notary drew up a marriage contract between Reynier Balthens "from Amsterdam" (that is, born in Amsterdam) and Maeyken Gijsberts, daughter of Gijsbert Rutten.[26] Since his illiterate bride contributed little or no worldly goods to the marriage, Balthens stipulated that property owned by either contracting party would be kept separate for the first two years of marriage. By this provision, he made sure that if he died within two years, his children by his first wife would not be deprived of any assets he had inherited from his father or accumulated on his own.

Balthens and Maeyken were married on the same day as the contract was signed. Their first child, a daughter, was born three years later. Beatrix, named either after her grandmother or after Reynier's stepmother, was christened on June 15, 1640.[27] Present were Beatrix Gerrits; Gijsbert Rutten, the infant's grandfather; Vermeer's mother, Digna Baltens; the workmaster Gerrit Hamel; and Mertyana van der Muyr, a relative of the family notary, Hendrick van der Muyr.

Digna was again present at the baptism of a second Beatrix (the first Beatrix having presumably died) on April 1, 1642.[28] This time the other witness was the workmaster Tobias Bres, who was associated with Balthens both in 1645 and in later ventures.[29] Bres was thirty-four years old

[23] F.J.G. ten Raa and F. de Baas, *Het staatsche leger 1568–1795* (Breda: De Koninklijke Militaire Academie, 1918), 4: 264. The request is dated 3 November 1645.

[24] Doc. no. 184, 19 April 1645.

[25] Doc. no. 147, 14 January 1637.

[26] Ibid.

[27] Doc. no. 155, 15 June 1640.

[28] Doc. no. 169, 1 April 1642.

[29] See document no. 248, 24 February 1653; no. 254, 6 May 1653; and no. 255, 4 December 1653.

in 1642,[30] a few years younger than Reynier Balthens. He was a frequent
visitor to Delft. In 1651 he was probably staying at Mechelen, where he
witnessed a power of attorney on behalf of Vermeer's father.[31] In a dep-
osition made at Bres's request four years after the birth of Reynier Bal-
thens's second Beatrix, a young woman named Maria Pietersdr. denied
the rumors going about that Captain Bres had "procreated a child" with
her.[32] She declared that he had never had "conversations of the flesh with
her, much less fathered her child." She promised never to see him or
otherwise make any claims against him regarding her child.

Vermeer's mother, along with workmaster Hendrick van Neercassel,
also attended the baptism of Balthasar, named after his paternal grand-
father, in March 1647.[33] Did she come down especially from Delft for the
three baptisms she attended from 1640 to 1647? She had not attended
the baptisms of any of the five children born to her brother from his first
marriage with Susanna. The forty-mile trips from Delft—by boat down
the Schie River, then up the Merwe River—must have taken a whole day.
Digna may have had business errands to carry out in Gorinchem on be-
half of her husband during these years. It is tempting to think that she
brought along her only son Johannes (who was eight years old in 1640
and fifteen in 1647) on one or more of these trips.

From time to time, in the late 1630s and 1640s, Beatrix Gerrits made
depositions before notaries concerning her activities as a midwife. In a
deposition concerning the symptoms of pregnancy made in July 1642
when she was fifty-seven, she and her colleague declared that a woman
must normally be aware that she is pregnant after carrying her child four
months or less, but in any case "no female person having carried a child
for half her period of pregnancy or at the very outset for twenty weeks,
can be unaware of it, but must notice it from various signs, by or before
that time."[34]

Returning to the life of Beatrix's stepson, Reynier Balthens, we find that
he continued his work as a military contractor until 1648, when the
United Provinces concluded peace with Spain. With the treaty of Müns-
ter, the Eighty-Years' War was finally over. For the first time since hostil-
ities had resumed in 1621, the States General's army had no pressing mil-
itary works to carry out. Balthens now had to depend for his living on a
civilian clientele, which was limited to municipalities. His precarious fi-
nancial situation, which came to a head a couple of years later, is already

[30] Workmaster Tobias Bres was said to be twenty-seven years old on 27 April 1635 (Gor-
inchem G.A., "Rechterlijk Archief," no. 557).
[31] See Chapter 4 at note 60.
[32] Delft G.A., records of Notary C. Brouwer, no. 1660, 20 December 1646.
[33] Doc. no. 194, 10 March 1647.
[34] Doc. no. 173, 5 July 1642.

revealed in a loan agreement that he made in February 1650 with his
stepmother.[35] Against a "larger sum" that she lent him, he pledged his
worldly goods and a certain amount of "Rotterdam, Delft, and Rouen
porcelain." Some of this earthenware Balthens had bought on credit in
Delft, perhaps for resale in Gorinchem. His principal creditor was Hen-
drick Marcellis van Gogh, one of the largest faience manufacturers in
Delft.[36] Among the personal possessions Balthens pledged as collateral
for Beatrix's loan were two beds, eight cushions, some chairs, a couple of
tables, a larder, kettles, a Bible, and a few unitemized books—all goods
typical of a modest Dutch household. The money that Balthens had col-
lected in The Hague five years earlier had probably been spent in the
meantime on the reimbursement of debts as well as on living expenses.
Small contractors, paid intermittently, were short of capital. They fre-
quently had to borrow money to defray the costs of their enterprises and
to live on until the next payment chanced to come in.

In the seventeenth century, Brouwershaven—a port lying on the north-
ern shore of Zeeland—was an important fishing and shipping center, far
larger than in our day. The town was then enclosed by a fortified wall,
which has since disappeared. Some time before the summer of 1652, cer-
tain entrepreneurs had begun the work of restoring the southern and
western portions of the ramparts, but due to a lack of funds and to some
unfavorable conditions that they had foreseen, they had abandoned the
project. In August of that year Balthens contracted to carry out the res-
toration in association with his old friend, Captain Tobias Bres. Some
fourteen months after the enterprise was started, a councillor and former
alderman of Brouwershaven by the name of Marinus Copmoyer, who
had advanced the money for the project, asked a witness to testify that
there was no way the work could have been accomplished "unless God
Almighty had vouchsafed an extraordinary and unimaginable dry spell in
the late summer during the entire period of the restoration."[37]

Balthens and Bres did complete the repairs after a few months, but the
work was "as badly done as could possibly be." The sludge that they had
dredged out of the canal to cover the top of the walls was nothing but
soft mud and water that continually slid back into the canal. Clearly, the
makeshift mortar had failed to set, owing to the moist and rainy weather
that as usual prevailed during the autumn months. This was just what the
first contractors had anticipated when they had given up the project. Cop-
moyer claimed that the failure to repair the fortifications properly had
exposed him to great financial risk, because he had laid out all the money
for the enterprise at a time when he did not know how difficult it would
be to accomplish.

[35] Doc. no. 226, 20 February 1650.
[36] Doc. no. 286, July 1661.
[37] Doc. no. 255, 4 December 1653.

In an appeal to the Court of Holland dated February 24, 1653,[38] Cop-
moyer explained that when he had financed the Brouwershaven operation
by advancing large sums of money to Balthens and Bres, he had specified
in the contract he signed with them that they would guarantee him indem-
nity against any further claims against him relating to the works carried
out (for which he was slated to receive payment from the treasury of Zie-
rikzee.) Later he learned that the treasurers had stopped payment on one
of the orders submitted by a certain workmaster named Jan Crab. Ac-
cording to the contract, Copmoyer was entitled to reimbursement by Bal-
thens and Bres for the sums forfeited. But he knew they had "no means
in the world of their own," and he thought they were liable to escape their
obligations by flight. He therefore caused them to be arrested, to guard
against their failure to reimburse him. This led to a local suit that resulted
in a sentence of the burgomasters and aldermen of Brouwershaven favor-
able to the defendants, who were released "unconditionally and without
prejudice."

Balthens and Bres apparently regained their freedom in November or
December 1652. Toward the end of December or in January, Digna Bal-
tens (widow of the recently deceased Reynier Jansz. Vermeer) traveled to
Brouwershaven. She had happened one day to be in a room of the house
where Tobias Bres was lodging when suddenly Marinus Copmoyer came
in, holding the key to Bres's coffer in his hands. Copmoyer told her that
he would like to have—nay that he *must* have—a certain letter. He
opened the coffer, took out two or three letters, and put them in his bag.
She "failed to see what the letters contained."[39] (She could hardly have
done so since she was illiterate.) Digna's visit to Brouwershaven doubt-
lessly related to her brother's participation in the disastrous affair of the
repairs to the town walls. But beyond the incident just reported, nothing
is known about what she actually was trying to accomplish by her trip.

A couple of months after the incident with the purloined letter, Cop-
moyer appealed the sentence of the Brouwershaven authorities to the
Court of Holland in The Hague. Claiming that he had suffered grievous
financial damage, he requested that Balthens and Bres be arrested again
and held until they could submit sufficient guarantees for the promised
indemnity or until the court had heard both parties. The magistrate in
charge of petitions wrote "fiat ut petitur" (let it be done as requested) on
the margin of the document.[40]

If our contractors were actually re-arrested, they did not linger long in
jail. On April 23, 1653, Balthens was back in Delft. He appeared before
a recently established notary (a detail that will be brought up again in the
next chapter) to give power of attorney to a correspondent in Brouwers-

[38] Doc. no. 248, 24 February 1653.
[39] Doc. no. 254, 6 May 1653.
[40] Doc. no. 248, 24 February 1653.

haven.[41] The correspondent was empowered to collect 1,500 guilders that Balthens had coming to him for the last installment due on a project in Zierikzee (on the south shore of the island, opposite Brouwershaven) where he had made two half-moons defending the access to the fortifications. The witness to the procuration was none other than Johannes Vermeer. No profession or craft was appended to the name of the young artist, who was then twenty years old and who had not yet joined the painters' guild.

Two weeks later, Tobias Bres came before the same notary and asked Digna Baltens to relate the story of the letter that Copmoyer had purloined in his room in Brouwershaven. This time the witnesses were the master painters Leonaert Bramer and Evert van Aelst.[42]

Balthens did not enjoy his freedom long. Before the end of the year the poor man had quit his troubled life. We know of his death because his wife Maeyken Gijsberts, who had moved to cheaper lodgings in Gorinchem, was registered in the tax books for 1653 as the widow of Reynier Balthens.[43]

It is hard to see how Balthens and Bres, having no means in the world of their own, could have secured their freedom after the Court of Holland decreed against them if the Vermeer family had not come to the rescue, as they had in 1620 when Balthens had first gone to jail for his participation in the counterfeiting affair. The only evidence we have for this assistance is the sudden downturn in the financial situation of Digna Baltens and Johannes Vermeer after the death of Reynier Jansz., which occurred a month or so before the unlucky contractors' arrest in November or December 1652.

First there was the failure to give any money on Reynier Jansz.'s behalf to the town's charitable organization, the Camer van Charitate, as was the custom when citizens died who left even moderate means to their heirs. There was also some temporizing on the repayment of family debts. It has already been related that the innkeeper of Mechelen owed 250 guilders to a wine merchant at the time of his death.[44] In March 1653, the entire debt was still due. The amount owed was inscribed among the "middling debts" in the papers of the merchant's estate. A "middling debt," while not as secure as a "good debt," did stand some chance of being collected, as "bad debts" did not. Six months later, a first installment of eighteen guilders had been remitted, less than one-twelfth of the original debt. Four years later (by July 27, 1657), the entire amount outstanding had been settled. When young Vermeer entered the Guild of St. Luke in December 1653, he paid only one and a half guilders toward his

[41] Doc. no. 252, 23 April 1653.
[42] Doc. no. 254, 6 May 1653.
[43] Gorinchem G.A., "Kohier van de verponding," no. 4140, fol. 48.
[44] See Chapter 4 at note 77. See also doc. no. 240, 15 June and 10 September 1652.

entrance fee of six guilders, an unusually small down payment.[45] He did not bring in the rest of his dues until July 1656.[46]

Similarly, Digna Baltens had bought some cloth, perhaps for her widow's weeds, on credit from a merchant shortly after her husband's death. The seventeen and a half guilders that she owed were only registered as paid in May 1657 in the merchant's estate papers.[47] Yet Digna Baltens, the sole heir of her husband according to their joint testament of February 1638, had inherited the paintings in stock as well as the inn and any liquid assets Reynier may have possessed at the time of his death.[48] The family's financial embarrassment was only relieved in 1656–1657, presumably because young Vermeer was by then beginning to earn some money from his art. It is likely, if Reynier Jansz. did leave liquid assets, that they were—in part or in whole—swallowed up in the expense of securing his brother-in-law Balthens's release.

In July 1661, the papers of the late faience maker Hendrick Marcellisz. van Gogh were delivered to the Orphan Chamber. Reynier Balthens, residing in The Green Way in Gorinchem, was listed among the debtors who owed money for faience delivered.[49] His debt for 122 guilders was among those said to be "uncollectible and worthless." Yet another entry in the papers, perhaps of later date, made mention of a smaller amount (39 guilders) that was "still outstanding." If this was the same old uncollectible debt, who had paid the difference? Balthens was long dead. The old midwife Beatrix Gerrits had finally passed away in 1656. Maeyken Gijsberts, if she had not already died by this time, was poor. Digna and her son Johannes Vermeer were probably the anonymous payers who had tried to clear the contractor's good name.

Captain Tobias Bres did not fare as badly as his partner Balthens after the disastrous affair in Brouwershaven. He settled in the city of Den Briel, a port at the mouth of the Maas River. The powers of attorney that he gave to various Delft citizens to carry on his affairs suggest that he was fairly well-to-do.[50] In the 1660s, his son Marcus Bres was named to the distinguished post of town surgeon of Delft. He had the honor of being mentioned as an outstanding representative of his profession in Dirck van Bleyswijck's *Description of the Town of Delft*, published in 1667.[51] The children of Balthens—Johannes Vermeer's first cousins—cannot be traced. If they survived to maturity, they led obscure lives in a town whose importance waned after peace was concluded with Spain.

[45] Doc. no. 256, 29 December 1653.
[46] Doc. no. 265, 24 July 1656.
[47] Doc. no. 245, 27 November 1652, 1 January 1653, and 11 May 1657.
[48] See Chapter 4 at note 46, and doc. no. 149, 17 February 1638.
[49] Doc. no. 286 July 1661.
[50] For example, Delft G.A., records of Notary C. van Vliet, no. 2033, 8 July 1657.
[51] Dirck van Bleyswijck, *Beschryvinge der Stadt Delft* (Delft, 1667), p. 584.

APPRENTICESHIP AND MARRIAGE

In over one hundred years of intermittently intense research on Vermeer in the Delft archives, starting with the efforts of the French amateur Henry Havard in the 1860s, not one document has turned up on the young artist's apprenticeship. No power of attorney, no transfer of funds to another city to pay for his training, no evidence of any kind. All trace of him has vanished between his baptism in October 1632 and his betrothal in April 1653. About all we can say with near certainty is that young Johannes grew up in his father's inn, first on the Voldersgracht in The Flying Fox, then on the Great Market Square in Mechelen, with only one sibling, a sister twelve years older than himself. The rest is speculation.

So far in this work I have had no reason to resort to imagination or conjecture, since there have been no major gaps to explain in the chronicle or missing nodes in the social network that I have tried to establish. Yet the lack of information on Vermeer's early life and on his training leaves a big hole that must somehow be filled if we are to have any idea of his artistic background. It is a proper object of speculation, in my view, to suggest sequences of events that are consistent with the more or less established facts at our disposal. The more tightly the facts can be fitted, the better for our speculation, but magic slippers will not be found that provide the perfect fit. The important thing is to identify conjectures and not let them be confused with solid facts. Plausible hypotheses, if nothing else, narrow the area where future investigation may yield new finds. The incentive to wade through archival material to discover who was the teacher of Vermeer will be greater if we have fairly strong prior expectations that Vermeer was apprenticed in Utrecht or Amsterdam than if every major town in Holland needs to be considered as a possible training ground.

To begin with Vermeer's early life, we may suppose that sister Gertruy helped her mother, Digna Baltens, and any servant the household may have had, making beds, serving tables, and running errands for the establishment. As a boy Johannes probably demonstrated early signs of his artistic gifts, surrounded as he was by the painters and art dealers that his father frequented for his picture business. Born when his mother was already thirty-seven years old, with no brothers or sisters of his own age to divide his parents' affection, he must have been the object of their solicitude and attention. If so, they may well have allowed him to take refuge

in drawing or painting from the chores that other members of the household had to carry out. This familiar situation may be reflected in one of his first known paintings—*Christ in the House of Martha and Mary*—which will be discussed in Chapter 8.

The first postbaptismal document mentioning the artist by name was discovered by the Dutch scholar Abraham Bredius nearly a century ago, in the papers of Notary Ranck.[1] On April 5, 1653, Captain Melling, fifty-nine years old, and Leonaert Bramer, painter, fifty-eight, appeared before the notary at the request of "Jan Reijniersz." (Johannes Vermeer) and "Trijntgen Reijniers" (his fiancée, Catharina Bolnes, daughter of Reynier Bolnes). They declared that on the previous day, on the evening of April 4, they had been at the house of Maria Thins (Catharina's mother) when Notary Ranck had asked juffrouw Maria Thins, who was assisted by her sister Cornelia, whether she wished to sign the act of consent for the registration of the marriage banns of her daughter, Trijntgen Reijniers, with Jan Reyniersz., also living here, so that the banns could be made public after the custom of the city. The witnesses heard Maria Thins say that she did not intend to sign the act, but was willing to suffer the banns to be published. She repeated several times that she would neither prevent nor hinder the publication of the banns. Willem de Langue, notary, art connoisseur, and a close acquaintance of the Vermeers, signed the attestation as a witness.

Maria Thins' objections to the marriage could have been social, religious, or both. She was a practicing Roman Catholic, descended from a distinguished family in Gouda. Young Johannes, on the other hand, had little to recommend him. His family was Reformed. His father was an innkeeper and picture dealer, professions that were in low esteem on the patrician scale of values. Maria perhaps also knew about Grandfather Balthasar's counterfeiting operation, Uncle Balthens's early imprisonment, and Grandmother Neeltge's bankruptcy. Then also, she must have known that sister Gertruy was married to an illiterate framemaker whose own sister Maria was a common housemaid (not to speak of the rumor that Maria had had an illegitimate child). Johannes's craft perhaps also counted against him, but if it did it detracted less from his attractiveness as a match for Catharina than did his religion or his mediocre family background. An artistic career, in those days, was not a social disability—at least for an innkeeper's son. From Vermeer's side, the marriage was not quite ideal either. Catharina was about a year older than he was. This small difference should be seen in the context of Karel van Mander's admonition to artists that they should marry a girl ten years younger than themselves. But Catharina's mother did have money and social standing.

[1] Doc. no. 249, 5 April 1653.

She had high connections in Catholic society that the young artist, at this stage in his career, may have regarded as promising sources of patronage.

This still leaves Catharina's motivation unaccounted for. Would it be unseemly to suggest that it was the force of love that attracted her to him? Irrespective of the favorable prospects that Vermeer's marriage to Catharina Bolnes may have brought him, love may have been a strong motive for him also. "Romantic love" was not unknown in mid-seventeenth-century Holland. Indeed, it was thought to be a source of artistic aspiration. None other than Leonaert Bramer had signed the *Album Amicorum* of the painter Wybrand de Geest in Rome with the motto "Love gives birth to art" ("Liefde baart konst").[2]

What were Captain Melling and Bramer doing in the house of Maria Thins when the notary asked her to sign the act of consent? It has usually been assumed that Bramer had interceded in favor of Johannes Vermeer. This inference has also given rise to the belief that Bramer was Vermeer's teacher. It is possibly significant that Bramer was a Catholic—or so it has been surmised ever since his name was found in a list of communicants in a Catholic church at the time he lived in Rome in the 1620s.[3] On the other hand, Bartholomeus Melling, who served as captain and sergeant-major in Brazil and later as a flag-bearer in the service of the States General,[4] probably belonged to the dominant Reformed religion. Captain Melling may have represented the Protestant and Bramer the Catholic side in the confrontation with Maria Thins.

The marriage contract ("huwelijke voorwaarde"), which was probably signed on the same occasion as the betrothal document of April 4, has unfortunately been lost. It is very probable, however, that it stipulated that the assets of the bridegroom-to-be would be kept separate from the bride's. This we may infer from a loan agreement that the couple signed three years later (discussed in Chapter 8), which specified that Catharina Bolnes was co-responsible for repaying the loan. No such clause would have been necessary if her assets had been merged with Johannes's. Maria Thins may have insisted on keeping her daughter's assets separated from those of her future son-in-law. This was a sound way to ensure that her property would be inherited by Catharina and her future progeny and would not be squandered by the fledgling artist.

[2] E. de Jongh, *Portretten van echt en trouw: Huwelijk en gezin in de Nederlandse kunst van de zeventiende eeuw*, exhibition catalogue, Frans Halsmuseum (Zwolle and Haarlem: Uitgeverij Waanders, 1986), p. 57. On "romantic love" in the seventeenth century, see also *ibid.*, p. 28. Catharina Bolnes's age is inferred from the statement that she was thirty years old in a document dated 11 April 1661 (doc. no. 282).

[3] P.T.A. Swillens, "R. K. Kunstenaars in de 17ᵉ Eeuw," *Katholiek Cultureel Tijdschrift* (1946): 416–19.

[4] Bartholomeus Melling, when he made his testament, declared that he was "a former captain and sergeant-major in Brazil and presently flagbearer" (Delft G.A., records of Notary J. Ranck, no. 2106, fol. 316). The name of Melling, who frequented well-established Delft merchants, appears in a number of Delft documents.

When the young people appeared for their betrothal at the Town Hall on April 4, the same day as the attestation recording Maria Thins's ambivalent attitude toward her daughter's marriage, the clerk wrote in the register: "Johannes Reyniersz. Vermeer, bachelor, living on the Market Place and Catharina Bolnes, spinster, also there."[5] Actually, Maria Thins's house stood on the Oude Langendijck, south of the New Church, a block away from the other side of the Great Market Square where Mechelen was located. The clerk's inaccuracy is more likely, in my judgment, than the possibility that Catharina was staying at the inn kept by Reynier Jansz., let alone that she was cohabiting with her fiancé.

Next to the entry recording the betrothal of the couple, a marginal note was inserted: "Attestation given in Schipluy, April 20th, 1653." The village of Schipluy—today's Schipluiden—was the place where the marriage was consecrated on Sunday, April 20. Schipluy, an hour's walk to the south of Delft, was a village where Catholics were well entrenched. Some of the municipal officers, including the man in charge of succoring the poor ("armmeester"), still gave their allegiance to the old religion. A Jesuit priest name Johannes Verwey and known as Father Wynants, born in Gouda and reputed for his proselytizing ardor, held services in Schipluy in the 1650s. The connections between the Jesuits in Schipluy and Delft were extremely close.[6]

The "hidden" church in Schipluy was the natural place for Maria Thins, whose own connections with the Jesuits were of long standing, to recommend for her daughter's wedding. Catholic services were held in the parish church. Religious considerations may have moved the couple, or Maria Thins, to celebrate the marriage there, but it is also worthy of note that one of the inhabitants of the village had borrowed a fairly large amount of money from Maria about this time. (Three years later Maria had his house sold at auction to repay the debt.)[7]

If Johannes Vermeer accepted Catholic sacraments in the Schipluy church, he must already have become a convert to the old faith. Maria had perhaps, at the time of the couple's betrothal, set as a tacit condition for the marriage that he should become a Catholic. She had refused to sign the act of consent because Johannes was not yet a Catholic, but she had said that she would not put an obstacle to the marriage because she knew he was about to become one. There was also a hint in the testament of Maria's brother Jan to this effect.[8]

On Tuesday, April 22, two days after the marriage, Johannes was back in Delft visiting the notary Willem de Langue, the old family friend who

[5] Doc. no. 250, 5 and 20 April 1653.
[6] M.P.R. Droog, "De parochie Schipluiden na de Hervorming," *Bijdragen voor de geschiedenis van het Bisdom van Haarlem* 32 (1908): 239–41.
[7] Doc. no. 263, 4 April 1656.
[8] See Chapter 9 at note 8, and doc. no. 281 of 1 February 1661.

had witnessed the deposition regarding Maria Thins's refusal to sign the act of consent three weeks earlier. Gerard ter Borch, the best known painter of elegant society pieces at the time, was there also. The two artists witnessed an "act of surety" drawn up by Johan van den Bosch, captain in the service of the States General and stationed in Den Briel, to enable Madame Dido van Treslong to collect one thousand guilders that were due her from the estate of the Lord of Treslong (former governor of Den Briel). Captain van den Bosch guaranteed that he would restitute the sum to the estate in case this proved necessary.[9] Were Johannes Vermeer and Gerard ter Borch witnesses who happened to be present when the document was drafted, or was either man connected with Captain van den Bosch or Dido van Treslong? No link can be documented, but it would not be surprising to find that Vermeer knew Van den Bosch via Captain Bres, who later settled in Den Briel, or via his uncle, Lieutenant Reynier Balthens.

It had not been known, before I came across this document a few years ago, that Ter Borch had ever been in Delft. He had last been noted in Amsterdam in November 1648. After that he had been in South Flanders and in Kampen, in the province of Overijssel. A couple of portraits, including one of the great landscape artist Jan van Goyen, are indicative of a stay in The Hague around 1652–1653.[10] The Hague was only an afternoon's ride away from Delft on the tow-boat.

The distinguished artist, to whom the notary referred with some deference as Monsieur Gerrit ter Borch, was thirty-six years old in 1653 and at the height of his powers as a portrait and genre painter. He signed his name below Van den Bosch's in a large and firm hand. Vermeer's signature, just below Ter Borch's, is smaller and more timid, as befitted a younger confrere who was not yet a master in the guild. The two artists may have met fortuitously that day at the notary's, but it seems much more likely that they were previously acquainted. Even though Ter Borch was a Protestant, it is not unlikely that he had come to Delft that week to attend Vermeer's marriage, which had been celebrated two days previously. If so, it would have been natural for Vermeer to introduce Ter Borch to his friend Willem de Langue. The notary, a connoisseur of paintings and a collector himself, would have been a useful contact for the out-of-town painter, always on the lookout for potential patrons. Ter Borch's painting *The Unwelcome Messenger* (Fig. 12) is loosely based on an earlier work by Anthony Palamedes of Delft (the artist to whom Reynier Jansz. probably handed over a small debt for peat). Ter Borch had probably seen Palamedes's work at the time of his visit to Delft. A portrait

[9] Doc. no. 251, 22 April 1653.
[10] S. J. Gudlaugsson, *Gerard ter Borch*, 2 vols. (The Hague: Martinus Nijhoff, 1959), 1: 71, 77, 86, 109, 113.

APPRENTICESHIP AND MARRIAGE

APPRENTICESHIP AND MARRIAGE 103

thought to be of members of the Liedekercke family may also have been executed in Delft at this time.

Was Vermeer Ter Borch's pupil? The only hitch in this otherwise attractive idea is that Vermeer's early works are totally different from Ter Borch's. It was only many years later, in the 1660s, that the works of the two artists began to converge. If Vermeer's style had matured early and he had shown great independence from established artists, then it would be possible to argue that he had studied with Ter Borch without undergoing his master's influence. But in point of fact he freely borrowed in his early work motifs and stylistic points from various artists: from Jacob van Loo, Erasmus Quellinus, even from his contemporaries Pieter de Hooch and Frans van Mieris. Ter Borch would surely have left his mark on Vermeer if he had been his master. The conclusion to all this speculation is that Vermeer had made friends with Ter Borch, perhaps in Amsterdam or in The Hague, without ever becoming his pupil.

Who, then, was Vermeer's master? The rules of the Guild of St. Luke required that each new member have studied at least six years with one or more masters before he was allowed to join. We have seen that Vermeer might have learned elementary drawing, along with some mathematics, from his neighbor on the Voldersgracht, Cornelis Daemen Rietwijck, a portrait painter in the guild, who had a sort of school where young people were taught how to draw and studied other subjects.[11] We know about the school from a deposition Rietwijck made in 1661, regarding a simple-minded boy who spent several years living with him and learning how to draw but who had made no progress in the art.

Then again, Johannes may have been regularly apprenticed, perhaps for the first two of his six-years' stint, with the still-life painter Evert van Aelst. Van Aelst owed Vermeer's father money when the boy was eleven years old, which he could have paid off by instructing him in the art of painting.[12] He is known to have been a successful teacher who included among his pupils the talented church painter Emanuel de Witte, his nephew the still-life painter Willem van Aelst, and Adam Pick.[13] Pick, who combined painting with innkeeping, may have influenced Vermeer's first genre compositions.[14] Evert an Aelst enjoyed a reputation for painting the shine and gleams on reflective metals—surely a skill that young Vermeer would have wished to acquire.

Bramer is also frequently mentioned as Vermeer's putative teacher. That he was a friend of the family appears more than likely. Not only did

[11] Montias, *Artists and Artisans*, pp. 174–75.
[12] See Chapter 4 at note 63.
[13] Montias, "New Documents," p. 286.
[14] A. Blankert with contributions by Rob Ruurs and Willem L. van de Watering, *Vermeer of Delft: Complete Edition of the Paintings* (Oxford: Phaidon, 1978), p. 33.

he testify at the request of Johannes and Catharina about Maria Thins's refusal to sign the act of consent for their marriage but he was present on May 6 with Evert van Aelst when Digna Baltens, two weeks after the encounter with Ter Borch, told the story before Notary Georgin of her adventure in Brouwershaven.[15] Yet there is very little about Bramer's style or his compositions that would allow one to guess Vermeer had been his pupil. The only parallel is in the subject matter—like Bramer, Vermeer painted religious and mythological "histories," at least early in his career. But Bramer's easel pictures, featuring small-size personages dominated by their architectural surroundings, have little in common with Vermeer's first known paintings, with their monumental figures situated close the picture's plane.

Finally, there is Carel Fabritius. Fabritius, ten years Vermeer's senior, a former pupil of Rembrandt in Amsterdam, had settled in Delft in 1650. Enormously talented and original, he had a strong impact on the Delft painters of his generation and the next. Pieter de Hooch, Emanuel de Witte, and Vermeer himself all learned from Fabritius's manner of depicting cool daylight, his understanding of perspective, and his magical way of imparting monumentality to small-scale compositions.

Vermeer owned at least three paintings by Fabritius at the time of his death.[16] Still, the only direct indication he may have been his disciple rests on a questionable interpretation of two verses in a poem by the printer Arnold Bon, published in 1668 in Van Bleyswijck's *Description of the City of Delft*. The poem compares Fabritius, who had died in a powder explosion in Delft in 1654, to a mythical phoenix. Vermeer, in one version of the poem, had risen from the fire in which Fabritius had been consumed and had "trodden his path." In the final version, the last two lines read: "But happily there rose from his fire, Vermeer, who masterlike, was able to emulate him."[17] Either version of the poem is compatible with the idea of a succession in time, one great painter following another, taking up his predecessor's legacy. A master–student relation cannot be excluded, but neither can it be demonstrated by invoking these ambiguous phrases.

If Vermeer was Fabritius's pupil, it was not for long. Fabritius only registered in the guild in October 1652, fourteen months before Vermeer did. It is very doubtful that Vermeer could have studied with Fabritius prior to the elder man's entry in the guild, considering that artists were required, by a rule that was generally enforced, to become masters in Delft before they could have any pupils of their own.[18]

[15] See Chapter 5 at note 42.
[16] See doc. no. 364, 29 February 1676.
[17] Blankert, *Vermeer of Delft*, pp. 147–48 and doc. no. 315 of 1667. Albert Blankert was the first to point out the interesting discrepancy between the two versions of the poem.
[18] Montias, *Artists and Artisans*, pp. 86–87.

So much for local candidates to whom the future phoenix may have been apprenticed. Whether or not Evert van Aelst or Bramer taught the boy in his first year of apprenticeship, I doubt he stayed with either of them in the last two to four years of his six-year stint. Although Vermeer's name is mentioned four times in Delft documents from April 5 to April 23, he is not called "schilder" (painter) on any of these occasions. Yet it was customary for an apprentice in Delft, especially if he appeared in a document with his master, to be identified by his trade. (Thus the simple-minded boy named Adriaen Duvese who was studying art with Cornelius Daemen Rietwijck was referred to as "schilder" when he witnessed a deed for a notary in the first year of his apprenticeship with Rietwijck in 1651.)[19] Even though exceptions do occur, one would not have expected all four of the references to omit the mention of painter if the young man was apprenticed in Delft at the time or had been apprenticed there not long before. Had Vermeer been living in Delft in the years immediately preceding his marriage, one would also have expected that his name would have turned up in some document, either as a witness to a deed or in some other capacity.

My guess is that Vermeer was apprenticed for the last two to four years of his training in Amsterdam or in Utrecht, or possibly in both these cities in succession. My (ever so slender) evidence for the Amsterdam connection turns on his father's own apprenticeship in that city and on influences in his first paintings; for the Utrecht connection, on his future in-laws' relation with the painter Abraham Bloemaert, who worked all his life in that city.

It would have been in keeping with what we know of Reynier Jansz.'s character—his ambition, his sense of where the main options lay—for him to have sent his son for training in Amsterdam, the city to which he had himself been sent to learn the craft of caffa weaving in 1611. The influences on Vermeer's work reinforce this supposition. His *Christ in the House of Martha and Mary* (Fig. 14), painted a couple of years after he joined the guild, is strongly reminiscent of Erasmus Quellinus's composition of the same subject.[20] Vermeer probably had seen the picture by Quellinus, painted between 1650 and 1652 when the Flemish master was at work on the New Town Hall in Amsterdam. The other early work generally accepted as by Vermeer's hand, *Diana and Her Companions* (Fig. 16), is strikingly similar to Jacob van Loo's rendition of this same subject, dated 1648 (Fig. 18). Van Loo in this period also worked in Amsterdam.

Van Loo, like Vermeer after him, began painting large canvases with mythological or religious scenes and then went on to paint smaller, more

[19] Ibid., p. 174.
[20] Blankert, *Vermeer of Delft*, pp. 16–17.

tightly executed genre compositions. He had already shifted to painting society pieces three or four years *before* Vermeer imitated his *Diana*.[21] Vermeer did not attempt genre painting until about 1656. His *Procuress* (Fig. 20), now in Dresden, was painted at least six years after Van Loo had first tried his hand at this new sort of subject. The ontogeny of the two painters followed a common line of development, one that Karel van Mander, the early theoretician of Dutch and Flemish painting, would have approved of. Young painters, Van Mander wrote, should begin their career by painting religious or mythological scenes, which would raise their sights and uplift their spirits.

It is often claimed that Vermeer some time during his mature life must have gone to Italy. No one, the argument goes, could have painted *Diana and Her Companions* who had not imbibed Italian principles at the source. The possibility discussed in Chapter 9 that the copy of the painting by Ficherelli (which appears to be signed by Vermeer), is really by the Delft artist may also be used to support this hypothesis.

Granted, there were too few original Italian paintings in Delft for a young artist to absorb and master the achievements of contemporary ultramontane painting.[22] Yet there were plentiful opportunities to study them elsewhere, particularly in Amsterdam, where many rich collectors owned important Venetian and other works, and where the best dealers carried on a lively trade in Italian pictures. The art dealer Johannes Renialme, who shuttled back and forth between Delft and Amsterdam, had paintings in his stock (or collection) by Padovanino, Jacobo and Leandro Bassano, Giuseppe Ribera, Claude Lorrain (a virtual Roman at the time), Jacomo Palma, Tintoretto, and Titian at the time of his death in 1657.[23] Since Renialme was acquainted with Notary Willem de Langue,[24] it should not have been difficult for young Vermeer to get an introduction to see the works in his inventory at any time in the early 1650s. Although a trip to Italy in the period prior to his entry in the guild cannot be excluded,[25] there is hardly a need for this hypothesis to explain the influences on his early work.

Turning now to a possible Utrecht period of apprenticeship, I should like to cite some facts that point in this direction. As regards a possible relation with Abraham Bloemaert, I will show in the next chapter that Jan Geensz. Thins, the cousin of Maria Thins who bought the house on

[21] Ibid., p. 24.

[22] On Italian paintings in Delft collections see Montias, *Artists and Artisans*, pp. 249–50.

[23] A. Bredius, *Künstler-inventare: Urkunden zur Geschichte der Holländischen Kunst des XVI*[ten], *XVII*[ten] *und XVIII*[ten] *Jahrhunderts*, 7 vols. (The Hague: Martinus Nijhoff, 1915–1921), 1: 230–39.

[24] Montias, *Artists and Artisans*, p. 214.

[25] It also argues against such a trip that Vermeer would have returned from Italy at an unusually young age (under twenty-one), younger by several years than any of the artists from Delft who are known to have made the ultramontane journey.

the Oude Langendijck where Vermeer spent his mature years and died, was a relative by marriage and a close friend of the Utrecht Mannerist, who was the next-of-kin present at his second marriage in 1647. Jan Geensz. in turn was extremely close to Maria Thins, whose father died when she was eight or nine. Thus Jan Geensz. was her beneficent uncle and guardian, far more than a cousin.

If Vermeer had been apprenticed to Abraham Bloemaert, who was painting and probably had pupils virtually until his death in 1651,[26] or to another Utrecht painter, this would help solve what is otherwise a puzzling problem. How did the young artist—Protestant, and the son of a man in a relatively low-status occupation—get to meet and court a girl like Catharina, who came from a prominent Catholic family? He could of course have met her on the Great Market Square, between the New Church and the Town Hall, but was this a place where a young man could decently court a young woman of high standing? They had no common church or other place where they could socialize. It makes better sense to suppose that they had first seen each other at some common acquaintance's house. Bramer's house in Delft or Bloemaert's in Utrecht would be prime candidates. A meeting at Bloemaert's house would be more probable if we accept the idea that Vermeer was absent from Delft in the last two to four years of his training. Apprenticeship to a Catholic artist, in whose studio he would have been exposed to Catholic religious ideas, would also explain why he apparently converted so quickly to Catholicism after his betrothal.

We may cite a distinguished precedent that should dispel any doubt that we might have about Protestant parents sending their son to a Catholic painter for his training. Rembrandt's parents, who were also Protestant, did not hesitate to send him to study with the very Catholic Pieter Lastman. Finally, there are more than enough influences of the Utrecht School on Vermeer's early work, from the early *Christ in the House of Martha and Mary* to *The Procuress* of 1656, to lend support to our conjecture. None of this is compelling, but neither is it beyond the bounds of reasonable supposition.

To understand the family situation Vermeer married into and the circumstances of his life when he moved in with his in-laws (probably in the mid-1650s but certainly by 1660), we must go back in time to trace the origins of the Thins family in Gouda. The dispute that had raged many years between Maria Thins and her husband Reynier Bolnes still had not subsided by the time Vermeer married their daughter Catharina.

[26] In May 1647, Abraham Bloemaert named his son Frederic to represent him in Amsterdam to collect ninety-two guilders from Samuel Griffets for instruction in painting given to Griffet's son from 21 September 1645 to 21 September 1646. There is no reason to believe Griffets was his last pupil (Utrecht G.A., records of Notary H. Ruysch, 20 May 1647). Marten J. Bok's research in the Utrecht archives confirms that Bloemaert had pupils beyond this date.

FAMILY LIFE IN GOUDA

Gouda, the sixth largest town of Holland in the seventeenth century, is situated on the Gouwe River, nearly twenty miles to the east of Delft and about the same distance to the southwest of Utrecht (Fig. 1). In early modern times the town had the reputation of having healthy air, which made it safe from the plague. According to a contemporary account, it was inhabited by people "who wished to retire from the bustle and confusion of large towns and who chose to live here for the beauty of the site and to find peace and rest."[1] Catharina Bolnes's parents, however much they may have enjoyed the air, never did find peace and rest in Gouda.

In 1572 Gouda, led by Burgomaster Jan Jacobsz. van Rosendael, had been one of the first towns to rally to the cause of Willem of Orange in the rebellion against Spain. Van Rosendael was of course Protestant, but many members of his extended family (including those who, nearly a hundred years later, were to become related to Vermeer's family) remained Catholic. By reason of their allegiance to the old faith, they were barred from all public offices at a time when members of patrician families could normally expect to gain membership sooner or later in the ruling bodies of their native cities.

Gouda was one of the towns of Holland least infected by the virus of religious violence in the sixteenth century. It was spared the ravages of the iconoclasts. The magnificent stained-glass windows of St. Jan's Church—some of which date from before the Alteration—survived more or less intact to this day. The Protestants who ran the town had to tolerate some discreet Catholic activity for fear that the Catholics, who made up a substantial part of the population, might become unruly. So the edicts, or "plakkaeten," of the States General—which forbade the holding of Catholic services or other public gatherings of the faithful—were weakly or only intermittently enforced.

By the middle of the seventeenth century, the Catholics of Gouda could worship in any of four "hidden" churches. Some proselytizing activity went on, especially after 1621 when the Society of Jesus resolved to send Jesuit missions to twenty-one Dutch cities, including Gouda and Delft. A mid-eighteenth century chronicle of the history of the Society of Jesus singled out the Gouda mission as having been particularly successful in recruiting new adherents to the faith: performing marriages, baptizing

[1] Jean de Parival, *Les Délices de la Hollande* (Amsterdam: Chez Jean de Ravestein, 1669), pp. 109–110.

children, and providing the rudiments of catechismal instruction. Jesuit priests gave absolution to believers "who for twenty or even fifty years had not come to the Lord's Table."[2]

Maria Thins, the mother of Vermeer's wife, belonged to one of the distinguished Gouda families who had remained Catholic and entertained close relations with the Jesuits. Her ancestors had been wealthy and charitable citizens. Before the Alteration her great-grandfather, Dirck Cornelisz. van Hensbeeck van Oudewater, had served as burgomaster of the city. In 1561, he commissioned a stained-glass window depicting the Sacrifice of Zacharias for the Church of St. Jan.[3] Lambert van Noort's drawing of Dirck Cornelisz. and his wife Aechte Hendricksdr., represented as donors of the Zacharias window, can still be seen in the church sacristy (Fig. 13). Altogether, six members of the Hensbeeck family founded hospices and beguinages where pious Catholic women could end their days in peace.

The Thins family, which had left its memorial estates in Oud Beijerland (in the South Holland islands not far from Rotterdam) to settle in Gouda in the early 1560s, also clung to the old Catholic faith. Willem Jansz. Thin, a bailiff of Oud Beijerland, married Catharina van Hensbeeck, Dirck Cornelisz.'s granddaughter, in 1584. The couple had five children: Cornelia, born about 1587; Maria (Vermeer's future mother-in-law), about 1593; Jan, about 1596; and Elisabeth, about 1599. The fifth child, Willem (whose birth year is not known), probably died in early manhood. He is the only one of the five who plays no role in our subsequent story.

Diewertje Hendricksdr. van Hensbeeck also deserves mention for the assets she bequeathed to the family. An older sister of Catharina van Hensbeeck, she lived as a spinster in the Thins household until she died in 1604. Her large estate was in part inherited by Catharina van Hensbeeck, who received a capital sum of 2,867 guilders plus the family house "De Trapjes" (The Steps), where Maria Thins lived as a child. Diewertje also bequeathed a capital sum of one thousand guilders to the Holy Ghost Hospice, which yielded 62 guilders 10 stuivers a year for distribution to the poor.[4] The capital sum augmented the bequest of three thousand guilders that had been made for the same charitable purpose by her grandfather Dirck Cornelisz. van Hensbeeck. Seventy years later, Vermeer's distressed widow applied to receive subsidies from these funds.[5]

Maria Thins was connected with a number of patrician families in the Netherlands, many of whose members had remained faithful to the old

[2] *Historiae societatis Jesus* (Rome: 1750), 6: 98–99.
[3] C.J. Matthijs, *De takken van de dorre boom: Genealogie van de Goudse familie Van Hensbeeck* (Gouda: Rapide-Gouda, 1976), p. 35.
[4] Ibid., p. 41.
[5] Doc. no. 383, 27 July 1677.

religion. She had ties by blood or marriage with the Schonenburchs of
Utrecht, the Hensbeecks and Ro(o)sendaels of Gouda, the De Roys of
Leyden, the Bogaerts of Amsterdam, the Cools and Blijenburchs of Dor-
drecht, the Buytenwechs of Leyden and Nieuwcoop, the Duvenvoorde
van Wassenaar, the Issendoorn à Blois, and the Duyst van Voorhoudt.
(These close and distant connections are traced in genealogical charts 2,
3, and 4, in Appendix C.) When she was a very old woman, Maria at-
tested to her lifelong acquaintance with members of several of these fam-
ilies.[6] More important still for our story, Maria was related by marriage
to the great Mannerist painter, Abraham Bloemaert of Utrecht (see
Chart 3).

The link with Bloemaert passed through Maria's cousin and very close
friend Jan Geensz. Thins. Willem Jansz. Thin, the bailiff of Oud Beijer-
land already mentioned, was the son of Elisabeth Geenen and Jan Wil-
lemsz. Thin, who died in 1570. Another son, named Geen Thin, had mar-
ried Clementia van Schonenburch in 1575. Their son, Jan Geensz. Thins,
was thus the cousin of Maria and Jan Willemsz. Thins and their siblings.
Jan Willemsz. was often distinguished from Jan Geensz. by being called
Jan Thins the Younger ("de Jonge"). Clementia van Schonenburch, the
mother of Jan Geensz., was the daughter of Egbert van Schonenburch, a
prominent and wealthy citizen of Utrecht. Clementia's sister Judith (or
Jutte) married the painter Abraham Bloemaert in 1592. Thus Abraham
Bloemaert was the uncle by marriage of Jan Geensz. Thins, who in turn
was the cousin of Maria Thins (see Chart 2).

The Schonenburch connection was not the only one linking Jan
Geensz. Thins to Abraham Bloemaert. After his wife Judith van Schonen-
burch died in 1598, the painter married Gerarda de Roy two years later.
Adriaen de Roy, the brother of Bloemaert's new bride, married Susanna
van de Bogaert in 1616.[7] As we shall see later in this chapter, Susanna,
thirty years later, after burying her first two husbands, wed Jan Geensz.
Thins. A document dated September 27, 1604,[8] gives another indication
of the close relations Jan Geensz. entertained with Bloemaert. Bloemaert's
first wife, Judith van Schonenburch, had left him the lifelong usufruct of
a piece of land, but she had bequeathed the property itself to her nephew
Jan Geensz. Thins and his sister Aeltgen. When Jan Geensz. had signified
his desire to sell the property to a widow who was renting the land, Bloe-
maert graciously gave his consent, retaining only a claim to the rents that
would accrue for the rest of the year.

In his first testament dated October 1618, Jan Geensz. Thins stipulated

[6] Doc. no. 347, 21 January 1674.

[7] For this genealogy I am grateful to W.A. Wijburg of Utrecht.

[8] Utrecht G.A., records of Notary J. van Herwaerden, document dated 23 September
1604.

that if his children whom he had procreated with his wife Cunera Splinters, were to die, his possessions would pass on to his cousins, thus to Cornelia, Elisabeth, Maria, and Jan Thins.[9] In fact, this provision never did take effect because he had two daughters Lucia and Clementia (who both survived to an adult age) with his wife Cunera. But it was still a token of his affection for his uncle Willem Jansz. Thin's children, fatherless after Willem died in 1601.

Maria Thins grew up in her ancestral home, De Trapjes, with her brothers Willem and Jan and her sisters Cornelia and Elisabeth. Her father, Willem Jansz. Thin, died in June 1601 when she was eight or nine years old. Her mother, Catharina van Hensbeeck, was remarried in 1605 to Gerrit Gerritsz. Camerling, a prominent citizen of Delft.[10] Some time later she moved to Delft and left the household in charge of her daughter Cornelia, who was by then in her late teens. From her second marriage Catharina had a daughter, Maria Camerling, who also lived in Delft, close to the house that Maria Thins, Catherina Bolnes, and Johannes Vermeer were to inhabit many years later.[11]

As noted, the Thins family in Gouda were devout Catholics. Secret services were held in De Trapjes. We would never have known about them if it were not for a sheriff's report, dated 1619, relating how he had disrupted one of these illegal gatherings.[12] (Even though the persecution of Catholics in Gouda was only intermittent and often ineffective, it was by no means absent.) In 1618 when Elisabeth, the youngest of the children of Catharina van Hensbeeck's first marriage, was nineteen years old, she resolved to become a nun in the Convent of the Annunciates in Louvain.[13] At this time the truce in the war with Spain was still in effect; the war was only resumed three years later. Still, for a young Dutch woman to take the vows in a Catholic convent in Spanish-dominated Brabant was tantamount to a seditious act.

The deposition that she drew up before her Catholic notary to formalize her commitment reads as if she were well aware of its gravity. She twice repeated her solemn assurance that no secular or clerical person— least of all her older sister Cornelia or her cousin Beatrix Duyst—had influenced her in her decision. She said that it was only through love of God and religious ardor that she had been moved to serve the Lord. She made no mention of any transfers of her assets to the convent, presumably because any such contribution would have been illegal. The States

[9] Doc. no. 27, 3 October 1618.
[10] Matthijs, *De takken*, p. 42.
[11] Ibid.
[12] Gouda G.A., "Crimineel Vonnisboek," R.A. 177, fol. 143, cited in A.J.J.M. van Peer, "Een zeventiende-eeuwse familie geschiedenis," typescript, Delft, circa 1975, p. 2.
[13] Doc. no. 23, 10 May 1618.

General had promulgated an ordinance prohibiting any inhabitant of the United Provinces from giving money to a "popish" institution.[14] The Jesuits, with their close ties to the Southern Provinces, were suspected of violating the law. In Gouda, three years earlier, rumors had spread that Father Arboreus had garnered fifty thousand guilders for transfer to Catholic territory. This, in the eyes of the Protestants, amounted to aiding and abetting the enemy. Yet Elisabeth must have given over some of her property to the convent in Louvain, probably to the extent of the dowry that she was slated to receive upon her marriage.

Elisabeth died in her convent in Louvain on October 9, 1640. According to the convent's records, "our beloved sister had very faithfully served the Lord in the Holy Orders for 22 years; she had been a veritable paragon of sisterly love."[15] It may well be that Vermeer named his second daughter Elisabeth after her—one more indication of the artist's regard for his Roman Catholic in-laws.

Remarkably, none of Maria Thins's other full-blooded siblings ever married, either. As a consequence, all the property that Willem, Cornelia, Elisabeth, and Jan Willemsz. inherited from the Van Hensbeecks and the Thins devolved upon Maria Thins and Catharina Bolnes—and then upon Vermeer's children. Maria Thins did not marry until January 1622, when she was twenty-nine years old.[16] A deposition she made over fifty years later (in 1674, to be precise) indicates that she spent some years in Delft before her marriage. In her statement she claimed that she had lived four years with Maria van Blijenburch, the wife of heer Hugo Cool.[17] Maria van Blijenburch was the daughter of Heyman Adriaensz. van Blijenburch, Lord of Dortsmonde, former burgomaster of Dordrecht. His son Cornelis Heymensz., also Lord of Dortsmonde, went to live in Delft about 1605, where he bought what must have been a magnificent house on the Doelen for 6,500 guilders plus two silver beakers.[18] By this time Maria van Bli-

[14] "Ordonnance des hauts et puissants seigneurs les Etats Generaux Unis des Pays Bas contenant deffenses a tous jesuites, prestres, moines et autres personnes dependantes du Siege de Rome de venir s'abiter en ce pays que personne ne pourra envoyer ces [sic] infants a l'escole ou les mettre en aucune place utile, universite ou college sous le commandement du Roi d'Espagne, pays des ennemis, n'y en aucun autre college des jesuites et n'avoir aucune correspondance d'or et d'argent monnoye, n'y autre bien, pour quelque necessite de quelques eglises, maison spirituelle et autres colleges ou faire des couvents" (Jouxte copie imprimée a La Haye, 1622). This "plakkaat" was renewed in more or less the same language in 1641 and 1649.
[15] Belgium, Archives Générales du Royaume, *Archives Ecclésiastiques du Brabant*, no. 15,259, fol. 151ᵛ, cited in a letter from C. Wyffels of the Archives Générales du Royaume, dated 12 July 1982.
[16] Doc. no. 74, 7 December 1621.
[17] Doc. no. 347 21 January 1674.
[18] Cornelis Heymensz. van Blijenburch wrote a diary ("Notabilia and various events") that has been preserved and was published in *Nederlandsche leeuw* 47 (1929): 332–38. On the genealogy of the Cool family, see *Nederlandsche leeuw* 59 (1949): 303–304 and the

jenburch had been the widow of Hugo Cool for eleven years. I suspect, but cannot be sure, that she joined her brother in Delft. She died in or about 1618.[19]

When could Maria Thins have been staying with Maria van Blijenburch? It is likely that she came to Delft to live with her mother Catharina van Hensbeeck and her stepfather Gerrit Gerritsz. Camerling soon after their marriage in 1605.[20] But in 1613 her stepfather, a prominent Delft Catholic, left Delft to serve in India with the East India Company. He drowned off the coast of Ceylon in 1627. Maria Gerrits Camerling, the daughter of Catharina van Hensbeeck and Gerrit Camerling, who was born about 1609, went to live with a great-aunt (also named Maria Gerrits Camerling) not long after her father had left for India. Maria Thins may have joined the household of the much older Maria van Blijenburch (born in 1555) between the date her stepfather left for India in 1613 and the death of Maria van Blijenburch in 1618.

The relations between the two half-sisters remained close after Maria Thins returned to Gouda (where, we recall, she married in 1622), and even after their mother Catharina van Hensbeeck died in 1633.[21] When Maria Gerrits Camerling made her testament in December 1635, she left the children of Maria Thins "all her linen and wool clothes, together with a painting of the Nativity with a gilded frame from her mother's estate." After she married Jan Heyndricksz. van der Wiel in 1637, however, she made another testament in favor of her husband and her children-to-be (three daughters were actually born to her between 1644 and 1651) so that Vermeer's wife Catharina, who would have benefited from the first testament, never did inherit the painting.

I now return to the tedious but essential task of tracing the network of Maria Thins's high-born relations (see Appendix C, Chart 4). We often

sources in the following note. All extracts from the *Nederlandsche leeuw* were communicated to me by W.A. Wijburg.

[19] In Matthys Balen Janszoon, *Beschryvinge der stadt Dordrecht* (Dordrecht: Simon onder den Linde, 1678), we find a fairly complete genealogy of the Cool and Van Blijenburch families (pp. 1010–11). There it states that Maria van Blijenburch died on 7 September 16.. [left blank] at the age of sixty-three, leaving three children. Her year of death (1618) can be ascertained by adding sixty-three to her birth year, which occurred in 1555 (Universiteitsbibliotheek Utrecht, Handschrifte, collectie Booth, no. 1828, file 25). These genealogical notes on the Van Blijenburch family were collected in the seventeenth century by C. Booth. Extracts from Booth's notes were kindly communicated to me by W. A. Wijburg.

[20] The information on the Camerling family, including the citation of Maria Gerrits's testament in the text below, is based on the article by Wouter Kotte, "De katholieke tak van het Delftse geslacht Camerling," *Archief voor de geschiedenis van de Katholieke Kerk in Nederland* 2 (1964): 161–63.

[21] The estate of Catharina Hendricks Hensbeeck was divided among Jan and Cornelia Willems Thins and Reynier Bolnes as husband of Maria Thins on the one hand and Maria Camerling on the other, on 29 September 1633 (Gouda G.A., records of Notary E. Th. Putterschouck, no. 93, fol. 254).

find mentioned, in documents of the Schoonhoven and Utrecht archives, links between the Cool and Thins families. Their origin goes back to the marriage of Adriaen Huygensz. Cool (the brother of Hugo Huygensz. Cool, the husband of Maria van Blijenburch) with Maria Geenen. The sister of Maria Geenen, Elisabeth Geenen, was the grandmother of Maria Thins as well as of her cousin Jan Geensz. Thins. Adriaen Adriaensz. Cool, the son of Adriaen Cool, was appointed a guardian of Jan Willemsz. Thins after the death of Jan's father, Willem Jansz. Thin, in 1601.[22]

This same Adriaen Adriaensz. married Erckenraad Duyst van Voorhoudt, the granddaughter of the former burgomaster of Leyden, Gerrit Beuckelsz. Buytenwech.[23] After the death of her husband in 1604, she became a nun in the Convent of Annunciates in Nivelles, near Louvain. (This institution had been founded about this time by the Mother Superior of the convent in Louvain, where Maria's sister Elisabeth Thins spent most of her life.) Erckenraad's Protestant father, Hendrick Duyst (c. 1534–1575), had been Hoogheemraad of Schieland and a Councillor to Prince Willem of Orange. Not only did Erckenraad revert to the Catholic faith but her son Hendrick Adriaensz. Duyst (1596–1662) became a member of the Society of Jesus under the name of Adriaen, which he chose in repudiation of his heretic grandfather's name. Father Adriaen rose in the order to become Rector of the University of Louvain and a delegate to the Congregation in Rome. He was twice Superior of the Dutch Jesuit Mission (in 1638–1642 and 1656–1659) and had his residence in Amsterdam.[24] He probably visited the missions in Gouda and Delft as the occasion required.

Beatrix Duyst van Voorhoudt, the "cousin" of Elisabeth Thins who was not supposed to have influenced her when she decided to become a nun, was the sister of Erckenraad. She apparently also had opted for the Catholic side in this family torn by religious difference. In 1643, Jan Willemsz. Thins represented the heirs of Beatrix Duyst van Voorhoudt in some transfers of property involving lands Beatrix had inherited from her grandfather, Gerrit Beuckelsz.[25]

Jan Geensz. Thins, Maria's cousin, also had close ties with the Buytenwech family with whom Maria Thins was so well acquainted. Johan de

[22] .J. C. Kort, "Repertorium op de lenen van de hofstede Arkel en Haastrecht," *Ons Voorgeslacht* 38 (1983): 129 (communicated to me by W. A. Wijburg).
[23] On these family relations, see the Cool genealogy mentioned in note 18 above. On the Buytenwech family, see Ph.J.C.G. van Hinsbergen, *Bijdrage tot de geschiedenis van Nieuwkoop en haar onderdelen*, pp. 8–9 (source was communicated to me by W. A. Wijburg).
[24] *Jaarboek*, Centraal Bureau van Genealogie, 12 (1958): 200–201, 210–11 (as communicated to me by W. A. Wijburg); letter of 31 January 1985 from C. Wyffels of the Archives Générales du Royaume (Belgium); and letter of 24 April 1985 from J.T.P. Barten, S.J., archivist of the Dutch Jesuit Province.
[25] Doc. no. 176, 18 January and 7 April 1643.

Bruyn van Buytenwech, the grandson of the former burgomaster of Leyden, had bought the high seigniory of Nieuwcoop and Noorden, and had become lord of this domain in 1617. Nieuwcoop, located at an equal distance from Gouda and Utrecht in the direction of Amsterdam, was a refuge not only for Buytenwech's fellow Catholics but also for the Remonstrant followers of Arminius whose teachings were condemned at the Synod of Dordrecht in 1618. As early as 1618, Jan Geensz. Thins had been named bailiff and "dijckgraaf" (dikereeve) of Nieuwcoop.[26] He was to remain dijckgraaf of Nieuwcoop the rest of his life. His brickmaking business in Moordrecht, next to Gouda, undoubtedly kept him from devoting more than a part of his time to the supervision of the waterworks in the vicinity of Nieuwcoop.

Johan de Bruyn van Buytenwech died childless in 1657. His title and domain went to Philippina van Wassenaar, the granddaughter of his brother Gerrit Buytenwech. Gerrit's wife, Cornelia Cool, was the daughter of Maria van Blijenburch, with whom Maria Thins had lived four years. Since Maria Thins later averred that she had been very well acquainted with Cornelia Cool, with her daughter Hester and her husband Albert van Duvenwoorde van Wassenaar, and with their daughter Odilia van Wassenaar, the sister of Philippina who inherited the seigniory, it would be fair to assume that she was at least an occasional guest in the manor of Nieuwcoop, which Johan van Buytenwech had renovated in the 1620s.

Maria Thins was virtually an old maid at the time she married Reynier Bolnes in early 1622, when she was twenty-nine. Reynier Bolnes was the son of Cornelis Pouwelsz. Bolnes, a prominent and prosperous brickmaker who contributed four thousand guilders to the marriage. Maria promised to supply all the assets she had inherited from her father. The marriage contract also specified that any earnings that might accrue during the couple's married years would go to augment their jointly held assets.[27] Twenty years later problems arose as to exactly what Cornelis Bolnes had promised to give the new couple.[28]

Maria and Reynier established a separate household in a house called "De Engel" (The Angel) near the harbor on the Gouwe River. Three of their children survived infancy: a boy Willem and two girls, Cornelia and Catharina. Catharina, Vermeer's future wife, was the youngest of the three. She was born in 1631 when her mother was already thirty-eight.[29]

[26] Van Hinsbergen, *Bijdrage*, p. 144. Jan Thins, "baljuw en dijkgraaf," contributed fifty guilders for the building of a new town hall in the village of Nieuwkoop.

[27] For the marriage contract, see doc. no. 74, 7 December 1621.

[28] Doc. no. 174, 9 November 1642.

[29] The only evidence we have of Catharina's birth year is a 1661 document where she was said to be thirty years old (doc. no. 282, 11 April 1661). It may be of interest to note that

Until 1635, when Catharina was three years old, Maria Thins and Rey-
nier Bolnes got along, or at least kept their relatives and neighbors out of
their disputes. By 1639 the marriage had deteriorated to such a degree
that Maria was collecting depositions from all and sundry about the ter-
rible things Bolnes had done to her, beginning four years earlier.[30]

In one of these many depositions, Maria's sister Cornelia Thins stated
before the family notary how she had come to Maria's house on St. Ja-
cob's Day 1635 and found her in tears. She asked what had happened.
Maria answered that her husband treated her so badly that she could not
keep house with him. She showed Cornelia how he had hit her with a tin
pot, which so bruised her that she could hardy walk about. Cornelia took
this to heart and asked to speak to Reynier Bolnes. She told him she
wished he would keep a better house with his wife. Bolnes was having
something to eat and was holding a knife in his hand. He got up, saying
"You black whore, what is it to you?" He grabbed her by the arm and
tore her sleeve all the way to the elbow, running after her with the knife
in his hand. She managed to get her arm loose when her sleeve was torn,
and rushed out the door.

A couple of days later Cornelia went to visit Maria, who was sick in
bed. Bolnes, with baleful eyes, was standing before her bed. "You must
get out of bed, you swine," he told her. Then he grabbed her by the hair
and without minding her pitiful pleas and cries, he pulled her naked
across the floor and left her lying there.

Later the same year the couple's maid, at eleven or twelve o'clock at
night, heard terrible cries. She ran in her nightgown to find out what the
matter was. By the light of a candle that she had lit, she saw that Bolnes
had a stick in his hand with which he was trying to beat his wife, "even
though she was pregnant to the last degree." The maid attempted to stop
him—as much as was in her power—and asked him why he wanted to
beat his wife. "She won't lie still," he answered "and she complains about
the hens that I keep above the bedstead, saying they won't let her sleep."
Whereupon the maid fulminated against him and stated that this was no
reason to beat her. "If you beat your wife for a small thing like that, I'll
box your ears!" Raging mad, Bolnes took hold of an earthenware pot and
a pair of bellows and threw them at the maid. She ducked. The pot hit the
wall and shattered into pieces. The bellows split in two. Yet when this
same maid was asked to testify before the aldermen in Gouda a few years

Digna Baltens and Maria Thins were thirty-seven and thirty-eight years old, respectively,
when Johannes and Catharina were born.

 [30] Unless otherwise documented, all the following incidents about the tempestuous mar-
riage of Maria Thins and Reynier Bolnes are cited from Van Peer's manuscript "Een zeven-
tiende-eeuwse familie geschiedenis," pp. 3–7. Most of the sources for Van Peer's account
are based on depositions made before Notary N. Straffintveldt in Gouda in the period
1639–1646 (Gouda G.A., records of Notary N. Straffintveldt, no. 219–226).

later, she denied ever having seen Reynier with a stick in his hand stand-
ing above his naked wife—admitting only that, on the occasion referred
to, she had noticed the bedding lying in front of the bed. She added that,
in her judgment, "the woman was more at fault than the man." By this
time she was working for Reynier's older sister, also named Cornelia,
who was present when she gave her testimony, and she may have been
inhibited in what she could say about her former employer. Yet it is hard
to believe that, on the solemn occasion of an appearance before the ald-
ermen, she would have assigned the greater part of the blame on Maria if
Maria had been the helpless victim that she claimed to be.

In May 1639 the Bolnes family left De Engel and moved to a house that
had once been occupied by Gouda's most famous stained-glass artist,
Wouter Crabeth.[31] The neighbors were craftspeople: tapestry workers,
tailors, and weavers. In seventeenth-century Holland, it was not at all
unusual for well-heeled burghers—as Reynier Bolnes and Maria Thins
undoubtedly were—to live next door to craftsmen and other much less
well situated individuals. Some of these neighbors, having heard a com-
motion going on in the Bolnes household soon after Reynier and Maria
moved to their new home, made their depositions before the notary at
Maria's request. One of them stated that she had often heard Reynier
Bolnes scream and shout and beat on the wall, not only in the daytime,
but sometimes the whole night long. She could hear the noise as well in
her own house as if she had been right next to it. Whenever this happened,
the members of her family would say, "Hark, Reynier is rumbling again."
She also declared she had never heard such crazy noise or seen such a
queer face, at least not on a man with all his senses. All this was confirmed
by other neighbors, who also complained about Reynier's hopping
around, singing crazy little ditties, and laughing to himself in ways they
had never seen or heard reasonable people do. Bolnes insulted his wife,
threatened her, ordered her to get out the house. Yet Maria "had never
talked back a single word, let alone mistreated him."

In the fall of 1639, Maria's brother Jan Willemsz. Thins came over to
live with his sister for a couple of months.[32] Maria was then sick in bed,
complaining of chest congestion. Jan slept by the hearth in the next room.
There was only a wainscotting between him and the couple's bed. He
heard Maria ask her husband if he would put out a candle that was splut-
tering in a pipe somewhere in the room, saying the smoke and the smell
were oppressing her. Bolnes sprang out of bed, shouting some rude

[31] Doc. no. 153, 7 February 1640.
[32] In 1622 and presumably for some time thereafter, Jan Willemsz. Thins was living with
his cousin Jan Geensz. in a house on the Westhaven (Gouda G.A., "Hoofdgeld register,"
O.A. 2292, fol. 29ᵛ; document communicated by Rob Ruurs). It is not known whether the
two cousins continued to share the same house in the 1630s and 1640s.

words, ran out of the room, and went to sleep with his son Willem. He slept for months in the room above hers, even after she had recovered. From this time on, he no longer wanted to eat his meals with his wife. When the table was served, he would order Willem to take the dishes into the front room and place them on a bench that was fastened to the wall. He would then sit on the bench with his son and eat. If Maria wanted to sit with them, she had to reach from afar or stand up to help herself. Willem left her so little room on the bench that she could hardly eat. One day, as she was about to sit with them, her husband said scornfully, "Away with you, go to the back room." Father and son ate their midday meal alone from then on.

Late one night, in October 1639, Maria arrived quite upset at her sister Cornelia's house, claiming that her husband had beaten her and chased her out of the house. The two women went to Reynier's sister, Cornelia Bolnes, known as Neeltje, to tell her what had happened. Cornelia Thins asked Neeltje whether she remembered how, four years earlier, Reynier had bruised Maria with a pot. Neeltje said she remembered it well. "So," Cornelia went on, "you must go and testify about it with us." But Neeltje demurred. "That isn't going to happen," she said, " I won't testify because he is my brother."

In January of the following year, the next-door neighbors heard shouts at nine o'clock in the evening coming from Bolnes's house. Their maid servant went to see what was going on and found Bolnes ranting at Maria. The neighbors instructed the maid to tell Maria she should come over to their house. When Maria arrived trembling, she said she had been kicked and beaten. The neighbors kept her till later that night. Then they went to Bolnes's house and tried to get in with a key, but he had bolted the door with a piece of wood. Finally, they hit the door so hard and shouted so loud he was forced to take his wife in, which he did with great imprecations. The next day, they heard Maria shout, "Neighbors, help us, my husband wants to murder us." Some carpenters who were working on the house next door and had also heard her cries told Bolnes that the sheriff would come and arrest him. When Maria showed her arm the next morning it was black and blue, as if it had been pinched all over.

A half-year later, the neighbors heard their maid, who was minding a child by the fire in a back room, shout, "Master and mistress, come back here, our neighbor, he is beating Maria Thins something awful." They went to the back of the house. The man called out to Bolnes, "Neighbor, what kind of housekeeping is this? You should be ashamed to live with your wife like that. We and all the neighbors ought to make a complaint against you. This is no neighborly way to behave. It's intolerable to live next to such neighbors. We'll have you put into a house of correction." The neighbor's wife chimed in that she too would help to get him into a

house of correction. Bolnes answered, "Why don't you put your husband in one?" "If he behaved like you," said the neighbor's wife, "that's what would happen to him." Another neighbor stated in his deposition before the notary that he had seen from his window how Reynier hit his wife pitifully as he was trying to pull her back into the house from the court-yard where she was standing. But she wouldn't let him, so he kept hitting her as hard as he could until the neighbors arrived. Still another neighbor reported hearing Maria shout, "Aye me! aye me! oh! oh! and such lam-entations as when a person is severely beaten," and then Maria cried, "Oh, he is kicking me so!" He too had heard another neighbor tell Bolnes that it would be better if they did put him in a house of correction, be-cause he was not worthy of living with honest neighbors. In the eyes of the neighbors, Bolnes was apparently more to blame for disturbing the peace than for the suffering he caused his wife.

The children were not exempt from these scenes. On one occasion, a neighbor reported hearing Maria shout, "Murder, murder, murder, fire, fire, murder, oh, neighbors, murder, murder!" He ran to the fence enclos-ing Bolnes's house and saw Cornelia (Catharina's older sister) with her head sunken down and her hair all disheveled about her shoulders, look-ing very downhearted, and her mother Maria standing there all upset. But Bolnes had gone back into the house before he could speak to him.

Eight days later, Catharina, who was about nine years old at the time, ran to the neighbors shouting, "Come to our house, my father is about to kill my sister Cornelia." Many people heard the commotion and gathered in the street. Some went into Maria's house. Maria implored them, say-ing, "Oh, neighbors, stay with us. Is there no one who will stand by me?" Bolnes, who had heard the noise outside, had gone upstairs. When the neighbors pressed their way in, they saw him coming down the stairs with a prayer book. In his bedroom, he took off his doublet, got on his knees, and started praying aloud. This comportment elicited from Maria the comment that in eighteen years of marriage she had never once seen him do that. When Bolnes was in bed, the neighbors asked him why he had beaten his little daughter. He answered that he had pulled her by the hair, hit her, and dragged her through the house because his wife wanted to beat Willem. "I'll do it again! Whenever she beats my son Willem I'll take it out on Cornelia." Bolnes made sure that his son stayed on his side. He once threatened to pummel him if he obeyed his mother in any way.

In 1640 Maria twice sought to bring an end to the intolerable situation in which she was languishing by requesting a formal "separation of bed and board." Bolnes contested his wife's allegations before the tribunal. According to the affidavit submitted on his behalf to the judges, "Maria outrages every decency in the way she acts, to her own eternal shame and to that of her children and relations, by calumnies and false accusations.

Even more so, Jan Thins, her brother, vents revengeful spite on him the defendant, and in so doing blurts out all that he might better have kept to himself."

Maria's attempts to obtain a legal separation from her husband were not successful at this time. The burgomasters convinced her to try to resume her life in common with Bolnes, who promised to mend his ways. Nevertheless, the brickmaster continued to make Maria's life miserable. He now took all the money out of the house and hid it in the garden house. One day a mason came to do some work in the garden house and found a bag of money next to the bedstead. When Bolnes arrived the mason asked him "Well, Bolnes, are you keeping your money in the garden now? It could well disappear." But Bolnes said that the garden house had a good lock and was safe enough.

When Maria Thins ordered the most necessary household goods in his name, Bolnes ran to all the shops in Gouda to announce that he would not pay anything that his wife had bought. According to a witness, Maria, who came from such a well-to-do and noble family, had to ask her husband for every penny, even to buy sand and yeast to scour the pots and clean the house. But Bolnes said he didn't care if she did it or not. (This indifference to cleanliness surely proved, in the eyes of his Dutch contemporaries, that Bolnes was demented.) When finally she begged him for money for food she had bought on credit, he hit and kicked her furiously and chased her out of the door with a fire tong. Maria fled to her sister's house. This time she left her husband for good.

The next morning after this commotion, between six and seven o'clock, Bolnes took his daughter Catharina by the hand (she was no more than ten years old) and knocked at the house of a tailor's widow. He asked whether she would take the little girl in, explaining that his wife had run away. He charged the woman not to let the child leave until he should come to get her. Later he did come for her and put her up in the garden house where he had kept the money. The widow had been amazed that the girl looked so poor and disheveled, "as if she had been a beggar's child."

Soon after this incident, in April 1641, a certain "Jan Thins" from Gouda bought a house on the Oude Langendijck in Delft.[33] The man who signed the contract for the house was not Maria Thins's brother Jan, but judging by his signature, their cousin Jan Geensz. Thins, or Jan Thins the Elder.

A few months later, another house was sold by Heyndrick Jacobsz. van der Velde, which was said to be next to that of "Johan Tin living in

[33] Doc. no. 160, 20 April 1641.

Gouda."[34] The evidence, summarized in Chapter 8, suggests that the house bought by Jan Geensz. was probably the one where Maria Thins and Johannes Vermeer were to live many years later. A part of the "Papists' Corner," it may have been bought by Jan Geensz. to provide space for the Jesuit church or school or to generate rental income for the Jesuit mission in Delft. It is very doubtful, in any case, that Jan Geensz. ever came to live there.

About this time, the rancor and bitterness that were tearing Catharina's parents apart spread to other members of the two families. In 1637 Maria's brother Jan was pitted against Reynier Bolnes in a suit concerning an undisclosed issue. After a number of unsuccessful efforts to arbitrate the dispute, the two men promised they would abide by the ruling of the arbiters. In the summer of 1641, Pouwels Bolnes, who had been a witness to his brother Reynier's marriage contract with Maria nineteen years earlier, got into a fight with her brother Jan Willemsz. Thins.

The encounter precipitated an avalanche of depositions.[35] According to witnesses, Pouwels Bolnes, a fat, white-haired man who was then in his fifties, met Jan Willemsz. Thins near the Sluice Bridge in Gouda, threw off his coat, and gave him a blow on the head, apparently with his fist. Jan's head, according to a witness, resonated like a hollow bowl. The blow left him stunned. At some point, both had knives in their hands. Later Jan Willemsz. had a surgeon testify that the wounds in his head and hand were so long and narrow they must have been made with a knife or similar instrument. It was impossible that they had been made with a fist.

The sequel of the dispute is not known. We have only the deposition on Jan's side to apportion blame in the affair. But an incident that occurred some years earlier, in which someone apparently mistook the sheath of Jan's knife for a pipe that the person attempted to grab and cut himself, took place under circumstances—drinking in a tavern, smoking tobacco, walking in the street with loose girls—that are hardly suggestive of Jan's stern rectitude and high moral character.[36]

By the time of the altercation between Jan Willemsz. Thins and Pouwels Bolnes in 1641, Maria had become convinced that her marriage could no longer be patched up. She again applied to the authorities for a legal separation. This time the aldermen approved her request. In November 1641 she was awarded custody of her daughters Cornelia and Catharina. Willem was assigned to his father. The aldermen ordered Bolnes

[34] Doc. no. 166, 23 November 1641.
[35] Document nos. 162, 163, and 164, of 16, 17, and 24 August 1641.
[36] Jan Willemsz. Thins had been vested with the responsibility, jointly with Cornelis't Jallis, of supervising the yearly distribution of clothing to the poor from the legacy of Diewertje Hendricks van Hensbeeck. In November 1625, the Gouda magistrates dismissed him owing to "his intolerable behavior and turbulence" (Matthijs, *De takken*, p. 42).

to draw up a sworn inventory of the goods the couple possessed in common, not including the clothing Maria and her daughters possessed.[37]

The sentence also enjoined him to pay his estranged wife twenty-four guilders a week pending the division of their possessions. This allowance was barely adequate for a woman and two children to live on according to the standard to which they were accustomed, even though it amounted to about four times the wage of an ordinary carpenter or mason.

Soon afterward, Maria's attorney went to collect the clothes that were coming to her. Bolnes delivered a whole collection of satin and velvet skirts, bodices, petticoats, mantles, jackets and muffs, together with a coffer and a chest. A couple of days later a pair of shoes, embroidered mules, and a Jesuit book of devotions by Father Canisius were dispatched to Cornelia's home. Maria's best clothes, including a black-cloth skirt, a pleated ruff, three caps, and some garments trimmed with lace, all fine and new, were still missing. She only got those back after her attorney made a formal protest.

The division of the property owned in common by Maria and Bolnes was complicated by the fact that siblings Jan and Cornelia were joint heirs with Maria of the goods left by their parents. These goods were all located in the family house De Engel, still occupied by Bolnes. An accounting of the division of these jointly possessed objects has come down to us.[38] It is of great importance for the list of paintings it contained, some of which were later transferred to Maria's home in Delft and were known to Vermeer. Two of them almost certainly appeared in the background of Vermeer's own paintings. "A painting wherein a procuress points to the hand" was apparently Dirck van Baburen's *Procuress*, a version of which now hangs in Boston's Museum of Fine Arts (Fig. 21). It is seen hanging on the wall of *The Concert* (Fig. 36) and of the *Lady Seated at the Virginals* (Fig. 50). The Baburen picture was painted in 1622, the year of Maria Thins's marriage with Bolnes. "A painting of one who sucks the breast," probably a "Roman Charity" or "The Story of Cimon and Pero," appears on the wall of the *Music Lesson* (Fig. 48). (Pero, the daughter of Cimon, suckled her imprisoned father who had been condemned to die by starvation.)

Other pictures that belonged to the Thins family included:

a portrait of Dirck Cornelisz. van Hensbeeck, Maria's great-great-grandfather who had given the stained-glass window to St. Jan's in Gouda in 1561
"A Trumpet Player"
"A Flute Player"

[37] Doc. no. 165, 16 November 1641.
[38] Doc. no. 167, 27 November 1641.

"A Landscape Wherein Someone Looks in the Hand" (a fortune
 teller)
"A Homo Bulla," possibly a man blowing bubbles, symbolizing the
 evanescence of life
"A Man Being Flayed" (Marsyas flayed by Apollo), and
"One Who Decries the World," perhaps a picture of Heraclitus, the
 weeping philosopher of mediaeval legend.

With the exception of the portrait, all the paintings mentioned so far
represented typical Utrecht School subjects. Only one painting, "A Win-
ter Scene with People Skating," might have been executed in Amsterdam,
Kampen, or Haarlem. Two-thirds of the items in the inventory were as-
signed to Jan Willemsz. Thins by the arbiters appointed by the aldermen.
Its entire contents were presumably inherited by Maria after the deaths
of her brother Jan in 1651 and her sister Cornelia in 1661.

Shortly after her formal separation from Bolnes, Maria left for Delft,
together with her daughters. Her brother Jan may have gone with them
or joined them later. We do not know where the family was lodged. The
only known fact about Maria's life in this period is that according to a
deposition that will presently be discussed, she and her brother Jan were
neighbors of a woman whose house was located in the Vlamingstraat in
1647.

Maria Thins maintained close ties with Gouda in the 1640s. Her hus-
band regularly paid her alimony into the hands of Cornelia Thins, who
still resided in Gouda. Maria from time to time traveled to the town on
the Gouwe River to pick up the money. Toward the beginning of 1643,
she visited Gouda on a sadder errand. Her daughter Cornelia had just
died, and she had her body shipped by boat to the place of her birth so
that it would be interred in the family grave in the Church of St. Jan.
Bolnes elected not to appear at his daughter's burial; he also forbade his
son to go.

As far as we know, Jan Geensz. Thins, who had bought the house on
the Oude Langendijck in Delft, was still living in Gouda in 1644 when his
wife Cunera Splinters died. In his second testament, dated March 20,
1644, he left his daughter Clementia, who had married Jacob van Rosen-
dael, 1,600 guilders in addition to her legitimate share, which amounted
to 6,000 guilders. He made over to his other daughter Lucia, in addition
to her legitimate share, a painting of the nativity by Abraham Bloemaert
and a drawing by Johan Wierinx.[39]

Two years later, when he was already sixty-six years old, Jan Geensz.
remarried. The bride, Susanna van de Bogaert, was the widow, first, of
Adriaen de Roy, counselor to the Admiralty in Zeeland, and second, of

[39] Doc. no. 180, 20 March 1644.

Gerard van Lanschot, a former treasurer of the city of Leyden. With a trembling hand, the aged Abraham Bloemaert signed as next-of-kin the contract for Susanna's third marriage with Jan Geensz. Thins. Bloemaert's second wife, Gerarda de Roy, the mother of the artists Frederick, Hendrick, and Cornelis Bloemaert, was the sister of Adriaen de Roy, the bride's second husband.[40] Two months later, Jan Geensz.'s daughter Clementia Thins, and her husband Jacob van Rosendael declared that they were satisfied with the goods they had inherited from the estate of Cunera Splinters, their mother and mother-in-law.[41]

On June 30, 1647 Jan Geensz. gave his cousin Jan Willemsz. Thins power of attorney to collect money from Bergen-op-Zoom.[42] The next day, sick in bed, he made his third testament, leaving the entire surplus beyond the legitimate shares to which his daughters Lucia and Clementia were entitled to the children of Clementia. Clementia was to enjoy the usufruct of the bequests until the marriage of her children.[43] These children, named Aleydis Magdalena and Cornelia Clementia, would become very close to Maria Thins and to Vermeer and his wife Catharina. These devoutly Catholic women helped to bring up the artist's children and grandchildren after his death.

Jan Geensz. died on July 13 and was buried in the Church of St. Jan in Gouda. The amount given on his behalf to the church for the pealing of the bells on July 22—twenty-six guilders—was extraordinarily high, as befitted such a wealthy man.[44] His daughter Clementia died a year later. A good deal of Jan Geensz.'s money must have been passed on to Clementia's daughters. It is not known who inherited Lucia's possessions, including possibly the Bloemaert painting and the Wierinx drawing mentioned in the 1644 testament.

In the mid-1640s, Maria's relations with her estranged husband Reynier and her son Willem continued to fester. Once, when she went to see her sister Cornelia in Gouda to collect her alimony, she asked that Willem be present. But Bolnes would not let him see his mother. In 1646, he accused Maria's sister Cornelia of trying to pull his son over to her side. "But you won't get him," he assured her. Cornelia said, "I am not trying to pull your son over to my side; we have enough of your daughter. But I wish that you'd bring him up better and that from time to time he would see his mother. It is a pity for his mother that she has to leave town without his even speaking to her once."

After some years, Bolnes, whose brick business was doing poorly, found the burden of paying Maria's alimony too heavy. He petitioned the

[40] Doc. no. 188, 30 September 1646.
[41] Doc. no. 189, 3 November 1646.
[42] Gouda G.A., records of Notary N. Straffintveldt, no. 227, fol. 231, 30 June 1647.
[43] Doc. no. 198, 1 July 1647.
[44] Doc. no. 200, 13 and 22 July 1647.

aldermen and received permission to reduce it. It fell into arrears anyway. In 1646, another brickmaker in Gouda informed Cornelia Thins that Bolnes was in debt to the extent of about eight thousand guilders and that his business was about to fold. Cornelia talked to Bolnes's brother Jan Cornelisz. about it, but he refused to interfere, saying, "I know that he is incapable of managing his affairs, but I will have nothing to do with him. He won't take advice."[45]

Jan Willemsz. Thins decided to hold a family council. An invitation was dispatched to Maria in Delft. She was to come to Cornelia's house along with her estranged husband. Jan started by asking Bolnes how much his goods, which had been evaluated at some twenty thousand guilders seven or eight years before, were now worth. Bolnes answered that he possessed a brickmaking place valued at nine thousand guilders, some land, a house, and two bonds worth one hundred guilders each. Altogether his assets might amount to eleven or twelve thousand guilders. When he was pressed about where the rest of the money had gone, he replied, "I don't know. It isn't there. This is the only accounting I can give."[46] Jan suggested that the judgment of the aldermen should now be fully carried out and that the goods held in common by Bolnes and Maria Thins should be divided on the basis of the value they had at the time when the judgment had been rendered in 1641.

Bolnes refused. Before appealing the aldermen's judgment before the Court of Holland, he gathered depositions that he might use for his suit. In January 1647 his son Willem, acting on his behalf, induced a sheriff, a brickmaker, and a sworn master of brickmaking to swear that Reynier was conducting his brick business "zealously and honestly." He had lost money hiring people whom he did not have the heart to dismiss, because they could not get work elsewhere.[47] At this time he was in Delft, staying at the inn of a fellow Catholic, Johan de Coorde, on the Oude Langendijck. There he consulted with two well-known notaries and elicited from them a deposition about "Jan Thins and his sister" (almost certainly Maria).[48] The notaries had gone to the house of Dorothea Michiels on the Vlamingstraat and heard from her that Jan Thins, who was living next door to her, was "keeping a very bad house" with his sister. The sister in question had told her that she had packed her belongings the preceding week because she had been mistreated by her brother and was resolved to leave.

It is not known when (or why) Jan Thins the Younger moved from Gouda to Delft, where he was to spend the rest of his life. This hearsay evidence is the only hint we have that Maria had difficulty getting along

[45] Doc. no. 191, 21 November 1646.
[46] Ibid.
[47] Doc. no. 192, 6 January 1647.
[48] Doc. no. 193, 15 January 1647.

not only with her husband and son but also with her brother. The fact
that she inherited Jan's possessions suggests the rift could not have been
all that great.

Bolnes now petitioned the Court of Holland and West Friesland for an
annulment of the aldermen's sentence. In his petition he claimed that he
had comported himself throughout his marriage in an honest manner,
that he had been a good father, but that his wife, who should have be-
haved in the same way, had been diverted from her Christian duty by
quarrel-mongers and malicious persons who had incited her against him.
She had left her conjugal domicile along with her two daughters and re-
fused to return home despite his frequent entreaties. Maria Thins brought
her affidavits to the court on December 27. The judge turned back
Bolnes's suit, condemned him to pay court costs, and confirmed the judg-
ment of the aldermen.[49]

Shortly after the sentence, Willem Bolnes came across his mother in the
street in Gouda. As a witness later related the incident, "He, Willem, with
great irreverence turned his arse toward her (excuse the expression), say-
ing 'That's what you get for it,' referring to the sentence of the Court of
Holland against Reynier Bolnes." Willem then went around bragging
about what he had done. Maria Thins confirmed to her brother Jan that
this had actually happened and that she had been very despondent about
it.[50]

It was not until March 1649 that Maria Thins came into possession of
all the assets coming to her, which amounted to 15,606 guilders.[51] She
had apparently received much more than half of her husband's posses-
sions as of that date. Bolnes had perhaps understated his assets in 1647,
or there may have been some goods belonging to Maria that had been in
Bolnes's custody since before their separation. This sum, sizable as it was,
would have only earned her 750 guilders per year at the common interest
of 5 percent, considerably less than her initial weekly alimony of 24 guild-
ers. She lived either on the capital or on the other assets of her own to
stretch out her income before she received inheritances from her siblings
Jan and Cornelia.

Anyone might have thought that once the court had made its final ad-
judication and Maria Thins had received her money, her long-standing
dispute with her husband would have come to an end. The brickmaking
establishment had been sold.[52] Indeed, as of June 15, 1649, Maria had

[49] Doc. no. 205, 15 February 1648; and The Hague, Algemeen Rijksarchief, "Civile sen-
tentiën," Hof van Holland, no. 751 (20 December 1647), cited in Van Peer, "Een zeven-
tiende-eeuwse familie geschiedenis," p. 17.

[50] Doc. no. 222, 15 July 1649. See also doc no. 214, 12 May 1649.

[51] Van Peer, "Een zeventiene-eeuwse familie geschiedenis," p. 18.

[52] Doc. no. 212, 5 January 1649.

annulled the power of attorney she had given to her brother Jan to act on her behalf because, she explained, there was no point in inconveniencing him since her affair with Bolnes was settled.[53] But less than a month later, she reappeared in Gouda before her notary, alleging that Bolnes had cheated her.[54] All the papers were with her brother Jan, who knew the case best, and she was therefore compelled to renew her procuration. Jan, "out of brotherly affection," could be expected to defend her interests "for years" if necessary. The tension quickly subsided. Nothing more was heard about Bolnes's attempt to cheat his wife.

Curiously enough, at least one relative had thought the break between Maria and her husband was not irremediable. In his will of April 4, 1650, Jan Cornelisz. Bolnes had left his brother, Reynier Bolnes, the revenue and usufruct of a house on the Peperstraet plus three morgen of land.[55] The assets themselves he had willed to Reynier's son Willem, who would be entitled to them when he came of age or got married. Not a penny of course had been earmarked for Catharina or Cornelia, the children on "the other side." Indeed, he barred them from any possibility of inheriting his money via Willem by stipulating that if Willem died without issue (in which case Catharina and Cornelia would have been next in line), the estate would revert to his collateral relatives. These would presumably be his brother Pouwels, his sister Cornelia ("Neeltje"), and their children. But he stipulated an extraordinary clause: that if the wife of Reynier Bolnes, within three months after his (Jan Bolnes's) death, were to resume sharing the bed and board of her husband, from whom she was presently separated, then—but not otherwise—Reynier Bolnes would stand to receive, in addition to the aforesaid revenues and usufruct, all Jan's household goods plus the usufruct of seven morgen of wooded lands. This usufruct, he allowed, could also be enjoyed by Reynier Bolnes's wife. Jan Bolnes died a few years after making his testament. Needless to say, his last-ditch effort at bringing Catharina's parents together came to nothing.

Neeltje Bolnes, Reynier's sister, who by this time was the widow of Claes Cornelisz. van Hensbeeck, bequeathed a part of her estate to Maria Thins's son Willem. Because her will did not bar Catharina from inheriting from her brother, some money from Neeltje's estate eventually passed on to Vermeer's wife.

According to the burial registers of St. Jan's Church in Gouda, "Jan Thins the Younger, bachelor, coming from Delft," was buried on July 6, 1651.[56] This was clearly Maria's brother, Jan Willemsz. It is most unfortunate that his testament has not come to light, because it may have con-

[53] Doc. no. 217, 15 June 1649.
[54] Doc. no. 220, 10 July 1649.
[55] Doc. no. 227, 4 April 1650.
[56] Doc. no. 233, 6 July 1651.

tained a clause concerning Catharina's inheritance that was of critical im-
portance for the young woman who married Johannes Vermeer two years
later. (More will be said on this in the next chapter.) We only know for
sure that Jan Willemsz. Thins left the bulk of his possessions to his sisters
Cornelia and Maria.

Five months after the death of Jan Willemsz., the tenants of lands in
Oud Beijerland, where some of the properties owned by the Thins family
were located, sent a notary to confer with Maria and Cornelia Thins,
"heirs of the late Jan Thins."[57] The notary betook himself to the house
"by the Brabant Peat Market where Jan Thins had lived and died" and
asked Maria (Cornelia being absent) whether she, as heir to the land, had
come to an agreement with Reynier Bolnes regarding their disposition,
since Bolnes was authorized to rent the lands out but not to sell them.
Maria stated that she had indeed come to such an agreement.

If Maria's brother had left his house just a few days before his death to
die in Gouda, the notary was not too far off the mark when he asserted
that the late Thins had "lived and died" in Delft. (But then again he may
have died in Delft, and his body may have been shipped to Gouda.) The
address "by the Brabant Peat Market" also raises a problem. The home
bought by Jan Geensz. Thins was on the Oude Langendijck. It was situ-
ated at the corner of the Molenpoort, a narrow alley between the Oude
Langendijck and the Burgwal, which itself was an extension of the Bra-
bant Peat Market.

The houses on the Oude Langendijck were sometimes said to be "next
to the Market" or "behind the Market," (meaning the Great Market
Square, faced by the Town Hall and New Church). But they were never
located by reference to the Peat Market, at the other end of the Molen-
poort. If Maria and Cornelia Thins were not inhabiting the house on the
Oude Langendijck at this point, they were probaby renting premises on
the Burgwal (perhaps from Adriaen Pietersz. Vrem, one of the pillars of
the Catholic Community, who lived at the corner of the Burgwal and the
Molenpoort and whose house was leased for the benefit of the Jesuit mis-
sion).[58]

In the early 1650s, Reynier Bolnes's affairs continued to go downhill.
In March 1653, a month before Catharina's marriage to Johannes Ver-
meer, he declared before the aldermen that he was incapable of paying his
property taxes in Gouda because he had "no worldly possessions and
now lived at the expense of his brother and sister, as their worships were
well aware."[59]

 [57] Doc. no. 238, 12 November 1651.
 [58] F. van Hoeck, "De jezuïeten-statie te Delft, 1592–1709–1771," *Haarlemsche bijdragen*
6 (1948): 444.
 [59] Swillens, *Johannes Vermeer*, p. 196.

A YOUNG ARTIST IN DELFT

The fledgling painter Johannes Vermeer and his young bride Catharina formed a most unusual couple when they were married in April 1653. All the men in Vermeer's family had been master craftsmen. Catharina's ancestors had inherited wealth; her father had owned an important brick-making establishment. Vermeer was of Reformed background; Catharina had grown up in a devoutly Catholic milieu. Such mixed marriages were rare in mid-seventeenth-century Delft. His family, to all appearances, was tied by bonds of trust and affection; hers was rent by quarrels that frequently issued in blows. She suffered her father's abuse and once went about "looking like a beggar's child."

Vermeer's conversion to Roman Catholicism presumably happened between the couple's betrothal and their wedding in Schipluy. Conversion to Catholicism was a momentous step. Catholics in Delft, where the overwhelming majority of the population appears to have been Protestant, [1] were more harassed than in Gouda. There were only two hidden churches here: the Jesuit church on the Oude Langendijck next door to Maria Thins (Fig. 32) and a secular church—one that did not belong to any order—near the Oude Delft Canal. This secular church was attached to a beguinage ("begijnhof"). The secular priests at the begijnhof were permeated by Jansenist doctrines that were more compatible with Protestant tenets than were those taught by the Jesuits. Doctrinal differences gave rise to mutual animosity. This split within the Catholic Church brought it into discredit, even among the more liberally inclined patricians and burghers of Delft. [2]

Although the municipal authorities, under the pressure of Reformed ministers, frequently issued regulations that made life difficult for the Catholics, their policy of repression was mitigated by political and economic considerations. On the one hand, many patrician families to which the magistrates belonged were divided along confessional lines and included individuals or whole branches that had remained loyal to the old religion. (The Camerling family, into which Maria Thins's mother had married after her first husband's death, was a typical instance.) On the

[1] From 1681 to 1685, the first period for which the preserved records of the Catholic Church appear to be complete, Catholic baptisms represented a fifth of Reformed baptisms in Delft (Jan Rogier, "De betekenis van de terugkeer van de minderbroeders te Delft in 1709," *Archief voor de geschiedenis van de Katholieke Kerk in Nederland* 2 [1960]: 202–203).

[2] Rogier, "De betekenis," pp. 182–83.

other hand, many Catholics were prominent in business and industry, and the prosperity of the town, of which the city fathers were very mindful, required that they, and their religious convictions, should be treated with some civility.[3]

Many of the most successful faienciers, including Willem Cleffius, the maker of the first red-clay teapots,[4] were Catholic. And even if the magistrates had wanted to be severely repressive, they would have found it difficult to carry out their edicts, as they themselves complained in January 1643:

> Despite the edicts against the adherents of the Pope and their allies, which have been many times reissued, we find that, instead of obeying the same, they have increased in boldness and not only continue their gatherings but also in great numbers come to other people [i.e., to proselytize], as if there were no edicts, and have bought house after house, which they have made their own for this purpose, which have entrances in the dividing walls such that they cannot be disrupted successfully.[5]

One important reason for all this weakness was that the sheriff and other representatives of the municipal authorities were regularly bribed to make sure that the edicts would not be enforced too zealously. The regularity with which this "protection money" was paid suggests that the practice was quasi-official.[6] It is also worthy of note that Catholic priests were normally registered with the city authorities when they took up their functions. In principle, only secular priests were supposed to be officially admitted, but some Jesuits are known to have passed themselves off as secular priests, probably with the connivance of the magistrates.[7]

The hostility of Delft Protestants toward Roman Catholics seems to

[3] These two points are convincingly argued in H. E. van Berckel, "Priesters te Delft en Delfshaven 1646–1696," *Bijdragen voor de geschiedenis van het Bisdom van Haarlem* 25 (1900): 260–62.

[4] A daughter, Margarita, of Catharina van der Wiel and Lambertus Cleffius, the son of Willem Cleffius, was baptized in the Jesuit church on 31 October 1673 (Delft G.A., records of the St. Joseph Kerk). Catharina van der Wiel was the daughter of Maria Gerrits van der Wiel, the half-sister of Maria Thins.

[5] Van Berckel, "Priesters te Delft," pp. 250–51.

[6] This "protection money" in the 1690s amounted to nine hundred guilders from the begijnhof church and seven hundred guilders from the (Jesuit) church "behind the market." The total in earlier years was said to be "2,000 to 2,200 guilders" (Van Berckel, "Priesters te Delft," p. 256). In a notarial deposition, the Catholic acolytes who had bribed a substitute sheriff complained that he had not kept his word to allow gatherings of the faithful in the countryside around Delft for a full year and that he threatened to stop them if they did not give him a certain quantity of butter above his regular gratuities (Delft G.A., records of Notary C. van Bleiswijck, no. 1901, 28 July 1649).

[7] Van Berckel, "Priesters te Delft," p. 230. Balthasar van der Beek (Beke), a Jesuit, was officially admitted as "wereltlijck priester" (secular priest) on 10 August 1663 (ibid., p. 237). See also Chapter 10 at note 37.

have reached a peak in the first half of the 1640s. Fabio Chigi, the papal nuncio in Cologne, reported to Cardinal Barberini in Rome in January 1645 that the Catholics had suffered so much insolence on the part of the heretics in Delft that they had applied to the city authorities for redress. Even though a magistrate had prohibited the violent disruptions of Catholic gatherings and "similar insults," subject to heavy penalties including corporal punishment, "the people continued to invent new pretexts against the Catholics."[8] The pressure on the magistrate was apparently so strong that he resolved to prohibit the officially tolerated residence of priests in Delft. He must have abandoned his attempt or relented, considering that priests continued to be admitted by the city authorities and to serve the two churches in the 1650s and thereafter.[9] Many of the town's Calvinist folk, however, would have gone along with the Protestant woman who urged that the authorities should deal with the Catholics "as they did in England" (under Cromwell's rule). This remark was reported by the wife of the art dealer Abraham de Coge, at whose house a meeting of Catholics had been disrupted.[10]

Even though the tension between Protestants and Catholics abated in the 1650s and 1660s, papists continued to be harassed and discriminated against. Living among themselves in the Papists' Corner ("Paepenhoek"), Catholics may have felt more protected than hedged in. In any case they were under no obligation to live there, and many chose not to, including Abraham de Coge, who resided on the Market Square.

Although we cannot be sure precisely where Maria Thins lived in the years following Catharina's marriage to Johannes Vermeer, we can assert with some confidence that she made her home in the Paepenhoek, either on the Oude Langendijck, "on" (or near) the Market Square, as the clerk had specified at the time Catharina's marriage was registered in April 1653, or in the house abutting the Peat Market that Maria and Cornelia Thins occupied in 1651. This still leaves open the question whether Vermeer and his new bride went to live in Maria Thins's house in the first years of their marriage. There is no proof that they joined Maria Thins's household before December 1660, when a child of "Johannes Vermeer on the Oude Langendijck" was buried in the Old Church.[11] Did they live in Mechelen for the first few years of their married life? Would Vermeer's patrician mother-in-law have allowed her daughter to dwell in as plebeian a place as an inn?

[8] J.D.M. Cornelissen. *Romeinsche bronnen voor den kerkelijken toestand der Nederlanden onder de Apostolische Vicarissen 1592–1729*, Rijksgeschiedkundige Publicatiën, no. 77, 2 vols. (The Hague: Martinus Nijhoff, 1932), 1: 701, 704.
[9] Ibid., 2: 69, and Van Berckel, "Priesters te Delft," pp. 232–49.
[10] Delft G.A., records of Notary J. Spoors, no. 1673, 3 August 1643.
[11] Doc. no. 279, 27 December 1660.

Given Vermeer's conversion to Catholicism, it would have been natural for him to settle in the Papists' Corner. The inn Mechelen, in the shadow of the New Church, frequented chiefly by Protestants, was not a good place to bring up children in the Catholic faith. Yet, in view of Maria's initial opposition to the marriage and of Vermeer's evident penury in the first two or three years of his life with Catharina—he could not pay his full entry fee to the guild in December 1653 and delayed completing his payment until July 1656—it is hard to believe that he had become a fully accepted member of the Thins household in this early period. The young couple perhaps rented rooms somewhere, until such time as they were invited to settle in the house on the Oude Langendijck.

The visual evidence from Vermeer's first paintings—those that were probably executed between 1653 and 1656—does not help us conclude anything very definite about his domicile. To be sure, *Christ in the House of Martha and Mary* (Fig. 14) is set in a modest interior, more like the hall of an inn than the marble-floored house of Maria Thins. But even if Vermeer had moved to the house on the Oude Langendijck, he might have visited or even kept an atelier in the family inn, which his widowed mother continued to own for many years. He could also have introduced elements of Mechelen into his paintings from memory. In the early to mid-1650s, genre painters such as Gabriel Metsu and Pieter de Hooch were still setting their figures in relatively humble interiors. Later, like Vermeer himself, they began to depict more elegant scenes. There is no ground for the supposition that a change in their personal circumstances accompanied the change in the settings they represented.

Whatever may have been Maria's motive for her failure to give formal permission for the marriage, there are clear indications that in subsequent years she became more favorably inclined toward her son-in-law. By 1656 she had already advanced three hundred guilders—a considerable sum of money—to Catharina and Johannes, which loan, according to her testament of June 1657, she was willing to forgive in the event of her death. The testament reveals the existence of the Vermeers' first child Maria, named after her godmother Maria Thins—another indication that there was no serious rift between the young artist and his mother-in-law by this time.[12]

Maria traveled to Gouda to dictate this testament, the first of six she was eventually to make. Besides forgiving money she had advanced to Catharina or her husband, she left her daughter her clothes ("linen as well as wool"), the linen chest she had inherited from her brother Jan, and "all the silverwork that Catharina has already gotten from her," including a silver underbelt and a key belt, together with her rings, bracelets, and

[12] Doc. no. 268, 18 June 1657.

YOUNG ARTIST IN DELFT

gilded chains. She bequeathed to her godchild Maria Vermeer, the daughter of Catharina, two hundred guilders. The only specific bequest she made for her son Willem was the bed whereon she slept, with two pairs of sheets, two bolsters, two blankets, and a bed cover.

All her other movable assets, including any silverwork she had not specifically allotted to Catharina, were bequeathed in equal portions to Willem and Catharina. As to her "unmovable goods"—her real estate and financial assets—Willem and Catharina were first to inherit their "legitimate portions," equal to one-sixth of the estate. The rest was to be divided half and half between the grandchild or grandchildren of Willem and Catharina. Thus only the rents and interests of the assets in excess of the legitimate portions were to accrue to Willem and Catharina during their lifetimes.

The three hundred guilders that Maria had lent to Catharina and Johannes in 1656 must have come in very handy. It made it possible for Vermeer to pay the remaining part of his guild entrance fee, outstanding since December 1653.

The only direct evidence of Vermeer's presence in Delft for the entire period from his entry into the guild on December 29, 1653, to the burial of one of his children seven years later consists of four notarial documents. In the first, dated January 10, 1654, thus less than two weeks after he had become a master in the guild, he appeared in the house of the widow of the former estate-auction master Joost Pietersz. Wout.[13] On this occasion she acknowledged a debt of five hundred guilders for various goods she had bought from the estate of a wealthy burgher named Govert Pietersz. Knol. "Johannis Vermeer master painter" signed as witness, together with a captain from the Land of Cleves named Lambertus Morleth. The notary, Adriaen Vrijenbergh, was most probably Roman Catholic.

Vermeer's presence in the house of an auctioneer of estates gives rise to speculation. The widow of the auction master may well have had pictures left over from her late husband's auction sales that for one reason or another were of interest to the young artist. The presence of Captain Morleth as a fellow witness may also be significant. We have seen that, in the previous year, Vermeer had appeared in documents with two captains (Van den Bosch and Melling) as well as with his own uncle, Lieutenant Balthens. That he should have been associated with military persons in all four of the first notarial documents mentioning his name that have come down to us can hardly be fortuitous. I suspect that Reynier Balthens and Tobias Bres were the key links in a network of Vermeer's military

[13] Doc. no. 258, 10 January 1654.

acquaintances. The presence of the officer[14] in *The Officer and the Laughing Girl* (Fig. 15), which is generally thought to have been painted around 1657, may be a reflection of Vermeer's interest in and familiarity with military personnel at this point in his life.

The next document seems perfectly routine. At the end of April 1654, Vermeer and Notary Govert Rota signed as witnesses for a debt acknowledgment by a carpenter to a food merchant. This time he was not even designated by the notary as a master painter.[15]

The third document, which Bredius discovered a century ago, is dated December 14, 1655. On this day "Sr Johannes Reijnijersz. Vermeer master painter," and his wife "Juffr. Catharina Bollenes" appeared before Notary Rota to guarantee a debt for 250 guilders that the artist's father had contracted, back in 1648, from yet another captain, Johan van Santen.[16] Nine years later interest on this debt was still being paid—by Digna Baltens or by Vermeer—to the heirs of another individual who had acquired the obligation.[17] The "Sr" (signior or seigneur) preceding Vermeer's name is a sure sign of the artist's rise in social status. It will be recalled that his father was never dignified with Sr, Mr, or any other title in the numerous extant documents in which he appeared.

Johan van Santen, as already noted, was the brother of the playwright, poet, and military officer Gerrit van Santen. Whereas Gerrit was a captain in the States' army, Johan seems to have been a captain in Delft's civil militia.

The last of the four documents is by far the most informative and important. On November 30, 1657, "Johannis Reynierszoon Vermeer" and Catharina Bolnes contracted a loan of two hundred guilders, repayable within one year at 4 ½ percent interest, from Pieter Claesz. van Ruijven.[18] This gentleman was the father of Magdalena Pieters van Ruijven, who later married Jacobus Abrahamsz. Dissius, the owner of the printing press "The Golden ABC" on the Market Square and the owner of twenty Vermeers at the time of his wife's death in 1682. It is likely, as I shall show in Chapter 13, that Pieter Claesz. had bought some of the Vermeers in Dissius's collection, including the picture called "A Drunken Sleeping Maid" in the Dissius sale of 1696.[19] This painting is probably identical

[14] The man with a hat in *The Officer and the Laughing Girl* has been called an officer because he wears a broad ribbon (sash or scarf) of the kind often worn by captains, lieutenants, and sergeants of the militia. Each quarter of the city had its own colored sash. On the other hand, Swillens claims that the sash was "not only a military distinction" and was also worn by ordinary citizens (*Johannes Vermeer*, p. 89).

[15] Doc. no. 259, 30 April 1654.

[16] Doc. no. 262, 14 December 1655.

[17] Doc. no. 299, 14 December 1664.

[18] Doc. no. 271, 30 November 1657.

[19] The Dissius–Van Ruijven connection is discussed in Chapter 13. See documents nos. 417, 420, and, for the Amsterdam sale, 440.

with the *Girl Asleep at a Table* (Fig. 25), which is generally dated a year or so after *The Procuress* (Fig. 20) of 1656. If Pieter Claesz. was a client of Vermeer as early as 1657, it is at least conceivable that the two hundred guilders the painter borrowed—at an unusually low rate of interest—was actually an advance on the future purchase of one or more paintings.

I already argued in Chapter 6 that the co-responsibility of Catharina Bolnes for repaying the loan implied that she was keeping her property, including any assets that she might inherit, separate from her husband's. It was clearly in the lender's interest to involve Catharina. She may have tried to limit her responsibility by having the words "for as much as the following may concern her" inserted after her name as a co-debtor was cited. But these words were crossed out in the contract, probably at Van Ruijven's request, so that she would have no pretext for refusing to reimburse the loan from her own assets in case her husband died or otherwise failed to come up with the money (or the paintings) a year hence.

In the next four years, from November 1657 to December 1661, when Vermeer guaranteed a loan on behalf of an acquaintance, not a trace of him can be found in Delft's notarial archives. This absence, in contrast to his father's frequent appearances as participant or witness in notarial documents, makes it seem as if he wished to withdraw from civil society, perhaps because he was engrossed in his work or because he had joined a religious minority subject to prejudice and discrimination.

We now pick up the thread of Vermeer's professional life, starting with his entry in St. Luke's Guild on December 29, 1653. He delivered his down payment of one and a half guilders, out of six guilders that he owed as a Delft-born citizen—"foreigners" paid double this normal fee—to the officers or syndics of the guild, called "headmen" in Delft. There were six headmen in all: two painters, two glassmakers, and two faiencemakers, each serving two years. On St. Luke's Day, October 18, the guild members nominated two candidates for each vacant post. The burgomasters and aldermen of the town then made the final selection from these nominees before the end of the year. In 1652, Abram Vromans and Anthony Palamedes were the two painters on the board of headmen. Abram Vromans, like his brother Pieter, was probably an imitator, if not a pupil, of Bramer. Palamedes was a leading specialist in genre painting and the best portrait painter since the death of Miereveld in 1641.[20]

Besides the headmen-painters, Vermeer had plenty of other talented colleagues with whom he could talk shop and exchange ideas. Among those whose paintings are known today, there were his old acquaintances Leonaert Bramer and Evert van Aelst; Carel Fabritius, who had arrived

[20] For the regulations of the Guild of St. Luke in Delft, see Montias, *Artists and Artisans*, Ch. 3; for the headmen of 1653, see F.D.O. Obreen, *Archief voor Nederlandsche Kunstge-schiedenis*, 7 vols. (Rotterdam: Van Hengel en Eeltjes, 1877–1890) 1: 54–55.

in Delft the previous year; the still-life painters Herman and Pieter Steen-
wijck; the church painters Gerard Houckgeest and Hendrick van Vliet;
the flower painter Balthasar van der Ast; the landscape painters Jan
Songe, Daniel Vosmaer, and Louis Elsevier; the seascape painters Herman
Witmont and Niclaes Vosmaer; Hendrick van der Burch, a genre painter
who became a follower of Pieter de Hooch; and Egbert van der Poel, who
specialized in barn scenes and outdoor views with inns and other build-
ings. Vermeer had probably met a number of them before, including Pie-
ter Steenwijck, Balthasar van der Ast, and Egbert van der Poel, whom his
father had known in connection with his picture business.

There were three other important artists, residents of neighboring
towns, with whom Vermeer may have become acquainted in his forma-
tive years. Paulus Potter, the distinguished animal painter, had actually
joined the guild in Delft in 1646 but left little or no other trace in the city
except for the paintings that are attributed to him in contemporary col-
lections. He lived in The Hague from 1649 to 1651; by 1653 he had al-
ready left town for Amsterdam. His critical importance for Delft painting
lies in the higher tonality, the brighter light that he introduced into his
work in the late 1640s. His lighter palette left a mark on the avant-garde
painters in Delft, including Houckgeest, De Witte, and Egbert van der
Poel. The famous genre painter Jan Steen rented a brewery in Delft in
1654. A portrait painted against the background of the Old Church,
dated 1655, testifies to his presence in Delft.[21] Yet Steen probably never
took up residence in Delft. He also failed to join the local guild. From
1649 to 1651 Adam Pijnacker lived in neighboring Schiedam but had
relatives in Delft and was a frequent visitor there, chiefly in the company
of the painter and innkeeper Adam Pick. Pijnacker, the only important
"Italianate" painter in the Delft circle around the mid-century point,
brought a new, idyllic conception of the southern, sun-drenched land-
scape to the local scene.

Pieter de Hooch, the master of intimate interiors and courtyard scenes,
arrived in Delft in 1654 from The Hague and registered in the guild a year
later. Vermeer felt the full impact of De Hooch's work only in the late
1650s, when his handling of light and perspective began to reflect the
technical achievements of his slightly older colleague. Later on, though,
it was De Hooch who fell under the sway of the more imaginative of the
two artists.[22] The presence in Delft of De Hooch and, at least on an inter-
mittent basis, of Jan Steen in the mid-1650s helped offset the great loss

[21] The Steen portrait is called, for no evident reason, "The Burgomaster of Delft and His
Daughter." See *Art in Seventeenth-Century Holland*, Catalogue of a loan exhibition at the
National Gallery, September 30 to December 12, 1976. (London: Publications Department,
National Gallery), pp. 82–83.

[22] On the relationship of De Hooch's art to Vermeer's, see Blankert, *Vermeer of Delft*, pp.
28–31, and Peter C. Sutton, *Pieter de Hooch: Complete Edition with a Catalogue Raisonné*
(New York: Phaidon Books, 1980), pp. 21–24.

the city had suffered with the death of Carel Fabritius. Fabritius had died in October 1654 from wounds suffered in the explosion of the municipal powder magazine, which laid waste the northeastern side of the city (and shattered the stained-glass windows of the New Church that had been spared by the iconoclasts in 1566).

All in all, Delft, a city of only 25,000 to 30,000 inhabitants in the 1650s, could boast of a vigorous, multisided artistic community where all the principal genres of paintings—from portraiture to still life—were represented. By 1654–1655, the community had attained the peak of its vitality. It was soon to disintegrate as many of Delft's painters left town in search of more attractive prospects in larger, richer cities, principally Amsterdam.

The decline in the number of artist painters in the guild was made up to some extent at least by the sustained prosperity of the faienciers' craft. Many Delftware potteries were launched in the 1640s and 1650s. The number of master faienciers who registered in the guild continued to grow rapidly in the 1660s as more skilled managers and technicians were hired to manage the potteries, at the time when the industry was undergoing transformation from owner-operated to larger and more complex enterprises of an incipient capitalist type. The potteries kept a few master painters on their staff, some as regular employees, others for odd jobs.

One of those who normally practiced easel painting but was occasionally employed by a pottery to portray preachers on faience and other scenes was the battle specialist of mediocre talent Isaac Junius, himself the son of a Calvinist minister in Delft. Though the best specialist painter on faience, Frederick van Frijtom, who painted exquisite monochrome-blue landscapes on rectangular plaques and round dishes beginning in the late 1650s, never became a master in the guild, he did not escape the influence of professional landscape painters in Delft and Rotterdam. The interplay between easel and faience painters finds its clearest expression in their parallel tendencies to increasingly simple and orderly arrangements in the 1650s and 1660s. Vermeer himself introduced decorative blue-and-white tiles and a severely simple white pitcher with a pewter cover (both tiles and pitcher evidently of Delft manufacture) in several of his paintings.

Aside from the painters and the masters in Delftware potteries, Vermeer rubbed elbows at guild meetings with sculptors, art dealers, glassmakers, book printers and sellers, and even with a few embroiderers, the last representatives of a once thriving craft. Among the printers he must have met Arnold Bon, the amateur poet who paired Vermeer with Fabritius in his laudatory verse.[23] There is no record of any contact with Delft sculptors, whose work was of relatively minor importance, even though

[23] Doc. no. 315.

Vermeer, at least in the 1660s, lived virtually next door to the workshop of one of the more successful masters, Adriaen Samuels, a member of the Catholic Community.[24]

In February 1657 the framemaker Anthony van der Wiel, who had married Vermeer's sister Gertruy, registered in the guild as an art dealer.[25] No vestige of his activity as a dealer can be traced in archival documents. He continued to make ebony frames in a workshop in the back of his home on the Vlamingstraat for the rest of his long life. He is even known to have sold ebony wood to other framemakers.[26] But it is doubtful whether he dealt in pictures on any significant scale. Digna Baltens, who had presumably inherited her husband's stock after his death, perhaps consigned a few paintings with him so that he could sell them to collectors and dealers who brought him orders for frames. As frequently happened to other would-be dealers, he may also have been caught selling paintings without prior registration in the guild and been forced to join to avoid paying fines.

The guild must have been the center of Vermeer's public life. There was little else in Delft of any conceivable interest for him. No publicly performed music, except for the playing of the organ in churches; no theater: the only Delft-born playwright, Gerrit van Santen, published his playlets in other towns but never saw them performed in Delft.[27] The Chamber of Rhetoricians, which had once staged poetical contests and other shows, had long been inactive. Aside from a little poetry, religious for the most part, the literary scene was bleak. There was not enough intellectual ferment beyond art in Delft to keep a young artist from plying his craft.

Moreover, Vermeer had almost certainly converted to the Roman Catholic faith, which as we have seen, was repressed and intermittently persecuted. Provincial as Delft already was, belonging to the Catholic Church further narrowed a man's horizon because he was barred from all municipal functions. Election to the board of headmen of the guild was about the only civil honor to which the young artist could aspire, and that, no matter how talented he might be, he could not look forward to for several years. Election to the board of headmen did not normally come before a man was in his thirties or early forties.

The social compass of Vermeer's life was not quite so narrow as the

[24] On Adriaen Symonsz. Samuels's presence on the Oude Langendijck, see Delft G.A., "Huizenprotocol," fol. 235, and records of Notary N. Vrienbergh, no. 2064, 16 August 1667. His son, who was also a master sculptor, witnessed an act for Maria Thins shortly after Vermeer's death (doc. no. 360, 9 January 1676).

[25] Doc. no. 267, 25 February 1657.

[26] Michiel van Hackum, ebony woodworker, owed Anthony van der Wiel twenty-eight guilders for wood (Delft G.A., records of Notary T. van Hasselt, no. 2155, 4 February 1666).

[27] On Gerrit Cornelisz. van Santen, playwright and painter, see A. C. Crena de Iongh, *G. C. van Santen's Lichte Wigger en Snappende Siitgen: Zeventiende-eeuwse gesprekken in Delfts dialect* (Assen: Van Gorcum), 1959.

public. The observance of mass, along with a few other faithful, was one social activity that was open to him. Another was to play music in a small group in his home or at a friend's. Music had been played on at least six instruments in Master Claes Corstiaensz.'s house when his stepson Reynier Jansz. was growing up.[28] Reynier may have passed on the musical skills he had acquired at home to his son.The number of Vermeer's paintings in which musical instruments prominently appear certainly confirms the artist's interest in music. There is also a more explicit visual hint of Vermeer's participation in music making. In *The Procuress*, (Fig. 20) the young man facing the viewer, who is generally thought to represent the artist, is holding the handle of a cittern, a sort of long-stemmed guitar that was popular at the time.

Another private diversion for the artist was reading. Five folio volumes and twenty-five assorted books (without recorded titles) that apparently belonged to him were found in his death inventory.[29] At a time when books were quite expensive (on the order of two to five guilders each for the quartos, which represented as many days' earnings of a semi-skilled craftsman), this was a respectable little collection. Some of the books, including the folios, probably served mainly as sources of visual inspiration; others supplied him with religious or mythological stories that he required as background for his paintings; from still others he no doubt drew spiritual nourishment.

These diversions aside, Vermeer was primarily occupied with his art. In the first years after he entered the guild his output was probably a good deal larger than the few paintings that have come down to us. His first efforts were of middling quality, at least by the standards of the period, so they stood less chance of surviving the neglect of time. They must also have been painted relatively quickly, as the broad brush strokes that are still visible testify.

The Procuress, dated 1656, was painted three years after Vermeer became a master in the guild. This is his only dated work of the 1650s. On the basis of plausible assumptions about the evolution of Vermeer's technique and style, art historians have argued that two of the artist's paintings must have been executed a year or two before *The Procuress*. These are *Christ in the House of Martha and Mary* (Fig. 14) and *Diana and Her Companions* (Fig. 16). Both are very large and rather broadly painted. Two more paintings that have not survived probably belonged to this early group. One is "The Visit to the Tomb" ascribed to "Van der Meer" in the death inventory of the art dealer and collector Johannes Renialme, who died in Amsterdam in June 1657.[30] Renialme had registered in the guild in Delft in 1644; he had probably become acquainted with Reynier

[28] See Chapter 1 at note 22.
[29] See doc. no. 364, 29 February 1676.
[30] Doc. no. 269, 27 June 1657.

Jansz. and his son Johannes through Notary Willem de Langue, with whom he was in contact. A number of other Delft artists, including Bramer, Anthony Palamedes, and Hendrick van Vliet, were represented in the inventory of his possessions. The "Visit to the Tomb," by which was surely meant "The Visit of the Three Holy Women to the Tomb of Christ," was appraised at twenty guilders. This was a fairly substantial price—though far from spectacular—for a young master who was more or less unknown in Amsterdam. The other lost painting, mentioned in a mid-eighteenth-century auction catalogue, was entitled "Jupiter, Venus, and Mercury." With *Diana and Her Companions*, it would represent Vermeer's only foray into mythology. Unfortunately, Jupiter, Venus, and Mercury do not appear jointly in any known subject drawn from mythology. Perhaps the auctioneer mistook a female figure for Venus when it actually represented Virtue or Psyche. Dosso Dossi's painting of Jupiter, Mercury, and Virtue (shown as a female figure) is conserved in Vienna. Raphael is known to have made a drawing of Mercury introducing Psyche to Jupiter.[31]

One more painting, this one extant but of uncertain authenticity, warrants our attention. This is the *St. Praxedes* (Fig. 17) copied after the contemporary Florentine master Felice Ficherelli, said to be dated 1653 or 1655. This painting, signed "Meer" in two places, in atmosphere and colors resembles Vermeer's *Diana*. One technical appraisal, by a conservator of a major German museum, concluded that the pigments and gesso of the picture were "characteristically Dutch."[32] The painting, first published as a Vermeer by Michael Kitson,[33] has recently been accepted as autograph by the Vermeer specialist Arthur Wheelock.[34] The attribution,

[31] "Jupiter, Venus en Mercurius door J. ver Meer," appears in the catalogue of the paintings of Willem van Berckel auctioned in Delft on March 24, 1761. This collection was formed earlier in the century by Gerard van Berckel. The Vermeer painting was first cited by Thera Wijsenbeek-Olthuis in *Achter de gevels van Delft: Bezit en bestaan van rijk en arm in een periode van achteruitgang (1700–1800)* (Hilversum: Verloren, 1987), p. 269. The Rijksprentenkabinet in Amsterdam owns a copy of the auction catalogue (nr. 24–III–1761). I am grateful to Marten J. Bok for the citation in the book of Wijsenbeek-Olthuis and to Egbert Haverkamp-Begemann for the reference to Raphael's drawing of Jupiter, Mercury, and Psyche. Dosso Dossi's painting in Vienna shows Virtue in the guise of a woman entreating Mercury for an audience with Jupiter, who is busy painting butterflies; Mercury with his finger on his mouth denies her access to the king of heaven. For alternative interpretations of this painting, see J. A. Emmens, "De schilderende Jupiter van Dosso Dossi" in *Miscellanea I. Q. van Regteren Altena* (Amsterdam: Schelterme en Holkema, 1986), pp. 52–54.

[32] Michael Hunt Stolbach, "Exhibition Catalogue," Spenser A. Samuels Gallery, November-December 1984, New York, no. 14. Vermeer's *Christ in the House of Martha and Mary* was signed "VERMEER." Sometimes Vermeer incorporated a V into the capital M of Meer (as in *The Lacemaker*, Fig. 53).

[33] Michael Kitson, "Florentine Baroque Art in New York," *Burlington Magazine*, 111 (1969): 409–410.

[34] Arthur K. Wheelock, Jr., "St. Praxedis: New Light on the Early Career of Vermeer," *Artibus et Historiae* 7 (1986): 71–89.

on the other hand, is rejected by Albert Blankert, another authority on Vermeer.[35]

Perhaps the most powerful argument against ascribing it to the Delft master is that we know of no other examples of contemporary Italian paintings that were copied in Holland and signed by the copyist. In fact, there were very few such paintings in the United Provinces at all; most so-called Italian pictures were Venetian or Roman works of the sixteenth century, such as those in the collection that Vermeer was asked to pass judgment on three years before his death.[36] If Vermeer had seen any recently painted Florentine pictures, he is likely to have seen them in Amsterdam. He could have done so, for example, at the home of Johannes de Renialme, the dealer-collector who owned "The Visit to the Tomb." But even Renialme's extensive collection comprised not a single picture attributed to a seventeenth-century Florentine artist. As for signed copies, few can be cited. The closest we can come in this respect is the "Interment" by Titian copied by Poelenburgh in Renialme's inventory,[37] which is likely to have been signed (since it otherwise would have been difficult for the notary or his clerk, or even for Renialme himself, to attribute the painting to the Utrecht master).

What does speak for the authenticity of the painting besides its visual appearance is its date—either 1653 or 1655 would be compatible with Vermeer's chronology—and its subject. St. Praxedes was a contemporary of St. Peter in Rome. With her sister Pudentiana, she washed away the blood of the martyrs. In the late sixteenth century her reputation was revived and she was revered in the Society of Jesus. St. Praxedes, in the rare examples where she has been identified, is shown collecting the blood of a martyr with a sponge. (The body of the martyr and his severed head can be seen in the left background of the painting attributed to Vermeer.) The sponge itself, or what passes for it, was preserved as a holy relic in a silver shrine in the Roman church dedicated to the saint. No depiction of the saint by herself—without her sister Pudentiana—was known to Mrs. Jameson, the early authority on Christian art.[38]

The emphasis on works—ministering to the martyrs—rather than on

[35] Blankert, *Vermeer of Delft*, p. 75, note 13. I cannot go along with Blankert's judgment that the attribution to Vermeer is undermined by its "crude execution." The execution seems no cruder than that of Vermeer's *Diana*, the product of an unseasoned master (though in the latter case we must make allowance for the poor preservation of the painting). Blankert also claims that the "M" of the signature "does not fit with the following letters." Part of the signature in black paint on the left-hand side of the painting appears to have been reinforced. However, the signature in light brown paint on the painting's lower side, below the saint's dress, does not seem to have been tampered with.

[36] Doc. no. 341, 23 May 1672.

[37] Bredius, *Künstler-inventare*, 1: 239. For an instance of a Dutch painter signing a copy, of a painting by a contemporary Dutch artist, see Montias, *Artists and Artisans*, p. 324.

[38] Mrs. Jameson, *Sacred and Legendary Art*, 2 vols., 2d ed. (London: Longman, Green and Co., 1911), 1: 623–24.

faith alone was attractive to the Catholic order at war with the Calvinist doctrine, which emphasized predestination and faith.[39] The Ficherelli *St. Praxedes* would have appealed to the Jesuits on the Oude Langendijck. Our imagination does not have to be stretched very far to speculate that the Jesuits had commissioned the young Delft artist to make a copy of the painting. It was perhaps even they who instructed Vermeer to put a golden crucifix in the hands of the saint (absent in the original); for a crucifix in seventeenth-century Holland was the symbolic object that, above all others, signaled its owner's adherence to the Roman Catholic faith.[40]

If Vermeer did execute the copy of Ficherelli's *St. Praxedes*—as I think is likely—then this may tell us something about his art and about his life at this stage in his career: about the former, that he was still learning and experimenting by copying Italian masters; about the latter, that he had drawn sufficiently close to the papists by 1655 to paint a devotional picture—complete with crucifix—that would have been acceptable to the Jesuits. This in itself would tend to support, albeit slightly, the conjecture that he was living in the Papists' Corner at this early date.

The starting point for the following speculations is the assumption that the subjects of Vermeer's early works were chosen by the artist rather than commissioned by a client or patron, or, if the work was commissioned, that the subject (or its specific representation) appealed to the artist. This assumption granted, then it must be significant for the study of Vermeer's personality that four of these early paintings are essentially concerned with women: with Martha and Mary in the Christ picture, with the Holy Women in "The Visit to the Tomb," with a female saint in *St. Praxedes*, and with Diana and her attendants in the Mauritshuis.

Most revealing psychologically, to my mind, is *Christ in the House of Martha and Mary* (Fig. 14). Martha is represented bringing a basket of bread to the table. Mary sits at the feet of Christ in the attitude of a devoted listener. The moment depicted is the one in which Martha has just been saying, "Lord, dost thou not care that my sister hath left me to serve alone? Bid her therefore that she help me." Jesus, pointing to her sister Mary, is shown answering her, "Martha, Martha, thou art careful and troubled about many things. But one thing is needful; and Mary hath chosen that good part, which shall not be taken away from her" (Luke 10: 40–42).

The parallels of this Biblical story with the circumstances of Vermeer's home life are suggestive. The artist had been brought up in a household

[39] Typical Counter-Reformation artists such as Pomerancio and Federico Zuccaro painted the two sister saints (ibid.).

[40] In my study of Delft and Amsterdam inventories, I found that the presence of a crucifix above the bedstead was an unmistakable sign of the individual's Roman Catholic faith.

with a mother and sister who were "heavily cumbered with serving," as St. Luke says about Martha. The gifted young boy, born in his parents' middle years, may well have been spared from everyday chores to cultivate his talent. It would not be surprising, then, if he had later transformed such an idyllic family situation into a picture of Christ, surrounded by adoring women, orating about the contemplative life—the life of the intellect and of art—more worthy by far than the bustling activity of an innkeeper or a housewife.

"The Visit to the Tomb" is not far removed psychologically from the story of Martha and Mary. In St. Mark's Evangel, the Holy Women are looking for the dead Christ to anoint Him (16: 1). He has been laid to rest in a sepulcher, which is empty because, unbeknownst to them, He has risen from the dead. We have here, as in the other picture, pious women attending the Savior, who is again the center of attention, even though only present in spirit.

The theme of women ministering to men is also manifest in the *St. Praxedes*. The congruence with the other two subjects just discussed is so strong that it is itself an argument in support of an attribution to Vermeer (always keeping in mind our assumption that the copyist of the picture exercised some choice over the subject matter of the paintings he copied).

Diana and Her Companions also embroiders on the themes of attendance and servitude, but the themes identified in *Christ in the House of Martha and Mary* are here transformed and disguised. The center of attention of the women this time is not Christ but the goddess Diana. To be sure, Diana was known for her chastity and for her skill in hunting, traditionally a manly virtue. In Jacob van Loo's painting (Fig. 18), which significantly influenced Vermeer's, the light is focused on the goddess. Only two of her nymphs are looking at her; neither serves or attends her. In Vermeer's painting, a nymph is conspicuously washing the feet of Diana. The washing of the goddess's feet is a silent, solemn ritual, a purification.

What lends the scene Vermeer has chosen to depict its sense of stillness, as in many of his subsequent paintings, is that the figures are either motionless or poised in the process of carrying out an action that can be sustained with grace and ease. The attendant nymph touches or gently upholds Diana's foot without effort or tension. In Van Loo's painting, the young nymph next to Diana raises her hand in an unsustainable pose. The nymph in the left background touching her own foot is also immobilized in an awkward stance, compared to her counterpart on the right of Vermeer's work. Even the dog, portrayed by Van Loo with his weight resting on one of his front paws, appears tense; Vermeer's dog, sitting on his haunches, is hieratically calm.

A typical device Vermeer uses to suggest repose, here and elsewhere, is

to conceal or shade over the eyes of his personages. All his nymphs glance down; Diana's face is so obscured by shadows that one cannot tell whether her eyes are open or shut. The "play of eyes" in Van Loo's painting is like the play of hands in a Caravaggist picture of cardplayers; it animates the group, but at the same time it imparts a busy, restless, life-on-this-earth quality that is at the opposite pole from Vermeer's Elysian calm. Vermeer's scene, according to Arthur Wheelock, takes place at night, by the light of the moon.[41] This is an appropriate setting for Diana, the goddess of night, whose only attribute in the picture is the crescent moon she wears on her head.

In addition to the stillness and the mystery of the ablution, we cannot avoid noticing in Vermeer's *Diana* what Jean Cocteau has called the *coté insolite* of Vermeer's pictures: the incongruous elements that creep into several of his early works. Here it takes the form of the nymph who has turned away from the main action, displaying a bare, muscular back, perhaps more suited to a man than to a woman. As far as we know from his extant works, this bare-backed creature is the first and last attempt Vermeer will make to paint a nude body.

An object in the picture that is also *insolite*, perhaps more by accident than by design, is the golden brass plate with the towel in the foreground of the painting. Because of Vermeer's imperfect mastery of perspective and space at this point in his development, it looks as if the plate had been placed on an incline and was about to slip out of the picture. At the subconscious level we are reminded of the brass vessels that hold the sponge and water for laving the body of Christ in numberless Lamentation paintings. The mise-en-scène with the plate also reminds us that Leonaert Bramer, who was certainly a family friend and perhaps Vermeer's early teacher as well, had once painted a large *Magdalen Washing the Feet of Christ*, which is thematically related to Vermeer's depiction of women ministering to men.[42]

The episode in Ovid's Metamorphoses depicted in *Diana and Her Companions* occurs just before the climax of the story. The nymphs are resting in a bosquet near a spring. Some are beginning to undress the goddess or to throw water at her feet. Suddenly Acteon, hunting with his dogs, discovers the sacred group. Diana attempts to avoid his stares at her nakedness by shielding herself with the bodies of her attendant nymphs. She then splashes water at the head of Acteon and hurls an imprecation at him. Through her divine power, he is at once metamorphosed into a stag. Later the unhappy youth is devoured by his own dogs. The moral of Ovid's tale: the voyeur has received the punishment he deserved.

[41] Arthur K. Wheelock, Jr., *Jan Vermeer* (New York: Harry N. Abrams, 1981), p. 68.
[42] Blankert, *Vermeer of Delft*, p. 17.

Between the dog and Diana in Vermeer's painting, a conspicuous thistle is outlined against the more brightly lit side of a large rock. The prickly plant traditionally symbolizes the male element, as in Frans Hal's famous marriage portrait in Haarlem. It is absent in Van Loo's painting. The thistle suggests the impending presence of Acteon, the protagonist of the scene. The idea of hinting at the nearby presence of a protagonist will often recur in Vermeer's mature art. In this particular case, the formal absence of Acteon from the scene contributes to the mysterious aura of the painting, in contrast to the earlier tradition of representing Acteon spying on the goddess and her nymphs or happening upon them.[43]

Besides the Amsterdam-based Van Loo, two Delft painters should be mentioned in connection with Vermeer's *Diana*. One was a much older colleague, Corstiaen van Couwenbergh, the other an obscure contemporary of the artist, Willem Verschoor. The first, who had registered as a master in the guild about a quarter of a century earlier, carried on the Utrecht tradition of "history" painting in Delft, chiefly under the influence of Geraerd van Honthorst. His *Bacchanalia* of 1626 already developed the general scheme that Vermeer was to follow in his *Diana* of placing naked and semi-naked personages in the foreground of a landscape.[44]

The second of these two painters registered in the guild a few months after Vermeer. The Dutch art historian E. J. Sluijter has pointed out that Verschoor's painting *Cephalus and Procris* (Fig. 19) bears some similarity in composition to Vermeer's *Diana* (especially in the diagonal construction and in the relation of the landscape to the figures). Verschoor's picture was probably influenced by Van Couwenbergh and Van Loo.[45] Unfortunately, little is known about Verschoor. He was never elected to the guild's board of headmen and, judging by his infrequent appearance in contemporary inventories, was probably an unsuccessful artist.[46]

[43] For a comprehensive survey of the Diana and Acteon theme in Dutch seventeenth-century painting, see Eric Jan Sluijter, De "heydensche fabulen" in de Noordnederlandse schilderkunst circa 1590–1670: Een proeve van beschrijving en interpretatie van schilderijen met verhalende onderwerpen uit de klassieke mythologie (The Hague: Quickservice Drukkerij Entschede 1986), pp. 30–33, 176–87. On the thistle as a symbol of eroticism, see E. de Jongh and P. J. Vinken, "Frans Hals als voortzetter van een emblematische traditie. Bij het huwelijksportret van Isaac Massa en Beatrix van der Laen," Oud Holland 76 (1961): 133–37. The interpretation of the painting given in the text—the allusion to the missing Acteon—is not totally secure owing to the lack of mutually reinforcing symbols. This is often the case with Vermeer's paintings, which minimize the hints that would enable us to interpret them.

[44] Eric Jan Sluijter, "De schilderkunst van c. 1570 tot c. 1650," in the exhibition catalogue De stad Delft: Cultuur en maatschappij van 1572 tot 1667, 2 vols. (Delft: Stedelijk Museum Het Prinsenhof, 1981), 1: 174, 2: 171.

[45] Ibid., 1: 175.

[46] In the death inventory of Anthony Thieren, a wealthy alderman of Delft who died on 4 July 1673, several paintings by Willem Verschoor were recorded: an office ("een cantoor"), a cat with a fish, a Nativity, an allegory of peace ("de vreed"), and a fruit dish (Delft G.A., records of Notary T. van Hasselt, no. 2158). It is likely that Verschoor, like Vermeer, started out as a history painter then went on to paint genre scenes and other subjects. In the

Similarities in subject or composition aside, it should be observed that Vermeer's *Diana* differs from mythological paintings by Van Couwenbergh and Verschoor not only in the absence of movement and theatricality, but in the warmer colors (especially the vivid reds, oranges, and yellows) that we associate with the influence of Italian (Venetian and possibly seventeenth-century Florentine) painting on Vermeer's art. Unlike any of his predecessors, Vermeer was able to create a mood that is at once elegiac and dreamlike, a very personal and private response to a primeval scene secretly espied.

The five paintings discussed so far—"The Visit to the Tomb," "Jupiter, Venus, and Mercury," *Christ in the House of Martha and Mary*, *St. Praxedes*, and *Diana and Her Companions*—all represented "histories," the subject category that Karel van Mander in his *Schilderboeck* placed highest in his normative scale and that he counseled every young artist to practice earnestly. With *The Procuress* (Fig. 20), painted in 1656, Vermeer broached a new category that, every since the eighteenth century, has been known as "genre." In fact, *The Procuress* is only a transitional work in this category: it could just as well have been called "The Story of the Prodigal Son" or "The Prodigal Son among the Whores," valid titles for histories. Vermeer's first true genre picture comes a year or two later with the *Girl Asleep at a Table*, also known as *The Drunken Maid* (Fig. 25).

Vermeer was surely inspired to paint *The Procuress* by the presence in Maria Thins's home (which was probably his home by then too) of Dirck van Baburen's *Procuress* (Fig. 21), presumably identical with the "Procuress Pointing in the Hand" described in the inventory drawn up when Catharina's parents separated in 1641. Maria Thins had brought the painting to her house in Delft. Vermeer later included portions of it in two of his works (*The Concert* (Fig. 36), painted about 1664, and the *Lady Seated at the Virginals* (Fig. 50) of 1674–1675). If the subject inspired him, Baburen's mise-en-scène did not. There is little in common between the two compositions. Vermeer's is vertical in format, Baburen's horizontal. Vermeer has represented four figures against Baburen's three. Baburen, in typical Caravaggist fashion, cuts off his figures at the hip; monumental, they take up nearly the entire picture space. Vermeer's construction of the right side of the picture is actually more reminiscent of Jan Lievens's *Fortune Teller*, which may have been in his father's (and later in his) possession.[47] About the only direct echo of Baburen's painting

Thieren inventory, there was also a drawing by Maria Verschoor and a copy by Couwenbergh. Anthony Thieren, who was almost certainly Reformed, may have been a relative of Willem Verschoor.

[47] See Fig. 11 and Chapter 4 at note 81.

in Vermeer's *Procuress* is the young man's manner of offering a coin to the girl.

From an aesthetic viewpoint, Vermeer's *Procuress* is distinguished by its two solid colors—red in the man's jacket, yellow in the courtesan's. These are the colors that one would expect to see, though more muted, in a candlelight scene. The influence of Rembrandt's chiaroscuro seems clearly perceptible, though it may have been filtered through the Amsterdam master's disciples. The idea of using intense colors with little or no local variation in large areas may have come from Rembrandt's pupil Nicholaes Maes.[48] Jacob van Velsen, a Delft painter of an earlier generation, may also be cited here. Van Velsen painted intimate genre scenes (Fig. 22) in saturated colors that remind us a little of Vermeer's. A Roman Catholic, he lived until his death in 1656—the year *The Procuress* was painted—on the Oude Langendijck, a few doors from Maria Thins's house.[49]

The young man holding the cittern in *The Procuress*, who probably bears the artist's features, is distinguished by a prognathous jaw and a wide mouth. He resembles the plain girl portrayed in the "Wrightsman Vermeer" of 1672–1674 (Fig. 52), who may have been one of his daughters.[50] The artist in *The Procuress* is dressed in a slitted jacket, of the kind worn by Italian musicians or Burgundian players. By putting on this garb, Vermeer distances himself from the contemporary world and stresses the allegorical or story-telling character of the painting. His dress is similar to the one he will put on six to eight years later when he paints himself in his studio (Fig. 37). In both paintings his long fine hair is covered with a black velvet beret.

Otto Naumann suggested in his monograph on Frans van Mieris that Vermeer's idea of placing a self-portrait slightly apart from the principal scene represented, and of using the expression on the portrait to make an ironic comment on the action, was perhaps borrowed from Van Mieris's *Charlatan*, painted between 1652 and 1655 (Fig. 23).[51] Naumann's sug-

[48] Wheelock, *Jan Vermeer*, p. 72.

[49] Bredius, *Künstler-inventare*, 3: 877. The presence in the same room of Van Velsen's death inventory of typically Roman Catholic subjects (several Mothers of Christ, Our Lord Jesus, The Annunciation) along with profane pictures including a "Brothel Scene," shows that a devoutly religious temperament was not necessarily averse to subjects that, though they might be considered licentious today, were seen as moral exhortations at the time (pp. 878–79).

[50] See Chapter 10 at note 82.

[51] Otto Naumann, *Frans van Mieris the Elder (1635–1681)*, 2 vols. (Doornspijk: Davaco Publishers, 1981), 1: 43, 99. In Van Mieris's *Doctor's Visit* in Vienna, painted in 1657, the older physician is depicted in much the same manner as the young artist in *The Charlatan* (including the lace collar); like the spectator in Vermeer's *Procuress*, he wears old-fashioned garb to signal his burlesque or theatrical character. He is also making an ironic comment on the young woman's malady. Note also that Van Mieris probably picked the motif of the

gestion is very persuasive. Van Mieris derived his own painting from Gerard Dou's own *Charlatan* of 1652, substituting his self-portrait for a spectator pushing a wheelbarrow in Dou's painting. This self-portrait was apparently the only feature of Van Mieris's *Charlatan* that interested the Delft artist. Both young men are shown in three-quarters pose, mouth slightly open, with long silky hair, wearing a black beret, and a broad lace collar. The chiaroscuro modeling of the collar and the use of a dark repoussoir to place the figure at a middle distance and to frame it are also similar.

The imaginative adaptation of Van Mieris's original conception shows that Vermeer at this stage in his evolution was already far from a mechanical borrower of other artists' ideas. Typical of his later method of work is the way he has enlarged Van Mieris's beret and turned it into a pattern-creating accessory: the lower contour of the beret exactly matches the wavy diagonal rim of the seducer's gray hat. The column introduced by Vermeer to enclose his self-portrait is also characteristic of his search for more convincing spatial arrangements at this early point in his career.

Van Mieris, born in 1635, was three years younger than Vermeer. If he painted his *Charlatan* between 1652 and 1655, he was at most twenty at the time. No personal contact between Van Mieris and Vermeer has been documented. Yet it is likely that some contact must have taken place, since it is very improbable that Van Mieris's *Charlatan* traveled from Leyden to Delft before being bought by a member of the Medici family.[52] A trip by canal from Delft to Leyden, on the way north to Amsterdam, would not have been beyond the young Delft artist's means, modest as they were at the time. A possible connection with Leyden artists and patrons, via Pieter van Ruijven, Vermeer's own patron, will be argued in Chapter 13.

It is not only because of the subject matter that *The Procuress* projects an entirely different effect from *Christ in the House of Martha and Mary* or *Diana and Her Companions*. In its baroque agitation—evident in the play of hands, the half-open mouth of the artist, the rakish angle of the suitor's hat, the tilt of the older woman's head—it also differs from later pictures, where the silent discourse of the earlier compositions is resumed. Its movement may be a reflection of Vermeer's artistic restlessness at this juncture, a final hesitation before embarking on his mature classical style.

There are anomalies in the picture that add to the mystery created by the chiaroscuro, probably influenced by Rembrandt, and the extraordinary colors. First, the procuress herself is unlike any other brothel keeper or matchmaker in similar paintings. Dressed entirely in black, she gives

beret-wearing painter either directly from one of Rembrandt's self-portraits or via his own teacher, Gerard Dou.
[52] Naumann, *Frans van Mieris* 2: 14.

the appearance of a nun officiating at an evil ritual, a black mass perhaps, or a selling of souls. Then there is the artist-musician holding on to his instrument with his right hand and toasting the lusting couple with a glass in his left. The lovers' unabashed lust is so provocative, they are so completely absorbed in each other to the exclusion of the rest of the world, that we can sympathize with the lewdly defiant gesture of the excluded spectator. After all, he turns to tell us, he too can enjoy himself with his drink and his strings. It is as if the voyeur who was absent in the Diana painting had now been invited into the picture to boast of his exploit.

There is one more *insolite* element in *The Procuress*: the precariously poised jug on the table to the right, which threatens to disturb the delicate balance of the scene.

From 1656, when *The Procuress* was painted, until 1668, the date of *The Astronomer* (which is not even entirely certain because it may have been added by a later hand), there is not one dated painting by Vermeer. It was once conjectured that *The Little Street* (Fig. 24) might represent the quarters of the St. Luke's Guild just before they were remodeled in 1661, but this identification appears unlikely.[53] Neither is there much evidence about cross-influences (from Vermeer to other painters, from other painters to Vermeer) that might help us to estimate the dates of his paintings from the securely dated works of other artists. We do not even know for sure how many pictures Vermeer painted before 1668 and how many afterward, although there is general agreement among art historians that some eighteen to twenty paintings belong to the first group and seven to nine to the second.

No one would deny that the *Girl Asleep at a Table* (Fig. 25) was painted soon after *The Procuress* and that the *Allegory of Faith* (Fig. 39) is one of Vermeer's last works, painted some time after *The Astronomer*. But when it comes to *The Love Letter* (Fig. 46), generally dated before *The Astronomer*, there is room for doubt. In any event, three paintings— the *Girl Asleep at a Table*, *The Officer and the Laughing Girl*, (Fig. 15), and *Girl Reading a Letter at an Open Window* (Fig 26) almost certainly belong to the early group. I shall assume as most art historians have that these can all be dated to the late 1650s, although I must recognize that firm evidence for this is lacking.

Girl Asleep at a Table is only a step or two removed from *The Procuress*. The emphasis is again on intense red and yellow colors. The palette is still fairly dark. A richly patterned rug also marks off the foreground.

[53] I have spelled out the reasons for rejecting this hypothesis in "Vermeer and His Milieu: Conclusion of an Archival Study," *Oud Holland* 94 (1980): 58–59. My principal argument is that the Old Men's House, which was only superficially remodeled to creat a Guild Hall, had its main axis parallel to the street, whereas the house represented in *The Little Street* clearly has its narrow side facing the street.

Even the girl looks much the same as the courtesan in the earlier picture. What is new in the artist's work is the much more pronounced interest in creating a convincingly ordered space. At this point in his development it takes the form mainly of the drawing of strict horizontals and verticals to enclose focal objects. The far side of the table, the door poster, the lower edge of the black frame of the painting above the girl, and the edge of the painting's frame on the left form a perfect square in which the sleeping maid has been encased.[54] The chair is obliquely placed to direct out attention to the central figure. The half-open door allows a peep into the second room. Yet the objects in the background are so neutral that the eye is hardly distracted. The scene in the middle ground remains the focus of the arrested action.

The painting on the wall above the *Girl Asleep* allows us to see part of the left leg of a standing child together with a mask in deep shadows. The figure has been recognized as a standing putto or Cupid holding up a card, in the style of Cesar van Everdingen, which reappears in *The Girl Interrupted at Her Music* in the Frick collection, and the *Standing Lady at the Virginals* (Fig. 49), in both cases without a trace of a mask. The mask signifies dissimulation or deceit.[55] Is the girl feigning to be asleep? And if so, why? If she is supposed to be a "drunken maid asleep at a table," as the 1696 sales catalogue of the Dissius collection described her,[56] what is she pretending to be that she is not? The mask standing upright faces the putto, the incarnation of love. Rather than being drunk, she may be feigning sleep as her lover is about to appear. Was it him that Vermeer first painted standing in the back of the room, seen through the door, but then painted over?[57] Pretense and dissimulation imply the existence of at least two actors in the drama: the abuser and the abused. If this interpretation holds up, the painting is situated in the same general territory as *Diana and Her Companions*: scenes where the impending presence of a protagonist supplies the otherwise missing tension.

Since a painting of a putto was mentioned in the death inventory of Vermeer in February 1676,[58] the one represented above the head of the sleeping girl may have belonged to the Thins-Vermeer household at the end of the artist's life. The fact that it was in the part of the estate that Maria Thins shared with Catharina Bolnes does not imply that it had

[54] Arthur Wheelock (*Jan Vermeer*, p. 74) points out that Vermeer's picture has been cropped on all sides. It presumably showed a larger part of the painting above the girl's head.

[55] The image of the putto with a mask stems from Otto van Veen's *Amorum emblemata* (Wheelock, *Jan Vermeer*, p. 74).

[56] In the catalogue of paintings sold on 16 May 1696 in Amsterdam ("Een dronke slapende meyd aen een Tafel, van den zelven" [Vermeer]) cited in doc. no. 439 of that date.

[57] Wheelock, *Jan Vermeer*, p. 75.

[58] Doc. no. 364, 29 February 1676.

always been there. It only gives us a very tentative hint that by the time the *Girl Asleep at a Table* was painted, Vermeer was already living in the Thins household. The presence of the chair with lion-head finials, which reappears in many of his later paintings, adds to this presumption.

The Frick Collection's *Officer and the Laughing Girl* (Fig. 15) and Dresden Gemäldegalerie's *Girl Reading a Letter at an Open Window* (Fig. 26) mark a decisive turn in the artist's technique and especially in his treatment of light. Until these pictures were painted, Vermeer seems to have been almost oblivious to the interest in the representation of light manifested by painters of the "Delft School." First, Paulus Potter, who had joined the local guild in 1646 although he continued to reside nearby in The Hague, had contributed his lighter, brighter palette to the painting of outdoor scenes. In 1650 and 1651 Adam Pijnacker, who lived a few miles away in Schiedam, was a frequent visitor in Delft. His landscapes, like Potter's, were marked by a higher tonality, but they were even more suffused with sunlight. The careful, precise balance of their compositional elements exudes peace and calm. About the same time, Geraerd Houck-geest, whose well-do-do family had business both in The Hague and Delft, represented bright daylight filtering through church windows, illu-minating the bare choirs of post-Reformation churches. With touches of intense local color—reds, yellows, and blues—he set in relief the figures animating his church interiors. Carel Fabritius brought these achieve-ments to a higher peak in the works that he painted between 1652 (when he first arrived in town) and his death in the powder explosion of July 1654.

In the last year of his life, Carel Fabritius had used a brightly illumi-nated wall as background for his portrait of a goldfinch: thick dabs of brown, black, gray, and bright yellow paint define the bird and its wooden perch, setting if off against the thickly impastoed white wall. Here he anticipates Vermeer in the way he draws with paint, models forms with light. The only painter in Delft who had learned his trade in Rembrandt's studio, he understood better than any other of his fellow members in the guild his master's use of chiaroscuro as a principle of composition, which he had learned to modulate to achieve subtle illusion-istic effects.

Yet the painter of the 1650s who exerted the most direct influence on Vermeer was Pieter de Hooch. Albert Blankert and Peter Sutton have shown that Vermeer borrowed part of De Hooch's *Interior Scene* (Fig. 27), with its figures set in the middle of a large room, brightly lit from the left, when he painted his *Officer and the Laughing Girl.*[59] In the Vermeer painting the figures have been moved closer to the picture plane and the

[59] Blankert, *Vermeer of Delft*, pp. 29–30; Sutton, *Pieter de Hooch*, pp. 21–24.

man and woman have been interchanged, but the use of a black mass as a repoussoir to suggest depth, the wall map partly cut off by a hat, and the overall lighting of the scene are quite reminiscent of the *Interior Scene*. Since both pictures are thought to have been painted in the same year, the only reason for inferring De Hooch's primacy is that he had for several years been constructing highly structured interior spaces in much the same manner as in the *Interior Scene*, whereas Vermeer's previous efforts, including the *Girl Asleep at a Table*, had been composed and lit in a substantially different way. De Hooch, three years older than Vermeer, had arrived in Delft from Haarlem about 1653, but he only joined the local Guild of St. Luke in December 1655, two years after his younger colleague. At the public sessions of the guild, as on St. Luke's Day, October 18, he could not have failed to meet Vermeer. But no explicit mention of contact between the two men has been discovered.[60]

With the *Girl Reading a Letter at an Open Window* (Fig. 26), Vermeer simplifies De Hooch's scheme. He has disencumbered his painting of virtually all the storytelling elements that animate, and at times clutter up, the society pieces of De Hooch and his other predecessors. Only one figure remains—silent, absorbed. Inanimate things fence her in: a wall, a chair, a window, a curtain, a brass rod, a rug-covered table.[61] The light is soft and diffused. Vermeer will never again flood an interior with light as he did, under De Hooch's influence, in the Frick painting. A strongly focused light would have disturbed the contemplative atmosphere in which he has surrounded his fair-haired model. The stillness of the air, the intimate confrontation of the reader with her letter, the wraithlike reflection in the window conspire to impart that sense of mystery, of "secret scenes secretly espied," which lies ambushed at the core of Vermeer's art.

In point of technique, the *Girl Reading a Letter at an Open Window* still resembles *The Officer and the Laughing Girl*. In both, Vermeer makes use for the first time in his known oeuvre of his famous "pointillism." Tiny white globules are scattered throughout the more brightly illuminated passages: in the woman's jacket and on the chair's back (in the Frick picture); in the foreground still life, in the yellow folds of the girl's jacket, and in the girl's hair (in the Dresden picture). The Dresden painting, which is very well preserved, is distinguished by the exquisite modulation of its chiaroscuro, its subtle transitions between lighter and darker tones. In this respect, Vermeer is already superior to Pieter de Hooch, at

[60] The closest we can come is that De Hooch's name frequently crops up in the records of Frans Boogert, who was Maria Thins's and Vermeer's family notary.

[61] Originally, before Vermeer painted in the curtain over a large roemer standing on the table and eliminated the picture of a putto hanging above and to the right of the reading woman, the picture must have appeared more cluttered than in its final execution. See the x-ray photograph of the Dresden painting in Wheelock, *Jan Vermeer*, p. 30, and the analysis of the painting on p. 32.

least by the illusionist standards of the period, in rendering fabrics and textures. De Hooch is less precise, more "impressionistic" than his younger colleague.

It has been suggested that Vermeer used optical devices, perhaps a double concave lens mounted in a camera obscura to achieve his truer-than-life effects.[62] The small globules of light with their faint iridescence tend to confirm the use of such lenses. Whether or not he relied on mechanical devices, he would hardly have attained the degree of precision that distinguishes his art—as in his background maps, which are sufficiently detailed and accurate to be traced to their originals—if he had not applied himself with the total concentration that comes only from the unshakable conviction that what one is doing is exactly right.

By the time he painted the Dresden picture in the late 1650s, Vermeer had completed his artistic training, in the sense that he had finally absorbed the impact of the artists—Van Baburen, Van Loo, Fabritius, Frans van Mieris, Pieter de Hooch, Nicolaes Maes—who decisively influenced the evolution of his style. He had not matured quickly or developed an independent style especially early. He had been late in acknowledging the discoveries in the treatment of light and space that his innovative colleagues of the Delft, Leyden, and Dordrecht schools had pioneered. But he had digested each of these influences fully before going on to study the next development in the modern art of his time. This slow maturation, grafted onto a prodigious natural talent, laid the ground for his later masterpieces.

[62] Notably by Lawrence Gowing in his *Vermeer*, 2d ed. (New York: Harper & Row, 1970), p. 23 and notes 7, 8, and 9 on pp. 69–70.

· 9 ·

WILLEM BOLNES

Around 1659 or 1660, Vermeer's brother-in-law Willem Bolnes left his irascible father's house in Gouda and went to live on one of the family properties in Schoonhoven. There he had himself built a modest little cottage. Although he received some income from properties that he had inherited from his family, he borrowed money from his mother and incurred debts, chiefly at local inns "for treats," which he expected Maria Thins to pay.[1] His father, Reynier Bolnes, by this time was too impoverished to come to his help. Willem apparently did no work of any kind.

At the end of 1660, the household in the house in Delft on the Oude Langendijck at the corner of the Molenpoort[2] consisted of Maria Thins, Johannes Vermeer and his wife Catharina, and three or four children, probably all girls, not counting an infant child who died in that year, and at least one female servant.[3] Maria, around six, and Elisabeth, three, the latter presumably named after the sister of Maria Thins who had become a nun in Louvain, were the oldest. It may have been for them that Vermeer bought a sail-equipped ice sled for eighty guilders, a year or two before his debt for the purchase was recorded in May 1660. (Unfortunately, we cannot be sure that the buyer of the sled was the artist Vermeer rather than his virtual namesake, the apothecary Johannes van der Meer.)[4]

From the inventory taken shortly after the artist's death, we can get some idea of the house where Maria Thins lived alongside her daughter, her son-in-law, her grandchildren, and a servant.[5] The house had a basement, a lower floor with a vestibule, a great hall, a small room adjoining the hall, an interior kitchen, a little back kitchen, a cooking kitchen, a washing kitchen, a corridor, and an upper floor with two rooms, one of which was taken up by Vermeer's studio. There was also a "place" (perhaps the privies), a little room where things were hung, and an attic. In addition there may have been one or two rooms upstairs reserved for Maria Thins, which were not mentioned in the inventory because only

[1] Doc. no. 299, 14 December 1664.

[2] We recall that a child of Vermeer living on the Oude Langendijck was buried on 27 December 1660 (doc. no. 279). That the house was located at the corner of the Molenpoort is indicated in Vermeer's death inventory of 24 February 1676 (doc. no. 361).

[3] See note 69 of Chapter 12.

[4] Doc. no. 274, 12 May 1660. There is a slight presumption that the artist, rather than the apothecary, owed the money for the ice sled, because the painters Gillis and Mattheus de Berg, who signed the inventory, were colleagues of Vermeer in the guild and that, if there was a choice, he may have been inclined to favor their father with his custom.

[5] Doc. no. 364, 29 February 1676.

those rooms were listed that contained furniture, paintings, or clothing belonging to the artist or his wife. (It is unlikely, moreover, that there could have been eight rooms on the lower floor and only two rooms on the upper.)

Only one bedstead, and four (built-in-the-wall) beds were recorded, one of which was a child's bed. No beds were to be found in the vestibule and great hall, which were presumably used for receptions and family living. There was one bed with pillows and covers in the interior kitchen, one in the cooking kitchen, and one in the cellar. The child's bed and the bedstead were in the small room adjoining the hall. Two cradles completed the sleeping facilities, one in the back room on the upper floor and one in the attic. Paintings hung in many rooms, but most of them were to be found in the vestibule, the great hall, the interior kitchen (perhaps a dining room), the cellar room and the two rooms upstairs. The younger children probably slept in the little room adjoining the hall and in the cooking kitchen, which had a child's chair and six old chairs (as well as tin dishes, beer mugs, and crockery), but no paintings. The adults and the oldest child slept in the interior kitchen and the cellar, which did have paintings, including a large Crucifixion (probably the one Vermeer painted in the background of the *Allegory of Faith*, Fig. 39).

On December 10, 1661, Maria Thins, who already had a family grave in Gouda, purchased a grave in the Old Church;[6] she now realized that she had come to settle in Delft for the rest of her life. But her decision also signified that her son-in-law had become an inseparable part of the family that she headed. There was enough room in the grave, which was dug below a slabstone of the church, to lay Vermeer, Catharina, and three of his young children to rest in addition to Maria herself and her son Willem.

At the beginning of 1661, Cornelia Thins, Maria's sister, who was still living in Gouda, fell seriously ill and called in the family notary to draw up her last will and testament.[7] The notary wrote down, according to the standard formula, that although she was sick in body, she still kept her memory and understanding. Sitting on a chair by the fire she dictated the disposition of her properties after her death. She left one hundred guilders to the poor, made bequests to some acquaintances and to her maid, and gave sixty guilders to the young men who would carry her coffin to the grave. She bequeathed to Elisabeth Vermeer, the daughter of her niece Catharina, an annuity of 60 guilders 13 stuivers. To Maria Vermeer, also a daughter of Catharina, she bequeathed her domain of Bon Repas, consisting of ten and a half morgen (about twenty-two acres) near Schoon-

[6] Doc. no. 289, 10 December 1661.
[7] Doc. no. 280, 28 January 1661; and doc. no. 281, 1 February 1661.

hoven. The usufruct of the estate would accrue to Maria Thins and, after her death, to "the father and mother of Maria [Vermeer] or the survivor of the two" until Maria reached the age of twenty. After Maria reached maturity, she would be entitled to draw the usufruct. The land, however, would remain entailed for two generations of Maria Vermeer's descendants.

Further, Cornelia deeded the income of her estate "De Hoge Werf" in Oud Beijerland, with eighteen and a half morgen of land, to Maria Thins and after her, to Catharina and her children. She also left Catharina an annuity of 100 guilders 5 stuivers and her household property. The household assets that she had inherited from her brother Jan Willemsz. Thins were to be divided between Maria Thins and Catharina. All her remaining property was assigned to Maria Thins, and after her death, to Catharina and her offspring, with the specific provision that Willem Bolnes "should not get or enjoy" a single stuiver of it, due to "his dissolute, licentious and useless life, as well as the disobedience, spite, and harm that he had done to his mother."

A couple of days later, on the first of February, Maria Thins arrived from Delft to visit her sick sister. The sisters recalled the notary. Cornelia now stated she wished to amend her will by revoking the clause in which she had given preference to Maria Vermeer above the other children (by bequeathing to her the domain of Bon Repas). Cornelia and Maria also declared before the notary that they wished to ratify and approve the marriage of Catharina Bolnes to Johannes Vermeer. (The notary had added in the margin and then struck out the words: "just as they had ratified, approved, and made it valid before the marriage had been consecrated in Delft.") They said the ratification was necessary for the testament of their brother Jan Thins, insofar as it regarded Catharina Bolnes, to "take full effect." They willed that the ownership of all their landed properties in Oud Beijerland should devolve after their death on the grandchildren of Catharina and that their usufruct should accrue in succession to Maria Thins, Catharina, her children, and her grandchildren.

What did Maria and Cornelia have in mind by this flurry of notarial activity so shortly before Cornelia's death? (She was buried three weeks later.)[8] Since Vermeer's daughter Maria could not have been more than nine years old, there is hardly anything she could have done that would have provoked her grandmother to deny her the preferred status that Cornelia originally wanted to give her. It appears likely that Vermeer and his

[8] Gouda G.A., Archief van de Hervormde Gemeente, "Jaar rekeningen St. Jan," 21 February 1661. The high amounts paid on her behalf for the ringing of bells—20 guilders 16 stuivers and 14 guilders 8 stuivers—testify to her high status. (This information was communicated to me by Rob Ruurs.)

wife already had four children at this time. Maria Thins may have felt that it would place the future of the three youngest at risk if so much property were vested in the eldest. Whatever the reason, Catharina did not wait long before she took advantage of Cornelia's will. On April 11, she sent Vermeer to represent her in The Hague to have Bon Repas registered in her name. On this occasion she was said to be thirty years old.[9]

The approval and ratification of Vermeer's marriage at this late date is puzzling. Jan Willemsz. Thins had evidently specified certain conditions in his will concerning the bequest he had made to his niece Catharina (who at the time of his death was still not married to Vermeer). Had he required that she marry a Roman Catholic before she or her children could lay claim to the properties? Why did the notary first write and then strike out the phrase that they had already approved the marriage *before* it was consecrated in Delft (presumably a minor inaccuracy for Schipluy)? It is conceivable that Jan had imposed two conditions: first, Catharina's husband would have to be Roman Catholic, and second, the couple would have to bring up their children in the faith. Whether or not this condition had been fulfilled after a prescribed number of years or after one or more children had reached a certain age might have been left up to the surviving sisters. The first condition had perhaps been fulfilled when Vermeer converted to Roman Catholicism in the three-week period between his betrothal and his marriage; the second, when Maria had been old enough to be confirmed in the faith. Whatever the reasons, Catharina and her children stood to inherit from Cornelia (and indirectly from her brother Jan) a fair amount of income, although there would not have been enough to support Vermeer for the rest of his life as a *rentier*. The usufruct of properties to which Catharina was entitled on her own and on her daughter's behalf before they came of age, after the death of Maria Thins, would have amounted to some 350–400 guilders per year. This would have been more than a semi-skilled decorator on faience or carpenter could earn if he worked all year long without ever being sick.

Four days after Vermeer had gone to The Hague to register Bon Repas in Catharina's name, Maria Thins was back in Gouda. This time she appeared before the trustees of the Orphan Chamber to settle the inheritance of her aunt Diewertje van Heensbeck, the sister of her mother Catharina van Heensbeck who had lived with them in Gouda until her death in 1604.[10] Besides Maria Thins herself, the only remaining heirs, now that Maria's brothers and sisters were all dead, were Adriana and Catharina van der Wiel, the daughters from her half sister Maria Camerling's marriage to Jan Hendricksz. van der Wiel.[11] Each side (Maria Thins and Van

[9] Doc. no. 282, 11 April 1661.
[10] Doc. no. 283, 15 April 1661.
[11] See doc. no. 338, 25 October 1671.

der Wiel) was assigned 5,183 guilders, which yielded a yearly income of
245 guilders. The capital was entailed up to the generation of Catharina,
who was slated to inherit it after her mother's death. The interest, along
with her other land rents and annuities, assured Maria Thins an income
of at least 1,500 guilders per year—enough for a patrician standard of
living.[12]

When the time came for Maria to make out a new will in May 1662,
her ties in Gouda were still sufficiently strong for her to travel to her na-
tive city to have the document drawn up by the family notary.[13] The eld-
erly woman (she was by then in her early seventies) was in good health;
yet mindful of the "certainty of death and of the uncertainty of the hour
of its occurrence," she wished to revoke her previous will and make new
dipositions for passing her properties. In addition to the bequests to Ca-
tharina she had already made in her first testament, which she now reaf-
firmed, she left her a gold cross, two silver dishes, and a gilded wine jug.
To her goddaughter ("pille") Maria Vermeer, she left a sum of two
hundred guilders, and to the other children of Catharina and Vermeer,
together a sum of 400 guilders.[14] To her son-in-law Johannes Vermeer
she bequeathed the sum of fifty guilders yearly for the rest of his life. The
capital, amounting to about 1,250 guilders, would accrue after his death
to his children with Catharina. To her son Willem she left a capital sum
of 150 guilders that he had borrowed from her at interest in October
1650 plus 120 guilders she had invested for him in a vicariate, together
with the bed on which she slept, along with two sheets and blankets. Her
other household goods—other than her linens—were to be divided
equally between Willem and Catharina. The linens were to go to Catha-
rina with the exception of six shirts, two pairs of sheets, two bolsters, and
twelve napkins that were earmarked for Willem. Besides various small
bequests she made to relatives in Gouda, she left a silver spoon to her late
sister Cornelia's servant and twenty guilders to her own maid, provided
she had lived for three years in the house by the time of her death and

[12] Maria Thins received about 600 guilders in interest from the 12,000 guilders she had
received from Reynier Bolnes after the court settlement dividing his property, 450–500
guilders rent per year on her properties in Oud Beijerland (doc. no. 359, 2 January 1676),
150 guilders per year for her property in Schoonhoven (100 guilders per year for 7½ morgen
in 1676; see doc. no. 360, 9 January 1676), 245 guilders a year from the obligation in
Gouda's Orphan Chamber, and at least 50–100 guilders for the house she owned in the
Haaghpoort (Delft G.A., "Huizenprotocol," fol. 9740) and the income from the house she
sold in Schipluy (doc. no. 263 of 4 April 1656). There were probably other assets, including
money lent at interest, that did not come from the sums she had obtained from Reynier
Bolnes, that should be added to our 1,500 guilders estimate. This estimate, incidentally,
does not include income from lands owned by Willem Bolnes that Maria Thins was later
authorized to administer. On the other hand, the annuities that she gave her daughter Ca-
tharina (doc. no. 375, 11 December 1676) have not been deducted from her income.
[13] Doc. no. 290, 14 May 1662.
[14] See note 69 of Chapter 12.

that she deserved the bequest (this at the discretion of Catharina). She maintained the same provisions as in her previous testament for the bulk of her estate, after subtracting the legitimate portions of Willem and Catharina.

As before, the remaining part of the estate was divided half and half between the grandchild or grandchildren of Willem and Catharina, who were to enjoy the usufruct of the properties during their lifetimes. Again, in case one or the other should predecease her, the properties were to be inherited by the grandchild or grandchildren of the survivor. She also specified that the properties left by her brother Jan in Bon Repas and Oud Beijerland were to be divided in this same manner. This provision presumably applied only to the domains that she had inherited from her brother, not to those that had already been passed on to Vermeer's children after Cornelia's death.

It is astonishing that Maria Thins, unlike her sister Cornelia who had cut Willem off without a stuiver for his misbehavior and disobedience toward his mother, had not taken a solitary measure to reduce Willem's share in her estate. To be sure, he was by now over thirty years old and unmarried, so there were good chances that the assets earmarked for his grandchild or grandchildren would accrue after his death to Vermeer's progeny, but this was by no means certain. The events that came about a few years later were to expose the fragility of these arrangements.

Although the details of Vermeer's artistic career in the 1660s are relegated to the next chapter, it is still relevant to mention here that he was elected a headman of the St. Luke's Guild in the autumn of 1662. This recognition, coming as it did just when he reached the age of thirty, reflects the esteem that he already enjoyed among his colleagues, even though the set from among whom headmen could now be chosen was greatly depleted by deaths and departures.[15]

The next year, 1663, was critical for the stasis of the Thins-Vermeer household. It started out on a conciliatory note. On January 17, Willem, still a resident of Schoonhoven, appeared before a notary in Delft to acknowledge a debt of three hundred guilders that he owed his mother, both by reason of money she had paid to his creditors on his behalf and of certain sums he had received from her in cash.[16] As collateral, to ensure the fulfillment of the contract, he assigned to her the income of three morgen of osier lands situated in Gellekenes and in the Barony of Liesfeld, not far from Schoonhoven. The interest on the loan was only 4 percent— low for a business transaction but perhaps normal for a loan to a member

[15] Doc. no. 291, 1662. See also the first paragraph of Chapter 10.
[16] Doc. no. 292, 17 January 1663.

of the family. (Dutch burghers—both Calvinists and Roman Catholics—commonly lent money at interest at this time to close family members.)

The next events, which transpired in a deposition made three years later, occurred a few months after the loan was contracted. They are so vividly described by the deponents that they deserve a complete and literal translation.[17]

"Today there appeared before Frans Boogert, notary in Delft, Willem de Coorde, Gerrit Cornelisz. stone carver, and Tanneke Everpoel, who testified at the request of Maria Thins that they were aware of the following facts. First, Tanneke Everpoel stated that in 1663 she had been residing at the house of the petitioner [Maria Thins] and of her son-in-law Johannes Vermeer. Tanneke and Gerrit Cornelisz. both declared that on various occasions Willem Bolnes had created a violent commotion in the house—to such an extent that many people gathered before the door—as he swore at his mother, calling her an old popish swine, a she-devil, and other such ugly swearwords that, for the sake of decency, must be passed over. She, Tanneke, also saw that Bolnes had pulled a knife and tried to wound his mother with it. She declared further that Maria Thins had suffered so much violence from her son that she dared not go out of her room and was forced to have her food and drink brought there. Also that Bolnes committed similar violence from time to time against the daughter of Maria Thins, the wife of Johannes Vermeer, threatening to beat her on diverse occasions with a stick, notwithstanding the fact that she was pregnant to the last degree. The witness added that this would have happened had she not prevented it [i.e., that Tanneke had put an obstacle in the way of his aggression].

"De Koorde then declared that on various occasions, upon the complaints of Bolne's sister, he had barred Bolnes, who was making a great deal of violence before the door of his sister, from entering. He also had seen Bolnes several times thrust at his sister with a stick at the end of which there was an iron pin ("pen"). All the witnesses testified that Maria Thins had greatly suffered from the violence of her son, who showed himself to be a man out of his mind, and that the petitioner finally had obtained from the magistrate of Delft that she be allowed to have her son 'set fast' [committed to custody]."

The commitment of Willem in the private house of correction run by Hermanus Taerling actually took place about a year after the tempestuous events recounted in the deposition.[18] The house was run by Taerling for "delinquent and mentally ill persons." Who was Tanneke Everpoel, who so bravely defended Catharina when she was with child? An

[17] Doc. no. 305, 3 July 1666.
[18] See doc. no. 372, 20 and 25 November 1676.

illiterate woman living in the Thins household, she can hardly have been anything but a servant, most probably the one slated to receive twenty guilders after the death of her mistress if she had remained three years in her employ. She was probably also the "Tanneken" who had a claim on Vermeer's estate in April 1676 (family servants were often referred to in contemporary documents by their first name.)[19] I will not resist the temptation of identifying her with *The Milkmaid* (Fig. 28), a statuesque woman, quite capable by the looks of her of resisting Willem's assaults. The painting is generally dated 1660–1661. If so, she had been in Maria's employ at least a year, or perhaps two, by the time her mistress made out her testament. There is consistency in all this, but of course no proof. It also remains to be shown that Vermeer painted in a realistic manner the objects and the individuals in his immediate surroundings.

Another witness to the deposition was Willem de Coorde. He was the son of the Catholic innkeeper at whose house on the Oude Langendijck Reynier Bolnes had stayed many years previously. The stone carver Gerrit Cornelisz., the last witness, was at one time an apprentice ("knecht") in the workshop of the Roman Catholic sculptor Adriaen Samuels, which was situated in the Molenpoort, a door or two from Maria's house.[20] Again we may ask ourselves what a common apprentice was doing in an upper-class dwelling like Maria Thins's. Could he have been used by Vermeer to grind his colors?

The deposition offers a fascinating glimpse into the domestic life of the Thins household. Willem's attack on his sister repeated his father's assault on his wife Maria Thins twenty years earlier when she too was "pregnant to the last degree." Psychohistorians who have emphasized the obsessive character of traumatic experiences—repeated again and again in the same or different forms, as the individual seeks to work his way out of an irresoluble conflict—would treat this case as an instance of an obsession transferred from one generation to the next, much as battered sons when they grow up inflict on their children the physical pain that had been inflicted on them by their fathers.[21] But what is it about the appearance of a woman about to give birth that should have provoked

[19] Doc. no. 367, 24 and 30 April 1676.

[20] According to a deposition of 16 August 1667, Gerrit Cornelisz. worked for the widow of Adriaen Simonsz. Samuels (Delft G.A., records of Notary N. Vrijenbergh, no. 2064). When the incident with Vermeer's wife took place, Samuels was still alive. Gerrit Cornelisz., who was twenty-nine years old when he testified on 2 December 1666 (Delft G.A., records of Notary T. van Hasselt, no. 2155), also worked for several years for the master sculptor Heyndrick Jansz. van der Schrick, whose workshop was also at the corner of the "Trapmolenpoort."

[21] The psychological hypotheses advanced here emerged from my conversations with the psychohistorian Rudolph Binion.

the assaults of the father and the son? We know nothing about the anxiety that was eating the souls of these two irascible men.

It is curious that neither Johannes Vermeer himself nor any of the five children that he had procreated by this time (if my calculations are correct) were present in any of the repeated encounters between Willem Bolnes and his mother and sister, as they were recounted by the witnesses.

While we are in the realm of speculative history, it is worth observing that two of Vermeer's paintings represent apparently pregnant women: the *Woman in Blue Reading A Letter* (Fig. 29) and the *Woman Holding a Balance* (formerly called *The Woman Weighing Gold*, Fig. 30), which were both painted within a year or two of the incident with Willem (between 1662 and 1665). It is as if the artist had sought to celebrate and solemnize the state of childbearing in the face of earthly brutality.[22] Both may have ostensible religious or mystic significance (Mary, Mother of God; predestination versus Catholic doctrine; astrology and divination); but at a subconscious level, they may have been created as a reaction to the trauma of the threatened interruption of pregnancy.

Between the incidents related in the deposition and the young man's commitment to the house of Hermanus Taerling, Willem suffered an "accident" that had to be healed by a physician and a surgeon and that was serious enough for him to be sent to Dordrecht for the period of his cure.[23] The "accident" was probably a wound, a permissible interpretation of the word as it was used at the time. The bill for seventy-four guilders sent by Dr. Franco Beest and the surgeon Marcus Bres, the son of the friend and partner of Vermeer's uncle, Reynier Balthens, was large

[22] Nanette Salomon, in her persuasive article, "Vermeer and the Balance of Destiny," in *Essays in Northern European Art Presented to Egbert Haverkamp-Begemann* (Doornspijk: Davaco Publishers, 1983), p. 216, argues that the woman in *Woman Holding a Balance* (Fig. 30) is pregnant. Salomon makes the pregnancy an essential aspect of the religious iconography of the picture. (The critics who argue that the dresses worn by the women portrayed give them the false appearance of being pregnant have not provided convincing examples to buttress their point). However, one must recognize that Arthur Wheelock's interpretation of the picture also makes sense. He argues that "the balance denotes [the woman's] responsibility to weigh and balance her own actions." She must choose between worldly riches and the life of the spirit with an awareness of the final judgment that awaits her (see *Jan Vermeer*, p. 106). Finally, Ivan Gaskell has suggested that the painting may be an "Allegory of Truth." In Cesare Ripa's *Iconologia*, Truth, dressed in white with a golden wig, holds a mirror in her right hand and a balance in her left. (I. Gaskell, "Vermeer, Judgement, and Truth," *The Burlington Magazine* 126, no. 978 [September 1984]: 557–61.) E. de Jongh has discovered an etching of Jan Wierinx in which Truth is shown with some of Ripa's attributes, together with a scene of the Last Judgment in the background. Her balance, however, tips toward the left. In my view, the equipoise of Vermeer's balance, which Nanette Salomon is the only one so far to have proposed an explanation for, is the key to the iconography of the painting. (Gaskell's article and E. de Jongh's suggestions are taken up in A. Blankert's "L'Oeuvre de Vermeer dans son Temps," in A. G. Aillaud, A. Blankert, and J. M. Montias, *Vermeer* [Paris: Editions Hazan, 1986] 183–4.

[23] Doc. no. 300, 28 November or December 1664.

enough to suggest that the accident had been quite serious. The bill was paid by Maria Thins on Willem's behalf.

Anyone of course could have inflicted Willem's wound—if it was a wound. He might have suffered it in a fight in one of the inns that he frequented. It is also conceivable that he was wounded as a sequel to one of the episodes described in the above deposition.

Once Willem was confined to Taerling's house of correction, at a cost of 310 guilders a year, his mother proceeded to lay claim to the rents on his properties, some of which he had inherited from his uncle, Jan Thins.[24] In a petition to the aldermen, made toward the end of 1664, she declared that her son owned five morgen of land in the seigniory of Raasbergen and Berchambacht, a small farm in Schoonhoven, and eight and a half morgen of land in Gellekenes and the Barony of Liesvelt, of which three morgen were good osier lands. Some of the income from these properties had been assigned to her when she had lent Willem three hundred guilders, but in fact she had not received any of her due.

The inventory of Willem's movable possessions, which she adjoined to her petition, was meager. The bed he slept on belonged to Catharina Vermeer. He owned a bed cover, two blankets, a colored mantle, some linen and wool garments, together with other clothes packed in the trunk that he had taken with him to Taerling's house, and a pair of pistols. He owned two other mantles, which he had left as security with a certain "widow and innkeeper" in Liesvelt for 50 guilders that he owed her for drinks and other expenditures. Willem's debts, which were listed in full detail in the annex to the petition, included the 300 guilders he had owed his mother since January 1663; the rents on the osier lands that he had assigned to her which had not been paid; 150 guilders she had lent him in 1660 plus the interest accrued on the debt; 100 guilders that she had advanced him on income he was slated to receive from certain landed properties; 25 guilders that she had paid on his behalf to Jan Heyndricksz. van der Wiel, the husband of her half sister Maria Camerling, against a debt that he, Willem, owed him; various small debts for food and drink and for clothing, owed mainly in Schoonhoven; 74 guilders that were due Dr. Van Beest and Marcus Bres for curing him of his "accident"; 310 guilders for one year's pension at Taerling's house; 24 guilders for his stay in Dordrecht while he was recovering from the accident; 12 guilders for wine prescribed by Dr. Van Beest for the cure of Bolnes's accident paid to "mother Baltes," who was most probably Vermeer's mother Digna Baltens; and sundry minor debts that Maria had paid on his behalf. These claims added up to 1,502 guilders. She petitioned the aldermen of Delft to give her permission to lease his properties and to collect the rents in

[24] Ibid.

repayment of the money he owed her. Maria Thins's petition was approved, and on January 13, 1665, she was entrusted with the custody of her son's property.[25]

The next thing we hear of Willem is that he was betrothed in Waelwijck, a few miles from Delft, with a girl named Mary Gerrits (or Maria Gerardsdr.) van Veer. The banns were issued on May 23, 1666.[26] Before the three weeks were over that legally separated the issuing of the banns from the marriage, Maria Thins embarked on a campaign to prevent the marriage. The stakes were high. If Mary Gerrits had had a legitimate child by Willem Bolnes, a good deal of property descending from Jan and Cornelia Thins and even from Diewertje van Hensbeeck would eventually have fallen to his children. This would have been catastrophic for the Vermeers and their children, who would have had to give up one-half of the properties coming to them after Maria Thins's death. In addition to any financial motives Maria might have had for opposing the marriage, she must have found the prospect of having Mary Gerrits as a daughter-in-law abhorrent. The depositions she collected in the next two months reveal and explain her distaste.

On June 4, 1666, a certain Maertge Wouters and another illiterate woman bore witness at Maria Thins's request to the following facts.[27] They had frequented the house of Hermanus Taerling, where Mary Gerrits served as a housemaid. Maertge Wouters had heard from Mary Gerrits that she had a suitor in Waelwijck. The witness did not know the identity of the suitor, but the context of the documents suggests that it was Willem Bolnes. Mary Gerrits had also told her that his relatives were not willing to let her marry him. She and her suitor had thought up the idea that she would pretend that she had been made pregnant by him so that his relatives would consent to the marriage. "As evidence for this, she had for some time bound herself up with a cushion on her belly to induce these relatives to believe she was pregnant." The other witness said that she had heard in Waelwijck that Mary Gerrits was pregnant. She had met Mary in the church with her bosom quite loosely laced and looking so bulky that, to all appearance, she must be with child. But she had learned that this was only a pretense and that there was nothing to it.

Three weeks later, the widow of Antoni Taerling, former substitute sheriff, and the wife of Hermanus himself made their deposition. They claimed that Mary Gerrits, when she had first hired herself out as a servant in the house of Hermanus Taerling, had claimed she had previously

[25] Doc. no 372, 20 November 1676.

[26] Doc. no 302, 23 May 1666. The more common spelling of the young maid's Christian name is Maria, but I have chosen the name Mary to distinguish her from Vermeer's mother-in-law.

[27] Doc. no. 303, 4 June 1666.

worked for an attorney in Bommel but that her stepfather had called her back to her family in Waelwijck because her mother was about to have a child and needed a servant herself. She had left her parents' house because she could not stand the way her stepfather treated her mother and so had come to Delft to seek employment. After she had served in Taerling's house for less than a year, she had brought a certain man to the house, saying that he was from Bommel and that she intended to marry him. (Whoever this person was, it was not Willem, who was of course well known in the house.) Mary had asked her employers to give her leave to go to Waelwijck to see whether her parents would consent to the marriage. Maeyken Pieters, the wife of Hermanus Taerling, had acceded to her request. Whereupon it happened that on a certain Sunday morning Willem Bolnes, who was a "committed person" in the house, had gone to church with Mary Gerrits. She had come back alone. When her employers had insisted she must know something about Willem's absence, she had sworn with many an oath that she had not the least knowledge about it.

It was then discovered that Willem had packed his trunk and hauled it away that morning. Again Mary denied any knowledge of it. The two women were incredulous and dismissed her. She pleaded so vehemently, however, that they decided to keep her for the time being. The next day she pretended that she had received a letter from her suitor in Bommel announcing that he was coming over the third day of Easter and asking her to let him know whether her relatives consented to the marriage. She requested permission to speak to her relatives and left on Tuesday. On her return she informed Maeyken Pieters that her relatives did not consent to the marriage because the suitor was a man of no account, but that she would marry a cattleman from Waelwijck. In the meantime she was going to learn the trade of selling silk cloth in a shop so that she could become a shopkeeper after her marriage.

The second witness, Anetge Harmens, widow of the substitute sheriff Antoni Taerling, declared that she had put away on some straw under her bed a purse with a silver chain belonging to her sister-in-law Maeyken Pieters. She had done so in the presence of Mary Gerrits. It happened that on Monday, the day preceding Mary's departure, the laundry had been washed. On Wednesday, the women noticed that some of the laundry was missing. It occurred to Maeyken Pieters that her purse might have disappeared too. She went upstairs and found that the purse with a silver chain and clasp was indeed missing. To all appearances it had been taken by Mary, who was the only one who knew where it had been put away. The two witnesses then became aware that everything Mary had told them, from the beginning of the stay at their house, had been lie and pretense. She had not lived in Bommel but in The Hague, where she had "kept her hands busy" (presumably stealing). Not only did she lie about the cattle-

man whom she was going to marry, but she had intended to marry Wil-
lem Bolnes and had been sleeping with him for some time, as she herself
had owned.

On July 3, Maria Thins collected the deposition concerning her son's
assaults before he had been confined to Taerling's house.[28] On July 18 she
was back at the notary's.[29] This time it was Hermanus Taerling's turn to
depose on her behalf. He stated that he had heard Willem Bolnes say that
Mary Gerrits had told him eight or ten days before Easter that Taerling
had given an order that he, Willem Bolnes, who until then had been al-
lowed to go in and out, should be confined to the house again. On Sunday
before Easter, after Bolnes had gotten dressed for church, Mary had told
him that this was the right time to go away for, if he did not, he would be
set fast again (as he had been confined before in accord with the sentence
of the magistrates). Persuaded by her words, he had thrown his clothes
together and left the house with her. He had taken leave of her on a bridge
near the New Church. Later she had followed him to Gouda. There she
had asked him to marry her, saying that she had already spoken about it
with her relatives. She invited him to come to Waelwijck to see her family,
but when he arrived he found that her family had no knowledge of the
marriage or the courtship. Then he realized that though she was anxious
to marry him and he was inclined to marry her, he would eventually have
been deceived.

Bolnes also stated that Mary had said to him that money would have
to be obtained. He had said he knew where he could get his father's
mourning mantle. The two had decided to pawn it at the loan office. They
had sent a woman with the mantle who had come back with sixteen
guilders: five ducatoons in silver and five stuivers. Mary had given the
woman the five stuivers for her pains and had left with the five ducatoons.
When she returned, she had some new stockings on and a little gold ring.
Taerling further reported that Mary had informed Willem Bolnes's father
that she had received a writ from the magistrates allowing her to go and
visit Willem in Taerling's house any time she wanted to. Finally, the mas-
ter of the house of correction denied ever having given her an order to
confine Willem to the house and stated that she had coaxed Willem out
of the house on a false pretext. Nor had she ever come to the house or
asked him whether she could speak to Willem since her departure.

From this we gather that Willem, of his own volition or under duress,
had returned to the house of correction. The marriage had not taken
place. Yet Mary Gerrits was not satisfied to let matters stand. She sued
Maria Thins in the Court of Holland. On January 21, 1667, Maria

[28] See note 17 above.
[29] Doc. no. 306, 18 July 1666.

named an attorney to represent her in this suit and, if necessary, to appeal.[30] Two days later she induced "Willem Bolnes bachelor" to give a deposition that she could use in the defense of her suit.[31] Bolnes declared that when he was formerly confined to the house of Hermanus Taerling on order of his mother (as he was presently), he had had permission to go in and out, but Mary Gerrits had informed him that his mother had given orders to have him shut up. He had been sufficiently intimidated by this news that he had acceded to Mary's suggestion that he run away from the house and escape his mother's supervision. He went on to state that she had so far misled him that he had formed the intention of marrying her and, to this effect, had allowed the banns to be registered. His mother, having had intelligence of this project, had set herself in opposition. She had gathered attestations concerning Mary's wickedness and even obtained a confession of some thefts that Mary said were of little importance. He himself had come to feel in the course of frequenting Mary that she was of a wicked nature. Now that he was again subject to his mother's tutelage, he declared that he no longer had any thought of marrying Mary Gerrits and that he was thankful to his mother not only for dissuading him from such a course but for setting herself in oppostition and again bringing him under her discipline and government. Bolnes concluded by expressing his consent that an act in legal form be drawn up from his deposition. The document was witnessed by his keeper Hermanus Taerling.

As Maria Thins's relationship with her son suffered these vicissitudes, her confidence in Vermeer increased. In May 1667 she gave him power of attorney to act in her behalf to collect various debts due to her and to Willem Bolnes that she was authorized to collect.[32] One of these debtors was a man in Gouda named Pieter Crynen, who owed her three thousand guilders for a brickery she had sold him. Vermeer was given permission to do anything he thought fit to defend her interests, including the sale of assets belonging to her.

Even after Willem's defeat and humiliation had been consummated, Maria Thins continued to vent her wrath on him. In her previous testaments she had refrained from prejudicing Willem's interests. When she drafted her third testament in September 1667, for the first time before a Delft notary,[33] she made sure that Catharina and her children would inherit the bulk of her worldly possessions. First she stipulated that her son would only get his minimum legitimate share, amounting to one-sixth of the estate. Although she was not required by law to justify her decision to

[30] Doc. no. 307, 21 January 1667.
[31] Doc. no. 309, 23 Janaury 1667.
[32] Doc. no. 311, 10 May 1667.
[33] Doc. no. 313, 27 September 1667.

limit her son's share to the legal minimum, she explained, "in order to remove any erroneous presumptions," that her son, from his youth on, had behaved in a hostile way toward her, called her names, threatened her, and forced her to give him money to such an extent that she had been obliged to complain to their lordships the burgomasters and aldermen of this city, who had entrusted her with the administration of his possessions. After he had been confined for a few years, he had entreated her with promises of bettering his behavior, and she had permitted him now and then to go in and out of the house to which he had been committed. But he had so far forgotten himself that, having won the favor of a certain Mary Gerrits, a service maid in the house, he had packed his goods and run away. A few days later she, Mary Gerrits, had followed him. This Mary, "a notorious person and a thief," had attempted to marry him and to this end had published the banns. But with the help of their lordships, who were still mindful of the bad behavior of her son, she had put a stop to the project, after which Mary had initiated a suit against her in the Court of Holland.

Even though she, testatrix, had enough reason to disinherit her son, she had still opted to give him his legitimate portion as a proof of her motherly affection. Yet, to ensure that he should not dilapidate his estate, as she anticipted he would do if he were to become master of his possessions, she also willed that he be given the choice of drawing the usufruct and income of half the goods left after her death in lieu of his legitimate portion. If he were to choose the usufruct of half of her estate, a choice that must be made within six weeks after her death, the capital corresponding to this income would, after his death, revert to Catharina Bolnes, wife of Johannes Vermeer. Whether Willem chose the minimum share or half the usufruct, the Orphan Chamber of Delft or any other body their lordships might see fit to appoint would administer the assets. In either case, she earnestly recommended to their lordships that Willem be kept in his place of confinement or any other place they might deem more suitable, unless they and her closest relatives ascertained that his behavior and comportment had sufficiently improved to justify releasing him. But she also earnestly entrusted to their wisdom to keep a watchful eye on her son and, unless the conditions she had stipulated be fulfilled, "not to incline to release him." The old woman was so obsessed with her unruly son that she omitted any mention in her testament of routine bequests to relatives, servants, or charity. Neither did she recall the loan she had once made to Catharina and Vermeer or the silver and gold objects she had conditionally given to them.

On May 2, 1668, the suit before the Court of Holland was still pending when Maria Thins stirred herself to collect one more deposition for her

defense.[34] This time Maertge Wouters, the same witness who two years earlier had said that Mary Gerrits had pretended to be pregnant, declared that she had met Mary Gerrits in The Hague on the preceding Tuesday. Mary had entreated her, since she did the washing at the house of Hermanus Taerling, to tell Willem Bolnes not to worry, that she was trying to get him released from the house as soon as possible. She hoped this would occur within six weeks, but in case she was unsuccessful, he should endure his confinement for another year. Eight days later, Maertge was washing the clothes at Taerling's house and conveyed the message. Willem, however, said he had nothing to do with Mary Gerrits and that he would not marry her even if she did win the suit. The washerwoman then said that if she had known the message would not be welcomed, she would not have undertaken to convey it. If Mary Gerrits were to ask her again, she would tell her that Bolnes did not want her and that she should not make any effort to get him. Hearing this, Bolnes ordered her to give Mary Gerrits that message.

Hermanus Taerling and Maeyken Pieters also testified at Maria Thins's request. Maeyken Pieters declared that she had also been present when Willem Bolnes had told Maertge Wouters that he did not wish to marry Mary Gerrits and had ordered her to convey this message to Mary. Taerling said that when he had told Bolnes that Mary Gerrits was still trying to marry him, Bolnes had answered that "if he were given the choice, he would rather have a millstone around his neck and be thrown into the sea than to marry her." He knew what it had been like when they were betrothed and he judged it would be worse if they were married, and that "she would not marry him except for his money, and when she had gone through his money, she would put horns on him" (by which he meant that she would cuckold him).

Two months later, on July 31, 1668, the Court of Holland issued its interlocutory or temporary sentence.[35] The judges, having heard the oral pleas and examined the arguments both in the suit brought by Maria Thins against Mary Gerrits and in the countersuit brought by Mary Gerrits against Maria Thins, ordered the two parties to address their suit, reply, and rejoinder in writing. It condemned the defendant in the original suit (Mary Gerrits) to pay court costs amounting to thirty-two guilders. It is not known whether Mary or her parents were able to pay this fairly substantial sum of money, let alone to pursue her countersuit. In any case, as far as we are aware, the girl from Waelwijck now desisted from all further efforts to capture Maria Thins's errant son.

This is the last we hear of Willem Bolnes. The ill-starred scion of a

[34] Doc. no. 317, 2 May 1668.
[35] Doc. no. 319, 31 July 1668.

patrician family died a few months after Johannes Vermeer. He was still
a bachelor and still presumably confined to the house of Taerling (al-
though his body was carried to the grave from Maria Thins's house on
the Oude Langendijck.) He was buried on March 23, 1676, in the tomb
that his mother had purchased fifteen years earlier.[36] Maria Thins, who
was then over eighty, survived him by four years.

[36] Doc. no. 365 of 23 March 1676. Willem's address in the burial records of the Old
Church was given as the Oude Langendijk on the corner of the Molenpoort.

THE MATURE ARTIST

Ever since the powder explosion of 1654 which had caused the death of
Carel Fabritius, Delft's community of artists had been shrinking. Many
painters had left town, most to settle in Amsterdam, some in The Hague.
Willem van Aelst, who painted still lifes, Emanuel de Witte (church inte-
riors), and Pieter de Hooch (genre paintings) were the most outstanding
of the group that migrated to the great emporium to the north. Jan Steen
and Adam Pynacker no longer stayed from time to time in Delft as they
had done in the early 1650s. The only painter of note to migrate to Delft
in that decade was Abraham van Beyeren, who registered in the guild in
1657 and stayed there a few years before returning to The Hague in the
early 1660s. Cornelis de Man returned to Delft after a long absence spent
traveling in France and Italy in the 1640s and early 1650s. The older
generation of Delft painters—Balthasar van der Ast, Willem van den Bun-
del, Jacob Pynas—was dying out. The survivors—Antony Palamedes,
Leonaert Bramer, Cornelis Rietwijck—were constantly called upon to be-
come headmen of St. Luke's Guild because there were hardly any quali-
fied younger people left to take their place. The guild had even been
obliged to choose Pieter Bronckhorst as headman in 1655 and Willem
Ploij in 1656. Bronckhorst was sixty-seven years old, Ploij seventy-two.
Guild members for four decades, they had pursued careers of self-effacing
mediocrity. It is not so much a credit to Vermeer's precocity as a sign of
the decline of Delft as an artistic center that he was elected headman at
the age of thirty, in the fall of 1662. He was the youngest artist to become
a guild officer since the guild had been reorganized in 1611. Newly dis-
covered evidence suggests that Vermeer continued to take an active part
in the guild after his two-year stint as headman.[1]

Despite its decline, Delft remained an important city of passage that
many artists occasionally visited. It contained many fine collections that
a local painter could easily have access to. And if he wanted more stimu-
lation, he could always take a seat in an inexpensive horse-towed barge
and glide in comfort to The Hague, Amsterdam, Leyden, or Rotterdam,
which he would reach in less than a day. All the major towns of Holland
were connected through a dense network of canals, along which barges
traveled back and forth according to a tightly ordained schedule.[2] Ease of
travel helped to keep the country ideologically and artistically compact.

[1] J. Stokman deduces from a comparison of Vermeer's signature with entries in the Master
Book of the Guild of St. Luke between 1663 and 1671 that Vermeer registered many new
masters in his own hand in this period (*N.R.C. Handelsblad* 4 February 1988). He again
became headman in 1671.

[2] On transportation by canal in Holland, see Jan de Vries, "Barges and Capitalism: Pas-

The artistic traffic was intense both during Delft's heyday as a *ville d'art* and afterward. Many out-of-town artists left a trace of their presence when they signed as witnesses at a local notary's office.[3] Ter Borch, as we saw in Chapter 8, suddenly appeared in Delft in March 1653, coming from some other undetermined place of residence; Moses van Uyttenbroek and Jan Baptista van Fornenburgh visited from The Hague, Pieter de Grebber from Haarlem. The excellent seascape painter Simon de Vlieger departed for Amsterdam in the late 1630's but delivered tapestry cartoons to the municipality of Delft in 1640 and 1641. Pieter de Hooch, who had also migrated to Amsterdam in the late 1650s, came back for at least one visit in 1663. There must have been other visitors who had other things to do while they were in town rather than witness deeds. It is hard to believe, for instance, that Nicolaes Maes and Samuel van Hoogstraten, who both lived in Dordrecht in the 1650s, did not once stop over in Delft on their way to The Hague or Amsterdam, perhaps to talk shop with Carel Fabritius who, like them, had once been a pupil of Rembrandt or, after Fabritius's death, to fraternize with other member of the artists' community. Maes had anticipated De Hooch's achievements of the 1650s in rendering realistic interior scenes with finely modulated contrasts of light and dark. Van Hoogstraten seems to have been the first to do trompe l'oeil paintings. Along with Fabritius he also constructed peep shows in boxes in which illusionistic scenes could be viewed in perspective through a small opening. Two heads ("tronien") by Van Hoogstraten were found in Vermeer's death inventory. Vermeer must also have seen the works of Maes, some features of which became part of the visual vocabulary of the Delft School.

With the exception of other artists in the guild with whom he had to maintain professional ties, there is little evidence to show that Vermeer entertained close contacts beyond the relatively segregated Papist's Corner, where he lived, condemned as a consequence of his Catholic marriage (and probable conversion to Catholicism) to second-class citizenship in a Protestant-dominated city. In the entire period of Vermeer's maturity, no document directly linking him with his patron Pieter Claesz. van Ruijven can be cited—even though he was close enough to the Van Ruijven family to be given a conditional bequest of five hundred guilders in the will of Pieter Claesz.'s wife, Maria de Knuijt, in 1665.[4] About the only contact with fellow citizens that can be documented in the early 1660s is the curious case in which he guaranteed a loan of seventy-eight guilders that Cle-

senger Transportation in the Dutch Economy, 1631–1839," *Bijdragen*, Afdeling Agrarische Geschiedenis, Landbouwhogeschool, Wageningen 21 (1978): 33–361.
 [3] Montias, *Artists and Artisans*, p. 331.
 [4] See Chapter 13. See also note 23 of Chapter 11.

ment van Sorgen owed to Philips van der Bilt.[5] When Clement van Sorgen, after losing his first wife, married Machtelt Dircks van der Dussen, an heiress of one of Delft's most distinguished families in 1640, he was, to all appearances, a rich man.[6] He must have been a close friend of Philips van der Bilt, from whom he had borrowed the money, since he appeared as a witness at the baptism of two of Philips's children in the late 1650s. (He was probably the godfather of the first child.)[7] Why he should have borrowed a mere seventy-eight guilders from Van der Bilt, for which he had to give as collateral two Japanese kimonos, is very puzzling. So is the need for these two apparent friends, who were surely Protestants, to bring in Vermeer, almost certainly Catholic by this time and probably less well off financially than either the lender or borrower, to guarantee the loan. Was Van Sorgen or Van der Bilt a patron of Vermeer? It is hard to think of any other relationship he might have had with these well-heeled burghers. In any case, the guarantee did not turn out to be financially onerous for the Vermeer family. Within less than a month he was discharged of his obligation.

We do not have any evidence of Vermeer's contacts with his own family after his marriage. His name does not appear in any surviving document concerning his mother's affairs—not even the record of the unsuccessful attempt to sell Mechelen in 1669.[8] It was no doubt for religious reasons that he failed to attend the baptisms of family members. When Beyken van der Wiel, his sister Gertruy's child, was christened in May 1654, for instance, his mother Digna Baltens witnessed the ceremony and probably acted as godmother,[9] but Vermeer was absent. In contrast, we find the name of his aunt, Adriaentge Claes, the half sister of his father Reynier Jansz., frequently associated with those of her brother-in-law Jan Heymensz. van der Hoeve and of his nephew Heymen van der Hoeve.[10] Yet

[5] Doc. no. 288, 10 December 1661 and 4 January 1662.

[6] The marriage contract between Clement van Sorgen and Machtelt van der Dussen, dated 19 July 1640, specified that if he were to die first, ten thousand guilders out of the bride's ready assets would be returned to her heirs (Delft G.A., records of Notary G. van der Wiel, no. 1960, fol. 37). She died in March 1644 (Delft G. A., Burials files). It is of course possible that Van Sorgen fell into financial difficulties after her death.

[7] At the baptism in the Old Church of Cornelia van der Bilt, the daughter of Philips van der Bilt and Helena van Straten, on 14 November 1656, Clement and Catharijna van Sorgen were the only witnesses (Delft G.A., Old Church, Baptism files). I infer from the baptisms in the Old Church that Van Sorgen and Van der Bilt were both Protestant. (I have not found any examples of an individual known to be Catholic from independent evidence who baptized one of his or her children in the Old or the New Church or who acted as witness at such a ceremony.)

[8] Doc. no. 329, 2 January 1669. Note, however, that Maria Thins had ordered wine from "mother Baltes"—most probably Vermeer's mother—as medicine for her son Willem after his "accident" (doc. no. 300, 28 November or December 1664).

[9] Doc. no. 260, 17 May 1654.

[10] See, for example, doc. no. 275, 16 May 1660 (concerning a family inheritance) and doc. no. 276, 1 July 1660 (the baptism of a child of Heymen van der Hoeve).

Vermeer must have at least had some professional contact with Heymen van der Hoeve, who had joined the Guild of St. Luke in June 1661, a year before the artist became headman.[11] To be sure, the generation of Vermeer's parents was dying out. Dirck Claesz. van der Minne, his father's half brother, had died in 1657. Both the baker Jan Heymensz. and his wife Maertge Jans (Vermeer's aunt and probably his godmother) died in 1661.[12] But Adriaentge Claes was still alive, and Vermeer had a number of first and second cousins that he could have frequented.[13] If he did so, no trace of these contacts has been preserved.

That Vermeer was beginning to distance himself from his familial past may also be seen in his apparent failure to name any of his children after his mother or his father, as was the common practice at the time, both in Protestant and in Catholic families. His first two daughters, born before 1658, were named Maria and Elisabeth, after his mother-in-law and her sister. His oldest son was christened Johannes, his next-to-last child Ignatius, presumably after the founder of the Society of Jesus, Ignatius de Loyola; a third son was named Franciscus.[14] His other daughters were Aleydis or Alida (after Aleydis van Rosendael), Gertruyd (after his sister), Catharina (after his wife), and Beatrix (possibly after his grandmother Beatrix van Buy). If there was a Reynier or a Digna, the name has not come down to us. Only the fact that Vermeer displayed the portraits of his father and mother in the great hall of Maria Thins's home until his death keeps me from concluding from all this negative evidence that he had altogether rejected his Calvinist family.

We do have two notarial acts to show that Vermeer was in contact with at least some members of his wife's family.

The first act concerned the Juffrouwen Aleydis Magdalena and Cornelia Clementia van Rosendael, who by this time were living in The Hague.

[11] Doc. no. 385, 27 June 1661.

[12] On Dirck Claesz., see doc. no. 270. Jan Heymensz. van der Hoeve was still alive on 21 April 1661 when he transferred some of his household goods and business inventory, including bakery goods, to his son, Jan Jansz. van der Hoeve, to compensate him for a guarantee on a debt of three hundred guilders that he, Jan Heymensz., had incurred (Delft G.A., records of Notary N. Vrijenbergh, no. 258). It appears from this document that Jan Heymensz.'s financial conditions had deteriorated by this time. He must have died in the next five months since, when his wife Maertge Jans was buried on 30 September, she was called a widow (doc. no. 287).

[13] Adriaentge Claes, together with her three unmarried daughters, Annetgen, Francyntgen, and Neltgen, continued to run her pigs' tripe business, at least until the beginning of the 1670s (doc. no. 328, 30 January 1670). Her two other children, Tryntgen and Theunis, had died before 1668 (doc. no. 321, 7 October 1668). Vermeer's other first cousins in Delft were the children of Jan Heymensz. van der Hoeve and Maertge Jans, of Anthony Jansz. Vermeer and Tryntje Isbrandtsdr., and of Dirck Claesz. van der Minnne and Trijntge Cornelis. The second cousin who seemed to be closest to the rest of the family was Heymen Gysbrechtsz. van der Hoeve, the son of Gysbrecht, the brother of Jan Heymensz. van der Hoeve.

[14] On Ignatius and Franciscus Vermeer, see Chapter 12.

We recall that their grandfather Jan Geensz. Thins, the cousin of Maria
Thins, had died in Gouda in 1647. It would seem that they had inherited
a good deal of money both from Jan Geensz., via their mother Clementia
Thins, and from their father, the attorney Jacob van Rosendael, who died
soon thereafter.[15] On January 22, 1667, the Rosendael sisters drew up a
procuration in The Hague on behalf of heer Michiel van Diest, captain of
the militia and merchant in Rotterdam, to settle a dispute that they had
had with another merchant in Rotterdam concerning the sale of some
property. Johannes Vermeer signed the procuration.[16] A few months later
the sisters sold to Dirck de Cock a grave in the St. Jacob Church in The
Hague. The sale of the grave, assuming that it had originally been bought
for either Aleydis or Cornelia, suggests that they might already have
planned to finish out their days and be buried in Delft, as at least one, and
probably both of them, eventually did.[17] How wealthy the two spinsters
were emerges from the contract for the sale of a house in the Nobelstraet
bought in 1670 by Johan Stalpaert van der Wijelen (1639–1683), a doc-
tor of medicine and professor of surgery, for fourteen thousand guilders.
The sale of this house, which must have been one of the finest residences
in The Hague, was made in the presence of a burgomaster of The Hague
and of an alderman related to the buyer.[18] Beginning in 1676, a few
months after Vermeer's death, we shall find Maria Thins in constant
touch with the Rosendael sisters, who took a compassionate interest in
the fate of the artist's widow and children.

The second act witnessed by Vermeer in 1667 concerns Jan Hen-
dricksz. van der Wiel, who had married Maria Camerling, the half sister
of Maria Thins. Attorney Van der Wiel was named executor of the will
of Annetge Jans, a spinster who lived in the Papists' Corner.[19] Among
many bequests, the testatrix, who was said to be "very well known to the
witnesses," left 3 guilders 3 stuivers to Margareta Huybrechts, a book-
seller living on the Oude Langendijck, and 10 guilders to Tryntge Dav-
idsdr., living in the beguinage or "begijnhof." The painter, who was re-
ferred to as "Johannes van der Meer artful painter," signed Johannes
Vermeer. It may be noted that both Van der Wiel and the Catholic notary
Cornelis Bleiswijck, before whom the testament was passed, lived in the

[15] See the testament of Aleydis van Rosendael of 10 November 1651 (The Hague G.A.,
records of Notary P. van Groeneweghen, no. 80, fol. 474).
[16] Doc. no. 308, 22 January 1667.
[17] The sale of the grave on 22 November 1667 is recorded in The Hague G.A., records of
Notary J. Vos, no. 348, fol. 210. Both Aleydis and Cornelia van Rosendael lived for many
years in Delft, beginning in 1678 (doc. no. 397), but only Cornelia is known to have died
and been buried there (doc. no. 441, 21 January 1700).
[18] The Hague G.A., records of Notary C. van der Hooch, no. 304, fol. 22, 17 March
1670.
[19] Doc. no. 314, 3 October 1667.

Pieter Gerrits Straat, which was the next street perpendicular to the Oude Langendijck to the west of the Molenpoort (Fig. 31).

To place Vermeer's milieu in clearer focus, I need to describe in greater detail the Catholic neighborhood where the artist dwelt. The house inhabited by Maria Thins on the corner of the Oude Langendijck and the Molenpoort was almost certainly the one bought by her cousin Jan Geensz. Thins in 1641. It stood on the eastern corner of the Molenpoort on a site at present occupied by the St. Joseph Catholic Church.[20] I suspect that cousin Thins had bought in on behalf of the Jesuits and for their profit (in which case Maria Thins paid them the rental money for the house). Jan Geensz. may even have been given the money by the Jesuits to purchase it and only lent his name to the contract. What gives this suggestion some plausibility is that two years after the transaction had taken place, in 1643, the town authorities complained about the Jesuits' illegal purchases of houses.[21] By 1686, but undoubtedly already much earlier, the Jesuits owned a substantial part of the Papists' Corner, as a memorandum written by one of them testifies. Fifteen houses were cited in this "Memoire Regarding the Houses of the [Jesuit] Station in Delft."[22]

[20] According to the records of the "Huizenprotocol" (Delft G.A., fol. 325v and 326) the two houses west of the Molenpoort, moving in the eastward direction, belonged to Cornelis van der Prins (later to the sculptor Adriaen Samuels) and Simon van Slingelant. The next house, belonging to Maria Willems, widow of Hendrick Claes, was probably in the Molenpoort. The next was the house of "Jan Thins in Gouda," which was then almost surely on the eastern corner. The three houses that followed were registered in the name of heer Georgius van der Velde. After that came the house of Jonckheer Lambrecht van der Horst and finally the brewery "In't heck" of Pieter Ghysenburch. The sequence of houses from west to east, starting with the house of Jan Thins and going on the three houses of Van der Velde, is confirmed by the "Verponding Boek" of 1638 (Delft G.A., fols. 93–95). It is contradicted, however, by two contracts of April and December 1641 (doc. nos. 160 and 166), when the sequence is reversed (i.e., the Thins house seems to lie to the east of the houses sold to Georgius van de Velde). The Huizenprotocol sequence is so explicit, however, that I am inclined to accept it and to conclude the notary was in error.

My conclusion on the location of Jan Thins's house was first reached by A.J.J.M. van Peer through a different route. He pointed out that the house sold to Jan Thins in 1641 extended southward to the back of the houses of Ghijsbrecht van Berensteijn and Jan Claes (Swiss), mason (doc. no 160). But Berensteijn's house, which in the eighteenth century became a home for mentally ill women, is known to have been located on the eastern corner of the Molenpoort and of the Burgwal (the extension of the Peat Market). Hence Jan Thins's house must also have been on the east side of the Molenpoort (Van Peer, "Jan Vermeer van Delft: Drie archiefvondsten," *Oud Holland* 83 [1968]: p. 223).

The house on the eastern corner of the Molenpoort portrayed in the "Caert figuratyf" of 1675–1678 (Fig. 31) had its long side facing the Molenpoort and its short side facing the Oude Langendijck. If the room in which Vermeer painted really had three windows as Swillens claims (Swillens, *Johannes Vermeer*, pp. 116–119), it could only have faced west. We do not know, however, how accurately the houses of the "Caert figuratyf" were drawn. Finally, it should be observed that the post of the wooden gate that closed off the Molenpoort (cited in a petition to the Lord Burgomasters of Delft of 13 November 1735) must have been attached to the northern end of the Thins house.

[21] See Chapter 8 at note 5.

[22] This "Memorie van de huizen der Statie van Delft, anno 1686" is cited in Van Hoeck, "De Jesuïeten-statie," pp. 443–44.

One of these was the church itself and another the Jesuit school, neither of which of course produced any rents. The thirteen other houses—all located on the Oude Langendijck and the Burgwal (or Peat Market) near the Molenpoort—yielded 607 guilders a year. One of the houses listed in the Memorandum, which lay at the southwestern corner of the Molenpoort on the Peat Market, was said to be "in the name of Adriaen Pietersz. Vreem," a pillar of both the Jesuits' church and of the begijnhof. The rental for this house, which amounted to fifty guilders a year, was earmarked for distribution to the poor. Several houses, including the church and the school and a house in between, were said to be in the name of Jonckheer Lambert van der Horst, a Catholic aristocrat living in Ryswijck.[23] Two dwelling homes and some small warehouses appeared in the name of the widow Van Nerven, born Machtelt van Best van Heemskerck, about whom more will be said presently. The house of Maria Thomas was rented for fifty guilders a year. This was probably the same person, later called Maijke Thomas, who had bought an interest-bearing obligation in 1642 that was transferred to Maria Thins and many years later sold by Vermeer.[24]

From the "Huizenprotocol," the municipal list of built-up properties, and from the memorandum, one can tentatively infer that the church was located just to the east of the Thins house. Next to the east came a little house, which was rented to a certain Polpje in 1686, and then the Jesuit school. In Figure 32, which shows the Jesuit church in the early eighteenth century, the houses represented going from left to right would be the school, the Polpje house, the church, and, seen partially on the edge of the drawing, the Thins house (or possibly the one just to the west of it, beyond the edge of the drawing). The church with its two doors consisted of an older structure on the left, said to be twenty-five feet wide, and an addition on the right built in 1678 that measured eighteen feet.[25] The relative widths of the two structures under one roof shown in Figure 32 correspond approximately to these known dimensions. The older struc-

[23] Lambert van der Horst was the grandson of Reijer Lambertsz. van der Horst, a prominent member of the Amsterdam "vroedschap" (town council) before the Alteration who refused to assume any municipal function after the Calvinists took over the city administration in 1578 (S.A.C. Dudok van Heel, "Waar waren de Amsterdamse Katholieken in de zomer van 1585? Enkele aantekeningen van het kohier van 1585," *Jaarboek Amstelodamum* 77 [1985]: 31).

[24] Doc. no. 334, 21 July 1673.

[25] Van Berckel, "Priesters te Delft," p. 259. The conjectural identification of the houses in the text leaves one loose end: from the "Huizenprotocol," we should have expected the school to belong to Jonckheer van der Horst, whereas the Polpje house and the church were owned by Van der Velde. It is not clear why, by 1686, when the memorandum was made, all three houses had come to be owned or "be in the name of" Van der Horst. From the text below, it would appear that Van der Velde still owned the house where Jesuit priests resided, thus presumably the church or a house next to it, in 1663.

ture may have stood a short distance to the east of the Thins house in the 1660s.

Machtelt van Best lived on the Oude Langendijck near the western corner of the Molenpoort in one of several houses she had bought in the neighborhood in 1653,[26] after receiving a large amount of property from the wealthy Haarlem attorney Georgius van der Velde, the brother of Heyndrick van der Velde, who had sold the house bought by Jan Gecnsz. Thins in 1641 and who owned two more houses next to it. I do not know what family relationship there existed between Georgius van der Velde and Machtelt van Best, but it must have been a close one since she seems to have shared most of the inheritance with his widow, including an important collection of paintings. Her lot had in it several fairly expensive pictures by Cornelis van Haarlem and drawings by Goltzius as well as landscapes and still lifes by well-known Haarlem artists. There were also some typical Catholic devotional pictures or sculptures, such as a Crucifixion with a standing Christ and a Virgin Mary.[27] If, as I surmise, she took the collection to Delft, it is very likely that her neighbor Vermeer was familiar with it. (Machtelt van Best lived as an old woman on the Oude Langendijck at least until 1677.)[28]

Among other neighbors of the Thins-Vermeer household, two other women should be mentioned. The first was Annitge Thomas van Aeckel, who taught school. Dirck de Cocq, the apothecary to whom Vermeer owed 6 guilders 13 stuivers for medicine in 1663, was apparently Catholic, like most of his clients.[29] I tentatively infer from the fact that De Cocq owed Annitge Thomas school money that she too was Catholic, perhaps the teacher in the Jesuit school for girls.[30] To defend her good name, she

[26] On 5 June 1653, Machtelt van Best acknowledged a debt of 1,800 guilders to the children of Cornelis Jansz. van Swieten for the purchase of two houses lying next to each other under one roof on the Oude Langendijck (Delft G.A., records of Notary J. van Ophoven, no. 1951).

[27] Doc. no. 241, 27 August 1652.

[28] A document of 1 January 1670 (Delft G.A., records of Notary F. van Hurck, no. 2101) refers to the settlement of a long-standing dispute between Machtelt van Best and the sculptor Adriaen Samuels (and later his widow Cornelia Dirxdr.) concerning the access that Samuels and his wife claimed to the Molenpoort through a path that crossed a courtyard in the back of Machtelt van Best's house. In her testament of 28 June 1677 (Delft G.A., records of Notary C. Bleiswijck, no. 1917), she refers to her two houses on the Oude Langendijck "extending from the Oude Langendijck to the Burchwal, otherwise called Peat Market."

[29] Doc. no. 297, 9 February 1664.

[30] On 12 May 1637, various witnesses, including Margrita Gerrits Kamerlinx, who was distantly related to Maria Gerrits Camerling, the half sister of Maria Thins, testified that a certain Anna Jansdr. had come to live with Hendrick Jacobsz. van der Velde to set up a school in which "young girls" could learn a handicraft, but had never done so (Delft G.A., records of Notary C. Bleiswijck, no. 1901). It is doubtful whether Anna Jansdr. is the person of that name who made out the will witnessed by Vermeer (doc. no. 314), because this testatrix was illiterate. Some sort of Jesuit School was definitely established in later years (Van Hoeck, "De Jezuiëten-statie," p. 443).

once requested some witnesses to testify against the apprentice sculptor Gerrit Cornelisz., who was working for the widow of the master sculptor Adriaen Samuels, for insulting her as a drunken whore and a thief.[31] (This same Gerrit Cornelisz. had testified about Willem Bolnes's assaults on Maria Thins and Catharina Bolnes a year earlier.)[32] The other woman of consequence was the bookseller Margareta Huybrechts, mentioned in the testament of Annetge Jans. The books listed in her death inventory, drawn up in 1671, included, in addition to a host of devotional Catholic works ("The Life of St. Theresa," "The Book of Catholic Martyrs," "A Sermon of Sasbout [Vosmaer]"), items that would have been useful to a painter like Vermeer, such as Giacomo Vignola's "[Le due regole di] prospettiva," Jacob Hoefnagel's "Archetypa [studiaque Patris G. Hoefnagli]," G. Rollenhagen's "Niclasius Emblematicus," and an Italian book of geometry. One client who owed her a small amount for books was "Juffr. Alides van Rosendael living in The Hague." Another was a certain Cornelia Vermeer, who may have been one of Vermeer's children.[33]

Heijndrick van der Velde (or den Velden) was probably the most active layperson in the Catholic Community, at least in that part of it which sided with the Jesuits. In 1637 he addressed a letter in Latin concerning the problems of the Catholics in Delft to some unidentified Church authority. The letter was cosigned by Adriaen Vreem, the other pillar of the community who lived on the southwestern side of the Molenpoort.[34] In 1659, together with the sculptor Adriaen Samuels, Van der Velde certified that a certain individual had been married by a Roman Catholic priest. The certification was made because the priest, owing to the repression to which the Church was subject, "could not himself make a declaration" to this effect."[35] Van der Velde, who was said to be "much beloved" by the Catholic Community,[36] must have been of great assistance to the Jesuits if he could perform on their behalf activities from which they were normally barred. In the light of all this evidence, it is not surprising to learn that when the Jesuit priest Balthasar van der Beke was "admitted"

[31] Delft G.A., record of Notary N. Vrijenbergh, no. 2064, 16 August 1667.

[32] Doc. no. 305, 3 July 1666.

[33] Delft G.A., records of Notary R. van Edenburgh, 19 June 1671, act 19. Note that if the Cornelia Vermeer who owed 2 guilders 6 stuivers was a daughter of the painter, she would not have been older than thirteen years old when the inventory was taken (since she had to be born after Elisabeth, who was probably born in the latter half of 1657). It is quite possible that the child was sent by her parents to buy books on their behalf and that small amounts were recorded in the bookseller's register in her name. An argument that adds a little weight to this conjecture is that we should have expected some child of Vermeer to have been named Cornelia: after Catharina Bolnes's own sister or her mother's sister, after Cornelia Clementia van Rosendael, or possibly even after grandmother Neeltge Goris.

[34] Van Hoeck, "De Jesuiëten-statie," p. 443; Vreem and Van der Velde complained about the secular priests in Delft.

[35] Delft G.A., records of Notary C. Bleiswijck, no. 1901, 29 October 1659.

[36] Delft G.A., records of Notary C. Bleiswijck, no. 1901, 29 September 1642.

by the city magistrates on August 10, 1663, he was said to be lodging "at the house of Van der Velde."[37]

The day after Balthasar van der Beke was officially admitted to serve in Delft, the Frenchman Balthasar de Monconys visited here for the second time.[38] Less than a week earlier he had made a first visit strictly as a tourist, that took in the principal sights but did not include personal calls. He had then gone to The Hague where he heard "le Père Léon," the almoner of the French Embassy, give a sermon and dined with him on a couple of occasions. When he took the barge from The Hague to Delft the second time, he was accompanied by Father Léon and another Catholic named Lieutenant Colonel Gentillo. On the short journey to Delft, Gentillo told his fellow travelers that a statue of the Virgin was kept on view in a Protestant church in Breda, even though such objects of Catholic worship had been thrown out or were kept out of sight in most Protestant churches. The reason for this exception was that Philip of Nassau, the brother of the Stadhouders Maurice and Frederik Hendrik, had been brought up a Catholic and had specified in his will that he wished the statue to be displayed. In Delft, which the three men visited only for one afternoon, Monsieur de Monconys called on Vermeer, who had no paintings of his own to show him. But "we"—meaning presumably Monconys, Father Léon, and Gentillo—"then saw one at the baker's." This baker, as has long been recognized, was almost surely Hendrick van Buyten, who was later to play a prominent role in the settlement of Vermeer's estate and actually owned three paintings by Vermeer at the time of his death in 1701.[39] The baker showed the visitors a painting by Vermeer of a single figure, for which he said "had been paid 600 livres" (probably six hundred guilders). The diary does not explain whether that exorbitant price had been paid by him or by someone else. Monconys opined that he would have thought he had overpaid for it had he bought it for six pistoles (sixty guilders).[40]

Monconys, brought up in Lyon by the Jesuits and a good Catholic, had an interest in the Jesuit missions in infidel territory. He had already visited

[37] Van Berckel, "Priesters te Delft," p. 237. Balthasar van der Beke was admitted as a "secular priest" ("wereltlijck priester"), a transparent fiction that the authorities chose to accept.
[38] Doc. no. 294, 11 August 1667; and Balthazar de Monconys, Journal de voyage de Monsieur de Monconys, 2 vols. (Lyon: H. Boissart et G. Remens, 1666), 2: 136, 147–49.
[39] Doc. no. 439, 1 July 1701.
[40] Otto Naumann, in his comments on this chapter, suggested that the baker might have lied about the price, "hoping to sell the painting to an ignorant foreigner." De Monconys may well have been correct when he estimated the price of a single-figure painting by Vermeer at only sixty guilders. This would seem to be more in line with the prices of the 1696 sale (doc. no. 439). On Monconys's use of the word "livres" and its probable equivalence to Dutch guilders, see Naumann, Frans van Mieris the Elder, 2: 26–29.

a "hidden church" in Rotterdam. Father Léon[41] was almost certainly a priest of the Carmelite Order who had been born Leo Maes in Brussels and took the name Leo a S. Laurentio (de St. Laurence) when he entered the order in 1648. He was a famous preacher: several of his sermons were published in the seventeenth and eighteenth centuries.[42] As a Carmelite, he stood under special protection of the French Ambassador. The year he met Vermeer—1663—was the last of his stay in The Hague, which he left to become "Prieur" in Louvain. Of the three travelers to Delft on August 11, he was presumably the only one who knew both Dutch and French and could interpret for Monconys. (I do not suppose that either Vermeer or Van Buyten could speak French.)

Monconys may have returned to Delft to accompany Father Léon on his visit to the Papists' Corner.[43] It is likely that Father Léon wished to welcome the newly accredited Van der Beke. By going along on the trip, Monconys could simultaneously satisfy his curiosity about another hidden church and meet an artist with a growing reputation.

Monconys's observation that Vermeer had no paintings to show him would seem to imply that the artist had no stock in trade. Unlike many other Dutch painters of the period who produced "on spec" and kept at least some of their works in their atelier in the expectation that clients and visitors would choose and buy those they liked from the available stock, Vermeer by this time probably worked mainly on commissions or at least on paintings he thought he had a good chance to sell to one of his clients or patrons. As I shall attempt to show below,[44] he painted so slowly—completing only two to three paintings a year—that he could not operate like many of his contemporaries, who had enough paintings on hand to garnish their walls. In this respect, as well as in some others, he resembled Gerard Dou, Frans van Mieris, and the other "fine painters" of his day who also worked mainly on commission.[45]

Vermeer, even if he was spiritually retired from the world, still had to sell his paintings to supplement the income that he and Catharina were getting from Maria Thins. We have seen that one of his works, "The Visit

[41] For the identification of Father Léon, I am obliged to Brother Philippe Hugeli of the Couvent des Carmes in Avon, France, and to Father J.T.P. Barten, S.J., archivist of the Dutch Jesuit Province.

[42] P. Irenaeus, *Biografisch overzicht van de vroomheid in de Nederlandse Carmel* (Tiel: Drukkerij-uitgeverij Lannoo, 1950), pp. 142–43.

[43] Elisabeth Neurdenburgh was the first to point out the significance of a previous visit, but she was not able to explain why Monconys returned to Delft. She did argue convincingly, though, that if Vermeer's fame had earlier reached Moncony's ears, he would have called on him the first time ("Noch enige opmerkingen over Johannes Vermeer van Delft," *Oud Holland* 66 [1951]: 34–35, 40).

[44] At note 52 and Appendix A.

[45] For a more systematic development of this idea, see my article "Cost and Value in 17th-Century Dutch Art," *Art History* 10 (December 1987).

to the Tomb," was estimated at twenty guilders in the estate of the dealer Johannes Renialme, who died in 1657.[46] In the estate inventory of an innkeeper named Cornelis de Helt who died in May 1661, the first item listed, which hung in the front hall, was "a painting in a black frame by Jan van der Meer."[47] The artist was almost certainly Johannes Vermeer. (The other Jan van der Meer, a landscape painter in Haarlem, was virtually unknown in Delft.) When the painting was sold at the estate auction it brought 20 guilders 10 stuivers, more than any other attributed painting in the sale. Finally a "face by Vermeer," estimated at only ten guilders, appeared in the death inventory of the sculptor Johannes Larson in The Hague who died in 1664.[48] Since Larson had business in Delft in 1660,[49] I suppose that he had bought the painting at that time, perhaps from Vermeer himself. The prices of all the three pictures for which we have estimates were low, relative to prices Vermeer obtained in later years or those his paintings brought at auction in Amsterdam in 1696. It is remarkable that the *Girl Asleep at a Table* and *The Officer and the Laughing Girl*, which have both been dated by major writers on Vermeer a year or two after *The Procuress* of 1656, were sold for 62 guilders and 44 guilders 10 stuivers respectively at the auction of 1696.[50] Thus, assuming tastes had not greatly changed from the early 1660s to the 1690s, we are led to conclude that even his relatively youthful works were valued a good deal higher than ten to twenty guilders, the prices of the three pictures that have been described, though not so high as *The Milkmaid* or *The Woman Weighing Gold* (now called *Woman Holding a Balance*), which brought 177 and 155 guilders respectively at the sale of 1696. The only Vermeer paintings at the Amsterdam sale that fetched less than twenty guilders were two "faces," which were perhaps of small dimension. The accomplished but small-sized *Lacemaker* (Fig. 53) sold for only twenty-eight guilders. The price quotations we have for the pictures in the De Helt and Larson estates were perhaps for works painted a number of years earlier or for works of small dimensions, or both. Finally, to add another note of doubt to this speculative conundrum, we cannot exclude the possibility that Vermeer's early works were priced as high as they were in the Amsterdam sale due to the reputation he had earned from his later paintings. If he had died in 1657 or 1658, his works might never have risen above the ten to twenty guilder range typical of workaday Delft painters such as Egbert van der Poel or Nicolaes Vosmaer. Whatever the truth, I find it hard to believe that the very beautiful *Girl with the*

[46] Doc. no. 269, 27 June 1657.
[47] Doc. no. 284, 16 May and 14 June 1661.
[48] Doc. no. 298, 4 August 1664.
[49] Delft G.A., records of Notary J. Ranck, no. 2116, 11 October 1660.
[50] Doc. no. 439, 16 May 1696.

Pearl Earring (Fig. 33), which is generally dated about 1664–1665, was the painting in the Larson estate.[51] Of fairly large dimensions for a single head, it would surely have been held in high enough esteem by contemporaries to be valued at more than ten guilders at the time the Larson inventory was taken in August 1664, precisely one year after Monconys had been told about the sale of a single-figure painting for six hundred guilders.

How much, then, did Vermeer earn from his activity as a painter? Clearly the answer depends on the number of paintings he painted and sold each year and the prices that he obtained for them. There is considerable uncertainty about both, but we can at least take a stab at the two components of the problem. In Appendix A I estimate the number of paintings Vermeer may have painted from *The Procuress* of 1656 to his death in 1675 on the basis of the following simple idea. Suppose that two-thirds of the paintings by Vermeer mentioned in seventeenth-century sources survived while one-third was lost.[52] We may assume, as a first approximation, that the paintings extant today that were *not* mentioned in seventeenth-century sources also represented two-thirds of the total number of paintings Vermeer originally painted that were not cited in any source available to us. We assume, in other words, that the rate of disappearance of cited paintings is the same as that of noncited ones. If thirteen noncited paintings survived, then the total of noncited paintings should have been roughly twenty (i.e., 13 is approximately two-thirds of 20). If there were twenty-six paintings that were cited in seventeenth-century sources and survived, then a total of about forty-six paintings should have been painted. From this estimate we would still have to subtract the unsold paintings that were in Vermeer's atelier when he died.

This method is subject to two sources of error. Because the titles of Vermeer's paintings in seventeenth-century inventories are rather vague (and may even be inaccurate), there is some doubt about the number of cited paintings that actually did survive. The other source of error is due to the possibility that the rate of disappearance of noncited paintings may have been greater than that of cited paintings (because they were less important and thus less worth preserving). In Appendix A I have made alternative estimates of the number of extant paintings that were not mentioned in seventeenth-century sources (thirteen and eleven). I have also made an independent calculation on the alternative (extreme) assumption that the rate of disappearance of noncited paintings was twice as great as that of cited paintings. If thirteen of the extant paintings were not cited in seventeen-century sources and the rates of survival of cited and non-

[51] This possibility was raised by Blankert, *Vermeer of Delft*, p. 163.
[52] For purposes of this example, I have used proportions deviating slightly from those in Appendix A.

cited paintings were the same, then about six noncited paintings must have disappeared in a course of time, and the total number of paintings executed between 1656 and 1675 should have been approximately forty-five. Starting with the same number of thirteen extant paintings that were not cited, ·if the rate of disappearance was twice as great for noncited as for cited paintings, then twenty-one paintings failed to survive, and a total of sixty paintings should have been painted between our benchmark dates. Reducing the starting number to eleven extant noncited pictures and going back to the first assumption regarding the rate of survival, we arrive at an estimate of four noncited paintings that did not survive and a total of forty-three paintings. The alternative (extreme) rate of disappearance yields fifteen and fifty-four paintings respectively.

In summary, I estimate that the total number of paintings executed between *The Procuress* and 1675 ranged from forty-three to sixty. These numbers have to be reduced at least by two paintings, the *Woman with a Pearl Necklace* (Fig. 43)[53] and *The Lady with a Maidservant* (Fig. 45),[54] which were probably unsold at the time of the artist's death.

Counting nineteen years that elapsed between 1656 and 1675, my estimates lead me to the conclusion that Vermeer sold between two and three paintings per year. This is a fairly large discrepancy, but we should not infer from these calculations that Vermeer's income varied strictly in proportion to the number of paintings he sold. The reason is that our rather extreme assumption about a double attrition rate of noncited pictures is only plausible if the noncited paintings were less important than the cited ones, hence more likely to disappear in the course of time. In that case they were probably smaller and less expensive, perhaps of the order of ten to twenty guilders, like the Larson "tronie." I do not think we can be far wrong if we conclude that Vermeer, on average, painted two highly finished, expensive pictures a year or three including one less expensive one. The alternative assumption should not affect Vermeer's total income very greatly, especially in view of the wide margin of uncertainty regarding the average prices the artist obtained for his works.

If Vermeer sold two pictures a year at the rather generous prices at which two of his pictures were estimated in 1676 when they were kept by the baker Hendrick van Buyten as collateral for bread delivered, he would have earned 617 guilders a year from his art.[55] If, on the other hand, the prices at which Vermeer sold his paintings were on a level with those obtained in the 1696 sale, which averaged a little less than one hundred guilders apiece, he would have earned only about two hundred guilders per year from this source—barely enough to keep his large family in

[53] See Chapter 13 at note 40.
[54] See Chapter 13 at note 53.
[55] Doc. no. 361, 27 January 1676.

bread. In either case, his yearly earnings were not constant through time: they were probably low in the late 1650s, when some of his paintings sold for ten to twenty guilders apiece; they rose in the 1660s, when he was perhaps able to obtain three hundred guilders or more per painting in his new "fine" style; they declined in the 1670s, as his widow testified after his death, because of the war with France of 1672 and the adverse economic conditions of the three subsequent years, during which he "sold very little or hardly anything."[56]

When business conditions were more favorable Vermeer made some money, in addition to his earnings as a painter, by trading in pictures, as Catharina told the magistrates after his death.[57] Since Catharina's testimony provides the only information that has ever surfaced about Vermeer's dealing in pictures—in contrast to the numerous mentions that have come down to us about his father's business—I am inclined to believe that his trading activity was on a very small scale. It would seem also that the twenty-six paintings valued at five hundred guilders which Vermeer had on hand at the time of his death in 1675 and which were sold to pay off debts to the Haarlem painter and art dealer Jan Coelenbier represented his whole inventory of paintings by other artists.[58] How modest this all was becomes evident when we compare it with the stock of the Amsterdam dealer Gerrit Uylenburgh when he went bankrupt in 1675. Uylenburgh had five times as many pictures in his inventory worth about one hundred guilders each (including some copies),[59] compared to nineteen guilders each for the lot sold to Coelenbier. It is doubtful that Vermeer netted more than one to two hundred guilders a year from a stock-in-trade of such a moderate size. We are forced to the conclusion that Vermeer could not have brought up his family, at least according to the standards to which Catharina was accustomed, if it had not been for the incomes the couple received from the estates of Jan and Cornelia Thins, and the subsidies granted by Maria Thins. Altogether, as I suggested in the last chapter, the incomes stemming from the legacies of Jan and Cornelia Thins may have amounted to 350–400 guilders a year, more than the minimum I have estimated for his earnings from his paintings and his dealings. I suspect also that the Vermeer family lived rent-free in Maria Thins's rather luxurious house. This virtual subsidy probably saved the artist 80–100 guilders a year. We also know from Maria Thins's testa-

[56] Doc. no. 367, 24 and 30 April 1676.
[57] Ibid.
[58] Doc. no. 364, 10 February 1676.
[59] S.A.C. Dudok van Heel, " 'Het Schilderhuis' van Govert Flinck en de kunsthandel van Uylenburgh aan de Lauriersgracht te Amsterdam," *Jaarboek Amstelodamum* 74 (1982): 84–86. I have assumed that there were 5 copies and 20 miscellaneous paintings where the inventory reads "four to six copies" and "about 20 pieces," respectively. The sculptures are not included in this calculation.

ment of January 1677 that she regularly advanced money to her daughter and her husband. Unfortunately the amounts she advanced successively each year were left blank in the document, as was the year in which she began to do so.[60] She also lent them some "extraordinary amounts" at some unspecified time. We do know from a deposition Maria made in December 1676 that, at one time or another, she had given her daughter six annuities totaling 167 guilders a year.[61] Whether these had been regular or extraordinary subsidies she did not say. In either case, they must have represented a substantial addition to the couple's income. Disregarding the free rent but counting Maria's subsidies, we arrive at a range of income from all sources of 850 to 1,500 guilders per year, the main source of variance being the uncertain average price at which Vermeer sold his paintings. The lower end of the range was about equivalent to the amount the manager of a Delftware pottery earned per year in the 1660s.

Vermeer was not poor by the standards of his day. If he had money troubles, the reason lay in the extraordinary expenses of raising eleven children, none of whom supported themselves from adolescence on, as children normally did in less well-situated families. We should also keep in mind that the artist's income fluctuated; it was appreciably higher in the 1660s than in the 1670s, the period when, as we shall see, the sale of his paintings dwindled and the expense of caring for his children became especially burdensome. Some of this shortfall, however, was partially offset, after 1671, by a small legacy from Vermeer's sister Gertruy and by the rental income from Mechelen (which was largely consumed by the interest due on the mortgage).[62]

The financial independence Vermeer enjoyed, partial and precarious as it was, gave him a greater opportunity to follow his own artistic inclination than most of his fellow members of the guild, who had to adapt their art to suit market demand. He could also paint fewer pictures than he might have had to if he had been forced to support his family exclusively from his art. A number of other Dutch artists, including Jacob van Velsen, Ferdinand Bol, Heyndrick Goudt, Jacob de Gheyn, and Aelbert Cuyp, belonged to the category of gentlemen painters who were free to practice their art as they chose—or not to practice it at all, as in the case of Bol, who ceased painting after marrying into a wealthy and distinguished family.

The help Vermeer received from his mother-in-law also helps to explain why he stayed in Delft after many of his fellow guild members moved to Amsterdam and The Hague. If he had gone to live in Amsterdam, he

[60] Doc. no. 376, 6 January 1677.
[61] Doc. no. 375, 11 December 1676.
[62] Doc. no. 337, 18 July 1671; and no. 340, 14 January 1672..

would have lost some of his income and might have suffered the experience of his erstwhile colleagues, Pieter de Hooch and Emanuel de Witte, who, no matter how talented they were, barely eked out a living in the big city.

Beside the scattered bits of information that we have about Vermeer's sources of income, we can perhaps also infer something about his circumstances from the visual evidence supplied by his paintings of luxurious interiors. The validity of our inference will depend critically on the realism of these paintings, especially on the degree to which they accurately reflected the surroundings in which he lived and worked.

We can classify the physical things represented by Vermeer according to the degree of certainty we have that they possessed counterparts in his visible world, that they in fact existed. First, in descending order of certainty, are representations of the city of Delft, published maps and globes, and paintings that Vermeer inserted in the interiors he depicted that are known from other sources. Next are objects mentioned in one of the testaments of Maria Thins or in his death inventory of 1676 that he is thought to have represented in his paintings. Least certain are the depictions of precisely rendered objects that frequently recur in his paintings and may therefore be presumed to have existed in their own right.

Let us first consider Vermeer's famous *View of Delft*, (Fig. 34) which has been analyzed in extraordinary detail by Arthur Wheelock and C. J. Kaldenbach.[63] The view has changed so much over the years that the photograph taken from what they believe to have been Vermeer's vantage point has in common with the painting little more than the Schie River in the foreground, the Old Church on the left peeking behind a row of houses, the New Church on the center right, and the general silhouette of the skyline. Even the New Church, whose spire was reconstructed in 1872, seems to have been portrayed in the painting a bit wider than it was at the time. For other comparisons we must rely on seventeenth- and eighteenth-century drawings and topographical maps, none of which is perfectly accurate (Fig. 35). Wheelock and Kaldenbach have also drawn on X-ray and infra-red photographs of the painting, which show how Vermeer's first intentions differed from the finished product.[64] These comparisons reveal that in the course of execution Vermeer moved toward greater compositional clarity and simplicity, at the expense of precise realism. When he increased the size of the two boats in front of the Rotterdam gate on the right—by lengthening the stern of one boat and the bow of the other—he created a smoother, more continuous transition in the water line from the bridge between the two gates to the extreme

[63] Arthur K. Wheelock, Jr., and C. J. Kaldenbach, "Vermeer's *View of Delft* and His Vision of Reality," *Artibus et Historiae* 3, no. 6 (1982): 9–35.

[64] Ibid., pp. 18–19.

right hand side of the picture. This, combined with an alteration of perspective that makes it appear as if the well of the Rotterdam gate formed an obtuse angle with the main gate building instead of being perpendicular to it as it must have been in reality, enabled Vermeer to play down the three-dimensionality of the sight and to emphasize its overall frontality. By lengthening the shadows projected in the water by the Rotterdam gate and its flanking towers to the lower edge of the picture significantly beyond their original profile, which must have been more realistic than in the final version, he succeeded in drawing together the city and the shore and added to the view's compactness.

A comparison of Vermeer's painting with topographic views taken from more or less the same angle, such as the one drawn by Abraham Rademaecker in the early eighteenth century, indicates that Vermeer made the houses in the foreground of the city more uniform in size and less closely packed than they were in reality. He apparently introduced these changes to achieve a more isocephalous, frieze-like effect, in the manner of a classical theorem (except that he was portraying houses rather than people lined up in a row as in a Roman bas-relief). He also reduced the size of the figures on the shore in the foreground so as not to distract the viewer's eye from the structures beyond the river. Except to a viewer who was extremely familiar with the site, the alterations he introduced must have enhanced the *illusion* of reality. Samuel van Hoogstraten, the outstanding theoretician of art in the second half of the seventeenth century, suggested that painting is a science that "deceives the eye with outlines and colors."[65] Van Hoogstraten, Wheelock points out, does not recommend that paintings copy nature but that they give the appearance of having copied nature.[66] And if Vermeer used an optical device such as a camera obscura, it was not so that he could get the view of Delft "just right" but to create special effects, to enhance the sensation of reality by stressing contrasts of light and dark, and to help him render his colors more vivid.[67]

Next we turn to the objects represented in Vermeer's paintings that can be identified. Baburen's *Procuress* (Fig. 21, also called *The Matchmaker*) appears in the background of *The Concert* (Fig. 36) and of the *Lady Seated at the Virginals* (Fig. 50). The first picture-within-a-picture is too abraded to compare with the original; the other is a fairly faithful copy (truncated on the right) of the original, at least if allowance is made for the simplification inevitable in this sort of background representation. The picture that occupies a large part of the wall behind the woman symbolizing Faith in the *Allegory of Faith* (Fig. 39) is a simplified version of

[65] Cited in Wheelock, *Jan Vermeer*, p. 28.
[66] Ibid., p. 33.
[67] Wheelock and Kaldenbach, "Vermeer's *View of Delft*," pp. 19–23.

the painting by Jacob Jordaens's *Crucifixion* in Antwerp's Terningh Foundation.[68] Most conspicuous are the omissions in the copy of the Mary Magdalena at the feet of Christ, the upper part of whose head would otherwise have appeared behind the right shoulder of Faith, and of the man climbing a ladder in back of the crucified Christ. Since the Thins-Vermeer family probably did not own the original Jordaens painting, it is conceivable that the "Christ on the Cross" mentioned in Vermeer's death inventory, after which the artist presumably worked, was itself a simplified copy in which Mary Magdalena and the man on the ladder had been eliminated. But the more likely explanation is that the introduction of these two figures would have confused Vermeer's painting: the top of Mary Magdalena's head sticking out behind the shoulder of Faith would have been impossible to "read"; the illuminated torso of the man on the ladder would have drawn the spectator's eye from the glass sphere symbolizing Faith hanging from the ceiling.

James Welu, who has made a careful and systematic study of the maps hanging in the background of Vermeer's paintings,[69] has discovered that they were astonishingly true to the published originals, even though the artist occasionally diverged from his prototypes for decorative or compositional effect. Even the mermaids, marine monsters, and sailing ships that animate the oceans are correctly reproduced in Vermeer paintings. Welu has pointed out that the map by Nicolaes Visscher in the background of *The Art of Painting* in Vienna (Fig. 37) shows the northern and southern provinces of the Netherlands as if they were still politically integrated and the Dutch Republic had not acquired a sovereign existence. We will never know whether the crease in the middle of the map, which symbolically divides the Catholic from the Protestant region, was arbitrarily inserted by Vermeer or was actually visible on the map that he portrayed. The globe that appears in *The Geographer* and *Allegory of Faith* (Fig. 39) is also a precise replica of the second edition of a globe produced by the Hondius family of cartographers. The book in front of the astronomer in the painting dated 1668 in the Louvre (Fig. 38, *The Astronomer*) is opened to the first two pages of Book III of Adriaen Metius's basic volume "On the Investigation or Observation of the Stars." One page shows the cartwheel astrolabe invented by Metius himself. The representation was precise enough to allow Welu to determine that Vermeer used the second edition of the book dated 1621.[70]

[68] Reproduced in Swillens, *Johannes Vermeer*, plate 57.
[69] James A. Welu, "Vermeer: His Cartographic Sources," *Art Bulletin*, 57 (1975): 529–47. The reference to *The Art of Painting* is on p. 536; to the *Allegory of Faith* on pp. 541, 544; to *The Officer and the Laughing Girl* on pp. 529f., and to the *Woman in Blue Reading a Letter*, pp. 532ff.
[70] James A. Welu, "Vermeer's Astronomer: Observations on an Open Book," *Art Bulletin*, 68 (1986): 263–67.

Yet Vermeer never lost sign of the painterly effect he sought to achieve
by placing his globes and maps in the background of his compositions.
The same map looks quite different in *The Officer and the Laughing Girl*
(Fig. 15) and the *Woman in Blue Reading a Letter* (Fig. 29). In the first
the land is painted a cerulean blue; in the second it blends with the muted
ochres of the entire surface. Clearly, if a large part of the map in the sec-
ond picture had been painted blue, the woman's blue coat would have
sunk into the background and her figure would have lost much of its vol-
ume and monumentality.

The coat of arms that appears in *The Glass of Wine* and *Woman with
Two Men* (Figs. 40 and 41) supplies another link to reality but an elusive
one. The arms are evidently those of Janetge Jacobsdr. Vogel, the first wife
of Moses van Nederveen, a patrician of Delft who died in 1624.[71] But, as
far as I have been able to ascertain, neither Janetge Vogel nor her husband
ever lived in the house in the corner of the Molenpoort on the Oude Lan-
gendijck, the ownership of which can be traced back to at least 1618
when it belonged to the notary Arent van Bolgersteijn.[72] It may also be
observed that the window being gently opened in the *Woman with a
Wine Jug* (Fig. 42) has the same pattern of lead mullions but only clear
glass in between. Vermeer may have seen the coat-of-arms elsewhere, per-
haps in the house on the Oude Delft where Van Nederveen and his wife
once dwelled,[73] and inserted it into the clear space framed by the oval-
shaped mullions. This would be especially likely if one of Janetge Vogel's
descendants had been Vermeer's patron.

Only one item that Maria Thins gave to her daughter Catharina in one
of her testaments seems to be represented in a Vermeer picture. This is the
gilded jug resting on a charger in the *Woman with a Wine Jug* that we
have just discussed. A gilded jug was such a rare and valuable object that
I doubt there could have been another one that was anything like it in the
Thins household.

A number of items mentioned in Vermeer's death inventory of 1676[74]
can be identified in his paintings on the basis of reasonable surmise, al-
though we cannot be sure that they are represented accurately because
the objects themselves are not available for us to see. The painting

[71] This coat of arms was first identified by Elisabeth Neurdenburg ("Johannes Vermeer:
Eenige opmerkingen naar aanleiding van de nieuwste studies over den Delftschen schilder,"
Oud Holland 59 (1942): 69, note 2). Neurdenburg came to the doubtful conclusion that
Vermeer must have lived in the house whose window or windows were decorated with this
coat of arms.
[72] Doc. no. 160, 20 April 1641.
[73] The house where Moses van Nederveen and Jannetge Jacobsdr. Vogel lived on the
Oude Delft was fairly far, as Delft distances go, from the Oude Langendijck (Delft G.A.,
"Verponding boek," 1620).
[74] Doc. no. 364, 29 February 1676.

"wherein a bass viol and a skull"[75] appears is probably the one hanging in the background of *Lady Writing a Letter* (Fig. 44). The putto in the inventory is shown with an upright mask lying next to his left leg behind the *Girl Asleep at a Table* (Fig. 25) and without the accompaniment of a mask behind the *Lady Standing at the Virginals* (Fig. 49).

The "yellow satin mantle trimmed with white fur" in the inventory can be recognized in six pictures: *Woman with a Pearl Necklace* (Fig. 43), *Lady Writing a Letter* (Fig. 44), *The Lady with a Maidservant* (Fig. 45), *The Love Letter* (Fig. 46), *The Guitar Player* (Fig. 47), and the *Woman Playing a Lute* in the Metropolitan. In two other paintings—*Woman Holding a Balance* (Fig. 30) and *The Concert* (Fig. 36) in the Isabella Gardner Museum—a young woman wears a blue jacket trimmed with white fur, also pleated at the elbows. The fur, however, is not spotted with black as the ermine in the other six pictures is. Yet this may be the same yellow jacket but painted blue to harmonize with Vermeer's color scheme. Blue, the traditional color of the Virgin's mantle, suits the pensive mood of the woman symbolically weighing unborn souls in front of a picture of the Last Judgment. In *The Concert*, a darker color for the dress of the standing singer was needed to provide a contrast with the yellow and black jacket of the seated girl playing the clavecin.

Other items in Vermeer's death inventory that may be identical with objects he represented in his pictures include a box with ebony inlay, most clearly visible in the *Lady Writing a Letter* (Fig. 44); the artist's "Turkish mantle," or jacket, and his "Turkish trousers," which may be those worn by the seated painter in *The Art of Painting* (Fig. 37); "nine Spanish leather chairs," perhaps those with the lion finials; the ebony crucifix, which is probably the one shown in the *Allegory of Faith* (Fig. 39); "eleven earthenware jugs with pewter lids," of which at least one example appears in *The Glass of Wine* (Fig. 40); "seven ells of gold-tooled leather on the wall," which may be the dark red and gold wall covering in the background of *The Love Letter* (Fig. 46) and the *Allegory of Faith*; and a "cane with an ivory knob on it," which, judging by its proximity in the inventory list to the easels, canvases, and panels in Vermeer's studio, suggests it may have been a maulstick, hence presumably the one shown in *The Art of Painting*. The last two items—the stamped gilded leather and the putative maulstick—may both mark a minor departure from strict realism. The gold tracery on the wall covering in *The Love Letter* does not seem to have precisely the same pattern as in the *Allegory of Faith*. The knob in *The Art of Painting* is colored red, whereas ivory, if natural, should be white. I have no explanation for the variation in pattern of the

[75] This painting was plausibly attributed to Cornelis van der Meulen by K. Boström ("Jan Vermeer and Cornelis van der Meulen," *Oud Holland* 66 (1951): 171–22).

leather covering; but the red hue of the knob helps to mark off the stick
from the map, colored gray and yellow, in the background.

Next let us consider objects represented in Vermeer's paintings that
have no ascertainable counterparts in Vermeer's possessions but whose
objective existence derives its claim from replication in two or more of
his works. Take, for example, the oriental rug that appears as early as
Christ in the House of Martha and Mary (Fig. 14). This rug seems to be
identical with the one represented in the *Girl Asleep at a Table* (Fig. 25).
They have in common a broad, light orange border ending in a fringe. But
the medallion in the former is colored yellow, in the latter green. It is not
evident whether Vermeer used one rug as a model and painted imaginary
variations on it or, less likely, whether he had two similar but distinct
objects before his eyes.

This problem of variations besets us at every turn in our investigation.
The leather chairs with lion finials are decorated with a pattern of yellow
lozenges in all the early paintings. Then, starting with the *Woman in Blue
Reading a Letter* (Fig. 29), the chairs appear to have been re-upholstered
in light blue velvet. Was this a change in reality? I would have thought so
if it were not that the lozenges crop up again in the *Lady Writing a Letter*
(Fig. 44), which is generally dated three or four years after the *Woman in
Blue*. The Baburen *Procuress* in the background of *The Concert*, dated
about 1664, is framed in black; the same Baburen in the background of
the *Lady Seated at the Virginals* (Fig. 50), generally dated nearly a decade
later, is framed in gold. We know that the fashion changed in the 1660s
and 1670s from black ebony to gold-leaf frames. Did Maria Thins have
her picture reframed? Or did Vermeer paint in an imaginary frame in the
later picture, either to blend in with the new fashion or because he wanted
some highlights in that particular part of his composition? The answer is
not to be found in the visible evidence provided by the paintings.

The alternating black and white marble tiles that decorate the floors in
many of Vermeer's paintings lend the interiors in which he enclosed his
figures a patrician air. Such floors were in fact a hallmark of luxury. Yet
the patterns formed by these tiles are not quite the same: the black tiles
form continuous lines in *The Music Lesson* (Fig. 48); they form black
crosses in *The Concert* (Fig. 36), *Woman Holding a Balance* (Fig. 30),
The Love Letter (Fig. 46), *Lady Standing at the Virginals* (Fig. 49), *Lady
Writing a Letter with Her Maid* (Fig. 51), and *Lady Seated at the Virgin-
als* (Fig. 50). But it is the white tiles that shape the crosses in the *Allegory
of Faith* (Fig. 39), perhaps to reinforce the motif of the Crucifixion al-
ready present in the painting in the background and in the crucifix stand-
ing next to the chalice. Did these three patterns decorate the floors of
three different rooms or is this another example of Vermeer's partiality
toward eye-pleasing variegation?

Similarities and differences can also be found in the tapestries, the blue and white wall tiles (some have corner decorations, others do not), and even in the keyboard instruments represented in *The Music Lesson, The Concert, Lady Standing at the Virginals*, and *Lady Seated at the Virginals*. All of these instruments seem to have the same base with turned legs. But the upper part of the one in *The Music Lesson* differs markedly from that in the other three, if only in that it bears an inscription about the pleasures of music on the upturned lid, whereas the other three display a painted landscape. The harp-shaped instrument in the Isabella Gardner Museum's *Concert* has a landscape on its upturned lid very similar to the two paintings on the lids of the virginals of the *Lady Standing* and the *Lady Sitting at the Virginals* in London. Yet it is a clavecin or harpsichord, which differs from virginals and spinets by the direction of its strings that lie perpendicular to the keyb̲o̲a̲r̲d̲.[76] All the instruments depicted—the clavecin and the three virginals—have a keyboard displaced to the right of center ("muselaer"), typical of Flemish and Dutch instruments. Two of the virginals depicted are bordered in black; the one played by the seated lady has no border at all. The black border makes for greater clarity: if it were not for it, the landscape on the lid in *Lady Standing at the Virginals* would melt into the cream-colored wall in the background. The instrument in *Lady Seated at the Virginals* is placed against a dark background, so there is no necessity for a frame to set it off. Were the four keyboard instruments that Vermeer depicted all different? How many of them could Maria Thins have owned? How many could Vermeer even have seen? There were very few in Delft, or so we may infer from the fact that they crop up so rarely in inventories. I suppose there was only one in the Thins's household, a clavecin or a virginal. Vermeer was more likely to indulge his fancy painting variations on a unique object for the purpose of arriving at the precise effects he sought to achieve than he was to observe and sketch (or store in his memory) distinct objects differing from each other in details.

The essential substratum, *die Dingen an sich*, in any event, must have been there: the mullioned windows, the black and white marble floors, the yellow-fringed rug, the Delft-blue tiles, the keyboard instrument. No one would have been so consistent in his choice of physical objects who did not work in their close proximity. The variations that Vermeer, like most of his contemporaries, played on these "realistic" elements were needed to enhance the beauty of the composition or to present a greater appearance of reality.

If, as I believe, Vermeer created patterns of his own in some of the rugs,

[76] For this comparison of clavecins and virginals and their keyboards, I am endebted to John Hollander and Kenneth Bé.

tapestries, and leather wall coverings that he depicted, both the impulse
and the skill may perhaps be traced to his exposure to his father's caffa-
making craft. He must have seen Reynier Jansz. weave fancy patterns in
silk satins, at least until he was twelve years old, when Reynier was last
called master caffa worker in a document. The artist's love of fancy tex-
tiles, so striking, for example, in *The Lacemaker* (Fig. 53), may too have
been nurtured at home.

We also meet this penchant toward graceful decoration in the patterns
Vermeer drew on the marble slabs of his interiors. Lawrence Gowing has
observed that the "calligraphic marbleing" of the slabs represents "an
inconsequent perfection unlike anything in the European tradition, re-
calling only the Chinese."[77]

The Dutch historian P. T. Swillens once made an exhaustive study of
the rooms depicted by Vermeer. Some of his conclusions rest on sound
observation, others are more tenuous. He argues convincingly that the
room with black and white floor titles—however arranged—was lit by
three windows, one or more of which were shaded by curtains, depending
on the light effect Vermeer sought to achieve.[78] The room with the green
and pink floor tiles shown in the early paintings—*The Officer and the
Laughing Girl*, (Fig. 15), *The Glass of Wine* (Fig. 40)—has the same
three-window layout as the one with the marble-tiled floor. Swillens ten-
tatively suggests that the two might be identical, but seen at two points in
time: by the 1660s the colored tiles of the earlier pictures, which look like
those in the middle-class interiors of Nicolaes Maes and Pieter de Hooch,
had been replaced by more elegant black and white marble tiles. This is
surely plausible, but it may also be that the marble floors were there all
along and that Vermeer transformed them into common ceramic tiles in
The Officer and the Laughing Girl and *The Glass of Wine* to achieve a
more plebeian look in harmony with the fashion of the mid-1650s. Then
again there may have been two rooms of the same size in Maria Thins's
house, one downstairs and one upstairs. The room downstairs would
have been the one called "the great hall" in Vermeer's death inventory.[79]
There were "three little drawings in front of the mantelpiece" in this hall.
The mantelpiece was perhaps the stately one depicted in *The Love Letter*
(Fig. 46), which shows the right half of the marble-floored rooms. The
second would have been in the "front room" upstairs mentioned in the
inventory, where Vermeer's easels, canvases, panels, and prints were
found after his death. So we have three hypotheses—actual replacement
of the tiles in one room, artistic metamorphosis of marble into ceramic

tiles, realistic representation of two different rooms—and no way to distinguish among them.

If we assume, as I think we must, that Vermeer represented more or less accurately the rooms and household objects in his environment, we cannot but be struck by the way he manipulated individual components of this reality to achieve his ends. He used background pictures for his mise-en-scène much as a modern stage director uses reproductions, photographs, posters, and furniture to situate a milieu, to evoke a mood, or to make an ironic comment on a scene. Take, for example, the background picture on the righthand side of *The Music Lesson* (Fig. 48). This is the Caravaggist picture—perhaps based on an original by Honthorst or Matthias Stomer—that Maria Thins already owned in Gouda and that appeared in the inventory list made up at the time she and her husband legally separated.[80] Vermeer has only shown about two-fifths of this "Roman Charity," chiefly the back side of the head and the chained arms of Cimon, whom we know to be, but cannot see, sucking his daughter's breast. What bearing does this background picture have on the scene represented? A standing young woman is viewed from the back, her face reflected in the forward-leaning mirror above her. On the lid of the virginals she is playing on are inscribed words about music, "the companion of joy, the balm of sorrow." A gentleman listens to her in silence. The presence of the painter—ubiquitous intruder, seer, voyeur—is barely suggested by the easel adumbrated in the mirror. A tenor viol lies on the marbled floor, unheeded. The mood is pensive, melancholy, oppressive. The picture on the wall hints, by focusing only on Cimon in chains, that the gentleman-listener is enthralled by the young woman. He is bound by virtual fetters, a metaphor for Cimon's irons. The analogy may be extended a step further: milk and music, each in its way, assuage the pains of captivity.

The Concert (Fig. 36) takes place in what appears to be the same room as *The Music Lesson*, if we make allowance for the change in the layout of the tiles in the marble floor. But the decor has been transformed. The mirror has disappeared. Instead of "The Roman Charity," Baburen's *Procuress* hangs on the wall. The virginals have turned into a clavecin, on the lid of which there appears a landscape instead of an inscription about the soothing powers of music. The mood is more convivial and worldly than it is in *The Music Lesson*. Perhaps Baburen's picture is intended as a reminder of the excesses to which music can lead. Harmony and chaos of the senses, Vermeer cautions us, are only separated by reason and self-control.

We now turn to the human figures that are portrayed in Vermeer's in-

[80] See Chapter 7.

teriors and to their relation to the living, sentient beings in his family and entourage. Four of them have already been tentatively identified. The long-haired young man with the beret in *The Procuress* looks like a self-portrait, as does the artist in *The Art of Painting*, who wears (almost) the same garb and whose long hair is also covered by a beret; the sturdy young woman pouring milk in *The Milkmaid* may have been the servant Tanneke Everpoel who worked for Maria Thins in the early 1660s, when the painting is believed to have been executed; the prognathous girl with the widely spaced eyes in the Wrightsman picture in the Metropolitan Museum—a portrait if ever there was one (Fig. 52)—bears a sufficient resemblance to the young man with the beret in *The Procuress* to suggest she may have been the artist's daughter. Vermeer was married in April 1653. His oldest daughter, Maria, could not have been much older than thirteen in 1666–1667 or twenty in 1672–1674, the two widely separated dates that Wheelock and Blankert respectively assign to the Wrightsman head.[81] If the head does represent Maria, the latter date must be closer to the truth. It is hardly conceivable that Maria or her younger sister Elisabeth could have been portrayed in the *Girl with the Pearl Earring* (Fig. 33), which is generally dated about 1665,[82] when the older of the two sisters was less than twelve years old.

We saw earlier that the yellow jacket with white fur trimming which appears in several of Vermeer's paintings belonged to Vermeer's wife. It is probable that either she or her daughter wore it when Vermeer used one or the other as a model. In *The Lady with a Maidservant* (Fig. 45), the handsome woman in the yellow jacket looks to be in her mid-thirties—the right age for Vermeer's wife, who was thirty-four to thirty-six in 1666–1668, the approximate date for the picture.[83] If so, the disheveled little girl who went around "looking like a beggar's child," after her mother had left her with her half-demented father, had grown up to become a distinguished-looking, elegant matron.

The *Lady Writing a Letter* (Fig.44), who also wears the yellow jacket, seems much younger than the lady with the maidservant. She is perhaps in her late teens. She has the same jutting-out jaw, bulging forehead, and round, widely spaced eyes as the rather homely girl in the Wrightsman picture, but here these features are somewhat muted and idealized. She is supposed to have been painted around 1666.[84] If she is Vermeer's daughter, she could hardly have been more than twelve or thirteen at the time.

[81] Wheelock, *Jan Vermeer*, p. 132, and Blankert, *Vermeer of Delft*, p. 170.

[82] All authors have dated the painting 1665 (Blankert, Wheelock), or earlier.

[83] Blankert dates the picture 1666–1667 (*Vermeer of Delft*, p. 164), Wheelock dates it 1667–1668 (*Jan Vermeer*, p. 134).

[84] Wheelock, (*Jan Vermeer*, p. 124), 1665–1666; Blankert (Vermeer of Delft, p. 164), "about 1666."

The yellow-jacketed girl playing the guitar or cittern in the Kenwood picture (Fig. 47) also has the characteristic jaw formation of the Wrightsman portrait. Assuming the date assigned to that picture (1671–1672) is about right, it could represent Maria at the age of seventeen or eighteen. (Elisabeth, born about 1657, is a less likely candidate since she was probably less than fifteen years old at the time the Kenwood picture was painted.)

All this, unfortunately, is tantalizingly inconclusive. What we can safely assert is that Vermeer, using elements drawn from an underlying reality, built genre pictures in which the story telling was reduced to a minimum of hints. In this respect he is comparable to Rembrandt, who also eliminated all superfluous anecdotal baggage. The Delft master eschewed the obviousness of other, less sophisticated contemporaries: Gabriel Metsu is often downright prurient; Van Mieris, arch; Jan Steen, boisterous, closer to Jacob Jordaens and other Flemish painters in his all-devouring appetite for life than to his more restrained northern colleagues; even Gerard ter Borch, as aristocratic and refined as he may be, is more anecdotal, less distant from his personages than Vermeer, who draws only the gossamer threads of a story or a moral exhortation. What distinguishes him from other Dutch and Flemish painters, in the last analysis, is his more fastidious taste, his more conscious determination to banish all duplicative, inessential, vulgar elements from his scenes, his deeper commitment to idealization. In these respects, Vermeer comes closer to Raphael's art than any of his northern contemporaries. There is another clearly conscious element in the way Vermeer goes about representing his subjects that contributes to their mysterious unreality. This is the strict geometricity of his compositions which jars with the everyday appearances of the scenes he depicts. It goes beyond adherence to the strict canons of perspective whereby every workaday painter can achieve the illusion of depth. Vermeer's geometry, together with his use of light, isolates and reveals forms, endows them with their immutable perfection. With them he realizes the "dream of stone" that Baudelaire identified with Beauty. Like Vermeer himself, Beauty abhors "le mouvement qui dépare les lignes."[85]

Arrangement, composition, elimination of unnecessary detail: all this comes before the phase of execution, at least for the painter who, following Karel van Mander's admonition, thinks out his picture before applying brush to canvas. As we have already seen, Vermeer, beginning with the paintings that he is thought to have painted a year or two after *The Procuress*, abjures in the course of execution any cognition of form but that directly suggested by his sense impressions. *The Lacemaker* (Fig. 53)

[85] Charles Baudelaire, *Les Fleurs du Mal* (Poitiers: Librairie Fonteneaux, 1949), sonnet XVII, p. 35.

and *Lady Seated at the Virginals* (Fig. 50) supply two examples, among many, of his technique. In the first, a bright light falls on the bridge of the nose of the girl absorbed in her bobbins. There is not the faintest appearance of the drawing of the bridge of her nose. For all we know her nose could be as crooked as the ridge of the shadowed side of her face. Vermeer would rather risk an ugly appearance—the magic lies in his ability to avert the danger—than to give up principle and draw a bridge line where his eyes perceive no change in the continuity of light values. In the late *Lady Seated at the Virginals*, the light falls evenly on the two hands of the player. Here only the schemata in our own minds—we know what a hand *should* look like—can tell us where the wrist of one hand ends and the wrist of the other begins. Design and cognition take place before the act of painting, when the persons and objects are placed in exactly the desired position within the box that will encapsule them, not in the process of painting them, which will be *chiefly* a matter of recording visual stimuli. (The exception is where Vermeer permits himself an occasional foray into autonomous pattern-making.) Even if the reception of these visual stimuli was aided by a camera obscura, what is significant is that Vermeer rarely tried to "improve" on the image received by the camera to delineate forms that were not suggested by changes in tonal values.

Now we come back full circle to Vermeer the seer-voyeur of the *Diana and Her Companions* and *The Procuress*. The feeling of mystery that transpires through Vermeer's paintings of people in interiors stems less, as his oeuvre evolves, from incongruous details or even from strict geometricity than from the unmediated impression of visual stimuli. Vermeer, once he has set his mise-en-scène, records visual stimuli as a child registers a scene, prior to ratiocination, prior to all but the unconscious recognition of its significance. A child who chanced on the sight, through an open door, of a woman with a lute holding a letter in her hand while a servant stood beside her (Fig. 46), might not understand the meaning of the scene or only dimly realize what was going on. But he would remember it just that way. The image that would register in the child's mind would be enhanced by the immobility of the personages—a constant feature of the artist's work. The scenes Vermeer portrays are storable memories, that can be recaptured at will. They convey the same sense of recollected tranquility as the still photograph with which Ingmar Bergman concluded his film *Wild Strawberries*: the ancient memory of the hero's parents fishing on a halcyon day. All this, of course, Vermeer achieved with conscious artfulness, in the business of *imitating* reality.

The "reflection" of an artist's environment in his paintings—whether it is straightforward or distorted—does not exhaust the subject of the general relation of environment to art. The way he selects the persons and objects in his entourage that will be represented in his pictures may also

be significant. The negative aspect of that selection is particularly interesting in the case of Vermeer. Here is a man living in daily contact with a brood of children—their cradles, beds, and chairs, according to the inventory taken after his death, were strewn all over the house—who chooses never to paint one of them, at least in any picture extant or described in contemporary records, that we know of. (The more or less trivial exceptions are the little boy and girl playing in front of a house in *The Little Street* and the baby held in the woman's arms in the foreground of the *View of Delft*.) At least as curious, though perhaps more understandable, is the absence in Vermeer's paintings of any hint of domestic strife, of the attacks of Willem Bolnes on Catharina and on his mother. Surely, we would not expect a naturalistic representation of an irate man pursuing his sister with a stick in his hand. But if Willem's onslaughts had really perturbed Vermeer, they might have resurfaced in his paintings in some other guise, perhaps as scenes of rapine and plunder, virtuous maidens pursued by centaurs, or women brutalized by men. The representations of serenely pregnant women are the closest we get to a hint of these disturbances. Nothing apparently could ruffle the quiet majesty of Vermeer's art. Whether or not he took Willem's outbursts seriously, he did not let them influence the choice of his subjects or the way he treated them. It is still true, as Proust wrote more than a half century ago, that Vermeer's paintings are "marked by withdrawal and silence," that "passion and suffering and sex are banished from his art."[86] Did he take refuge in painting from the turbulence of his daily life? Did he transmute, by what psychologists call a "reaction formation," an unpleasant reality into an Elysian vision?[87] To support the notion of "reaction formation," one would have to argue that Vermeer, throughout his working years, was beset with problems that were psychologically equivalent to Willem's outbursts. With the exception of the money troubles and the difficulty he had bringing up his children in the 1670s, I cannot be persuaded that Vermeer had such a wretched life. I am more inclined to believe that his subjects and the way he handled them are rooted in much earlier experiences and were invariant to the things that happened to him in his adult years. His style and the contents of his paintings did evolve in the years of his maturity, but not necessarily in response to changes in his environment.

One hallmark of a great artist is his ability to set himself new tasks after he has successfully solved the problems that had once engaged his attention. With *The Milkmaid* (Fig. 28) of 1660–1661, Vermeer had reached the end of the path first traced out by Maes and De Hooch. He had mas-

[86] Cited in "Vermeer and the Future of Exhibitions," *The Burlington Magazine* 108 (1966): 387.

[87] The idea of Vermeer's possible "reaction formation" was suggested to me by Rudolph Binion.

tered perfectly the problem of representing a single figure surrounded by commonplace objects—a basket, a loaf of bread, a copper pan, a milk jug, a lead-glazed pot—bathing in natural sunlight. Each part of the milk-maid's dress (the soft violet-gray of her upturned sleeves is one of my favorite passages in his entire oeuvre), each piece of bread in the basket and on the table, each earthenware pot has the texture, the palpable quality that we would expect, but at the same time has been transformed into a substance more precious and more beautiful. All the objects represented have that tactile quality we find in the best Dutch art, yet they are exquisitely integrated, by means of precise perspective and delicate chiaroscuro, into the whole design.

What was Vermeer to do after he achieved the perfection of *The Milk-maid* at the beginning of the 1660s, fifteen years or so before his death? His style did continue to evolve: he simplified his modeling; he painted more thinly, with less impasto; his pointillism became subdued; the globules of light protruded less conspicuously from the surface of the painting. Only his preoccupation—not to speak of his obsession—with the precise representation of visible things shown in a natural light remained the same. Yet he was able to project his art in new directions, first in landscape, later, in allegory.

As far as we are aware he painted only three views of Delft: *The Little Street* (Fig.24); a "House Standing in Delft" (now lost);[88] and *View of Delft* (Fig. 34), whose realism (or lack of it) has already been discussed. The two extant pictures are thought to have been painted in the early 1660s, when Vermeer was still applying a fairly loaded brush to build up the paint surface of his pictures. The pointillism of the *View of Delft* suggests that it was painted later than *The Little Street*—though perhaps only by a year or two. City views were still a very novel form of landscape in the early 1660s. Most of those we know about were made to commemorate an event like the powder explosion of Delft in 1654, which Egbert van der Poel and Daniel Vosmaer painted over and over again. Neither *The Little Street* nor the *View of Delft* appear to have any programmatic content.[89] (As already mentioned, P. T. Swillens's attempt to link the for-

[88] The catalogue of paintings sold in Amsterdam in 1696 (doc. no. 436) included "A view of a house standing in Delft," and, next on the list, "A view of some houses." I believe that *The Little Street* in the Rijksmuseum is the latter rather than the former (cf. Blankert, *Vermeer of Delft*, p. 158).

[89] At the end of May 1660, Charles II of England visited Delft very briefly. He reached the southern port of the city from Rotterdam and left by The Hague Gate. The arrival of the King and his suite at the Rotterdam Gate was portrayed by N. (Adriaen van der?) Venne and engraved by David Philippe (Fig. 35) in *Relation en forme de journal du voyage et séjour que le Sérénissime et Très-Puissant Prince Charles II Roy de la Grande Bretagne etc. . . . a fait en Hollande depuis le 21 Mai jusques au 2 Juin 1660* (The Hague: Adriaen Vlacq, 1660). The silhouette of Delft in the background, taken from a vantage point not very distant from Vermeer's in his *View of Delft*, seems rather inaccurately drawn (and was not

mer to the reconstruction of the chapel of the Old Men's Home on the
Voldersgracht to serve as the hall of the St. Luke's Guild is quite uncon-
vincing.)

Between 1663 and 1665, Vermeer fell under the sway of the Leyden-
based Frans van Mieris. From Van Mieris and, directly or indirectly, from
Van Mieris's teacher Gerard Dou, he absorbed the art of "Fein Malerei,"
the tight, meticulous technique, executed with tiny, silk-soft brushes, for
which Dutch masters became renowned in the last third of the seven-
teenth century. But the influences on Delft's greatest artist were never un-
alloyed. Vermeer purged Van Mieris of his baroque, ever so slightly vul-
gar animation. Like Ter Borch, Vermeer imparted a noble mystery to his
interiors by immobilizing the figures or, if they were engaged in move-
ment, by endowing them with the ability to sustain a pose gracefully and
effortlessly (just as he had already done in his early *Diana* landscape).
Compare for instance the tense, arched back of the singer in Van Mieris's
Duet in Schwerin (Fig. 54) with the relaxed grace of Vermeer's women in
The Music Lesson (Fig. 48) and *The Concert* (Fig. 36).[90] The stateliness
of Vermeer's figures may be compared to Piero della Francesca's, which
also exude silence.

Just as Vermeer had perfected the compositional ideas and stylistic in-
novations of Fabritius, Pieter de Hooch, and Nicolaes Maes in the late
1650s, so he now raised the achievements of the painters of "society
pieces" to a higher plane. The pinnacle of his work in this new style is his
first fully articulated allegory, *The Art of Painting* (Fig. 37), which was
probably painted in the mid-1660s, in any case before *The Astronomer*
of 1668. The lovely female figure holding the trombone is based on the
figure of "Fame" in Ripa's *Iconologia*, the standard repertory for the ap-
propriate symbols of allegories in the seventeenth century. Crowned with
laurels never sere and dressed in virginal blue, she may also stand for Clio,
the muse of history, who trumpets the painter's fame. She carries a large
tome—perhaps Karel van Mander's *Schilderboeck* on the lives of Dutch
and Flemish painters, which sought to elevate and ennoble the art of
painting. "No other painting," Albert Blankert wrote not long ago about
The Art of Painting, "so flawlessly integrates naturalistic technique,
brightly illuminated space, and a complexly integrated composition."[91]
The painting was an intimate statement, which was probably not in-
tended for sale. Vermeer kept the painting for about ten years, until his
death, after which his widow did everything she could to maintain it in
her possession.[92]

therefore used as a point of topographical reference in discussing the accuracy of Vermeer's
View of Delft, above). I wish to thank Allen Chong for bringing this print to my attention.

[90] Blankert, *Vermeer of Delft*, p. 43.

[91] Ibid., pp. 47–49.

[92] See document nos. 379 and 380 of 12 and 13 March 1677.

A number of scholars have remarked on the similarity in composition between *The Art of Painting* and the *Allegory of Faith* (Fig. 39), painted eight or nine years later: the tapestry framing the left side of both pictures; the distance of the painter from the scene which allows him to show both floors and rafters from much the same perspective; the globe which plays the same role in the *Allegory of Faith* as the chandelier in *The Art of Painting*.[93] It is quite possible that someone saw the earlier picture in the artist's studio and ordered a Catholic allegory with a similar composition. Vermeer's patronage, in this case, may have come from the Jesuits next door or from other pious Catholics. The serpent, symbol of Protestant heresy, spits blood. It is crushed by a slab, which stands for the stone on which Christ ordered Peter, alias Simon, to erect His Church and found the papacy. The heretics may not actually have persecuted the "papists" in Delft, but they hemmed them in and forced them to worship in secret. They would have been shocked by the *Allegory of Faith*, which could only have hung in a Catholic chapel or in a devout Catholic home.[94] Its similarity to the ever popular *Art of Painting* notwithstanding, the *Allegory* has not been much admired of late. The pose of the figure of Faith is too histrionic, the manner of painting too glossy and slick for the modern viewer. And yet it holds up very well against the works of other Dutch painters of the period—Frans van Mieris, Eglon van der Neer, and, later, Adriaen van der Werff—who favored such a cold classical style. Vermeer, in the Catholic ghetto of a town that was rapidly reverting to its sixteenth-century provincialism, had to emulate the "fine-painting" fashion of Leyden and Amsterdam, the more dynamic cities of Holland, if he wanted to transcend the limitations imposed by his physical isolation.

[93] Blankert, *Vermeer of Delft*, p. 59.

[94] On 8 December 1679, the Jesuits in Delft celebrated with all the pomp they could muster the Feast of the Immaculate Conception. They did so, as they themselves remarked, because the "seculars" (the members of the other Catholic church in Delft, which did not belong to a religious order) had neglected the feast in the past, no doubt for doctrinal reasons. A statue made especially for the occasion stood in the middle of the altar. It showed "the Holy Virgin with the moon crescent and the crushed snake, while the Child on her arm grasped a cross, planted on the foot of His Mother, the foot with which she smashed the head of the snake." The clothes of the Holy Virgin were decorated with gold and pearls (Jan Rogier, "De betekenis," p. 180). Compared to this gaudy image, Vermeer's *Allegory of Faith* is positively austere. I wonder, if the Jesuits had commissioned the *Allegory*, whether they would not have insisted on a more conventionally religious iconography. In my view, a commission by a wealthy patron with a more discerning taste—or more willing to let Vermeer exercise his own fastidious taste—is more probable. It is interesting to note here that the "seculars" had been opposed to the Jesuits' excessive propaganda in favor of "scapulars, beads and relics" (ibid., p. 183). If we may judge from his quietist temperament, Vermeer may have felt some sympathy for this point of view.

· 11 ·

FRENZY AND DEATH

In 1663, eleven years after Vermeer's father died, a master carpenter and a master mason from Delft transacted some guild business with colleagues from Leyden "in the house of Reynier Vermeer in his lifetime innkeeper in Mechelen."[1] These craftsmen were probably typical of the clients who now frequented the inn, which Vermeer's mother, Digna Baltens, continued to run despite her advancing age. When she was seventy-four years old, she decided it was time to retire. On the second day of the year 1669, Digna Baltens, "widow and custodian of the estate of the late Reynier Vermeer," put up the inn for sale at auction.[2] She brought to the notary several deeds, including one going back to 1597, which was probably not long after the inn had been built. She and her husband had owned the place for twenty-eight years. The inn had long been mortgaged to a brewer in Haarlem and to Arent Jorisz. Pijnacker, Notary Willem de Langue's brother-in-law. Reynier Jansz. and, after his death, his widow had paid interest charges amounting to 105 guilders a year to the brewer and 20 guilders a year to Pijnacker ever since the inn had been acquired.

Real estate auctions in Delft involved a two-part process. First there was a regular "English auction," with bids going up by intervals of two ducatoons. The highest bidder, on the occasion of this first auction for the sale of Mechelen, was a man with the high-sounding name of Isaacq van Bodegrave, who offered 2,950 guilders. Then the Dutch auction started. The inn was first offered for 5,000 guilders and reduced by two-ducatoon intervals. When there was no bidder for Mechelen at 3,700 guilders, the auction was stopped. Since Digna Baltens had not received the minimum price she wanted, she withdrew the property from sale.

A few months later, the old woman resolved to lease the inn. She drew up a contract with a shoemaker, Leendert van Ackerdyck, who was to lease the place "for the purpose of using it as an inn as the lessor had done for many years."[3] The rent was 190 guilders a year, which, at a typical 5 percent interest rate, would have been the return on a perpetual bond or obligation worth 3,800 guilders. The last sum was just above Digna's reservation price at the recent auction. The rent left her only 65 guilders a year after paying the interest on both mortgages. The lease ran for three years starting in May 1669. The former shoemaker was entitled to take

[1] Doc. no. 295, 16 October 1663.
[2] Doc. no. 324, 2 January 1669.
[3] Doc. no. 325, 1 February 1669.

over the premises even earlier, as soon as Digna Baltens had been able to sell her furniture. The inn was leased empty, except for the beer and wine racks in the cellar and the board on which jugs and tankards were placed, which was nailed to the wall. All of these the lessee could use as he pleased.

Digna Baltens now went to live with her daughter Gertruy on the Vlamingstraat, the same street behind the New Church where Willem Bolnes was confined in the house of Taerling. Gertruy's husband Anthony van der Wiel was still making ebony frames in his workshop in the back of the house. He also carried on a sideline business in ebony wood. The earnings from his craft, together with his sales and some art dealing on the side, brought the childless couple an income that must have been above average for Delft citizens. They surely had enough to support the old innkeeper, who had a small income of her own from the lease of Mechelen. Digna did not enjoy their hospitality very long. She must have died on February 10 or 11, 1670, since, according to the register of the New Church, she was buried on the 13th.[4]

At nine o'clock on the evening of February 11, Notary Assendelft was called to the house on the Vlamingstraat to draft the new testament and last will of Anthony van der Wiel and Gertruy Vermeer.[5] Was Gertruy's mother already dead or was she about to die? Why, in either case, was the notary summoned at this late hour? The testament itself sheds only the dimmest light on these questions. After the notary had declared both testator and testatrix to be in good health and of sound mind, he wrote down their last will and testament. Each was to be the universal heir of the other, but specific provisions were made in case one should predecease the other. If Gertruy were to die before Anthony, her husband within five years would have to turn over to her "relatives and heirs *ab intestato*" all her clothes and personal effects and the sum of four hundred guilders. Who were these "relatives and heirs *ab intestato*"? Gertruy had no live children.[6] Her mother was dead or about to die. Only her brother would have had a claim on her estate if she had died intestate. But why was he not named in connection with Gertruy's specific bequest? Perhaps because, if Digna was still alive, Gertruy would have been obliged to make a separate bequest to her also and that, in anticipation of her impending death, she preferred to maintain this temporary ambiguity. Whatever the reason, Anthony had no such reservation about naming *his* heirs. In case he were to die first, the will called upon Gertruy, within five years after his death, to turn over to his unmarried sister Maria van der Wiel three

[4] Doc. no. 330, 13 February 1670.
[5] Doc. no. 329, 11 February 1670.
[6] The only recorded child, named Beyken van der Wiel, was baptized on 17 May 1654 (doc. no. 260). She probably did not survive infancy.

hundred guilders. (Maria was the girl who many years before had been accused of having had an illegitimate child.) To Anthony's brother Jacob living in The Hague, Gertruy was to deliver all his woodworking equipment, not including his stock of ebony. One witness to the will was Arent Pijnacker, who held a mortgage on Mechelen. The other was Pieter van Ruijven, Lord of Spalant, the patron of Vermeer. The testatrix must have been very upset or even ill, the notary's remark about her good health notwithstanding, because she signed the will "Geertruit Vormeer" in a trembling hand. The first name was an acceptable variant of Gertruy, but Vormeer was an astonishing oversight: the name comes from Van der Meer, which is never contracted in any other way than Vermeer.

Gertruy was probably in poor health when she signed her will. She died at the beginning of May 1670, less than three months later.[7] Anthony dutifully made contributions to the Camer van Charitate on behalf of both his mother-in-law and his wife, giving 6 stuivers for each.[8] This was about the sum we would expect from a successful craftsman in his position. Six months later he remarried, to a girl named Abigail van der Briel.[9] He died in 1693 at a ripe old age.[10]

On July 13, 1670, a division was made of Digna Balten's estate. With the approval of Anthony, Vermeer received as his part the inn Mechelen, for which he had assumed responsibility for meeting the mortgage payments.[11] The house was still leased to the shoemaker Van Ackerdyck. At the beginning of 1673, he leased it again, this time to his namesake, the apothecary Johannes van der Meer, for six years at 180 guilders per year, which was 10 guilders less than his mother had obtained from the shoemaker.[12]

The previous year, 1672, had been the "year of catastrophe." Louis XIV of France invaded the eastern part of the Netherlands and advanced to within a day's march of Amsterdam; the English, on a flimsy pretext, attacked the Dutch merchant fleet before declaring war. Willem of Orange, the future King of England, was called to power as Stadhouder of Holland. He only succeeded in saving the most westerly territory by opening the dikes and inundating a large area of the country. The Dutch populace found a scapegoat to atone for the Republic's troubles. The Grand Pensioner Johan de Witt, the leading Dutch statesman of his time, was torn limb from limb in The Hague, along with his brother Cornelius. The Dutch army, under Willem's leadership, gradually stiffened its resist-

[7] Doc. no. 331, 2 May 1670.
[8] Doc. no. 333, 26 August 1670; and no. 336, 27 May 1671.
[9] Doc. no. 335, 8 November 1670.
[10] Anthony van der Wiel was buried on 11 May 1693 (Delft G.A., Burial files).
[11] Doc. no. 332, 13 July 1670.
[12] Doc. no. 340, 14 January 1672.

ance. By 1674 the worst was over, but a lasting peace and the final res-
toration of the Republic's frontiers were delayed until 1678. As bad as
business already was in 1672 and 1673, Vermeer was lucky to get as
much for the lease of the inn as he did.

A year before the invasion, in July 1671, Johannes Vermeer had ap-
peared before Notary Assendelft to acknowledge that he had received an
inheritance consisting of 148 guilders, from his sister's estate. Vermeer
assumed responsibility for paying the claims on his mother's estate, but
he was also entitled to receive the proceeds from all debts "which are still
to be claimed from various persons."[13] Since individuals who did not own
businesses rarely had any accounts receivable, I consider this reference to
collectible debts as supporting the other evidence I have previously re-
ported that Digna Baltens was running Mechelen as an inn after her hus-
band's death.[14]

As his sister's heir *ab intestato* by the testament of Anthony and Ger-
truy of February 1670, Vermeer was bequeathed four hundred guilders
plus her clothing and all her personal effects. It is not known why he
received a sum that was so much smaller than he should normally have
anticipated. My guess, however, is that the debts owed by Digna Baltens
exceeded her claims on unpaid accounts and that therefore his sister's
estate was smaller than expected.

The 148 guilders Vermeer obtained from his sister's estate, the claims
he had on Mechelen customers, and the rental income above mortgage
costs on the inn made additions to his income that compensated only in
part for his inability to sell his paintings or those of other masters in
which he was dealing by reason of the war with France. (This serious loss
was deplored by his widow shortly after his death.)[15] Maria Thins may
also have increased her subsidies to the Vermeer household in these criti-
cal years. It is hard to believe that, after 1668, Vermeer did not profit at
all from the revenues accruing to the Diewertje van Hensbeeck legacy that
he collected on his mother-in-law's behalf from the Orphan Chamber in
Gouda.[16]

In October 1671, Vermeer, for the second and last time, had been
elected a headman of St. Luke's Guild.[17] In May 1672, in the first of his
two-year period of service, he was called to appraise some Italian paint-

[13] Doc. no. 337, 18 July 1671. All other previously published readings of the document
report that Vermeer received 648 guilders. The number is spelled out twice in the original,
the second time unambiguously as one hundred and forty-eight guilders.
[14] Doc. no. 295, 16 October 1663, and various clauses of the contract offering Mechelen
for sale (doc. no. 325).
[15] Doc. no. 367, 30 April 1676.
[16] Doc. no. 318, 2 June 1668; no 342, 3 and 9 June and 2 September 1673; and no. 353,
29 December 1674.
[17] Doc. no. 334, 28 October 1670.

ings in The Hague, together with Johannes Jordaens, an older colleague who had spent many years in Italy.[18] Since Vermeer probably had never left the Netherlands, it is likely that he was chosen by virtue of his eminence in the guild.

The story of the Italian paintings is this. Gerard and Jan Reynst, wealthy Amsterdam merchants, had amassed a vast collection of paintings and statues. They had done so primarily as a means "to attain a higher social respectability."[19] In May 1670 the "Cabinet" of Gerard Reynst (Jan had died many years earlier) was sold at auction in Amsterdam. The prominent art dealer Gerrit Uylenburgh, who had apparently organized the auction, kept a number of paintings and sculptures that had not sold. In the summer of 1671 he offered twelve Italian pictures and some sculptures to Friedrich Wilhelm, the Grand Elector of Brandenburg, who kept them for some time on approval. He was the grandson of the Elector Johann Sigismund who was implicated in the counterfeiting operation that had been carried out by Vermeer's grandfather and uncle in 1619 and early 1620. The adventure was surely known to Vermeer. It must have been piquant for him to be asked to judge whether the paintings in the Grand Elector's custody were "authentic" or "counterfeit." The painter Hendrick Fromantiou, who was the Elector's agent and connoisseur in art matters, was convinced the paintings were imitations and so informed his patron. The Grand Elector, swayed by Fromantiou's arguments, turned down the paintings. Uylenburgh refused to take them back. The dealer and the agent now culled testimonies for and against the pictures. First the painters Carel Dujardin and Wilhelm Dodijn went through the list in great detail and declared that most of the paintings were imitations or copies of the great masters—Michaelangelo, Titian, Tintoretto, Giorgione, Jacopo Palma, Holbein—to whom they had been attributed. Then Rembrandt's talented pupils, Gerbrandt van den Eeckhout and Philip de Koninck, together with the Italianate painter Johan Lingelbach, declared that the paintings did have some merit and deserved to hang in the a collection of Italian art. After that, Fromantiou induced the painters Philips Momper, Abraham van Beyeren, and Pieter Codde to testify to the contrary. A week later the twelve paintings were sent to The Hague where they were exhibited on the premises of Pictura, the painters' guild. A number of local artists made their deposition against the authenticity of the pictures. On May 23, 1672, the same day Vermeer and Jordaens gave their testimony, Constantin Huygens, Holland's great statesman, con-

[18] Doc. no. 341, 23 May 1672.
[19] Anne-Marie Logan, The "Cabinet of the Brothers Gerard and Jan Reynst (Amsterdam, Oxford, and New York: North Holland Publishing Company, 1979), pp. 91–97. All the information in the text on the Reynst collection and on the controversy concerning their sale is taken from this source.

noisseur of art, and intellectual-at-large wrote in French defending Uylen-
burgh to an officer in the Elector's army. The dealer, he claimed, was
being fiercely persecuted by Fromantiou, who was doing his utmost to
collect opinions deprecating the twelve paintings as copies. Huygens as-
sured his correspondent that, after making a minute examination of the
paintings, he had come to the conclusion that none of them was a copy,
although "some might be worth more than others." Moreover, they had
all been recognized as originals when they had hung in the Reynst collec-
tion. Now it was the turn of Jordaens and Vermeer, "outstanding art-
painters in Delft," to make their appraisal before a Hague notary. They
declared at the request of Sr. Hendrick Fromantiou that they had seen in
the hall of the confrerie the twelve pieces listed in the catalogue that Fro-
mentiou had shown them, together with the prices at which they had been
assessed. The Venus and Cupid by Michaelangelo was listed at 350 rijcks-
daelders worth 2.5 guilders each, or 875 guilders; a portrait of Giorgione
by Titian at 250 rijcksdaelders; a shepherd and shepherdess by Titian at
160 rijcksdaelders; and so forth. The two deponents stated that in their
opinion the pictures were "not only not outstanding Italian paintings, but
to the contrary, great pieces of rubbish and bad paintings, not worth by
far the tenth part of the afore-mentioned proposed prices." The Grand
Elector finally succeeded in returning the paintings, keeping only a Ribera
Head of St. John and some sculptures equivalent to the deposit he had
given Uylenburgh. The contested pictures were sold at auction in Amster-
dam in February 1673. Unfortunately we have no record of the prices
they brought.

Who was right in the controversy? Were the paintings recent copies
ordered by Uylenburgh, workshop or studio productions, or originals by
famous masters? The evidence is thin. Only one of the paintings is ex-
tant—a "Dance of Naked Children" given to Palma in the Uylenburgh
catalogue—which ended up in the Six collection in Amsterdam. This is
probably a sixteenth-century painting of the school, workshop, or entou-
rage of the younger Palma. Two others, by Giorgione and Paris Bordone,
are known from engravings.[20] They seem to be pictures of the period and
related to the masters to whom they were attributed, but they are unlikely
to have been autograph works by these masters. All in all, the Fromantiou
faction, which included Vermeer, seems to have been closer to the truth
than Huygens and the other defenders of Uylenburgh, although their crit-
icism may have been exaggerated. The sharp division in the painters'
community, with painters who had spent years in Italy on both sides of
the controversy, illustrates the difficulty of making judgments when there
were so few paintings by eminent Italian masters in Holland at the time,

[20] Ibid., pp. 95–96.

and none that could be hung next to and compared with those that were being questioned.

In June 1673, Vermeer petitioned the magistrates of Gouda in connection with the Diewertje van Hensbeeck legacy.[21] He recalled that the capital sum left by Diewertje van Hensbeeck and deposited in the Orphan Chamber of Gouda had been assigned to Maria Thins's mother Catharina Hendricks, with the provision that she and, after her death, her children should be entitled to draw the yearly income from the capital. Diewertje van Hensbeeck had stipulated that the capital itself could not be alienated until the generation of Catharina Hendricks's grandchildren, of whom Vermeer's wife, Catharina Bolnes, was one (the other one of course being the irascible Willem Bolnes). Five years earlier Maria Thins had passed an act in Delft empowering her son-in-law to collect the yearly income on her behalf, which he was now requesting. (Even though Vermeer, in his wife's name, now "owned" the capital, it was still subject to the supervision of the Chamber as long as Maria Thins lived, since she was entitled to the entire usufruct of her share of the capital.) The magistrates, after consulting the masters of the Orphan Chamber, approved the petition. We have no record of Vermeer's collection of the interests due on Maria Thins's share of the capital in 1673, but in December of the following year he received five hundred guilders, which was apparently the interest for 1674 on his wife's share of the capital. He signed a receipt for this sum on behalf of his "mother."[22] The slip—whether the clerk's or Vermeer's—further attests to the close ties that bound the artist and his mother-in-law at this time.

In the last two years of his life, Vermeer suddenly became a more public person, leaving more traces of his presence in notarial and other records than he did in the late 1650s or 1660s.

In July 1673, Vermeer's presence was noted in Amsterdam when he sold two bonds by the States of Holland and West Friesland, together worth eight hundred guilders, to a certain Hendrick de Schepper.[23] On January 18, 1674, Vermeer acted as a witness for a debt recognition by an inhabitant of Overschie, near Delft, to his half sister.[24] Both, as far as we can tell, were total strangers to him. From that time until his death on December of the following year, his notarial appearances were chiefly made to handle the affairs of Maria Thins and of his wife Catharina.

Three days after witnessing the debt acknowledgment, Vermeer accom-

[21] Doc. no. 342, 3 and 9 June and 2 September 1673.

[22] Doc. no. 353, 29 December 1674.

[23] Doc. no. 344, 21 July 1673. One of the obligations was in the name of Maijke Thomas, who lived in the Paepenhoek (see Chapter 10 at note 24). The other was in the name of Magdalena Pieters, who may be tentatively identified with Magdalena Pieters van Ruijven, the daughter of Vermeer's patron.

[24] Doc. no. 346, 18 January 1674.

panied Maria Thins to a new notary and signed her deposition concerning some high-born people she had "frequented in a familiar way and had had good acquaintance with."[25] The deposition had been requested by Elbert van Isendoorn à Blois as guardian of his legally minor children. This gentleman had married Odilia van Wassenaer in 1658 after the death of his first wife.[26] The deposition may have been prompted by Odilia's death "nine days after Palm Sunday 1672."[27] (The double portrait by the Flemish painter Michel-Angelo Immenraedt of Odilia and her sister Philippina Maria shows the two young women in the guise of shepherdesses in 1661 [Fig. 55].) Odilia van Wassenaer, Maria Thins explained, was the daughter of Aelbrecht van Wassenaer (Lord of Alkemade, "hoogheemraed" of Delfland in 1632). Aelbrecht van Wassenaer had married Hester Cornelia de Bruyn van Buytewech, lady of Nieuwcoop[28] (named "Cornelia van Butewegt" in the deposition), who was a daughter of Cornelia Cool. This last-named person was in turn the only daughter of Hugo Cool and Maria van Blijenburch with whom Maria Thins had lived four years (probably in Delft from 1614 to 1618). It is conceivable but improbable that even though Maria Thins "frequented in a familiar way" Elbert van Isendoorn à Blois and his wife Odilia, who were Vermeer's contemporaries, the artist himself did not.

At the end of March 1674, Maria Thins, in her own name as a custodian of the estates of Joan and Cornelia Thins, named Geerlof Verborn in Oud Beijerland to represent her in the forthcoming allocation of common lands in that district. Sr Johannes Vermeer, master painter, witnessed the procuration.[29]

Reynier Bolnes, the estranged husband of Maria Thins, died on April 4 and was buried in the Church of St. Jan in Gouda—the same church to which Maria Thins's ancestors had donated a great stained-glass window.[30] A month later, Vermeer traveled to Gouda to make the most pressing decisions regarding his late father-in-law's affairs. Both on his behalf and on behalf of Willem Bolnes, he leased Reynier Bolnes's house on the Peperstraet for 140 guilders a year.[31] On May 24 Maria Thins, who had been charged by the burgomasters and aldermen with the supervision of her son Willem Bolnes, together with Johannes Vermeer representing his wife, appeared before the family notary Frans Boogert to settle the inheritance due to Catharina and Willem Bolnes from the estate of Hendrick

[25] Doc. no. 347, 21 January 1674.
[26] *Nieuw Nederlandsch Biografisch Woordenboek*, 10 vols. (Leyden: A. W. Sijthoff, 1912), 2: 1517–18.
[27] *Nederlandsche Leeuw* 21 (1907): 249.
[28] On the Buytewechs and the Nieuwcoop connection, see Chapter 7 at note 23 and ff.
[29] Doc. no. 348, 31 March 1674.
[30] Doc. no. 349, 4 and 7 April 1674.
[31] Doc. no. 350, 4 May 1674.

van Hensbeeck.[32] This Van Hensbeeck, who belonged to a different branch of the Hensbeeck family than Catharina Bolnes ancestors, was the son of Claes van Hensbeeck, who had married Cornelia Bolnes, the sister of Reynier Bolnes.[33] A dispute between Reynier Bolnes and the "other heirs" of Heyndrick van Hensbeeck had apparently been settled by arbitration. Maria Thins agreed to respect the compromise that had been hammered out by the arbiters two years earlier.

Two days later, on May 26, Maria Vermeer, the eldest daughter of the painter, was betrothed to Johannes Gillisz. Cramer, the son of well-to-do silk merchants. The marriage was solemnized in Schipluy, probably in the same Roman Catholic church where Johannes and Catharina had been married twenty-one years earlier. Official registration of the marriage took place before the magistrates of St. Maerten.[34] Maria was the only one of Vermeer's children who found an independent source of support during his lifetime.

On March 5, 1675, Maria Thins gave the "honorable Johannes Vermeer" power of attorney to act in her name in the division of the estate of the late Reynier Bolnes and to collect the assets to which her son Willem was entitled out of the estate.[35] On March 26, Vermeer showed up in Gouda to renew some leases for landed properties that Maria Thins had inherited from her late husband. The lessee, Jan Schouten, had apparently paid Reynier Bolnes for the rent beginning on St. Martin's Day 1671 and ending the same day 1672; but, due to the war with France, Schouten had not been able to pay anything on the 1673 and 1674 rents.[36] I presume this was because the land had been flooded after the new Stadhouder, Willem III, had ordered the dikes opened to defend part of the country against the French invasion. What makes this explanation likely is that the document in question stated that Maria Thins's tenant had been forced to put up a mud dike to limit the damage, the cost of which had been taken into account in cancelling the arrears. The three morgen of land mentioned in the contract were again leased to Schouten for seventy-two guilders a year.

In July, the painter made a last trip to Amsterdam, this time to borrow 1,000 guilders from Jacob Rombouts, a local merchant.[37] From an act passed by Maria Thins fourteen months after Vermeer's death,[38] we learn that this transaction may have violated the old woman's trust, if not the law. She had instructed Vermeer to collect 2,900 guilders restricted capi-

[32] Doc. no. 351, 24 May 1674.
[33] C. J. Matthijs, De takken van de dorre boom, pp. 23–26.
[34] Doc. no. 352, 26 May and 10 June 1674.
[35] Doc. no. 354, 5 March 1675.
[36] Doc. no. 355, 26 March 1675.
[37] Doc. no. 356, July 1675.
[38] Doc. no. 378, 22 February 1677.

tal from the Orphan Chamber in Gouda to whose usufruct she was enti-
tled. Instead of holding on to this sum ("onder hem te houden"), as he
had agreed with Maria Thins he would, he had pawned it to get the 1,000
guilders loan from Jacob Rombouts. She had lost the interest on the sum
and had eventually been forced to pay back the loan, or most of it, in
order to recover the collateral sum from the creditor (more precisely,
from his widow).[39] She had then returned the obligation to the Orphan
Chamber, as the law required. Vermeer must have been desperately
pressed for funds to behave in such a way, if he really did. Such comport-
ment would be so much out of character with the whole life of Vermeer
as we know it that I am inclined to believe that Maria Thins may have
distorted the story, perhaps to reduce her responsibility in the affair.

The dramatic end of Vermeer's life was told by his widow a year and a
half after his death, when she applied to the States of Holland and West
Friesland for permission to use the rest of the capital still tied up in the
Diewertje van Hensbeeck trust to help bring up her children.[40] She stated
in her petition that her late husband Johannes Vermeer "during the long
and ruinous war with France not only had been unable to sell any of his
art but also, to his great detriment, was left sitting with the paintings of
other masters that he was dealing in. As a result and owing to the very
great burden of his children, having no means of his own, he had lapsed
into such decay and decadence, which he had so taken to heart that, as if
he had fallen into a frenzy, in a day or day and a half he had gone from
being healthy to being dead." A very plausible interpretation of this story
is that Vermeer, frantic over his inability to earn money to support his
large family and to repay his debts, had a stroke or a heart attack from
which he had died in a day or two.

Another petition that Maria Thins and Catharina Bolnes made to the
magistrates of Gouda in 1678 added some important details to this tale
of distress.[41] They claimed that the artful painter had left behind ten chil-
dren under age, the oldest now being twenty-one and the youngest four
years old. Since the statement was made two years and nine months after
Vermeer's death, it implies that the oldest child at the time of his demise
was about eighteen and the youngest between one and two years old.
Two of the children, the woman lamented, were very sick and one had
been "piteously wounded" in the explosion of a ship coming from the
city of Mechelen carrying gunpowder. Things had come to such a pass
that the petitioner, Vermeer's widow, could no longer feed her children
and pay the apothecary and surgeons. The petition does not explain

[39] Doc. no. 389, 2 April 1678.
[40] Doc. no. 383, 27 July 1677.
[41] Doc. no. 393, 1 September 1678.

whether the two children had been sick and the third wounded in the explosion before or after the artist's death.

What was one of Vermeer's children doing in a ship coming from Mechelen, in Spanish-dominated Brabant? We know from Maria Thins's testament of 1677 that Johannes, the oldest son, had been assigned some funds for his studies from a trust fund two years after his father's death.[42] From the fact that he was still a minor—less than twenty-five years old—in May 1689,[43] we may infer that he was at most eleven when Vermeer died. If he had gone to a local school in Delft, which would normally cost three to five guilders per year for a young boy, it would hardly have been necessary for his grandmother to stipulate in her testament that, in case the income from the trust did not suffice, other funds belonging to her could be used to defray the costs. It is likely then that he was studying out of town. In view of the religious inclinations of the family, I strongly suspect that Johannes had been sent to the Spanish Netherlands to study, probably in Mechelen, where Juffr. Aleydis Magdalena van Rosendael was delegated to settle some business on Maria Thins's behalf in 1680. At the time there was a college in Mechelen run by the Fathers of the Oratory, where a cousin of Aleydis Magdalena and Cornelia Clementia van Rosendael, Jacob Ignatius van Rosendael, had gone to school a few years previously.[44] If this was indeed the place where the family chose to send young Johannes, it would have been on a journey home from school that he was wounded. At all events he survived the accident: he married, had a child, and then left the Netherlands forever.[45]

Johannes Vermeer died on December 13 or 14, 1675. On December 15, his body was brought to the Old Church on the Oude Delft Canal. The grave that Maria Thins had purchased in 1661 already contained three children of unspecified sex who had died in 1667, 1669, and 1673. The next day Vermeer's coffin was laid in the family grave.[46] His last deceased child was placed upon his coffin.

The inscription in the church register noted that Vermeer was leaving "eight children under age." The following April his widow declared that she had been left with "eleven living children."[47] In the 1678 petition to

[42] Doc. no. 376, 6 January 1677.

[43] Doc. no. 430, 2 May 1689.

[44] Doc. no. 406, 4 October 1680. In doc. no. 391 of 9 April 1678, there is a mention of Maria Thins's affairs in Brabant, which may also refer to Johannes's schooling. Jacob Ignatius van Rosendael, born in Utrecht in 1648, was inscribed in the school by the Fathers of the Oratory in Mechelen in 1659, when he was eleven years old (*Genealogische en Heraldische Biaden* (1906): 356). Johannes Vermeer was about twelve years old when Maria Thins first made provision for his schooling. (I owe the source mentioning Jacob Ignatius van Rosendael to W. A. Wijburg.)

[45] See Chapter 12 at note 70 and ff.

[46] Doc. no. 357, 15 and 16 December 1675.

[47] Doc. no. 367, 24 and 30 April 1676.

the magistrates of Gouda already cited, she claimed that she had ten children under age, the oldest of whom, she implied, was eighteen in 1675, the youngest about one year old.[48] Since the couple had been married only twenty-two years, there could not have been any offspring older than the legal age of 25 by 1675. However, Maria Vermeer, the oldest daughter, had left home to get married a year and a half before Vermeer's death. Marriage was generally considered the equivalent of having reached the legal age of maturity. Thus she was undoubtedly the eleventh child who was left "alive" cited in the petition of 1678 (and in some others as well that will be described in the next chapter). Elisabeth or Lisbeth would then have been the oldest child under age who was said to be twenty-one in the petition of September 1678. As we have already seen, she was probably born in the second half of 1657 or in early 1658, shortly after the testament of Maria Thins drawn up in June 1657, which only mentioned her godchild Maria.[49] This hypothesis still does not explain the discrepancy between "eight children under age" noted in the burial register and the ten children cited in the petition. From later depositions, including one of 1684 where Catharina again specifically referred to the eleven children left after her husband's death, of whom eight were still living with her,[50] I can only conclude that the burial register was in error. Perhaps the sexton or clerk had only counted the children who were actually present in the home when their father died.

Only nine names of Vermeer's children are known with certainty: Maria, Elisabeth, Johannes, and Ignatius from the testaments of Cornelia and Maria Thins; Beatrix from the testament of Aleydis van Rosendael of 1703; Franciscus from a contract for a loan dated 1690; and Aleydis (or Alida), Gertruyd, and Catharina from a petition drawn up in 1713.[51] I have also suggested that the Cornelia Vermeer who owed a small sum to a book dealer in the Papists' Corner may have been a child of the painter.[52] Finally, I shall argue in the next chapter that the eleventh child, who was probably born in the second half of 1674, died before it was five years old. We shall probably never learn her or his name.

We now know that Vermeer left a testament, which unfortunately is no longer extant.[53] From a reference to it by his widow a few years later, it would seem that Catharina was left as the guardian of the children under

[48] Doc. no. 387, 1 September 1678.

[49] Doc. no. 268, 18 June 1657.

[50] Doc. no. 419, 21 October 1684. The procuration by attorney Hendrick van der Eem of 27 July 1677 (doc. no. 382) also mentions ten minor children.

[51] For the petition of 1713, see document 448; for the testament of 1703, doc. no. 443; for the loan document, doc. no. 434.

[52] Chapter 10 at note 33.

[53] Doc. no. 426, 27 December 1687.

legal age. It almost certainly excluded the Orphan Chamber from any role in the succession.

Nothing has been said so far about the impact of Vermeer's personal life on his art in these last years. Was he able to concentrate on his painting now that he had to bustle about in Delft, Gouda, and Amsterdam on family business and that he had to worry about food, schooling, and medicine for his children?

One thing that we can judge with our own eyes is this. *Lady Seated at the Virginals* (Fig. 50), considered to be his last painting because it progressed further along the path of stylization and simplification of modeling characteristic of his late work, betrays some falling off in the quality of its execution. As Blankert observed in his book on Vermeer, "the folds of the costume are now harsh and coarsely executed, and the blots making up the frame of the painting on the black wall lack the sureness of touch [of his earlier work]."[54] Was this decline due to the harried circumstances of his life in this last period? This is plausible, but I am more tempted to conjure up an explanation inherent in the work itself. In his last paintings, Vermeer seems to have lost the confidence, the inner conviction that imparted life energy to his art. The *Allegory of Faith* is labored and contrived, a chore accomplished rather than a joyful effusion. The *Lady Seated at the Virginals* lacks force. It is as if Vermeer, having worked out his obsessions—the intimate urgings that had prompted him to paint with exquisite precision pensive women pent up in shallow spaces—had, in the end, shed his passionate interest in representing these silent scenes.

[54] Blankert, *Vermeer of Delft*, p. 59.

· 12 ·

AFTERMATH

On December 16, 1675, the day Vermeer's coffin was placed in the family grave, an inscription was made under his name in the book recording death donations to Delft's Camer van Charitate. The inscription in Dutch read: "niet te halen," which may be translated as "nothing to get."[1] The reference was to the box that was normally sent to the house of the deceased. In this box his family or heirs were supposed to deposit his "best outer garment" or a suitable donation for the poor. Why was no donation made after the artist's death? Was it because the widow, burdened with so many children, was too poor? Or because the family was Catholic and did not wish to contribute to an organization run by Calvinists? As we shall see, a contribution to the Camer was made after the death of Maria Thins, which would seem to rule out the religious explanation. The failure to donate is most probably rooted in Catharina's insolvency, declared a few months later.

The family's financial situation had been seriously aggravated by the war with France, not only because Vermeer's earnings had been adversely affected (as his widow was soon to testify) but because the rents on some of the principal properties belonging to Maria Thins had remained unpaid. Soon after her son-in-law's death, the matriarch undertook to remedy this state of affairs by negotiating new leases. At her request, her tenant in Oud Beijerland, Emmerentia Jacobs, acknowledged on January 2, 1676, that she owed her 1,683 guilders 13 stuivers for the lease of twenty-seven morgen of land that had fallen due since 1673.[2] The tenant was to pay two hundred guilders a year on the sum due until full restitution. (This was clearly a major concession, considering that it would take over fifteen years to repay the entire debt without interest.) The new lease called on widow Jacobs to pay 486 guilders a year for the twenty-seven morgen. A week later Maria Thins leased seven and a half morgen of hay and pasture land lying near Schoonhoven for one hundred guilders a year.[3] One of the two witnesses to this act was Simon Ariensz. Samuels, master stone carver, the son of the late Adriaen Simonsz. Samuels, himself a master sculptor or stone carver. This Roman Catholic family lived in the Molenpoort next door to Vermeer.

The first creditor to stake his claim on the Vermeer estate was the baker Hendrick van Buyten. The relation between the families of Van Buyten

[1] Doc. no. 358, 16 December 1675.
[2] Doc. no. 359, 2 January 1676.
[3] Doc. no. 360, 9 January 1676.

and Vermeer was longstanding and close. As early as 1631 Hendrick's father, Adriaen, had appeared in a document with the artist's father.[4] We have seen how Monsieur de Monconys, upon visiting Vermeer in 1663, had been steered to a baker who was most probably Hendrick van Buyten. In a deposition of January 1676, a month and a half after Vermeer's death, Catharina Bolnes appeared before Notary Van Assendelft[5] to acknowledge that she had "sold and transferred" two paintings by her late husband to Van Buyten: the first with two figures, one of them writing a letter; the second showing a personage playing a "cyter" (a cittern or similar stringed instrument). My analysis of the inventory drawn up after Van Buyten's death, discussed in the next chapter, suggests that the *Lady with a Maidservant* (Fig. 45), presently hanging in the Frick Museum, was the two-figure painting cited in the 1676 contract; the other painting may have been *The Guitar Player* (Fig. 47) or, less likely the *Woman Playing a Lute* in the Metropolitan Museum.[6]

Catharina further declared that she had been paid 617 guilders 6 stuivers for the two paintings, which she owed Van Buyten for bread delivered. He in turn recognized that his bill had been cancelled by the sale. Catharina and Van Buyten agreed that if she paid him fifty guilders a year to the full restitution of the 617 guilders 6 stuivers and if, meanwhile, he was paid 109 guilders, 5 stuivers, another debt also arising from the delivery of bread, he would return the paintings to her or to her heirs. But if it should happen that Catharina's mother Maria Thins should die before the debt was settled, then the rest would have to be repaid at the rate of two hundred guilders a year plus interest at 4 percent, starting from the date of her mother's death. She would also have to pay interest if the regular payments of fifty guilders a year were not made on time. Van Buyten, in a second part of the same contract, stated that he had made the accommodations because Catharina had persistently urged him to. Nevertheless, in case she was not able to meet her obligations, he would be allowed to sell the paintings, and she would still have to make good any amount by which the sale fell short of the 617 guilders 6 stuivers due to him.

Van Buyten must have delivered a great deal of bread to accumulate a total credit of over 726 guilders, an amount larger than I have come across in any Delft inventory for an amount due a baker. If the family ate brown bread, it cost them, in the 1670s, about 1 stuiver 8 pennies per pound. A white loaf of one and a half pounds cost 2 stuivers 10 pennies or roughly eleven pounds for one guilder.[7] We are then talking

[4] Doc. no. 132, 12 August 1631.

[5] Doc. no. 361, 27 January 1676.

[6] On these two paintings see Chapter 13.

[7] According to a deposition of 21 October 1676, a loaf of brown bread weighing three pounds legally cost 4 stuivers 8 pennies, and a loaf of white bread weighing one and a half

about deliveries amounting to nearly 8,000 pounds of white bread, which a family of this high standing presumably consumed. The household, according to Catharina's later testimony, included eleven children in all, of which at least Maria and Elizabeth were already young adults by the early 1670s. Such a family might eat six to ten pounds of bread per day, depending on the range and adequacy of the rest of their diet. The debt might therefore be the equivalent of two or three years of bread deliveries. Vermeer had then failed to pay for the bread his family consumed since 1672 or early 1673, which would correspond to the onset of the decline in his financial situation that his widow deplored in her subsequent petitions. Still, a delay of two or three years would seem to be a very long time for the supplier of a common staple to refrain from pressing for payment. Van Buyten had perhaps intended all along to build up a large credit so that he could eventually dun Vermeer, who was no doubt a reluctant seller, for a painting or two to offset his debt. The arrangement he made with Catharina was not ungenerous. She had over twelve years to refund the main part of the debt at fifty guilders per year, and she did not even have to pay interest. The clause calling for accelerated repayment with interest in case of Maria Thins's death reflected the obvious fact that Catharina would come into money after her mother's death and that she would be in a much better position to pay her debts.

Van Buyten, who lived from 1632 to 1701,[8] could well afford to wait for his money. Although his parents had left him only a moderate inheritance, his wealth had grown not only as a result of his successful baking business but also because he had divided with his brother Adriaen the estate of a wealthy relative named Aryen Maertensz. van Rossen in 1669.[9] His share alone had amounted to 3,829 guilders. It is known that both he and his sister Emmerentia van Buyten lent money at interest.[10] When he died at the beginning of the eighteenth century, he left 250 guilders to the Camer van Charitate and 600 guilders to the Orphan Chamber. His yearly income from obligations was estimated at 2,855 guilders.[11] More will be said about his circumstances in the last chapter.

The second creditor with whom Catharina had to settle was a certain

pounds cost 2 stuivers 10 pennies (Delft G.A., records of Notary A. van den Velde, no. 2178).

[8] Hendrick van Buyten was eighteen years old when his father, the shoemaker Adriaen Hendricksz. van Buyten (alias Van Houten), died in 1650. His sister Emmerentia was nearly twenty-two at the time and his brother Adriaen was twelve years old. (Delft G.A., Orphan Chamber, *boedel* no. 264). His death date is given in Orphan Chamber *boedel* no. 265 IX. See also Chapter 13.

[9] Delft G.A., records of Notary Dirck Rees, no. 2144, 1 April 1669.

[10] For example, the debt obligations owed to him listed in the records of Notary G. van Assendelft, no. 2132, fols. 497 and 507.

[11] Delft G.A., Orphan Chamber, *boedel* no. 265, I, II, and IX.

Jannetje Stevens, who sold woolen cloth and other "shop wares."[12] We learn from a later deposition that this spinster, whose name comes up from time to time in the estate papers of Delft citizens, had claims on Vermeer's estate that she tried to realize from the proceeds of the sale of twenty-six paintings that had belonged to the artist. The Haarlem-based art dealer Jan Coelenbier bought the paintings for five hundred guilders in February 1676 directly from Catharina but "for the account and in the name of Jannetje Stevens."[13] Jannetje, in other words, was entitled to receive the proceeds from the sale as compensation for the debts the Vermeer family owed her "for various merchandise." Since Coelenbier had some claims on Jannetje Stevens, he was only obligated to pay her a part of the five hundred guilders he owed for the acquisition of the paintings. He would pay her the difference in money or in goods. In the meantime he had transported the paintings from Amsterdam, where the transaction had taken place, to Haarlem and brought them to his house for a few months. From the sequel of this story, however, it appears that he was only holding the paintings as security for the money Jannetje Stevens owed him.

The average price per painting in this transaction was under twenty guilders. Although a painting by Vermeer had been evaluated at only ten guilders in 1664 and a "tronie" at seventeen in 1696, the prices normally paid for his works were so much higher that it is almost inconceivable that this collection consisted entirely, or even in any significant part, of his own productions. I have assumed earlier that the pictures made up the bulk of Vermeer's stock-in-trade as a dealer.

Two weeks after she had sold the twenty-seven paintings in Amsterdam, Catharina appeared before a notary in The Hague to effect a curious transaction.[14] In her capacity as her husband's widow and guardian of his children, she ceded "in full and free property" to her mother Maria Thins "a painting by her late husband wherein is depicted 'The Art of Painting,' " as well as her rights to the income from a certain property in Bon Repas near Schoonhoven, any claims she might have on half of a five-morgen property in Oud Beijerland, and life annuities together amounting to two hundred guilders yearly. She stated that the sale or transfer was made as a partial payment on the debts that she owed her mother. The transaction is curious, because one would not normally expect a person to go before a notary to transfer a piece of property to her mother. I suspect that Maria Thins's subsequent denial that she had secluded some of her daughter's assets to defraud the estate's creditors was disingen-

[12] On 1 April 1671 Jannetje Stevens was owed the sum of seventy-two guilders for the delivery of woolen cloths (Delft G.A., records of Notary J. van Veen, no. 2223).
[13] Doc. no. 362, 10 February 1676.
[14] Doc. no. 363, 22 or 24 February 1676.

uous. Catharina wanted to ensure—though it turned out later that the creditors would not allow themselves to be bilked so easily—that a key painting in Vermeer's oeuvre to which she was apparently attached would stay in the family. It is significant that the transfer took place two days before the inventory of the estate was taken.

At the end of February 1676, a notary's clerk came to Maria Thins's to draw up an inventory of the possessions of Catharina Vermeer and of those she owned jointly with her mother.[15] The latter had probably been inherited from Cornelia Thins, who had stipulated in her testament that her household goods be divided equally between Catharina and her mother.[16]

The goods were listed in two parts: those belonging outright to Catharina, and those that Catharina and Maria Thins shared "each to the full extent of one half." We shall discuss below whether all of the artist's possessions owned jointly with his wife were listed. The clothing and linen listed was assigned to Catharina's lot. Most of the items assigned in joint ownership to mother and daughter consisted of furniture and household wares. Cornelia Thins, who was the oldest child of Maria's family, must have inherited the ten paintings of family ancestors in the jointly owned lot.

The following description of the inventory concentrates on paintings and other items omitted from the summary listing in Chapter 9.

The goods were dispersed among twelve rooms, including three kitchens or pantries, a corridor, a "place," a closet room where things were hung, and an attic. The back kitchen had many pots and pans, while the so-called cooking kitchen contained mainly furniture, including a bed and bedding and was probably used as a bedroom for one or more of the children. The inner kitchen contained ten paintings, a bed, a bed cover, three chairs, a table, a chest, a coat rack, and three cushions. This kitchen may have served as a dining room as well as a bedroom. The four main rooms were the front hall and the great hall downstairs and the "back room" and the "front room" upstairs.

The notary's descriptions were terse. Of the sixty-one paintings mentioned in the entire inventory, only five were attributed: one by Fabritius (probably Carel) in the front hall, two "tronien" (faces) also by Fabritius in the great hall, and two more "tronien" by Samuel van Hoogstraten in the inner kitchen, all belonging outright to Catharina Vermeer. The ten portraits in "poor black frames" of Maria Thins's family already mentioned were also in the great hall. In the backroom upstairs, the notary found a "tronie," a "cupido" (perhaps the one hanging behind *Lady*

[15] Doc. no. 364, 29 February 1676.
[16] Doc. no. 280, 28 January 1661.

Standing at the Virginals (Fig. 49), and six other paintings without description. He also noted there five books in folio and twenty-five books, which were all in Catharina's lot. The only other reading material enumerated consisted of "five or six books" in the little hanging room. Two portraits of Vermeer's father and mother—perhaps those already listed in the 1623 inventory of Reynier Jansz.'s possessions—hung in the great hall, together with a drawing of the coat-of-arms of Johannes Vermeer. A great painting of "Mars and Apollo in a poor black frame" was in the divided portion of the inventory. The fact that the portraits of Vermeer's father and mother and his coat-of-arms were in Catharina's lot and those of Maria Thins's family in the divided lot confirms our hypothesis: Catharina kept the items that had always been her husband's and shared in those inherited from her aunt Cornelia. This is supported by the allotment to Catharina of all the painter's equipment that Vermeer had used (with the exception of a stone slab for grinding colors that had been relegated to the attic); a cane or maulstick with an ivory knob; two easels; three palettes; six panels; ten painter's canvases; and three bundles of prints, all located in the front room upstairs, which must have served as Vermeer's studio.

The three paintings by Fabritius and the two "tronien" by Hoogstraten were apportioned to Catharina, as we should have expected if they had belonged to Vermeer. The two "tronien painted in Turkish fashion," also in Catharina's lot, are likely to have been Vermeer's work: portraits clothed in what then passed for oriental dress. The *Girl with the Pearl Earring* (Fig. 33) and the Wrightsman *Head of a Girl*, (Fig. 52) both of whom wear turbans, are examples of such "tronien." The painting of a "Woman with a Necklace," which is probably identical with Vermeer's *Woman with a Pearl Necklace* (Fig. 43), was also in Catharina's portion. The clothing worn by Vermeer ("a Turkish mantle of the aforesaid late signor Vermeer," a loose robe called "innocente," and "Turkish trousers") and those worn by his wife (the yellow satin mantle with the white fur trimmings, an old green mantle with white fur trimmings, an ashgray mantle) remained in Catharina's possession, as did Vermeer's linen, which included ten ruffs and eleven fancy cuffs ("ponietten").

The inventory is full of kitchenware, children's clothing ("21 children's shirts, so good as bad"), bedding, and ordinary furniture, but it is conspicuously lacking in luxuries. If Catharina by this time possessed the gilded jug or tankard and the gold jewelry bequeathed to her in Maria Thins's testaments of 1657 and 1661, it should have been in her lot. Yet there is not a single gold or silver object in either portion of the inventory. It is probable that Vermeer owned some musical instruments, if not a virginals or a bass viol, at least a guitar, a lute, or perhaps even a trombone, such as the model holds in *The Art of Painting* (Fig. 37). None is

recorded. The clothing is not impressive either. The mantles belonging to
Catharina were at least ten years old, if we may judge from the dates of
the paintings in which they first appeared. The ruffs belonging to signor
Vermeer must have been acquired many years before since they had long
been out of fashion. There is no mention of the luxurious, lace-decorated
clothes of the type that Maria Thins removed from her home in Gouda
when she separated from her husband. Are we to suppose that she had
never given her daughter a single piece of lace?

I conclude that the inventory of Catharina's possessions did not cover
all of her movable goods. Some of her best things had been put away.
Either that or the notary's clerk had been told they belonged outright to
Maria Thins and were not part of the goods that mother and daughter
owned in common. "The Art of Painting" had been formally transferred
from daughter to mother, but other, less valuable items may have gone
the same route without benefit of notarial supervision. This subterfuge
may have been intended with an eye to the petition for "letters of cession"
on her debts that she would soon submit to the magistrates.

We saw in Chapter 9 that the inventory mentioned four beds, one bed-
stead, and two cradles. By the end of 1675 or the beginning of 1676, there
may have been as many as ten children in the house (if only the oldest
child, Maria, who was married, had left home) or as few as eight, the
number listed by the clerk when Vermeer was buried. If this last number
is interpreted as the number of children living at home, it would imply
that two of them—perhaps Johannes and one other—had been sent away
to school or were boarding with relatives of the Thins family. The young-
est child must have been born in late 1674, since he was said to be about
two years old in July 1677 and four years old in September 1678. In Feb-
ruary 1676, he could still have been using the cradle in the back room
upstairs. The next youngest—almost certainly Ignatius—must have been
born in September 1672 at the latest, if we consider that Catharina had
lost an infant child ("baerkint") in June 1673.[17] This next-to-youngest
living child would then have been at least three and a half years old at the
end of February 1676, presumably too old for a cradle. This would ex-
plain why the only other cradle in the house had been put away in the
attic. With the baby sleeping in his cradle, there were still between seven
and nine children (the oldest of whom, Elisabeth, was eighteen years old)
sharing two adult-sized beds, one child's bed, and one bedstead ("ledi-
cant")—a crowded state of affairs but, by the standards of the seven-
teenth century, when children generally slept several to a bed, not implau-
sible. If the family still had a servant by this time, she presumably slept
on a mattress on the floor.

[17] See also the discussion of Ignatius's age below, at note 55.

As far as we know, Catharina Bolnes and her children continued to live in the house at the corner of the Molenpoort at least until 1680 (Maria Thins was said to be living there at the time of her death).

As for Willem Bolnes, he remained confined in the house of Taerling. He died in the last week of March 1676 and was buried in the family grave in the Old Church.[18] Maria Thins was now his principal heir rather than the guardian and custodian of his estate as she had been before. On April 28 she named an attorney to represent her in the succession.[19] The agreement on the division of young Bolnes's assets, which will be discussed presently, was signed the following November.[20]

On April 24, Catharina Bolnes petitioned the higher court for a moratorium on her debts.[21] Her plea of poverty was similar to that which she made two years later before the magistrates of Gouda, set forth in the last chapter. She claimed that she had been charged with the care of eleven living children and that her husband during the recent war with the King of France "had been able to earn very little or hardly anything at all." Also, in order to feed his children, he had been forced to sell at a great loss the works of art he had bought and in which he was dealing. Because of all this he had fallen so deeply into debt that she, the petitioner, was not able to pay all her creditors, "who were not willing to make allowance at all for the great losses and misfortune caused by the war." These then were the reasons why she was requesting letters of cession to postpone payments of her debts. The letters were granted the same day. They implied that Catharina was now personally bankrupt and that she had "repudiated" the estate of her husband, which would have to be administered by a trustee appointed by the alderman of the city.

The creditors to whom the artist's widow owed money were: Maria Thins, the brewer Hoogenhouck, Rombouts, Dirckx, Van Leeuwen, Heindrickie Dircks, Tanneken, Hendrick van Buytenen, and Emmerentia. Vermeer, we recall, had borrowed a thousand guilders from Jacob Rombouts a few months before his death. This Rombouts was presumably the creditor of that name who now claimed money from him. Maria Thins made a compromise with his widow two years later, whereby she promised to pay the capital sum but not the interest on the debt.[22] "Van Leeuwen" was perhaps Maria van Leeuwen, the wife of the apothecary Dirck de Cocq, to whom Vermeer owed a few guilders for medicines in 1664 (doc. no. 297). "Tanneken" may have been the maid Tanneke van Everpoel mentioned in the 1663 document concerning Willem Bolnes's assault on

[18] Doc. no. 365, 23 March 1676.
[19] Doc. no. 366, 28 April 1676.
[20] Doc. no. 372, 20 and 25 November 1676.
[21] Doc. no. 367, 24 and 30 April 1676.
[22] Doc. no. 356, July 1675.

his mother and sister. "Hendrick van Buytenen" was, of course, the baker who usually called himself Van Buyten. Emmerentia was most probably his sister. We cannot even guess who "Dirckx" and "Heindrickie Dircks" may have been.

On September 25, 1676, Maria Thins made out her fourth testament, revoking all three preceding wills.[23] Both Vermeer and her son Willem had died since she had signed her last will, which was now obsolete. She explained that she was presently lodged in The Hague in the house of Aleydis Magdalena and Cornelia Clementia van Rosendael (daughters of Jacob van Rosendael and granddaughters of her cousin Jan Geensz. Thins). The testatrix named as universal heirs the children of the late Johannes Vermeer and of her daughter Catharina Bolnes. To Catharina she left only one-sixth of the estate, her minimum legal share. But even from this meager portion she stipulated that all the sums she had advanced to the couple during Vermeer's lifetime plus the amount she had spent for the upkeep of her daughter and her daughter's children from the time of the moratorium would have to be subtracted.

Maria clearly wanted to minimize the amount of property she would leave her daughter, since it was apt to be confiscated and sold for the benefit of the creditors of her bankrupt estate. By her foresight, she made sure that her grandchildren would not suffer, or would suffer as little as possible, from her daughter's bankruptcy. To this might be added the old woman's fear that Catharina might not be competent to manage her own affairs. There is ground for suspecting that Vermeer's widow did not have a good head for business matters: she herself stated less than a year later that "she had never concerned herself further or otherwise than with her housekeeping and her children," and she seemed to be unaware for some time of her financial predicament.[24]

After naming Pieter de Bye as the executor of her testament, Maria Thins requested that he give an account of his administration once a year to Hendrick van der Eem, the guardian of Vermeer's children, as well as to Aleydis and Cornelia van Rosendael and to Johannes Cramer, the husband of Maria Vermeer. She recommended to Catharina that she take all possible care in bringing up her children, the testatrix's heirs. Catharina should see to it that they learn a business or an honest trade because "the number of her children was too great for them to go about idle and not take up an occupation." Finally, to "avoid unnecessary expense," she declared that she wished to be buried "with honor but at the least possible expense."

The next day after making her testament, Maria Thins petitioned the

[23] Doc. no. 368, 25 September 1676.
[24] Doc. no. 382, 27 July 1677.

States of Holland and West Friesland for permission to transfer a "vicar-
iate," or trust, vested in a church in Schoonhoven, which belonged to her
late son Willem, to Johannes, the son of her daughter Catharina and of
her late son-in-law Johannes Vermeer.[25] The income from the vicariate
was used to pay for Johannes's schooling.

On September 30, the aldermen of Delft appointed Anthony van Leeu-
wenhoek as curator of the estate and of the assets of Catharina Bolnes in
consequence of the letters of cession on her debts which had been granted
at her request.[26]

Van Leeuwenhoek, born in Delft the same year as Vermeer, was the
chief contributor to the natural sciences in his native city in the second
half of the seventeenth century and the first years of the eighteenth. After
improving the microscope (by introducing lenses of very short focus), he
made a series of observations on the red corpuscles, bacteria, spermato-
zoa, crystalline lenses, and plant cotyledons that marked decisive ad-
vances in the empirical investigation of natural phenomena.[27] His relation
to Vermeer presents a tantalizing problem. Because Vermeer, like Van
Leeuwenhoek, used lenses—or so art historians have inferred from his
apparent use of the camera obscura—it is natural to conclude that the
two men knew each other well and that they exchanged information on
optics and other technical interests they had in common. Unfortunately,
there is no direct evidence to support this idea. Arthur Wheelock, who
speculates at some length about the possible connection that may have
linked the two greatest men Delft had produced, notes that they probably
knew each other through the silk-weaving business (Vermeer's father hav-
ing been a caffa worker and Van Leeuwenhoek having traded in silk
goods) and that they probably shared an interest in globes and maps. He
finds a resemblance between Van Leeuwenhoek's portrait painted by Jan
Verkolje and the man portrayed in *The Astronomer* (Fig. 38) and *The
Geographer*. He suggests that these paintings may even have been com-
missioned by the natural scientist.[28] All of this is plausible, but not en-
tirely persuasive. For one thing, I do not see any particular resemblance
between the elegant, distinguished-looking scholars portrayed in *The As-
tronomer* and *The Geographer* and the coarse-featured Van Leeuwen-
hoek. What is more important, I doubt whether Van Leeuwenhoek was
appointed to the curatorship because he was a friend of the family. If he

[25] Doc. no. 369, 26 September 1676.

[26] Doc. no. 370, 30 September 1676.

[27] The extensive literature on Van Leeuwenhoek includes the books by Abraham Schier-
beek with Maria Roosenboom, *Measuring the Invisible World: The Life and Work of An-
toni van Leeuwenhoek* (London: Abelard-Schuman, 1959), and Abraham Schierbeek, *An-
toni van Leeuwenhoek: Zijn leven en zijn werken*, 2 vols. (Lockem: de Tijdstroom, 1950–
1951).

[28] Wheelock, *Jan Vermeer* pp. 13–14, 136, 138.

had been Catharina's choice or Maria Thins's, he would doubtless have been a Roman Catholic; but he was actually Reformed. There is not a trace of documentary connection between Van Leeuwenhoek and Vermeer or between their families, which somehow we would have expected to show up if they had had regular dealings with each other. Finally, Van Leeuwenhoek does not seem to have been partial to Vermeer's widow in his curatorship, as subsequent developments reveal.[29]

It was almost certainly at Van Leeuwenhoek's behest that the Delft magistrates sent the attorney Christiaen van Vliet to The Hague on November 9, 1676 to question Maria Thins.[30] Van Vliet wanted to know more about the assets of the late Willem Bolnes, some of which he thought might have been inherited by his sister Catharina and therefore would belong to her bankrupt estate. Maria Thins and her daughter appeared before notary Van Coesfelt in The Hague and declared that her son had never possessed any property other than the vicariate in the Church of Schoonhoven, in which was vested the income of five morgen of land, a farm located in the Schuttersteeg under Schoonhoven, and eight and a half morgen of land in the Barony of Liesveld. She authorized Van Vliet to report her accounting to the magistrates of Delft and promised that if any other of Willem's possessions came to her knowledge she would report the fact immediately.

A week later the attorney Pieter de Bye, representing Maria Thins, and Van Leeuwenhoek, representing the bankrupt estate of Catharina Bolnes, arrived at an agreement before the aldermen of Delft respecting the inheritance of Willem Bolnes.[31] The agreement was reached after the aldermen had inspected and approved Maria Thins's accounting of the assets of her son, which she had been authorized to administer. It stipulated that Maria Thins would take full responsibility for settling her late son Willem's debts. She was authorized to use, beside other assets, money he had inherited from Hendrick Claesz. van Hensbeeck, in order to settle his outstanding debts. These assets had not been mentioned when Maria had been questioned by Van Vliet a week earlier. This Hensbeeck was the son of Neeltje (Cornelia) Bolnes, the sister-in-law of Maria Thins who, many years before, had refused to testify against her brother Reynier Bolnes (Maria Thins's husband). Neeltje had married Claes Cornelisz. van Hensbeeck (1578–1648), who belonged to a quite separate branch of the

[29] One argument supporting Wheelock's conjectures carries more conviction. Wheelock could not find any other case, at least in immediately preceding or following years, in which the city magistrates entrusted Van Leeuwenhoek with the curatorship of an estate. This would seem to plead for a specific reason (if not a special connection between the two men) for charging Van Leeuwenhoek with the responsibility of managing the artist's bankrupt estate on this occasion.

[30] Doc. no. 371, 19 November 1676.

[31] Doc. no. 372, 20 and 25 November 1676.

Hensbeeck family from Maria Thins's mother Catharina van Hensbeeck. Their son Hendrick Claesz., who owned a brickmaking plant in Gouda, appears to have been fairly wealthy when he died in 1671.[32] The money that he had bequeathed to Willem had been inherited after his death by Catharina. Unlike Jan Bolnes, Hendrick Claesz. had apparently not made a provision in his will to bar Catharina, who had taken her mother's side in her epic struggle with the Bolnes family, from inheriting any of his property. Van Leeuwenhoek, the curator of Catharina's assets, had accepted to transfer the rights to her part of the inheritance from Hendrick Claesz. to her mother, in exchange for which Maria Thins agreed to hand over five hundred guilders to Van Leeuwenhoek. In addition he requested and received sixty guilders for his services.

On December 11, 1676, a month after signing the agreement with Van Leeuwenhoek, Maria Thins made the deposition in which she denied that she had secreted away "any goods of her daughter or of her son-in-law in fraudem creditorum" (to defraud the creditors).[33] Solicitor Van Vliet had been sent to The Hague by the aldermen of Delft to investigate the allegation, no doubt originating with Van Leeuwenhoek, that Maria Thins and her daughter had conspired to conceal some of Catharina's assets. This time Maria swore with a solemn oath that the six life annuities that had been transferred to her the previous February totaled 167 guilders a year and not 200 guilders as she had stated by mistake.[34] She had given these annuities to her daughter in former years. Three of them, which had been made out on Willem's life, had lapsed after his death. One of the annuities belonged to Elisabeth Vermeer. Only the last two, which yielded 50 guilders 5 stuivers a year, were in Catharina's name.

A month later Maria Thins, who was still lodging with Aleydis Magdalena and Cornelia Clementia in their house in The Hague, dictated her fifth testament.[35] Again she restricted her daughter's inheritance to the minimum legal share (one-sixth), from which would have to be deducted all the money that Catharina owed her plus any sums that she was daily expending on her behalf and for the upkeep of her children plus those she might still expend for these purposes until her death. Altogether, she claimed, those debts amounted to a great deal more than Catharina's legal share. (The "ordinary" and "extraordinary" sums of money that she had advanced her daughter were left blank, as was the year in which these advances were made.) She again named her daughter's children as univer-

[32] On the complicated genealogy of the Van Hensbeecks, see Matthijs, *De takken van de dorre boom*, pp. 23–24. When Hendrick Claesz. van Hensbeeck died in May 1671, he left an estate worth at least 8,383 guilders (p. 24).

[33] Doc. no. 375, 11 December 1676.

[34] See above at note 14.

[35] Doc. no. 376, 6 January 1677.

sal heirs, not only of any tangible assets that she might leave at her death but also of her claims on Catharina, in her capacity as a creditor with prior claims. She made a new stipulation concerning the upkeep of her grandson Johannes: if the income from the vicariate in Schoonhoven did not suffice to permit him to continue his studies, then his guardian, Hendrick van der Eem, would be authorized to assist him with funds from other sources in her estate. She also expressly enjoined that her assets must remain undivided. They should not be parceled out among her grandchildren until the youngest had reached the age of fourteen. Since the youngest child was only about eighteen months old at the time,[36] her injunction implied that the estate, except for Catharina's share, would remain intact until 1689. Maria also willed that the four youngest children "be fed, clothed, and supported in such trade, occupation, or handicraft as their guardians shall deem appropriate" from the revenues of her properties until the youngest should have reached the age of fourteen. If there were a surplus available over and above the sums necessary for the upkeep of these four children, it would be divided among the remaining children. Once the youngest had reached the age of fourteen, the children were authorized to dispose of their inheritance as they pleased. She named Pieter de Bye, advocate before the Court of Holland, executor of her testament, beseeching him not to allow the estate to be divided until the youngest child reached the age of fourteen.

In early February 1677, Anthony van Leeuwenhoek appeared as plaintiff before the aldermen of Delft in the dispute with Jannetje Stevens, defendant, concerning the claims initially made by her against Vermeer's estate and the twenty-six paintings that she had transferred to Coelenbier.[37] They agreed, with the approval of the board of aldermen, that the plaintiff, in his capacity as curator of the estate of Johannes Vermeer, would pay the defendant 342 guilders in one sum and as full payment of the 442 guilders that the defendant claimed from the estate. In compensation, the defendant, Jannetje Stevens, would hand over to the estate at the first opportunity the twenty-six paintings at present deposited with Johannes Coelenbier in Haarlem, to which Coelenbier agreed. She pledged that the proceeds of the auction at which the paintings would be sold would entirely accrue to the estate, up to the sum of five hundred guilders. Jannetje's nephew, Steven van der Werf, constituted himself guarantor for the transaction. On February 5, 1677, the lord aldermen of the town of Delft approved the agreement.

The auction of the paintings was scheduled to take place on May 15 on the premises of St. Luke's Guild Hall. On March 12, Maria Thins, still in

[36] According to the petition of 27 July 1677 (doc. no. 383), the youngest child was then two years old. He was four years old in September 1678 (doc. no. 393).

[37] Doc. no. 377, 2 and 5 February 1677.

The Hague, caused her notary to deliver to Van Leeuwenhoek her "insin-
uatie," that is, a notification of her complaint and of her intent to take
legal steps if his response did not give her satisfaction.[38] The notary first
noted that "The Art of Painting" had been transferred from Catharina
Bolnes to her mother Maria Thins on February 24, 1676, as compensa-
tion for various sums that were due to her. A copy of the act of transfer
had been given to Van Leeuwenhoek in his capacity as curator of Ver-
meer's estate. Nevertheless, Van Leeuwenhoek had had notices printed,
one of which had been sent to Maria Thins, advertising the sale of this
painting in the auction scheduled for March 15. So she had ordered her
notary to present himself before the aforementioned Van Leeuwenhoek
to inform him that she did not consider that the painting in question
should be sold by him since it must serve to reduce the debt owed to her.
Or, "if he, Van Leeuwenhoek, should sell it, he should stipulate that it
[the proceeds?] can be seized by me and that the money for which the
same painting may have been sold should not be paid out by me [to the
creditors] but should serve to reduce the debt that is still owed to me."[39]
The next day the notary stated that he had appeared in the presence of
Anthony van Leeuwenhoek and had read him Maria Thins's "insinuatie."
Van Leeuwenhoek had replied that he had been unable to obtain posses-
sion of the painting to which the notary had alluded except by lawsuit
and transfer from Jannetje Stevens and that for this he had had to pay the
sum of 342 guilders, not including the costs of the suit, and that it was
his intent to go ahead with the sale, the "insinuatie" notwithstanding. In
case the insinuating party—Maria Thins—pretended to have any claim,
she would have to invoke her rights of preference (i.e., that she was a
creditor with a prior claim on the repayment of debts due by the estate).

In her "insinuatie" Maria Thins was clearly referring to "The Art of
Painting." It is also evident from his reply that Van Leeuwenhoek had
understood that this was the painting she had in mind.[40] But how did the

[38] Doc. no. 379, 12 March 1677.
[39] The translation in Blankert, *Vermeer of Delft*, p. 152, states that "the money coming
from this sale shall not be paid out to me but serve to reduce the debt owed to me," which
does not make much sense. The confusion is due to the omission by Abraham Bredius, on
whose transcription the translation is based, of crucial portions of the original act. It is clear
from the two parts of the "insinuatie" (doc. nos. 379 and 380) that Maria Thins had been
trying either to prevent the sale of the painting altogether or, if it was sold, to get reimbursed
from the proceeds for the debts owed to her by her daughter.
[40] A comment accompanying the translation of doc. no. 379 in Blankert, *Vermeer of
Delft*, p. 152, states that A. Bredius was wrong in supposing that the "insinuatie" concerned
the sale by Van Leeuwenhoek of "The Art of Painting." From the text, it is evident that it
concerns the sale of twenty-six paintings transferred to Jan Coelenbier. In my view Bredius
interpreted the two-part "insinuatie" correctly. The first part of March 12 refers to "The
Art of Painting" and to no other. The second refers to the painting ("schilderije," not to
"schilderijen" or paintings, as in the Blankert transcription) mentioned in the first part
("daerin vermelt"), thus "The Art of Painting." What Van Leeuwenhoek apparently meant

picture get into the hands of Jannetje Stevens and then later after he had
won his suit, into those of Van Leeuwenhoek? It could not possibly have
been sold by Catharina Bolnes to Coelenbier on February 10, 1676, and
then "ceded in full and free property" to her mother two weeks later. The
transfer to her mother of an asset that she had already sold would never
have stood up in any court of law, and no self-respecting notary would
have allowed such a declaration. One possible explanation is that "The
Art of Painting" was seized by Jannetje Stevens or by Van Leeuwenhoek
some time after the transfer of February 27. If so, Van Leeuwenhoek was
confused when he implied to the notary that it had been part of the orig-
inal lot that he had recovered from Jannetje Stevens by lawsuit after pay-
ing 342 guilders to Jannetje.

Nothing further is known about the auction sale of March 15, 1677,
or about the disposition of "The Art of Painting." It is possible, but un-
likely, that the "Portrait of Vermeer in a Room with Various Accessories"
in the sale that took place in Amsterdam in 1696 is identical with the
painting Catharina had transferred to her mother.[41] (Its first certain reap-
pearance occurred in 1813 when Count Czernin bought it from the estate
of Gottfried van Swieten—as a work of Pieter de Hooch.)[42]

On February 22, 1677, Maria Thins began her campaign to release and
turn into cash the capital sum of 2,900 guilders from the Diewertje van
Hensbeeck legacy that was still tied up in the Orphan Chamber in
Gouda.[43] First she gave Aleydis Magdalena van Rosendael power to col-
lect the funds from the Orphan Chamber. It was on the occasion of this
procuration that she explained the capital had been collected by her son-
in-law, Johannes Vermeer, in 1675 and pawned for one thousand guilders
and that she had been obliged to reimburse this sum to release the obli-
gation, which she had restituted to the Orphan Chamber (as the law re-
quired). On July 16, Aleydis brought the petition of Catharina Bolnes and
Hendrick van der Eem to the States of Holland and West Friesland for
the release of the funds.[44] A part of the States' decision, which incorpo-
rated the arguments advanced by the petitioners, has already been sum-
marized in the last chapter. The artist, we recall, had suffered grievously
from his inability to sell either his paintings or those of other masters in
which he was dealing during the protracted war with France. His sudden
death was linked to his frantic concern over supporting his large family.
The petitioner, Catharina Bolnes, had been left with ten children under

was that in order to take possession ("machtigh werden") of the painting, he had had to sue
Annetje (Jannetje) Stevens for the twenty-six paintings, of which "The Art of Painting" was
one.
[41] Doc. no. 439, 16 May 1696.
[42] Blankert, *Vermeer of Delft*, p. 163.
[43] Doc. no. 378, 22 February 1677.
[44] Doc. nos. 382 and 383, 27 July 1677.

age, the youngest of whom was now about two years old. "Since she had never concerned herself further or otherwise than with her housekeeping and her children, it was some time that the bad and poor condition of her estate had come to her knowledge" and since she was burdened with significant debts, she had been forced to take refuge in the miserable benefits of cession and to turn over all her goods to her creditors. At present all of her ten children under age had nothing in the world of their own on which to live and not a single one was capable of earning a living, so that she had been obliged to seek help "not only from her relatives but also from strangers, a thing which she, coming from honest people, had not let happen gladly." She then went on to give an account of the origins of the Diewertje van Hensbeeck trust fund and to request that the trust fund be liquidated and the capital be turned over to her so that she could support her children and not become a burden on relatives, strangers, or Orphan Chambers. The States approved the request and allowed Catharina Bolnes to collect the capital, amounting to 2,900 guilders, from the Orphan Chamber of Gouda to dispose of as she wished. On August 9 of the same year, Aleydis van Rosendael acknowledged receipt of the Orphan Chamber's transfer of capital, "the usufruct of which Maria Thins was enjoying but that she had desisted from" (to the benefit of her daughter).[45] A year later, in September 1678, Maria Thins and Catharina Bolnes applied to the magistrates of Gouda for permission to transfer capital sums amounting to 1,200 guilders deposited in the Orphan Chamber of Gouda "from the first to the second petitioner" (from Maria to her daughter).[46] They claimed that Catharina's oldest [unmarried] child was now twenty-one and the youngest four years old. Two of her children were quite sick and one, as I have already related, had been severely wounded in the explosion of a ship coming from Mechelen. "Since the [second] petitioner was no longer able to feed her children and to pay the apothecaries and surgeons" and since "none of the children could earn any but small amounts," the petitioners would be pleased to let "the first petitioner desist from the annuity in favor of the second." The petition seems to have been approved.

Meanwhile, in the summer of 1677, Maria Thins had made an affidavit before the magistrates of The Hague, at the request of the Juffrouwen Aleydis and Cornelia van Rosendael, tracing their lineage back to her own grandparents Jan Thin and Elisabeth Geenen.[47] The sisters, as we have already seen, were the great-grandchildren of Gheno Thins, the brother of Maria's father Willem Jansz. Thin, who had died in 1601. It is

[45] Doc. no. 385, 9 August 1677.
[46] Doc. no. 393, 1 September 1678.
[47] Doc. no. 381, 24 July 1677.

now known why Aleydis and Cornelia had wished to establish their lineage at this time.

After her brother's death, Catharina had inherited the house in the Peperstraet in Gouda in which her father had lived and died and three morgen of land in Wilnis that had apparently belonged to her brother Willem. In February 1678 Van Leeuwenhoek, having got wind of these legacies, empowered the Thins family notary in Gouda to sell the properties on behalf of Vermeer's bankrupt estate, presumably for the benefit of the creditors. In the spring of 1678 he also tried to seize some assets that Catharina had inherited from Hendrick Claesz. van Hensbeeck, despite the agreement made two years earlier before the Delft magistrates that assigned to Maria Thins the properties owned by her son Willem in compensation for the money she had spent on him. The matriarch was apparently successful in blocking this attempt.[48]

In April 1678 Maria Thins settled the claim that Jacob Rombouts's widow, Johanna Kiest, still had against Vermeer's estate in consequence of the one thousand guilders loan he had obtained from her by pawning the obligation for 2,900 guilders (which was supposed to be restituted to the Orphan Chamber in Gouda). It would seem that, contrary to her earlier claim, Maria had not paid the widow or at least not the entire sum of one thousand guilders. Maria now stated that, since Johanna Kiest would not be able to recover her capital in full (from the bankrupt estate of Vermeer), she would be willing, for reasons she did not reveal, to have Johanna reimbursed after her own death from the cash money in her estate, provided that Johanna had first done everything in her power to get her due (presumably from the bankrupt estate). Maria refused, however, to pay any interest on the money still owed.[49]

The following October Maria Thins, now living in the begijnhof in Delft with her nieces Aleydis and Cornelia van Rosendael, drew up a procuration on behalf of Aleydis, the purpose of which was again to help support Vermeer's numerous children from family funds in Gouda. She was not too proud to invoke on behalf of her grandchildren a clause in the testament of her great-grandparents Dirck Cornelisz. van Hensbeeck and Aechte Hendricksdr. They had left a fund, administered by the Holy Hospice of Gouda, from which woolen and linen clothes and small amounts of money were distributed to needy persons each year on All Souls' Say. In this distribution, preference was given to impoverished relatives of the Van Hensbeeck family. Maria Thins's request seems to have been approved.[50]

[48] Doc. no. 388, 1 February 1678; and doc. no. 390, 2 April 1678.
[49] Doc. no. 389, 2 April 1678.
[50] Doc. no. 394, 17 October 1678. On this charitable donation see Mattijs, *De takken van de dorre boom*, pp. 37, 39 (where a part of the original charter is reproduced).

On November 16, 1678, the artist's mother-in-law, who was now eighty-five years old, appointed the notary Frans Boogert to represent her as a creditor with a prior claim on the estate of her late son-in-law Johannes Vermeer.[51] A court sentence was issued in July 1679 that apparently awarded her favored status. Four months later she drew up a procuration in the name of the notary Jan Boogert to help her carry out the sentence, claiming that she had not been repaid for any of the debts her daughter had acknowledged she owed her back in February 1676.[52] All this legal maneuvering was of course not aimed against Catharina but was meant to protect family assets from the creditors represented by Van Leeuwenhoek.

At this time Maria Thins's income, which had been adversely affected by the failure of her tenants to pay their rents, was still suffering from these arrears. In July 1679 she had to bring suit against the tenant of her farm in Oud Beijerland to recover her rent money. The matter was eventually settled in February 1680 when Maria accepted payments somewhat inferior to the sums contracted.[53]

At the beginning of 1680, she passed her sixth and last testament before Notary Frans Boogert, who had handled her affairs for nearly twenty years.[54] She again maintained the basic divisions of her estate provided for in her last two testaments. This time, though, she willed that her 27-morgen property in Oud Beijerland, which had come from her parents and had been carefully "nurtured and preserved" and was likely after her death to be "consumed, sold, and alienated" by her heirs, should remain intact until her youngest grandchild, named Ignatius, should reach the age of sixteen. The executors of her will were only authorized to mortgage or sell any of her entailed property in case Catharina Bolnes should not have enough means to live on, and this was to be judged at their discretion. In any case, priority must be given in using her assets to bring up the children who were still under age. The eighty-seven-year-old woman closed her testament on a querulous note. She asked that an accounting of the moneys spent from her estate be shown to her daughter Catharina, to the attorney Hendrick van der Eem, and "to two honest people but with the special stipulation and request that the husband of her granddaughter Maria Vermeer, named Johannes Cramer, not be consulted for this purpose because she does not want him to supervise the accounting, for weighty reasons and motives." Cramer was the fourth and last male relative that she is known to have quarreled with, after her husband Reynier Bolnes, her brother Jan, and her son Willem. Johannes

[51] Doc. no. 395, 26 November 1678.
[52] Doc. no. 399, 23 October 1679.
[53] Doc. no. 398, 12 July 1679; and doc. no. 402, 7 February 1680.
[54] Doc. no. 401, 24 January 1680.

Vermeer must have been endowed with an exemplary character to remain in his mother-in-law's good graces for so many years. If he was not downright submissive, he must at least have been patient and pliable enough to win and hold her affection.

It has sometimes been argued that, because Ignatius was referred to as "the youngest child" in Maria Thins's last testament, he was necessarily the youngest child of Vermeer when the artist died in 1675. This youngest child, we know, was two years old in July 1677 and four years old in September 1678,[55] which implies that he must have been born between July and September 1674. He (or she) would then have been just under twelve years old in September 1686. But Ignatius Vermeer was at least fourteen years old on this latter date, when he first signed a notarial act as a witness. (Boys were authorized to witness acts from the age of fourteen, girls from the age of twelve.)[56] Since all these facts are reasonably solid, I conclude that the youngest child alive in 1675 had died sometime between 1678, when he was last mentioned, and January 1680, when Maria Thins referred to Ignatius as the youngest child. My inference is confirmed by the sale of property, which had been restricted by Maria Thins's last testament until he was sixteen years of age. Since this sale occurred in April 1688,[57] it is evident that Ignatius must have been born no later than April 1672 (assuming, as I think we should, that the testament had been respected).

In her last act passed before a notary, dated October 4, 1680, Maria Thins thanked the Juffrouwen Aleydis and Cornelia van Rosendael for administering her property since July 8 of that year. They had apparently discharged this duty and "settled and liquidated" the accounts of their administration for the last time on July 8 "before the notary Boymans and certain witnesses" in Mechelen. Mechelen was the town in the Spanish Netherlands from which one of Catharina's children—presumed to be Johannes—had returned to Delft some years previously by barge, on which he had been "piteously wounded" in an explosion. It is likely that the Juffrouwen Van Rosendael had gone to Mechelen to pay for the schooling of Johannes or to make other arrangements with the school (probably the college run by the Fathers of the Oratory), which it would have been illegal to make in Holland.[58]

Maria Thins's turbulent life had now come to an end. Four days before Christmas 1680 the Jesuit Pater Phillippus de Pauw brought her the Last

[55] Doc. no. 383, 27 July 1677; and doc. no. 393, 1 September 1678.

[56] Doc. no. 422, 23 September 1686. The information on the minimum age of witnesses was given to me by H. W. Van Leeuwen of the Delft Municipal Archive.

[57] Doc. no. 428, 17 May 1688.

[58] Doc. no. 406, 4 October 1680. On the illegality of school payments in the southern Netherlands, see Chapter 7, note 14.

Sacraments in her house in Delft on the Oude Langendijck at the corner
of the Molenpoort, to which she had recently returned. She died two days
later. She was buried on December 27, as simply as fourteen pallbearers
would allow. The grave in the Choir of the Old Church in which she was
laid next to Johannes Vermeer was now full, and was sealed.[59] Catharina,
when her turn came to die, would have to be buried somewhere else.
There was enough money in the estate not only for the fourteen pallbear-
ers but for a donation of twenty-five guilders to the Camer van Charitate,
which was remitted two months later.[60]

That Maria Thins was still occupying her old premises on the Oude
Langendijck when she died strongly suggests that Catharina and her chil-
dren were still living there as well. They probably continued to do so until
Catharina left for Breda three or four years later.

Catharina's inheritance was apparently not sufficient to live on. In
1681, still resident of Delft, she borrowed four hundred guilders twice,
once at 5 percent and the other at 4½ percent interest.[61] At this time Van
Leeuwenhoek was still curator of Catharina's bankrupt estate. His last
act took place in November 1682 when Hendrick van der Eem, the
guardian of Vermeer's children, gave him a procuration to sell two obli-
gations, one for 1,200 and one for 200 guilders, on behalf of the estate.[62]
These capital sums, yielding 48 guilders and 8 guilders 8 stuivers per year
respectively, had been inherited by Willem Bolnes from Hendrick Claesz.
van Hensbeeck and had then devolved on Maria Thins, and following her
death, on Catharina Bolnes. It is not known whether these transactions
enabled Van Leeuwenhoek to make final payments to the estate's credi-
tors and to wind up the succession or whether subsequent payments were
made whose record has been lost.

By 1684, Vermeer's widow had moved to Breda, a city in the southern
part of the Republic, near the border with the Spanish Netherlands. The
overwhelming majority of Breda's population had remained Catholic. In
October of that year Catharina again turned to the Orphan Chamber of
Gouda for assistance.[63] In her petition she explained that after the death
of her husband she had been left with eleven children and that she was
now living in Breda with little means to support eight children. She was
especially concerned about her daughter Gertruyd "because she has been
so afflicted by the Lord God with sickness that she can earn nothing."
(Gertruyd survived childhood despite her illness: she was still alive thirty
years later.)

[59] Doc. nos. 407 and 408, 23 and 27 December 1680.
[60] Doc. no. 409, 27 December 1680 and 12 February 1681.
[61] Doc. nos. 410 and 411, 16 and 28 July 1681.
[62] Doc. no. 416, 19 November 1682.
[63] Doc. no. 419, 21 October 1684.

Catharina's claim that she was supporting eight children may be interpreted to mean that she still had nine children, of whom Maria, the only one who had become married up to this point, no longer was dependent on her. If so, she had lost another child since 1678, in addition to the youngest to have survived Vermeer's death who, as I have just shown, probably died between 1678 and January 1680.

Note that any of the children born before 1659 who had survived to 1684 had already reached the legal age of twenty-five by this time. My inference about the loss of a child between 1678 and 1684 assumes that Catharina could still have been supporting one or two children who were over the legal age by the latter date.

In her request, Catharina went on to declare that she had been advised to apply to Their Lordships and to inform them that her great-great-grandfather Dirck Cornelisz. van Hensbeeck, his wife Aechte Hendricks, and her grandaunt Diewertje Hendricks on her mother's side had left a capital sum for distribution to the poor each year on All Souls' Day. She recalled that her grandaunt had stipulated that poor relatives of the Van Hensbeeck family should be given preference in the distribution above all others. The burgomasters approved her request. They allotted her ninety-six guilders a year for two years and, by a later decision, for another three years. It is remarkable testimony to Holland's stability that some of the Van Hensbeeck descendants—not directly related to the Vermeer family—were still drawing minimal sums from these donations a few years ago.

On September 23, 1686, Ignatius Vermeer signed, in a firm, mature hand, the first of many acts he would witness in the next three years for Notary Hendrick ter Beeck van Coesfelt in The Hague.[64] There can hardly be any doubt that this was Vermeer's child: not only, on two subsequent occasions, did he sign as a witness with Pieter de Bye, the executor of his grandmother's will, but Notary Van Coesfelt was very soon to become his guardian. It is perhaps of interest to note that some of the documents he signed mentioned individuals living in Delft, including one concerning the widow of the sculptor Hendrick Jansz. van der Schrick, who had lived (and perhaps was still living) in the Molenpoort next door to the Vermeer family.[65]

The only trace Catharina left of her presence in Breda in the local notarial archives is a debt acknowledgement dated October 29, 1687, three years after her petition to the magistrates in Gouda.[66] The debt that "Catharina Bolnes, widow of the late Johannes Vermeir [sic]," owed Pitronella de Lange, widow of the merchant Geerard van Weldt, consisted of

[64] Doc. no. 422, 23 September 1686.

[65] The Hague G.A., records of Notary H. T. van Coesfelt, no. 964, 10 November 1687.

[66] Doc. no. 425, 29 October 1687.

two parts: a "capital sum" of 300 guilders that Catharina had borrowed in September 1685 at 5 percent interest and the sum of 175 guilders "expended on food, house rent, and the delivery of store goods for herself as well as for some of her children." Pitronella asked no interest on this latter sum. However, she specified that, if the entire debt of 475 guilders were not repaid by the first of May 1688, then interest at 5 percent would be charged on both parts of the debt. Moreover, the debtor would not be permitted to delay restitution any longer than the creditor should desire. Catharina Bolnes signed the deed in her usual elegant hand.

By the time the debt came due, both widows were dead. The Breda notary noted in the margin of the original document on June 15, 1688, that the entire sum of 475 guilders (though apparently not the interest due on the debt since 1685) had been repaid to the heirs of Pitronella de Lange by Notary Van Coesfelt in The Hague, who had by then become guardian of Vermeer's children.

Two months after she had signed the debt obligation to Pitronella de Lange in Breda, Catharina returned to Delft to visit her daughter Maria. On December 27, 1687, lying sick in bed, so weak that she could only make a few scratches for a signature, she had Notary Ouwendijck draw up her last act.[67] "Out of her own volition and on the strength of the testament of her late husband and also pursuant to the testament of her mother Maria Thins," she appointed Hendrick ter Beeck van Coesfelt, notary in The Hague, as guardian of her children, "excluding all others and especially the Orphan master of this town." It is not known why she took the step of removing Hendrick van der Eem from the guardianship. Weighty reasons must have moved her, considering that this was one of the few independent decisions she made in her entire life, indeed the only one we know of, with the exception of the loans she had incurred in 1681 and 1687. Three days later, on December 30, she was given the Last Sacraments by Philippus de Pauw of the Jesuit Station of the Cross, the same priest who had administered the Sacraments to her mother eight years earlier. She was buried in the New Church on January 2, 1688, thirteen years after her husband. She was about fifty-six years old. She could hardly have been destitute: there was enough money in the estate to pay for twelve pallbearers to carry her coffin to the grave. Yet no money was given in her behalf to the Camer van Charitate. The burial register noted that she still had five children under age—that is, under twenty-five and unmarried—all of whom must therefore have been born after the end of 1662. Her address was given as the House with the Blue Hand on the Verwersdijk, which belonged to her son-in-law Johannes Cramer and to

[67] Doc. no. 426, 27 December 1687.

his wife Maria Vermeer.[68] (Johannes and Maria may also have helped to pay for the twelve pallbearers.)

How did the eight children that Catharina was supporting in 1684 shrink to "five children under age" by the end of 1687? Beatrix married about 1686 and was presumably counted among the children of legal age. Two other children born before 1662 had reached the age of twenty-five sometime between 1683, when Elisabeth—if she was still alive—would have reached this legal age, and 1687.[69]

Johannes, the eldest son,[70] also married before his mother's death, or very shortly afterward, as we may infer from the fact that he had a legitimate son named Johannes Antonius, who was born in October 1688.[71] The baptism took place in a Roman Catholic church in Slijkvaart near Rotterdam, in the vicinity of Charlois where Johannes's brother Franciscus was living about this time. Nothing is known about the child's mother Maria Anna Frank, the godfather Antonij van Wichelen, or the godmother Maria Catrijna de Vlieger.

On May 2, 1689, Vermeer's son Johannes, on this occasion surnamed Van der Meer, was vested with the feud of Bon Repas near Schoonhoven. Although he was said to be living in Delft, a couple of hours' ride by water coach from The Hague, he does not seem to have been present when the feudal transfer took place in the seat of the Republic's government. His guardian Hendrick van Coesfelt swore the oath of fealty in his place "by

[68] Doc. no. 427, 30 December 1687 and 2 January 1688.

[69] I conjecture that, in addition to the oldest child, Maria, there were three or four children—all girls—in existence by the time Maria Thins made out her testament in May 1662 (doc. no. 290). For if there had only been two such children to share the four hundred guilders bequest left to the "other children," each would have received two hundred guilders, the same bequest left to Maria, the eldest child, and there would have been no point to singling out Maria's two hundred guilders bequest. On the other hand, if more than four children in addition to Maria had been alive in 1662, then there could not have been five children of minor age left at the time of Catharina's death at the end of 1687. Such a high number would be incompatible with the logical inference I made earlier in this chapter that Catharina's youngest child must have died between 1678 and 1680. (If six out of eleven children were born before 1662, then at most five minor children—born in 1663 or thereafter—could have been left alive in 1687. But if one of these had died, Catharina could not have had five children under legal age at the time of her death.)

[70] It is virtually certain that Johannes Vermeer was the oldest son, because he inherited the feud of Bon Repas. According to Hugo de Groot, a feud is inherited by the eldest son and, in case there is no son, by the eldest daughter. The succession is then by age, sons having precedence over daughters. (*Inleydinge tot de Hollandsche Rechts-Geleertheyt*, edition of 1738, [Amsterdam: J. Boon], p. 216). I am grateful to Professor Jacob Smit for having researched this problem for me.

[71] Doc. no. 429, 25 October 1688. There is strong circumstantial evidence that the Johannes Vermeer who baptized his child on this date was the artist's son: (1) Jan Vermeer III claimed that he was born in Rotterdam when he was bethrothed in Leyden in 1714 (doc. no. 450); (2) he was said to be thirty-two years old in June 1720 (doc. no. 452), which would approximately correspond to his birth in 1688. The probability of a coincidence in names is further circumscribed by the fact that the baptism took place in a Roman Catholic church.

reason of his minority." Johannes may already have departed for the southern Netherlands or was about to do so, leaving behind his baby son Johannes Antonius, and perhaps his wife as well.[72] It is possible, as we shall see presently, that he became a notary in Brugge in the Spanish Netherlands. His child, Johannes Antonius, who would later go by the name of Jan, was brought up by his aunt Maria and her husband Johannes Cramer.

In May 1688, Johannes Cramer, as the husband of Maria Vermeer, named Hendrick van Coesfelt, who had recently become guardian of Vermeer's children, to represent him to effect the transfer of property in Oud Beijerland.[73] The details of the sale, which had taken place the preceding April, make clear that the lands in question must have been those that had been "carefully nurtured and preserved" by Maria Thins and her ancestors. These assets were to remain undivided until Ignatius had reached the age of sixteen. It was no doubt because he had recently reached this age that the properties were now sold. Since we do not know exactly how the estate of Maria Thins was supposed to be divided among Vermeer's children, we can only surmise that Maria Vermeer-Cramer was only entitled to a part of the properties that had just been sold.

Franciscus—the only previously unknown child of Vermeer that I have been able to identify with certainty—makes his first appearance in the notarial archives on May 18, 1689.[74] At that time "Sr. Franciscus Vermeer, master surgeon in Charlois [a village just south of Rotterdam]," presently in The Hague, borrowed two hundred guilders from an acquaintance of his guardian, the notary Hendrick van Coesfelt. Even though he was almost surely younger than the legal age of twenty-five, he was able to secure the loan without the guarantee of his guardian because he was already married and "marriage makes a body his own master."[75] Less than two months later Franciscus and his wife Maria de Wee, or Duee as she herself signed, contracted for another loan, this time from

[72] In June 1720, Johannes Vermeer II was said to have been "outside of the country for some thirty years" (doc. no. 452). For details on the oath of fealty for the domain of Bon Repas, see doc. no. 430.

[73] Doc. no. 428, 17 May 1688.

[74] Doc. no. 431, 18 May 1689. That Franciscus was the brother of Ignatius Vermeer is stated explicitly in doc. no. 434, 4 July 1690.

[75] I have already shown that Johannes was the eldest son (note 70 above). Yet Johannes was not yet of legal age—he was less than twenty-five years old—on 2 May 1689 (doc. no. 430). Simon van Leeuwen, originally writing in 1678, stated that marriage enabled a person to dispose of his assets and act as his own master, as if he were of legal age (Het Rooms-Hollands Regt, 11th edition, 1744, p. 99). There must have been a restriction on this equivalence, regarding the oath of fealty upon acquiring a feud by inheritance, since Johannes's guardian had had to take an oath in his place "because of his minority," even though he was already married (doc. no. 430). Note that Franciscus could not have been much under twenty-two or twenty-three years old in 1689, for he was already a master surgeon.

Monsieur Jean Marchand La Gree, for four hundred guilders.[76] The next day the young couple made out their testament. They named each other universal legatee, with the usual routine provisions for the upkeep of any child or children that they might procreate with the grace of God. (It is very likely that their marriage had taken place not long before.)[77]

A year later Franciscus was back in The Hague. He was still called master surgeon, but no mention was made of his domicile in Charlois. On this occasion he borrowed another hundred guilders from a pastrymaker. In contrast to the liberal provisions of the earlier loans, which did not call for any real guarantees or collateral, Van Coesfelt had to promise that, in case the loan and interest were not repaid on time, he would reimburse the pastrymaker from the mortgage payments to which the brothers Franciscus and Ignatius were entitled from a property belonging to a certain Juffr. Gaymans.[78] This mortgage, in which the notary had invested 1,500 guilders on behalf of his wards, became a bone of contention in later years.

The subsidies that Catharina Bolnes had drawn from the Gouda Orphan Chamber continued for some time after her death. In 1690 Johannes Cramer attempted to renew them, claiming that there was still "one unlucky child" born of Catharina and Johannes Vermeer and one grandchild.[79] The masters of the Orphan Chamber, upon verifying these claims, found that the child in question had already been married four years and opined that it was up to her husband to take care of her. They also judged it to be unfair for an abandoned child of Delft parents to be supported by the Gouda Orphan Chamber, and cut the subsidy down to half (forty-eight guilders a year), leaving the other half to another descendant of the Van Hensbeecks. The "abandoned child" was perhaps Jan, the son of Johannes Vermeer and Maria Anna Frank. The unlucky child may have been the daughter of Beatrix Vermeer. We know from the testament of Aleydis van Rosendael that her husband's name was Johannes Christophorus Hosperius. Beatrix and Johannes Christophorus apparently died a few years after bringing a daughter, christened Elisabeth Catharina, into the world. The little girl was raised by Aleydis van Rosendael, who was her distant cousin. She was the great-great-grandaughter of Willem Jansz. Thin, the uncle of Aleydis van Rosendael's grandfather Jan Geensz. Thins. But the Rosendaels and the Thins-Vermeers had entertained such close relations that Aleydis was naturally inclined to call Beatrix her niece or cousin ("nichte"), as she did in her testament.[80]

[76] Doc. no. 432, 9 July 1689.
[77] Doc. no. 433, 10 July 1689.
[78] Doc. no. 434, 4 July 1690.
[79] Doc. no. 436, 1690.
[80] Doc. no. 443, 23 December 1703.

The prologue to this testament, dated December 23, 1703, gives an insight into the civil status of lay nuns at this time. Aleydis declared before a Delft notary that she had never made her vows to become a beguine or a nun in the Roman Catholic Church. "Neither had a priest of the church ever clothed her in a religious vestment saying these or similar words: 'Receive this vestment of purity and keep it for eternity.' " She had never made vows of any kind or become a bride of Christ. Although she had lived for fifty years as a lay nun and had worn a black silk robe, she was not, for legal purposes, a "filia spiritalis" or ecclesiastic maiden. To retain control over the disposal of her properties—which, by ordinance of the States General was denied to those who had taken their vows, for fear that they would donate their goods to convents or other Catholic institutions—she had never become a full-fledged beguine. Having established her legal right to make a testament, she made provisions for the division of her estate. She bequeathed 100 guilders to her "nichte" Anna van Dijck, the eldest daughter of Bartholomeus van Dijck; 100 guilders to another "nichte," Anna Maria van Rosendael, daughter of the rector of the Latin School in Gouda, Johannes van Rosendael; and another 100 guilders to Johannes Vermeer, son of her cousin Johannes Vermeer and grandson of the painter, living in the house of Sr. Johannes Cramer, merchant in Delft. As her universal legatee, she named Elisabeth Catharina Hosperius, the daughter of her "nichte" Beatrix Vermeer and of Johannes Christophorus Hosperius, who had been living with her since the age of three years and nine months. Aleydis's testament, which was made three years after the death of her sister Cornelia Clementia in Delft,[81] may have shortly preceded her own. However, no trace of her burial record, either in Delft or in The Hague, has been found.

Meanwhile Hendrick ter Beeck van Coesfelt, whom Catharina Bolnes had named guardian of her children three days before her death, continued to manage their financial affairs. By a procuration passed in 1698, Franciscus and Ignatius empowered their guardian to act in their behalf in a suit involving the house in The Hague in which the notary had invested 1,500 guilders on their account. The procuration had been passed in Brugge (Bruges), in the Spanish Netherlands, "before the Notary Jan Vermeer."[82] Was this an extraordinary coincidence of names or was the notary the eldest son of the artist, who had studied abroad and then disappeared a year or two after fathering his son Jan? Even though my fairly casual search through the records of the Gemeente Archief and Rijksarchief in Brugge did not turn up his name, I think it is very likely the Brugge notary was indeed the artist's son.

[81] Doc. no. 441, 21 January 1700.
[82] Doc. no. 447, 27 June 1708.

The suit had been brought by Van Coesfelt on behalf of his wards be-
cause Juffr. Gaymans, the sister and heiress of Arent Gaymans who had
initially drawn up the mortgage, had stopped making interest payments
on it on the pretext that the mortgage had been illegally issued, because
Arent Gaymans did not have full title to the house. In his cross-suit, the
defendant representing the last heir demanded that past interest payments
amounting to six hundred guilders since July 1700 should be returned to
him. Van Coesfelt asked for full payment of interest plus restitution of the
original capital sum. The suit, on appeal, reached the High Court of Hol-
land in March 1708. The initial arguments of both parties in the request
to the High Court has been preserved,[83] but not the court's sentence, if it
ever issued one. The renewal of the procuration of Ignatius Vermeer in
June 1708 indicates that the suit dragged on after the request had been
entered, with unknown consequences.

At this time the domain of Bon Repas, the chief asset remaining to the
children of Johannes Vermeer, was still entailed. Pieter de Bye, the exec-
utor of the will of Maria Thins, saw to it that this domain and other
property descended from Maria Thins were leased and back rents col-
lected.[84] In 1706 Johannes Cramer tried to free the domain from the en-
tail in order to sell it, but his request was apparently turned down by the
Court of Holland.[85] On December 12, 1713, Maria, Aleydis, and Ger-
truyd Vermeer, together with Jan Vermeer (the grandson of the artist) and
Otto van Hesselt, armed with a procuration allowing him to represent
Ignatius Vermeer and Elisabeth Catharina Hosperius, all acting in behalf
of Catharina Vermeer, children and grandchildren of Johannes Vermeer
and Catharina Bolnes, appeared before the notary in The Hague to renew
the attempt.[86] As the last remaining heirs of Johannes Vermeer, they gave
power of attorney to the attorney Cornelis de Bye to represent them be-
fore the Court of Holland to obtain authorization to sell eight morgen of
entailed land near Schoonhoven in the polder of Bon Repas. That Ver-
meer's sons Johannes and Franciscus were neither present nor represented
suggests that they had either died or did not wish to participate in the
division of the estate. It is also likely that Elisabeth, the second oldest
daughter, was no longer alive. The three daughters who were present to
issue the power of attorney signed in a literate manner. Jan Vermeer made
a cross in lieu of signature.

[83] Doc. no. 446, 20 March 1708.

[84] Doc. no. 444, 27 December 1705. On October 5, 1692, Pieter de Bye, as executor of
the testament of Maria Thins, empowered Aleydis Magdalena van Rosendael to sell a grave
that had belonged to Maria Thins in Gouda and "to do everything that has to be done
concerning the estate of the aforenamed Maria Thins, whether in Gouda or elsewhere as
may be required" (The Hague, G.A., records of Notary H. T. van Coesfelt, no. 971).

[85] Doc. no. 445, 27 February 1706.

[86] Doc. no. 448, 12 December 1713.

The attorney's petition was apparently again rejected by the Court of
Holland because the land was still registered in the book of feuds in the
name of the artist's son Johannes Vermeer, whose death had not been
confirmed. Johannes's son Johannes Antonius, known as Jan, finally re-
ceived the authorization to sell the property in 1720, when he was thirty-
two.[87] The Court justified its decision by "the presumption of his father's
death," noting that the father had been abroad for about thirty years and
no news had been received from him. Bon Repas was finally sold in June
1721.[88]

Some years earlier Jan had moved to Leyden, the center of the cloth
industry in Holland. He had married Elisabeth de Roo, a girl from Delft,
in June 1714.[89] His children were baptized as Catholics in a Leyden
church. In religion at least the young man remained true to the tradition
of his Gouda ancestors and to the putative conversion of his grandfather.

Jan Vermeer, the artist's grandson, was the first illiterate member of
Vermeer's family, at least in the male line, since his great-great-grand-
father the tailor Jan Reyersz. (who at least is presumed to have been illit-
erate). In five generations the Vermeer family had risen from a lowly sta-
tus—an obscure craftsman, a fiddler, a secondhand dealer, a counterfeiter
of coins—to high social and artistic distinction in the artist's lifetime, to
descend again to the level of an illiterate craftsman.

Some of the impoverished children of Vermeer continued to receive
subsidies from the Gouda Orphan Chamber, from the funds given by
Dirck Cornelisz. van Hensbeeck in 1565, well into the eighteenth century.
The last to do so was Aleydis (Alida) Vermeer, who died in The Hague in
1749.[90]

At least one branch of the family escaped the fate of "shirtsleeves to
shirtsleeves" in three (or four) generations. When Maria Vermeer, the art-
ist's oldest daughter married the silk merchant Johannes Cramer in 1674,
he was already fairly well off.[91] By the time of his death in 1714 he could
provide each of his children with two thousand guilders upon their com-
ing of age—to be sure, from moneys that were owed to him by his broth-
er's widow.[92] We know the names of several of the couple's children who

[87] Doc. no. 452, 25 June 1720.
[88] Doc. no. 453, 19 June 1721.
[89] Leyden G.A. "Schepen huwelijk, Raadhuis inteken register," Lr JF 18 V. The marriage
took place on 21 July 1714. The children born of this marriage were Joan in 1715 (Maria
Vermeer witnessed the baptism), Maria in 1716 (Catharina Cramer, witness), Jacobus in
1719, Joannes in 1722, and Cornelia in 1725 (communication of J. F. van den Engh of
Almen).
[90] Doc. no. 454, 1749.
[91] His father was already a cloth merchant. Johannes had only one brother, Dominicus.
(See the testament of Gillis Gillisz. Cramer and Annetge Jan Theunisdr. van Tilburgh of 20
February 1678; Delft G.A., records of Notary Ph. Bries, no. 2322.)
[92] Doc. no. 449, 24 June 1714.

were baptized in the Jesuit Station in Delft.[93] One name, Aegidius, was used three times, in 1685, 1687, and 1690, probably because the first two had died. Persistence paid off: the third lived to become a Catholic priest. Dominus Aegidius Cramer was a witness to the baptism of one of Maria Vermeer's grandchildren, Maria Theresa, in 1719.[94] The mother of the child was Maria Cramers, the father Hugonis van der Velde. The latter was probably related to Heijndrick van der Velde who had played a major role as a Catholic layman in the Papists' Corner in the 1640s and 1650s. When Maria Vermeer baptized her children, she was not always careful to preserve her father's name, which was perhaps already falling into oblivion even in the Jesuit Station. In 1680 and 1682, her name was given as Maria van Meren, in 1683 as Maria Thins (!), in 1690 as Maria van der Meer. There does not seem to have been a Johannes to perpetuate either his father's name or his grandfather's.

We saw earlier how Maria Thins kept altering her testament to ensure that her grandchildren and her great-grandchildren would not become paupers. On the whole I think she succeeded fairly well. The sons were educated or at least apprenticed in a well-remunerated occupation, as in the case of Franciscus, who became a master surgeon. Maria Thins could not predict that only two of the daughters would ever marry (Maria and Beatrix), while the others (Aleydis, Gertruy, and Catharina) had to subsist on the modest revenues from the lands in Oud Beijerland and Schoonhoven and on what was left of the Van Hensbeeck legacies in Gouda. If the abandoned son of Johannes Vermeer II remained illiterate, the fault was not hers but that of her son-in-law, Johannes Cramer, who had brought up the boy. Had she not warned the executors of her last testament that Cramer was not to be trusted? She was undoubtedly a domineering old lady, but she was also solicitous of her family's welfare, compassionate, and far-seeing.

This completes my account of the rise and fall of the Vermeer family over a century and a half, from 1598 when Vermeer's grandfather, the tailor Jan Reyersz., cashed a debt obligation, to 1749 when his daughter Aleydis Vermeer died in The Hague. In retrospect it would seem that chance factors affecting the child-bearing activity, or lack of it, of different members of the family played a major role in determining its fortunes. The fact that Reynier Jansz. Vos alias Vermeer had only two children helped the family's ascent, just as the numerous progeny of the artist contributed to the family's downfall. The financial collapse of the artist would have been even more precipitous were it not for the penchant of Maria Thins's family for celibacy: her aunt Diewertje died a spinster; not

[93] Doc. nos. 404, 414, 418, 421, and 435.
[94] Doc. no. 451, 3 April 1719.

one of Maria's four brothers and sisters ever married; her son Willem was briefly betrothed but remained a bachelor. On Vermeer's side, even his sister Gertruy had only one child, who apparently died in infancy. Johannes and Catharina and their numerous children profited from the failure of all these relatives to leave viable heirs. Unfortunately, these multiple windfalls could only palliate the disastrous effects of Catharina's unbridled fertility. The survival at least to adolescence or early adulthood of nine or ten of the fifteen children born by Catharina Bolnes—a number far exceeding the statistical expectation at the time—narrowed the prospects of those who did manage to escape death in their early years.

· 13 ·

VERMEER'S CLIENTS AND PATRONS

If Vermeer's children and grandchildren slipped into oblivion soon after his death, the reputation of his art remained strong among discerning collectors. Two collectors of major importance, the baker Hendrick van Buyten and Jacob Abrahamsz. Dissius, kept their Vermeer paintings until the day they died. When important pictures by Vermeer were sold, as in Amsterdam in 1696 and 1699, they brought high prices.

The only collector of Vermeer's paintings who may properly be called his patron was Pieter Claesz. van Ruijven, the father-in-law of Jacob Dissius. The relationship between Van Ruijven and Vermeer clearly went beyond the routine contacts of an artist with a client. Van Ruijven lent Vermeer money; he witnessed the will of his sister Gertruy in her own house shortly before her death. More significantly, Van Ruijven's wife Maria de Knuijt left Vermeer a conditional bequest of five hundred guilders in her testament.

Pieter Claesz. van Ruijven was related to some of Delft's most prominent families including the Van Santens and the Graswinckels.[1] His cousin Jan Hermansz. van Ruijven married Christina Delff, the sister of the painter Jacob Delff (Fig. 4), who was the son of the engraver Willem Delff and the grandson of the portrait painter Michiel van Miereveld. It was perhaps because some of the Van Ruijvens had been accused of Remonstrant sympathies in the aftermath of the Oldenbarnevelt episode that they were barred from the highest municipal posts. The only function to which Pieter Claesz.'s father Niclaes Pietersz. van Ruijven, brewer in The Ox, could accede was to become a master of the Camer van Charitate (in 1623 and 1624).[2] This Niclaes Pietersz. married Maria Graswinckel,

[1] The genealogy of Pieter Claesz. van Ruijven is traced in *Nederlandsche leeuw* 88 (1970): 101–104. I owe this reference to W. A. Wijburg, who has been able to establish that Maria Thins and Pieter Claesz. van Ruijven were distantly related. To be precise, Adriaen Cool, who was the son of Catharina Bolnes's great-great-aunt Maria Geenen, had married Erckenraad Duyst van Voorhoudt (see genealogical chart no. 4), who was the great-granddaughter of Hendrick Duyst (†1530). The brother of Hendrick Duyst, named Dirck Duyst, was the great-grandfather of Pieter Claesz.'s grandmother, Sara Mennincx. In this case, I would guess that the religious gap separating the families of Pieter van Ruijven and Catharina Bolnes was more important than their distant kinship. Pieter Claesz.'s great-grandfather on his father's side was named Jan Dircksz. van Ruijven. His grandfather Pieter Jansz. van Ruijven was married to Maria van Santen. The connection to Jacob Delff was formed via Jan Hermansz. van Ruijven, whose mother Trijntje Pieters van Ruijven was a daughter of Pieter Jansz. van Ruijven (*Nederlandsche leeuw* 32 [1914], column 294).

[2] *Nederlandsche leeuw* 29 (1911), column 104.

the daughter of Cornelis Jansz. Graswinckel and Sara Mennincx. The Graswinckels were among the most distinguished of Delft's old patrician families. Two of Sara Mennincx's sisters, Maria and Oncommera, were married in succession to the famous tapestry maker of Flemish origin, Franchoys Spierinx, who settled in Delft some time before 1600. The son of Franchoys Spierinx and Oncommera Mennincx, Pieter Spierincx Silvercroon, became Sweden's envoy to Holland. It was this same Pieter Spierincx who paid Gerard Dou an annual fee of five hundred guilders in the late 1630s, apparently to secure the right of first refusal on Dou's paintings.[3] Dou's patron was thus the son of Pieter Claesz. van Ruijven's great-aunt. He was also the godfather of Pieter Claesz.'s sister Pieternella, who was baptized in the New Church in Delft on May 9, 1642,[4] when Pieter Claesz. was eighteen years old. Living as he did in his parents' household, he could not have failed to meet his mother's first cousin at least on this occasion. Pieter Spierincx died in 1652, one year before Vermeer entered the Guild of St. Luke.

Pieter Claesz. van Ruijven born in December 1624,[5] was eight years older than Vermeer. He is not known to have had any trade or profession. Like his father before him, his only municipal function was as a master of the Camer van Charitate (from 1668 to 1672).[6] He and his wife Maria Simonsdr. de Knuijt, whom he married in August 1653,[7] presumably inherited most of their wealth, which they later augmented by judicious investments.[8]

It was perhaps through Pieter van Ruijven's brother, the notary Johan van Ruijven, or Pieter's cousin Jan Hermansz. van Ruijven, both of

[3] Naumann, *Frans van Mieris the Elder*, p. 25.

[4] Delft G. A., New Church, Baptism files. Pieter Spierincx's mother, Oncommera Mennincx, was a witness at the baptism of Pieter Claesz.'s sister Sara on 27 April 1631 (Delft G. A., Old Church, Baptism files). The only female witness, she was most probably Sara's godmother. Tryn Rochus, the silver-tongued partner of Vermeer's grandmother Neeltge Goris, was once reported to have slandered Oncommera Mennincx for having had "two or three children" with Franchoys Spierincx before she was married to him (cf. Chapter 3 at note 17). The other alleged slanderer had been the mother of Dingeman van der Plaat who, together with Vermeer's father Reynier Jansz., had wounded a corporal in a brawl. The world of Delft was really very small, although it is not always easy to establish links between families as widely separated by class and status as Vermeer's and Van Ruijven's.

[5] Pieter Claesz. van Ruijven, son of Niclaes Pietersz. van Ruijven and Maria Graswinckel, was baptized in the Old Church on 10 December 1624. The witnesses were Hermanus van der Ceel (the family notary of Neeltge Goris and Reynier Jansz. from 1620 to 1626), Baertge Adams, and Adriana Munnincx. (Delft G. A., Old Church, Baptism files). Adriana Munnincx was probably a sister of Pieter Spierincx's mother Oncommera.

[6] *Nederlandsche leeuw* 29 (1911), column 198. The family's brewery business seems to have failed sometime after Niclaes Pietersz.'s death (c. 1650) (Delft G. A., records of Notary W. Assendelft, no. 1867, 12 August 1658).

[7] Delft G. A., Betrothal and Marriage files.

[8] The "boedel" of Magdalena van Ruijven contained a large number of government debentures. Pieter van Ruijven also purchased actions of the United East Indies Company (Delft G. A., records of Notary J. Ophoven, no. 1952, fol. 206, 18 August 1658).

whom were well known in Delft, that Vermeer met his future patron.[9]
The first certain contact between Pieter van Ruijven and Vermeer oc-
curred in 1657, when Pieter lent Johannes and Catharina two hundred
guilders.[10] This loan, I argued earlier, may have been an advance toward
the purchase of one or more paintings. The sale of the *Girl Asleep at a
Table* (Fig. 25), generally dated 1657–1658, *The Officer and the Laugh-
ing Girl* (Fig. 15) of 1658–1659, *The Little Street* (Fig. 24) of 1658–1660,
and the *Girl Reading a Letter at an Open Window* (Fig. 26) of 1659–
1660, all four of which turned up in the auction of Dissius's paintings in
1696 and had almost certainly once belonged earlier to Pieter van Ru-
ijven, may have helped to repay the loan of 1657.[11]

On October 19, 1665, Pieter Claesz. van Ruijven and Maria de Knuijt
passed their last will and testament before Notary Nicholaes Paets in Ley-
den. The choice of a Leyden notary may have been dictated by the need
for discretion:[12] the testators stipulated that they did not wish certain
members of the family, including the notary Johan van Ruijven, to learn
the disposition of their estate. It is probably significant, in view of the Van
Ruijven family's Remonstrant proclivities, that Notary Paets was one of
the most eminent members of the Remonstrant community in Leyden.

Three separate documents were drafted, approved, and signed: a joint
testament of the couple, the appointment of the guardians to any child or
children left after their death, and a separate testament of Maria de
Knuijt, which would only become valid if she survived her husband.[13]

In the joint testament, Pieter Claesz. and Maria, living on the east side
of the Oude Delft Canal in Delft, named each other universal legatees.
The survivor was to bring up any child or children left after the decease
of one or the other of the testators. (This clause probably referred to Mag-
dalena van Ruijven, the only child of the couple left alive after their death,
who was exactly ten years old at this time.)[14] This same survivor was also

[9] Doc. no. 249 of 4 April 1653. The painter Pieter Jansz. van Ruijven (1651–1719) was
the son of Pieter Claesz.'s cousin, Jan Hermansz. van Ruijven. Pieter Jansz. registered in the
Guild of St. Luke on 23 May 1672. When he became headman in 1679, he was younger by
over a year than Vermeer when he was first elected, at which time Vermeer was the youngest
artist to hold office since the New Guild Letter of 1611. Among the few photographs of
Pieter Jansz. van Ruijven's paintings preserved in the Rijksbureau voor Kunsthistorische
Documentatie in The Hague, I could detect no perceptible influence of Vermeer. (For a re-
production of one of his signed paintings, dated 1679, which may be a self-portrait, see
Montias, *Artists and Artisans*, p. 217).

[10] Doc. no. 271, 30 November 1657.

[11] Doc. no. 436, 16 May 1696.

[12] Pieter van Ruijven is known to have had business in Leyden. In 1663 he was named in
a suit concerning the wealthy estate of Johannes Spiljeurs (Delft G. A., records of W. van
Assendelft, May 1663, act no. 3316).

[13] Doc. no. 301, 19 October 1665. Notary Nicolaes Paets was related to Frans van Mier-
is's patron, Cornelis Paedts. (On the latter, see Naumann, *Frans van Mieris*, pp. 24–27.)

[14] Magdalena van Ruijven, daughter of Pieter van Ruijven and Maria van Ruijven (who

VERMEER'S CLIENTS AND PATRONS

to give six thousand guilders in one sum to this child or children. In the second document, they named Gerrit van der Wel, notary in Delft, as guardian of their surviving child or children. In case of his death or absence, the secretary of the Orphan Chamber in Delft was to be appointed in his place, with the authority to name a substitute to replace him. They specifically excluded Jan Claesz. van Ruijven, notary in Delft, or any of the testator's nephews or cousins from the guardianship—and from any knowledge regarding the succession. The testator recalled that his maternal grandmother Sara Mennincx, widow of Cornelis Jansz. Graswinckel, had left her property to him and to his descendents in a trust (fidei commissum) but that, in defiance of her testament, his father Niclaes Pietersz. van Ruijven had sold and appropriated to himself these assets. Nevertheless, he did not wish to bring suit over this alienation to reappropriate the goods to which he and his descendants were entitled. After the death of the survivor of the two testators, the guardians of the children should put away and preserve the linen, gold, silver, and other similar wares in the estate, in order to turn it over to them after they had reached legal age or gotten married. The testators further stipulated that the masters of the Orphan Chamber and the guardians should dispose of the paintings ("de schilder konst") that would be found in the house of the deceased according to the dispositions specified in a certain book marked with the letter A, on which would be written "Dispositions of my 'Schilderkonst' and other matters." They wished this book to be considered an integral part of the testament.

In the testament of Maria de Knuijt, which would only acquire validity in case of her husband's predecease, the testatrix approved the two previous acts and named as her universal heir her child or children and their descendants. If she left no child or children after her husband's death, then her property should be divided into three equal parts: one-third she bequeathed to the Orphan Chamber of Delft to aid the poor, another third to the Camer van Charitate also for the support of the poor, and the last third to the "Preachers of the True Reformed Religion in Delft," who were to distribute them in turn to "expelled preachers having studied the Holy Theology."[15] Sara and Maria van Ruijven, sisters of her husband Pieter van Ruijven, would be permitted to enjoy the usufruct of all her property their entire lives and to choose among her household goods any that they might wish to have with the exception of the best "schilder-

often used her husband's name instead of her own), was baptized in the Old Church on 12 October 1655. The witnesses were Jan van Ruijven (the notary), Maria van Ruijven (the sister of Pieter Claesz.), and Machtelt de Knuijt (almost certainly the sister of Maria de Knuijt) (Delft G. A., Old Church, Baptism files).

[15] These were Reformed preachers who had been expelled from Habsburg Bohemia, France, and other Catholic territories.

konst." Finally, she made various bequests "in the aforesaid case," which I interpret to mean in case she were to die childless. If this interpretation is correct, the bequests that follow were to be made before the rest of the estate was divided into three equal parts.

Maria de Knuijt left six thousand guilders to the children of her late brother Vincent de Knuijt and after their death to their descendants; six thousand guilders to Floris Visscher, her husband's nephew or cousin, merchant in Amsterdam, and, after his death, to his descendants; one thousand guilders to the surgeon Johannes Dircxz. de Geus and, after his death, to his descendants; and five hundred guilders to Johannes Vermeer, painter. Following the bequest to Vermeer, these words were crossed out: "in case of his [Vermeer's] predecease, neither to his children nor to his descendants." They were replaced by the marginal addition: "However, in case of his predecease the above aforesaid bequest will be annulled" ("sall 't voors. legaet te niet zijn"). The different wording had the effect of excluding Catharina Bolnes from the succession. Of all these conditional bequests, the one to Vermeer was then the only one that was clearly reserved for him and him alone. The reason for this discrimination was perhaps that Maria de Knuijt, whose sympathies with the Reformed Church were clearly expressed in the disposition of the bulk of her estate if she died childless, did not wish any of her money to benefit Jesuits or Jesuit sympathizers. Although I do not know the precise family relationship between the testatrix and the surgeon De Geus, I infer that such a relationship existed from the burial of two of his children in the family grave of Pieter Claesz. van Ruijven and Maria de Knuijt.[16] Johannes Vermeer was then the only individual who did not belong to Pieter van Ruijven's or Maria de Knuijt's family who was singled out for a special bequest. This is a rare, perhaps unique, instance of a seventeenth-century Dutch patron's testamentary bequest to an artist. This token of affection together with the repeated mentions of a special "schilderkonst" suggest that Pieter van Ruijven and Maria de Knuijt had bought a number of painting by Vermeer by 1665, when this testament was made.

I have already speculated that several paintings in the Dissius sale of 1696 probably entered the Van Ruijven collection shortly after they were painted in the late 1650s. From 1660 to 1665, other pictures that eventually descended to Jacob Dissius may have been acquired by the Van Ruijvens, including The Milkmaid (Fig. 28) of abouth 1660, The Concert (Fig. 36) of about 1664–1665, and the very large View of Delft (Fig. 34), generally dated 1663. It is also probable that three paintings by Emanuel de Witte and four paintings by Simon de Vlieger, which also turned up in

[16] E. A. van Beresteyn, *Grafmonumenten en grafzerken in de Oude Kerk te Delft* (Assen: Van Gorcum en comp. N. V. uitgevers, 1938), p. 148.

the Dissius inventory,[17] belonged to the best "schilderkonst" consigned in the little book marked A (which has unfortunately disappeared).

Van Ruijven and his wife, passionate collectors though they may have been, were wealthy enough to buy paintings without denting their fortune. On April 11, 1669, Willem, Baron of Renesse (or Renaisse) put up for sale at auction the domain of Spalant, consisting of twenty-one and a half morgen of land situated near the village of Ketel not far from Schiedam. With the domain, which occupied more than half the Seigniory of Spalant came the title of Lord of Spalant. The property was bought by Pieter Claesz. for sixteen thousand guilders.[18] When he witnessed the last will and testament of Anthony van der Wiel and Gertruyt Vermeer in their home ten months later, he proudly called himself Lord of Spalant.[19] He may have been there simply to buy frames, but he is more likely to have attended the act to promote or protect Vermeer's interests. (As we saw in Chapter 11, Gertruy did leave four hundred guilders to her "heirs *ab intestato*," who probably consisted exclusively of her brother Vermeer, in case she predeceased her husband, as she actually did.)

The only testamentary provision we know of that Pieter van Ruijven and his wife made after the will they had passed before Notary Paets in Leyden was a codicil dated June 1674.[20] By this time he was said to be living in The Hague but presently lodged on the Voorstraet (where he is known to have owned a house).[21] After confirming the validity of the Leyden will of 1665, he noted that, since that time, he had bought the domain of Spalant and registered the feud in his name. He now bequeathed the Seigniory to his daughter after his death, subject to his wife's enjoyment of the usufruct during her life. The daughter in question was almost certainly Magdalena.[22]

Pieter van Ruijven was buried on August 7, 1674,[23] seventeen months before the artist he had protected, and most probably befriended, for the greater part of his career. Pieter Claesz.'s daughter Magdalena married Jacob Abrahamsz. Dissius on April 14, 1680.[24] The marriage contract has not been preserved. This is unfortunate, because it may have been the key to the otherwise unexplainable settlement of Magdalena's estate after her

[17] See below at note 34 and after note 41.
[18] Delft G. A., records of Notary W. van Assendelft, 11 April 1669, act no. 3663.
[19] Doc. no. 329, 11 February 1670.
[20] Delft G. A., records of Notary A. van de Velde, 30 June 1674, fol. 377.
[21] Delft G. A., "Huizenprotocol," part III, no. 3439/491A, fol. 767. The other house, situated on the Oude Delft, is recorded in Part III, no. 4128/1180A, fol. 923.
[22] A daughter of Pieter Claesz. van Ruijven and Maria de Knuijt named Maria was baptized on 22 July 1657 in the Old Church. A son named Simon was baptized in the same church on 27 January 1662 (Delft G. A., Old Church, Baptism files). Both these children must have died early since no other heir beside Magdalena was ever mentioned.
[23] Beresteyn, *Grafmonumenten*, p. 418.
[24] Delft G. A., Betrothal and Marriage files.

death. The conjecture, which I owe to S.A.C. Dudok van Heel, is that Jacob's father Abraham Dissius, who owned the printing press "The Golden ABC" on the Market Square, may have given him the press as a sort of dowry in order to redress the inequality of wealth between his son and his bride-to-be. Magdalena had already inherited considerable assets, including the domain of Spalant from her father, subject to her mother's right of usufruct. Jacob, who was twenty-seven years old at the time of his marriage,[25] had no means of his own: he had registered in the Guild of St. Luke as a bookbinder in 1676. He did not register in the guild as a bookseller—thus presumably as the owner of a bookselling establishment—until six months after his marriage in November 1680.[26] Even then he had so little money that, when his wife died two years later, he had to borrow from his father to pay her ordinary death debts (costs of burial, mourning clothes, and so forth).[27] Jacob's main asset was his distinguished Protestant background: he was the grandson of Minister Jacobus Dissius, pastor in Het Wout, near Delft, and of Maria von Starrenberg.[28]

On December 3, 1680, the young couple passed their testament before a notary in Delft.[29] They named each other universal heirs, subject to the usual provision that the survivor must bring up their child or children in an appropriate manner. If the testator remarried after his wife's death, he obligated himself to pay her mother (Maria de Knuijt), if she was still alive, five hundred guilders, and if she was already dead, her relatives and collateral descendants two hundred guilders. On the other hand, if they both died without children and without having remarried while their parents on either side were still alive, then they willed that their estate, including the domain of Spalant, be divided into two equal parts, the parents on each side receiving half. In the case of the domain of Spalant, however, the division was not to be effected until the death of Maria de Knuijt (who was entitled to the domain's usufruct). Magdalena van Ruijven, referring explicitly to the twenty-one and a half morgen in Spalant

[25] Jacob Dissius was baptized in the New Church on 23 November 1653. His grandfather Jacobus Dissius and his aunt Jannetje Dissius were witnesses (Delft G. A., New Church, Baptism files).

[26] The registrations in the guild of Jacob Dissius, his father Abraham, and his uncle Jacob Jacobsz. are cited in Obreen, *Archief voor Nederlandsche kunstgeschiedenis*, 1: 52, 58, 83, 86.

[27] Doc. no. 417, early April 1683.

[28] Jacob's uncle Karel Dissius, who dealt in gloves and other apparel, was married to Machtelt de Langue, the niece of Willem Reyersz. de Langue, the notary, collector, and friend of the Vermeer family. These and other kinship relations in the Dissius family can be traced from a document relating to the sale of a house belonging to the De Langue family in the records of Notary T. van Hasselt, no. 2151, 9 August 1660 (Delft G. A.).

[29] Delft G. A., records of Notary D. van der Hoeve, no. 2359, of 20 June 1682, act no. 26. This act contains the testament of 3 December 1680, which was opened and read on 20 June 1682.

with which she had been vested in December 1680 and of which she was therefore entitled to dispose, subject to her mother's usufruct, willed that after her death the domain should be assigned to her "beloved husband Jacob Abrahamsz. Dissius." To give effect to this provision, she wished that, at the first opportunity, his name should be inscribed in the register of feuds in place of her name so that he should enjoy the fruits and rents of the domain immediately after her mother's death. No special provision was made for the paintings or for any other of the couple's household goods.

Three months later, on February 26, 1681, Maria de Knuijt was buried next to her husband in the family grave in the Old Church.[30] Her daughter Magdalena did not survive her long. She was only twenty-seven years old when she died on June 16, 1682.[31] She seems to have left no surviving child. Jacob Dissius was the apparent heir of the entire Van Ruijven estate, including the paintings.

Nine months after the death of Magdalena Pieters van Ruijven, an inventory was prepared of the property left to her husband Jacob Dissius, in which twenty Vermeers were recorded (one more than Bredius reported a century go).[32] I presume that the bulk of the estate, including the household goods and paintings, had been inherited by Magdalena from her father, Pieter Claesz.

The inventory listed all the goods, movable and unmovable, accruing to Jacob Dissius both on his own head and as inherited through the death of his wife. Among the principal assets were the domain of Spalant, numerous interest-bearing obligations in the name of Maria de Knuijt bought between 1672 and 1674, and the rental money—175 guilders per year—on the house in the Voorstraet, all of course devolved from Magdalena. The only asset that was explicitly said to belong to Jacob Dissius "on his own head" was a life annuity yielding one hundred guilders per year. The principal liability of the estate was the four hundred guilders that Dissius had borrowed from his father to pay various expenses connected with Magdalena's death.

After the unmovable assets, the notary's clerk listed the movable goods in each room of the Dissius house. In the front hall, he noted eight paintings by Vermeer together with three more paintings by Vermeer in boxes, all of unspecified subjects. The front hall also contained a seascape by Porcellis and a landscape. In the back room there were four paintings by Vermeer, two paintings of churches, two "tronien," two night scenes, one landscape, and "one [painting] with houses." This room also contained a

[30] Beresteyn, *Grafmonumenten*, p. 148.
[31] The Dissius inventory of April 1683 (doc. no. 417) cites the exact date of Magdalena's death.
[32] Doc. no. 417, early April 1683.

chest with a viola da gamba, a hand-held viol, two flutes, and music books. In the kitchen, which was apparently also a bedroom, there was a painting by Vermeer, two "tronien," a night scene, two landscapes, a "little church," and a "painter." In the basement room there were two paintings by Vermeer, plus a landscape and a church. The list closed with two paintings by Vermeer and two small landscapes whose precise location in the house was not specified.

Two years later, in April 1683, the estate was divided between Jacob and his father Abraham Dissius.[33] The introduction to this notarial document set forth the terms of the division. It stated that Jacob Abrahamsz. Dissius and Magdalena Pieters van Ruijven had owned the goods in the estate in common and that Magdalena had left as her heir her father-in-law, Abraham Jacobsz. Dissius, in conformance with her testament of December 3 and the act of superscription of December 10, 1680. Actually, the testament, confirmed by the act of superscription, had named the survivor of the two testators as universal heir. Magdalena's father-in-law Abraham Dissius was only to inherit the bulk of the estate in case both testators died without children, neither having remarried and Magdalena's mother being also deceased. Maria de Knuijt had indeed died, and Magdalena had left no children, but, since Jacob was very much alive, it is not immediately obvious why he had to give up half of the estate to his father. I have already cited S.A.C. Dudok van Heel's suggestion that the marriage contract may have contained a clause that allowed Abraham to share in his daughter-in-law's estate. In any event, the succession had not proceeded without controversy. It was only after Magdalena's heirs *ab intestato*, who must have included her husband, her father's sisters Sara and Maria, and her mother's brother Vincent de Knuijt, had appeared with Abraham Dissius before the commissioners of the High Court of Holland on July 18, 1684, and again on February 16, 1685, that the decision was handed down that prescribed the division of the estate half and half between Abraham Dissius and his son Jacob. It was probably also the commissioners who had stipulated precisely how the division would have to be made.

All the movable goods in the estate, including the printing press, were divided into two lots. The household goods in the estate, starting in the 1683 inventory with "a lot of firewood" and ending with "two black hats," would accrue to lot A, with the exception of fourteen paintings that would be transferred to lot B. Lot B consisted chiefly of the printing establishment and the equipment going with it. The paintings that were to be transferred from lot A to lot B were: three landscapes by S. de Vlieger, three temples or churches by Emanuel de Witte, two portraits or "tron-

[33] Doc. no. 420, between 14 and 20 April 1685.

ien," and six paintings by Johannes Vermeer to be chosen from lot A by the individual who would receive lot B.

Of the four paintings of churches in the 1683 inventory, the 1685 disposition of the estate assigned three by Emanuel de Witte to lot B. At least one of the three, and probably two, adorned the back room along with the four paintings by Vermeer that were said to hang there.[34] Of the seven landscapes in the inventory, three by Simon de Vlieger had similarly been shifted to lot B.

When the two principal heirs, father and son, chose among the lots by chance, lot A fell to Jacob and lot B to his father Abraham.

Less than a year later, on March 12, 1694, Abraham Dissius was buried in the New Church.[35] His property, including the fourteen paintings that had been transferred from lot A to lot B, were presumably inherited by his son Jacob, who seems to have been his universal heir.[36]

Jacob Dissius himself died in October 1695. The widower on the Market Square in The Golden ABC was transported by coach, with eighteen pallbearers, to his family's resting place in Het Wout.[37] Six months later an advertisement appeared in Amsterdam announcing an auction containing twenty-one paintings by Vermeer, "extraordinarily vigorously and delightfully painted."[38] This was one more than were listed in the 1683 inventory. Clearly Jacob must have bought back or inherited from his father the six paintings by Vermeer that had fallen to Abraham's lot. How did the Dissius collection expand from twenty to twenty-one Vermeers between 1685 and 1695? Perhaps the twenty-first was there all along. It is possible that the "painting with houses" in the 1683 inventory was identical with *The Little Street* (Fig. 24), in which case it would have been omitted by error from the list of paintings attributed to Vermeer.

The top prices for the twenty-one paintings by Vermeer sold in Amsterdam on May 16, 1696, were 155 guilders for the "Young Lady Weighing Gold" (*Woman Holding a Balance*, Fig. 30), 175 guilders for the "Maid Pouring Out Milk" (*The Milkmaid*, Fig. 28), and 200 guilders for "The City of Delft in Perspective" (*The View of Delft*, Fig. 34).[39] All three survive to this day. Only two relatively expensive paintings have disappeared: "One in which a gentleman is washing his hands in a see-through

[34] The clerk had initially specified that one of the church paintings in the back room portrayed a burial. This is likely to have been the "grave of the Old Prince in Delft" by De Witte in the Dissius sale of 1696 (doc. no. 439).

[35] Delft G. A., New Church, Burial files.

[36] Jacob seems to have been the only one of six children fathered by Abraham Dissius who survived infancy. It is worth noting that Jacob Dissius, in his testament of 7 February 1684, made his father his universal heir (Delft G. A., records of Notary P. de Bries, no. 2326, act 15).

[37] Doc. no. 437, 14 October 1695.

[38] Doc. no. 438, April 1696.

[39] Doc. no. 439, 16 May 1696.

room, with sculptures" and "A gentleman and a young lady making music," which sold for 95 and 81 guilders, respectively. The lowest prices were for "tronien," including two for seventeen guilders each. The small but accomplished *Lacemaker* (Fig. 53) brought no more than twenty-eight guilders.

It may be noted in passing that only one of the paintings by Vermeer in the Amsterdam sale (the first listed in the catalogue) was in a case or box. This was the "Young Lady Weighing Gold," more properly called *Woman Holding a Balance*. It must have been one of the three paintings by Vermeer in boxes in the front hall of the Dissius house.

Not all paintings by Vermeer owned by Dissius had been acquired by Pieter van Ruijven. The *Woman with a Pearl Necklace* (Fig. 43), which is very likely to have been listed in Vermeer's death inventory of 1676 as a "Woman with a necklace,"[40] was probably bought from his widow after the artist's death either by Magdalena van Ruijven or Jacob Dissius. Since this picture is generally dated 1664–1665, in any case before *The Astronomer* (Fig. 38) of 1668, it follows that whatever arrangement Pieter van Ruijven had made with Vermeer, it did not call for the immediate transfer of all newly completed works.

Some of the paintings by Vermeer sold in 1696 may have entered the Van Ruijven collection between the testament of 1665 and the death of Pieter Claesz., including the *Lady Writing a Letter* (Fig. 44), *The Lacemaker* (Fig. 53), and either the *Lady Standing at the Virginals* (Fig. 49) or the *Lady Seated at the Virginals* (Fig. 50), all of which are generally dated in the 1670s. Van Ruijven may also have acquired one or more of the Vermeer "tronien" during the four or five years preceding the artist's death. Catharina Bolnes may have been exaggerating when she claimed that her husband had sold "very little or hardly anything at all" since 1672.[41]

The catalogue of the sale of May 16, 1696 opened with twelve paintings by Vermeer. They were followed by three paintings by Emanuel de Witte: "The Old Church in Amsterdam," "The Tomb of the Old Prince," and "another church." These were almost certainly among the fourteen paintings transferred from lot A to lot B in the Dissius inventory. (Numerous versions exist of the Old Church in Amsterdam and of the Tomb of the Old Prince in the New Church in Delft by De Witte. Figures 56 and 57 are fine examples of De Witte's handling of these two subjects.)

None of the next fifteen pictures listed in the catalogue by various Dutch and Italian painters would seem to be identical with paintings described in the 1683 inventory. Then came nine lots by Vermeer, starting

[40] Doc. no. 364, 29 February 1676.
[41] Doc. no. 367, 24 and 30 April 1676.

with "The city of Delft in perspective." These were followed by "a large landscape" by Simon de Vlieger and three other landscapes by the same artist. These are all likely to have belonged to Dissius. The next painting listed after the four De Vliegers was a "tronie" by Rembrandt, which only sold for 7 guilders 5 stuivers. It may have been one of the two "tronien" transferred from lot A to lot B in 1685. None of the paintings listed after the Rembrandt "tronie" appears to have belonged to Dissius in 1683.

The twenty-one Vermeers in the sale brought a total of 1,503 guilders 10 stuivers; the three by Emanuel de Witte, 160 guilders; and the four landscapes by De Vlieger, 125 guilders 15 stuivers. The grand total came to 1,796 guilders 10 stuivers (including the Rembrandt "tronie"), a very respectable sum, even by Amsterdam standards. Clearly, though, not all the paintings recorded in the Dissius inventory of 1683 were sold in 1696. There was nothing in the catalogue resembling the Porcellis seascape, the three night scenes, and the "painter." Moreover, there were only three of the four churches in the inventory, four of the seven landscapes and at most one of the four "tronien." (It is possible but unlikely that some of the landscapes appeared elsewhere in the list of paintings sold.) Perhaps only the "beste schilderkonst" noted in the book marked A in the Van Ruijven testament of 1665 plus the Vermeers acquired after that time were thought good enough to appear in the Amsterdam auction. The rest may have gone directly to the collateral heirs of Jacob Dissius (his first cousins on his father's side).

Only three other seventeenth-century purchasers of Vermeer's paintings after 1661 are known: Diego Duarte, Herman van Swoll, and Hendrick van Buyten. Only the last is known to have been in direct contact with Vermeer.

The rich Antwerp jeweler and banker Diego Duarte owned "a little piece with a lady playing the clavecin with accessories by Vermeer," estimated at 150 guilders in July 1682.[42] This may have been either the *Lady Standing* or *Seated at the Virginals*. Whichever it was, the other was in the Van Ruijven–Dissius collection.

In 1699, when Herman van Swoll's collection was sold in Amsterdam, "A seated woman with several [symbolical or allegorical] meanings representing the New Testament" by Vermeer of Delft fetched four hundred guilders.[43] This painting was probably identical with the *Allegory of Faith* (Fig. 39). Since there is no evident reason why the Jesuit Station in Delft should have sold a painting at this time, my suspicion is reinforced that the Van Swoll picture was originally painted for a private patron rather than for the Jesuits themselves.[44] The very high price the painting brought

[42] Doc. no. 415, 12 July 1682.
[43] Doc. no. 440, 22 April 1699.
[44] Cf. Chapter 10, note 94.

shows that Vermeer, when he painted in the flat, classical mode that was in vogue at the time, could produce a painting that was nearly as valuable as any sold by the most fashionable painters of the period.

Herman Stoffelsz. van Swoll, from whose estate the "Allegory" was sold, was born in Amsterdam in 1632 and died there in 1698. The son of a Protestant baker, he made a fortune as a controller ("suppoost") of the Amsterdam Wisselbank and as postmaster of the Hamburger Comptoir in Amsterdam. He had a house built on the Amsterdam Herengracht in 1668, where he lived until his death. Nicolaas Berchem, and probably Gerard de Lairesse as well, painted decorations with mythological and allegorical figures in the house. His collection contained many Italian paintings as well as the most distinguished representatives of "modern" Dutch art.[45] These, however, were not necessarily all originals. It is known that he employed Nicolaes Verkolje (born in Delft in 1673, died in Amsterdam in 1746) to make copies after originals, for which he was paid twelve guilders per copy.[46]

Our last collector is the baker Hendrick van Buyten, whom we have encountered at several junctures in this book. After he died in July 1701, leaving a widow but no children, his estate was administered by the Orphan Chamber of Delft. The contents of his "boedel" in the Delft Orphan Chamber archives are distributed among ten bundles enclosed in five large boxes.[47] Some of the papers date as recently as 1849, when printed notices were sent out to a long list of heirs notifying them of the small amounts of interest on restricted capital funds that they still had coming to them from their "granduncle's" inheritance.

The inventory of the estate listed the movable possessions of Hendrick van Buyten and his wife Adriana Waelpot. She was the daughter of the printer Jan Pieters Waelpot and of Catharina Karelts.[48] He was born the same year as Vermeer (1632), she, the same year as Catharina Bolnes (1631). After Hendrick had lost his first wife, Machtelt van Asson (a baker's daughter), he married Adriana in November 1683.[49] Adriana's father

[45] On Herman van Swoll, see Willem van de Watering's article, "The Later Allegorical Paintings of Niclaas Berchem," Leger Galleries, Exhibition of Old Master Paintings, 1981. I am grateful to Jennifer Kiliam for this reference.

[46] S.A.C. Dudok van Heel. "Honderdvijftig advertenties van kunstverkopingen uit veertig jaargangen van de *Amsterdamsche Courant* 1673–1711," *Jaarboek Amstelodamum* 67 (1980): 150. In the advertisement for the 1699 sale in the *Amsterdamsche Courant*, it was said the collection had been formed "with great trouble over a period of many years." "The Allegory of the New Testament" was singled out as "an artful piece by Vermeer of Delft" (ibid., p. 160).

[47] The Orphan Chamber *boedel* was assigned the numbers 265 I to X. The inventory was found in 265 IX.

[48] Delft G. A., Baptism files, 21 September 1631.

[49] Delft G. A., Betrothal and Marriage files. The betrothal took place on 27 November 1683.

owned an important printing press in Delft, comparable to that of Abraham Dissius. From the presence of the *Institution* by Jean Calvin in Van Buyten's inventory, we may safely conclude that he belonged to the Reformed religion. Thus both Jacob Dissius and Van Buyten were Calvinists and either owned or were connected with important printing establishments.

The marriage contract between Hendrick and Adriana of December 6, 1683 had specified that the properties brought to the marriage by husband and wife were to remain separate ("geen gemeenschap"). The paintings listed below were all part of Van Buyten's possessions at the time of his second marriage. He had apparently acquired no paintings between 1683 and 1701. We can be virtually certain that he owned no paintings that had belonged to Jacob Dissius in April 1683 and that were still in the Dissius household two years later, when the estate was divided.

The total Van Buyten estate was valued at 24,829 guilders, one of the largest I have seen in my study of Delft inventories.

The first work of art listed in the inventory of Van Buyten's household goods was "a large painting by Vermeer" ("een groot stuck schilderie van Vermeer") in the front hall. (The inventories of Cornelis van Helt in 1661[50] and of Jacob Dissius in 1683, too, began with paintings by Vermeer in the "voorhuijs.") Also in the front hall there was a painting by Bramer, a society piece by (Anthony) Palamedes, another little painting by Palamedes, and one by (Nicholas?) Bronckhorst, who painted seascapes. There were seventeen other unattributed paintings in this hall, representing landscapes, still lifes, genre paintings, one history painting (Moses), and one of Prince Willem when he was young adorned with flowers. A side room next to the front hall contained three landscapes by (Pieter) Van Asch (next to the bedstead) and "two little pieces by Vermeer" ("stuckjes van Vermeer")[51] plus eleven other paintings, large and small. In a back hall the notary found seven little paintings ("stuckjes schilderie") and three little paintings on panel ("borretjes"). (The distinction was sometimes made between "schilderien" painted on canvas and

[50] Chapter 10 at note 45.

[51] In another, posterior version of the same inventory (Delft G. A., records of W. van Ruijven, no. 2295, act no. 114), the only difference in the description of the paintings that I could find was that the two paintings by Vermeer in the room next to the front hall were called "stucken" rather than "stuckjes." It is not obvious whether the clerk decided the paintings were not as small as he had previously made them out to be or whether he was inattentive in copying the original inventory. The diminutive "stukxken," incidentally, was applied to "The Lady playing the clavecin" in the Duarte inventory, which measured either 51.7 x 45.2 cms (*Lady Standing at the Virginals*) or 51.5 x 45.5 cms (*Lady Seated at the Virginals*). *The Guitar Player* (53 x 46.3 cms) and the *Woman in Blue Reading a Letter* (46.5 x 39 cms) were approximately of the same dimensions and might have been perceived as "stuckjes." (The dimensions are cited from Blankert, *Vermeer of Delft*, pp. 160, 167, 169, 170.)

"borts" or "borretjes" on panel). The only other items of interest were a
few Protestant books and "two boxes for paintings" in the attic, which
are likely to have been those in which Vermeer paintings had once been
preserved. (No other artist on the list of attributed paintings was "fine"
enough to have so encased his paintings.)

It is remarkable that all five of the painters cited in Van Buyten's inven-
tory—Vermeer, Bramer, Anthony Palamedes, (Nicholas) Bronckhorst,
and Pieter van Asch—were born in Delft, became masters of the local
guild, and died in Delft. All had registered in the guild before 1653. Com-
pared to the Van Ruijven–Dissius collection, Van Buyten's appears to
have been somewhat provincial and old-fashioned. (Three out of four of
the painters in the Dissius collection at one time registered in the Delft
guild, but two of them—Simon de Vlieger and Emanuel de Witte—left for
Amsterdam and continued to be productive there. Porcellis was initially
a Haarlem artist but also worked in Amsterdam and Zoetermeer.) The
Van Buyten collection probably had not changed very much from the
1650s or 1660s until the baker's marriage in 1683, with the likely excep-
tion of the two paintings he had acquired from Vermeer's widow shortly
after the artist's death: the "person playing on a cittern" and the painting
"representing two persons one of whom is sitting writing a letter." The
first of these may be *The Guitar Player* (Fig. 47) or, less likely, the *Woman
Playing a Lute* of the Metropolitan. The second is probably *The Lady
With a Maidservant* (Fig. 45). The latter, which measures 92 x 78.7 cm.,[52]
is certainly large enough for the clerk who drafted the inventory to have
perceived it as a "groot stuck schilderie." The fact that the painting was
apparently left unfinished[53]—as the undifferentiated, excessively uniform
passages, especially in the main figure, testify—adds to the verisimilitude
of this hypothesis, considering that the picture was still in the artist's stu-
dio at the time of his death. If this was the large painting in the front hall,
then the "person playing on a cittern" was in the room next to the front
hall.[54] Its companion was perhaps the one-figure painting that had been
shown to Monconys in 1663. In case this painting was really a "stuckje"

[52] Blankert, *Vermeer of Delft*, p. 164.
[53] Ibid., p. 55.
[54] On the size of the painting, see note 51. Regarding the possibility that the "person
playing on a cittern" may have been confused with a lutenist (e.g., the *Woman Playing a
Lute* of the Metropolitan Museum), one would have expected the contemporaries of Ver-
meer to know the difference between a cittern and a lute. Nevertheless, it should be observed
that *The Guitar Player*, now in Kenwood, can be traced back to a public sale in 1794, when
it was described as "a woman playing on a lute" (Blankert, *Vermeer of Delft*, p. 169).
Another version of this picture also exists (now in the Johnson collection in Philadelphia),
which most connoisseurs have deemed to be a copy after the Kenwood original. The late
hair style of the guitar player in the Johnson picture (let alone the weak execution) would
seem to rule it out as a viable candidate for the painting that was once in the Van Buyten
collection.

as the clerk noted in 1701, Monconys may have had good reason to question the exorbitant price of six hundred livres that Van Buyten said had been paid for it.

Van Buyten, in his testament of May 18, 1701, left his wife Adriana Waelpot all the household goods in the inventory of the goods that he had contributed to the marriage for her lifelong use. However, by an agreement made with the other heirs before Notary Willem van Ruijven (which has not been preserved), she consented to have these goods sold at auction and to collect half the proceeds. The sale, which took place on April 26, 1702, brought only 674 guilders 6 stuivers. Because the schedule ("contracedulle") of the sale has been lost, there is no way to figure out precisely how much the three paintings by Vermeer accounted of this total.

We may confidently conclude from the evidence about Vermeer's clientele gathered here that he enjoyed a strong local reputation during most of his career. He probably enjoyed some reputation beyond Delft as well, as the high prices he obtained in the Amsterdam sales of the Dissius and Swoll collections testify. Beyond reputation, sales, and the artist's financial success, there is another side to patronage that we have not explored at all so far. A patron or even an occasional client provides a link to the social world not normally accessible to an artist of modest background. In Vermeer's case, he did have the well-heeled, patrician relatives of his wife, but those Roman Catholics apparently did not collect art or at least did not buy from him. Van Ruijven, Van Buyten, as well perhaps as Van Swoll in Amsterdam, gave the artist entrée into the world of Reformed collectors. The pictures that Vermeer exhibited in their homes were seen by other collectors and by the artist friends of these clients. An artist with a reputation like Vermeer's could visit painters and collectors in other cities who were friends of his local protectors. I am particularly intrigued here by the possibility that Vermeer might have penetrated the Leyden artistic scene thanks to Pieter Claesz. van Ruijven. We have seen that Van Ruijven was closely related to Pieter Spierincx Silvercroon, the patron of Gerard Dou. He also knew the Remonstrant notary Nicolaes Paets in Leyden. It was perhaps through Spierincx or Paets that Vermeer gained access to Leyden artists of his generation such as Frans van Mieris. This point is significant because he was most probably influenced early in his career by artists of the Leyden School. We have seen, for example, that as early as his *Procuress* of 1656 (Fig. 20), he borrowed the motif of the artist's self-portrait in Frans van Mieris's *Charlatan* (Fig. 23). Could he have known Van Mieris through Pieter van Ruijven? More important, could Pieter Spierincx have suggested to Van Ruijven the idea of acquiring the right to first refusal on all of Vermeer's paintings? This conjecture is at least consistent with the probable dates of Vermeer's paintings in the Dissius collection, which seem to be spread fairly evenly throughout the

artist's career from 1657 to his death. We should also consider the possibility of Vermeer's influence on Leyden painters. The Van Ruijven connection may help to explain the impact of Vermeer on Gabriel Metsu and on Van Mieris himself in the late 1660s.[55]

The extraordinary patronage of one collector, who may have bought about half of Vermeer's production in the years 1657 to 1675, was a mixed blessing for the artist. His reputation might have spread in wider circles and his name might have been better remembered after his death had there been more collectors eager to trumpet his fame. It would also have been helpful if Van Ruijven's collection had been located in a cosmopolitan center like Amsterdam rather than in a provincial town like Delft.

From the end of the seventeenth century on, Vermeer's paintings had begun to leave Delft and scatter to the four winds. Eventually, not one was left in his native city. The relatively high prices Vermeer's paintings brought in the eighteenth century indicate that there were always connoisseurs capable of appreciating them. But it was long after his last child died in the middle of the "siècle des lumières" that a conscious critical reevaluation of Vermeer's work occurred.[56]

THE rise and fall of the house of Vermeer parallelled the rise and fall of Delft as an artistic center. The immigration from the southern Netherlands in the period 1580 to 1610, which infused a new vitality in Dutch culture, is echoed in the marriage of the daughter of an Antwerp-born counterfeiter with a caffa worker of Delft parentage. Reynier Jansz. might never have become an art dealer if it had not been for his exposure to the faster, more exciting milieu of his art-collecting father-in-law. Vermeer's marriage to a girl from a Catholic family is also symbolic of the reconciliation of Protestants and Catholics, who gradually overcame the passionate hatred they had borne for each other over the greater part of the Eighty Years' War with Spain, whose conclusion by the Treaty of Münster in 1648 only predated the artist's marriage by five years. Vermeer became a full-fledged master in his craft shortly after the mid-century point, when Delft attained its apogée as a major center of Dutch painting. He outlasted the period of Delft's prosperity and artistic flowering by a few years. By the time of his death, there was only the thriving blue-and-white faience industry left to keep his native city from relapsing into the provincial somnolence from which the influx of immigrants from the Southern Provinces had awakened it a century earlier.

[55] On the "dialogue between Leyden and Delft," see Naumann, *Frans van Mieris*, pp. 67–68.

[56] For a precise and balanced account of Vermeer's reputation in the eighteenth and nineteenth centuries, see Blankert, *Vermeer of Delft*, pp. 63–69.

APPENDIXES

APPENDIX A
AN ESTIMATE OF THE TOTAL NUMBER
OF PAINTINGS VERMEER PAINTED
BETWEEN 1656 AND 1675

Specialists are divided on the number of extant paintings that can reliably be attributed to Vermeer. Albert Blankert, for instance, rejects both the *Girl with a Red Hat* and the *Girl with a Flute* in the National Gallery of Art in Washington. He calls the *Woman Playing a Lute* in the Metropolitan Museum a " 'lost' authentic Vermeer." Of the *Girl Interrupted at Her Music* in the Frick Museum, he writes that "the painting is . . . unmistakably Vermeer-like," yet "its modelling, especially of the costumes, is superficial and gives no evidence of Vermeer's superior technique."[1]

I am inclined to side with the majority opinion that accepts the *Woman Playing a Lute*, the *Girl Interrupted at her Music*, and the *Girl With a Red Hat* as genuine Vermeers. I am sufficiently ambivalent about the *Girl with a Flute* (which is also rejected by Arthur Wheelock) to bar it from the corpus.[2] If these assumptions are granted, there should be thirty-four surviving pictures by Vermeer, of which thirty-one were painted between 1656, the date of *The Procuress* in Dresden, and the death of the artist in 1675. Of these thirty-one paintings, eighteen were mentioned by title in the seventeenth century if we assume that none of the surviving "tronien" was so mentioned (hypothesis I), whereas twenty were mentioned if two of the heads cited in seventeenth-century inventories correspond to the Wrightsman *Head of a Girl* and the *Girl with a Red Hat* (hypothesis II).

According to my first hypothesis, the paintings cited before 1700 that are extant today are: (1) *Girl Asleep at a Table*; (2) *The Officer and the Laughing Girl*; (3) *The Milkmaid*; (4) *The Little Street*; (5) *View of Delft*; (6) the *Woman and Two Men* in Braunschweig (accepting W. van de Watering's provenance in Blankert's *Vermeer of Delft*, p. 159); (7) *Woman with a Pearl Necklace* (in Vermeer's own collection); (8) *Woman Weighing Gold* (or *Woman Holding a Balance*); (9) *The Art of Painting*;

[1] Albert Blankert with contributions by Rob Ruurs and Willem van de Watering, *Vermeer of Delft: Complete Edition of the Paintings* (Oxford: Phaidon, 1978), pp. 171–72.

[2] Arthur K. Wheelock, Jr., *Jan Vermeer* (New York: Harry N. Abrams, 1981), p. 156. I find it very difficult to accept Wheelock's suggestion that the painting was made by a pupil of Vermeer—one who had access to the lion-finial chairs that Vermeer frequently depicted and a tapestry with fruits and leaves similar to the one painted by Vermeer in *The Love Letter*. It is hard to believe that an apprentice in Vermeer's entourage would not have once signed a document with his master or appeared as a witness in a testimony concerning Vermeer or his family. I am more inclined to believe that the painting was begun by Vermeer and finished after his death by an inferior painter, perhaps by Jan Coelenbier, who bought paintings from Vermeer's widow soon after his death (see doc. no. 362, 10 February 1676).

(10) *Lady Writing a Letter*; (11) *The Lady with a Maidservant*; (12) *Lady Standing at the Virginals*; (13) *The Lacemaker*; (14) *Lady Writing a Letter with Her Maid*; (15) *The Guitar Player*; (16) *The Allegory of Faith*; (17)*Lady Seated at the Virginals*; and (18) *Woman Playing a Lute*. Those cited in seventeenth-century inventories that have disappeared are: (1) the "tronie" in Larson's inventory; (2) "The portrait of Vermeer with various accessories" (Dissius); (3) The "Seigneur washing his hands" (Dissius); (4) "A gentleman and a Lady making music in a room" (Dissius); (5) "A view of a house standing in Delft" (Dissius); (6) "A 'tronie' in antique dress" (Dissius); (7) "Another" (Dissius); and (8) "A pendant of the same" (Dissius).

According to my first hypothesis, the following paintings that have survived were *not* mentioned in seventeenth-century inventories: (1) *Girl Reading a Letter at an Open Window*; (2) *Woman with a Wine Jug*; (3) *Woman in Blue Reading a Letter*; (4)*The Concert*; (5) *Girl with the Pearl Earring*; (6) *The Astronomer*; (7) *The Geographer*; (8) *Head of a Girl* (Wrightsman Collection); (9) *Girl Interrupted at Her Music* (Frick); (10) *The Glass of Wine* (Berlin); (11) *The Music Lesson*; (12) *The Love Letter* (Rijksmuseum); and (13) *Girl with a Red Hat* (National Gallery of Art, Washington). My second hypothesis assumes that items 8 and 13 (or possibly 5 and 13) should be subtracted from this list and added to the eighteen cited.

Consider first the assumption that the rate of disappearance of uncited paintings was the same as the (known) rate of disappearance of cited paintings. For the first hypothesis we have:

	Cited	Noncited	Total
Survived	18	13	31
Did not survive	8	(5.8)	(13.8)
Total	26	(18.8)	(44.8)

The numbers without parentheses are those supplied above (i.e., out of 26 paintings cited in seventeenth century sources, 18 survived and 8 did not). According to the above assumption, if 18 out of 26 cited paintings survived (69.2 percent), then a total of 18.8 noncited paintings must have been painted (inasmuch as 13 survived). The remaining figures in parentheses follow from addition or subtraction.

The same assumption and the second hypothesis about the initial data yield a total of 15.4 noncited paintings painted, 4.4 noncited paintings that did not survive, a total of 12.4 paintings that did not survive, and a grand total of 43.4 paintings painted.

The assumption that the rate of disappearance of noncited paintings

was twice as great as that of cited paintings yields the following results for the first hypothesis.

	Cited	Noncited	Total
Survived	18	13	31
Did not survive	8	(20.8)	(28.8)
Total	26	(33.8)	(59.8)

Here we see that 30.7 percent (8 out of 26) of the cited paintings failed to survive. Double this percentage comes to 61.4. Therefore, in the column for noncited paintings, 13 plus 61.4 percent of the total number of noncited paintings must equal that same number. Solving yields 33.8 for the number of noncited paintings. The other figures follow from addition or subtraction.

The same assumption coupled with the second hypothesis about initial numbers yields a total of 25.7 noncited paintings, 14.7 noncited paintings that did not survive, a total of 22.7 paintings that did not survive, and a grand total of 53.7 paintings painted.

APPENDIX B
LIST OF DOCUMENTS

The documents in the following list are summaries of the originals, except for passages that are literally translated, which are enclosed in quotation marks. Literal transcriptions from the Dutch originals, introduced wherever there may be possible doubt or confusion about the precise meaning of a document, are enclosed in parentheses and set in quotation marks. Brackets are used to enclose the author's explanations or remarks.

All proper names cited in the documents are spelled precisely as they appear in the original.

Unless a published source is cited for a document, it was first discovered by the author in an archival source.

Abbreviations such as G.A. (Gemeente Archief) may be easily understood by referring to the list of manuscript sources at the beginning of the bibliography. The following abbreviated references are used in the list of documents—O-H I: John Michael Montias, "New Documents on Vermeer and His Family," *Oud Holland* 91 (1977): 267–87; O-H II: idem, "Vermeer and His Milieu: Conclusion of an Archival Study," *Oud Holland* 94 (1980): 44–62; *Resolutiën der Staten-Generaal: Resolutiën der Staten-Generaal*, part 4, 1619–1620, Rijksgeschiedkundige publicatiën, grote serie, nieuwe reeks (The Hague: Martinus Nijhoff, 1981). In addition, all references to author's last name and year of publication refer to items to be found in the bibliography. Blankert 1978 contains a list of documents about Vermeer and his family published before 1977 that the reader may find useful.

1. 4 January 1596. Balthen Geerts is married to Beatrix van Buy in the St. Jacob Church in Antwerp. The marginal notation "nostri" signifies that both the bridegroom and bride belonged to the St. Jacob parish. The witnesses are: Philips Scholy and Joost Frans. (Antwerp Gemeente Archief, marriage registers of the St. Jacob parish.)

2. 11 January 1597. Jan Reijersz., tailor, living in the House of Nassau, transfers to Pieter Clement, procurer before the court of Delft, a sealed debt obligation, incurred by Jan Albertsz. living in Overschie before the sheriffs and aldermen of Overschie on 20 December 1591. Jan Albertsz. was committed to pay 18 guilders per year on the debt, on which 48 guilders were still due. Vermeer's paternal grandfather acknowledges that he had been paid in full for the obligation. Claes Corstiaensz. and Jacob Dirxsz., smith, neighbors of Jan Reijersz., are witnesses. (Delft Gemeente Archief, [henceforth Delft G.A.]; records of Notary H. van Overgaeu, no. 1543.)

3. 2 May 1597. Jan Reyersz. in the Broerhuyssteeg is buried in the New Church. (Delft G.A., Burial files.)

4. 19 and 29 October 1597. Betrothal and marriage of Claes Corstiaensz., tailor, widower, and Neeltge Gorisdr., widow of Jan Reyersz., tailor, both living in the Broerhuyssteeg. (Delft G.A., Marriage files.)

5. August 1604. Maritge Jans, in de Drie Hamertgens on the Broerhuys cemetery, becomes a member of the Reformed Community. (Delft G.A., Files of Registered Members of the Reformed Community.)

6. 15 August 1609. Balthasar Geerardsz., broker ("maeckelaer"), acts as intermediary in the sale of a debenture for a capital of 300 Flemish pounds [1,800 guilders] incurred by the East India Company. The seller is Elias van Ceulen, the buyer Jan Hendricxz. (Van Dillen 1930, p. 46.)

7. 13 March 1610. Willem Cluyt, notary in Amsterdam, at the request of Balthasar Gerritsz., representing Emanuel Pierssene, merchant in Dieppe, France, notifies Duyffse Isbrantsdr. that Pierssene will appeal to a higher court the case that she has just won against him before the judges of Amsterdam. (Amsterdam Gemeente Archief [henceforth Amsterdam G.A.], records of Notary W. Cluyt, N.A.A. no. 340, fol. 14. Document kindly communicated by S.A.C. Dudok van Heel.)

8. 22 June 1610. Balthasar Gerritsz., merchant's servant ("koopmans dienaer") buys a house located "in't hol" at the corner of the Sloopsteeg for 400 guilders. (Amsterdam G.A., "Kwijtschelding," no. 33, fol. 55.) The same day he acknowledges a mortgage debt for this amount to Gelle Jacobsz. (Amsterdam G.A., "Schepen Kennissen," no. 14, fol. 221.) These two documents were kindly communicated to me by S.A.C. Dudok van Heel.

9. 17 July 1610. Balthasar Gerritsz., merchant's servant, 37 years of age, testifies at the request of Mr. Hendrick Bonart, goldsmith, about a conversation he heard three days after Easter in an inn called "In de stat Hamburch" outside Leyden. The conversation concerned the maid of a tavern keeper in Amsterdam who had gone to the cellar with a man named Pieter Packen. Jan Gerritsz., goldsmith, also heard the conversation. This last person was almost certainly the goldsmith Jan Gerritsz. Ruts, who had close dealings with Frans Bastiaensz. van Mieris, the uncle of the painter Frans van Mieris. (Amsterdam G.A., records of Notary F. van Banchem, N.A.A. no. 268, fol. 58ᵛ. Kind communication of S.A.C. Dudok van Heel.)

10. 17 December 1610. Testament of Cornelis Ariensz., broommaker, who bequeaths a silver chain to Neeltge Goris and, after her death, to her children and her children's children in case one of his heirs, named Annitge Bouwens, should remain single until her death. Claes Corstiaensz. and Dirck Claesz. "cramer" [Claes Corstiaensz.'s son] witness the will. (Delft G.A., records of Notary H. van Overgaeu, no. 1541.)

11. 17 May 1611. Claes Corstiaensz., "speelman," witnesses a power of attorney given by Nicasius Cocqu, "caffawercker," to his nephew Niclaes Cocqu, merchant in Amsterdam. (Delft G.A., records of Notary Adriaen Rijshouck, no. 1763.)

12. 13 September 1611. Balthasar Gerritsz., 38 years old, merchant's servant, testifies at the request of Hans Bouwer that he, Bouwer, had not been reimbursed by Pieter Loos for an important sum that his factor in Antwerp had paid to Anthony van Surck on Loos's behalf. The signature, Balten Geersen, is consistent with that in document no. 94 of 8 December 1623. (Amsterdam G.A., records of Notary Jacob Gijsbertsz., no. 38, kind communication of I. van Eeghen.)

13. 20 January 1612. Sale by order of the municipality of Amsterdam of the house belonging to Balthasar Gerritsz. This sale is mentioned in a document dated 14 August 1615 recording the subsequent sale of the house. (Amsterdam G.A., Rech-

terlijk Archieven no. 2164, "Executie Kwijtschelding," fol. 112, kindly communicated by S.A.C. Dudok van Heel.)

14. 18 May 1612. Contract between Rogier Lawrensz. [Laurens] and Johan Rummelaer, embroiderer in Delft. Rummelaer will sell silk goods in Amsterdam on Lawrensz.'s behalf. (Delft G.A., records of Notary Adriaen Rijshouck, no. 1764.)

15. 19 January 1613. Niclaes Corstiaensz. borrows 50 guilders from Clement Ghysbrechtsz. Verarck. (See doc. no. 107.)

16. 29 May 1615. Meester Claes Corstiaensz. borrows 200 guilders from Adriaen Clementsz. van Overschie. (See doc. no. 111.)

17. 27 June 1615. Reynier Jansz. van Delft, "kaffawercker," 24 years old, having lived four years in Amsterdam, is betrothed to Digna Balthazars, 20, from Antwerp, living in the Verweryen. She is accompanied by her father Balthazar Geerardsz. Reynier Jansz. submitted his stepfather's consent by July 19, when the marriage took place before Jacobus Triglandius. (For further details, see O-H I p. 268 and Blankert 1978, p. 145.)

18. 23 December 1616. Jan, son of Jan Heijmensz., baker, and Maertge Jans, is baptized in the New Church. The witnesses are: Jan Otten, Dingnum Baltens, Neeltge Goris. (Delft G.A., New Church, Baptism files.)

19. 13 June 1617. Cornelis, son of Dirck Claesz. van der Minne and Trijntgen Cornelis, is baptized in the Old Church. The witnesses are: Jan Heymans, baker; Maertge Cornelis; and Ariaentgen Claes. (Delft G.A., Old Church, Baptism files.)

20. 20 September 1617. Neeltje, daughter of Anthonij Jansz. and Trijntge IJsbrants, is baptized in the New Church. The witnesses are: Jacob Jacobsz., Maertje Jans, and Ariaentge Claes. (Delft G.A., New Church, Baptism files.)

21. 9 October 1617. Burial of Claes Corstiaensz. on the Cattle Market in the New Church. (Delft G.A., "Begraafboek," no. 37, fol. 166ᵛ.)

22. 11 November 1617. Neeltge Goris, widow of Niclaes Christiaensz., in The Three Hammers on the Broerhuys, sells two obligations to her "son" [her stepson] Dirck Claesz. One obligation had been incurred by Jan Henrix, smith, for 250 guilders, the other by Gerritge Jansdr., wife of Arent Reyersz., for 160 guilders. (Delft G.A., records of Notary Pieter de Roon, no. 1619.)

23. 10 May 1618. Elisabeth Thins, spinster, 19 years old, declares her intention of "entering the Convent of the Annunciates in Loven [Louvain] and there to serve the Lord Almighty." She asserts that she has not been moved or influenced by her sister Cornelia Thins, her cousin ("nichte") Beatrix Duyst, or any other blood relative. (Gouda G.A., records of Notary Th. Puttershouck, no. 94.)

24. 21 July and 5 August 1618. Betrothal and marriage of Jan Thonisz. Back, butcher, and Ariaentge Claes [half sister of Reynier Jansz.]. (Delft G.A., Marriage files.)

25. 14 August 1618. Jan Adriaensz., silversmith, makes a deposition at the request of Jan Thins. Geensz. He declares that, of the three children left by Adriaen Cool, only Hendrick Cool is alive and that the petitioner [Jan Thins] is the legitimate blood relative ("blootvoogt") of Adriaen Cool and of his wife Erckenraad Duyst. (Gouda G.A., records of Notary T. Puttershoeck, no. 94.)

26. 28 September 1618. Geertruijt, daughter of Anthonij Jansz. and Catrina IJsbrants, is baptized in the New Church. The witnesses are: Reyer Jansz., Jan Tonisz., Neeltge Goris, and Maertge Jans. (Delft G.A., New Church, Baptism files.)

27. 3 October 1618. Testament of Johan [Geensz.] Thin. He names as his universal legatees his children procreated by his wife Cunera Splinters. "In case it happened that the testator's children should have died unmarried or without having acceded

to maturity ('jaren van perfectie'), then his assets would devolve by form of substitution on the children of the late Willem Thin, the testator's uncle in equal portions." (Gouda G.A., records of Notary Th. Puttershoeck, no. 33, fol. 42.)

28. 7 October 1618. Niclaes, son of Dirck Claesz. van der Minne, maker of hat felt ("hoedstoffveerder"), and Trijntge Cornelis, is baptized in the New Church. The witnesses are: Jan Thonisz. and Neeltge Goris. (Delft G.A., New Church, Baptism files.)

29. 28 October 1618. Anthonij, son of Jan Heijmansz. and Maertge Jans, is baptized in the New Church. The witnesses are Jan Anthonisz., Trijn IJsbrants [the wife of Anthonij Jansz. Vermeer, the brother of Reynier Jansz.], and Trijn Theunis [wife of Gysbrecht Heymensz. van der Hoeve and presumed sister of Jan Anthonisz. Back]. (Delft G.A., New Church, Baptism files.)

30. 21 December 1618. "Tanneken, daughter of Reynier," is baptized in the New Church. The name of the mother was omitted. The witnesses are: Neeltge Goris and Reynier Jansz. (Delft G.A., New Church, Baptism files.)

31. 11 February 1619. Death of Notary Herman van Overgaeu. His estate papers contain various debts owed by the late Claes Corstiaensz. and by Neeltge Goris, the first, for 600 guilders, dated 29 April 1608. (Delft G.A., Orphan Chamber, *boedel* no. 1283 I.)

32. 17 May 1619. Grietge, daughter of Jan Thonisz. Back, butcher, and of Ariaentge Claes, is baptized in the New Church. The witnesses are Dirck Claeszoon van der Minne, Dingenum Balthasars, and Neltje Anthonis. (Delft G.A., New Church, Baptism files.)

33. 16 October 1619. Willem Hendricksz. van der Lidt, straw-hat maker, 53, Adriaen Pietersz., surgeon, 33, and Jacob Dircksz., smith, 58 [neighbors on the Broerhuyssteeg of Neeltge Goris], testify at her request that the brother of her daughter-in-law Reynier Balthasar [Balthens], presently in prison in The Hague, had been their neighbor and had conducted himself in an upright manner at all times as befits a young man. Jan Heymensz., baker, and Jeroen Fransz., joiner, witness the deposition. In a second deposition, made the same day, again at the request of Neeltge Goris, Jan Jansz., faiencier, 50, and Jeroen Fransz., joiner, 39, declared that Reynier Balthasar had spent one year, from August 1618 to August 1619, learning the trade of joiner with Jeroen Fransz., sleeping in the house of Jan Jansz. During all this time he had behaved as a young man should. The surgeon Pieter Adriaensz. and Reynier Jansz., "caffawercker," signed as witnesses. A part of the original text is transcribed in o-h I, p. 268. (Delft G.A., records of Notary H. van der Ceel, no. 1635.)

34. 15 March 1620. Geertruijt, daughter of Reijer Janszoon, "caffawercker," and Dingenum Baltens, is baptized in the New Church. The witnesses are: Jan Thonisz., butcher; Neeltge Goris; and Maertge Jans. (Delft G.A., New Church, Baptism files.)

35. Interrogations of 28 April 1620; 1, 2, 5, 25, 26, and 28 May 1620; and 2 July 1620. (Amsterdam G.A., "Secreet confessie boek," R.A. 533, fols. 150–168 and ff. to article 92 and "Justitie boek," R.A. 293, fols. 1–25ᵛ.) These are summarized in the text and in o-h I, p. 269. In connection with his history of the Hoeffijser debt, W.F.H. Oldewelt had already published some details concerning the counterfeiting operation (Oldewelt 1959, pp. 43–45).

36. 30 April 1620. Neeltge Goris, widow of Claes Corstiaensz. "speelman," swears at the request of the heirs of Bastiaen Goosensz., merchant in Rotterdam, that she gave the brother-in-law of Bastiaen Goosensz. 29 guilders as part payment on a 70

guilders debt she owed to Bastiaen Goosensz. The witnesses are meester Adriaen (Pietersz.), surgeon, and Heyndrick Gerritsz., surgeon's servant ("chirurgijns-knecht"). (Delft G.A., records of Notary H. van der Ceel, no. 1635.)

37. 7 May 1620. Report of the Commisary Franchoys van der Burgh to the deputed councillors of the States of Holland and West Friesland on the interrogation of Gerrit de Bury (The Hague Algemeen Rijksarchief, "Gedruckte resolutiën van de staten van Holland en West Friesland.")

38. 13 May 1620. The first accounting prepared for the Orphan Chamber of the estate of Servaes Meesz., mattress worker ("tycktwercker"), who had died about two years previously, cites a debt of 53 guilders 5 stuivers owed by Neeltge Goris, widow of Master Claes "speelman" in The Three Hammers. At this time she paid 40 guilders claiming, for the rest, that she had delivered a mattress cover ("tyckt") priced at 12 guilders to the late Liedewye Dirxdr. (the widow of the deceased) through the hands of her son Dirck Faes. The latter claims to know nothing of this delivery. At the time of the third accounting, dated 4 October 1623, Neeltge Goris still maintained that she had delivered the mattress cover. The debt seems to have been written off at this point. (Delft G.A., Orphan Chamber, *boedel* no. 1177.)

39. 21 May 1620. The bailiff of The Hague reports to the deputed councillors of the States of Holland and West Friesland that he has been in Antwerp and spoken with Balthasar Gerrits, after which he made a written transcript of Balthasar's statement. This statement has now been read to the deputies. (The Hague Algemeen Rijksarchief [henceforth the Hague R.A.], "Gedruckte resolutiën van de Staten van Holland en West Friesland.")

40. 21 May 1620. The States General receive a report from the deputed councillors from the States of Holland and West Friesland to the effect that the Resident Sticke is implicated in the counterfeiting operation of De Bury. Johan Doubleth is ordered to go to Deventer to find out in secret if Sticke is staying there with his mother or elsewhere. If this is the case he must arrest him. A letter is written to Bronchem, an officer in Zutphen, charging him to go to Crayenburch near Haselünne in the Bishopric of Münster to arrest Sticke if he finds him there. (*Resolutiën der Staten-Generaal*, no. 3259, p. 472.)

41. 22 May 1620. The States General inform His Excellency [Prince Maurits] of their decision regarding Sticke. (*Resolutiën der Staten-Generaal*, no. 3283, p. 474.)

42. 26 May 1620. The deputed councillors from Holland report to the States General that Resident Sticke has been arrested in Amsterdam and has acknowledged that his brother, the Knight [Christoffel] Sticke, knows about the counterfeiting plot. (*Resolutiën der Staten-Generaal*, no. 3315, p. 478.)

43. 27 May 1620. Johan Doubleth sends a report relating that he heard in Deventer that Sticke was still there on May 21 but that he had left for Holland on the next day. The deputed councillors from Holland transmit a report from Amsterdam about the interrogation of Resident Sticke who claims that his only accomplice was his brother. The Knight [Christoffel Sticke] is said to have gone to Berlin to ask for forgiveness. The States General order the commanding officer of Nijmegen to find out whether the Knight Sticke, whose brother and a certain Burri [De Bury] are sitting in jail in Amsterdam, finds himself in Cleves or in its surroundings. He must request from the Stadhouder [of the Elector of Brandenburg] in Cleves that they arrest the man. (*Resolutiën der Staten-Generaal*, no. 3317, p. 479.)

44. 7 June 1620. Cornelis Lenertsz., grain buyer [husband of Tryn Rochus] and Neeltge Goris acknowledge a debt of 100 guilders from Cornelis Ghyssensz., keeper of the tavern "In de Wandelinge" outside Delft. The debt stems from the

rental of the platform or wharf on which the lottery of Rogier Laurens was to be held. Cornelis Lenertsz. and Neeltge Goris promise to pay Cornelis Ghyssensz. the money before the lottery stalls are taken down after the lottery has taken place. Jan Anthonisz. Back, butcher, and Dirck Aryensz. witness the document. (Delft G.A., records of Notary A. Ryshouck, no. 1812.)

45. 10 June 1620. The States General resolve to ask the delegates of Amsterdam to conduct Sticke and De Bury to The Hague. (*Resolutiën der Staten-Generaal*, no. 3400, p. 492.)

46. 11 June 1620. The States General receive a letter from Knight [Christoffel] Sticke, dated May 30, in which he writes that the Stadhouder [of the Elector of Branden- burg] has informed him that the States General wish to arrest him. He is ready to take responsibility for his actions before his old friend the Elector. He urges Their High and Mighty Powers [the States General] not to spoil the reputation of the Elector by taking excessively severe action against his brother and "to take into account the good name of his father, one of the first and earliest patriots." (*Reso- lutiën der Staten-Generaal*, no. 3410, p. 494.)

47. 11 June 1620. A letter of Conradt Brienen, the counselor of the Elector of Bran- denburg, is read before the States General. Brienen complains that the Resident Sticke has been thrown into a horrid jail ("infame gevangenis") without prior in- culpation. The States General resolve to send a full dossier on Sticke to Brienen. (*Resolutiën der Staten-Generaal*, no. 3416, p. 495.)

48. 23 June 1620. The States General resolve, in view of the improbability that the Knight [Christoffel] Sticke will be sent to The Hague, to dispatch to the Stadhouder and councillors in Cleves all the damaging information [i.e., copies of the interro- gation of Hendrick Sticke] so that they may detain the Knight Sticke there until such time as they may receive all the particulars regarding his case. (*Resolutiën der Staten-Generaal*, no. 3489, p. 505.)

49. 25 June 1620. The deputed councillors of the States of Holland and West Fries- land instruct the bailiff of The Hague to go to Amsterdam with Balthasar Gerritsz. to interrogate Sticke and De Bury in Balthasar Gerritsz.'s presence. Balthasar will be given a safe conduct that will enable him to leave freely with the bailiff. (The Hague A.R., "Gedruckte resolutiën van de Staten van Holland en West Friesland.")

50. 8 and 9 July 1620. Johan Phillipsz. Bouchorst, the envoy of the Stadhouder [of Brandenburg] and of the councillors of Cleves, appears before the States General to request that Resident Sticke be tried in the Elector of Brandenburg's jurisdiction. No decision is taken at this time by the States General. (*Resolutiën der Staten- Generaal*, nos. 3602, 3602b, and 3602c, p. 529.)

51. 11 July 1620. The plea of Christoffel Sticke in favor of his brother Hendrick, written from Cleves on 2 July 1620, is received by the States General. The council- lors from Holland are urged to expedite the affair of the Resident. (*Resolutiën der Staten-Generaal*, no. 3662, p. 538.)

52. 18 July 1620. Letter from the Court of Holland to the States General in answer to their request regarding the case of Resident Sticke. The opinion of the Court is that the envoy of a foreign state may be tried for crimes committed in the Nether- lands as long as they had nothing to do with his mission. (The Hague A.R., S.G. 6052.)

53. 19 July 1620. Letter by Christoffel Sticke addressed to the High and Mighty Lords of the States General requesting his brother Hendrick's pardon. He claims that the Elector has been mocked and demeaned by his envoy's being thrown into an ig- nominious jail and by his lengthy detention. As to the accusations against his own

person, he will have more trouble recovering his honor than proving his innocence. (The Hague A.R., S.G. 6052.)

54. 24 July 1620. An answer to Bouchorst's request is drafted (cf. doc. no. 50 above). The councillors from Holland are requested to demand that Resident Sticke be properly treated. (*Resolutiën der Staten-Generaal*, no. 3702, p. 543.)

55. 3 August 1620. Adriaen van der Borch, returning from Amsterdam to The Hague, brings the States General a report of his interrogation of Hendrick Sticke, a copy of which is sent to the Stadhouder [of the Elector] in Cleves. (*Resolutiën der Staten-Generaal*, no. 3753, p. 553.) The summary record of this interrogation, preserved in The Hague A.R., S.G. 6052 ("Stucken raeckende de valsche munters, Gerrit de Bury ende Hendrick Sticke") contain little information not already available in doc. no. 35 above. However, some questions not recorded in this last-named source are directed toward ascertaining the guilt of the Knight Christoffel Sticke, who certainly knew about the plot and, according to De Bury, had himself made the suggestion that a mint be set up in the domain of the Count of Bentheim, brother of the Count of Teckelenburg. This was denied, however, by Hendrick Sticke. The interrogation also sought to discover whether Lieutenant Colonel Sticke, another brother of Hendrick's, his mother, and a nephew also named Sticke were implicated in the affair, but no damaging information concerning these suspects came to light.

56. 5 August 1620. The burgomasters and aldermen of Amsterdam sentence Hendrick Sticke to be executed by the sword. The sentence asserts that the decrees ("placaeten") of the States General of 1606, reconfirmed in 1610, ban the counterfeiting of all coin "of foreign states, kings, and princes as well as of these lands." Resident Sticke is said to have contributed two-thirds of the sum advanced in the counterfeiting operation in The Hague and De Bury one-third. There were no other accomplices. Resident Sticke is accused of having paid the masters and servants ("knechts") that carried out the work and to have plotted with one of the masters [Balthasar Gerrits] to set up a mint in Crayenburch "to forge or to press all sorts of coins." He had shown the master groschen circulating in Germany and neighboring lands to see whether they could not be counterfeited and ordered four dies to be made accordingly. He had a certain quantity of these groschen pressed, which he received and part of which he gave to his brother Christoffel Sticke in Cleves to have them tested and to see whether they could not be circulated in this territory. He also had a die made for the Schrikenberger. After the mint in The Hague had failed [had been discovered] "he had summoned the aforesaid master from Antwerp, where he had taken refuge, to his house in Crayenburch and had asked him to have a machine ('instrument') made in Luyck [Liège] to press coins." He had then advanced a certain sum of money to get the son of the master out of jail and had written De Bury to ask him to advance more money to this end. For all these reasons it may be concluded that he, Sticke, is the principal culprit. The death sentence follows. (The Hague A.R., S.G. 6052.)

57. 6 August 1620. The burgomasters and aldermen of Amsterdam sentence Gerrit de Bury to be executed by the sword. He is accused of having leased the house in The Hague where the counterfeiting took place, of having hired the master and "knechts" who carried out the work, and of having advanced money for the operation. The other charges more or less coincide with those levied against Hendrick Sticke. In addition he had ordered the master [Balthasar Gerrits] to make dies for the three-stuiver coins. When the dies were ready, he had 200 of the three-stuiver coins pressed. Once the counterfeiting operation in The Hague had been discovered

and the "knechts" of the master had been arrested, he had advanced money for the release of the master's son. He had then gone to Deventer with Hendrick Sticke to see Christoffel Sticke. The latter, having learned of the collapse of the operation in The Hague, had made the suggestion, according to De Bury, that a mint be set up on the territory of the Count of Bentheim where the pressing of the groschen could be resumed with the help of the same master that he had employed in The Hague. From all this it is concluded that Gerrit de Bury was "also implicated" ("mede aengegaen") in the secret counterfeiting of coins. The death sentence follows. (The Hague A.R., S.G. 6052.)

58. 7 August 1620. Conraidt Brienen and Nicolaes van den Bouckhorst appear before the States General. They report that Resident Sticke is to be executed in Amsterdam the following day. Since Sticke is employed by the Elector of Brandenburg, they ask that copies of the confession be dispatched to him. In the meantime they ask for a postponement of the execution of the sentence. Bouckhorst insists that the life of the Resident be spared to save the family which otherwise would die out. The High and Mighty Lords of the States General consult and caucus. The deputed councillors from Holland insist that Sticke is their prisoner and that the jurisdiction belongs entirely to Amsterdam. The States of Holland have resolved in their assembly that the sentence should be executed. The other provinces having nothing to say in the matter, the councillors from Holland "cannot and will not rescind their decision." The States General declare that this affair regards the Province of Holland. They suggest that the prisoners turn to the deputed councillors of Holland for the commutation of their sentence and for grace. (Resolutiën der Staten-Generaal, no. 3781, p. 558.)

59. 13 August 1620. After hearing the death sentence meted out by the aldermen of Amsterdam in the case of Hendrick Sticke, agent or Resident of the Elector of Brandenburg, and of Gerrit de Bury for counterfeiting the coins of sovereign states, the deputed councillors of the States of Holland and West Friesland thanked the deputies from Amsterdam for good justice being done ("goede gedane Iustitie"). (The Hague A.R., "Gedruckte resolutiën van de Staten van Holland en West Friesland.")

60. 1 September 1620. The States General urge the Stadhouder [of the Elector of Brandenburg] and the Councillors in Cleves, seeing that they will not extradite the Knight [Christoffel] Sticke to The Hague, to prosecute him "as the common good requires." (Resolutiën der Staten-Generaal, no. 3916, p. 580.)

61. 25 September 1620. Adriaen Adriaensz., swordmaker, 48 years old, declares at the request of Jacob Schimmel, also swordmaker, that, on approximately Whitsunday of the present year [thus about June 1620], Rogier Laurens had met the deponent in an inn in Delft and asked him whether he knew the petitioner Jacob Schimmel. Laurens had told Adriaen Adriaensz. that he had bought muskets, halebards, and side arms from Schimmel for 1,400 or 1,500 guilders. Laurens asked Adriaen Adriaensz. what he thought the side arms he had bought might be worth, to which Adriaensz. had answered 11 or 12 guilders apiece on average. Laurens then told him that he had paid 10 guilders apiece for them. (Delft G.A., records of Notary Cornelis Coeckebakker, no. 1611.)

62. 17 October 1620. Jan Michielsz., ship carpenter ("scheepstimmerman"), living in Delfshaven, is betrothed to Neeltge Gorisdr., widow of Claes Corstiaensz. living on the New Cattle Market. (Delft G.A., "Stadsondertrouwboek," no. 124, fol. 57.) The marriage was registered on 1 November 1620. (Delft G.A., "Kerkelijk boek," no. 5, fol. 135.)

63. 17 October 1620. Reynier Jansz. "caffawercker"; Jan Heymensz., baker, husband of Maritien [Maertge] Jansdr.; and Jan Tonisz. Bax, butcher, husband of Adriana Jansdr. [sic; Adriana was the daughter of Claes Corstiaensz.] declare, for themselves and on behalf of Antonij Jansz., stone carver ("steenhouder"), their brother, presently in the East Indies, that they have been requited ("vergenuecht") by Neeltgen Goris, widow of Claes Corstiaensz., their mother for any and all claims that they might have on the goods left by Claes Corstiaensz. their father [or stepfather]. (Delft G.A., records of Notary H. van der Ceel, no. 1635.)

64. 21 October 1620. Pieter Hoeffijser, general-receiver of the excise in Amsterdam, reports to the States General that the conduct of his office has suffered as a result of the pressure he was under owing to the affair of his brother-in-law Hendrick Sticke. (*Resolutiën der Staten-Generaal*, no. 4130, p. 618.)

65. 18 November 1620. In the accounting to the Orphan Chamber by Jonckheer Arent van Renoy [registered among the painters in the Guild of St. Luke in Delft] of the estate of the painter Pieter den Dorst, several mentions are made of small debts due by the estate to Neeltge Goris and Tryn Rochus for services rendered to Maria Francensdr. van Bodegem, the widow of the deceased. From this document (fol. 6v and fol. 7) it appears that Neeltge Goris was already active as a secondhand dealer ("uitdraegster") in December 1619 when she had sold on behalf of the estate some clothing that had been pawned in Haarlem and then brought back to Delft. Tryn Rochus had apparently helped with the liquidation of the estate by auction in April 1619. (Delft G.A., Orphan Chamber, *boedel* of Pieter den Dorst, no. 500.)

66. 17 December 1620. Reynier Jansz., "caffawercker," witnesses the testament of Jan van der Straet, widower of Adriana van der Bos. (Delft G.A., records of Notary H. van der Ceel, no. 1635.)

67. 28 February 1621. Joost Jorisz. and four other witnesses testify at the request of Cornelis Gysens, living in Vrouwenrecht, about the lottery set up on the petitioner's wharf from May 28 to June 18, the day of the Delft Kermes, 1620. One of the witnesses, named Gerrit Vrancken van Montfort, 70 years of age, from The Hague, kept the books and recorded the costs incurred by Rogier Laurens, master of the lottery, and by his entourage, servants, and trumpeters. Claes Cornelisz., being an alderman of Vrouwenrecht, declares that he kept in his house the box where the lottery prize tickets ("brieffges") had been deposited and handed it to the master of the lottery on June 18 when the latter departed. (Delft G.A., records of Notary C. Coeckebakker, no. 1611, fol. 146.)

68. 24 May and 16 July 1621. Reynier Balthensz. is betrothed in Delft to Susannetgen Heyndrixdr. from Schiedam. He is accompanied by his good acquaintance Michiel Cornelis and his "mother" [actually his stepmother] Beatrix Gerrits; she is accompanied by her good acquaintance Neeltgen Pieters and by her father Henric Jacobsz.. The marriage took place in Schiedam on July 28th. (Schiedam G.A., "Trouwboek," Marriage files.)

69. 20 August 1621. "Antoni Jansse ghelghieter" [brass caster] signs a document as witness. (Delft G.A., records of Notary C. Coeckebakker, no. 1611.)

70. 24 September 1621. Testament of Jan Michielsz., shipmaker ("scheepsmaecker"), presently married to Neeltien Goris, living in the New Castle Market in "The Three Hammers." He is sick in body but still in command of his five senses. He names as his universal legatee his lawful wife Neeltge Goris without necessity of inventory, or any other accounting. However, he requests that after her death, her heirs be obliged to give 100 guilders to the children of Maes Tonis, his nephew living in Haarlem, and 100 guilders to Tonis Joosten, his nephew also living in Haarlem.

Jacob Dircksz., smith, witnesses the deed. Jan Michielsz. sets his mark, an anchor in an oval. (Delft G.A., records of Notary H. van der Ceel, no. 1636.)

71. 28 September 1621. Jan Michielsz. is buried in the New Church (Delft G.A., Burial files). On 22 July 1623, his heirs donate six guilders to the Camer van Charitate for the redemption of his best outer garment ("beste opperste kleed"). (Delft G.A., Camer van Charitate, "Beste Opperste Kleed Boeken," 1623, fol. 20.)

72. 15 October 1621. Jan Tonisz. Back, butcher, acknowledges a debt to Govert Coenen for 725 guilders arising from his purchase of 100 sheep for slaughtering. However, in case Coenen were to become married within the next two years, Jan Tonisz. shall have the 100 sheep for nothing. Neeltgen Goris, widow of Jan Michielsz. "scheepmaecker," guarantees repayment of the debt with all her possessions. Marcus van Capelle and Ysbrant Heyndricksz. witness the debt acknowledgment. [Ysbrant Heyndricksz. is tentatively identified as the father-in-law of Anthony Jansz., the brother of Reynier Jansz.] (Delft G.A., records of Notary H. van der Ceel, no. 1636.)

73. 3 November 1621. "Antoni Jansse ghelghieter" signs as witness a deposition at the request of Wynant Pietersz., baker. The other witness is Jan Aryens, glassmaker [registered in the Guild of St. Luke on 3 June 1613]. The notary refers to Reynier Jansz.'s brother as "Anthoni Jansz. geelgyeter, citizen of [this] town." (Delft G.A., records of Notary C. Coeckebakker, no. 1610, fol. 117.)

74. 7 December 1621. The honorable Reynier Cornelisz. Bollenes [Bolnes], bachelor, citizen of Gouda, assisted by Cornelis Pouwelsz. Bollenes, his father and guardian, and Aeltgen Jans de Zwaen his mother, Claes Cornelisz. van Hensbeeck, his brother-in-law, and Pouwels Cornelisz. Bollenes, his brother, on one side, and the honorable Maria Willems Thins, spinster, citizen of the town of Gouda, accompanied by Catharina Hendrixdr. van Hensbeeck her mother, Johan Thins Willemsz. her brother, and Johan [Geensz.] Thins her cousin, on the other, announce their forthcoming marriage. Cornelis Pouwelsz. Bollenes with his son Reynier Bolnes promise to contribute to the marriage, in addition to clothes and certain other goods, the sum of four thousand guilders. (Gouda G.A., records of Notary T. E. Puttershouck, N.A. 20, fols. 5–6.) The marriage was celebrated in Gouda on 9 January 1622, in the presence of six of the seven aldermen of the city. (Swillens 1950, p. 193.)

75. 12 December 1621. Neeltien Goris, widow and curator of the estate of the late Jan Michielsz., sells a home situated in Delfshaven to Pieter Ariensz., sailor, for 300 guilders. (Delft G.A., records of Notary H. van der Ceel, no. 1636.)

76. 12 January 1622. Govert Coenen, dealer in fats ("speckman"), transfers 214 guilders to Neeltien Goris, last widow of Jan Michielsz., shipmaker, representing the arrears on a loan of 220 guilders that he owed her. Cornelis Jacobsz. and Jacob Jacobsz. witness the transfer. (Delft G.A., records of Notary H. van der Ceel, no. 1637.)

77. 5 April 1622. Neeltgen, daughter of Dirck Claesz. van der Minne and Trijntgen Cornelis, is baptized in the Old Church. The witnesses are: Cornelis Dionys, Neeltge Jacobs, and Neeltge Goris. (Delft G.A., Old Church, Baptism files.)

78. 25 April 1622. Claes Cornelisz. Brugman, silversmith; Neeltgen Goris, widow of Master Claes Corstiaensz., speelman; and Catharina Rochusdr., wife of Cornelis Lenertsz. van der IJssel, each for a third part, having obtained consent from the burgomasters of Delft to set up a lottery stand during the Delft Kermes of 1622 sign a contract with Rogier Laurens [signs Lauwersz.]. Brugman will advance 6,000 guilders and some jewelry. The lottery proceeds will accrue to Brugman until

he has recovered his stake. In addition Rogier Laurens must pay Brugman for his troubles 200 guilders and a pair of Milanese silk hose. Laurens must also repay Brugman 1,000 guilders that Brugman has promised to give to the poor in order to obtain the consent. Finally he must deliver silk goods for 1,200 to 1,500 guilders that Brugman will be able to employ as part of his contribution to the lottery. If the lottery is prevented from taking place, the contract will be null and void. (Delft G.A., records of Notary A. Rijshouck, no. 1814.)

79. 4 May 1622. Neeltien Goris, widow, and Belitgen Tonis, spinster, both living in Delft, lease a house for one year for 60 guilders to Heyn Jansz. The house, belonging to Aert Leendertsz. van der Aelst, is situated on the North side of the Broerhuys[steeg]. (Delft G.A., records of Notary H. van der Ceel, no. 1637.)

80. 24 May 1622. Dircktien Lourens, widow of Jan Aryensz. Turck as principal; Trijntjen Pietersdr., widow of Adriaen Pietersz. Toors; and Neeltien Gorisdr., widow of Jan Michielsz. van den Beeck, as sureties and co-principals acknowledge a debt of 400 guilders to the guardians of the orphan children of the Notary Johan Molijn at an interest of the penny sixteenth [6.3 percent per annum]. An addendum to the document stated that 25 guilders interest was paid on 24 May 1623. (Delft G.A., records of Notary Johan de Molijn, no. 1569.) The late Jan Aryensz. [or Adriaensz.] Turck and Adriaen Pietersz. Toors, surgeon, were next-door neighbors of Neeltge Goris. A contract between Adriaen Pietersz. and Jan Adriaensz. Turck, dated 19 April 1619, was witnessed by Jan Heymensz., baker, and Jan Tonisz., butcher. (Delft G.A., records of Notary H. van der Ceel, no. 1635.)

81. 1 and 3 June 1622. Petitions of Cornelia Gregory [Neeltge Goris] to hold a draw-lottery for silverware in Groningen. The first petition (June 1) is turned down by the burgomasters of Groningen, the second accepted. (Groningen G.A., "Rechterlijke archieven" IIIa 22.)

82. 18 June 1622. Rogier Laurens's formal notification and protest ("insinuatie") against Neeltge Goris and Tryn Rochus [full translation in the text]. (Delft G.A., records of Notary A. Rijshouck, no. 1814.)

83. 20 July 1622. Cornelia Gregory, widow of Jan Michielsz., draws up a procuration (power of attorney) on behalf of Frans Willemsz. living in Dordrecht and Rogier Laurentsz. living in Amsterdam to set up a lottery in Groningen in the September free market for which she has obtained consent from the burgomasters of that city. (Delft G.A., records of Notary H. van der Ceel, no. 1637.)

84. 6 August 1622. Jan Heymantsz., baker, borrows 266 guilders 10 stuivers from Quyrinch Jansz. van der Hooch [a well-known merchant in Delft]. The sum arises from an agreement made before the masters of the Orphan Chamber on 5 June 1620 concerning a house bought by Jan Heymensz. Neeltge Goris, widow of Jan Michielsz. van den Beeck, assisted by the Notary H. van der Ceel as her guardian, guarantees the loan. Dirck Dircksz., brass caster, is a witness. (Delft G.A., records of Notary H. van der Ceel, no. 1637.)

85. 15 October 1622. Notary Rijshouck acting on Rogier Laurens's behalf notifies Claes Brugman, silversmith, that he, Laurens, is not in violation, as Brugman claims, of the contract they signed on 25 April (doc. no. 78). On the contrary Laurens asserts that he, Brugman, has not lived up to the contract since he has failed to deliver to him 6,000 guilders of silverwork that he had promised. (Delft G.A., records of Notary A. Rijshouck, no. 1814.)

86. 6 January 1623. Anna, daughter of Anthonij Jansz. and Trijntge Ysbrants, is baptized in the New Church. The witnesses are: Reynier Jansz., Jan Thonisz. Back, Trijntge Pieters, and Maertge Jans. (Delft G.A., New Church, Baptism files.)

87. 10 January 1623. Caterina Rochus, 62 years of age, declares at the request of Frans Willemsz. of Dordrecht that Claes Cornelisz. Brugman, silversmith, some time ago had complained that Belitgen, the wife of the petitioner, had guaranteed a loan for Rogier Laurens for about 200 guilders and that the aforesaid Belitgen now denied this and refused to pay. (Delft G.A., records of Notary H. van der Ceel, no. 1638.)

88. 11 February 1623. Jan Anthonisz. Back, butcher, and Neeltgen Goris, widow of Jan Michielsz. van den Beeck, draw up a contract stipulating that Jan Anthonisz. will buy oxen, calves, cows, lambs, and hogs at the most advantageous prices for his "mother" Neeltgen Goris, who shall advance the money to this end. Jan Anthonisz. will neither earn a profit nor incur a loss from the transactions; all profits and losses will be incurred by Neeltgen Goris. Jan Anthonisz. will slaughter the animals and sell the products. He will do this along with his wife, Aryantgen Claes, who will use her house and shop for this purpose. Neeltgen Goris promises to pay Jan Antonisz. eight guilders "for all this and no more." Jan Antonisz. must not buy any animal for himself but only for Neeltgen Goris. He acknowledges having received 200 guilders from Neeltgen Goris to buy animals with, for which he must provide a suitable accounting. (Delft G.A., records of H. van der Ceel, no. 1638.)

89. 28 March 1623. Inventory of the movable goods that Jan Tonisz. Back, butcher in Delft, has sold to Neeltgen Gorisdr. Details in O-H I, pp. 273–74. (Delft G.A., records of Notary H. van der Ceel, no. 1638.)

90. 30 April 1623. Reynier Jansz., "caffawercker," and Jan Thonisz Back, butcher, guarantee a loan of 749 guilders 5 stuivers 8 pennies that Neeltien Gorisdr. owes to Hans Lemmes, a cloth and bedding merchant, for ticking delivered. Neeltien promises to buy more cloth from Lemmes during the period when the loan will be reimbursed. She will pay 100 guilders per year plus interest every half year. (Delft G.A., records of Notary H. van der Ceel, no. 1638.)

91. 1 June 1623. Anna Anthonijsdr., daughter of Anthonij Jansz. and of Tryntge Isbrantsdr., is baptized in the New Church. The only witness is Reynier Jansz. (Delft G.A., New Church, Baptism files.)

92. 2 October 1623. Neeltgen Goris, dealer in bedding ("bedde vercoopster") living in the Broerhuyserve or New Cattle Market, 56 years old, testifies at the request of Pieter Pietersz. Ghysenburch de Jonge, brewer "in't heck" in Delft. She declares that, when she was in an inn in The Hague with a neighbor on the Broerhuys named Geertgen Jacobsdr., she had heard Geertgen tell her husband Willem van Ansen, former Governor of Banda and Councillor of the Indies, that she owed money to various persons. Neeltge Goris observed that her neighbor had failed to mention a debt that she, Geertgen, had incurred from Ghysenburch for 75 or 80 guilders, whereupon Van Ansen recalled that he had given his wife money to repay the debt. The deposition was witnessed by Michiel Joosten, cooper [a neighbor], and Willem Harmansz. (Delft G.A., records of Notary A. Rijshouck, no. 1815.)

93. 15 October 1623. Niclaas, son of Reynier Balthens and Susanneken Henricxdr., is baptized in Gorinchem. The witnesses are Steven Pieters, Thomas Rochusz., and Tanneken Balthus. (Communicated by A. J. Busch, archivist in Gorinchem.)

94. 8 December 1623. Inventory of all such movable goods as Reynier Jansz., "caffawercker," in full ownership is selling and transferring to Balten Claes Gerritsz. in The Hague. An extract of this inventory, which covers three folio papers, was published in O-H I, pp. 274–75. Following the inventory, the notary noted that the goods had been estimated by himself with the exception of the paintings that had been estimated by Joris Gerritsz. van Lier [a master painter in the Guild of St.

Luke]. In a second part of the document, Reynier Jansz., "caffawercker" living on the Broerhuys, declares that he has ceded all the goods in the inventory to Balten Claes Gerritsz. in counterpart for an equivalent sum [left blank] that Balten has lent him. In a third part of the document Balten Claes Gerritsz. declares that the goods in the inventory have been taken from Reynier Jansz.'s house, deposited in the public street, and then delivered to him again. Balten Claes Gerritsz., at Reynier Jansz.'s urgent request, out of consideration for Reynier's difficult situation ("swaeren staet"), and moved by fatherly affection, has lent him back the goods that he, Reynier, will be able to keep "in precario" until such time as Balten Claes Gerritsz. may want to have them back. The latter signs Balten Claes Gersen. (Delft G.A., records of Notary H. van der Ceel, no. 1638.)

95. 13 December 1623. Jan Heymansz., baker in "Het Wapen van Wassenaer" in the North End, undertakes to repay Gerard Welhouck, merchant, a debt of 147 guilders which his mother-in-law Neeltgen Goris, widow of Jan Michielsz., shipper, owes the aforesaid Welhouck. This commitment is in compliance with a sentence of the judges of this city. (Delft G.A., records of Notary H. Vockestaert, no. 1588.) Jan Heymansz. had begun to lease "Het Wapen van Wassenaer" (for 120 guilders a year) in 1620. (Records of Notary H. van der Ceel, no. 1635, 20 March 1620.)

96. 4 January 1624. Thielman Jansz., brewer's servant ("brouwersknecht"), 40 years old, declares at the request of Hans Lemmes, ticking worker ("tyck wercker"), that some fourteen days or three weeks ago, before the Delft Kermes, he sold Neeltge Goris, dealer in bedding ("beddevercoopster") in The Three Hammers on the Broerhuys or New Cattle Market, diverse bags of feathers weighing 328 pounds including the bags, which feathers belonged to Gerard Welhouck, presently an alderman of Delft, on whose behalf he, deponent, declares he delivered the aforesaid feathers in the Weighing Hall of Delft. (Delft G.A., records of Notary A. Rijshouck, no. 1788.)

97. 27 January 1624. Antonij Jansz. promises to pay a debt amounting to 793 guilders 18 stuivers 9 pennies that his mother owes in back debts plus interest to the merchant Hans Lemmes (see document no. 90). The amount Antonij will pay must not exceed one-fourth of the wages that he will earn on his forthcoming voyage to sea. Neither will he pay interest on the debt. (Delft G.A., records of Notary H. van der Ceel, no. 1639.)

98. 10 March 1624. Neeltgen Gorisdr., assisted by Jan Heymansz., baker, and Dirck Claesz. van der Minne, her guardians for this transaction, leases to Willem Jansz. Meyns [or Mogens], drummer of the Guard of Prince Hendrick, stationed in Delft, her house situated in the Grote Broerhuyssteeg, named The Three Hammers ("De drie hameren") for the next three coming years, starting 1 May 1624, for the sum of 100 guilders in the first two years and 18 Flemish pounds [108 guilders] in the third. If the house is sold, then the rental contract will be null and void. (Delft G.A., records of Notary H. van der Ceel, no. 1639.)

99. 22 April 1624. Jan Anthonisz. Bax promises Jan Heymansz., baker, his brother-in-law, that he will take over one-fourth of the liabilities that Jan Heymansz. will have to pay by reason of the guarantee ("borgtochte") he gave for his mother-in-law Neeltjen Goris, with the exception of the guarantee on the house named "The Three Hammers," for which Jan Heymansz. will remain guarantor ("borge") and whose liability Jan Heymansz. will continue to assume. (Delft G.A., records of Notary H. van der Ceel, no. 1639.)

100. 25 April 1624. Jan Tonisz. Bacx receives 200 guilders from Annitge Fransdr. van Leeuwen, widow and custodian of the estate of the late Jacob Cornelisz. Mol-

wijck, living in Delfshaven. He will buy and slaughter sheep, calves, oxen, and hogs on her account and without taking advantage on his own from the transactions. He will receive only an appropriate salary [unspecified] for his services. (Delft G.A., records of Notary H. van der Ceel, no. 1639.)

101. 25 September 1624. Neltge Gorisdr. transfers the entire sum of 316 guilders owed to her for three years for the lease of her house "The Three Hammers" to Dirck Claes van der Minne and Jan Heymansz. von der Hoeve, her guarantors for previous loans, to compensate them for the money they already have paid and still promise to pay as guarantors of these loans. (Delft G.A., records of Notary H. van der Ceel, no. 1639.)

102. 8 December 1624. Anthoni Jansz. [the brother of Reynier Jansz.] declares at the request of Gryetyen Claesdr., widow of Jacob Jansz van Cortyen, that Jacob Jansz. died some time ago in East India in front of the Fort of Jaccatra [Djakarta] on the ship *Bergerboot*. The deponent saw Jacob Jansz. the day before he died and helped to bury him. (Delft G.A., records of Notary H. van der Ceel, no. 1639.)

103. 2 January 1625. Cornelis Adriaensz., ready to sail with the ship *Delfshaven* to the East Indies, names his brother Jan Ariensz., glassmaker, to represent him to collect a debt of 165 guilders owed to him by Aryen Willemsz. van Ryswijck. [On Jan Ariensz., who already appeared as a co-witness with Antony Jansz. in November 1621, see doc. no. 73.] The document is drawn up in the presence of Reynier de Vos (who signs Reijnier Jansz. Voos) and Anthonij Jansen [Vermeer's uncle]. (Delft G.A., records of Notary C. Brouwer, no. 1659.)

104. 4 January 1625. In the estate papers of Cornelis Bastiensz., sailor on a flat-bottomed bark ("cagenaer"), drawn up and delivered to the Orphan Chamber on this date, Neeltge Goris living at the corner of the Cruystraet appears as a debtor for 62 guilders that she still owed on a larger sum that she had borrowed from the deceased. When the estate was divided among the children of Cornelis Bastiaensz. and Ariaentge Henrixdr. on 13 October 1625, the same amount was still outstanding. A note in the margin, dated October 14, showed that the debt had been collected. However, in a later accounting of the estate, dated 12 February 1638, Neeltge Goris was still said to owe 54 guilders. (Delft G.A., Orphan Chamber, *boedel* no. 980.)

105. 17 January 1625. In the estate papers of Pietertgen Claesdr., widow of Gysbrecht Assuerus, slate roofer, containing several successive accountings by the trustees of the estate rendered to the Regents of the Orphan Chamber, various debts owed by Neeltge Goris and her daughter Ariaentge Claes appear. One obligation incurred by Ariaentge Claes, dealer ("coopvrou"), on 27 January 1621 was for 25 guilders at 7 percent. She also owed 50 guilders on another obligation. Another, owed by Neeltgen Goris, was for 125 guilders, incurred on 26 May 1624, also at 7 percent. She promised to pay within half a year. Neeltge Goris had also borrowed 75 guilders on 10 October 1621 at 7 percent and 100 guilders on 7 January 1624. In the next accounting of the estate of Pietertgen. Claesdr. delivered to the Orphan Chamber on 14 March 1625, Neeltgen Goris still owed 125 guilders, but she had paid the interest on the debt and returned 100 guilders "through the hands of Tryn Rochus." Even though she had been legally admonished and notified ("geïnsinueert") she had not paid back either the 100 guilders or the 75 guilders debt that she still owed. Neither had Ariaentge Claes returned the 50 guilders she owed, although she too had been notified. One year later, on 6 May 1626, the next accounting showed that all these debts and the interest thereon had been paid up by Neeltge Goris and Ariaentge Claes after the trustees of the estate had brought suit

to collect the debts ("naer voorgaende rechtsvorderinge"). (Delft G.A., Orphan Chamber, *boedel* no. 1263.)

106. 6 April 1625. Neltje, daughter of Anthony Jansz. Vermeer and Tryntge IJsbrantsdr., is baptized in the New Church. The witnesses are: Maertje Jansdr. and Dignom Balten. (Delft G.A., New Church, Baptism files.)

107. 27 May 1625. The estate papers of Clement Ghysbrechtsz. Verarck record a debt owed by the widow of Niclaes Corstiaensz. as principal and by Jannitgen Dirxdr. widow of Jan Ghysbrechtsz., butcher, and Ghysbrecht Jansz., also butcher, as co-principals and sureties for 50 guilders incurred on 19 January 1613. (Delft G.A., records of Notary Guillaume de Graeff, no. 1701.)

108. 12 July 1625 and 29 September 1626. Cornelis Claesz., brandywineman in the East End of Delft ("int oosteynde"), died on 12 July 1625. The accounting of the estate to the Orphan Chamber, drawn up soon after his death, showed that Reynier Jansz. on the Pig Market ("opte varckemart") [the Small-Cattle Market] still owed 17 guilders for brandywine out of a larger debt. The debt was paid in full before 29 September 1626. (Delft G.A., Orphan Chamber, *boedel* no. 315.)

109. 26 July and 4 August 1625. The full text of these two documents is transcribed in Swillens 1950, pp. 181–82. They were published for the first time by A. C. Boogaard-Bosch in *Nieuwe Rotterdamsche Courant* on January 25, 1939. The translation is summarized in Chapter 4 at note 7.

110. 17 November 1625. Geertgen van Bylandt, living in Thiel, legitimate mother of the late Willem van Bylandt, names corporal Hans Pietersz. to collect 24 guilders from Dingenum Cornelisz., and in case of failure of payment, from his mother. (Delft G.A., records of Notary A. van Twelle, no. 1653.)

111. 4 February 1626. The inventory and accounting of the estate of Adriaen Clementsz. van Overschie, who died on 1 September 1624, is delivered to Delft's Orphan Chamber. Among the debts owed to the estate, we find an obligation incurred by Meester Claes Corstiaensz. living on the New Cattle Market as principal and Jan Heymansz. baker and Dirck Claesz. "cramer" in the Jacob Gerritsz. Steegh as sureties and co-principals for the sum of 200 guilders at the penny sixteenth contracted on 29 May 1615. The interest has been paid until May 1623 but 16 guilders 13 stuivers 5 pennies were still due for the period 1 May 1623 to 1 September 1624. (Delft G.A., Orphan Chamber, *boedel* no. 1286.) For the subsequent fate of this debt, see below, doc. no. 123.

112. 19 June 1626. Maria and Anna, twin daughters of Jan Heijmensz. and Maertge Jansdr., are baptized in the New Church. The witnesses are: Neeltge Goris, Araientge Claes, Trijntge Ysbrants, Heijndricke Jans, Jan Thonisz. Back, and Franchoijs Volland. (Delft G.A., New Church, Baptism files.)

113. 14 April 1627. Bastiaen Bastiaensz., basketmaker, about 60 years old, and Bruijn Jansz. Menningh, joiner ("schrijnwercker"), about 31, state under oath, at the request of Sr. Johannes van der Rosieren, merchant in Amsterdam, that they are very well acquainted with Balthasar Claesz., presently living in this city [Gorinchem], who is an artful master of clockworks and other wonderful inventions ("een konstich meester van vuijr wercken ende andere wonderlijcke inventien") and that they are well aware that the aforesaid Balthasar is considered and respected as a person of good means ("goede middelen") and excellent housekeeping ("treffelijcke huijs houding"). Balthasar, they declare, has in his house a remarkable quantity of artful paintings, which are estimated by everyone who has seen them to be worth a few thousand guilders and which, so the witnesses understand, fully belong to him. In addition he possesses a beautiful library, as no one in this

town has, which is worth, by all appearances, far more than a thousand guilders. He is in all manners a very qualified person ("gequalifeert persoon"), who in particular is not being harassed for any debts ("die sonderlinx om geene schulden wert gemolesteerdt"). The aforesaid Bastiaen Bastiaensz., by reason of direct knowledge, testifies that he has been at various times at the house of the aforesaid Balthasar, that he has seen his paintings and other goods, that he has heard about his condition ("sijnen staet") from Balthasar's familiar friends ("familiaere vrienden"). The aforesaid Bruijn Jansz. testifies that he has made most of the frames of the aforesaid paintings and that he is therefore very knowledgeable about the condition of Balthasar Claesz. (Gorinchem G.A., "Rechterlijk Archief," inv. no. 553.)

114. 7 May 1627. A "contract or agreement" is drawn up between Laurens van Otteren, on the one hand, and Joannes van der Rosieren and Pieter van Otteren, on the other, concerning the art of making steel from iron. By the terms of the contract Laurens van Otteren, along with other good merchants, will form a company regarding the aforesaid art on such terms as he shall determine. The profits will be divided half and half between the members of the company and the aforesaid Rosieren and Pieter van Otteren. Among other provisions it is specified that Laurens van Otteren may not depart from this city (Amsterdam) without having first taught and divulged ("geleert ende geopenbaert") the art to one of the contracting parties. (Amsterdam G.A., records of Notary L. Lamberti, N.A. 591, fols. 831–32; kindly communicated by S.A.C. Dudok van Heel.)

115. 16 May 1627. Laurens van Otteren on the one hand, and Joannes Rogiers, Lauren's brother-in-law, and Pieter van Otteren, Laurens's brother, on the other, agree to the following terms regarding the art of making iron into steel, which art is only known to Laurens van Otteren. The aforesaid Johannes Rogier will do his utmost to induce some participants to contract with Laurens van Otteren until the company will have been fully subscribed. In compensation Joannes Rogiers shall earn one-fourth of any profits the company will earn in the United Provinces in the next ten years. Pieter van Otteren will also earn a fourth part of the profits for lending his brother all due help and assistance. If Laurens van Otteren should depart to another country he will be obliged to convey his art to Pieter van Otteren in such a manner that the latter shall be able to replace him in the company. In case Laurens should leave these United Provinces to set up another company, his share will be reduced from one-half to one-fourth and the other three-fourths will be shared equally between Johannes van Rogier and Pieter van Otteren. (Amsterdam G.A., records of Notary Pieter van Persse, N.A. 750, no. 253; kindly communicated by S.A.C. Dudok van Heel.)

116. 17 July 1627. Tryntgen Isbrantsdr., wife of Anthonij Jansz., presently in the East Indies, acknowledges that her husband Anthonij Jansz., out of the sum of 200 guilders that Neeltgen Goris, widow of Jan Michielsz., shipmaker, the mother of her husband, had borrowed from Louris Cornelisz., sailor ("bootsgesel"), on 17 January 1623, had taken, received, and enjoyed the sum of 75 guilders, which sum had been spent to outfit him for his journey to the East Indies where he is presently ("tot uijtrustinge van haer comparante mans reijsse daer op hij tegenwoordich is"). She promises to pay Louris Cornelisz. the sum of 75 guilders plus interest at the sixteenth penny from the monthly wages that he has already earned or will be earning. She signs with a cross. Maerten Aertsz. van Pruyssen, beer porter, and Jan Segersz., sailor ("varentgesel") witness the act. (Delft G.A., records of Notary C. Brouwer, no. 1659.)

117. 6 September 1627. "Neeltgen Goris opte beeste mart" [on the Cattle Market] is buried in the New Church. (Delft G.A., Burials files.)

118. 5 December 1627. Wouter Jacobsz., envoy ("bode"), at the request of some creditors of the late Neeltgen Goris, widow of Claes Corstiaensz. "speelman," has been authorized by messrs. the burgomasters and aldermen of the Weth to sell at public auction the house of the aforesaid Neeltgen Goris situated on the Broerhuys, named The Three Hammers, as well as the movable possessions in the estate left by Neeltgen Goris. The house will be sold under the supervision of two aldermen and the movable possessions by the auctionmaster ("boelhuysmeester"). The proceeds from the house and the movable goods are to be brought to the [town] secretary for the creditors entitled to the money. (Delft G.A., O.R.A. no. 170.)

119. 14 December 1627. Lysabeth, daughter of Reynier Balthens and Susanneken Henricxdr., is baptized in Gorinchem. Witnesses: Aert van Herwarden and Beatris Gerrits [the stepmother of Reynier Balthens]. (Communicated by A. J. Busch, archivist in Gorinchem.)

120. 6 January 1628. Among the debts owed to the estate of the late Dirck Dominicus Kouckebacker, Jan Theunisz. Back, butcher, appears as owing 168 guilders for 12 hogs. He promises to pay the entire debt. (Delft G.A., records of Notary W. van Assendelft, no. 1855, doc. no. 103, fol. 8.)

121. 27 January 1628. Mr [meester] Baltus Claesz. engineer ("ingenieur"), in his capacity as husband and guardian of Beatris Gerritsdr., names as his legal representative and empowers Claes Geritsz. Vouck to collect in his name such sums of money as he is entitled to receive in Amsterdam in the aforesaid capacity from the commissaries of the garrison in that city on behalf of Gerrit Vouck, the appearer's father-in-law, who, during his life, served in the company of Captain Hasselaer, with respect to his wages. (Gorinchem G.A., "Rechterlijk Archief," no. 553.) Claes Geritsz. Vouck was the brother of Beatrix Gerrits, the second wife of Balthasar Claes Gerrits.

122. 12 August 1628. Reynier Jansz. Vos signs as witness a deed concerning tapestry works. (Delft G.A., records of Notary H. van der Ceel, no. 1641.)

123. 3 November 1628. Inventory of the estate of Annitgen Adriaensdr. van Overschie, late wife of the Notary Guillaume de Graeff. The claim on the debt incurred by Claes Corstiaensz. on 29 May 1615 (doc. no. 16), which had been owed to Adriaen Clementsz. van Overschie, had been inherited by his daughter Annitgen Adriaens who also had recently died. Some time in 1626, 75 guilders had been paid on the principal. Jan Heymansz. and Dirck Claesz., who had guaranteed the debt, were now said to be liable for its unpaid portion amounting to 125 guilders. According to a sentence of the aldermen of Delft dated 12 August 1626, they were to pay 25 guilders on 12 August 1628 and the remaining 100 guilders in the two following years, plus interest. By 10 August 1632, the debt had been paid in full in the hands of Notary De Graeff including interest. (Delft G.A., Orphan Chamber, *boedel* no. 1287.)

124. 9 February 1629. Reynier Jansz. Vos signs as witness an acknowledgment of a debt owed by Cornelis Cornelisz., reed roofer ("rietdecker"), to the merchant Thonis de Jonge. He is referred for the first time as innkeeper ("herbergier"). (Delft G.A., records of Notary W. de Langue, no. 1687.)

125. 17 March 1629. Tryntge Isbrants, widow of Anthony Jansz. stonecutter, living on the New Cattle Market ("Nieuwe Beestemarckt") [Small-Cattle Market], is betrothed to Joris Balfort (Delft G.A., Betrothal and Marriage files).

126. 16 April 1629. Beatrix Gerrits, midwife, testifies that the mother of the child that she had delivered had sworn that the child's father was none other than her employer as housemaid; she had "conversations of the flesh" with no one else. (Gorinchem G.A., "Rechterlijk Archief," no. 554, act no. 148.)

127. 28 April 1629. Testament of Reynier Balthens and Susanna Hendricksdr. They name each other universal legatees. She signs with a mark. Witness: Ruth Jacobsz. Homel. (Gorinchem G.A., records of Notary H. van der Muyr.)

128. 4 June 1629. Hendricksken, daughter of Reynier Balthens and Susanneken Henricxdr., is baptized in Gorinchem. Witnesses: Arent Pietersz. and Jacob Danielsz. de Leeuw. (Communicated by A. J. Busch, archivist in Gorinchem.)

129. 15 September 1630. Helena, daughter of Renier Balthens and Susanneken Hendricxdr., is baptized in Gorinchem. Witnesses: Folpert van Beesdt and Aart van Herwaerden. (Communicated by A. J. Busch, archivist in Gorinchem.)

130. 23 March 1631. Reijnier, son of Jan Heijmensz. and Maertge Jans, is christened in the New Church. The witnesses are Gijsbrecht Heijmensz. [the brother of Jan Heijmensz.], Jan Sijmonsz., and Dingnum Balthasars [Vermeer's mother]. (Delft G.A., New Church, Baptism files.)

131. 3 June 1631. Date of the inventory of the estate of Franchois Camerling, dealer in silk cloth ("zydelakencooper"), who had died in July 1629. Among the "middling debts" ("middelbare schulden") due to the estate, "stemming from the silk cloth trade" we find two debts owed by Reynier Jansz. "caffawercker": 9 guilders 15 stuivers and 8 guilders 7 stuivers 8 pennies, together 18 guilders 2 stuivers 8 pennies. The "middling debts" are defined in the inventory as those that are neither "entirely good nor bad" ("geheel goet noch quaet"). (Delft G.A., records of Notary H. Vockestaert, no. 1598.)

132. 12 August 1631. Arien Hendrixsz. van Buyten, shoemaker, and Johan Croes, tailor, both militia men ("schutteren") in Delft; together with Lyntge Leendertsdr., wife of Gillis van Lelienberch; Annitgen Pieters, widow of Cornelis Jansz. Bischop; and Pieternelletge Jacobs, wife of Wichman Gillisz., baker, testify at the request of Gysbrecht Jansz. Vianen, herald ("bode") in Delft, first Van Buyten, that on 7 June 1630 and various times thereafter Beatrix Hendrixdr., wife of Gysbrecht Vianen, came to his house and ordered several pairs of wooden-sole shoes ("klickers"), which he, Van Buyten, brought to the house of Reynier Vosch, innkeeper, which she said he [Reynier] should bring to her niece in Amsterdam. . . . One day Beatrix came to the house of Lyntge Leenderts totally unconscious ("gants buyten kennisse") and quite drunk ("beschonken"). She undressed and went to sleep there. (Delft G.A., records of Notary W. de Langue, no. 1687.)

133. 13 October 1631. "Reijnier Vos or Reijnier van der Minne" is registered in the Guild of St. Luke as master art dealer ("Mr. Constvercoper"), paying six guilders as his entry fee as a citizen of Delft. (Obreen 1877, 1: 27).

134. 17 April 1632. The supplicant Beatris Geritsdr., widow of the late Mr. Balthasar Claesz. "alias Myn heer" (alias Monsieur), declares before the burgomasters and other magistrates of Gorinchem that she lived for twelve years in Amsterdam and there exercised the office of town midwife ("stadts vroetvrouw"). After the death of her first husband she had married Mr. Baltus. They had both come to live in Gorinchem. After some time, in regard to her experience and skill in the aforesaid office, she had been persuaded by her good friends to resume her calling about six years ago. This she has been doing daily, both by night and by day. She has been used with great satisfaction not only by well-off but also by poor people whom she is serving more than any town midwife (which she does gladly). She had been ad-

vised by her good friends that she should apply to be admitted as a town midwife so that she could be remunerated by the city, but she had not been able to do so because her husband had used her in trips and travels in secret services of the land ("overmits zy by haer man in secret diensten van den lande met reysen ende trecken werde gebruyct"). She presently desires to settle in the town ("haer aen dese stadt te verbinden"), being still in the most fitting years of her life to serve as midwife, being now a widow who is missing the earnings of her husband who has left her no assets but only debts ("geen middelen maer wel schulden"), so that she cannot manage with her own earnings, and therefore implores the magistrates, in recognition of her past services, to name her as a town midwife with a yearly salary. A marginal note records the decision of the town authorities ("vroetschap") to name the supplicant town midwife with a remuneration of 42 guilders per year. (Gorinchem G.A., inv. no. 47, fol. 167. Document communicated by A. J. Busch.)

135. 15 July 1632. Cornelis Theunisz, "caffawercker," presently serving under the Captain Major of the Delft militia, empowers his wife Barber Jacobsdr. to manage all of his affairs. Reynier Jansz. Vos, "caffawercker." and Cryen Jacobsz. den Appel, beer worker ("byercruijer"), sign as witnesses. (Delft G.A., records of Notary A. van der Block, no. 1733.)

136. 31 October 1632. Joannis, son of Reynier Jansson and of Dingnum Balthasars, is baptized in the New Church. The witnesses are: Pr Brammer, Jan Heijndricxzoon, and Maertge Jans. (Delft G.A., New Church, "Doopboek," no. 12; first published in Obreen 1881, 4: 291.)

137. 6 February 1633. Neeltge, daughter of Jan Anthonisz. and Ariaentge Claes, is christened in the New Church. The witnesses are: Reijnier Jansz., Maertge Jans, and Trijntgen Thonisdr. [the wife of Gysbrecht Heymensz. van der Hoeve, the brother of Jan Heymensz., and the presumed sister of Jan Anthonisz. Back]. (Delft G.A., New Church, Baptism files.)

138. 11 July 1633. Pieter Dionysz., Cornelis Ariensz., Aert Gysbertsz. Hamel, and Reynier Baltensz., all workmasters ("werck meesters") in Gorinchem, declare that they have formed an association ("gemeenschap") or company with Jan van Hemert and Arien Jansz., also workmasters, exclusively with regard to the making of certain fortified works in the last siege of Ryn-Berk [Rhineberg or Rhijnberch] between the quarters of Count Johan Maurice and the Lord of Bredenrode, whereas all other works undertaken were to be made outside the association, each on his own account. (Gorinchem G.A., "Rechterlijk Archief," no. 556.)

139. 15 July 1633. The notary and attorney Hendrick van der Muyr and Franck Anthonisz. Beugel swear at the request of Cornelis Ariensz., workmaster, and his associates ("cum sociis") that on Saturday last, being July 9, they had been present in an inn in Gorinchem and witnessed the confrontation between Jan Jansz. van Hemert and Adriaen Jansz. van Breda, also workmasters, on one side and Cornelis Ariensz. and associates on the other. The dispute was resolved as follows: Cornelis Ariaensz., Mr. Pieter Dyonysz., Reynier Baltesz. and Aert [last name left blank], the son-in-law of Pieter van Rossum, declared that there would be no more association among the parties present in making fortified works before the city of Rynberch except for the first five works that had been commissioned and that a payment of 85 guilders by Arien Jansz. and Jan van Hemert should be made to Cornelis Ariensz. and associates. All parties then gave each other the hand by way of agreement. (Gorinchem G.A., Rechterlijk Archief, no. 556.)

140. 17 July 1633. Jan Thonisz. Back is buried in the New Church. (Delft G.A., New Church, Burial files.)

141. 12 August 1633. Ariaentge Claes, as mother of her five children procreated by Jan Thonisz. Back her late husband, namely Trijntgen, eleven years old Annetgen, nine, Fransge, seven, Thonis, eighteen months, and Neeltge, six months, appeared before the Masters of the Orphan Chamber and delivered to the supervision of Ghysbrecht Heymensz. van der Houve and IJsbrant Hendricxz., butcher, the inventory of the goods that she had possessed in common with her husband and that he had left behind. The Orphan Masters found the estate such that she could not bring up her children. The same day the trustees delivered the inventory of the goods left by Maritge Pieters, the grandmother of the children on the father's side. Since the debts exceeded the assets, the trustees were authorized to repudiate the estate. (Delft G.A., records of the Orphan Chamber, no. 83, fol. 88.)

142. 13 September 1633. Geertruy, daughter of Reynier Balthens and Susanneken Henricxdr., is baptized in Gorinchem. The witnesses are: Barnardus Jansz. Fyoth and Mayken Snoecks. (Communicated by A. J. Busch, archivist in Gorinchem.)

143. 27 January 1635. Reynier Jansz. Vos, 43, Cornelis Theunisz., 31, Theunis Jansz., 23, and Abraham Jeronimusz., 18 years old, all caffa workers, at the request of Cornelis Jansz. van Noorden, affirm, testify, and declare, first Theunis Jansz. and Abraham Jeronimusz., that on the 25th of this month Robbrecht Post called to one side the petitioner [Cornelis Jansz.], who was standing near the deponents on the Buytenweech in the Houttuynen [on the outskirts of Delft], and the deponents saw that Robbert and the petitioner had each pulled out his knife. Seeing this they called the two other deponents [Reynier Jansz. and Cornelis Theunisz.]. All four deponents alike affirm that Robbert constantly assailed the petitioner with a knife in the hand. The petitioner retreated, also with a knife in the hand, with which he was fending Robbert off. The deponents having fended Robbert off with kolf-sticks said, "Cornelis, put up your knife," which the petitioner actually did. Robbert nevertheless, with his knife in hand, did all in his power to come between the deponents to cut and to pierce him [Cornelis]. The petitioner said, "if you have something to say, then sue me before the magistrates" ("spreeckt my met recht an"), you can now pay me with blows ("kont ghij my nu met slagen betalen"). Robbert answered, "that's why, if I had had you in a tavern, you would have gotten off differently" ("ghij soud daer anders aff gehad hebben"); "keep it well in mind." When things had quieted down, the deponents went on the ice again; Robbert again assailed the petitioner who, in getting away on ice, fell. When he got up again Robbert in the presence of the deponent gave the petitioner some blows around the head. The deponents being startled ("geschooten synde"), Robbert said, "I wish I could get hold of you" ("ick wilde ick soude u bet hebben"). The deponents said, "not as long as we are present." The petitioner then came back to solid ground, wrapped his mantle around him and went away. Robbert followed him with many words and threats all the way to the Nickersteegh, where the deponents took leave of him. The act was witnessed by Cornelis Jansz., carpenter, and Jan Jansz., miller. (Delft G.A., records of Notary G. van der Wel, no 1938, fols. 98 $^{r+v}$.)

144. 21 April 1635. The aldermen of Gorinchem, having taken cognizance of the afore-displayed affirmation made by Reynier Baltensz. for the purpose of confirming his invention subsequent to the preferential sentence regarding the estate of Pieter van der Griend, declare that this same interlocutory [temporary judicial] decision is now terminated and that the aforesaid Reynier Baltensz. remains entitled to share with other creditors in his claims against the same estate. (Gorinchem G.A., "Rechterlijk Archief," no. 557.) Pieter van der Griend (or van de Griendt) was married to Maria Dominici de Maulpas living in Delfgauw outside Delft on 22 June 1625. Jan Walravens was appointed by the court as curator of his estate

on 17 January 1631. He was assisted in his curatorship by Aerndt van den Collick and Govert Jans van Gestel. (Communication of A. J. Busch of the Gorinchem archive.)

145. 17 October 1635. Reynier Jansz. Vos, caffaworker and tapster ("waert") in The Flying Fox ("in de Vliegende Vos") on the Voldersgracht, promises to indemnify and exempt from liability Huych Jansz. van Boodegem, brewer in The Stork ("in de oeyevaer") in Delft, for the guarantee that he, Boodegem, had given for the appearer [Reynier Jansz.] in regard to a debt that he [Reynier Jansz.] owed to Hester van Bleyswijck, widow of Ghysbrecht van Zuyele, breweress ("brouwerse") in the conduit ("int conduyt"), for the payment of the sum of 202 guilders six stuivers that the appearer still owed for beers he had fetched according to the accounts of the aforesaid Hester van Bleyswijck. The appearer binds his person and all his goods to the above as well as for any amounts that he may owe Van Boodegem for beers fetched according to Bodegem's register. (Delft G.A., records of Notary G. van der Wel, no. 1938, fol. 98.)

146. 13 December 1635. Maria Gerrits Camerlingh, daughter of Gerrit Gerritsz. Camerlingh and Catharina van Hensbeeck, draws up her testament. She leaves "the children of the aforesaid Maria Thins all her linen and woolen cloths, together with a painting of the Birth of Christ with a gilded frame, which had come from her mother's estate" ("sterffhuis"). (Delft G.A., records of Notary J. van Steeland, no. 1635, fol. 198, cited in Kotte 1964, p. 161.)

147. 14 January 1637. Reynier Balthes, widower from Amsterdam, weds Mayken Gijsberts, daughter of Gijsbert Rutten, from Gorinchem. The illiterate bride brings no property to the marriage. The marriage contract specifies that, in the first two years, the bridegroom will retain his separate property, after which all goods will be possessed in common. (Gorinchem G.A., records of Notary H. van der Muyr, no. 3971–150.)

148. 30 December 1637. "I, Notary Willem van Assendelft, at the request of Heijndrick van der Burch, merchant in Amsterdam, called at the house of Reynier Jansz. Vosch living on the Voldersgraft. Since the latter was not at home, I showed his wife the original lease schedule ('huijr cedulle') for the house in which he, Vosch, is living, dated 27 January 1635, and informed her that Pieter Corstiaensz. Hopprus's rent schedule had been handed over to Van der Burch so that he might collect the rents that were due and were to become due, with the provision that whatever amounts were to be received would be deducted by Hopprus from the interests ('verloope rente') due to Van der Burch on the house mortgage. The wife of the same Reyer Vosch answered me, notary, that she would tell her husband but that she would not honor the request [?] unless it were noted in the rent schedule. Furthermore there were two other [claims] that had been assigned on it [the schedule] ('op geassingueert') that she had not yet agreed to." (Delft G.A., records of Notary W. van Assendelft, no. 1859.)

149. 17 February 1638. Reynier Jansz. Vosch, caffawercker, and Dingnom Baltens, living on the Voldersgracht, both of sound mind and body, draw up their testament and last will. They name each other universal legatees. The surviving party is beholden to feed, clothe, and send to school to learn to read and write their child or children and to teach [them] a trade ("ambacht"). This must all be done until they become of age ("ten mondigen dage") or to the state of marriage, whereupon each of them should be outfitted and given a marriage feast, all according to the condition of the survivor. All this will be in lieu of the legitimate portion to which the children will be entitled in the estate of the first deceased, whether father or mother.

The survivor is named sole and absolute guardian over the child or children. No other guardian is to be named by the Orphan Chamber of Delft, which is excluded from the succession, or by anyone else. The witnesses are Adrianus Canzius and Anthonij de Heyde, the notary's clerks. The testator signs Reijnier Jansz. Vos, the testatrix Dyngnom Batens [sic]. (Delft G.A., records of Notary W. de Langue, no. 1689.)

150. 1 March 1638. Inventory of the goods belonging to the estate of Joost Lenertsz. van Hoorendijk who lived on the Turffmarkt [peat market] and died 21 February 1638. Reynier Vosch on the Voldersgracht owes a remnant of 4 guilders 15 stuivers 8 pennies for peat delivered. Anthony Palamedes, the son-in-law of the deceased, is curator of the estate. (Delft G.A., records of Notary G. Rota, no. 1976.)

151. 11 December 1639. First accounting of the estate of Grietgen Ariensdr., late wife of Gillis Cornelisz. Verboom, leaving five children under age. Gillis Verboom had consumed ("genoten") at the house of Reynier Vos for 45 guilders 8 stuivers. This debt was offset against another for 47 guilders 13 stuivers that Jan Heyndricksz., ebony worker, owed Verboom. A note dated 20 April 1640, stated that . . . pounds [amount left blank] of green ebony wood brought by Gillis Verboom from the Geoetroyerde West Indische Compagnie were found in the cellar of Frans Verboom. (Delft G.A., records of Notary C. P. Bleiswijck, no. 1899, 20 April 1640, and no. 1900, 11 December 1639 and 20 September 1640.)

152. 28 January 1640. Notary Willem van Assendelft, at the request of Pieter Corstiaensz. Hopprus, goes to the house of Reynier Jansz. Vos and notifies him that Pieter Corstiaensz. intends to sell the house where he, Pieter Corstiaensz., is living, together with a room next to it, to Anthonis Dircxz. van Beusecum for 2,400 guilders. The seller is willing to give him preference and let him [Reynier Jansz.] have the house at the same price and under the same conditions. Reynier Jansz. answers that he does not want to buy the house but wishes to adhere to his lease, which still has one year to run before it expires next May. [The notary may have written mistakenly that Pieter Corstiaensz. lived in the house. It appears rather that Reynier Jansz. was living there.] (Delft G.A., records of Notary W. van Assendelft, no. 1860, fol. 1813.)

153. 7 February 1640. Susanna Ruselaers, wife of Johan Ruselaer, tapestry worker ("tapijtwercker"), 31 years old, and Maeiken Guiliaems, the maid of Susanna Ruselaers, 22, declare at the request of Maria Thins, wife of Reinier Bolnes, that since May 1639, at which time Maria Thins came to live with her husband in the house of Wouter Crabeth on the Spieringstraet, they have lived together very badly. He has hurled various insults at her without any cause on her part. The maid describes how Reynier Bolnes beat Maria, who had to take refuge in the Ruselaers house. The attestation is confirmed by Cornelis Jansz. Bart, carpenter, and by Aettgen Jans, widow of Aert Theeuwen, who saw that Maria's arm was black and blue from a beating. (Gouda G.A., records of N. Straffintveldt, no. 220, fol. 40, transcribed by Rob Ruurs.)

154. 15 May 1640. Pieter Christyaensz. Operis, shoemaker, sells to Anthonis Dircxz. van Beusecum merchant in Delft a house situated on the north side of the Voldersgracht, next to the house of Willem Anthonijsz. van Staveren on the east side and Cornelis van Schagen on the west side. The house had been bought from the heirs of Cornelis Florisz., "speelman." The price is 2,100 guilders. The buyer will assume the liability of the 850 guilders mortgage on the house held by Heynrick van der Burch. A marginal note that the buyer must endure the lease of the house, which still has one year to run, with the provision that the rent money amounting to 23

Flemish pounds [138 guilders] after the expiration of the lease may be deducted from the purchase price of the house. By an addendum to the contract, Pieter Corstiaensz. sold Van Beusecum all the movable goods belonging to him in the house for 40 guilders or two silver beakers of equivalent value. The contract was signed by Pieter Corstiaensz. in a quasi-illiterate and by Van Beusecum in a highly literate manner. (Delft G.A., records of Notary W. van Assendelft, no. 1860, fol. 1837 $^{r+v}$.)

155. 15 June 1640. Beatris, daughter of Reynier Balthens and Mayken Gijsberts is baptized in Gorinchem. Witnesses: Beatris Gerrets, Gijsbert Rutten [Mayken's father], Dingna Baltens [Vermeer's mother], Geret Hamel, and Martyna van der Muer. (Communicated by A. J. Busch, archivist of Gorinchem.)

156. 6 September 1640. Reijnier Jansz. Vermeer living in the Voldersgracht, 49 years old, declares at the request of Jan Batista [Van Fornenburch] painter living in The Hague, that he has well known Barent Batista, the legitimate son of the petitioner. Barent Batista in the year 1631 sailed to the East Indies as a soldier on the ship S'Hertogenbosch of the Chamber of Delft [of the East India Company]. The witness testifies on the basis of his own knowledge that the same [Barent Batista] stayed in his house, from whence he went to the ship. He [Reynier Jansz.] was charged by the petitioner [Jan Batista] to buy a little cask of brandywine, which he sent him [Barent Batista] on the ship. The deponent declares further that he understands that Barent Batista was shot in the East Indies and died there and that the petitioner with his wife are his only heirs. The deponent signs Reijnier Jansz. Vermeer. The witnesses are Pieter van Groenewegen and Balthasar van der Ast [no profession indicated]. (Delft G.A., records of Notary A. van der Block, no. 1740, fol. 130 $^{r+v}$.)

157. 7 September 1640. Jan Batista, painter, declares that he is the unique heir of the late Barent Batista his son, procreated with Susanna Jansdr. [?], his wife, who is still alive and known to the witnesses, and that Barent Batista died in the East Indies. He transfers to Jacob Junius, clerk or bookkeeper of the East India Chamber in Delft, the sum of 187 guilders that his son has earned with the East India Company and still has coming to him in the Chambers of Amsterdam and Horn, namely in the Castle of Batavia 24 guilders, at Warmont, 28 guilders 10 stuivers 8 pennies, at Buijren 8 guilders 6 st. 7 pen. and also 50 guilders 4 st. o pen., in the Castle of Nassau 24 guilders 19 st., at Cleenwesel 33 guilders, and at Waterlandt 18 guilders 3 st. 5 pen., following an accounting that was delivered to Jacob Junius. He cedes all claims to these sums to Jacob Junius. Reynier Jansz. Vermeer alias Vos and Pieter Steenwijck, painter, witness the deposition. "Jan Batta van Foorenberch" signs in a barely literate hand. (Delft G.A., records of A. van der Block no. 1740, fol. 131.)

158. 30 October 1640. Pieter Lievens de Bock, Adriaen Jansz. Katoir, and Willem Adriaensz., acolytes ("dienaren") of the Anabaptist Community of Christ ("Doopgesinde Gemeynte Christi"), sign a contract with Anthony Dircxz. [van Beusecum], the buyer of the house of Willem Anthonisz. [van Staveren] brushmaker and owner of the house of Pieter Corstiaensz. shoemaker, called "The Little Fox" ("Het vosgen"), standing next to each other on the Voldersgracht, to buy these two houses. (Delft G.A., records of Notary J. van Beest, no. 1668.)

159. 2 March 1641. Jan Jacobsz. Trijsburch, carpenter, 40 years old, testifies at the request of Maria Thins, wife of Reinier Bolnes, that in the past autumn of the year 1640, he came to the garden house of the aforesaid Bolnes before the latter arrived and found a little sack with money in it near the bedstead. When Bolnes was asked about its safety, he answered that the little house was locked and that it was strong

enough. (Gouda G.A., records of Notary N. Straffintveldt no. 220, fol. 46ᵛ.) Jan Trijsburch repeated his testimony before the bailiff and aldermen of Gouda this same day. (Gouda G.A., "Stadt Tuychtboeck," no. 1637, fol. 165ᵛ.) Both these documents were transcribed by Rob Ruurs.

160. 20 April 1641. Heijndrick Jacobsz. van den Velden, acting for himself and as administrator of the goods of his simple-minded ("ingnocenten") brother Arent van den Velden, children of the late Jacob Ewoutsz. van den Velden, sells to Jan Thins living in Gouda, who acknowledges having bought from him, a house and court on the Ouden Langendijck in Delft, next to the house belonging to the aforesaid Heijndrick van den Velde on the west side and the house belonging to the late Dirck Jorisz. van Vliet on the east side, extending southward from the street to the back of the house[s] of Ghijsbrecht van Berensteijn and Jan Claesz. [Swiss], mason. The house had been bought by Jacob van den Velde from the notary Arent van Bolgersteijn on March 31, 1618. The buyer promises to pay 2,400 guilders in one sum. He will also pay the 40th penny tax of the States General on the sale of immovable property and the doit on the guilder ("duijt op de gulden) for the poor. The seller promises that the house is unencumbered by any mortgage or other lien. The signature of Jan Thins reveals that the buyer of the house was Jan Geensz. Thins, dijckgraef of Nieuwcoop, and not Jan Willemsz. Thins, also called Jan Thins de Jonge, as had been thought previously. (Delft G.A., records of Notary C. Bleiswijck, no. 1914, fol. 120ʳ⁺ᵛ.) First published in Van Peer, 1968, p. 223.

161. 23 April 1641. Willem Jansz. Sloting and Pieter Willemsz. van Vlijet sell to Reijnier Vosch a house and court ("huys ende erve") named Mechelen on the Market for 2,700 guilders. The local real estate tax levied by the Camer van Charitate (the "deut op de gulden") comes to 16 guilders 17 st. 8 pen. (Delft G.A., "Archief van de Camer van Charitate," no. 237, fol. 40ʳ⁺ᵛ.) (The undated document appears among the transactions effected in the first half of 1641. The exact date is cited in doc. no. 324 of 2 January 1669.)

162. 16 August 1641. In a deposition made at the request of Johan Tjns de jonge, Herman de Vrje, goldsmith, 38 years old, and Floris Buys living in Schoonhoven, 20, declare that on August 12, they saw a fight between Paulus Bolnes and Tjns. Bolnes took off his mantle and gave Tjns a severe blow on the head. (Gouda G.A., records of Notary N. Straffintveldt, no. 221, fol. 157.)

163. 17 August 1641. Abraham Jansz., tailor, 39 years old and Lysbeth Jans, 42, declare at the request of Johan Tjns de Jonge that Paulus Bolnes gave Tjns a blow on the head such that his head sounded as if it were a bowl that had been struck. A skipper testified that he had seen Pouwels Bolnes with a knife in his gloved hand. (Gouda G.A., records of N. Straffintveldt, no. 221.)

164. 24 August 1641. Mr. Johan Dardet, French surgeon, declares at the request of Johan Thins de Jonge that the wounds the petitioner has received both in his head and hand must have been made with a knife or similar instrument. (Gouda G.A., records of Notary N. Straffintveldt, no. 221, fol. 167.)

165. 16 November 1641. Specification of the clothing of Maria Thins and her two daughters delivered by Reynier Bolnes to attorney Johan Hondius with a procuration from Maria Thins in pursuance of the sentence of the aldermen of this city: a number of different articles of dress, a box, a table cloth, a handbook of Pater Canisius, etc. (Gouda G.A., records of Notary N. Straffintveldt, no. 221, fols. 230–31.)

166. 23 November 1641. Heyndrick Jacobs van den Velde sells Georgius van den Velden living in Haarlem and mevrouw Aefgen van den Velden two houses stand-

ing next to each other on the Ouden Langendijck, one next to the house of the seller himself on the west side and to Johan Tin living in Gouda on the east side, extending from the street southward to behind the house of Jonckheer Arent Sandelingh and the house of the late Jan Claesz. Swys, mason, with a free passage to the Burchwal, and the other house next to the seller's house on the east side and to the house of Jonckheer Lambartus van der Horst living in Riswijck on the west side. (Delft G.A., records of Notary C. Bleiswijck, no. 1914.)

167. 27 November 1641. Division by lots of the goods described below, two-thirds assigned to Johan Thins, one-third to Cornelia Thins and Reynier Bolnes in the name of his wife, altogether divided in three lots; which goods are presently lodged with Reynier Bolnes. In addition to the paintings (listed in ch. 7 at note 38 and in Blankert 1978, p. 145), a few other items were divided, including a cypress chest (in lot A assigned to Johan Thins), a little box and a sermon book of Hendricus Adrianus (in lot B assigned to Reynier Bolnes), and two cushions with coats of arms (in lot C assigned to Johan Thins). (Gouda G.A., records of Notary N. Straffintveldt, no. 221, fol. 256.) This document was first published in Van Peer 1968, p. 221.

168. 21 December 1641. Maria Thins claims that certain clothes belonging to her were left behind with Reynier Bolnes after he chased her out of the house ("tot tyde zij van hem is wech gejaecht") and that she is entitled to them according to the sentence of the Court of Holland. (Gouda G.A., records of Notary N. Straffintveldt, no. 221, fol. 282.)

169. 1 April 1642. Beatris, daughter of Reynier Balthens and Mayken Gijsberts, is baptized in Gorinchem. The witnesses are Tobyas Bres [friend and partner of Balthens] and Dingnom Baltus [Vermeer's mother]. (Communicated by A. J. Busch, archivist in Gorinchem.)

170. 30 April 1642. Sara Jansdr., wife of Jan Danielsz., tailor, declares at the request of Maria Thins that she had come to the house of the petitioner to clean a vat, for which she needed sand and yeast. The petitioner told her that she had appeared before the burgomasters with her husband and nevertheless dared demand no money from him ("doch dat sij evenwel geen gelt en dorst eyschen"). He would not even give her a blank [a very small coin] for the scouring materials, saying, "you might well leave the thing unscoured." (Gorinchem G.A., records of Notary N. Straffintveldt, no. 222, fol. 120.)

171. 7 May 1642. Reynier Baltensz., lieutenant of the pioneers in the field, of competent age, appears before Notary Schoonderwoert in The Hague and declares at the request of Anthony Wijardt, brewer in Gorinchem, that the money and materials that the petitioner had lent to Dirck Fredericksz. Hamel had been expended for the construction of 15 huts ("vijff als thien hutten") in Rijnberch. The huts were all constructed and finished at one and the same time. The deponent asserts that he helped build the huts. The witnesses are Cornelis Jansz. Pesser and Andries Roelofsz. Prins, workmaster of fortifications. (Dirck Hamel was the brother of Gerrit Hamel, a witness to the baptism of Beatris, the daughter of Reynier Balthens on 15 June 1640.) (The Hague G.A., records of Notary D. Schoonderwoert, no. 133, fol. 80.)

172. 3 July 1642. Jan Heymensz. van der Hoeve, Johan Asson, Pieter Dominicusz. Bosboom, and Joris Jooster de Vlieger, all headmen of the bakers' guild, testify, at the request of the headmen of the bakers' guild in The Hague, that no bread made outside the city of Delft may be brought into the city. "Reynier Vosch caffawercker" signs as witness. (Delft G.A., records of Notary W. de Langue, no. 1690.)

173. 5 July 1642. Heysken Jorisdr. van Astens and Beatris Geridsdr. Vouck, widowed last of Baltus Claesz., 57 years old, both sworn midwives of this city, attest at the request of Merten van der Alst, by the oath that they have made for their office, that no woman who has been with child for twenty weeks or more can be unaware that she was pregnant, this from various signs manifesting themselves at or before this time. They are ready to give clear evidence for this on request. (Gorinchem G.A., "Rechterlijk Archief." no. 560.)

174. 9 November 1642. Johan Thins Willemsz. [de Jonge crossed out], 40 years old, and Cornelia Tins, 55, declare at the request of Maria Tins, wife of Reynier Bolnes, that at the time of the marriage of the petitioner with the aforesaid Bolnes, the father of the same Bolnes had promised the couple a sum of 1,000 guilders over and above the 4,000 guilders that were promised for their marriage and that were mentioned in the marriage contract. The deponents were present when these 1,000 guilders were paid out to the bride and bridegroom. (Gouda G.A., records of Notary N. Straffintveldt, no. 222, fol. 338.)

175. 18 January 1643. Jan Thins, 63 years old, Cornelis Hensbeecq, 69, and Jacob de Straen, 30, all brick bakers, declare at the request of Jan Jorisz. Janbaes, brick baker in Dordrecht, that the common brick bakers were authorized by the delegates of the States of Holland and West Friesland to consume up to 50,000 bricks without paying any tax. (Gouda G.A., records of Notary N. Straffintveldt, no. 223.)

176. 18 January and 7 April 1643. On January 18, Mr. Simon van Veen representing the late Juffrouw Beatrix Duijst van Voorhoudt appointed Johan Thins Willemsz. in Gouda to represent her before the Court of Gouda to secure her claim to an interest-bearing obligation ("rente brief") that she had inherited from the late Burchgen Henricxdr. The obligation is now invested in a house in the Coninck-straat owned by Pieter Gillisz.. On April 7, Van Veen appeared again to name Johan Thins to represent the claims of Beatrix Duijst to estates left in the free seigniory of Hasertswoude in behalf of Gerrit Beuckelsz. Buytewech. (Utrecht G.A., records of Notary B. van Eck, Archive no. 4020 a002.)

177. 21 March 1643. Dirck Willemsz. de Greef, 60 years old, and Jan Wits, 38, declare under oath at the request of Robbrecht Schade, captain of the pioneers in the service of these United Netherlands, that Reynier Baltusz., former lieutenant of the petitioner, did little or no service for the country ("aen het lant") last summer 1642. He marched from Lovesteijn to Bothbergen in eight or ten days, betook himself to the Wemers [Weimar] camp to make his profit, and from there made only two or three trips hastily over the bridge to the camp of the Sovereign States [of the United Provinces] where His Highness the Prince of Orange was, and each time most speedily withdrew to the Wemers camp and spent most of his time there. The witnesses have good knowledge of this because he, Dirck Willemsz., the past summer served the petitioner the whole time as pioneer and Jan Wits because he served as a corporal of the pioneers of Captain Bres. In another deposition of the same day, Lauwerens Jochemsz., lieutenant of Jacques de With, captain of a company of pioneers, and Govert Pietersz., lieutenant of Tobias Bres, also captain of a company of pioneers, similarly declared under oath at the request of Captain Schade that Reynier Balthensz. had done little or no service in the summer of 1642. They related the same story as the first two deponents but added that, before Balthens had withdrawn to the Wemers camp, he had taken out of the storehouse of the field army of the Sovereign States in the name of the petitioner 30 spades and 24 shovels, which he had taken to the Wemers camp and left with the Hessians ("by de

Hesse"). He had then run away ("wech liep") and taken the money that he had received with him, without completing the work that he had undertaken or doing the least service from this date on for the petitioner as captain. (Gorinchem G.A., "Rechterlijk Archief" no. 560.)

178. 27 March 1643. Gerrit Jansz., ebony worker, declares at the request of Reijer Vosch, citizen here, that Evert van Aelst came several times to the petitioner to ask him for a painting belonging to him, Van Aelst, which painting he had given the petitioner to sell [words crossed out: with the charge that he should use the money that he would make from it . . .] But as Van Aelst now was able to sell it, he promised and even swore to the deponent that he would pay the petitioner in a short time, with the first opportunity. Trusting in this promise, the deponent had gone to the petitioner and had finally moved him thereto, so that the painting next May will already have been with Aelst for two years. Steven Ariensz., shoemaker, and his "knecht" Hercules Jonasz. witness the deposition. The original text of the deposition was transcribed in O-H I, p. 278. (Delft G.A., records of Notary W. de Langue, no. 1691.)

179. 9 October 1643. Gijsbertie, daughter of Reynier Balthens and Mayken Gijsberts, is baptized in Gorinchem. Witnesses: Willemken Huyberts and Eelken Huyberts. (Communicated by A. J. Busch, archivist of Gorinchem.)

180. 20 March 1644. Last will and testament of Johan [Geensz.] Thins, the widower of Cunera Claes Splinters. He leaves his daughter Lucia a painting of the Birth of Christ by Abraham Bloemaert and a small drawing done with the pen by Johan van Wieryncx. He leaves his daughters Clementia and Lucia their legitimate portion (6,000 guilders) plus 1,400 guilders each. (Gouda G.A., records of Notary N. Straffintveldt, no. 225, fol. 38.)

181. 11 February 1645. Reijnier Jansz. Vos, master caffa worker, 53 years old, and Gerrit van Slingelant, bachelor, living in Dordrecht, 22, declare at the request of Cornelis Balbiaen, doctor in medicine, that at the time of the Delft kermess, Sara Pots, a daughter by a previous marriage ("voordochter") of Doctor Balbiaen, was at the house of the aforesaid Reijnier Jansz. and said to her mother in front of the deponents that she had taken a silver spoon in the house of Maritgen Willemsdr. van Linschoten, widow of Adriaen Jacobsz. Balbiaen, and had broken the same into pieces and sold it in the house of the widow of Frans Verboom gold or silversmith in the Golden Coach, whereupon Sara had cried bitterly and prayed that this not be repeated, which the witnesses have not done. But on being asked to testify on the truth of the matter, they have not been able to refuse. They are willing to confirm their deposition by oath. Adriaen Barentsz. Keijser, escutcheon bearer ("cnaep") of the Cloth Hall ("loijhalle"), and Johan van Suijermont, journeyman baker, witness the deposition. (Delft G.A., records of Notary A. van der Block, no. 1745, fol. 25.)

182. 15 March 1645. Reynier Balthensz., lieutenant of the Company of Pioneers of Captain Robbert Schade and Hendrick Claesz. [van Neercassel], workmasters, both living in Gorinchem, declare that they have ceded and transferred in full property to Johan Pietersz. Scholl, steward ("bottelier") of His Highness the Prince of Orange, two-thirds of the sum of 8,000 guilders that they are entitled to according to a certain ordinance dated 9 December of the preceding year of the noble and mighty Lords of the High and Mighty Delegates in the Field ("Ed. Mo. heeren hare ho. mog. gedeputeerden te velde") upon the commissioner Thomas van Oorschot, delegated here in The Hague. And this in full payment of the promised wages still outstanding for the transport of the left gallery ("vant overbrengen vande slincker-

gaelerije") before Sas van Gent. The declarants acknowledge having been paid in full for the transfer and discharge the transferee of any liability for any claim on their two thirds share of the ordinance. Reijnier Jansz. Vos [no profession cited] and Jan Jacobsz. Sundert witness the deed. (The Hague G.A., records of Notary D. van Schoonderwert, no. 184, fol. 280^{r+v}.)

183. 14 April 1645. The first accounting of the estate of Warnaert Adamsz. van Sommelman, who had died on 18 July 1636, records a debt owed by Reynier de Vos for 14 guilders 17 stuivers for soap, candle, or some other animal fats. Sommelman's house was situated on the Broerhuyssteech. The location of the house and the nature of the debt make it probable that it was owed by Reynier Jansz. (Delft G.A., records of Notary C. Bleiswijck, no. 1899.)

184. 19 April 1645. Hendrick Claesz. van Neercassel, workmaster, 35 years old, declares under solemn oath at the request of Reynier Baltusz., also workmaster, that in the previous year 1644 as the army of His Highness the Prince of Orange was breaking up at Assenede in Flanders, Baltusz. had requested payment of 80 guilders from Jacob Jacobsz. van Dijck, workmaster living in Dordrecht, for certain contested sums that he had paid in his behalf. Jan de Vos, a workmaster in Delft, who owed money to Van Dijck, promised he would pay that sum. In the middle of January 1645, the deponent [Van Neercassel] being with the petitioner in the house of Reijnier Jansz. Vermeer living in "Mechelen" on the Market in Delft, Jan de Vos came in and he, Van Neercassel, saw him give two half-rijder coins to the petitioner, at the latter's request, as an account toward the 80 guilders. (Gorinchem G.A., "Rechterlijk Archief," no. 561.)

185. 31 July 1645. Johan Croeser, brewer in the Swaenhals, died on this day. The list of debts due to the estate includes a debt of 82 guilders 10 stuivers for beer delivered owed by Reijnier de Vos (Delft G.A., Orphan Chamber no. 589). This debt was not yet liquidated in 1660. According to this latter document, the beer had been delivered in 1645. (See doc. no. 278 of 12 November 1660.)

186. 2 August 1645. Claes Pietersz. van Hoorn, steward ("bootelijer"), 36 years old, and Reynier Hals, cabin waiter ("kaijuit wachter"), 17, together with Heyndrick Engelsz. van Santen, "beschijeter" [cannoneer] 31, newly arrived home from the East Indies with the ship *Nieu Delft*, attest at the request of Lijntgen Pieters van Amsterdam, widow of Hejndrick Dircxz. van der Graeff, late skipper on the ship *Nieu Delft*, that they sailed from the Indies to these lands with the skipper Heyndrick Dircxz. last December. About six weeks before their arrival here, Heyndrick Dircxz. died on the ship. Reijnier Hals shortly after the skipper's death found in the latter's cabin a project [draft of a will] whereby he received a bequest of 100 guilders; similarly Wybrant van der Cost, undermerchant ("ondercoopman"), received a bequest of a side arm with a silver hilt and a silvered strap; Coenraedt Calrmansz., uppermerchant ("oppercoopman"), received 200 guilders, amended in the aforesaid project to 250 guilders. The witnesses alike declared that after they had seen the project they heard the uppermerchant and undermerchant say many times that the project was no good and that it could not hold up ("niet en soude mogen bestaen"). They also heard the undermerchant say: "if it cannot hold up, there is no need [for it]; we will make sure that the widow of Heyndrick Dircxz will not get it" [in the original, "Wij sullen wel macken dat het de weduwe van den voorn. Heijndrick Dircxz. van der Graeff niet en sal crijgen." It is clear from the context that "het" refers to the estate or the bequests, not to the project itself] even if we should give it to the poor. Reijnier Hals then testified alone that the upper- and undermerchants had told him, "keep quiet, just be still, we'll make sure that

you get your hundred guilders." Reynier Jansz. Vos, who also appeared as a deponent, declared, at the request of the same petitioner, that last Friday, which was the 28th of July, when the aforesaid Van der Cost was at his house together with the petitioner, he, Vos, heard him say to the petitioner that her husband had made a project ("macking") [crossed out: "testament"] which would not hold good ("niet en soude mogen volstaen"). Van der Cost had also told her that if she was willing to be satisfied with the project that he would make sure that it would be made valid, but otherwise that she would have to give up half the estate. Whereupon the witness [Vos] said that the petitioner had another testament. Van der Cost asked to read it. Having read it he declared that it was not good ("niet en ducht") because it did not mention the legitimate share [to which blood relatives were entitled]. But if she was willing to be satisfied with the project made on the ship (which he, the aforesaid witness, said could not be valid), he, Van der Cost would make sure that it would become effective ("sijn effect soude gecrijgen"). Pieter Colijn and the notary's clerk witnessed the deposition. Claes Pietersz., Reijnier Hals, and Reijnier Jansz. Vos signed the deposition, but Heyndrick Engelsz. van Santen did not sign until the next day, August 3rd. His signature was witnessed by Simon Ravesteijn, grocer ("cruijdenier"), and the future notary Simon Jansz. Mesch. (Delft G.A., records of Notary G. Rota, no. 1978.)

187. 14 June 1646. Death of Cornelis Lourisz. van der Hoeve, brewer in "The Three Suns." In the first inventory made of the estate (fol. 248 of the *boedel*), an entry for "Reynier de Vos on the Market Square in 'Mechelen' " shows that he owed 64 guilders 15 stuivers for beer delivered. The first accounting of the estate to the masters of the Orphan Chamber of Delft includes the following entry among the debts due to the estate: "Reynier de Vosch on the Market Square [owes] 64 guilders 15 stuivers, less three guilders, due to a discount of five stuivers on each of 12½ containers ("vaaten") of good beer. There remain 61 guilders 15 stuivers which have been answered for here ("die alhier worden verantwoort") thus LXI gul. XV st." Reynier Jansz.'s debt no longer appeared in the second accounting dated 8 February 1656. (Delft G.A., records of Notary G. van der Wel, no. 1929, 10 August 1649; also Archive of the Orphan Chamber, *boedel* no. 849.)

188. 30 September 1646 [old style; Utrecht notaries were still using the Julian calendar at this time. It is about ten days earlier than the Gregorian calendar in use in most parts of Holland since 1582.] The bridegroom-to-be Johan Thins, dijckgraef of Nieukoop and Noorden, widower of Cunera Claes Splinters, and the bride-to-be Susanna van der Boguaerde, widow, first of the late Mr. Adriaen de Roy, Counselor to the Admiralty in Zeeland, and last of the heer Mr. Gerard van Lanschot, former treasurer of the city of Leyden, confirm their sealed marriage contract of 20 September last. They declare themselves ready to enter the state of marriage. The agreement is passed in the house of the bride-to-be in the Zuijlenstraet [in Utrecht] in the presence of the honorable jonckheer Francois van Zueghem and the heer Abraham Blommert, citizen of Utrecht, as marriage kins ("huwelix vrunden"). Jan Thins signs precisely in the same manner as he did the contract for the purchase of the house on the Oude Langendijck in Delft (doc. no. 160). The painter Bloemaert signs in a trembling hand. (Utrecht G.A., records of Notary N. Verduyn, no. 4009 a 024).

189. 3 November 1646. Jacob van Rosendael and Joffrou Losia Thins, his sister-in-law, on the one hand, and Mr. Hugo de Roij and his sister Constantia de Roij, on the other, declare, first Van Rosendael in the name of his wife and as guardian of Clementia Thins, daughter of the heer Johan Thins dijckgraeff of Nieukoop, present bridegroom, and Joffr. Losia Thins for herself, that they have received from

their father and father-in-law respectively the testamentary goods to which they were entitled from the estate of their mother Joffr. Cunera Splinters. In addition Mr. Hugo de Roij and Constantia de Roy assert that they are satisfied with the settlement made by their mother Susanna van den Bogaert, present bride, at the time of her second marriage with the late heer burgomaster Lanschott as well as with the inheritance from their father Mr. Adriaen de Roij. (Utrecht G.A., records of Notary N. Verduijn, no. 4009 a 024, fol. 319^{r+v}.)

190. 19 November 1646, midday, around 12 noon. In the name of the Lord etc., Reynier Baltusz. workmaster, and Maeyken Gijsbertsdr., his wife, citizen and citizeness of this town, well known to me, notary, the aforesaid Meijken Gysberts lying sick in bed, but otherwise both with their full reason and understanding, wishing to dispose of their temporal goods, draw up their last will and testament. The survivor is named universal legatee. He or she must supply the child or children with food, drink, clothing, schooling or apprenticeship, and other necessities until it or they become of age or marry. Mayken Gijsberts apposes a trembling mark. The witnesses are Anthonis Henricksz. de Breedt and Henrick Claesz. van Neercassel, workmaster. (Gorinchem G.A. notarial archive, inv. no. 3977.)

191. 21 November 1646. Cornelia Thins, 59 years old, Jannetge Rocus, 41, both spinsters, appear at the request of Maria Thins and testify that they heard from Dirck Jorisz. Hofmajer that Reynier Bolnes (the previous lucky and profitable years of the brickbakers notwithstanding) had fallen behind and gone down with his bakery to the extent of 8,000 guilders. Cornelia Thins only heard about this from Dirck Jorisz. at the time when Reynier Bolnes was sentenced to give Maria Thins an alimony of 10 guilders a week. Reynier Bolnes had told Dirck Jorisz. all about his business problems and revealed his debts to him. Dirck Jorisz. confirmed all this, saying that Reynier Bolnes wished to name Jan Bolnes, his brother, as arbiter. But Jan had said that Reynier would heed no advice. Cornelia also heard that Reynier was unfit to manage his brick business. Johan Thins, 50 years old, declared that, yesterday 20 November 1646, Reynier Bolnes, in the presence of his wife, upon being earnestly beseeched to tell just how it went with his estate said that his goods had been worth 20,000 guilders seven or eight years ago, but all his possessions now, including a brickery worth 9,000 guilders, three morgen of land, a garden outside the Dijckspoort in Gouda, one-third of a morgen of land on which no rent was paid, and two debt obligations worth 100 guilders each, were only estimated at 11–12,000 guilders, against which he had made about 2,000 guilders worth of debts. These testimonies were made in the house of Cornelia Thins. (Gouda G.A., records of Notary N. Straffintveldt, fol. 388^{r+v}.)

192. 6 January 1647. Johan Claesz. Brouck, sheriff, Joost Leendertsz., brickbaker, and Arent Jansz., sworn master [of brickmaking] declare at the request of Willem Bolnes, acting in behalf of Reynier Bolnes, that Reynier Bolnes conducted his brick business, which he had acquired from Elfgen Joosten Verbye, zealously and honestly for six years. He had hired some men and women employees that he subsequently could not lay off without causing them great harm because they could not be hired elsewhere. Moreover he needed a great deal of money to renovate his brickery. (Gouda G.A., records of Notary N. Straffintveldt, no. 227, fol. 7.)

193. 15 January 1647. Jacob van Santen, notary, and Symon Jansz. Mesch declare at the request of Reynier Bolnesch brickbaker living in the jurisdiction of the town of Gouda that they went today to the house of Dorothe Michiels, wife of Corstiaen Jaspersz., living on the north side of the Vlamingstraet and that they heard there from the same [Dorothe Michiels] that her neighbor, who is said to be named Joan

Thijns, living in her, Dorothe's house, next door to her own, is keeping a very bad house with his sister (who is living with him). Dorothe also told them that Joan Thijns's sister had said to her that she had packed her goods in the last week (due to her dissatisfaction and the poor treatment on the part of her brother) and that she was resolved to go away ("doorgaen"). The deposition was made in the house of Mr. Johan de Coorde, innkeeper, in his presence and in the presence of Johan de Coorde de Jonge, surgeon. (Delft G.A., records of Notary G. Rota, no. 2015.) Johan de Coorde, a Roman Catholic, kept an inn, the "Pater Noster," on the Oude Langendijck.

194. 10 March 1647. Balthasar, son of Reynier Balthens and Mayken Gijsberts, is baptized in Gorinchem. Witnesses: Peeter Andriesz. Boon, Hendrick Claessen van Neercassel, and Dingnom Baltus. (Communicated by A. J. Busch, archivist of Gorinchem.)

195. 15 June 1647. Reynier Jansz. Vos witnesses a deposition by Geertge Buijten, widow of Willem Fransz., shoemaker, 70 years old, who declared that Josina Maerschalk, wife of Hugo Sas [a merchant of silk goods] had taken some pairs of stockings and other clothing to the house of the auction master ("boelhuysmeester") to sell them for cash. (Delft G.A., records of Notary S. van der Walle, no. 1971.)

196. 22 June and 10 July 1647. Betrothal and marriage of Gertruyd Vermeer and Anthony van der Wiel. On the first of these dates, Baijke van der Wiel, widow of Gerrit Jansz. van der Wiel, ebony worker, recognizes having made a *donatio inter vivos* or gift among the living, as a wedding dowry or death bequest, to her son Anthonij Gerritsz. van der Wiel of all the ebony-working equipment that he has been using in the shop to this day, this in recompense for the loyal services and solicitude that he has shown since his father's death in supporting the family. Anthonij van der Wiel also appeared to accept the gift and thanked his mother for it. Reynier Jansz. Vosch and Jacob Jonasz., joiner, witness the deposition. (Delft G.A., records of Notary W. de Langue, no. 1693.)

197. 30 June 1647. Johan Thins, dijckgraef of Nieuwcoop over Noorden, gives a procuration to Johan Thins Willemsz., his cousin ("neef"), to collect from Thomas Willeborts, receiver in Bergen-op-Zoom, sums of money to which he, the constituent, is entitled. (Gouda G.A., records of Notary N. Straffintveldt, no. 227, fol. 231.)

198. 1 July 1647. Johan Geensz. Thins, lying sick in bed, makes a new testament. He gives any surplus, over and above the legitimate share due to his daughters Lucia and Clementia, to the children of Clementia [wife of Jacob van Rosendael]. Clementia will be able to enjoy the usufruct of the bequests until the marriage of her children. The testament is passed and witnessed in Moordrecht [near Gouda] on the site of the testator's brickery in the presence of Adriaen Schoonhoven. The testator signed Jan Thins in a trembling hand (Gouda G.A., records of Notary N. Straffintveldt, no. 227.)

199. 3 July 1647. Susanna van der Boogaert, wife of Johan Thins [Geensz.] draws up her testament. She leaves all her possessions to her children Mr. Hugo de Roi, Constantia de Roi, and Casparus van Lantschot. Johan Thins adds a codicil to his will. All this was done in Moordrecht as in the preceding document. (Gouda G.A. records of Notary N. Straffintveldt, no. 227, fol. 241.)

200. 13 and 22 July 1647. Johan Thins, dijckgraaf of Nieuwcoop on Noorden, died on July 13 (*Wapenheraut*, 1917, p. 115, cited in Van Peer 1968, p. 223). This was Jan Geensz. Thins, the cousin and not the brother of Maria Thins as Van Peer

supposed. The accounts of the Church of St. Jan show the following entry for 22 July 1647: "Jan Thins Geenensz., own grave 5 guilders 12 stuivers, with the great clock 26 guilders." (Gouda, Archief van de Hervormde Gemeente, "Jaar rekeningen St. Jan." Communicated by Rob Ruurs.)

201. 7 August 1647. Johan van der Wiel, as the husband of Maria Gerrits Camerling, draws up a procuration to collect from Reynier Bolnes in Gouda goods in a certain trust ("fidei commissum") stemming from the testament of Diewertgen Heyndricksdr. van Hensbeeck to which she is entitled. He declares that Maria Gerrits is the only daughter of Catharina Heynricxdr. van Hensbeeck. (Delft G.A., records of Notary A. S. Schieveen, no. 1632.)

202. 17 August 1647. Jacob van Rosendael, husband of Clementia Thins, and Lucia Thins, children and heirs of the late Johan Thins, draw up a procuration to collect 82 guilders from the estate of Herman van Wyelingen for delivered bricks. They also acknowledge a debt of 1,000 guilders each as advance on the estate of Johan Thins. (Gouda G.A., records of Notary N. Straffintveldt, no. 227, fol. 295.)

203. 28 January 1648. Pieter Corstiaensz. Opperis, Meynert Meynertsz. Verhan, Jan Heymensz. van der Hoeve, Ghysbrecht Heymensz. van der Hoeve, all next of kin ("naeste vrunden") of Jan Anthonisz., son of Anthonis Jansz. Back, presently in Guinea, have designated a certain white-wood box containing various deeds, articles of clothing, and a debt obligation for 100 guilders. The box was lodged in the house of Ghysbrecht Heymensz. The witnesses had the box opened by a locksmith. Afterwards the goods were left in the guard of Ghysbrecht Heymensz. In addition to the deponents, Thonis Jansz. Back, maker of foot stoves, apposed his mark. (Delft G.A., records of Notary A. van der Block, no. 1748.) It is clear from the context that Jan Anthonisz., and not his father, the maker of foot stoves, was "presently in Guinea." Since Anthony Jansz., the son of the butcher Jan Thonisz. Back, who had married Reynier Jansz.'s half sister Adriaentge, was only 16 years old in January 1648 (doc. no. 141), the individual of that name referred to in this document who already had a son in Guinea was presumably someone else, perhaps a cousin.

204. 8 February 1648. Pieter Vermeer, beer mixer ("bierscheyer") in Amsterdam, recognizes a debt that he owes Joris Vrancken Croostwijck in Amsterdam. The debt acknowledgment is made in the house of Reynier Vosch, innkeeper in Mechelen. A second debt acknowledgment was made the same day by the same Pieter Vermeer to Croostwijck in the house of Reynier Jansz. Vosch, tapster ("waert") in Mechelen, in the presence of Jan Cornelisz. Cnell, living in Rotterdam, and Egbert Lievensz. van der Poel, master painter. (Delft G.A., records of Notary G. Rota, no. 1980.)

205. 15 February 1648. Maria Thins orders Notary Straffintveldt to go to the house of Reynier Bolnes and inform him that he must choose a time and place to divide their jointly held assets. The notary reminds Bolnes that on 10 August 1642 the aldermen of Gouda, whose sentence was confirmed by the Court of Holland on 20 December 1647, had ordered an inventory to be drawn up, under the supervision of the lord burgomasters and two of the judges [in the case], of all their joint possessions in order to proceed to an orderly separation. On 2 February 1648 Bolnes had notified Johan Thins [the younger] that he was ready to meet for this purpose on the 17th of February next at the house of Cornelia Thins and to pay the alimony and other debts he owed to the "insinuating" party [Maria Thins]. Reynier Bolnes answered the notary: "Let Johan Thins set a precise time. I shall be ready." (Gouda G.A., records of Notary N. Straffintveldt, no. 228.)

206. 27 June 1648. Reijnier Bolnes living in Gouderack [near Gouda] borrows 100 guilders at 5 percent interest from his nephew Herman Bolnes. He will return the money after the suit between himself and his wife has been terminated and the separation of the goods held in common executed. (Gouda G.A., records of Notary N. Straffintveldt, no. 228.)

207. 7 August 1648. The inventory of the estate of Pieter Jansz. Bruijnel, who died on this date, contains the following entry: "Dingena who has lived on the corner of the Oude Mannen Steech [the narrow street between the Voldersgracht and the Market Place] owes as remnant of a larger sum 2 guilders 19 stuivers." Payment was made on 12 August 1652. Bruijnel sold oats and beans, probably for horses. (Delft G.A., Orphan Chamber, *boedel* no. 250.)

208. 1 September 1648. Claes, the son of Reynier Balthens and Mayken Gijsberts, was baptized in Gorinchem on this date. Witness: Betteken Cornelis. (Communicated by A. J. Busch, archivist in Gorinchem.)

209. 28 November 1648. "Insinuatie" by Paulus, Jan, and Neeltgen Cornelisdr. Bolnes, brothers and sister of Reynier Bolnes, against Maria Thins. They wish to facilitate the division of the goods and set 29 November 1648 as the last delay. Maria and Johan Thins, who were contracted by the notary, answered him: "We will act in pursuance to the sentence of the Court of Holland." Reynier Bolnes appointed Hendrick van Hensbeeck and Herman Bolnes to represent him against his wife in all the questions at issue. (Gouda G.A., records of Notary N. Straffintveldt, no. 228, fol. 387.)

210. 4 December 1648, 8 P.M. In the Name of the Lord . . . Anthony Gerritsz. van der Wiel ebony worker and Geertruijt Reijniersdr. van der Meer [crossed out: "Vosch"], his legitimate wife, living in the Vlamingstraat, appear before the notary to make their testament. They are both healthy in body and sound in mind. They name the survivor of them both universal legatee, for all goods, movable and unmovable, that the first deceased may have left behind, with this proviso: that the survivor will be bound to bring up any child or children with whom God may bless them, to feed, clothe and equip such child or children, in health or in sickness, send it or them to school to learn to read and write and to instruct it or them in such handicraft as may seem appropriate, all this till it or they come of age or get married, at which time it or they will be provided with a trousseau. Such expenditures will be deducted from the legitimate share he or she may have in the first deceased's estate. If it so happened that the first deceased came to die without child or children or if such child or children had died, the testators desire that the survivor keep all the goods of the first deceased with this exception: if the testator were to die first, then the testatrix will be bound to give to his mother the sum of 50 guilders; and if the testatrix should die first, then the testator will give the testatrix's father and mother in place of their legitimate share the sum of 50 guilders. The testators wish to appoint the surviving party as guardian to their child or children and no one else, including the Orphan Chamber of this city. Pieter Men, silversmith, and Jacob Jonasz., joiner, witness the deed. Anthony Gerritsz. signs with a star, "Geertruit Reiniers" with a painstakingly written but literate signature. (Delft G.A., records of Notary W. de Langue, no. 1693.)

211. 5 December 1648. Reynier Jansz. Vos living on the Market Place appears before the notary, as principal, and Johan van Santen living on the Coorenmart, as surety and co-principal, and acknowledge having borrowed 250 guilders from . . . [left blank] or the holder of this [acknowledgment] at an interest of 5 guilders 10 stuivers per 100 guilders per year [5½ percent]. The acknowledgment is made in the

house of Reijnier Vos in the presence of Gerrit Jansz. Druijff living in this city. (Delft G.A., records of Notary S. Mesch, no. 2045.) For the subsequent fate of this debt, see doc. no. 262 of 14 December 1655 and doc. no. 299 of 14 December 1664.

212. 5 January 1649. Reynier Bolnes and Johan Thins [de Jonge], representing Maria Thins, declare that they will allow the prospective buyers of their brickmaking establishment, Hendrick and Pieter Crynen, to visit it in conformity with the provisions of the contract whereby it has been temporarily leased to a third party. (Gouda G.A., records of Notary N. Straffintveldt, no. 229.)

213. 9 January 1649. Maria Thins names her brother Johan Thins to represent her in all affairs outstanding against her husband Reynier Bolnes. (Gouda G.A., records of Notary N. Straffintveldt, no. 229.)

214. 12 May 1649. Cornelia Thins, 62 years old, testifies before the notary concerning the bad behavior of Willem Bolnes. Willem would only come in her house after his mother had gone. He had turned his back to her when they had met by chance. Once Willem had brought the alimony [due to Maria] to her house, he said about his own mother, "she is a beastly dam" ("een diere moer"). During the dispute between his father and mother, Willem had shown Maria Thins not the least filial affection. (Gouda G.A., records of Notary N. Straffintveldt, no. 229.)

215. 27 May 1649. Jan Heijmensz. van der Hoeve, baker, 61 years old, and Maritge Jansdr., his wife, 55; Maritge Dircxdr., widow of Pieter Mourinxz., 56; and Sofije Cornelisdr. van Ackersdijck, spinster, 17, declare at the request of Cornelis Dircxz. van den Mecht, also baker (former "knecht" of Etgen Cornelisdr., widow of Jan Simonsz. van der Laen) that they were at the house and in front of the bed of the aforesaid Etgen Cornelisdr. on 13th of April last about seven o'clock, when they heard from the mouth of Etgen Cornelisdr. that she had bequeathed to the aforesaid Cornelis Dircxz. the sum of 100 guilders and all the baking equipment. (Delft G.A., records of Notary S. Mesch, no. 2046.) Jan Heymensz. was the executor of the will of Etgen Cornelisdr. (Same notary, no. 2046, 7 June 1649.)

216. 1 June 1649. Barben de Meer, widow of Gerrit Jansz. van der Wiel, sells her house "De Molen" on the south side of the Vlamingstraet to her son Anthony Gerritsz. van der Wiel for 1,000 guilders. (Delft G.A., records of Notary W. de Langue, no. 1694.)

217. 15 June 1649. Maria Thins annuls the procuration she had given to Johan Thins [de Jonge] in view of the settlement of the dispute with Reynier Bolnes. (Gouda G.A., records of Notary N. Straffintveldt, no. 229.)

218. 1 July 1649. Hendrick Hensbeeck and Herman Bolnes cause the notary Straffintveldt to warn and admonish ("insinueeren") Maria Thins regarding the delays in the settlement of the dispute. They wish to sell the lands in Oud Beijeren. Yesterday and again at 7:30 [P.M.] today they had received an oral agreement from Maria Thins, but no final agreement had been signed. Maria answers the notary that she cannot do anything without her brother who has the papers with him. In any case the sale [of the lands] can wait two or three weeks. (Gouda G.A., records of Notary N. Straffintveldt, no. 229.)

219. 3 July 1649. "Insinuatie" by Maria Thins against Herman Bolnes. Maria Thins adds to her statement of July 1 that she is waiting for her brother Joan who is coming next monday July 5th, at which time she means to settle the division of the assets under the supervision of her brother without delay. Herman Bolnes accepts Maria Thins's "insinuatie" and asserts that he is satisfied. (Gouda G.A., records of Notary N. Straffintveldt, no. 229.)

220. 10 July 1649. Maria Thins reappears before the notary and claims that the dispute with Reynier Bolnes is not ended and that she has been cheated. All the papers relating to the affair are with her brother Joan Thins [de Jonge]. She therefore renews her procuration. He is empowered to act as he pleases in her behalf "out of brotherly affection" ("uyt broederlijcke affectie"). He may invest her money, sell her lands etc. (Gouda G.A., records of Notary N. Straffintveldt, no. 229.)

221. 13 July 1649. Maria Thins, wife of Reynier Bolnes, 56 years old, declares that she had invited her son Willem Bolnes to the funeral of his sister Cornelia Bolnes but that he had refused to do so. At a certain time he, Willem, was at the house of Gysbert Licht, her neighbor, who said to him: "Willem your mother is here at your sister's side. Won't you go by there?" He answered: "I am fed up with it ('Ick hebbe den bruij daer van'). I won't go in." This deposition was made in the house of Cornelia Thins. (Gouda G.A., records of Notary N. Straffintveldt, no. 229.)

222. 15 July 1649. Dirck Cornelisz. Verkerck, of competent age [16 years old crossed out], living in Delft, declares at the request of Maria [Joan crossed out] Thins, also living here, that about one and a half [years] ago, Willem Bolnes, son of the petitioner, told Glaude Jansz. Kerckeringh, town surgeon of Gouda, that he had met his mother and, with great irreverence, with your permission, had turned his arse toward her ("met verlof den naers toegekeert hadde"), saying, "this is what you get for it" ("dat heb ghij daer voor"), meaning the sentence passed by the Court of Holland shortly beforehand concerning her and Reynier Bollenes. The surgeon and his wife were shocked by this and told the story to Joan Thins, adding that Willem Bolnes had bragged ("sijn roem gedragen") that he had turned his arse toward his mother. Johan Thins, who also appeared as deponent, declared that Mr. Glaude Kerckeringh had repeated to him these same words and when he, deponent, was at home and his sister had come by, he found her very despondent ("heel bedroeft") over what happened, and she had taken leave from the aforesaid Willem Bollenes ("is haer van de voorn. Willem Bollenes wedervaren"). Dirck Cornelisz., who was living with Mr. Kerckeringh, had heard all this from him, and so had Johan Thins. Willem Aertsz. Dijnsen and Cornelis Georgin [future notary] witnessed the deposition. (Delft G.A., records of Notary J. Spoors, no. 1674, fol. 649 $^{r+v}$.)

223. 30 August 1649. Maria Thins leases 6½ morgen of lands in Oud Beyerland to Johan Thins for 111 guilders 13 stuivers due at kermess each year. Cornelia Thins signs. (Gouda G.A., records of Notary N. Straffintveldt, no. 229.)

224. 10 September 1649. The notary notifies Joan Thins that 5 morgen of land in Oud Beyerlandt which fell to the lot of Reynier Bolnes [in the division of the assets jointly held with Maria Thins] will be leased to him for 150 guilders per year. (Gouda G.A., records of Notary N. Straffintveldt, no. 229.)

225. 15 February 1650. Death of Adriaen Hendricksz. van Houten [alias Van Buijten], shoemaker. He leaves three children: Emerentia, who will be 22 years old on May 22nd next, Hendrick, 18 years old on May 19, and Adriaen, 12 years old. The movable goods left to his widow Jaepgen Adriaensdr. are evaluated at 796 guilders 1 stuiver 10 pennies. (Delft G.A., Orphan Chamber, *boedel* no. 264.)

226. 20 February 1650. Reynier Baltensz. appears before the notary to acknowledge that Beatrix Gerards, midwife, [his] mother-in-law ["schonmoeder," actually his stepmother] had lent him some merchandise ("winckel waren") consisting of faienceware from Rotterdam, Delft and Rouen, faience cans, crocks, pots, beer glasses, wine glasses and other similar things that belonged to her and not to him as she had lent him money in species that he had duly received. In recognition of the same he thereby was transferring to her all this merchandise, large and small,

none excluded, and, besides, from his own property, his movable goods consisting of two beds, four blankets, six cushions, two pairs of curtains, two borders ("rabatten"), three dishes, . . . , two stretchable tables, six Spanish chairs, a table cover, . . . , eight cushions on which to sit, one chest made of joinery work, a buffet, a bench, a closed-off bench ("besloote banck"), a few pots and pans, both large and small, a good Bible and other books, all this on account of a larger sum that he owes his mother-in-law. Beatrix Gerrits also appeared to accept the transfer. (Gorinchem G.A., records of Notary H. van der Muyr, no. 3971, document numbered 271. This document was kindly communicated and transcribed by A. J. Busch, archivist in Gorinchem. The ellipses in the above transcription represent unreadable words in this poorly preserved document.)

227. 4 April 1650. Testament of Johan Bolnes, brother of Reynier Bolnes. He leaves Reynier the usufruct of his house on the Peperstraet in Gouda and of three morgen of land, the ownership of which he leaves to the legitimate children of Willem Bolnes when they come of age or become married. But if Willem Bolnes were to die without children, the property will descend to his [the testator's] blood relatives. He desires, in case the wife of Reynier Bolnes should again be united in bed and board with her husband within three months after the testator's death, but not otherwise, that Reynier Bolnes should have, in addition to the above usufruct, all the household goods in his house plus the usufruct of seven morgen of land in Asperen, which usufruct the wife of the aforesaid Bolnes [Maria Thins] will also enjoy. The testator bequeaths all his other property to Paulus and Cornelia Bolnes. (Gouda G.A., records of Notary N. Straffintveldt, no. 230.)

228. 5 June 1650. Willem Willemsz. van den Bundel, painter, sells to Anthonij Gerritsz. van der Wiel, ebony worker, his house on the south side of the Vlamingstraet named "de drie valcken" [The Three Falcons] with an exit on the St. Ursula Straat. In exchange Anthonj will transfer his house "de Molen" [The Mill] to Van den Bundel. Anthonj van der Wiel will pay all the taxes and other expenses regarding the transaction. Van der Wiel will assume the mortgage of 1,300 guilders at 5 percent on the "de drie valcken" and Van den Bundel the mortgage of 800 guilders on "de Molen." Anthonij signs with his mark, a star. The witnesses are Cornelis Cornelisz. Hambroch, Reynier Jansz. Vos, Peter Geritsen [Anthonij's brother], and Jan Pouwelsz. (Delft G.A., records of Notary W. de Langue, no. 1694.)

229. 24 June 1650. Reijnier Jansz. Vosch, innkeeper, 58 years old, together with Jacob Corstiaensz. Goosens, instrument maker, 54, and Pieter Corstiaensz. Operust, leather tanner, 48, testify at the request of Frans Danielsz. le Cock, shoemaker, and his wife Jannitgen Franssen van de Water, both living presently in Haarlem. They attest in lieu of oath that they have known the petitioner a long time when they were living in Delft, that they have had familiar and civil intercourse with them ("familiare ende burgerlijcke conversatie"), and frequented them. They declare that the petitioners comported themselves in an honest and pious manner. They never heard anything about their bad comportment, commerce, or life. They also declare that the petitioners left the city a number of years ago for Haarlem with honor and without having suffered bankruptcy. In a companion piece of the same day, Jannitgen Franssen van de Water, 50 years old, and Maertgen Thomasdr., spinster, living in Rotterdam, 40, testify at the request of Grietge Jacobsdr., wife of Joost Michielsz., skipper, living in Amsterdam, that they heard Annitgen and Lysbeth IJsbrantsdr. call the petitioner a whore and also that she was the whore of Pijer Peltten, and that Pijer Peltten had made a little leg on the child that the petitioner was carrying in her arms ("Pijer Pelt een beentge aent kindt, het welcke sij op haer arm was dragende, hadde gemaeckt"). Both depositions were witnessed by

Andries Ras, a neighbor, and Cornelis Harteveldt, the notary's clerk. (Delft G.A., records of Notary G. Rota, no. 1981.)

230. 24 August 1650. Bortel Jansz. Verhage, sailmaker, living on the Geer in Delft, declares that he has handed over to Jan Heymensz. van der Houve, baker, his cousin, the following goods belonging to him, deponent: 36 pieces of cotton cloth, six East Indian table cloths, and two pieces of Gingham, which he, deponent, has lately brought from the East Indies. Jan Heymensz. declares that he has received the goods and is prepared to restore them to Bortel Jansz. at any time upon his request. Bortel Jansz. signs with a cross, Jan Heymensz. van der Hoeve signs painstakingly his entire name. Jan Davitsz. and Arien Jaspersz., both basketmakers on the Geer, witness the deposition. (Delft G.A., records of Notary S. Mesch, no. 2047.)

231. 13 September 1650. Geret, son of Reynier Balthens and Mayken Gijsberts, is baptized in Gorinchem. No witnesses are recorded. (Communicated by A. J. Busch, archivist in Gorinchem.)

232. 14 November 1650. Barbara Jorisdr. van Lier, 21 years old, living in the Vlamingstraet in the house of her father (the painter Joris Gerritsz. van Lier) declares at the request of Maria Gerritsdr. van der Wiel, formerly a maid in the house of the late Niclaes van der Horst, that last Saturday between two and three of the afternoon, Itge Jacobs, wife of Cornelis Jansz., caffaworker, said to the petitioner that pieces had fallen out of her ("stucken uijt haer gevallen waren"). Bastiaen Govertsz., joiner, and Carel Cornelisz., basketmaker, witnessed the deposition. In a companion deposition of the same date, Josijntge de Vosch, wife of Lambrecht Harmen living in the house of Colonel Masieneufe [Maisoneuve], in the Vlamingstraet, declared at the request of Maria Gerrits van der Wiel that, last Thursday or Friday, among other words that she had with Itge Jacobsdr. concerning the brother of the petitioner and the dispute that she, Itge, had with him, she had said to Itge, "neighbor you say all the time that you are right but when you come before the magistrates then you are in the wrong ('so hebje ongelijck')," whereupon Itge said, "such folk as have had a piece fall out of them should rather keep quiet." The deposition was witnessed by the sons of the notary. (Delft G.A., records of Notary W. de Langue, no. 1696.)

233. 6 July 1651. An entry in the death lists of the Church of St. Jan in Gouda reads: "Young Jan Tijn from Delft arrived on the 6th [of this month], unmarried" ("IJonge Tijn van Delft ghekomen op den 6 dito een ijon man"). (Gouda G.A., "Sterftelijsten St. Janskerk," inv. no. 25. Communicated by Rob Ruurs.)

234. 8 July 1651. Reynier Jansz. van der Meer living on the Market place and Jan Heymensz., baker, guarantee a loan of 250 guilders to Harmen Gerritsz. Valckenhoff, faiencier ("plattielbacker"). (Delft G.A., register of the Orphan Chamber, no. 6, fol. 451ᵛ.)

235. 17 July 1651. The following amounts were paid on behalf of Jan Thins [de Jonge] on this date: For his own grave, 5 guilders 12 stuivers, for ringing the bells 7 guilders 10 stuivers and 5 guilders. (Gouda G.A., Archief van de Hervormde Gemeente, "Jaar rekeningen St. Jan." Communicated by Rob Ruurs.)

236. 12 August 1651. Reijnier van der Meer, otherwise named Vos, innkeeper, living on the north side of the Market, well known to the notary, Andries Bogaert, constitutes and empowers Aernolt Sweers living in The Hague to collect and receive from Reijnier van Heuckelom 126 guilders 7 stuivers, owed by him to the constituent, according to his register, for board ("teercosten") and others. In case Van Heuckelom should refuse, Sweers is empowered to sue him. Tobias Bres and Fred-

erick Schoonhoven witness the act. The innkeeper signs Reijnier Jansz. Vos. (Delft G.A., records of Notary A. Bogaert, no. 1887. First published in Van Peer 1959, p. 240.)

237. 29 September 1651. On this date Reynier Vos and Gysbrecht van der Hoeve, the brother of Jan Heymensz. van der Hoeve, guaranteed the mortgage for 1,000 guilders at 5 percent interest on the house purchased by Jan Heymensz. on the Nieuwe Straat. (See doc. no. 320 of 10 September 1668.)

238. 12 November 1651. "The first notary requested, assisted by two witnesses, shall betake himself to the house of Maria and Cornelia Thins, sisters, heirs of the late Jan Thins, their brother, presently here in Delft, to ask them whether they have not agreed with Renier Bollenes concerning the lands in Oud Beyerlandt leased by us undersigned from the aforesaid Bollenes, as against which Johan Thins had obtained a penal letter ('mandament penael') pursuant to the testament of his father, claiming that he was next in line to this lease, in such manner that Bollenes was allowed to lease the lands but not to sell them, but, due to the fact that the lands had not been in use, Bollenes was entitled to the sum of over 200 guilders, and whether Bollenes had not promised us, the undersigned, to keep the 'insinuees' [Cornelia and Maria Thins] from intruding ('hun geinsuneerden aff te houden'). The undersigned demand a categorical answer." They sign Jacob Jacobsz. Rosmorle[?] and Huybrecht Hermensz. "On this same day, I, Jacob Spoors, notary, in presence of the undersigned witnesses, transported myself to the house where the aforesaid Thin had lived and died, here on the Brabant Peat Market, where I delivered the above protestation to Joffr. Maria Thins, in the absence of Joffr. Cornelia Thins. Maria Thins answered that they [i.e., the sisters] had agreed in all respects with Reijnier Bollenes concerning the authorization that had been given." Adriaen van Son and Leendert de Lange witnessed the "insinuatie." (Delft G.A., records of Notary J. Spoors, no. 1675, fol. 169^{r+v}.)

239. 5 May 1652. Reynier Jansz. Vermeer witnesses the sale of a house to Hendrick Leenderts de Hooch, grain merchant. (Delft G.A., records of Notary C. Georgin, no. 2083.)

240. 15 June and 10 September 1652. In the estate papers of the wine merchant Simon Jansz. Doncker, who died on September 10, a loose fragment of a schedule of deliveries, shows that the wine merchant had delivered to Reynier Vermeer 17½ stoop French wine and 6¾ stoop Spanish wine (a "stoop" contained about three quarts) on June 15. On 26 March 1653 when the first accounting of the estate was submitted by the trustees appointed by the Orphan Chamber, the cumulative amount owed by Reynier Vos for this and previous deliveries was said to be 250 guilders 4 stuivers. The amount owed by Reynier Vos was inscribed among the middling debts ("middelbare schulden") due to the estate. At that time nothing had been paid toward the settlement of his debt by the heirs of Reynier Jansz. The debt was divided into two equal lots of 125 guilders 2 stuivers each, one of which was assigned to the children of the wine dealer and the other to his widow. On 14 November 1653 when a second accounting was submitted, 18 guilders 1 stuiver had been paid toward the children's share. In the margin was written "remnant 107 guilders 1 stuiver." By 24 July 1657, when a third accounting was made, this entire sum had been received by the estate. It is probable that the debt in the widow's lot was also paid before this date. (Delft G.A., Orphan Chamber, *boedel* no. 493.)

241. 27 August 1652. Division of the estate of Georgin van den Velde who had recently died in Haarlem. The paintings were divided into two lots of 1,256 guilders

10 stuivers each, between which Joffr. Machtelt van Beest, widow of Willem van Erve [or Van Nerven], and Joffr. Aeffie van de Velde chose at random ("blinde lotingh"). Machtelt van Beest received lot A which contained a painting by Claes Pietersz. [Berchem?] estimated at 74 guilders; "The Wolf" by Goltius [probably a drawing] at 36 guilders; two pieces by Verbeeck at 12 guilders; a hunt by Bleycker, at 36 guilders; a piece by Breij [probably Salomon de Bray] at 12 guilders; a "portrait of Uncle Jan," at 48 guilders; a picture of Maria by an unknown master at 24 guilders; a Descent from the Cross by Master Cornelis [Van Haarlem], at 52 guilders; a piece with naked persons by Cornelis, at 66 guilders; a large piece by Grebber and Goltius, at 72 guilders; a drawing by Goltius of two Spanish faces at 20 guilders; a piece by Parcel [Porcellis?], at 54 guilders; a copy after [Jacob or Jan] Pynas, at 18 guilders; a small portrait by [Willem or Adriaen] Key, at 48 guilders; a portrait by Mostert at 40 guilders; a piece with personages by D. Hals, at 42 guilders; a piece with melons by Van Heussen, at 24 guilders; another piece with artichokes by Van Heussen, at 30 guilders; a piece by Van der Ast, at 18 guilders; a bouquet of flowers by Bolongier at 24 guilders; a banquet by Floris van Schoten at 15 guilders; a crab by Goltius, at 15 guilders; a piece by Van Mander, at 30 guilders; a piece by Coignet, at 20 guilders; an Italian ruin, at 12 guilders; some faces by Geert St. Jan, at 12 guilders; an altar piece by Heemskerck at 18 guilders; and other unattributed paintings. After this apportionment, the painting by Grebber was turned over to Joffr. Van de Velde, on the basis of an agreement between the two heirs; Machtelt van Beest received as compensation a great mirror, an old oaken chest, and an altar piece with two doors (valued at 12 guilders). An appended note showed that Machtelt van Beest received in addition a crucifix with a standing Christ and a picture of [the Virgin] Mary. The document is signed by the painter Pieter Molijn who appraised the works of art. (Haarlem G.A., records of Notary C. van Kittesteijn, N. A. 182, fol. 152^{r+v}.)

242. 22 September 1652. Testament of Arijaentgen Claesdr. widow of Jan Teunisz. Back, butcher. She is in good health and of sound mind. She declares that she was left with five children and that the estate, which she held in common with her husband, was turned over to the Orphan Chamber, which, after due examination, found that it contained more debts than assets. For the sake of her honor and with the knowledge of the Orphan Chamber, instead of abandoning the estate, she decided to cling to it. She knows of no more debts still outstanding that had been contracted during her husband's life, but, in case any creditors should impound (or place under arrest) any of the goods left after her death, she wishes that they be protected and passed on to her children's children or, in case there should not be any, to the heirs *ab intestato*, on the mother's side, the children of the last child to die. With this last proviso, she names her unwed children as heirs, with the exception of her tripe-dealing business ("neering van't penscoopen"), which she depends on for a living. This business she leaves to any child or children who wishes to engage in it as best suits her or them. The testament (passed in the house of the testatrix) is witnessed by Adolff van Kelder, a neighbor, and the notary's clerk. Arijaentgen signs in a barely literate manner. (Delft G.A., records of Notary J. Ranck, no. 2104, doc. marked no. 7.)

243. 12 October 1652. "Reinier Jansz. Vermeer on the Market Place" was buried on this date. (Delft G.A., Burial book, New Church, first published in Van Peer 1959, p. 240.) No donation was made on his behalf to the Opperste Kleed. (Delft G.A., Camer van Charitate, "Opperste Kleed Boek" no. 73, entry for Reynier Jansz. Vermeer, October 1652.)

244. 28 October 1652. Testament of Dirck Claesz. van der Minne and of his wife Tryntge Cornelisdr., living on the Jacob Geritsstraat; she is sick in bed. They leave all their goods to their children Cornelis, Nicolaes, and Neeltge. (Delft G.A., records of Notary S. Mesch, no. 2049.)

245. 27 November 1652, 1 January 1653, and 11 May 1657. Among the debts due to the estate of Cornelis Leendertsz. van Schagen, cloth merchant, who died on 27 November 1652, the widow of Reynier de Vosch appears in the first accounting to the Orphan Chamber, dated 1 January 1653, as owing 17 guilders 10 stuivers. A note in the accounting of 11 May 1657 shows that the entire amount had been received from the widow "in full payment." (Delft G.A., records of Notary W. de Langue, no. 1695, and Orphan Chamber, *boedel* no. 1505 I.)

246. 1652 [exact date unknown, presumably before the death of Reynier Vermeer in October 1652]. The last three out of eleven entries in a list of names on the back of a drawing copied by Lenaert Bramer after Heyndrick [Henricus] Bramer read: "Ten huise van Mons^r Adam Pick, ten huise van Reinier Vermeer, ten huise van Leenaart Bramer." It is probable that the numbers of the drawings collected by each of the eleven collectors on the list were inscribed to the right of the names on a part of the back of the drawing that has been clipped. The names of the first nine collectors are preceded by terms of deferential addresses (de heer, captain, monsieur). Reynier Vermeer is the only one besides Bramer himself who is not referred to in this manner. Bramer's sketches after paintings in Delft originally numbered at least 107 (the number inscribed on the drawing with the names of the collectors). Of these 66 are either preserved in an album in the Rijksprentenkabinet or have been identified in other collections. The album in the Rijksprentenkabinet was first described by E. W. Moes ("Een merkwaardige verzameling teekeningen," *Oud Holland* 3 [1895]: 182–92). The Bramer drawings are extensively discussed in Michiel C. Plomp's Doctoral Hoofdvak Scriptie, Utrecht University, " 'Een Merkwaardige Verzameling Teekeningen' door Leonard Bramer, " 1983–1984.

247. 28 January 1653. On this date Dingnum Jans [sic] appeared before the Orphan Chamber of Delft and showed the testament that she had made with her late husband Reynier Jansz. Vos on 17 February 1638 (doc. no. 149). The testament, now "confirmed by the death of her husband," excluded the Orphan Chamber. Done before all the masters of the Orphan Chamber. (Delft G.A., Orphan Chamber archives for South Holland, no. 84, fol. 368.)

248. 24 February 1653. Marinus Copmoyer's petition to the Court of Holland. Marinus Copmoyer, Councillor and former alderman of the town of Brouwershaven, informs the court that he had supplied considerable sums of money to Tobias Bres and Reynier Baltens, workmasters, who, by a special contract, had promised [him] full indemnity against all claims regarding any payment orders transferred and ceded [to third parties] within the town of Brouwershaven ("de gecedeerde ende getransporteerde actien over alle de wercken by hun binnen de stede Brouwershaven gemaeckt"). Payment had been stopped by Mattheus Rollant and Martinus de Jonghe, rentmasters in Zierikzee, on a payment order transferred to a certain Jan Crab, also workmaster. This interdiction of payment could not be undone without suit and, if it were undone, it could again be rendered valid by decision of a subordinate court ("Subalterne Recht"). Since the two workmasters have no means in the world, are strangers ("vreemdelinghen") and suspect of taking flight ("suspect de fuga"), the petitioner personally caused them to be arrested. After hearing the causes of the arrest, the burgomasters and aldermen of the aforesaid city [Brouwershaven], issued a definitive sentence releasing the arrested persons

free and without liability ("costeloos ende schadeloos"). The petitioner, finding himself severely afflicted by this sentence, constitutes himself appellant to the present court, the Secretary having refused to issue a sentence in the case. He requests from the court a mandate with a compulsory clause and an injunction ("mandament mette clausule compulsoir ende van inhibitie") together with a clause of arrest whereby the first process-server ("deurwaeder") requested by the Higher Authority ("van wegen de Hooghe Overicheyt") shall be authorized again to arrest and secure the two persons who had been released in disregard of the supplicant's appeal. He requests that, in case of opposition, the arrest be sustained until all the parties have been heard or a sufficient security will have been deposited to ensure the promised indemnity. A marginal notation, signed[?] by "d'heer Blocq," indicates that the petition was approved ("fiat ut petitur"). (The Hague A.R., Hof van Holland, "Sententiën," inv. no. 3005.)

249. 5 April 1653. "Captain Melling, about 59 years of age, and Leonaert Bramer, painter, about 58, appeared before the notary Johannes Ranck on this date and declared at the request of Jan Reijniersz. [Vermeer] and Trijntgen Reijniers [Catharina Bolnes] that they were present yesterday night on the fourth of this month at the house and in the presence of Joffr. Maria Tints, living in this town, when the question was raised by the afore-mentioned notary in our presence as to whether the aforesaid Joffr. Tints (assisted by Cornelia Tints, her sister) was prepared to sign the act of consent for the registration of the marriage vows between Joffr. Maria Tints's daughter, named Trijntge Reijniers, and Jan Reyniersz., also living here, in order to make public these vows according to the custom of this town; whom we then heard give for an answer that she did not intend to sign but would suffer the banns to be published and would tolerate it; and she said several times that she would not prevent or hinder them. The witnesses offered to confirm the foregoing by oath." Gerrit Jansz. van Oosten and Willem de Langue, notary, witnessed the act. (Delft G.A., records of Notary J. Ranck, no. 2012.) The full original text is transcribed in Blankert 1978, p. 146. The document was first published in Obreen 1881, 4: 292.

250. 5 and 20 April 1653. In "the register of the persons who entered the holy marital state in the town of Delft," an entry for the fifth of April reads: "Johannes Reijniersz. Vermeer, bachelor [living] on the Market Place; Catharina Bolenes, young daughter [spinster], also there." [A marginal note adds: "Attestation given in Schipluij, 20 April 1653."] First published in Obreen 1881, 4: 292. See also Goudappel 1977, pp. 20–26.

251. 22 April 1653. Johan van den Bosch, captain in the service of the States General, stationed in Den Briel, offers surety to enable Juffr. Dido van Treslong to collect a sum of 1,000 guilders due to her from the estate of the late Lord of Treslong, former Governor of Den Briel, which sum he, Van der Bosch, guarantees will be restituted if this proves necessary. Mons' Gerrit Terburch and Johan van der Meer witness this act of surety. The older painter signs Geraerdt Ter Borch, the younger Johannis Vermeer. (Delft G.A., records of Notary W. de Langue, no. 1695.)

252. 23 April 1653. "Reynier Baltensz. workmaster in Gorinchem, known to me notary, declares that he has empowered by the present [act] Leenderts Pauwelsz. Voocht living in Brouwershaven in order to receive on his behalf such sums of money as are owed to him over works undertaken and carried out or others, whatever they might be, and, if the debtors are unwilling, to sue them before a court of law." The procuration is drawn up especially to solicit payment for the sum of 1,500 guilders that are due to him over the last payment for making two half-

moons in Zierikzee at the corbel and the Southwall gate. Jan Willemsz. Cammius [or Kam], silk merchant, and Johannis Reyniersz. van der Meer witness the procuration. The painter signs Johannis Vermeer. (Delft G.A., records of Notary C. Georgin, no. 2083.)

253. 2 May 1653. Marinus Copmoyer, Counsellor and former alderman of Brouwershaven, appears before the notary and declares that he has empowered Cornelis Borsman, attorney before the high and provincial Court of Holland, in order to represent him and act on his behalf in any suits that he may have to undertake before this court and especially concerning such matters as are still pending against Tobias Bres and Reynier Baltens as well as Anthonis Pluympoth, bailiff of Brouwershaven, so that he may act as plaintiff or defendant, compromise or mitigate, as may seem appropriate. (The Hague G.A., records of Notary Q. Gaeswyck, no. 189, fol. 460.)

254. 6 May 1653. Dingena Baltensdr., widow of Reynier van der Meer, living here, appears before the notary and declares at the request of Tobias Bres, workmaster, that "about five months ago, without being aware of the precise time, she had been in Brouwershaven in the house and room where the petitioner was lodging. She then saw a certain Marinus Copmoyer living in Brouwershaven enter, holding the keys to the petitioner's coffer in his hand, saying that he would like to have, yea that he *must* take a letter out of the coffer (pointing to the petitioner's coffer), which he opened and touching the papers and taking two or three letters in his hand, said, I should like to put these letters in my bag, I must have them, which he then did, and she deponent declares having seen this but not to know what they contained." Leonaert Bramer and Evert van Aelst, master painters, witnessed the deposition. The document is painstakingly signed Dyngnom Baltes. (Delft G.A., records of Notary C. Georgin, no. 2083.)

255. 4 December 1653. "Frederick Willemsz., citizen of Brouwershaven, presently here [in The Hague] and introduced to the notary, appeared and declared at the request of Marinus Copmoyer that, in the latter part of the summer of the last year 1652, Tobias Bres and Reynier Baltens, workmasters, had undertaken a part of the restoration of fortified works on the south and west walls of Brouwershaven, which in part had first been undertaken by some other persons who, for lack of money or other adverse circumstances that they had foreseen, had let the work slide and stopped it, after which it had been taken up again by Bres and Baltens. The deponent declared further that the repairs of the aforesaid works by Bres and Baltens would have been impossible and infeasible unless God Almighty had vouchsafed an extraordinary and unimaginable drought in the late summer during the entire period of the restoration. Bres and Baltens had first set to work in the last days of August and after a few months in the year 1652 they had completed the work, notwithstanding the fact that this work was as badly done as can possibly be. The deponent declared on the basis of his own knowledge that he had conversed with various persons, including those who had first taken on the job, concerning the undertaking, and that the repairs to the works would have been impossible. He attested on the basis of his own knowledge that the sludge ("slijck") that came from the canal and had been brought on top of the walls was nothing but soft mud and water, which constantly ran down the walls into the canals, so that the petitioner (seeing all this) was exposed to great danger in supplying his money for the repairs to the works. The deponent is prepared to confirm his deposition by oath." The notary's clerks witnessed the deposition. (The Hague G.A., records of Notary Q. Gaeswyck, doc no. 490.)

256. 29 December 1653. "Johannis Vermeer has himself registered as a master painter [in the Guild of St. Luke], being a citizen, and he has paid one guilder 10 stuivers toward his master money [entrance fee]; there remain 4 guilders 10 stuivers [to pay]." (Delft G.A., archives of the Guild of St. Luke, "Register van alle de nieuwe meesters en winckelhouders," first published in Obreen 1877, 1: 56.)

257. 1653 (exact date unknown). The widow of Reynier Balthens is assessed a tax of 2 guilders 10 stuivers on the house she is renting. (Gorinchem G.A., "Kohier van de verponding," no. 4140, fol. 48.)

258. 10 January 1654. Geertjen Joppen, widow of Joost Pietersz. Wout, auction master ("boelhuysmeester"), 58 years old, declares at the request of the heirs of Hester Joosten, former tavern keeper ("waerdinne") in the Comans Colff, that she is behind in her payments to and owes Maria Goverts Knol 500 guilders for goods that she had bought from the estate ("opt boelhuys") of Govert Pietersz. Knol, her father. The deposition is made at the house of the deponent [in the Pieterstraat, south of the Market] in the presence of Lambertus Morleth, captain in the town of Clacken in the Land of Cleves, and Johannes Vermeer, master painter, who signs Johannis Vermeer. (Delft G.A., records of Notary N. Vrijenbergh, no. 2052.)

259. 30 April 1654. Cornelis Jansz. Warmen, carpenter, living in Nieucoop in the district ("ambacht") of Pynacker, acknowledges a debt of 190 guilders to Dirck Meyndert, lumber dealer, for lumber delivered. The debt acknowledgment is made in the presence of Govert Rota, notary, and Johannes Vermeer [no profession indicated]. (Delft G.A., records of Notary A. C. Bogaert, no. 1888.)

260. 17 May 1654. Beyken van der Wiel, daughter of Gertruy van der Meer and Anthony van der Wiel, is baptized in the New Church. The witnesses are Pieter Gerritsz. [a brother of Anthony van der Wiel] and Dina Baltensdr. [Vermeer's mother]. (Delft G.A., New Church, Baptism files.)

261. September 1654. The death inventory of the wife of the painter Cornelis Sachtleven in Rotterdam contains, among the debts due to the estate ("inschulden"), the following note: "Reynier Vermeer owes the sum of 25 guilders with respect to the aforesaid" [the purchase of a painting or paintings]. (Letter from F.A.M. Schoone of the Archiefdienst of the Gemeente Rotterdam. First published in *Oud Holland* 31 [1913]: 258.)

262. 14 December 1655. "On this day there appeared before me Govert Rota, in the presence of the undersigned witnesses, Sʳ Johannes Reijnijersz. Vermeer ["Vosch" crossed out], master painter, and Juffrᵉ Catharina Bolennes living in this city, his wife, who declared that heer Johan van Santen, Captain of the Orange Pennant Militiamen ("Orange vendel schutters"), on 5 December 1648, had constituted himself surety and co-principal for Reijnijer Jansz. Vosch, the appearers' late father and father-In-law respectively, for a sum of 250 guilders, running at an interest of 5 guilders 10 stuivers per 100 guilders a year, as set forth in the obligation made out to a blind name by the late notary Simon Mesch and passed before certain witnesses. The appearers, wishing to free the heer Van Santen of liability, have constituted themselves secondary sureties ("contraborgen") and co-principais for the sum of 250 guilders together with the interests due on the sum until full payment and restitution will have been effected." They both relinquish all legal rights that debtors may claim under certain circumstances ("benefitien ordonis execussionis ende divisionis" and, in the case of Catherina Bollenes "de benefiten authenthica ende qua mulier ende senatus consultj villeanij"). They promise to free Captain van Santen and his heir and descendants of any liability for the loan, for which they pledge their respective persons and all their goods. To secure the contents of

their pledge [in case of violation], they are willing to be condemned and name irrevocably to this end the attorneys Franchois Bogaert and Franchois Hurcq of the Court of Justice to effect the condemnation. They promise to respect the condemnation and to pay any attendant costs. The act is passed in the presence of Sr. Maerten Wigant, living here, and Pieter de Coninck, the notary's clerk. The painter signs Johannis Vermeer, his wife: Catharina Bolnes. Her signature is a model of penmanship. (Delft G.A., records of Notary G. Rota, no. 1986, fol. 257.) This document was first published, in part, in Bredius 1885, p. 218.

263. 4 April 1656. Joffr. Maria Thijns, living in Delft, constitutes Gerrart Vinck, attorney before the Court of Holland, living in The Hague to represent her in a suit before the court regarding a certain verdict issued by the court against Tryntgen Jansdr., widow of Adriaen Jansz. Back, which was to be executed on her house in the village of Schipluijde. The attorney may appeal or otherwise prosecute the case in any way he deems fit. The witnesses are the notary's clerks. (Delft G.A., records of Notary J. Ranck, no. 2114, act no. 321.)

264. 1 May 1656. Adriaen Cornelisz., baker, buys at auction the house of Tryntge Jansdr., widow of Adriaen Jansz. Bacx, for 1,075 guilders. The house was sold in pursuance of the decree of the Court of Holland issued on 19 January 1656 in the suit brought by Maria Thins against Tryntge Jansdr. and her surety Frans Willemsz. Tetro for 700 guilders and the interest thereon owed by the defendant to the plaintiff. The court had decided to have the defendant's house auctioned off and to pay the amount due to Maria Thins from the proceeds. Adriaen Cornelisz., who bought the house, already owned a house next to it on the west side. (The Hague A.R., inv. no. 3372–3529, fol. 1 and ff.)

265. 24 July 1656. On this day, Vermeer paid the remaining portion of his master's fee in the Guild of St. Luke (4 guilders 10 stuivers). See doc. no. 256 above.

266. 14 January 1657. Maria Gerrits Camerling, the half sister of Maria Thins, 48 years of age, is buried in the choir of the New Church in Delft on this date. (*Grafmonumenten en grafzerken in de Nieuwe Kerk te Delft*, no. 92, cited in van Peer 1975, p. 19.)

267. 25 February 1657. Anthoni Gerritsen van der Wiel [the husband of Vermeer's sister Gertruy] pays his entrance fee to the Guild of St. Luke, being a citizen. He is registered as an art dealer ("konstverkoper"). (Obreen 1877, 1: 61.)

268. 18 June 1657. First known testament of Maria Thins. Before dividing up her estate, she requests that 100 guilders be given to the poor "as bread and otherwise" for the sake of charity, under the supervision of her sister Cornelia. She bequeaths to her daughter Catharina all her clothes, linen, and wool and everything else that belonged [personally] to her, testatrix, during her lifetime, together with the linen chest she had inherited from Johan Thin Willemsz. de jonge, and all the silverware that Catharina has already gotten from her before this, to wit a silver underbelt ("onderriem") and a key belt, and a sum of 300 guilders that she had advanced Catharina and her husband in the year 1656, along with her rings, bracelets, and gilded chain. She bequeaths to her godchild Maria Vermeer, the daughter of Catharina, 200 guilders. She leaves her son Willem the bed whereon she is presently sleeping together with two pairs of sheets, two bolsters, two blankets, and a bed cover. All other movable property, household goods, and silver she leaves, in equal portions, to her children Willem and Catharina. As to all other goods, movable and unmovable, financial assets, and entitlements, none excluded, left after her death, she names and institutes as heirs the legitimate child or children of Willem Bolnes for the one-half and the child or children of Catharina Bolnes for the other,

and in case of the death of either, the child or children of the survivor, except that
Willem and Catharina Bolnes will each be entitled to his or her legitimate share.
The testatrix further desires that Willem and Catharina shall enjoy during their life
long any surplus over the legitimate shares, the heirs to which property their chil-
dren have been named and instituted. Twenty-three lines of the testament were
crossed out (and made completely illegible) "on order of Maria Thins after the
testament had been drafted." (Gouda G.A., records of Notary N. Straffintveldt, no.
236, fols. 131 and 132.)

269. 27 June 1657. In the list of paintings in the Amsterdam estate of Johannes de
Renialme, who registered in the Guild of St. Luke in Delft on August 1644, the
following entry appears: "Een graft besoeckende van der Meer 20 gulden" [A pic-
ture of the visit to the grave by Van der Meer, 20 guilders]." (Bredius 1915–1921,
1: 233.)

270. 20 July 1657. Dirck Claesz. van der Minne died on this date. In the inventory of
his possessions, the following items appear:
A painting of Martha and Maria
A vanitas
A landscape
Two small paintings of musicians
The estate contained six musical instruments: a lute, a trombone ("schuyftrom-
pet"), a shawm ("schalmey," a primitive oboe-like instrument), two viols, and a
cornet. As his heirs, Dirck Claesz. van der Minne leaves Cornelis Dircksz. van der
Minne, surgeon in Munster; Claes Dircksz. van der Minne, surgeon in the East
Indies; Neeltge Dirxdr. van der Minne, married to Cornelis Pietersz. Huycksloot;
Aryen Gerritsz. van Sanen and Dirck Gerritsz. van Sanen, both in the East Indies,
children of Adriaentge Dirxdr. van der Minne, in her life married to Gerrit Ad-
riaensz. van Sanen; Aernort Pietersz. van der Minne, Cornelia Pietersdr. van der
Minne, and Johannis Pietersz. van der Minne, young children of the late Pieter
Dircksz. van der Minne. (Delft G.A., records of Notary W. van Assendelft, no.
1867, act no. 2987.)

271. 30 November 1657. Johannis Reyniersz. Vermeer, painter, and Catharina Rey-
nier Bolnes, his wife, [crossed out in the original: for as much as the following may
concern her] living in Delft, acknowledge that they duly owe Pieter Claesz. van
Ruyven or his legally empowered representatives the sum of 200 guilders arising
from money duly lent and handed over to them on this day. They promise to return
the sum within a year, by the last day of November, 1658, together with the interest
on it at 4 guilders 10 stuivers per hundred a year, as well as any interest that might
be outstanding beyond this date until full repayment shall have been effected. They
bind their respective persons and their assets to this end and are willing to let them-
selves be condemned by the judges of this city [in case of nonrepayment] and irrev-
ocably constitute Govert Rota, Jacob Spoors, and Frans Bogart, attorneys before
the court ("vierschaar") of this city, both to request this condemnation and to con-
sent thereto. The notary's clerks witness the act. (Delft G. A., records of Notary
J. van Ophoven, no. 1952, fol. 99.) This document was first published, in part, by
Bredius 1885, p. 218.

272. 25 April 1658. Jan Heymansz. van der Hoeve, baker, sells Corstiaen Jaspersz.
[Delfos] tobacco merchant, a house on the south side of the Vlamingstraet for
1,400 guilders. There are two mortgages on the house, one for 600 guilders owed
to Beatris Pieters Middelhouck, and the other to Pieter van Uden, for 500 guilders.
The seller will remain in the house for four more years, paying 50 guilders per year.

(Delft G. A., records of Notary C. Bleiswijck, no. 1915, fols. 115–16.) Dorothea Michiels, the wife of Corstiaen Jaspersz., had made a deposition concerning her neighbors Maria and Jan Willemsz. Thins, on behalf of Reynier Bolnes, on 15 January 1647. (Doc. no. 193.)

273. 28 December 1658. A house mentioned in the estate papers of the widow Schilperoort is described as "Standing on the North side of the Market Place, next to [that of] the widow of Reynier Vos, alias Van der Meer, on the East side." It was also said to be "next to [the house of] Dingenum Balten, widow of Reynier Vos, called 'Mechelen.' " (Archives of the Orphan Chamber, cited in Swillens 1950, p. 25.)

274. 12 May 1660. In the estate of Daniel Gillisz. de Bergh, sailmaker, a debt for 80 guilders due by "Johan van der Meer" for the ice sled ("over de ys slede") is listed among the debts due to the estate. This sled was presumably equipped with a sail and moved by the power of the wind to slide over the ice. The estate accounts are signed by the painters Gillis and Mattheus de Berg. [It is uncertain whether the Johan van der Meer referred to in this debt was the artist Vermeer (whose name was often spelled "Van der Meer," as witness doc. no. 297, 9 February 1664) or the apothecary of that name who was later to lease Mechelen (doc. no. 340, 14 January 1672).] (Delft G. A., records of Notary G. van der Wel, no. 1931.)

275. 16 May 1660. Arijaentge Claes van der Minne, widow of Jan Theunisz. Back, Heymen van der Hoeve, and Johannes Ranck, notary in Delft, make a declaration at the request of Crijntgen Jacobs, widow of Isbrant van Castijllije. First Arijaentge Claes declares that she had heard out of the mouth of Jacob Isbrantsz. and of his wife Stijntge Baerens, who had come to her house, the following words: "We have received our money from our father's bequest ('bewijs')." Heymen van der Houve declared that Jacob Isbrantsz. and Stijntge Baerents in the house of his [Heymen's] father and in his presence had told his father [Gysbrecht Heymensz.] and his mother [Trijntge Teunisdr.] that he, Jacob Isbrantsz., had received the aforesaid bequest from him [his father?] and pointed to the money that he had received, which he [Heymen] had seen. Finally Johannes Ranck declared that Stijntgen Baerens had come to his office, along with the petitioner [Crijntgen Jacobs], and said "I have nothing more to claim from my father's bequest and as you know, I will say so before the masters of the Orphan Chamber since I am fully satisfied." The half sister of Reynier Jansz. signed in full "Aerjaentge Klaes van der Mijnne." Jacob Isbrantsz. was apparently the son of Isbrant van Castijllije. (Delft G. A., records of Notary J. Ranck, no. 2116, fol. 734.)

276. 1 July 1660. Gysbrecht van der Hoeve, son of Heijmen van der Hoeve and Margrieta Claes, is baptized in the New Church. The witnesses are: Jan [Heymensz.] van der Hoeve, Aryaentge Claes, and Trijntge Jans. The father, Heijmen [Gysbrechtsz.] van der Hoeve [or Houve], was the son of Gysbrecht Heymensz. van der Hoeve, the brother of Jan Heymensz. van der Hoeve. (Delft G. A., New Church, Baptism files.)

277. 17 September 1660. Anthonij van der Wiel, ebony worker, names Pouwels Sweets, merchant in Amsterdam, to act in his name and collect 48 guilders 15 stuivers due to him by Maerten Kresser [Kretzer], also living in Amsterdam, for ebony frames delivered, according to his [Anthonij's] register and the accounting that he has delivered. Sweets should try to collect the money à l'amiable if possible, but otherwise he may bring suit on the constituent's behalf. Anthony van der Wiel signs with a star. (Delft G. A., records of Notary J. Ranck, no. 2116, fol. 777.)

278. 12 November 1660. In the inventory of the assets brought by Jacobina Manrique, who had formerly been married to the brewer Johan Croesert, to her second marriage with Gerrit van den Heijm, item no. 114 reads: "Reijnier de Vos owes for beer delivered the sum of 82 guilders 10 stuivers, which is to be settled" ("daermede te liquideren staet"). (Delft G. A., records of T. van Hasselt, no. 2152.)

279. 27 December 1660. "On this date a child of Johannes Vermeer on the Oude Langedijck" ("een kint van Johannes Vermeer aen den O. Langedijck") was buried in the Old Church. (Delft G. A., "Begraafboeken" no. 40, fol. 40, Old Church.) This notice was discovered by H. W. van Leeuwen. The grave in which the artist's other children who died in infancy were buried was not bought by Maria Thins until 10 December 1661 (doc. no. 289).

280. 28 January 1661, 6 P.M. Testament of Cornelia Thins, sister of Maria Thins, citizen of Gouda, seriously sick in body, but sitting in a chair by the fire. After revoking her previous testaments, she bequeaths 100 guilders to the poor and makes bequests to her maid and to other ladies ("joffers"), and wills 60 guilders as drink money for the young men who will carry her body to the grave. Finally she divides her property as follows. To Lisbeth Jans Vermeer, the little daughter of Catharina Bolnes, she bequeaths a life annuity ("lijfrente") of 60 guilders 13 stuivers per year, to run during the life of Catharina Bolnes. The annuity is an obligation issued by the United Provinces ("Gemeenland") and deposited in the Comptoir of Receiver Cincq. She bequeaths to Maria Jans Vermeer, the little daughter of Catharina Bolnes, a domain with about ten and a half morgen of land lying in Bonrepas near Schoonhoven, being a land of the Earldom of Holland and West Friesland, the ownership of which domain was confirmed by an open letter of octroi issued by the States of Holland and West Friesland, dated 28 May 1658. She stipulates, however, that her sister Maria Thins shall draw the usufruct and income from the property as long as she lives. After her sister's death, the usufruct shall be enjoyed by the father and mother of Maria Jans Vermeer or the survivor of the two, until Maria shall have attained the age of 20 years, all this for the upkeep of Maria Jans, who, when she will have attained this age, will be able to draw the usufruct as long as she lives. The ownership of the domain will then devolve on the grandchildren of Catharina Bolnes, although the usufruct will accrue to the grandchildren of Maria Jans Vermeer. She makes the same disposition for her domain "de Hoge Werf" (The High Wharf) in Oud Beijerland, 18 and one-half morgen in area, of which Maria Thins her life long will draw the usufruct and after her death Catharina Bolnes and, after her, her child or children. She also donates to Catharina Bolnes a life annuity of 100 guilders 5 stuivers per year, as well as her household goods ("inboedel ende huis raad"), together with those of her brother Jan, which must be divided between Maria Thins and Catharina. Maria Thins is to inherit all her other goods and, after her death, Catharina and her descendants. Willem Bolnes, son of her sister Maria, is explicitly excluded from the succession. The testatrix states that she does not want him to obtain one stuiver out of her goods because of his "dissolute, licentious, and useless life as well as of the disobedience, spite, and harm done to his mother." (Gouda G. A., records of Notary N. Straffintveldt, no. 239, cited in Van Peer 1975, pp. 21–22.)

281. 1 February 1661. Cornelia Thins, in the presence of Maria Thins who has come from Delft, amends her testament. She revokes the disposition according to which Maria Jans Vermeer was to enjoy an advantage over and above the other children of Catharina Bolnes ("enig voordeel zal genieten boven de andere kinderen"). In addition both sisters "ratify by the present, approve, and make valid the marriage of Catharina Bolnes, the niece of Cornelia Thin and daughter of Maria Thin, with

Johannes Vermeer, bachelor in Delft [added by notary in margin: just as they had ratified, approved, and made it valid before the marriage had been consecrated in Delft], in such a way that the testament of her brother Johan Thin with regard to Catharina Bolnes can be made to take full effect" ("volkomen effect zal mogen sorteren"). They declare further that it is their desire that all the lands that they possess in Oud Beijerland after their death shall devolve on the grandchildren of Catharina Bolnes, even though Maria Thin shall draw the yearly usufruct from these properties and after her death Catharina Bolnes and, after her, her child or children. (Gouda G. A., records of Notary N. Straffintveldt, no. 239, fol. 280, cited in Van Peer 1975, pp. 22–23.)

282. 11 April 1661. A notice in the "Repertorium op de lenen" (the register of the feuds) in The Hague shows that the domain of Bon Repas accrued to Catharina Bolnes, 30 years old, by the death and testament of Cornelia Thin. On this date, "in place of the aforementioned Catharina Bolnes, the aforementioned Johannes Vermeer, her husband and guardian, has done us homage, oath, and fidelity, in the hands of our dear and faithful Pensionary Johan de Witt as Stadhouder and Master of the register of our feuds.") (The Hague A. R., no. 227, cited in Van Peer 1951, pp. 618–19. I basically have followed the English translation in Blankert 1978, p. 147.)

283. 15 April 1661. On this day there appeared before the Orphan Chamber of Gouda, Maria Thins, wife of Regnier Bolnes, daughter of Catharina Henricx Hensbeecq, and Jan Henricsz. van der Wiel who had married the late Maria Camerling who was also a daughter of Catharina Hensbeecq., as father and testamentary guardian over the children begotten by the aforementioned Maria Camerlingh. The appearers declared that the restricted assets ("verbonden goederen") of Dievertgen Henrix Hensbeecq amounted to the sum of 10,367 guilders 3 stuivers and 14 penningen, as recorded in the Orphan Book no. 12, fol. 10. This sum is made up as follows:

out of the old division by lots ("cavel")	2,073 f.	8 st.	13 p.
one-fourth share in a portion of the goods left by testamentary disposition by the late Elisabeth Thins	518 f.	7 st.	3 p.
one-third share out of Johan Thins's inheritance	863 f.	18 st.	10 p.
one-half inherited from the recently deceased Cornelia Thins	1,727 f.	17 st.	5 p.
whereto is added an equal sum for the other half	5,183 f.	11 st.	15 p.
	10,367 f.	3 st.	14 p.

And in fulfillment of the above the following were found in the boxes or have been brought in.

First for the portion or share of Maria Thins:

An unrestricted interest-yielding obligation ("losrentebrieff") drawn on the States of Holland and West Friesland in the name of Regnier Bolnes yielding 36 guilders a year	900 f.
Another such obligation yielding 24 guilders a year	600 f.
Another such obligation in the name of Cornelia Willems Thins with the same yield	600 f.
Another in the same name yielding 16 guilders a year	400 f.

Another in the name of Regnier Bolnes yielding the
 same as above 400 f.
Another on Adryaen Cornelisz. Coijman yielding 30
 guilders a year 500 f.
Another owed by ("tot lasten van") Gerrit Ad-
 riaensz. in Berckwoude yielding 29 guilders a year 400 f.
Another owed by Aert van Westrenen living in
 Utrecht, as owner of the lands of Jan Goosensz. in
 Langerack, yielding 28 guilders a year 500 f.
Another owed by Gerrit Leijsterre transferred to
 Cornelia Thins and attached on her house named
 "De Engel" in the port yielding 32 guilders a year 800 f.
Were brought in in cash as a supplement of their
 share to bring it up to the correct sum 23 f. 11 st. 15 p.

 5,183 f. 11 st. 15 p.

Marginal notes added at subsequent dates (23 December 1667, 12 January 1668,
12 May 1671), indicate that some of these obligations were subsequently pried
loose ("verlost") and turned into cash by Maria Thins or by Johannes Vermeer.
(Gouda, Orphan Chamber no. 59.)

284. 16 May and 14 June 1661. The first item in the inventory of Cornelis Cornelisz.
de Helt, innkeeper in "de Jonge Prins," who died on May 16, reads: "In the front
hall / Firstly a painting in a black frame by Jan van der Meer."
 In the same room there were two landscapes, three seascapes, one kitchen scene,
two flower pieces, and three smaller paintings without artists' names. In the kitchen
there hung a "poëterie" (mythological scene) by [Adriaen] Van de Venne, in an
interior room a fruit piece by Gillis van de Berch, in a small hall, a painting by
[Pieter] Vromans. De Helt's possessions were auctioned off on June 14th. The
painting by "Van der Meer" sold for 20 guilders 10 stuivers, one by Van Beyeren
for 8 guilders 10 stuivers, one by "Molier" (probably Pieter Mulier) also for 8
guilders 10 stuivers, one by [Jacob] Van Loo for 8 guilders 13 stuivers, and the one
by Vromans for 10 guilders 15 stuivers. Only two paintings sold for more than the
presumed Vermeer: two unattributed panels for 21 guilders 5 stuivers and 36 guil-
ders respectively and the Five Senses for 30 guilders 15 stuivers. (Delft G.A., Or-
phan Chamber, *boedel* no. 673 I and II.)

285. 27 June 1661. Heijmen van der Houve is registered as a chair painter ("stoelver-
wer," more generally furniture painter) in the Guild of St. Luke. He pays 1 guilder
5 stuivers, the entry fee furniture makers, who also belonged to the Guild of St.
Joseph, were charged for the right to paint and sell the furniture they made. Heij-
men van der Hoeve was the son of Jan Heymensz.'s brother Gysbrecht Heymensz.
van der Hoeve. He was a second cousin of Johannes Vermeer. (Obreen 1877,
1: 65.)

286. July 1661. In part I of the estate papers of the well-known Mennonite faiencier
Hendrick Marcellis van Goch, there appears among the debts for faience products
delivered that are said to be uncollectible and worthless by his heirs the following
entry: "Reynier Baltense in the green meadow in Gorcum owes the sum of 122
guilders 19 st." ("in de groene weij tot Gorcum . . . schuldig 122 gulden 19 st.").
Reyneir Balthens lived in "de groene weij" in Gorinchem. In part III of these estate
papers, we find that Reynier Balthens "was still owing" ("was schuldig . . . noch")
39 guilders 8 stuivers. (Delft G.A., Orphan Chamber, *boedel* no. 635 I and III.)

287. 30 September 1661. Maertge Jans, widow of Jan Heijmensz. van der Hoeve, is buried in the New Church. (Delft G.A., Burial files, New Church.)

288. 10 December 1661 and 4 January 1662. Johannes Vermeer, master painter in this city, constitutes himself guarantor for Clemens van Sorgen for the sum of 78 guilders claimed by Philips van der Bilt from the said Van Sorgen and for which the same Van der Bilt has been keeping two Japanese robes belonging to him, Van Sorgen, which robes Van der Bilt has brought to the town hall in this city, on the order of the lords aldermen, so that they might be picked up by him, Van Sorgen, under the benefit of the guaranty, he [Vermeer] promising to pay and settle the sum together with the pertinent legal costs, renouncing *beneficium ordini sine excussionis* [the guarantor's right to compel the creditor who has sued him before the principal to sue the principal first].

A marginal notation, dated 4 January 1662, reads: "Philips van der Bilt appeared before the Secretary of the Town of Delft and discharged Joannes Vermeer of the deposited adjoining guarantee." (Delft G.A., "Register der Acten van Cautien voor Schepenen van Delft," f. 74, first published in Obreen 1881, 4: 293–94. My translation is based on Blankert 1978, p. 147.)

289. 10 December 1661. On this date Maria Thins bought the grave in the Old Church in which various members of her family were later interred. (Van Peer 1968, p. 223.)

290. 14 May 1662. Maria Thins instructs her family notary in Gouda to amend her testament of 1657. She adds to the silver and gold that Catharina has already received from her a gold cross, two silver dishes, and a gilded wine tankard. She gives to her goddaughter Maria, in the form of a predecease bequest, a sum of 200 guilders, and to the other children [unnamed] of Catharina and Vermeer together a sum of 400 guilders. She also gives her son-in-law Johan Vermeer an annuity of 50 guilders per year in the form of a similar bequest, so long as he shall live, as interest on a capital sum [ca. 1,250 guilders] that must remain intact during his lifetime, and, after his death, will accrue to his children born of Catharina. She deeds 20 guilders to a servant, provided the latter will have lived with her three years before her [testatrix's] death and have deserved the bequest, to the discretion of Catharina. She further stipulates that Willem and Catharina will receive the usufruct [i.e., the rents] of her landed properties in Bon Repas and Oud Beijerland. These properties will remain unalienable not only for the lifetime of Catharina and Willem but for that of their children. They will finally accrue in the form of disposable property to her grandchildren. The provisions concerning Willem Bolnes are set forth in the text. (Gouda G.A., records of Notary N. Straffintveldt, no. 240, fols. 104–105, cited in Van Peer, 1978, pp. 24–25.)

291. (Between 14 August and 31 December) 1662. "The officiating headmen in this year were Cornelis de Man, Arent van Sanen, Aelbrecht Keijser, Johannes Vermeer, Jan Dirckse van der Laen, Ghijsbrecht Kruijck." The order in which the names are recorded in this entry in the register of all the new masters and shopkeepers belonging to the Guild of St. Luke suggests that Cornelis de Man was in his second year as headman ("outgoing headman") and Johannes Vermeer in his first ("incoming headman"). Arent van Sanen and Jan Dirckse van der Laen were glassmakers, Aelbrecht Keijser and Ghijsbrecht Kruijck faienciers. (Obreen 1877, 1: 68.)

292. 17 January 1663. "On this date there appeared before me, notary, Willem Bolnes, living near Schoonhoven, and acknowledged that he owed his mother Juffrouw Maria Tin the sum of 300 guilders arising from debts she had paid on his behalf and from moneys given him for his own use." He promises to return the

money at 4 percent interest within three years. To ensure the repayment, Willem assigns to his mother by the present act the three-year's proceeds from three morgen of osier lands located in Gellekenes in the Barony of Liesveld belonging to him as owner of a certain vicariate concerning these osier lands and thus entitled to the osier growth in 1663, 1664, and 1665. He promises not to alienate the lands in this period. The act is passed in the house of the Joffrouw Maria Tin in presence of Johannes Vermeer ["master" crossed out] painter and Wouter Jansz. Bylt [or Bijl] stonecarver ("steenhouwer"). (Delft G.A., records of Notary G. van Assendelft, no. 2130, act. no. 74.)

293. 24 April 1663. Tonis Jansz. Back, baker, Aryantge Claesdr., widow of Jan Thonisz. Back, his mother, and Claes Pietersz. Hoflandt, all living in the Vlamingstraet, borrow 150 guilders at 5 percent for one year from Margarita Molyns, widow of Johannes Sneewints. (Delft G.A., records of Notary C. Brouwer, no. 1660.)

294. 11 August 1663. "A Delphes ie vis le Peintre Vermer qui n'avoit point de ses ouvrages: mais nous en vismes un chez un boulanger qu'on avait payé six cens livres, quoyqu'il n'y eust qu'une figure, que i'aurois creu trop payer de six pistoles." (Monconys 1666, 2: 149.)

295. 16 October 1663. Mathijs Jorisz. Duijmhoff, 25, and Michiel Michielsz. Buijou, 24, declare at the request of Sr Heindrick Jacobse van der Houck and Jan van Acker, headmen of the carpenter and masons guild, that they were present in the house of Reinier Vermeer, in his life innkeeper in Mechelen, when they heard Jan Jonasz. and Isaac Cornelisz., both master carpenters, discuss the price of a cord of old and new lumber. Both deponents are illiterate. (Delft G.A., records of Notary J. van Ruiven, no. 1967.)

296. (Between 12 November and 31 December) 1663. "The officiating headmen of this year were Joannes Vermeer, Arent van Saenen, Gijsbrecht Cruick, Anthonij Pallemedes, Frans Jansz. van der Fijn, Jan Gerritse van der Houven." Johannes Vermeer was second-year ("outgoing") headman, Palamedes ("incoming") first-year headman. Arent van Saenen and Frans van der Fijn were glassmakers, Gijsbrecht Cruick and Jan Gerritse van der Houven faienciers. (Obreen 1877, 7: 69.)

297. 9 February 1664. An entry among the debts owed for medicines delivered due to the estate of Maria van Leeuwen [the wife of Dirck de Cocq, apothecary], who had died on 17 November 1663, reads:
 Jan van der Meer painter for *utsupra* [medicines] 6 guilders 13 st.
Vermeer's Roman Catholic neighbor, the sculptor Adriaen Samuels, owed 7 guilders 5 stuivers; Abraham de Coge, the Roman Catholic painter, faiencier, and art dealer owed 1 guilder 14 stuivers. Annitge Thomas owed him 24 guilders 8 stuivers, but he owed her 36 guilders 4 stuivers for school money for Susannetgen Gommelraet. De Cocq was almost certainly Roman Catholic. (Delft G.A., records of Notary N.Vrijenbergh, no. 2061, fol. 21.)

298. 4 August 1664. In the "inventory of the goods left by Jean Larson, in his life sculptor in The Hague . . . drawn up in the house of the deceased," an entry reads:
 A face by Vermeer ("een tronie van Vermeer")
When the sculptor's paintings were sold at auction and the proceeds recorded in the "contrabouck," also called contracedulle, "an original by Van der Meer" ("een principael van Van der Meer") sold for 10 guilders. This was less than for paintings by Martinus Lengele (14 guilders), Le Ducq (29 guilders 5 stuivers), Engelse (15 guilders 5 stuivers), [Adriaen] Van der Cabel (12 guilders 10 stuivers and 15 guilders), Verbrugge (43 guilders), [Cornelis?] Holstein (25 guilders), and Willingh (86

guilders) but more than paintings by Diest, Cool, Van der Bilt, Schinkel, and [Anthony van] Ravestein (a portrait for 8 guilders 15 stuivers). Bredius 1915–1921, 1: 325 and 328.

299. 14 December 1664. An entry in the estate papers of Elisabeth Jansdr., widow of Willem de Godder, headed "notarial obligation," reads: "Reynier Jansz. Vosch innkeeper, living on the Market Square as principal and Johan van Santen living on the Corn Market as guarantor and co-principal, owe the sum of 250 guilders at an interest of 5 guilders 5 stuivers per 100 a year, the first interest on which was due and delivered on 5 December 1669 [apparently an error for 1649], and further following [one illegible word] in front of Notary Simon Mesch and certain witnesses in date 5 December 1648. Thus here 250 guilders, [there] remains the [outstanding] interest since 5 December 1663." (Delft G.A., records of Notary A. Verkerck, no. 2200.)

300. 28 November or December 1664 [the month was omitted from the date. However, the interest payments due on the debt for 150 guilders listed in the text below suggests it must have been November or December]. An undated petition of Maria Thins to the sheriff, aldermen, and magistrates of Delft, which was inserted out of chronological order in the records of Notary Jacob Spoors, was found next to a list of the debts that her son Willem owed her, which probably accompanied the petition. The list of debts is dated "op den xxviiie xvi vier ende tsestich" (the 28th 1664). The petition reads as follows:

"First the supplicant reverently informs the Honorable Lords ("E. E. Achtb.") of the law ("Weth") that it has been necessary, owing to the bad comportment of her son Willem Bolnes and of his inability to regulate himself (after obtaining the consent of the honorable burgomasters of this city), to confine and secure him in the house of the late substitue sheriff Anthony Taerlingh. The supplicant, having supplied a notable sum of money both in cash and in back expenses, had requested from their honors to allow her to rent certain vicariate lands that he possessed, namely five morgen of land lying in the seigniory of Raasbergen and Berchambacht; a farm ("hoffije") in the Schuttersteech under Schoonhoven; and twelve morgen of land lying in Gellekenes and the barony of Liesvelt, which were all unrented, and to receive the rent money and to proceed in all respects as might be needed. Upon which request the honorable lords had written in the margin that they authorized the rental of these lands for one year but they they would dispose later [i.e., concerning future rentals] upon subsequent request. In consequence of the authorization, the supplicant had leased the aforementioned lands for one year, but at a much lower price than she would have leased them for a longer period. Among these lands there are three morgen of osier lands, the wood growth of which can only be harvested ("affgepact") every three years. This wood growth had been assigned to her by Willem Bolnes in recognition of an important sum that he owed her not only for money she had given him but over board money [she had given] to the late substitute sheriff Anthony Taerlingh [on his behalf], as well as the master's fee given to the doctor and surgeon to cure an accident done to the aforenamed Bolnes ("aanden voornoemden Bolnes gedaan"); and over other alimonies ("alimentatien") expended and still being expended, altogether amounting to 1,502 guilders 9 stuivers 12 pennies, according to the written statement that she had caused to be made and delivered to the Honorable Lords. So she, supplicant, turns to the Honorable Lords beseeching them for the above reasons to be pleased to authorize to allow her to rent the abovementioned vicariate lands for at least the next ten years and to collect the rental moneys as they will fall due and to do everything that might be necessary in this connection." The accompanying

statement concerning Willem Bolnes's vicariate lands and the debts owed to his mother follows.

First five morgen of land in the seigniory of Raasbergen and Berchambacht which land the aforenamed Bolnes has leased to . . . [left blank].
without her Joffr. Thins knowing rightly for how much and how much Bolnes has received from the same . . .
Which land is now unleased ("uijte huijr")
Item, a certain farm in the Schuttersteech onder Schoonhoven
This farm has been leased by Bolnes to the Lord and Master Blocq, advocate in Schoonhoven, for the sum of 12 guilders, but he had already received money in anticipation so that there was little or no rental money to be got.
Lastly eight and a half morgen of land in Gellekenes and the Barony of Liesvelt, of which three morgen were osier lands. The growth of the osier lands can only be harvested every three years, only two of which have elapsed. Even though Bolnes has assigned his mother the three-year growth as part payment to be deducted from his 300 guilders debt at 4 percent interest running since 17 January 1663 [doc. no. 292], she has received nothing so far. The remaining five and a half morgen were leased (with the authorization of the Honorable Lords written in the margin of a certain request) to Cornelis Jansz. Fuck for 92 guilders in a lump sum, the taxes and other levies on the land having to be paid by Joffr. Thins. But no rental money has so far been paid.
Other goods belonging to Willem Bolnes:
The aforenamed Bolnes had himself built ("timmeren") a little house on the osier lands mentioned above where he formerly lived. This little house (on the basis of the above authorization) was rented by Joffr. Thins to Maartgen Meessen for 10 guilders 10 stuivers, which she [Thins] has not yet received.
Movable goods:
First a bed and ear pillow which have been lent to Bolnes by his mother with the consent of his sister Joffr. Catrinne Bolnes, wife of Sr. Johannes Vermeer, since the bed came from the estate of the late Johan Thin, which goods were assigned to his [Bolnes's] mother in fidei commissum subject to the right of lifelong use ("lijf-tocht") and which, upon her death, must devolve upon Joffr. Catrina Bolnes.
A bed sheet
Two blankets, one white and one green
Two ruffs
One shirt
One handkerchief
Three little tole boxes ("bussies")
A colored mantle
A pulpit
Two pistols ("snaphaanslope")
Together with some other linen and wool articles belonging to Bolnes for the duration of his life that were locked in a trunk, which, along with the aforementioned movable goods, were sent and delivered to the house of the subsitute sheriff Taerlingh.
In addition the aforenamed Bolnes owns two mantles which he left for security with a widow and innkeeper at the fording place under the Barony of Liesvelt for 50 guilders that he owed her for drinks consumed.
Liabilites and debts owed by Bolnes to his mother:
Two obligations for three hundred guilders at 4 per-
 cent interest passed before Notary Geraerd van As-
 sendelft on 17 Januàry 1663 300 f.

Three years' interest, secured on the growth of osier lands to be harvested in 1666	36 f.
An obligation for 150 guilders dated 2 November 1660 at 4 percent interest	150 f.
Over four years' interest on the above capital sum from 2 November 1660 to 2 November 1664	24 f.
The sum of 50 guilders advanced by her in two parts to pay for a one-third share in the yearly income of the vicariate lands to the receiver of the spiritual goods ("ontfanger van de geestelijcke goederen"), following the receiver's receipt	50 f.
Paid by Joffr. Maria Thins for her son to Johan Heijndrixz. van der Wiel to liquidate an obligation that he owed him	25 f.
Given her son to pay for various charges on the vicariate	36 f.
Paid to Maartge Baarthouts as solicitation money to be freed of the obligation of paying a third share in the income of the vicariate	4 f.
Paid for her son to Frederick van Gissen in Schoonhoven according to his receipt	4 f. 16 st.
Paid for him to Heinjdrick van Breuwel, baker in Schoonhoven, for bread delivered	4 f. 15 st.
Paid for him to Neeltgen van Hassel, shopkeeper, for foodstuffs delivered	28 f. 14 st.
To Johannes Gisius, innkeeper in Schoonhoven, for drinks consumed	1 f. 10 st.
To Pieter Ariensz., innkeeper at the fording place	1 f. 8 st.
To Claes Pietersz. according to his receipt	4 f.
To Heyndrick Evertsz., smith, according to his receipt	2 f.
To Andries Coenen for beer according to his receipt	2 f. 10 st.
To Pieter Gerritsz., miller, for a quarter year's boarding costs ("montcosten") for Bolnes	45 f. 10 st.
To Cornelis van der Burch, brewer in Schoonhoven, for beer delivered	35 f. 2 st. 8 pen.
Paid for various imposts and charges on the vicariate lands	12 f. 16 st. 12 pen.
To Christina Assuerus, shopkeeper on the Boterbrugge [probably in Delft], for white linen cloth delivered to Bolnes	12 f. 12 st.
To Dirck Deurhoff and Geertge Deurhoff according to their separate receipts	32 f. 9st.
To Isacq Jacobsz. Vermandel, cloth dealer, for delivered cloth for Bolnes	81 f. 18 st.
To Maria van Ruijven, shopkeeper, for two shirts for Bolnes [Maria van Ruijven was the sister of Pieter Claesz. van Ruijven, who had advanced her the money to start her shop.]	5 f. 5 st.
Paid for two pairs of slippers for Bolnes	3 f. 14 st.
To Gerrit Lievensz., carpenter, for wages due to him by Bolnes	12 f.

Paid to the widow of Doctor Van Beest and to Mr. Marcus Bres, surgeon, together the sum of 72 guilders to cure a certain accident done to the aforenamed Bolnes, plus 2 guilders to Bres for an additional cure	74 f.		

And as Doctor Beest had ordered that Bolnes, in connection with the cure for the accident, should consume some wine, there were paid on his behalf 12 guilders to Mother Baltes ["moer Baltes"; most likely Vermeer's mother Digna Baltens, in Mechelen] and 4 guilders 4 st. to Lodewijcq van Pollinckhoven, according to their respective receipts 16 f. 4 st.

To the apothecary Both for two purgatives for Bolnes 1 f. 12 st.

To the tailor Jan Jansz. for making up some clothes for Bolnes 31 f.

To same for the same purpose 7 f. 5 st. 8 pen.

Paid to the substitute sheriff Anthonij Taerlingh for a year's boarding costs for Bolnes 310 f.

Paid to Barent van Milanen in Schoonhoven for planting 7,000 new slips in the meadows and mudflats of the osier lands mentioned above 42 f.

Over wages for the same 43 f.

Paid in Dordrecht for Bolnes where he had been boarded to cure his accident, for various expenses including travel costs 20 f.

For miscellaneous expenditures on Bolnes's behalf 31 f.

Paid to Michiel Stepsius notary to draft two separate requests, each 1 guilder 14 st. and 32 st. for the registration of the two requests with the (city) secretary 5 f.

To same for preparing this statement and inventory on 28 sheets 2 f. 18 st.

For a duplicate to be delivered to the lord aldermen 1 f. 10 st.

Thus done and inventoried by Joffr. Maria Thins who declared that all the foregoing debts and expenses were correct. (Delft G.A., loose sheets found in the records of Notary J. Spoors, no. 1681, which run from 1675 to January 1677.)

301. 19 October 1665. "In the name of the Lord . . . amen . . . in the forenoon, around 12 o'clock, on the 19th of October of the year after the birth of our Lord and Savior Jesus Christ 1665, there came and appeared before me Nicolaes Paets, public notary, . . . residing in Leyden, . . . Juffr. Maria Simonsdr. de Knuijt, wife of Sr. Pieter Nicolaesz. van Ruijven living on the east side of the Oude Delft in Delft, known to me notary, healthy in mind and body . . . , letting it be known that there is nothing more certain than death and less certain than the time and hour thereof, not wishing therefore to part from this world before having disposed of her temporal possessions . . . , commending her soul before it had departed from this mortal body to the infinite mercy of Lord Almighty and her body to a Christian burial, approving the acts of guardianship and exclusion of the Orphan Chamber passed on March 2nd 1657 and 24 March 1664 before Notary W. van Assendelft by the side of her dear husband, [phrase added in margin: and the testament and act of guardianship she and her aforesaid husband have passed on this date before me notary], and disposing anew [of her possessions], so she, testatrix (in case she were to live longer than her husband in which case all that follows shall be ordained and

take place but not otherwise), names as her universal legatee, of all the goods, obligations, and assets, none in the world excepted, that she might leave after her death, her child or children that she already has or that, through the grace of God Almighty she might still beget, and, in case of the death of one or another of them, the child or children and further descendants of the same. However, in case she, testatrix, should leave a child or children under age she has ordained a guardianship over the same on this date and she wills that this act be complied with in all respects, along with the artwork ("schilderkonst") that is spoken of there; but, in case she were to survive her husband and die without child or children or the latters' descendants ..., she wills and orders by the present that all her property, none excepted, and without the least deduction for the claims of collateral descendants ("trebellianique") or other shares recognized in law, shall devolve on the Orphan Chamber of the town of Delft for the benefit of the poor supported there to the extent of one-third, on the Camer van Charitate in the same town for the benefit of the poor for a like third, and for the last third on the Preachers of the true Reformed Religion ("Predicanten van de waere gereformeerde Religie") in Delft to be distributed by the same and by each of them (after the expiration of the above-said usufruct [In fact no such usufruct has so far been mentioned in the document: the notary was probably referring to the usufruct on the property (the best artwork excepted) that Pieter van Ruijven and Maria de Knuijt in their joint testament had wanted Pieter's sisters Maria and Sara van Ruijven to enjoy.]) for the relief of expelled preachers ("verdrevene Predicanten") and of others having studied the H[oly] Theology who in this time might apply to them for help and assistance [phrase added in the margin: except that the sisters of her, testatrix's, husband named Maria and Sara Nicolaesdochteren van Ruijven, both, or the survivor of the two, will be permitted, for their upkeep, their lifelong, to enjoy the usufruct or fruit of all the property left after her, testatrix's, death, of whatever nature it might be]. They will be able to take whatever movable goods they wish, none excepted, save the best paintings ("schilderkonst"). Maria and Sara van Ruijven will administer the estate as they please. However if the Regents of the Orphan Chamber offer to give them the administration, they will be able to do so to the highest satisfaction of the testatrix. ... In the above-mentioned case [this marginal notation seems to refer to the case if Maria de Knuijt were to die after her husband without child or children; there is also the possibility that the condition may be merely that Maria de Knuijt should survive her husband] the appearer leaves and bequeathes to the children of the late Vincent de Knuijt her brother, and in case of predecease of one or more of them, to the child or children of this predeceased child and further descendants by representation in place of their deceased parents, altogether 6,000 guilders under the supervision of the Orphan Chamber of the town of Delft, to be administered by the Secretary of the Orphan Chamber until each of these will have become of age ..., [marginal addition: to Johan van Ruijven Notary, her husband's brother, and in case of his predecease to his child or children, the sum of 1,000 guilders]. She bequeathes to Floris Visscher, merchant in Amsterdam, her husband's cousin ("neve") and in case of his predecease to his child or children the sum of 6,000; ditto to Johannes Dircxz. de Geus, surgeon, and in case of his predecease to his child or children and descendants by representation the sum of 1,000 guilders; also to Johannes Vermeer Painter 500 guilders [phrase crossed out: and in case of his predecease neither to his children nor to his descendants]; [marginal addition replacing crossed-out sentence: however, in case of his predecease the above bequest will be annulled ("sall 't voors. legaet te niet zijn")]; all of which bequests shall be made within three months after the testatrix's death. ... Thus

done and passed by the appearer on the day, month, and house in the town of Leyden in my, notary's, house in the presence of Johannis van Kijckenburgh and Adriaen Croock as witnesses. (Leyden G.A., records of Notary N. Paets, no. 676, act no. 99.)

302. 23 May 1666. Betrothal of Willem Bolnes with Maria Gerards de Veer in Waal-wijk (Swillens 1950, p. 193). Swillens writes that the couple were married on this date, but, from doc. no. 306, it appears rather that they were only betrothed and that the marriage never took place.

303. 4 June 1666. Maritge Wouters, 50, and Heindricge Dirxdr. Veremans, 28, testify before Notary Boogert at the request of Maria Thins. The deposition is extensively summarized in the text (Ch. 9 at note 26) and in O-H II, p. 52. (Delft G.A., records of Notary F. Boogert, no. 2006.)

304. 24 June 1666. Annetge Harmens, widow of Antoni Taerling, former substitute sheriff of Delft, and Maeyke Pieters, the wife of Hermanus Taerling, both living in this town, make their deposition at the request of Maria Thins. The deposition is extensively summarized in the text and in O-H II, pp.52–53. (Delft G.A., records of Notary F. Boogert, no. 2006).

305. 3 July 1666. Deposition of Willem Coorde, Gerrit Cornelisz. and Tanneke Ev-erpoel. The entire deposition is translated in Chapter 9. The complete original is transcribed in O-H II, p. 53. (Delft G.A., records of Notary F. Boogert, no. 2006.)

306. 18 July 1666. Hermanus Taerling and Maeyken Katersvleet, and Johannes Payer, all residing within this city, declare at the request of Maria Thins that they have heard on various occasions out of the mouth of Willem Bolnes, who is pres-ently in the house of the aforenamed Taerling, that Marij Gerrits van Waelwijck, living in the house of the same Taerling as service maid, had informed him [Bolnes], eight days before Easter, that the same Taerling had ordered her to set him, Bolnes, fast [lock up, emprison, prevent from going in and out], (who up till then had been allowed to go in and out from time to time), just as he had formerly been held fast in the house of Taerling with knowledge of the magistrates, and that when he, on Sunday before Easter, had got dressed to go to church, she, Mary Gerrits had told him that it was now the right time to leave, otherwise he would again be set fast, and he was thereby moved to put together two bundles of clothing, and had then gone out of the house of the aforenamed Taerling. He had then taken his leave of her by the little Schaeken bridge in this city (without having gone to church) and that she secretly had followed him to Gouda. There he had asked her to marry him. She had spoken to her relatives about it and had asked Bolnes to go to Waelwijck with her to speak to her relatives. There he had discovered that the relatives had no knowledge of the marriage or the courting ("vriage") and that she said no court-ing or vows had yet taken place, but that he had given them further knowledge that since he saw that she was moved to marry him, he was inclined to marry her. How-ever, he had later come to understand that he would have been greatly cheated. The witnesses further declared that Bolnes had told them that when a certain attestation by the witnesses had come from The Hague [?] concerning Mary Gerrits and that she had to bring in a contrary attestation that she was an honest young woman ("dochter"), the same Mary Gerrits had said that finances must be sought to obtain money. He had then said he knew where a certain mantle of his father lay and that one should bring this mourning mantle to the lending bank ("Bank van lening") and pawn it there to obtain money. She had then used a woman for this purpose who had obtained 16 [?] guilders, consisting of 5 ducatoons and 5 stuivers. She had given the woman 5 stuivers for her troubles and had gone away with the 5

ducatoons so that he had not got back any of the money. When she returned she had on a pair of new stockings and a little gold ring. Taerling further declared that he was informed that Mary Gerrits had told the father of the aforenamed Bolnes that she had a writ from the court allowing her to visit Bolnes freely and that she had been in his [Taerling's] house but he [Taerling] had not allowed her to visit the aforenamed Bolnes ("doch dat hij haer by de voorn. Bolnes niet en hadde willen laten"). Taerling further declared that he was unaware, first, that he had told her [Mary] that Bolnes should again be set fast or that he [Taerling] had any order to do so and that Mary Gerrits had absolutely lied about it and thus had lured Bolnes out of his house on this false pretext. Similarly, he declared it to be untrue that Mary Gerrits had come to his house in order to speak with Bolnes or that he had spoken with her or she with him since her departure, much less that she had sought any such thing from him ("veel min sodanige versoec aen hem soude hebben gedaen"). The notary's clerks, Adriaen Boogert and Willem van Westerhoven, witnessed the deposition. (Delft G.A., records of Notary F. Boogert, no. 2006.)

307. 21 January 1667. Juffr. Maria Thins names Maerten Kemels attorney ("procureur") before the Court of Justice of Holland to act against all persons but especially against Maria Gerrits, spinster, in Waelwijck, to sue, appeal, etc., on her behalf and in her name. (Delft G.A., records of Notary F. Boogert, no. 2006.)

308. 22 January 1667. Jouffr. Aleydis Magdalena and Cornelia Clementia van Rosendael draw up a procuration on behalf of heer Michiel van Diest, captain of the militia and merchant in Rotterdam, to settle a dispute between the constituents and Heijndrick de Haes, also merchant in Rotterdam, concerning the purchase of a house and lands. The act is witnessed by heer Johannis Vermeer and by Bartholomeus Delen. (The Hague G.A., records of Notary W. van Millert, no. 483.)

309. 23 January 1667. Declaration by Willem Bolnes, bachelor, presently confined in the house of Harmen Taerling. This declaration [which differs from a deposition in that it was not explicitly made at the request of any petitioner] is extensively summarized in Chapter 9. (Delft G.A., records of Notary F. Boogert, no. 2006.)

310. 7 March 1667. Juffr. Maria Thins, living in this city, having been authorized by the city magistrates ("heeren van de Weth") to administer the goods of her son Willem Bolenes, constitutes and empowers Jan van Putts attorney in Schoonhoven to become acquainted with and to pursue certain affairs that she has in Schoonhoven, Gellkenes, and surroundings on behalf of her son so that he may obtain certain goods that he possesses there and especially from and against Cornelis Jansz. Fuck, tenant of some lands belonging to her son, to obtain a sentence, appeal, etc., and act in her name concerning all these matters. (Delft G.A., records of Notary F. Boogert, no. 2006.)

311. 10 May 1667. Juffr. Maria Thins, living in this city, for herself and in her capacity as mother and guardian of her son Willem Bolnes, having been authorized to administer his assets, constituted and empowers Johannes Vermeer, her son-in-law, to obtain from the hand of her debtors all the moneys due to her, and, in particular, to receive the sum of 3,400 guilders capital and the interest due on this sum that are owed to her privately by Pieter Crijnen, which have been secured by a mortgage on a certain brickmaking place ("steenplaets") lying in Moort near Gouda, which had been sold to him by her, constituent, and in addition the sum of 250 guilders that are due to her, as heir of her sister Cornelia Thins, from the aforenamed Pieter Crijnen, together with the interest thereon, and also to obtain from the church masters of Moort or from its regents the sum of 1,000 guilders plus interest, and also the sum of 200 guilders that in her aforementioned capacity are due to her

from the sale of the osier lands that her son had sold under the supervision of the
magistrates of Liesvelt. The constituee [Johannes Vermeer] should obtain receipts
in due form from all these debtors. He should then reinvest or otherwise alienate
("demanueren") the proceeds as he shall see fit. He should also pay out any debts
that the constituent may owe and generally, both in receiving and expending [the
moneys], act and behave as if she, constituent, were present. (Delft G.A., records
of Notary F. Boogert, no. 2006.)

312. 10 July 1667. A child of Johannes Vermeer is buried in the New Church on this
 date. He is laid in the grave bought by Maria Thins on 10 December 1661. The
 grave is said to be empty except for this infant child. (Van Peer 1968, p. 223.)

313. 27 September 1667. Maria Thins, living on the Oude Langedijck, very well
 known to the notary, draws up her testament. An extensive summary of this doc-
 ument appears in Chapter 9 and in O-H II, pp. 54–55. (Delft G.A., records of No-
 tary F. Boogert, no. 2006. This testament was first cited in Van Peer 1957, p. 95.)

314. 3 October 1667. Testament of Annetge Jans, spinster of age. She leaves most of
 her property to her sister Maritge Jans. Among many small bequests is one for three
 guilders and three stuivers to Margareta Hubrechts [bookseller on the Oude Lan-
 gendijck]. She appoints Johan Henrixzoon van der Wiel as executor of her testa-
 ment. "Johannes van der Meer artful painter" witnesses the act. (Delft G.A., rec-
 ords of Notary C. Bleiswijck no. 1895, fol. 68–69ᵛ.) A testament of Jannetge van
 Buyten, "sister of the baker Hendrick van Buyten," dated 3 March 1667, for which
 Jan Heyndricksz. van der Wiel was named executor, and which was witnessed by
 Vermeer is mentioned in Van Peer 1957, p. 95. In spite of careful, repeated searches
 through Notary Van Bleiswijck's protocols (for which Van Peer cites no volume
 number), this document could not be found. Furthermore, no sister of Hendrick
 van Buyten with this name has been identified.

315. 1667. Johannes Vermeer is mentioned twice in Dirck van Bleyswyck's *Beschry-
 vinge der stadt Delft*, printed by Arnold Bon, bookseller on the Market Square.
 The first only mentions his name and his birth year, 1632, the last name in a list of
 eminent Delft painters who are still alive. The second appears in a poem by Arnold
 Bon on the death of Carel Fabritius, of which two versions are known. The first
 reads:
 Thus expired this Phoenix [Carel Fabritius] to our loss
 In the midst and in the best of his powers,
 But happily there rose from his fire
 Vermeer, who, masterlike, trod his path.
 The second reads:
 Thus died this Phoenix when he was thirty years of age
 In the midst and in the best of his powers,
 But happily there rose from his fire
 Vermeer, who, masterlike, was able to emulate him
 ("die't meesterlyck hem na kost klaren").
 (The translations are those in Blankert 1978 pp. 147–48. Albert Blankert discov-
 ered the second version in a copy of Van Bleyswyck's book in the Widener Library
 of Harvard University.)

316. 28 January 1668. Maria Thins, living in this city, constitutes and empowers Isack
 Luijt, secretary of the Orphan Chamber in Gouda, to collect in her name and on
 her behalf, at the office of the heer collector Groendijck in Gouda, the interest-
 bearing obligation ("losrente") registered folio number 4685, for 900 guilders cap-
 ital, two other obligations for 600 guilders each at this same office registered folio

3169, and two more obligations each for 400 guilders, registered folio 3309, also to obtain from the same office, together with the interests. The obligations are derived from the estates of Willem Jansz. Tin or Diewertje Heijnsbeecq. Also he is instructed to collect the interests on the sum of 800 guilders mortgage on the house of Gerrit Leijstarre. The witnesses are Philps de Bries and Willem van Westerhoven. (Delft G.A., records of Notary F. Boogert, no. 2007.)

317. 2 May 1668. Deposition of Maertge Wouters, wife of Francoijs Benetou[?], corporal in the company of the heer Captain Hunburch, at the request of Juffr. Maria Tins, mother of Willem Bollenes. The act is extensively summarized in Chapter 9. Harmanis Taerelinck and Maeijken Pieters Katersvelt both sign in a literate manner. Maertge Wouters sets her mark. (Delft G.A., records of Notary F. Boogert, 2007.)

318. 2 June 1668. Joffr. Maria Thins, living in this city, declares that Diewertje Heijndrix Dirxdr. van Hensbeeck, her mother's sister, deceased in Gouda, by her testament of 27 November 1603, passed before Notary Adriaen Vermeulens Jansz. in Gouda, had named Catarina Heyndrix, the appearer's mother, together with the children of the late Dirck Heyndrixz. and Cornelis Heyndrixz., and, after their death, their children by representation, in such a way that the property of Diewertje Heyndrix should be divided into three portions, with the provision that the appearer's mother and, after her death, her children, of which the appearer was one, should not draw more than the usufruct and the yearly income, during their life long. She also desired that the main capital should be restricted ("verbonden") and subject to restitution, up to the grandchildren of Catarina Heindrix, who are now the appearer's children. After her daughter Catarina Bolenes was married to Johannes Vermeer, the capital became unrestricted in his name ("op welcke de voorsz. goederen jegenwoordig los sijn"). So the appearer has constituted and empowered by the present her son-in-law Johannes [crossed out: Van der] Vermeer to release and collect the sum of 400 guilders out of the appearer's portion of the assets of Diewertge Heindrix, together with the interest on this sum, at the Orphan Chamber of Gouda [where, by provision of the testament of Diewertge Heindrix the unrestricted interest-bearing obligations of the assets of Diewertge Heindrix were to be deposited] and, in case any further capital sums may be released, up to half of the assets of Diewertge Heindrix deposited in the Orphan Chamber representing part of the appearer's portion, this half [portion] being due to her aforementioned daughter or the constituee, as having married her, as having only two children. [This sentence is somewhat confused. What is apparently meant is that the one-half share is due to her, Catharina Bolnes, because her mother Maria Thins had only two children. Catharina herself must at least have had seven children who were still alive by this time (see note 58 of ch. 12).] Furthermore, the constituent [Maria Thins] orders the constituee [Johannes Vermeer] to collect from the Orphan Chamber in Gouda all such usufruct as are due to her her life long, as having been received out of the hands of her son. In any case, the appearer declared, that her son Johannes van der Meer, is empowered to acquit and discharge the Orphan Masters, to give receipts and quittances to the Orphan Chamber in so far as it may be necessary, with the promise that the constituent may never be troubled or molested for the capital or the interests thereon, and that from now on everything will be done by her son [son-in-law crossed out] as if she were present. The ambiguous sentence cited above is transcribed in O-H II, pp. 55–56. (Delft G.A., records of Notary F. Boogert, no. 2007.)

319. 31 July 1668. In the affair pending before the Court of Holland between Maria Thins of Delft, separated from her husband Reynier Bolnes, the appealing party

("impetrante van mandement van authorisatie ende rau actie") and defendant in the countersuit ("verweerster in reconventie") on the one hand, and Maria Gerrits van Waelwijck defendant ("gedaechde") and plaintiff ("eischeresse") in the above-mentioned case [i.e., the countersuit], the court having heard the oral pleas and having examined the entire matter orders the parties to address their suit, reply, and rejoinder in writing within fourteen days, and condemns the defendant ("gedaechde") in the costs incurred in the pleas, which are estimated at 32 guilders. Done in The Hague by the Lords and by Frederick van Dorp etc. (The Hague, A.R., "Interpositien van de decreten by den Hove van Holland," 1664–1675, Archief Q, no. 85.)

320. 10 September 1668. Joris van Singe living in Rotterdam authorizes Catharina Dasvelt, widow of Dionys van Swalewenburch, formerly widower of the late Annitge Jans van der Houve, daughter of Jan Heymensz. van der Hoeve, baker during his life, to demand 1,000 guilders plus interest at 5 percent owed to him since 1 September 1667 on a mortgage on a house on the north side of the Nieuwe Straat. The mortgage, according to the original contract deposited in the Orphan Chamber, dated 29 September 1651, was assumed by Jan Heymensz. van der Houve as principal, Reynier Vos, painter ("schilder"), and Gysbrecht Heymensz. van der Houve, maker of footstoves, as guarantors or sureties. The constituent demands that the money be paid witin six months. (Delft G.A., records of Notary A. Verkerck, no. 2202.)

321. 7 October 1668. Arij Pietersz. Huysloot, living in this city, transfers in full property to Arijaentgen Claes, widow of Jan Theunisz. Back, his mother-in-law, his one-sixth share in the inheritance from his late uncle, Ary Crijnen Stouthart, during his life fish buyer in Maessluijs, consisting in both movable and unmovable property, gold, silver, and coin. He makes this transfer because his mother-in-law supported, ever since her death, the two children procreated by his late wife Trijntgen Jans Back. He declares that the assistance in food, drink, and clothing that she gave the children has already been in excess of his portion of the inheritance. Aryaentge Claes is authorized to go to the house of the late Arij Crijnen and to help make the inventory of his property. She also appears before the notary to accept the transfer. (Delft G.A., records of Notary J. Ranck, no. 2121, fol. 1424.)

322. 13 November 1668. Juffr. Maria Thins, authorized to administer the property of her son Willem Bolnes, leases to Gerrit Leendersz. and Aelbert Jansz. van Oosten, for themselves as well as for their associates, the osier [timber lands] that her son possesses in the Barony of Liesvelt, between the "tiend wech" and the high dike ("hogen dijck"), for six years, of which two years will already have elapsed at the time of the kermess or Petri ad Cathedram, the sixth year falling on kermess 1672 or at the latest on St. Pieter 1673, unless, in their judgment the osiers should be allowed to stand one year longer [i.e., before being cut], in which case they should let them stand a year longer; they will then be obliged to pay for seven years. The lessees undertake to pay 84 guilders per year for the osier. They both set their mark in lieu of signature. (Delft G.A., records of Notary F. Boogert, no. 2007.)

323. 11 December 1668. Juffr. Maria Thins [crossed out: widow of Reijnier Bolones], authorized to administer the property of her son Willem Bolones, leases to Pieter Cornelisz. Trom living in Bovenbergh in Berchambacht five morgen of pasture and hayland located in the Duverodt[?] in Bovenbergh for the next four years, starting at St. Pieter ad Cathedram of the coming year 1669 and expiring on St. Pieter's 1673, and this for 155 guilders a year. Trom must pay the charges on the land ("ongelden"). Maria Thins undertakes to put up the high dike belonging to these

lands. Trom sets his mark in lieu of signature. The notary's clerks witness the contract. (Delft G.A., records of Notary F. Boogert, no. 2007.)

324. 2 January 1669. In the manner and on the conditions hereafter set forth, Dina Baltens, widow and custodian of the estate of the late Reynier Vermeer, offers for public sale by the present a house and court standing on the southwestern Corner of the Old Manshouse Path ("Oudemanshuijssteeg"), contiguous to the east with the aforenamed path and to the west with the widow of Vincent de Knuijt [the brother-in-law of Vermeer's patron Pieter Claesz. van Ruijven], extending in the back from the Market Place to the canal ("delfte"). She has brought the original deeds, the oldest of which is the sale decreed by the court of Holland on 23 May 1597 and the most recent whereby the house has been transferred to the aforementioned Vermeer on April 23, 1641, which was registered with the [city] secretary "L° three R folio 164."

At the time of the transfer of the house to the buyer, on February 1st or May 1st at his choice, the buyer will have to deposit 1,000 guilders. For the rest of the money promised the buyer will have to pass an appropriate debt instrument [mortgage].

"In reduction of which purchase sum," the buyer will have to take up [assume the responsibility for] two mortgage debts on the house; first, a capital sum of 2,100 guilders belonging to Nicolaes van Tetrode, brewer in Haarlem, at 5 percent interest, reduced to 4 percent, the interest due each year on Delft kermes, the first year's interest on which debt the buyer will have to pay on 23 April 1669; second, a capital sum of 400 guilders belonging to Arent Jorisz. Pijnacker, as guardian of the children of . . . [left blank], at 5 percent interest, also reduced to 4 percent.

The seller guarantees that the house is unencumbered of any charges or debts incurred during her own or her husband's possession, except for those mentioned above.

The seller stipulates that the price must be net of any charges on the house, including the 40th penny for the benefit of the United Provinces ("gemeenland") and the doit on the guilder for the poor.

Any person offering a bid for the house shall be obliged to maintain this bid for twice 24 hours, during which time the seller shall be free to let the purchase go through ("de coop laten volgen"), at her pleasure, and in case somebody should make a higher bid, she will be able, subsequent to a single disclosure to the auctioneer ("naer simpele denunciatie aende roeper"), to choose which of the two she wishes to designate as buyer.

The buyer will pay the auctioneer's fee, as well as three guilders for the cost of printing and distributing the announcements ("biljetten"), six guilders for the notary's preparatory work on the auction and for other services, and twice one guilder 16 stuivers for two duplicates [of the offer] with the seals of the country.

The auction occurred on 2 January 1669. The closing paragraphs of the offer are transcribed in full below:

Opgesteken twee ducatoons die int hoogste bod soude blyven ende is int hoogste bod gebleven Isaacq van Bodegraven vleishouwer voorde somme van twee duysent negen hondert vijftig . 2,950 gl. 0–0

Opgesteken drie ducatoons die 1,200 gl. soude verhogen ende afgeslagen tot op 300 gl. ende niet geruijmt

Opgehangen op 5,000 gl. ende afgeslagen tot op 3,700 gl. dog niet geruijmt.

My interpretation of these paragraphs is this. First an ordinary auction took place, each bid taken being two ducatoons (approximately 6.6 guilders) higher than the

last. The highest bid was made by the butcher Isaacq van Bodegrave for 2,950 guilders.

On the basis of three ducatoon differences, starting at a markup of 1,200 guilders above the 2,950 guilders bid and descending to a 300 guilders markup, [the house was] not sold.

Offered for 5,000 guilders and descending to 3,700 guilders, but the house was not sold. (Delft G.A., records of Notary F. Boogert, no. 2007.)

325. 1 February 1669. Dina Baltensdr., widow of Reijnier Vermeer, and Leendert van Ackerdijck, shoemaker, draw up a contract for the lease of "Mechelen," to be used as an inn as the first appearer has done for many years ("omme tot een herberge gebruijct te werden gelijc de eerste comparante de selve lange jaeren heeft gedaen"). The house is leased for the next three years starting in May 1669 and expiring on the first of May 1672; however, the lessee may move in earlier if the lessor finds the opportunity of selling her furniture and vacates the premises. The lessee will pay the lessor 190 guilders a year in quarterly installments. The lessor will deliver the house with windows and floor secure ("glass ende vloerdicht"), as the lessee acknowledges it has been delivered at the beginning of the lease. It will also have to be returned in the same condition. Any breakage or damage done by him or his family will have to be repaired at his expense. It is further stipulated that the lessor will allow the lessee to use for his own commodity the beer and wine racks ("stellingen") and the "kannebort" [the board on which jugs and tankards were placed], which is nailed fast [to the wall]. In case the lessor were to sell the house before the expiration of the contract for a given price, she will first offer it at a no greater price to the lessee. Grietge Cornelis, who also appeared, declared that she would guarantee the lessee's debt as co-principal. Vermeer's mother signed "dynae baltes" [a more or less illiterate signature]. The shoemaker signed in a barely literate way. Grietge Cornelis set her mark [a cross]. (Delft G.A., records of Notary F. Boogert, no. 2007.)

326. 16 July 1669. A child of Johannes Vermeer was buried on this date and laid in the family grave in the Old Church. (Van Peer 1968, p. 223.)

327. 5 October 1669. The masters of the Orphan Chamber of Delft in answer to the unnamed "honorable, wise, provident and very discrete lords" [almost certainly the masters of the Orphan Chamber of Gouda], dated the second of this month, state that they have examined the request "addressed to you by Jan Hendrixz. van der Wiel" to become guardian over his two presently under-legal-age daughters [i.e., less than 25], "hereupon having consulted our registers, we have found that the aforenamed Van der Wiel and his wife, by testament dated 18 September 1638, had named the survivor of the two as unique guardian with the exclusion of all other parties, including the [Orphan] Chamber, an extract of which testament was shown us today." "We deem that it is not our wont to occupy ourselves with the guardianship of such children or their property in such a case, unless we be specifically requested to do so by testamentary provisions, which did not happen in this case. Thus we are not inclined to make any further cognizance of this matter, much less to vest the aforenamed van der Wiel with a new capacity as guardian or with any authorization to collect this property. . . ." Therefore we ask you to excuse us in this matter. But we can assure you that if such an affair came up of a testamentary guardian, in all [respects] as well endowed ("gemunieert") as the aforenamed van der Wiel, that we should make no difficulty in approving his honest request. Done in Delft on this date and signed Isaac Graswinckel. (Gouda G.A., Orphan Chamber, no. 718.)

328. 30 January 1670. Testament of Ariaentge Claesdr., widow of Jan Theunisz. Back, butcher. Sick in body, lying in bed, but with full use of her mind and memory, she revokes her testament of 22 September 1652 (doc. no. 242) and names as her legatees her three unmarried daughters Annetgen Jans, Francyntgen Jans, and Neltgen Jans. She stipulates that all that she will leave behind after her death shall remain the common property of her three daughters, with the understanding that if any of them came to be married, she would first draw all the clothing of linen and wool, the gold and the silver that she had used for herself and her adornment during her life plus one-third of the testatrix's best linen in the best chest, 100 guilders in cash, and a bed and pillow with all the bedding that goes with them. The rest will remain in the possession of the unmarried daughters, to be passed on to the remaining ones as one after the other dies, up to the last of them. Except that the business of buying and selling pig's tripe and the activities related thereto (which she, testatrix, has been carrying on with her three daughters) will continue to be carried on by any one [of the daughters] who wants to do so alone, with the other two or with only one of them for profit or for loss. After the business is wound up, due to marriage or for some other reasons, the testatrix wishes that the equipment be sold for the profit of the unmarried daughter who shall have carried on the business the longest. After she, testatrix, had married off two children, named Theunisz. Jansz. Back and Tryntge Jans Back (now both deceased, each leaving two children), she had given each a good endowment ("uijtzetting"), indeed one above her means, which the unmarried daughters have not enjoyed but to the contrary lavished all their zeal and industry on the business and the handicraft ("handarbeijt") and brought the profits into the common pool ("gemeen boedel") for the upkeep of the business and for the payment of debts. Moreover the testatrix spent money from her own purse, according to her means, to bury them in an honest manner and pay some of their debts and indeed to guarantee a debt of 400 guilders which still remains to be paid. Moreover she had taken into her home the two remaining children of Trijntgen Jans and supplied them with food, drink, and clothing and an honest upbringing, which has lasted seven years for her daughter's children and for her son's two years, and is still going on. [Marginal addition: In addition to all this, her grandchildren will inherit from her estate 100 guilders— 25 guilders each—when they come of age, which funds cannot be alienated beforehand.] Other clauses of the will reinforce the testatrix's desire to institute her three daughters (and their children after marriage) as sole legatees. Finally she desires that the house in which she lives presently should not be sold after her death but should be given to the one of the daughters who will carry on the business. Philippus van Heul and Nicolaes van Hooren are the witnesses. (Delft G.A., records of Notary J. Ranck, no. 2107 fol. 395.)

329. 11 February 1670, 9 P.M. Testament of Anthony van der Wiel and Geertruyt Reijniersdr. Vermeer, well known to the notary and to the witnesses, both in good health and in sound mind. They revoke all previous testaments. Each institutes the survivor of the two as universal legatee, under the explicit condition that if she, testatrix, were to die first, then her husband, within six years, would have to give her relatives and heirs *ab intestato* all her clothes and all that she used personally during the course of her life, together with the sum of 400 guilders. But if it came to pass that he were to die first, she, testatrix, would have to make the following bequests: first to the testator's sister, Maria Gerrits van der Wiel, single person of legal age, the sum of 300 guilders; second to the testator's brother, Jacobus van der Wiel living in The Hague, all the equipment for working ebony wood, except that no part of his ebony-wood business should be considered included therein, but he

[the testator's brother] shall in consideration of this turn over to his sister Maria Gerrits 50 guilders and no more. Moreover all the testator's clothing and personal possessions should be turned over to his brothers and sisters. It is further stipulated that all that remains unsold after her death shall be divided among and bequeathed to the testator's relatives and heirs ab intestato each half and half. This act was passed in the house of the testators in the presence of Arent van Pynacker and Pieter van Ruyven, Lord of Spaleand. Anthony van der Wiel sets his mark [a star]; she signs "Geertruit Vormeer" in a trembling hand. (Delft G.A., records of Notary G. van Assendelft, no. 2128, fols. 311^{r+v}.)

330. 13 February 1670. Dyna Baltens, widow of Reynier Vermeer, in the Vlaming-straat, is buried in the New Church. (Delft G.A., Burial files, first published in Obreen 1881, 4: 291.)

331. 2 May 1670. Geertruy Vermeer, wife of Anthony van der Wiel, was buried in the New Church on this date. (Delft G.A., "Begraafboek" no. 41, fol. 142v.)

332. 13 July 1670. In the division of the estate of Digna Baltens, Anthony van der Wiel agrees that his brother-in-law Johannes Vermeer shall receive as his portion "the house and court named Mechelen standing on the North side of the Great Market," with the proviso that the abovenamed brother-in-law has agreed to pay the charges on the house according to the respective mortgage deeds, as well as part and future interests thereon, and debts pertaining thereto. Anthony van der Wiel acknowledges having received such compensation ("sodanige effenen") from the estate which has given him full satisfaction. For this reason he has turned over the aforesaid house to Vermeer and will transfer the registration thereof to his name. (Delft G.A., records of Notary F. Boogert, no. 2008, fol. 90^{r+v}, first published, in part, in Bouricius 1925: 271.)

333. 26 August 1670. A donation of 6 guilders 6 stuivers is given to the Camer van Charitate on behalf of Dingnum Baltens. (Delft G.A., Camer van Charitate, "Beste Opperste Kleed Boek" no. 74, part II, fol. 8.)

334. 28 October 1670. "The headmen of the Guild [in this year] were: Louijs Else-vier, Michiel van Houck, Gijsbrecht Kruyck, Joannes Vermeer, Jasper Serrot, Jacob Kerton." Louijs Elsevier is outgoing headman, Vermeer incoming headman of the painters. Michiel van Houck and Jasper Serrot are glassmakers, Gijsbrecht Kruyck and Jacob Kerton [or Ducarton] faienciers. (Obreen 1877, 1: 77.)

335. 8 November 1670. Marriage contract between Anthony van der Wiel, widower, and Abigael van Briell. (Delft G.A., records of Notary G. van Assendelft, no. 2128.)

336. 27 May 1671. A donation of 6 guilders 6 stuivers is given to the Camer van Charitate on behalf of Geertruyt Vermeer. (Delft G.A., Camer van Charitate, "Beste Opperste Kleed Boek" no. 74, part II, fol. 11v.)

337. 18 July 1671. Johannes Vermeer art-painter ("konstschilder") appears before the notary and acknowledges that he has been fully requited and paid by Anthonj van der Wiell, the heir of the late Geertruyt Vermeer, the appearer's sister, from the estate of Geertruyt Vermeer and that he has no more claims to lay on this estate, directly or indirectly. Anthonj van der Wiel has requited his brother-in-law in all respects except for the sum of 148 guilders that his brother-in-law still has coming to him from this estate. [Abraham Bredius (*Oud Holland* 3 [1885], p. 218), and subsequent researchers (see Blankert 1978, p. 148) read "ses hondert acht ende veertich"(648) guilders. The first mention of the sum is hard to decipher and may possibly allow this reading (although even here I am inclined to read "een" for "ses"), but the second, cited below, can only be read as "een hondert acht ende veertich" (148) guilders.] Vermeer and Van der Wiel, who also appeared before the

notary, declare that they have been fully compensated both from the inheritance of Dina Baltens, the widow and guardian of the estate of Reynier Vermeer, their mother and mother-in-law respectively, and from the inheritance of Gertruijt Vermeer, the late wife of Van der Wiell, so they have no claims to lay on each other, except for the 148 guilders, which he, Van der Weill, is willing to pay anytime upon request to his brother-in-law; but that he, Johannes Vermeer, has taken upon himself all the debts and charges on the estate of his mother without troubling or molesting his brother-in-law in any manner and he promises to compensate him [Anthony van der Wiel] for any claims that may be made upon him in this respect. He [Vermeer] shall also retain for his profit the debts due to the estate ("inschulden") which are still to be claimed from various persons. The artist signs "Joannes Vermeer," his brother-in-law "Antoni van der Wiel," in a surprisingly fluent way for an individual who normally signed with an illiterate mark. (Delft G.A., records of Notary G. Van Assendelft, no. 2131, fol. 368^{r+v}.)

338. 25 October 1671. The inventory of the estate of Sr. Johan Heyndricxz. van der Wiel, widower of the late Maria Camerling, who died on this date mentions two children under age, Adriana and Catarina. The deceased was a wealthy man who owned several houses, many interest-bearing obligations, and rich furniture, including 21 paintings and a tapestry of the birth of Christ in one room, 31 paintings in another, and 10 paintings in the front hall. None of the paintings in the inventory is described or attributed. Among the obligations was one contracted on 10 April 1663 by the widow of Anthony Jansz. van den Back as principal and Aryantge Claes, widow of Jan Theunisz. van den Back, his mother, as surety, for 200 guilders. (Delft G.A., records of Notary A. Verkerck, no. 2204.)

339. 28 October 1671. The headmen of the Guild of St. Luke were Joannes Vermeer, Jasper Serot, Jacob Corton, Cornelis de Man, Cijbrant van der Laen, Claes Jansz. Metschert. Vermeer was the outgoing headman, Corneis de Man the incoming headman of the painters. Jasper Serot and Cijbrant van der Laen were glassmakers, Jacob Corton [Kerton or Ducarton] and Claes Jansz. Metschert faienciers (Obreen 1877, 1: 28).

340. 14 January 1672. Johannes Vermeer leases the house called "Mechelen," situated on the north side of the Market Place, on the southwestern corner of the Oudemanshuis steegje, to Johan van der Meer [apothecary] for the next six years, starting the first of May of the present year, for 180 guilders per year. (Delft G.A., records of Notary F. Boogert, no. 2008, first published in Bredius 1910, p. 62.)

341. 24 May 1672. Joannes Jordaen and Johannes Vermeer, outstanding painters in Delft, appeared before Notary Pieter van Swieten in The Hague and together at the request of Sr. Hendrick de Formantou that they, deponents, have seen and examined in their Guild Hall 12 paintings, which were described as outstanding Italian paintings in the list or catalogue shown to them by the petitioner, as well as assessed as stated after each painting, namely:

	Rijksdaelders
a Venus and Cupid, figures larger than life, by Michiel Angelo Bonarotti, Dutch currency	350 : 320
a Portrait of Giorgion del Castelfranco by Titiaen from life	250 : 240
a shepherd and shepherdess by Titiaen	160 : 150
Pendant of the same size by Titiaen	120 : 110
a dance of naked children life-size by Iacomo Palma	250 : 240
a Venetian lady by Paris Pordinon	160 : 150
a Portrait of a Prelate by Hans Holbeen	120 : 110

a Ceres with abundance, with many naked children by
 Giorgin del Casel Franco 120 : 110
a portrait of an old man by Raphael Urbin 150 : 140
a St. Paul, half length, lifesize, by the Old Jacomo Palma 80 : 70
a Beautiful Venetian woman by Titiaen 200 : 185
a landscape by Titiaen with a Satyr caressing the nymph 240 : 230

[The first figure on the right may represent the assessed value of the painting in Dutch rijksdaelders, the second in Brandenburg rijksdaelders, worth about 10 percent more.]

The aforementioned paintings being sealed with the signet of His Serene Highness the Elector of Brandenburgh, which paintings not only are not outstanding Italian paintings, but, on the contrary, great pieces of rubbish and bad paintings, not worth by far the tenth part of the aforementioned proposed prices, which they, the deponents, cannot estimate, since the items have no value ("niet en connen estimeren, dewijle deselve nicht geacht en konnen werden"). (For a full transliteration see Blankert 1978, p. 148. I have used, with minor amendments, the translation given in this source. The document was first published in Bredius 1916, "Italiaansche," pp. 88–91.)

342. 3 and 9 June and 2 September 1673. Petition of Johannes Vermeer, husband of Catharina Bolnes, daughter of Maria Thins living in Delft, to the magistrates of the town of Gouda. After relating the origin and subsequent disposition of the Diewertge Hendrics legacy in the same terms as in doc. no. 318, the supplicant declares that his mother-in-law Maria Thins has empowered him to take up ("oplichten") half the capital to which she is entitled from the Orphan Chamber, so that he may transfer to her the yearly income therefrom. Seeing also that up to half the capital has devolved on him, supplicant, in his capacity as husband of his wife [Catharina Bolnes], and since his mother-in-law has turned over to him the collection of the usufruct and interests and is satisfied to receive the same from his hands, so he implores the masters of the Orphan Chamber to be pleased to place the same in his hands, for which he will write a proper receipt. In a marginal notation dated June 9, the masters of the Orphan Chamber in Gouda state that they deem it advisable that the petitioner's wife's father and brother and other interested persons should be heard [concerning the request]. In another marginal notation, dated September 2nd, the masters of the Orphan Chamber state that they see no reason why the request should not be granted and advise the magistrates to do so provided due restitution is made under proper guarantees.

Following the request itself, the magistrates of the town of Gouda, upon advice of the masters of the Orphan Chamber of Gouda, resolved to approve the petitioner's request "to collect and receive the property, provided due restitution is made with appropriate sureties." [The "restitution" probably refers to the necessity, after collecting the past interest on the obligations deposited on the Chamber, of returning the principal sum, which remained inalienable.] A due receipt will have to be signed by the petitioner and his mother-in-law. This act is signed 2 September 1673. (Gouda G.A., Orphan Chamber, no. 569.)

343. 27 June 1673. A child of Johan Vermeer was buried in the family grave in the Old Church on this date. (Van Peer 1968, p. 223.)

344. 21 July 1673. Johannes Vermeer, painter [crossed out "merchant"] in Delft, presently in this city [Amsterdam] transfers to Sr. Hendrick de Schepper living in this city two interest-bearing obligations, one dated 1 April 1642, for the sum of 300 guilders issued in the name of Maijken Thomas, charged to heer Nicolaes Bogaert, receiver of the common lands' revenue for the quarter of Delft, register folio

159, and the other dated 1 April 1672, for the sum of 500 guilders issued in the name of Magdalena Pieters, charged to Maerten Paeuw, General Receiver for Holland and West Friesland folio 1539, registered p° 64 v° 809, the interest on which was paid till April 1673. The appearer recognizes having been paid for the two obligations and the interest thereon. These two obligations were sold to . . . [left blank] on 25 January 1675. (Amsterdam G.A., records of Notary H. Outgers, no. 3216, fol. 62, cited in part in A. Bredius 1910, p. 62.)

345. Early 1674. A receipt, perhaps written entirely in her hand, is signed by Maria Thins for 112 guilders 8 pennies for interest due for the year ending 31 December 1673, from the heer Johan van Dam, Secretary of the Orphan Chamber in Gouda, on capital sums deposited in the Chamber. (Gouda G.A., Orphan Chamber, loose sheet, no. 569.)

346. 18 January 1674. The respectable ("den E.") [crossed out "eersamen"] Johannes Van der Meer, artful painter ("konstrijck schilder"), and Aert de Swart, master carpenter, sign as witnesses a debt acknowledgment for 1,500 guilders owed by Maerten Dircksz. van der Kleij, living on the Sweet near Ouwerschie [Overschie], to Cornelia Leendertsdr. Kroesers, his half sister. The debt arose from the division of the inheritance of her late father and mother. (Delft G.A., records of Notary C. Bleiswijck, no. 1913, fol. 130; this document was first noted by K. Wilkie and cited in Blankert 1978, p. 149.)

347. 21 January 1674. Juffr. Maria Thins, widow of Reijnier Bolnes [crossed out Vermeer], living in this city, appeared before the notary at the request of heer Elbert van Isendoorn, Lord of Kannenburch, as father and guardian of his children not yet of legal age ("onmondige kinderen"), procreated by his wife Odilia van Wassenaer, and declared that she, appearer, knew Juffr. Maria van Blijenburch who was married to the heer Hugo Cools, who had two brothers and a sister, and that the aforementioned Juffr. Maria van Blijenburg and Hugo Cools left behind one daughter named Cornelia Cools, and that the latter was married to Mr. Gerard Butewej, who together had a child named Juffr. Cornelia van Buteweyt, who was married to heer Aelbert van Wassenaer, Lord of Alkemade. As justification of her knowledge [of the facts above] the attestant states that she lived four years with Maria van Blijenburch and [of her knowledge] of the lineage ("maagschap") of the aforesaid persons, that she had frequented them in a familiar way and had good acquaintance with them. The act was passed in Delft in the presence of Sr. Johan Vermeer and Jan den Apel as witnesses. (Delft G.A., records of Notary A. van der Velde, no. 2177.)

348. 31 March 1674. Juffr. Maria Thins, very well known to the notary (Jacob Spoors), in her capacity as owner of dike lands in Oudbeijerland, both for herself and as administrator of the goods left behind by Johan Tin, and as legatee of Cornelia Thin, constitutes and empowers Geerloff Verborn, sheriff, secretary, and treasurer ("rentmeester") of the seigneury of Pierschie, there to appear in her name and on her behalf, along with the other owners, at the next accounting of the common lands, to render and close accounts and so forth, and in view of the death of Anthonij de Vlieger, the former treasurer of Oudbeijerland, in place of the same Anthonij de Vlieger, to name as treasurer and to give her vote to Glaude van Dieborn[?] so that he may be vested with this office. The act was passed in Delft in the presence of Sr. Johannes Vermeer, master painter, and Johannis Vincent Verboren, the notary's clerk. (Delft G.A., records of Notary J. Spoors no. 1680 fol. 516ʳ⁺ᵛ.)

349. 4 and 7 April 1674. Reinier Bolnes dies on April 4 and is buried in the St. Janskerk in Gouda on April 7. (Gouda G.A. Begraafboek "St. Janskerk"—kind com-

munication of Rob Ruurs.) According to Rob Ruurs, the fee for burial was paid on
7 May [crossed out April] and for the ringing of bells on April 7. He believes that
the latter date is a clerk's error for May 7.

350. 4 May 1674. Johannes Vermeer travels to Gouda to settle some of his late father-
in-law's affairs, both on his own behalf and that of Willem Bolnes, as heir of his
father. He leases the house in which Reynier Bolnes had died on the Peperstraat for
one year for 140 guilders. (Gouda G.A., records of Notary Straffintveldt, cited in
Van Peer 1975, p. 30.)

351. 24 May 1674. Maria Tins, widow of the late Reinier Bolones, being authorized
by the city magistrates ("Weth") to supervise her son Willem Bollenes, and Johan-
nis Vermeer having married Catharina Bolones, together heirs of the late Reinier
Bolones, who was also heir of the late Heijndrick Hensbeecq, declare before the
notary that they approve and ratify the compromise [made] during his lifetime by
Reinier Bolones, on one side, and the other heirs of Heijndrick Hensbeecq, on the
other, mediated by the Court and High Council of Holland, and passed before
Notary Straffintveldt in Gouda on 25 July 1672, and promise to submit to the deci-
sion of the arbiters. Maria Thins further empowers the attorneys mentioned in this
compromise to ensure that the conditions stated in the compromise will be fulfilled.
(Delft G.A., records of Notary F. Boogert, no. 2009.) Heijnrick Claesz. van Hens-
beeck, c. 1605–1671, was the son of Claes Cornelisz. van Hensbeeck who had
married Cornelia ("Neeltje"), the daughter of Cornelis Pouwelsz. Bolnes, the sister
of Reynier Bolnes. (Matthijs 1976, pp. 25–26.)

352. 26 May and 10 June 1674. Maria Vermeer, the eldest daughter of the artist, and
Johan Gillisz. Cramer, merchant, are betrothed and married. The entry in the
"Register of the Names of Persons who Have Entered the State of Holy Matri-
mony" states: "Johan Gillisz. Cramer, bachelor, on the Verwersdijck. Maria Ver-
meer, spinster, on the Oude Langedijck. Attestation given on 10 June 1674, married
at Schipluy on this date before the magistrates of St. Maerten." (Delft G.A.,
"Trouwboek," fol. 101ᵛ.)

353. 29 December 1674. Johannes Vermeer appears before the Orphan Chamber of
Gouda. After invoking the marginal notation ("apostille") of the Lord magistrates
of 2 September 1673 and the act of 2 June 1668 whereby Maria Thins desisted
from the usufruct of the Diewertge Hendrix legacy and empowered him to collect
this usufruct, he recognizes having received 500 guilders from the capital sum de-
posited in the Orphan Chamber on behalf of his "mother" [his mother-in-law].
Johan Schade, living in Gouda, also appeared and constituted himself surety for
this collection. (Gouda G.A., Orphan Chamber, "Weesboek" no. 9, fol. 10.) A
loose-leaf receipt in the records of the Orphan Chamber of Gouda, which was
probably not written in Vermeer's own hand [considering that the handwriting for
the receipt signed by Vermeer is the same as that for the receipt signed by Maria
Thins for the interests that fell due in December 1675, after Vermeer's death],
states: "The year's interests which fell due on the last day of December 1674 were
paid to me on behalf of my mother" ("wegens mijn moeder"), signed Joannes Ver-
meer. Just below this receipt is a brief note stating that the year's interests for 1675
"were paid to me," signed Maria Thins. (Gouda, Orphan Chamber, no. 569.)

354. 5 March 1675. The respectable Juffr. Maria Thins, widow of Reynier Bollenes,
mother and guardian of her son Willem Bollenes, empowers the honorable Johan-
nes Vermeer, her son-in-law, Artful Painter, to act in her name, first in the affair of
the late Henrick Hensbeeck, deceased in Gouda, to proceed in the division of the
estate, etc., and to collect the money due to Willem Bolnes, and also to receive the

yearly incomes on behalf of her son Willem Bolnes and to transact, administer the same, as a good administration should do, which she attestant fully entrusts to her son-in-law. Pieter Roemer, glassmaker, witnesses the act. (Delft G.A., records of Notary C. Bleiswijck no. 1917, fol. 418, first published in Bredius 1885, p. 218.)

355. 26 March 1675. Johannes Vermeer, acting on behalf of Maria Thins, relinquishes to Jan Schouten, lessee of three morgen of land owned by Maria Thins in Wilnes, as heiress of her late husband Reynier Bolnes, the rents he owes on the property for 1673 and 1674 "due to the war times" so that these two years may be considered paid in full. He recognizes having been compensated, including the cost of the extraordinary low-dike ("kade") that Jan Schouten had to make and the clay that he contributed thereto. He renews the lease for 72 guilders a year. (Gouda G.A., records of Notary N. Straffintveldt, cited in Van Peer 1975, p. 32.)

356. 20 July 1675. Johannes Vermeer borrows 1,000 guilders from Jacob Rombouts, merchant in Amsterdam. (Amsterdam G.A., records of Notary Jacob Hellerus, cited in doc. no. 389 of 2 April 1678, first published in Bredius 1910, p. 64.) See also doc. no. 378 of 22 February 1677.

357. 15 and 16 December 1675. In the register of the persons buried in the Old Church, an entry for 15 December 1675 states: "Jan Vermeer, art-painter on the Oude Langendijck, in the church, 8 children under age." The register of graves states that "on 16 December 1675 Johan Vermeer was laid in this grave and the above-mentioned infant ('baerkint') was placed on the coffin of the aforenamed Vermeer." The infant mentioned here was buried on 27 June 1673 (doc. no. 343). (These two documents were first published, respectively, in Obreen 1881, 4: 294, and Van Peer 1968, p. 223.)

358. 16 December 1675. An entry in the "Beste Opperste Kleed Boek" of the Camer van Charitate for this date reads: "Johannes Vermeer art painter on the Oude Lange Dijck 'Niet te halen' [nothing to get]" (Delft G.A., Camer van Charitate, "Beste Opperste Kleed Boek," no. 74, part II, fol. 50ᵛ.)

359. 2 January 1676. Emmerentia Jacobs, widow of Claes Cornelisz. Stout living in Oud Beyerland, acknowledges owing Juffr. Maria Tins widow of Reynier Bolnes [Bollenes crossed out] or the holder of this act 1,683 guilders 13 stuivers as the unpaid portion of rents on 27 morgen of land lying in Oud Beyerland, the last of which was due last May 1675. Of this sum "the appearer promises to pay 300 guilders before Easter and another 100 guilders before next Christmas, 100 guilders before Christmas 1677, and 100 guilders before Christmas 1678, and so forth till 1,000 guilders shall have been paid." On the same day Maria Thins leases to the widow Jacobs the same 27 morgen for the next seven years, for 486 guilders a year. (Delft G.A., records of Notary J. van Veen, no. 2224, fols. 107–108.)

360. 9 January 1676. Maria Thins leases to Hendrick van Oosten, building man, living in Boenderpas [Bon Repas] outside Schoonhoven, about seven and a half morgen of hemp and pasture and hayland, of which four morgen in Boenderpas adjoining to the south [the land of] Barent Ghysen and in the north [the land of] Jan Ghysbrechtsz., the remaining 3½ morgen in Gellekenes under the Barony of Liesvelt, and this for four years beginning Petri ad Cathedram of this year 1676 and the last expiring Christmas 1679, for 100 guilders a year. The lessee will be obliged to keep the lands in good order, to use the hemp lands only for hemp, the pasture lands only for pasture, the hay lands for hay, etc. The contract is witnessed by Simon Aryensz. Samuels, master stonecarver, and Isaac Aryensz. Schou, worker

in white wood ("witwercker") (Delft G.A., records of Notary J. van Veen, no. 2224, fol. 110, cited in part in Van Peer 1975, p. 33.)

361. 27 January 1676. On this date Catharina Bolnes, widow of the late Johannes Vermeer, during his life painter in Delft, appeared before the notary and declared that she had sold to Hendrick van Buyten, master baker in this town, two paintings done by the said Vermeer, one representing two persons one of whom is sitting and writing a letter and the other with a person playing a cittern ("cyter"), and declared that she had been paid the sum of 617 guilders 6 stuivers for the two paintings, which sum, she, deponent, owed to Van Buyten for bread delivered, which bill he now considers null and void. Furthermore [the contractants] agreed that in case the aforementioned widow should pay him, Van Buyten, on 1 May 1677 the sum of 50 guilders and each succeeding May Day the same sum of 50 guilders, until full restitution of the said 617 guilders 6 stuivers, and if meanwhile he is paid the entire 109 guilders 5 stuivers also due for past deliveries of bread, he, Van Buyten, will then again relinquish in full property to the said widow or her heirs the two paintings sold to him. However, if it should come to pass that the mother of the said widow should die before the aforesaid sum had been restituted, then redemption ("lossing") of any sum that might remain outstanding must be effected with 200 guilders a year, in which case she must also pay interest on this remaining portion at four percent per year, just as interest must be paid in case the stipulated repayment of 50 guilders had not been precisely paid. But once the sums due had been repaid in the aforesaid fashion (together with the payment due on any goods that will henceforth be delivered), he, Van Buyten, will then be obliged to restitute the two paintings designated above.

In another part of the contract, which repeats the above terms, Van Buyten declares that he had made these arrangements for the conditional restitution of the paintings "after being seriously beseeched and upon urgent persistence of the transferrer" [Catharina Bolnes]. In case the widow should fail to meet her obligations, Van Buyten will be allowed to sell the paintings, whereupon she will still be obligated to make good any amount that would still fall short of the 617 guilders 6 stuivers [due to him] after the paintings are sold. (Delft G.A., records of Notary G. van Assendelft, no. 2132. First published in Bredius 1885, pp. 219–20. I have in large part followed the translation in Blankert 1978, pp. 149–50.)

362. 10 February 1676. On 30 November 1676 Sr. Jan Colombier declared at the request of Jannetje Stevens, spinster living in Delft, that he had bought on 10 February 1676 from the widow of Johannes van der Meer, in an apothecary in Amsterdam called "de drie limoenen" (The Three Lemons), "26 paintings, large and small, for 500 guilders, for the account and in the name of the petitioner [Jannetje Stevens], which sum should be reserved for the repayment of that which the aforementioned widow of Johannes Vermeer owed to the aforesaid petitioner for shopwares." The paintings were delivered by the widow of Johannes van der Meer on the spot to Colombier who transported all 26 of them to Haarlem where they were brought to his house and now remain, since he, Colombier, has claims on the petitioner and intends to settle ("soude voldoen") the difference with her by giving her goods or money. (Haarlem G.A. records of Notary P. Baes, first published in Bredius 1916, "Schilderijen," p. 161.)

363. 22 or 24 February 1676. [The date in the original seems to read 22. On the other hand, the "insinuatie" of 12 March 1677 (doc. no. 379) apparently refers to 24 February.] Juffr. Catharina Bollenes, widow of the late Sr. Johan van der Meer ["Ver" crossed out] appears before the notary and declares that she has hereby ceded in full and free property, as part payment on her debt, both for herself and

in her capacity as widow and trustee, and also as guardian of her children pro-
created by the aforementioned Vermeer, her late husband, to her mother Juffr.
Maria Tins, widow of the late Reynier Bollenes, a painting done by her aforemen-
tioned late husband, wherein is depicted "The Art of Painting" ("de Schilder-
const") as well as her right to the income from a certain property in Bon Repas
near Schoonhoven, inherited from Cornelia Tin and subject to fideicommissum
[whereby Cornelia Thins had stipulated that the property would be passed on, after
her sister Maria's death, to Catharina], as also any claims she might have on half
of five morgen and a few rods of land in Oud-Beyerland, plus life annuities together
amounting to 200 pounds [i.e., guilders] per year also inherited from Cornelia Tins.
She desists from all these assets, without keeping any for herself, in order to reduce
the debt she owes her mother. (The Hague G.A., records of Notary J. Vosch, no.
3561, fol. 28. First published in part in Bredius 1910, p. 220.)

364. 29 February 1676. The inventory of movable goods from Vermeer's estate listed
below was divided into two parts. The goods recorded in each room were divided
into those two parts, and the parts were originally listed side by side. Below, how-
ever, the two lists are given consecutively. The rooms have been numbered, and
these numbers are repeated in each list to help the reader understand how the orig-
inal inventory was made up.

 1. Specification of all the household and movable goods that Catharina
 Bolnes, widow of the late Sr. Joannes Vermeer, living on the Oude Lan-
 gendijck, at the corner of the Molepoort, has coming to her in posses-
 sion, [which goods] are deposited in the aforementioned housing.

 2. *In the front hall ("Voorhuys")*
 a fruit painting
 a small seascape
 a landscape
 a painting by Fabritius

 3. *In the great hall ("groote zael")*
 a painting representing a peasant barn
 another painting
 two paintings, "tronien" (faces) by Fabritius
 one wherein three gourds and other fruit
 two portraits of Sr. Vermeer's late father and mother
 three small drawings in front of the mantlepiece with black frames
 a drawn coat-of-arms of the aforenamed Sr. Vermeer with a black frame
 a pair of green silk curtains with a valance in front of the bedstead
 a mantlepiece covering of the same material
 a striped curtain
 an iron armor with a helmet
 a pike
 a lead hat fringe[?] ("lode hoede rand")
 linen and wool
 a Turkish mantle of the aforesaid late Sr. Vermeer
 a ditto "innocente" [loose robe worn by men]
 a [pair of] Turkish trouser[s]
 a white satin coat
 a ditto yellow
 a white satin bodice
 a yellow satin mantle with white fur trimming
 an old green mantle with white fur trimmings

Juffr. Vermeer's ash-gray travel mantle
a black Turkish mantle
a black cloth gown ("tabbert")
a black cloth robe
twelve bedsheets, good and bad
twenty-two ditto pillowcases ("sloopen"), large and small
five damask[?] ("kruysserviet") tablecloths
nine napkins
twenty-one children's shirts so good as bad
two women's shirts
28 bonnets
11 children's small collars
17 back pocket handkerchiefs
two Indian coats ("labaertjens")
seven pairs of muffs ("moutgens")
three white caps
three children's aprons
two night shirts
ten men's ruffs
thirteen pairs of fancy cuffs ("ponietten")

4. *In the small room adjoining the great hall*
a great wooden painted coffer with iron fittings
a bad bed ("ledicant") with a green cover on it
a round table tray ("tafelblad")
a fire screen ("viermande")
a little rack
a great high tole ("blick") vat
a tole bedpan ("confoortje")
two copper snuffers
an iron candleholder
seven glass flasks
three roemers
twelve earthenware plates
and other earthenware of little importance

5. *In the interior kitchen*
a large painting representing Christ on the Cross
two "tronie" paintings done by Hoogstraten
a painting wherein all sorts of women's stuff ("vrouwentuych")
one of Veronica [Christ's face]
two "tronien" painted in Turkish fashion
a little seascape
a painting hanging in front of the mantelpiece
a (painting) wherein has been painted a bass viol with a skull
a pair of striped curtains
a little sideboard
two brown foot warmers ("stoven")
about seven ells of gold-tooled leather on the wall

6. *In the little back kitchen*
an iron grill
a pewter salad colander
a vessel hamper ("een vate ben")
an old lantern

7. *In the cooking kitchen ("koockeucken")*
a bed with a head pillow
two ear cushion
two blankets, one green with one white
a bed cover
a rug cover
a red-painted little table
a coat rack
a child's chair
a striped mantelpiece coverlet
six old chairs
an old beer jug

7a. *In the washing kitchen ("waskeukentgen")*
two spinning wheels
a cradle

7aa. *In the corridor*
two racks on which to dry linen
a wicker basket
a wooden sitting bench ("scharrebort")

8. *Over in the basement room ("keldercamer")*
a bed with a head pillow
two ear pillows
two blankets, one green with one white
a bed cover
a painting of Christ on the Cross
a painting representing a woman wearing a necklace
three bad chairs
a wooden trestle

9. *In the place ("plaets")*
a tin waterpot
10 tin spoons

10. *Above in the back room*
two rug covers
a wicker basket wherein the mother sits and holds her child warm
("bakermath")
a "tronie" painting
a cupid (painting)
two chairs
two copper bedpans ("confoorten")
five books in folio
25 other (books) of all kinds
two earthenware dishes

11. *In the front room*
two Spanish chairs
a cane with an ivory knob on it
two painter's easels
three palettes
six panels
ten painter's canvases
three bundles with all sorts of prints
a desk ("lessenaar")
here and there some rummage not worthy of being itemized separately

The above-standing goods were recorded by me, notary, admitted by the
Court of Holland, at the behest of the aforementioned widow, who de-
clared having acted in good faith, and if anything were to occur to her
that she had forgotten, she will supply this amplification at any time.
In token whereof, signed by her. Delft, the last day of February 1676.

<div align="right">Catharina Bolnes</div>

[The following was originally written in a second column next to the preceding
list.]

1. Specification of all such household goods and furniture ("inboel") as
Juffr. Maria Thins, widow of the late Reynier Bolnes, and her daughter
Juffr. Catharina Bolnes, widow of Joannes Vermeer, each to the true
extent of one-half, having coming to them, [which goods] are deposited
in the house of the aforenamed widow on the Oude Langendijck on the
corner of the Molenpoort.

2. *First in the front hall*
a cabinet of joinery work
a large painting of Mars and Apollo in a bad black frame
2 paintings somewhat smaller
four more paintings with bad frames
a mirror with an ebony frame
a wooden footbench
four bad green chairs
two bad tapestry-covered cushions

3. *In the great hall*
a cabinet of joinery work with inlaid ebony
a whitewood pull-out table
a little oak chest
nine red-leather Spanish chairs
three green sit-cushions
a green tablecloth
an ebony wood crucifix
ten portraits of the lineage of the aforenamed Juffr. Tins all with bad
black frames
a painting representing the Mother of Christ in an oak frame
one more painting of the Three Kings

4. *In the small room* adjoining the great hall
an oak table
a child's bed with a head pillow
an ear cushion
a green lined coverlet
two paintings
a red-painted board of a chest
a pair of bad green curtains
a ditto mantelpiece coverlet
two old tapestry-covered sit-cushions
a bad mirror
two metal-ringed [child's] chairs ("beugelstoelen")
two small secret coffers
five earthenware shell-shaped dishes
five other pieces of earthenware
three Cologne butter dishes

eleven earthenware jugs with pewter lids
a copper mortar with a pestle
a copper candlestick
a copper bedpan
a tin butterpot
a tin ladle with a wooden handle
5. *In the interior kitchen*
a bed with a head pillow
three ear cushions
two blankets, one green with one white
a bedcover
an oak chest
a coat rack
three chairs
three green sit-cushions
a striped cloth
6. *In the little back kitchen*
a chest to store peat
a shelf for cans and jugs ("kannebort")
an iron spit with its accessories
a wooden spit
a copper pan to bake small pancakes ("broederspanne")
a copper bedpan
a copper kettle
two copper pots
a copper milkpan
four iron pots
an iron flat-iron
7. *In the cooking kitchen*
a pair of striped curtains with a valance
a cupboard
a wooden rack
three blue sit-cushions with fringes
four tin porringers ("eetkommitgens")
two pewter dishes
four pewter beer mugs
an iron band
a tongue
a shovel for ashes
a pewter flat candlestick
21 shell-shaped dishes
8. *Over in the cellar room*
six tapestry-covered chairs
a painting with a gilded frame
one [painting] with an oakwood frame
a little mirror
9. *In the place ("plaets")*
three pewter waterpots
a copper kettle
9a. *In the little hanging room*
a red-painted chest

a little foot bench
two meat barrels
five or six old books
three small paintings in black frames
an old coffer with its contents
seven copper candlesticks
a little copper kettle
an iron grill
a tongue
three iron ladles ("slicklepels")
10. *Above in the back room*
six paintings
10 embroidered sit-cushions
a mirror
two chests
a coat rack
a coffer
two copper kettles
11. *In the front room*
an oak pull-table with a leaf on it
a small wooden cupboard "kas" with drawers
11a. *Above in the attic*
a stone table on which to grind colors along with the stone
a wicker cradle
13 clothes sticks

Thus, recorded by me, undersigned notary, at the behest of the abovementioned . . . [left blank], who declared having acted in good faith, without having held back (to her knowledge) anything, and signed by her in due form in Delft on the last day of February 1676,

Signed, Catharina Bolnes

(Delft G.A., records of J. van Veen, no. 2224, first published in its entirety in Van Peer 1957, pp. 98–103.)

365. 23 March 1676. Willem Bolnes, bachelor, on the Oude Langendijck at the corner of the Molenpoort, is buried in the family grave in the Old Church. (Van Peer 1968, p. 223.)

366. 28 April 1676. Juffr. Maria Thins appoints Pieter de Bye, attorney before the courts, in order to act in her name and on her behalf to collect debts due to her from debtors in Delft, Gouda, and elsewhere, to collect rental moneys from lands and houses and interest and to lease out her lands and, in particular, to appear before the lords of the magistrature of Delft and to present the accounting and record of the administration of the property and income of her son Willem Bolnes, in consequence of the authorization given to her by the aldermen of Delft on 13 January 1665. De Bye is also empowered to collect payment on amounts due to her by her daughter Catarina Bolnes and her late husband Johannes Vermeer and, in case of unwillingness, to compel the same by law ("bij unwillichheijt de selve daer toe met recht te constringeren"). (The Hague G.A., records of Notary H. T. van Coesfelt, no. 955.)

367. 24 and 30 April 1676. Request of Catharina Bolnes, widow of Johannes Vermeer, to the High Court ("Hoogen Raad") [of Holland and Zeeland] wherein she declares that "she, supplicant, charged with the care of <u>eleven living children</u> [underlined in the original], because her aforementioned husband during the recent

war with the King of France, a few years ago now, had been able to earn very little or hardly anything at all, but also [because] the [works of] art that he had bought and with which he was trading had to be sold at great loss in order to feed his aforementioned children, owing to which he had then so far run into debts that she, supplicant, is not able to pay ("voldoen") all her creditors (who are not willing to make allowance for the great losses and misfortune caused by the said war) but [desire] to be paid from the money she is owed, which the supplicant is not able to do" ("maer van haer achterwesen gecontenteert, tgeene die supplicante niet mogelijck en is"). "So the supplicant humbly beseeches the High and Mighty Lords of the High Court to issue letters of cession with *committimus*." The High Court approved the request and "ordered the court in Delft to issue the cession with *committimus*" on 30 April 1676 ("fiat mandemant ende cessie met committimus op den gerecht van Delft").

Creditors:
 Maria Tins
 N. Hoogenhouck, brewer
 N. Rombouts
 N. Dirckx.
 N. Van Leeuwen
 Heindrickie Dircks
 Tanneken
 Heindrick van Buijtenen
 Emmerentia

[The first name was unknown (to the clerk who drew up the list) of those whose first initial is given as "N."] (The Hague A.R., Hoge Raad van Holland en Zeeland, no 80A.) The request was first published in part in Bredius 1910, p. 62, and the list of creditors in Van Peer 1957, p. 96. Two of the names in Van Peer's list have been corrected on the basis of the original document.

368. 25 September 1676. "Maria Thins, widow of signeur Reynier Bolnes, living here in The Hague in the house of Juffrouwen Aleidis Magdalena and Cornelia Clementia van Rosendael in the Juffrouw Idastraatje, well known to me, notary, of sound mind etc., declared upon ripe deliberation, that she had considered and pondered in which way she should dispose and order the goods that she would leave behind after her death and who should inherit them." She revoked all previous testaments and, before disposing of her estate, she committed her soul, "whenever it should depart from her body, to the boundless mercy of God Almighty and her body to a Christian burial." She designated as her heirs all the children procreated by her daughter Catharina Bolnes and by her stepson, the late signeur Johannes Vermeer, that should be alive after her death. In order that her daughter's creditors should not lay claims on her mother's inheritance, she leaves her only her legitimate share [a sixth of the estate]. She stipulates that all that she has furnished ("verstreckt") to her and to her husband must be subtracted from this [the legitimate share], which far exceeds this legitimate share. She names Mr. Pieter de Bye as executor to make sure that the provisions of her testament will be carried out precisely. He will have custody over all her property, and make sure that none of her heirs will receive his or her portion of the inheritance until he or she shall have reached the age of 25 or become married. He will supply an account of his administration to Mr. Hendrick van Eem, the guardian over Vermeer's children, and also to her nieces Juffrouwen Aleidis and Cornelia Rosendael, and to signeur Cramer as well. She "recommends to her daughter, who is most responsible for looking after her children, that she be pleased to take due care of the education ("educatie") of her

[testatrix's] heirs, that she teach them some commerce or handicraft so that they may earn their living, since the number of the children is too great for them to go about in idleness and to undertake nothing ('niets by de hand te nemen')." To avoid unnecessary expenses the testatrix "desires to be buried in the Old Church with honor but with the least expense, which responsibility she leaves to messrs. de Bye and Van der Eem and to Signeur Cramer." (The Hague G.A., records of Notary H. T. van Coesfelt, no. 955, cited in Van Peer 1975, pp. 38–39.)

369. 26 September 1676. Maria Tin has the notary Hendrick van Coesfelt draw up a petition to the States of Holland and West Friesland on her behalf "as legal and sole patroness of a certain vicariate founded in the church of the town of Schoon-hoven on the Altar of the Saints Laurence and Barbara, which has now become vacant by reason of the death of her, appearer's, son Willem Bolnes." She declares she has conferred [the title to] the same vicariate on her grandson Johannes Ver-meer, son of her daughter Catharina Bolnes and of her son-in-law Johannes Ver-meer, during his lifetime artful painter who lived in the town of Delft. (The Hague G.A., records of Notary H. T. van Coesfelt, no. 955; first published in Van Peer 1951, p. 621.)

370. 30 September 1676. The Lords Aldermen of the town of Delft hereby appoint Anthonij van Leeuwenhouck as curator of the estate and of the assets of Catharina Bolnes, widow of the late Johannes Vermeer during his lifetime master painter, who had requested and obtained letters of cession. (Delft G.A., "Kamerboek der Stadt Delft" 1671–1684; first published in Obreen 1881, 4: 295.)

371. 19 November 1676. Maria Thins, accompanied by her daughter Catharina Bolnes, appears before the notary and declares in the presence of Christian van Vliet, delegated by the Court of Delft, that Willem Bolnes never possessed any other assets than the vicariate property funded in the Church of St. Laurens and the St. Barbara alter in Schoonhoven, consisting of five morgen of land in the sei-gniory of Arentsbergen and Bergambacht, a farm located in the Schuttersteeg under Schoonhoven, and eight and a half morgen of land under Gelkenes in the Barony of Liesveld. She empowers the attorney Van Vliet to inform the Lords of Justice in Delft to this effect, with the promise that, should any other assets occur to her mind, she would immediately report them. (The Hague G.A., records of Notary H. T. van Coesfelt, cited in Van Peer 1975, p. 41.)

372. 20 and 25 November 1676. On November 20, Mr. Pieter de Bye, furnished with a power of attorney from Maria Tins by notarial act of 28 April 1676, on one side, and Anthony van Leeuwenhoek, curator over the estate and the assets of Catharina Bolnes, widow of Johannes Vermeer, having obtained letters of cession, as univer-sal heir of the late Willem Bolnes, her brother, assisted by his [Van Leeuwenhoek's] attorney Floris van der Werf, on the other, appeared before Adriaen van der Hoef and Mr. Nicolaes van Assendelft, aldermen of this town, appointed to this effect by the Lord Aldermen of Delft. De Bye exhibited in his aforementioned capacity the account of the administration of Maria Tins, having been authorized, by act of the Lord Aldermen of this town of 13 January 1665, [to administer] the estate and assets of the late Willem Bolnes, her son, who had been confined in the house of Harmanus Taerling, being deceased the [left blank] March of this year. This ac-count having been examined by us commissaries, with the approval of the Lord Aldermen, the two parties, through our intercession, came to an agreement, namely that Maria Tins, in compensation for the debts and liabilities that she had repaid and will continue to repay, will keep and take over in her name all the assets, actions, credits and so forth that Willem Bolnes, through the death of his cousin

Hendrick Claesz. Hensbeecq, had acquired, together with the fruits, profits, and revenues therefrom already due or that will fall due, all of which are transferred and ceded by the curator to Maria Tins, with the understanding that she will be responsible for any attendant liabilities, including the fortieth penny tax that will have to be paid on the transfer of these assets. In addition Maria Tins will be obliged to pay the above-mentioned curator 500 guilders together with 60 guilders for the costs of his appearance at the time of the examination of the aforesaid account. The Lord Aldermen of Delft having seen and examined the above agreement have approved the same by act of 25 November 1676. (Delft G.A., "Kamerboek der Stad Delft" 1671–1684, first published in full in Obreen 1881, 4: 295–98.)

373. 20 November 1676. Juffr. Maria Thins empowers Adriaentge Hendricx Heinsbeeck, spinster of age, to receive 145 guilders, more or less, deposited with the secretary of Moordrecht [near Gouda]. (The Hague G.A., records of Notary H. T. van Coesfelt, no. 955.)

374. 30 November 1676. Deposition of Jan Coelenbier at the request of Jannetje Stevens of this date in which he referred to the transaction of 10 February 1676 (doc. no. 362).

375. 11 December 1676. Maria Thins constitutes attorney Van Vliet and empowers him to appear before the aldermen of Delft and there to swear on her behalf that the life annuities that were transferred to her by her daughter Catharina on 24 February 1676 (doc. no. 363) were six in number and amounted to a sum of 167 guilders and that it was by error stated to be 200 guilders (in doc. no. 363). She had given these annuities to her daughter in past years. Owing to the death of her son Willem Bolnes, three of these had lapsed, a fourth belonged to Elisabeth Vermeer, and there were only two left yielding 50 guilders 5 stuivers a year each during the lifetime of Catharina. She declared further that she had kept no assets of her daughter or her deceased husband Johannes Vermeer in her possession *in fraudem creditorum*, neither is she in bad faith. (The Hague G.A., records of Notary H. van Coesfelt, no. 955, first published in Bredius 1910, p. 63.)

376. 6 January 1677. Maria Thins, living in the house of Juffr. Aleidis Magdalena and Cornelia Clementia in the Juffr. Ida Straet, revokes all previous testaments and amendments thereto, including a testamentary disposition of 11 May 1674 passed before Notary Herman Vereverhorst with Michiel Jacobsz. Bracxhoofden and Pieter van Leeuwen as witnesses. [This testament is no longer extant.] She again makes the children of her daughter Catharina Bolnes and of her daughter's husband Johannes Vermeer universal heirs but she adds the following stipulation: that her estate should remain undivided and unapportioned by lots ("onvercavelt") until the youngest child shall have reached the age of fourteen. She expressly desires that the four youngest children until that time be fed, clothed, and supported from the fruits and revenues of her estate in such trade, occupation or handicrafts as their guardians to be named, besides the attorney Mr. Hendrick van der Eem, shall deem appropriate. Any surplus that might be available and above this may then be divided by lots among the other children. When the youngest child shall have attained the age of fourteen, then any child having reached legal age may deal with his allotted share of the inheritance as his own free property. However, if in this aforesaid period Johannes Vermeer, the son of Catarina Bolnes, could not continue his studies funded from the income of the vicariate goods on the Altar of St. Barbara and Laurents in the Church of Schoonhoven, or if one or the other of the remaining children should need more assistance, then she expressly desires that the

executor of her testament along with Mr. Henrick van der Eem shall assist the aforementioned Johannes Vermeer or the child or children needing assistance from the monies that would otherwise be employed for bringing up the four youngest children, in such a way as they, jointly, shall see fit. She leaves to her daughter Catharina Bolnes her legitimate share after deducting whatever [sums] she had furnished her daughter and her husband the late Johan Vermeer each year since [left blank], besides the extraordinary sum of [left blank], besides the amounts that she had supplied ("verstreckt") her daughter for the children's sustenance since she [Catharina Bolnes] received letters of cession and that she, testatrix, is giving daily and will continue to give, all of which greatly exceeds her daughter's legitimate share. Furthermore she, testatrix, entitles and authorizes by the present her daughter's children [to receive] anything that she might still be owing to her daughter and her son-in-law Johannes Vermeer after settling the preference and competition of their creditors (" 't welcke sij testatrice aende voorn. haere dochter ende swager Johannes Vermeer naer gehoudene preferentie ende concurentie met de selfs crediteuren bevonden sal werden te achteren te sijn"). [The notary appears to have meant the opposite, namely that Maria Thins wished her grandchildren to receive any assets that her daughter might still be owing to her after settling the claims of the other creditors.] In order that her testament may be complied with exactly, she names Mr. Pieter de Bije, advocate before the Court of Holland living here in The Hague, as executor, entreating him to accept this executorship. She desires him, immediately after her death, to take all her assets and secure them under him ("onder hem te slaan") and that they remain with him and that none of the heirs should demand from the heer De Bije that he be allotted his portion, unless, and until the youngest child shall have reached the age of fourteen, when the aforementioned heer executor shall be empowered to allot his or her portion to any of the heirs that shall have attained the age of 25 or gotten married. In the meanwhile the executor should administer her, testatrix's, assets as he shall deem fit. He should deduct for himself such salary as executors or administrators are usually paid. Any heir opposing the executor's administration shall risk losing his share of the inheritance to the benefit of the remaining heirs. If the executor is requested, in case he should wish to pry loose any capital running at interest, to reinvest them, [he should,] if possible, inform and communicate the same to Mr. Hendrick van Eem, to her, testatrix's nieces, Juffr. Aleidis and Cornelia Rosendael as well as to Sr. Cramer and to anyone else with whom any of the heirs might come to marry. She earnestly recommends to heer Hendrick van Eem, to her nieces Juffr. Aleidis and Cornelia Rosendael and especially to her daughter, to whom it most behooves to look out for her children, that they be pleased to have good regard for the education ("educatie") of the aforementioned children, that the same be taught some business ("coopmanschappe") or honest handicraft to enable them to earn their living, since, in her judgment, the number of these chldren is too great to allow them to go about in idleness. Finally, she recommends that her burial in the Old Church should take place with a minimum of costs. (The Hague G.A., records of Notary H. T. van Coesfelt, no. 955, first published in part in Bredius 1910, p. 63.)

377. 2 and 5 February 1677. "In pursuance of the appointment of the Lords Aldermen of the Town of Delft, dated the . . . [left blank] January last, on this date, 2 February 1677, there appeared before us, Adriaen van der Hoef and Mr. Nicholas van Assendelft, aldermen of this town, as commissioners, with the adjunction of the secretary Mr. Hendrick Vockestaert, Anthony van Leeuwenhoek as curator of the estate of the late Johannes Vermeer, during his life master painter, plaintiff ("eijscher"), assisted by Floris van der Werf, his attorney on one side, and Jannetge

Stevens, spinster of legal age, defendant ("gedaegde"), assisted by her nephew Steven van der Werf, master mason in Delft, and Philip de Bries, her attorney, on the other side; and through the intercession of us commissioners and adjunct, concerning their differences, the same parties have agreed and arranged, with the approval of the College of Their Honors Messrs. the Aldermen, as follows: to wit, that the plaintiff in his aforesaid capacity shall pay the defendant 342 guilders in one sum and as full payment of those 442 guilders that she, defendant, claims from the estate of the aforementioned Vermeer, which claim and the validity thereof the defendant then will be obliged to affirm with solemn oath at any time, upon request, in consideration of which the defendant has undertaken to do and promises ... to hand over to the plaintiff in his aforesaid capacity, at the first opportunity, those 26 paintings belonging to the aforesaid estate as at present are deposited with Johannes Columbier, living in Haarlem, under special pledge and promise of the same defendant, which he [Columbier] also does herewith, that the aforesaid paintings through public auction will all accrue to the sole benefit of the aforesaid estate up to the sum of 500 guilders, for which the aforesaid Steven van der Werven has declared himself principal guarantor, under special renunciation of his right to compel the creditor who has sued him before the principal to sue the principal first .. for all of which the participants pledge their persons and property." On 5 February, the Lord Aldermen, upon mutual consultation approved the above oral report. (Delft G. A., "Kamerboek der Stadt Delft" 1671–1684, first published in Obreen 1881, 4: 298–300. I have followed, with minor exceptions, the translation in Blankert 1978, pp. 151–52.)

378. 22 February 1677. Jouffr. Maria Thins appears "as beneficiary of the usufruct of the restricted property of Willem Thins Jansz. and Diwertie Hensbeeck subject to the custody of the Orphan Chamber of Gouda, which, after her death must devolve on Catarina Bolnes and, in case of her prior death, on her legitimate descendants." Whereas the procuration she had passed before Notary F. Boogert on 2 June 1668 (doc. no. 318) "by which she, Maria Thins, had empowered her son-in-law Johannes Vermeer to collect and to receive from the Orphan Chamber half of the restricted assets deposited there, seeing that the usufruct of the same are to be received by her every year out of the hands of her son-in-law, whereby she, appearer, had declared to take her satisfaction, as further specified in the procuration, her aforenamed son-in-law in consequence had collected from the Orphan Chamber an obligation for 2,900 guilders capital charged to the Orphan Chamber of Gouda dated 21 February 1668, which he, instead of keeping it under him as had been agreed, had pawned for the sum of 1,000 guilders ("de welcke hij in plaetse van onder hem te houden soo als versproocken was hadde verpandt voor de somme van duijsent gulden"), in order to recover which the appearer had been obliged to advance [the money]. Not only was the interest on the 1,000 guilders on the obligation missing, but the appearer had had to negotiate that money against 6 percent [interest] ("die dan de voorn. Comparante omme de selve obligatie wederom machtich te worden, hadde moeten uijtschieten, ende mits dien niet alleen misschende is de interest van de voors. duijsent gul. van de voors. obligatie, maer dat sij dat gelt oock heeft moeten negotieren jegens 6 PC\u1d57ᵒ"). "Furthermore her daughter having made cession [of her goods], the appearer is now burdened ("belast blijft sitten") with her daughter Catarina Bolnes and ten minor children who have nothing in the world save the expectation of the aforementioned and other restricted properties, which the appearer has decided, from now on, to use for the support of her daughter and the latter's children, except that, first and foremost, there must be deducted the aforementioned sum of 1,000 guilders that she had

advanced. So the appearer, for herself and as the grandmother and guardian of her
daughter and of the latter's children, constitutes and empowers by the present
Jouffr. Aleidis Magdalena van Rosendael, her cousin, to collect and to receive the
above-mentioned 2,900 guilders in fulfillment and requitement of the obligation of
the Orphan Chamber of Gouda." She also gives her cousin power to pass an act of
receipt for the benefit of the Orphan Chamber or its masters. (The Hague G.A.,
records of Notary H. T. van Coesfelt, no. 955.)

379. 12 March 1677. Anthony van Leeuwenhoek is formally notified and warned
("geinsinueert") by Maria Thins: "According to the deed of transfer made before
Notary J. Vosch on 24 February 1676 [doc. no. 363] whereby my daughter, in
deduction of the money she owed me, both for herself and as guardian of her chil-
dren, procreated by the late Johannes Vermeer, had handed over, assigned, and
transferred [to me] in full property a certain painting, painted by the aforemen-
tioned Vermeer, wherein is represented the Art of Painting, of which act of transfer
Monsieur Anthony Leeuwenhoek, as curator of the estate of the aforementioned
Vermeer and Catharina Bolnes, has been given vision and copy; and whereas never-
theless, the aforementioned Sr. Leeuwenhoek in the aforesaid capacity intends to
sell, by posting of printed notices (one of which has been sent to me) by public
auction to the highest bidder on the coming 15th of March 1677 in the St. Lucas
Guild Chamber in Delft the aforementioned painting, which has been transferred
to me as heretofore mentioned; so the first notary requested to do so shall present
himself before the person of Sr. Leeuwenhoek to 'insinuate' and inform him in my
name that I do not wish that the aforementioned painting that has been transferred
to me should be sold by him since it must serve to reduce the debt that is still owed
to me by my daughter and from my son-in-law's estate; or if he [Van Leeuwenhoek]
should sell it, he should stipulate that [it] can be seized by me and that the money
for which the same painting may have been sold should not be paid out by me [to
the estate or the creditors] but should be deducted from [the debts due by] the
estate of my daughter and son-in-law" ("ick niet en verstaen dat de voorschreven
aen mij opgedragen schilderye by hem sal werden vercocht, als moetende coomen
in minderinge van mijn achterwesen, off wel, dat hij de selve vercopende sal stipu-
leren dat bij mij genaest sal mogen werden ende dat de penningen daervoor de selve
schilderije soude mogen werden vercocht bij mij niet en sullen werden uijtgekeert
maer affslaech sullen strecken in minderinge van mijne voorn. dochter ende swa-
gers boedel"). "An in case of neglect of the above, [the notary is] to protest against
the above-named Leeuwenhoeck for all costs, damages, and interests that might be
incurred and to relate what occurred in writing. Done in The Hague on 12 March
1677." (Delft G.A., records of Notary C. Ouwendijck, no. 2211, fol. 23. The ver-
sion first published in Bredius 1885, p. 221, is incomplete and severely garbled as
is the translation in Blankert 1978, p. 152.)

380. 13 March 1677. "Pursuant to the above 'insinuatie,' I, undersigned notary, have
presented myself before the person of Anthony Leeuwenhoek and have read to him
the same 'insinuatie,' who replied that he had been unable to take possession of the
painting mentioned therein except by lawsuit and by transfer from Annetge Stevens
and that for this he had had to pay the sum of 342 guilders, the cost of the lawsuit
excluded, that he intended (the 'insinuatie' notwithstanding) to proceed with the
sale of it and that, should the insinuatrix [Maria Thins] pretend to have any rights
thereto, she would have to enter a claim as a preferred creditor." (Delft G.A., rec-
ords of Notary C. van Oudendijck, no. 2211, fol. 23ᵛ, first published in Bredius
1885, p. 221.)

381. 24 July 1677. "We sheriff, burgomasters, aldermen, and rulers of the town of The Hague in Holland certify that there came and appeared before us Maria Thins, widow of the late Reynier Bolnes, who declared, at the request of Aleydis Magh-dalena and Cornelia Clementia van Rosendael, that she was aware [of the follow-ing facts]: that Jan Thins, who was married with Elisabeth Geene, left a son named Geno Thins, who was married with Clementia van Schoonenburch, who pro-created Jan Thins, the grandfather of the above-mentioned Juffrouwen, who pro-created Clementia Thins who was married with Mr. Jacob van Roosendael, in his life, attorney before the Court of Holland, who were the father and mother of the Juffrouwen van Roosendael, of whom [i.e., of this father and mother] they are the sole and universal heirs." She gives reasons of knowledge whereby she has known all these [individuals] and frequented them. (The Hague G.A., "Rechterlijk Ar-chief" no. 638, first published in *Nederlandsche Leeuw* 34 [1916], pp. 217–18. I am grateful to W. A. Wijburg for bringing this source, which has never been cited in the Vermeer literature, to my attention.)

382. 27 July 1677. "Mr. Henrick van der Eem, attorney before the court, as guardian over the ten minor children of the late Johannes Vermeer, in his life artful painter, procreated by Juffr. Catarina [crossed out Maria] Bolnes, and in place of the same Catarina Bolnes, constitutes and empowers Juffr. Aleidis Magdalena van Rosen-dael to deal with all matters concerning her minor children in his appearer's and in Catarina Bolnes's absence, to collect land and house rents, to compel unwilling debtors by law to acquit themselves, and in particular to collect the sum of 2,000 guilders with the interest thereon from the Masters of the Orphan Chamber in Gouda where this sum is deposited, which sum was subject to a *fideicommissum* made on Juffr. Bolnes and now in behalf of her ten minor children, which has now been dissolved by the High and Mighty Lords of the States of Holland and West Friesland." [The *fideicommissum* entitled Catharina Bolnes and her children to consume the usufruct of, or interest on, the principal. The States of Holland and West Friesland, by dissolving the *fideicommissum*, allowed Catharina Bolnes, to collect the principal.] The constituee is also empowered to collect from the same Orphan Chamber an obligation for 800 guilders consisting of a mortgage on the house and court named "de Engel" located in the port of Gouda, of which the rents have been received yearly by Juffr. Maria Thins, the mother of Juffr. Catarina Bolnes; as also an obligation for 400 guilders charged to the office of the receiver Thierens in Delft, the interest on which has also been received by Maria Thins. (The Hague G.A., records of Notary H. T. van Coesfelt, no. 956.) This procuration was also entered in the records of the Orphan Chamber in Gouda (no. 9, fol. 277).

383. 27 July 1677. Petition by Catharina Bolnes and Maria Thins to the States of Holland and West Friesland: "The petitioners [Catharina Bolnes and Maria Thins] reverently inform the States that Johannes Vermeer, during the ruinous and pro-tracted war not only was unable to sell any of his art ("van sijne kunst niet was hebbende kunnen vercopen") but also, to his great detriment, was left sitting with the paintings of other masters that he was dealing in ("van andere mrs. daermede hij was handelende"), as a result of which and owing to the very great burden of [his] children, having nothing of his own ("niets van sijn selve hebbende"), he had lapsed into such decay and decadence, which he had so taken to heart that, as if he had fallen into a frenzy, in a day and a half he had gone from being healthy to being dead ("tot soodanigen verval ende decadentie was gekomen, 't welck hij soodanich ter harten hadde getrocken, dat hij gelijck als in frenesie vervallende in een dach of anderhalff was gesont ende doodt geweest"). They further state that the first peti-tioner [Catharina Bolnes] was now piteously left sitting with ten minor children,

of whom the youngest was about two ("met tien onmondige kinderen waervan het jongste omtrent de twee jaren out was") and, since she had never concerned herself further or otherwise than with her housekeeping and her children ("haer noyt verders ofte anders als met hare huyshouding ende kinderen hadt bemoeyt"), it was some time later that the bad and poor condition of her estate had come to her knowledge and, since she was burdened with considerable debts, she had been forced to take refuge in the miserable benefit of cession ("miserabele benefitie van cessie") and had abandoned all her goods to the profit of her creditors, and the letters of cession had been officially granted ("de brieven van cessie waren gejnterineert"). And now, because her ten minor children had nothing in the world to live on and until now not one of these children was capable of fully earning a living ("tot noch toe van alle de selve kinderen niet een capabel was omme de kost ten vollen te kunnen winnen"), she had been obliged to seek assistance not only from her relatives but also from strangers, which she, supplicant, stemming from honest people, had not let happen gladly ("sulcx sy dan genootsaeckt soude wesen assistentie te versoecken niet alleenlijck bij hare vrunden, maer oock bij vreemden waertoe sy supplicante, als gekomen sijnde van eerlyke luyden, niet geerne en soude vervallen"). And as also, pursuant to the testament of Dieuwertge Hensbeecq, her, supplicant's, grandmother [grandaunt], "the Orphan Chamber in Gouda owed the sum of 2,900 guilders, deposited therein in the form of interest-bearing obligations, which moneys by the aforesaid testament devolved upon the first supplicant and her children, subject to the *fideicommissum* that her mother Maria Thins may draw the yearly revenues and interests from this capital her life long, and that now the aforementioned Maria Thins is resolved to use a part or the entire capital, and considering that the *fideicommissum* was not in direct line but collateral, and owing to the large number ("menichte") of children of the supplicant, . . . and considering that there are many and pregnant reasons why the minor children should be brought up from this capital, which must necessarily devolve upon her, and so that she [Catharina Bolnes] may not come to be a burden on relatives and strangers, poor-law boards ("diaconien"), or orphanages as long as she can be supported from these 2,900 guilders subject to *fideicommissum*, so the supplicants, in their respective qualities, turn to us [States of Holland and West Friesland] and humbly beseech us that we, in consideration of the great burden of the aforementioned ten minor children . . . have the kindness to release the inheritance coming from Diewertge Hendricks from the *fideicommissum* and authorize the supplicants to collect ("lichten") the aforementioned obligations or money from the Orphan Chamber and to use, sell, or otherwise deal with the same so as the supplicants shall see fit." The States finding it proper that the orphan children should be brought up from the inheritance of their great-grandmother [great-grandaunt] Dieuwertgen Hendricks Hensbeeck authorize Catharina Bolnes to collect 2,900 guilders from the Orphan Chamber of Gouda. (Gouda G.A., Orphan Chamber, "Weesboek" 9, fols. 277^{r+v}. An extract of this document was first published in Matthijs 1976, p. 43. I am grateful to Dr. Matthijs for letting me use his transcription, which I completed after consulting the original text.)

384. 1 August 1677. Juffr. Aleidis Magdalena van Rosendael, armed with a procuration dated last July 27, made out by heer Henrick van der Eem, guardian over the minor children of the late Johannes Vermeer, in his life artful painter, having lived in Delft, has transferred in full property to [left blank] a certain obligation for 2,000 guilders capital [deposited] at the office of the lord receiver [left blank], charged to [left blank] in date [left blank]. (The Hague G.A., records of Notary H. T. Coesfelt, no. 956.)

385. 9 August 1677. Juffr. Aleydis Magdalena van Rosendael, having received the procuration of Mr. Hendrick van der Hem [Eem], guardian over the minor orphan children of Johannes van der Meer, procreated by Catharina Bolnes, acknowledges receipt of 2,900 guilders capital, whereof Maria Thins was drawing the usufruct and income, which she has relinquished ("de jaerlijcke vruchten was genietend, die daer van heeft gedesisteert"). (Gouda G.A., Orphan Chamber, "Weesboek" 9, fol. 276ᵛ, transcription by Dr. Matthijs.)

386. 10 August 1677. Juffr. Aleidis Magdalena van Rosendael, spinster of age, armed with a procuration of Mr. Hendrick van der Eem and of Catharina Bolnes, transfers in full property to [left blank] an obligation for 2,900 guilders capital issued by the office of the receiver general Cornelis de Jonge van Ellemeet, dated 28 December 1667, folio 400 verso and, on the 30th of the same [month], accredited by the High and Mighty Lords of the States of the United Netherlands, there registered under folio 298. She acknowledges that she has been paid for this "the entire proceeds from the first to the last penny."(The Hague G.A., records of Notary H. T. van Coesfelt, no. 956.)

387. 11 August 1677. Juffr. Maria Thins, widow of Sr. Reijnier Bolnes, gives to understand that Juffr. Aleidis Magdalena van Rosendael, her cousin, on the 10th of this month had transferred to [left blank] or the bearer a certain obligation for 3,000 guilders capital in the name and at the office of the receiver general Cornelis de Jonge van Ellemeet [dated, accredited, and registered as in doc. no. 386]. Juffr. Rosendael having promised, for further security of the obligation, to guarantee it as if it were her own property, the appearer promises to exempt Juffr. Rosendael of any trouble, damages, or costs that might ensue at any time with respect to this same obligation. (The Hague G.A., records of Notary H. T. van Coesfelt, no. 956.)

388. 1 February 1678. Anthonij Leeuwenhoeck, appointed by the Hon. Lord Aldermen of Delft guardian over the insolvent and repudiated estate and property of Catharina Bolnes, widow and former keeper of the estate of Johannes Vermeer, painter in his lifetime in this town, empowers Niclaes Straffintvelt, notary in Gouda, to transfer in his name to the purchasers [i.e., sell] a precise third part of a house and court with a bleaching field at the back situated in the Peperstraat, as well as a third part of three morgen of land located in Wilnis outside Gouda, inherited by the aforementioned Catharina Bolnes from the estate of the late Jan Bolnes, her late uncle . . . to receive the ready money, to settle and to liquidate etc. (Delft G.A., records of Notary F. van der Werff, no. 2230, first published in Bredius 1885, pp. 221–22. I have followed the translation in Blankert 1978, pp. 152–53.)

389. 2 April 1678. Jouffr. Maria Thins, widow of Sr. Reijnier Bolnes appears before Notary H. T. van Coesfelt and declares that Jouffr. Johanna Kiest, wife of heer Jacob Rombouts, merchant in Amsterdam, had supplied to her son-in-law, the late Johannes Vermeer, a capital sum of 1,000 guilders according to the debt recognition passed before Notary Jacobus Hellerus and certain witnesses on 20 July 1675. As it happens that Johanna Kiest will not be able to recuperate her capital in full, the appearer, for reasons that have moved her to do so, was inclined to let her have the remnant or unpaid portion ("restant ofte defect") of the 1,000 guilders capital sum, to oblige her, as she is doing by the present, in such wise that the above named Jouffr. Kiest, after she will have done everything [to get her due] and be able to obtain nothing more from the estate of the above-named Johannes Vermeer or from his widow toward the arrears on the money owed to her, after the death of her, appearer, out of her most liquid assets ("uijt haere gereeste goederen"), shall be paid the remnant or unpaid portion of the capital, but not any past or future

interests due on it, and without honoring any other claims on her son-in-law or daughter. (The Hague G.A., records of H. T. van Coesfelt, no. 956.)

390. 2 April 1678. "There appeared before me Notary H. T. van Coesfelt Juffr. Maria Thins, acting on her own and with a power of transfer from Anthonij Leeuwen-hoeck, as curator of the estate and property of Catharina Bolnes, widow of the late Johannes Vermeer, recipient of letters of cession, as unique and universal heir of Willem Bolnes, her late brother, of all his property and shares ("actien"), together with the shares and assets that the aforenamed Willem Bolnes inherited from his cousin ("neve") Henrick Claesz. Heinsbeeck, with the revenues therefrom, both those that have accrued and those that are to accrue, and also pursuant to the agreement made with curator Leeuwenhoeck under supervision of the aldermen on behalf of the appearer [Maria Thins] on 20 November 1676, which appearer de-clared that she has empowered the respectable Willem Schuijffhill, attorney before the High Court ("Hoogen Raede") of Holland, to summon Monsieur Johan Schade, former apothecary, together with Arien Cruijff and N.N. [unknown first and middle names] Lijsterre in Gouda with a view to have them deliver and pay to the appearer all such capital sums and interest-bearing obligations, or their value, along with the interests thereon, as are due to her." He may bring these debtors before a court of justice and eventually appeal the sentence in case of refusal. (The Hague G.A., records of Notary H. T. van Coesfelt, no. 956.)

391. 9 April 1678. Jouffr. Maria Thins appears before Notary H. T. van Coesfelt and declares that the Jouffrouwen Aleidis Magdalena and Cornelia Clementia van Rosendael, her cousins ("nichten"), on the basis of the procuration that she, ap-pearer, had given them, as well as at her earnest request, oral charge, and order had undertaken various affairs for her here in The Hague, in Brabant, and else-where, for which the same Juffrouwen had given her receipts. The appearer states that she is fully satisfied with all the actions that her cousins have performed to this date and thanks them for all the troubles they have taken. She expressly forbids that any of her heirs should make claims on or request any further accounting from her cousins and hereby renews the procuration she has given them. (The Hague G.A., records of Notary H. T. van Coesfelt, no. 956.)

392. 28 August 1678. Aleidis Magdalena van Rosendael collects two unrestricted in-terest-bearing obligations ("losrenten") from the Orphan Chamber of Gouda, one for 400 guilders and the other for 800 guilders. (Gouda G.A., Orphan Chamber, "Weesboek" 10, fol. 179ᵛ.)

393. 1 September 1678. In a petition to the Lord Magistrates of the town of Gouda, Maria Thins and Catharina Bolnes reverently inform their Lordships that the first supplicant is still entitled to [the usufruct on] a life annuity on a capital sum of 1,200 guilders lodged in the Orphan Chamber, of which the second supplicant is the owner. Seeing that the oldest (of the [second] supplicant's) children is 21 years old and the youngest four years old and that two of them are very sick and one was piteously wounded in a ship from Mechelen by occasion of the fact that there was gunpowder in it which was ignited ("dat daer buskruijt in waer, 't welck aen-gingh"), the [second] supplicant is no longer able to feed her children and to pay the apothecaries and surgeons, as a result of which none of her children can yet earn any but small amounts so the supplicants have arrived at the counsel that the first supplicant should desist from the life annuity in favor of the second [for which the supplicants request approval of the States]. (Gouda G.A., Orphan Chamber, "Weesboek" 10, fol. 179ᵛ. An extract was cited in Matthijs 1976, p. 43.)

394. 17 October 1678. Maria Thins gives a procuration to Jouffr. Aleidis Magdalena van Rosendael living in Delft, her cousin, to appear in her name before the Masters

of the Heilige Geesthuijs in Gouda and from these Masters or from the Matrons of the same Geesthuijs to receive the allocation of wool and linen clothes as well as the cash payment ordinarily distributed each year on All Soul's Day, which must be given to her, appearer, or to persons representing her on the basis of the testamentary disposition of Diewertje, the daughter of Hendrick Dircxzoon van Hensbeeck, dated 27 November 1603, as well as of the codicil [to the will] of Dirck Cornelisz. van Hensbeeck of 2 June 1562, after receiving which clothes and money, she [appearer] may redistribute them to needy persons as she may see fit. Maria Thins also empowers her cousin to lease her lands and houses. (The Hague G.A., records of Notary H. T. van Coesfelt, no. 956, cited, with an inexact date, in Van Peer 1975, p. 45.)

395. 26 November 1678. Maria Tin authorizes the attorney Frans Bogaert in Delft to represent her as plaintiff seeking preferential status as creditor ("als eyescheresse van preferentie") with respect to other creditors of the late Johannes Vermeer, her son-in-law. (Published in Bredius 1910, p. 63.)

396. 2 March 1679. Aleidis Magdalena and Cornelia Clementia van Rosendael, spinsters of [legal] age, constitute themselves sureties for Maria Thins for the restitution of a sum of 800 guilders and the interest thereon, for which sum Gerrit Pietersz. Lijsteren has been condemned by a provisional sentence of the Court of Holland dated 7 December 1678. The constituents bind their persons and property for this guarantee. (Delft G.A., records of Notary R. van Edenburgh, no. 2265, fol. 19.)

397. 2 March 1679. Maria Thins exempts the Juffr. Aleidis Magdalena and Cornelia Clementia van Rosendael of all financial responsibility for the guarantee in doc. no. 396. (Delft G.A., records of Notary R. van Edenburgh, no. 2265, fol. 19.)

398. 12 July 1679. Mr. Pieter de Bije, armed with a procuration from Juffr. Maria Thins dated 28 April 1676, directs Monsieur Henrick van Bergen, notary and attorney before the Court of Oud Beyerlant, in the name of the constituent, to impound ("te nemen in arrest") the produce and cattle ("vrugten ende bestiaelen") on the lands belonging to Juffr. Maria Thins consisting of 27 morgen located in Oud Beyerland, to sue before the court for his arrest, to summon Jan Leendertsz. Evenblij, married to Emmerentia Jacobs, the widow of Claes Cornelis Stoutge, and to cause the same Jan Evenblij to be condemned for arrears in the payment of rents based on the lease contract passed before Notary Jan van Veen in Delft on 2 January 1676. Adriaen Isselsteyn, artful painter, witnesses the act. (The Hague G.A., records of Notary H. T. van Coesfelt, no. 957.)

399. 23 October 1679. Jouffr. Maria Thins widow of Sr. Reynier Bolnes living in Delft names Jan Boogert, attorney in Delft, to represent her in carrying out the sentence in the case of preferential status ("in cas van preferentie") that came before the judges of the aforementioned town of Delft between the registered creditors of the late Johan Vermeer and Catharina Bolnes, [which sentence was] dated 3 July 1679. She declares with solemn oath that the sum of 220 guilders cited in the above-mentioned sentence that had been expended by her to pay for the death debts of the aforementioned Johannes Vermeer were effectively expended by her, appearer, and not from moneys in the estate of the aforementioned Vermeer and Catharina Bolnes, directly or indirectly, and that she has not been repaid for them. Similarly the items in the accounting or liquidation of 22 February 1676 which she had claimed from her daughter, and which have also been cited in the sentence, are still owed to her by her daughter. (Rotterdam G.A., records of Notary Z. van der Brugge, cited in unpublished notes by A. Bredius in the Rijksbureau voor Kunsthistorische Dokumentatie in The Hague.)

400. 30 October 1679. H. van der Eem, the guardian of Johannes Vermeer, presently the owner of osier lands located in the Waerlants over Gellekenes in the Barony of Liesvelt, inherited from Jan Thins, empowers Juffr. Aleidis Magdalena van Rosendael, living in Delft, to sell on his behalf the osier shoots ("rijshouwen") growing on these osier lands. She may also sell a garden located next to Schoonhoven. (The Hague G.A., records of Notary H. T. van Coesfelt, no. 957.)

401. 24 January 1680. Maria Thins, drawing up a new testament, expresses the fear that her landed estates ("landerijen") in Oud Beyerland, which had come from her ancestors and had been so carefully nurtured and preserved, would, in case they were to be inherited in full power and property by her heirs, quickly be consumed, sold, or alienated. When the children's children of her heirs should come to die, then the estates would accrue to the descendants of her father Willem Thins who would then have free disposal over them. Accordingly she, by her testament, has given full power to the executor to ensure that her property shall remain undivided until the youngest child named Ignatius Vermeer should become 16 years old. As to her daughter Catharina, the executor should exercise his discretion since she perhaps will not be able to have enough means to live on. Accordingly, the testatrix stipulates that if she, Catharina Bolnes, cannot live adequately from the rents and interests of her assets, then these assets may be mortgaged or even sold. But the minor children must first be reared and brought up. She requests that the executor make a yearly accounting of the administration of her property to her daughter Catharina and to two honest people, but with the special stipulation and request that the husband of her granddaughter Maria Vermeer, named Johannes Cramer, not be consulted because she does not want him to supervise the accounting, this for weighty reasons and motives. (Delft G.A., records of Notary J. Boogert, no. 2007, first published in part in Bredius 1910, p. 63.)

402. 7 February 1680. Juffr. Maria Thins, living in Delft and presently finding herself here [in The Hague], on one side, and Jan Leendertsz. Evenblij and his wife Emmerentia Jacobs (widow of Claes Cornelisz. Stoutge), on the other, declare that they have had disagreements and difficulties regarding the payment of land rents on various leases by the two last appearers, and a suit had been brought [to compel payment]. To put a stop to the suit, the parties agreed that the last two appearers shall see to it that Aert Huygensz. Spruijt shall pay, and Aert Huygensz. Spruijt, who also appeared, agreed to pay, the sum of 500 guilders to the first appearer [Maria Thins]. Spruijt also agrees to pay the first appearer the sum of 300 guilders on 1 May 1680. The above-named Evenblij and his wife agree to pay Maria Thins 200 guilders, plus 100 guilders to Henrick van Bergen, attorney in Oud Beyerland, on behalf of Maria Thins, within six days, plus 150 guilders on 1 May 1681 and the remaining 150 guilders on 1 May 1682. After these payments have been made, all outstanding claims will have been settled. Henrick van Bergen witnesses the act. On the same day, Maria Thins leased to Aert Huygensz. Spruijt 27 morgen and a few rods of land located in Oud Beyerland near the Hoopsonder Maet for the next three years, starting Kermess 1679 of the past year for 486 guilders per year. Jan Leendertsz. Evenblij also appeared and declared that he has desisted from any claims he might have on the lease of these lands. (These consecutive documents appear in The Hague G.A., records of Notary H. T. van Coesfelt, no. 957.)

403. 26 August 1680. Testament of Johannes Cramer and Maria Vermeer. The testator and testatrix name each other universal heirs. In case he, testator, should die first, then she, testatrix, can either choose half of the estate or an income of 100 guilders per year. In this case, Johannes's brother Dominicus Cramer will be named

guardian over the testator's children. (Delft G.A., records of Notary C. Ouwen-dijck, no. 2212.)

404. 10 September 1680. Anna Maria, daughter of Joannes Cramer and Maria van Meren, is baptized in the Jesuit Church. The witness is Anna, mother of the woman who had given birth ("kraamvrou"). [Anna may be an error for Catharina, the child's grandmother.] (Delft G.A., Jesuit Station of the Cross, Baptism files.)

405. September 1680. Maria Thins authorizes the herald ("bode") of the town of Gouda to sell her house "De Engel" located in the port of Gouda for 750 guilders. (Van Peer 1975, p. 47.)

406. 4 October 1680. Maria Thins, presently in this city [Delft] appears before the notary and declares that she has settled and liquidated with her cousins Juffr. Aleida Magdalena and Cornelia Clementia van Rozendael the administration that the aforementioned Juffrouwen have had over her property since the eighth of July 1680 on which date they settled and liquidated for the last time, as is shown by the act of discharge ("acquijt") passed on that day before the notary Boymans [prob-ably Severin Boynans, notary in Mechelen; this document could not be located in the Staatsarchief in Antwerp where a few acts passed by this notary have been preserved] and certain witnesses in Mechelen on that date. She also acknowledges to have been paid in full with respect to certain sums that had been received by the aforementioned Juffr. Alida Magdalena, on the basis of a procuration dated 27 July 1677, from Mr. Henric van der Eem as guardian of Johannes van der Meer, stem-ming from a certain vicariate that she, appearer, had conferred on the same Van der Meer. She has taken in the sums received by her cousins ("nichten") from the vicariate and used them to support her grandchildren. Furthermore she greatly thanks the Juffrouwen, her cousins, for all their troubles, giving to understand that the aforementioned cousins had constituted themselves sureties and co-principals on an obligation ("rentge") for 100 guilders capital and interest on a house belong-ing to Burgje Crijnen in Oudewaer as well as on an obligation for 3,000 guilders, and on another for 800 guilders with the interest thereon, for which obligations acts were passed before Notary Henrick Teerbeeck van Coesfelt in The Hague in 1677 and the other before Roelandus van Edenburgh on 2 March 1679. She had promised at that time to idemnify her cousins and to this end she declares that her cousins may, at any time and at their pleasure, up to the sums for which they have constituted themselves sureties, secure themselves repayment from her estates and other assets. The act was witnessed by Jan Hey and Robertus van Zijl. (Delft G.A., records of Notary J. Boogert, no. 2007, fol. 505–506.)

407. 23 December 1680. Philippus de Pauw, priest of the Jesuit Mission in Delft, gives Maria Thins the Last Sacraments. (Van Peer 1975, p. 47b.)

408. 27 December 1680. Maria Tin, widow of Reijnier Bolnes, is buried in Delft. The grave she had bought on 19 July 1671 in the Old Church is "now full." (Van Peer 1968, p. 223.) In the burials register, Maria Thins is said to have lived on the Oude Langendijck at the corner of the Molenpoort. Fourteen pall-bearers carried her to her grave. (Delft G.A., Old Church, Burial files.)

409. 27 December 1680 and 12 February 1681. An entry in the "Beste Opperste Kleed Boek" of Delft's Camer van Charitate on the first date reads: "Maria Thins widow of Reynier Bolnes on the Oude Langendijck, Old Church, paid." The entry in the same source for the second date reads: "The sum of 25 guilders 4 stuivers was brought to the Camer by Confrater Van der Hoefe for the redemption of the best upper garment ("beste opperste cleet") of Joffr. Maria Tins, widow of the late

Reynier Bolnes." (Delft G.A., archives of the Camer van Charitate, "Beste Op-
perste Kleed Boeken," no 74A, second part.)

410. 16 July 1681. Catharina Bolnes borrows 400 guilders from Pieter van Bleeck for
one year at 5 percent interest. She promises to repay from incomes from properties
inherited from her uncle Johannes Willemsz. Tin and from her aunt Cornelia Wil-
lems Tins. Pieter de Bije, executor of the testament of Maria Tins, guarantees the
loan. (The Hague G.A., records of Notary H. T. van Coesfelt, no. 959, published
in part in Bredius 1910, p. 63.)

411. 28 July 1681. Catharina Bolnes borrows 400 guilders from Francois Smagge for
one year at 4.5 percent interest. Pieter de Bije guarantees the loans. (The Hague
G.A., records of Notary H. T. van Coesfelt, no. 959, published in part in Bredius
1910, p. 63.)

412. 16 October 1681. Mr. Hendrick van der Eem, as appointed guardian over the
children left by Sr. Johannes Vermeer procreated by Catarina Bolnes, together with
Mr. Pieter de Bije, as executor of the testament of Maria Tins, constitute heer Johan
Boon, envoy ("bode") of the town of Gouda, in order to sell or transfer in the
appearer's names an interest-bearing obligation for 480 guilders charged to Jacob
Jacobsz. Does[?], basketmaker in Gouda, another for 600 guilders, dated 19 Oc-
tober 1656, and one for 300 guilders dated 24 June 1670, both issued by Aert
Gysbrechtsz. van Broeck, and one for 150 guilders, as the remaining part of an
obligation issued by Aryen Krijff and Dirck Wittekoop. (The Hague G.A., records
of Notary H. T. van Coesfelt, no. 959.)

413. 15 December 1681. "The Notary Jan Boogert, appropriately assisted, shall be-
take himself, on behalf of the undersigned, to Mr. Hendrick van der Eem, guardian
of the children of Catarina Bolnes procreated by Johannes Vermeer, and remon-
strate with him concerning an act passed before Notary Jan Boogert on 4 October
1680" (above, doc. no. 406). The insinuating parties [Aleidis Magdalena and Cor-
nelia Clementia van Rosendael] point out that, in this act, Maria Thins had stipu-
lated that they were to be exempt of any costs or damages for the guarantee they
had given her for 100 guilders per year interest on a mortgage on the house of
Burgje Crijnen van Oudewater and for capital sums of 3,000 guilders and 800
guilders. Maria Thins had promised, for herself and for her heirs, to pay all taxes
including the 40th penny tax, the costs of registering the documents, and all further
attendant costs on these transactions. The insinuating parties inform Mr. van der
Eem that he should make these payments within 14 days and, in case of refusal,
they will protest all costs, damages, and interests regarding this matter. Aleidis
Magdalena and Cornelia Clementia van Rosendael sign the "insinuatie." In the
second part of the "insinuatie," the notary reports that he informed Mr. van der
Eem of the above "insinuatie" and protest and that Mr. van der Eem answered that
he would make his communication regarding the matter to Pieter de Bije, executor
of the testament of Maria Thins, and that "one would try to give satisfaction to the
insinuating parties." (Delft G.A., records of Notary J. Boogert, no. 2308, fol. 274.)

414. 23 April 1682. Catharina Cramers, daughter of Joannes Cramers and Maria van
Meren, is baptized in the Jesuit church. Christina Pirot is a witness. (Delft G.A.,
Jesuit Station of the Cross, Baptism files.)

415. 12 July 1682. In the inventory of Diego Duarte in Antwerp, an entry reads:
"182. A small painting ("stukxchen") with a lady playing on the clavecin with
accessories by Vermeer." (H. G. Dogaer, "De inventaris der schilderyen van Diego
Duarte," in *Jaerboek van het Koninklijk Museum voor Schone Kunsten*, Antwerp,
1971, cited in Blankert 1978, p. 153.)

416. 19 November 1682. Mr. Henrick van der Eem, pursuant to the testament of Maria Thins, guardian over the children of Catharina Bolnes, widow of Johan van der Meer, empowers Anthony van Leeuwenhoeck, to sell two obligations, one for 1,200 guilders yielding 48 guilders per year and the other for 210 guilders yielding 8 guilders 8 stuivers per year deposited in Gouda, proceeding from property of Willem Bolnes to which Maria Thins had obtained possession as a result of the death of Hendrick Claesz. van Hensbeeck. (Delft G.A., records of Notary F. van der Werff, no. 2232, act no. 113.)

417. Early April 1683. Inventory of the estate and property due to Jacobus Abrahamsz. Dissius on his own account inherited as a result of the death of Juffr. Magdalena van Ruyven ("Inventoris van den boedel ende goederen toecomende Jacobus Abrahamsz. Dissius uijt syn eijgen hoofde aen hem aenbesturven door't overlyden van Juffr. Magdalena van Ruyven") who died 16 June 1682.

In the front room ("op de voorkamer")
8 paintings by Vermeer
3 ditto by the same in [crossed out "with"] boxes ("kasies")
a seascape by Porcellis
a landscape
Among other items, "a little coffer containing 3 diamond rings"
In the back room
4 paintings by Vermeer
2 paintings [crossed out "one of"] of churches [crossed out "and the other of a burial"]
2 being "tronyen"
2 being nightscenes ("nachies")
1 ditto landscape
1 ditto with houses
A chest of drawers with
a viola de gamba
a hand-held viol ("een hantviool")
two flutes
a few music books
In the kitchen
a painting by Vermeer
2 "tronyen"
a night scene ("nachie")
2 landscapes
a little church
a painter ("een schilder")
In the basement room ("op de kelder kamer")
2 paintings by Vermeer
a landscape
a church
Various items of clothing, including
2 turkish men's mantles
Besides the above items there still follow
2 paintings by Vermeer
2 small landscapes
Jacobus Dissius gave 100 guilders 16 stuivers to the Camer van Charitate on his wife's behalf. (Delft G.A., records of Notary P. de Bries, no. 2325, fol. 31 and ff., published in part in Bredius 1885, p. 222.)

418. 29 September 1683. The daughter [no name given] of Joannes Cramer and
Maria Thins [*sic*] is baptized in the Jesuit Church. The witness is Dominicus Cra-
mer (absent). [Dominicus Cramer was the brother of Johannes Cramer.]

419. 21 October 1684. In a request to the Lord Burgomasters of the town of Gouda,
Catharina Bolnes asserts that, after the death of her husband, she was left with
eleven children and that she is now living in Breda and has little means to subsist
on. Since this has been going on for eight years, she has reached such a state that it
is not possible for her to bring up eight children without assistance. Principally her
daughter Gertrui causes her much concern because the child "has been so afflicted
by the Lord God with sickness that she can earn nothing" ("Van God de Heer
soodanich met sieckte is besocht dat zij niets kan winnen"). Furthermore, she re-
minds the lord burgomasters that her ancestors had left a substantial amount of
capital, the yearly interest on which was to be divided among the housesitting poor.
[The housesitting poor ("huiszittend arme") are poor people who neither are living
in a charitable institution nor are wandering beggars.] Earlier 196 guilders per year
had been allotted but now only 128 guilders were available. The burgomasters
approve her request and allot her 96 guilders for two years. After these two years,
the allocation was renewed, again for 96 guilders a year, for another three years
(see doc. no. 436). (Gouda G.A., "Requestboek" 1683–1695, cited in Van Peer
1951, pp. 619–20 and, more fully, in Van Peer 1975, p. 43.)

420. Between 14 and 20 April 1685. "State of the goods and chattel of Jacobus Abra-
hamsz. Dissius and Magdalena Pieters van Ruijven, his wife, owned in common,
and, by the same Magdalena Pieters van Ruijven, vacated and left after her death."
She had left as her heirs her father-in-law Abraham Jacobsz. Dissius, and her hus-
band Jacobus Dissius pursuant to the testament of the aforesaid Magdalena Pieters
van Ruijven signed on 3 December 1680 and following the acts of superscription
passed before Notary Daniel van der Houve and certain witnesses on 10 December
1680 and the acts made before the commissaries of the High Court ("Hoge
Raade") on 18 July 1684 and 16 February 1685 (fol. 1 of act 29). [These acts are
no longer extant.]

 Jacobus Abrahamsz. Dissius is to receive one-half and Abraham Jacobsz. Dissius
the other half of the estate ("boedel").

 Subject to the clauses below, the furniture and household goods are assigned to
lot A, the book printing press and other printing equipment to lot B.

 "All the furniture and household goods, linen and wool, jewels, gold and silver
etc., with the exception of 14 paintings, beginning with folio 5 recto of the inven-
tory 'a lot of firewood' and ending on folio 11 verso 'two black hats' are here
assessed and assigned to one lot ('cavel') to be apportioned (fol. 20)."

 Fourteen paintings which are comprised in the movable goods are excluded from
lot A and assigned to lot B. They consist of:

 3 landscapes by S. de Vlieger
 3 churches by E. de Wit
 2 portraits or "tronien"

and 6 by J. Vermeer at the choice of the one who will receive for his lot the above
mentioned bookprinting press, the shop wares, etc. ("ter keure van der gene die de
voorsz. Boecked ruckerye winkelwaren etc. sal te beur te vallen") (fol. 21).

 Lot A fell to Jacobus Abrahamsz. Dissius to whom it has been assigned in fulfill-
ment of the one half share coming to him (fol. 35). Lot B fell to Abraham Jacobsz.
Dissius to whom it has been assigned in fulfillment of the other half coming to him
(fol. 44). Lot B included the book printing press and all the equipment plus 14

paintings [again listed as itemized above]. (Delft G.A., records of Notary P. de Bries, no. 2327, act no. 29.)

421. 10 November 1685. Aegidus Cramer, son of Joannes Cramer and Maria Vermeer, is baptized in the Jesuit Church. Dominicus Cramer and Christina Pijrrot are witnesses. (Delft G.A., Jesuit Station of the Cross, Baptism files.)

422. 23 September 1686. Ignatius Vermeer signs an act for his guardian-to-be the Notary H. T. van Coesfelt concerning the heer Cornelis van der Goes living in Delft. No profession is cited for the young Vermeer. The signature is quite literate. (The Hague G.A., records of Notary H. T. van Coesfelt, no. 964.)

423. 24 September 1686. Maria Jans Vermeer, lying sick in bed, and Johannes Cramer draw up a new testament, again naming each other unique and universal heirs. They claim that, in the assessment of the tax on the 200th penny, they are not worth more than 1,000 guilders ("niet hoger op 1,000 gulden gequalifeert te sijn"). The legitimate portion of each child is set at 1,000 guilders. Dominicus Cramer is named guardian over the children. The testatrix signs Maria Cramer. (Delft G.A., records of Notary P. de Bries no, 2328, fol. 82.)

424. 15 October 1687. Aegidius Cramer [II], son of Joannes Cramer and Maria Vermeer, is baptized in the Jesuit Church. The witnesses are Dominicus Cramer and Christina Pirrot. (Delft G.A., Jesuit Station of the Cross, Baptism files.)

425. 29 October 1687. "Juffr. Catharina Bolnes, widow of the late Johannes Vermeir [sic], living in this town [Breda] appears before the notary to acknowledge that she owes the respectable Juffr. Pitronella de Lange, widow of Gerard van Weldt, also living in this town, the sum of 300 guilders by reason of money lent to her, debtor, on 8 September 1685, at five percent, as also the sum of 175 guilders by reason of boarding costs ('montkosten'), lodging, and delivery of shopwares, both to her, debtor, and to some of her children." She promises to return the entire sum of 475 guilders on May 1st of the coming year 1688, the first 300 guilders at 5 percent interest since 8 September 1685, and the remaining 175 guilders without interest. If the money is not returned in time, she will owe interest on the entire sum since 8 September 1685. A marginal note indicates that Gerard van Welt, house brewer, for himself as also acting on behalf of his three brothers, all heirs of Juffr. Pitronella de Lange, declared that the entire capital 475 guilders had been restituted by Notary Sr. Coesvelt in The Hague, signed 15 June 1688. (Breda G.A., records of Notary P. Beeris, no. 286, fol. 30ᵛ and 31.)

426. 27 December 1687. "Juffr. Catharina Bolnes, widow of the late Johannes van der Meer, presently in this town [Delft], known to me, notary, both out of her own volition and on the strength of the testament of her late husband and also pursuant to the will and desire of her late mother Juffr. Maria Tins, appoints by the present Hendrick ter Beck van Coesfelt, notary living in The Hague, as guardian over her minor children with the power to appoint a co-guardian or someone else in his place if he deems fit with all such authority as is vested in a guardian. She excludes from this guardianship all others whoever they might be and especially the Orphan Masters of this town." The act is passed in the lodging of the appearer, lying sick in bed, in the presence of Engeldorf van der Myll, the notary's clerk, and Gerrit Velthaer. The testatrix was so weak she could only make a few scratches, which the notary identified as her signature. (Delft G.A., records of Notary C. Ouwendijck, no. 2216.)

427. 30 December 1687 and 2 January 1688. Domicella Catharina Bollenis is given the Last Sacraments on December 30. (Van Peer 1946, p. 469.) Mejuvrouw Catharina Bolnits is carried to her grave on January 2nd by 12 pallbearers, coming from

the house "De blauwe hant" (The Blue Hand) on the Verwersdijck; she leaves five children under age ("12 dragers, 5 m.j.k."). (Delft G.A., New Church Burial files, first published in Obreen 1881, 4: 300.) The entry for "Catharina Bolnes, widow of Johan van der Meer," for 2 January 1688 in the "Beste Opperste Kleed Boek" (no. 74a) shows that nothing ("niet") had been given by her heirs.

428. 17 May 1688. Monsr Johannes Cramer, as the husband of Juffr. Maria Vermeer, constitutes Hendrick T. van Coesfelt, notary in The Hague, especially for the purpose of appearing in his name before the bailiff or the sheriff and aldermen of Oud Beijerland and, under their supervision, to cede and transfer to Heer Van der Mast, councillor and member of the Vroedschap of Dordrecht and rentmaster of Oud Beijerland, 5 morgen and 263 rods of land located in the Groeneweg in Oud Beijerland leased to Herman Huyberts, and to Heer Henricus van Lent van Uytten broeck, living in The Hague, 27 morgen and a few rods of land, leased to Aert Huijgen Spruijt, and another 2 morgen 200 rods of hay land, called De Geer, also located in Oud Beijerland, leased to Johannes de Ban, which lands were purchased by the above-named Heer Van der Mast and Heer Van Lent on 20 April of this year in Rotterdam under specified conditions, namely the Heer Van der Mast his portion for 1,550 guilders and the Heer Lent van Uyttenbroeck both his lots for the sum of 12,300 guilders. (Delft G.A., records of Notary J. Boogert no. 2311, fol. 64).

429. 25 October 1688. "Jo'es [Johannes] Antonius, son of Jan Vermeer and Maria Anna Frank," is baptized in the Roman Catholic church at Slijkvaart near Rotterdam. The witnesses are Antonij van Wichelen and Maria Catrijna de Vlieger. (Rotterdam G.A., "Doopboek," published, with some inaccuracies, in Van Peer 1951, p. 620.)

430. 2 May 1689. On this date, Johannes van der Meer, living in Delft, aged . . . [left blank] in consequence of the death of his mother Catharina van Bolnes, was vested with a feud in "Bon Repas" near Schoonhoven. By reason of his minority ("mits sijnen onmondichheijt"), his guardian, the notary H. T. van Coesfelt, took the oath of fealty in his place. "Johannes van der Meer remains under obligation to take the oath himself within a year after he shall have reached his full legal age." In case Hendrick Terbeck van Coesvelt were to die at a time when Johannes van der Meer was still minor, "the latter's guardians are to name a vassal to represent him and take the oath in his place." (Algemeen Rijksarchief, Rijksarchief in Zuid-Holland, "Archiv van de Leenkamer van Holland," no. 161, fols. 147–48, cited in part in Obreen 1881, 4: 301. The name of Van Coesfelt was given mistakenly as Van Colefelt in this source.)

431. 18 May 1689. "Sr. Franciscus Vermeer, master surgeon living in Charlois, well known to me, notary, acknowledges duly owing 200 guilders to Sr. Pieter van Bleeck." The money has been paid out to the borrower through the hands of the notary. The loan is made at 4 [crossed out: 5] percent per year. (The Hague G.A., records of Notary H. T. van Coesfelt, no. 967.)

432. 9 July 1689. Monsieur Franciscus Vermeer, master surgeon and Juffr. Maria de Wee, married and living in Charlois, borrow from Monsr Jean Marchand La Gree 400 guilders for one year at 4 guilders 10 stuivers interest per year. (The Hague G.A., records of Notary H. T. van Coesfelt, no. 967.)

433. 10 July 1689. Testament of Monsieur François Vermeer, master surgeon, and Juffr. Maria de Wee, married and living in Charlois, now finding themselves in The Hague. They annul all previous testaments [left unspecified]. They declare that, out of conjugal love and affection that they bear toward each other, they desire that

the survivor of them both should be their unique and universal heir. This "survivor will be obligated to support such child or children as, by the grace of God, they may come to procreate, until the majority or marriage of the same, and to bring up the same in art and experience so that they may go through the world with honor" ("ende groot te maecken in Kunst ende ervarentheijt omme met eeren door de werelt te comen geraecken"). They name the survivor of them both guardian over their child or children, thereby excluding all magistrates and chambers. The witnesses are Johan van Hemert, master tailor, and Cornelis van Minnebeeck, cloth dealer. The testator signs François Vermeer, the testatrix Maria Duce, both in literate fashion. (The Hague G.A., records of Notary H. T. van Coesfelt, no. 967.)

434. 4 July 1690. "Sr. Franciscus Vermeer, master surgeon, known to me notary, acknowledges duly owing Sr. Cornelis Conijn, pastrymaker, living in this city 100 guilders at an interest of 4 guilders 10 stuivers per year." This loan "will be reimbursed by me, notary, out of the funds accruing from a certain house and court standing and situated on the corner of the Pooten here, belonging to Juffr. Gaymans and her brothers, in which the appearer [Franciscus Vermeer] along with his brother Ignatius Vermeer have invested a capital sum of 1,500 guilders [in the form of a mortgage], or out of other funds possessed by the appearer." The notary will endorse the note with his guarantee that the loan will be reimbursed to Sr. Conijn, along with the interests thereon. The witnesses are Monsʳ Carel de Pijper, retired captain, and Francois de Launoy. (The Hague G.A., records of Notary H. T. van Coesfelt, no. 967.)

435. 20 July 1690. Aegidius Cramer [III], son of Johannes Gillisz. Cramers and of Maria van der Meer, is baptized in the Jesuit church. Dominicus Cramer, Christina van Bleiswijck and Christina Pirot are witnesses. (Delft G.A., Jesuit Station of the Cross, Baptism files.)

436. 1690. The subsidy given to Catharina Bolnes by the Masters of the Orphan Chamber in Gouda ceased in this year. Joannes Cramer requested a continuation for another three years, adducing that she still had one unlucky child and a grandchild. The Masters of the Orphan Chamber, after investigating the matter, concluded that the child in question had already been married four years and that her husband had the responsibility of taking care of her. Moreover, they found it would be unfair ("onbillijk") for them to support the abandoned child of Delft citizens. Nonetheless, the burgomasters decided to give half of the former 96 guilders allocation to Jan de Cramer and the other half to Josias Bonte, the husband of Geertruy Dircksdr. van Hensbeeck, who was also a direct descendant of Dirck Cornelisz. van Hensbeeck. (Gouda G.A., "Requestboek" 1683–1695, cited in Van Peer 1951, p. 620, and Matthijs 1976, p. 46.)

437. 14 October 1695. Jacob Abrahamsz. Dissius, on the Market Place in "The Golden ABC," is taken for burial to " 't Wout" with a coach and 18 pallbearers. (Delft G.A., burial records of the New Church, cited in Neurdenburg 1942, p. 73.)

438. April 1696. An advertisement is given out for an auction in which are mentioned "excellent artful paintings, among them 21 pieces extraordinarily vigorously and delightfully painted by the late J. Vermeer of Delft, representing several compositions, being the best he ever made. . . ." (S.A.C. Dudok van Heel, *Jaarboek Amstelodamum* 37 [1975], p. 159; English translation in Blankert 1978, p. 154.)

439. 16 May 1696. Catalogue of paintings sold on this date in Amsterdam.

 1. A young lady weighing gold, in a box by J. van der Meer
 of Delft, extraordinarily artful and vigorously painted 155 – 0
 2. A maid pouring out milk, extremely well done, by ditto 175 – 0

3.	The portrait of Vermeer in a room with various accessories uncommonly beautifully painted by him	45 – 0
4.	A young lady playing the guitar, very good of the same	70 – 0
5.	In which a gentleman is washing his hands in a see-through room with sculptures, artful and rare, by ditto	95 – 0
6.	A young lady playing the clavecin in a room, with a listening gentleman by the same	80 – 0
7.	A young lady who is being brought a letter by a maid by ditto	70 – 0
8.	A drunken sleeping maid at a table, by the same	62 – 0
9.	A gay company in a room, vigorous and good, by ditto	73 – 0
10.	A gentleman and a young lady making music in a room, by the same	81 – 0
11.	A soldier with a laughing girl, very beautiful, by ditto	44 – 10
12.	A young lady doing needlework, by the same	28 – 0
13.	The Old Church in Amsterdam, artful, by Emanuel de Wit	74 – 0
14.	The Grave of the Old Prince, by the same	52 – 0
15.	Another Church	34 – 0
31.	The Town of Delft in perspective, to be seen from the South, by J. van der Meer of Delft	200 – 0
32.	A view of a house standing in Delft, by the same	72 – 10
33.	A view of some houses by ditto	48 – 0

[Number 34 was skipped in the Hoet catalogue.]

35.	A writing young lady, very good, by the same	63 – 0
36.	A young lady adorning herself ("een paleerende"), very beautiful, by ditto	30 – 0
37.	A lady playing the clavecin, by ditto	42 – 0
38.	A tronie in antique dress, uncommonly artful	36 – 0
39.	Another ditto Vermeer	17 – 0
40.	A pendant of the same	17 – 0
41.	A large landscape by Simon de Vlieger, his very best	26 – 0
42.	A smaller one by the same	32 – 10
43.	Another one by ditto	30 – 0
44.	Another larger one by ditto	37 – 5
45.	A "tronie" by Rembrant	7 – 5

(Hoet 1752, pp. 34–36; partial list in Blankert 1978, p. 154.)

440. 22 April 1699. In the catalogue of paintings sold by Herman van Swoll on this date in Amsterdam, item no. 25 is described as follows: "a seated woman with several [symbolic and allegorical] meanings, representing the New Testament by Vermeer of Delft, vigorously and glowingly painted 400 – 0." (Hoet 1752, p. 487, cited in Blankert 1978, p. 154.)

441. 21 January 1700. Cornelia Clementia van Rosendael is buried in the Old Church in Delft. (Delft G.A., Burial files.)

442. 1 July 1701. State and inventory of the goods contributed to the marriage of Sr Heyndrick van Buyten and Juffr. Adriana Waelpot.

The marriage contract passed before Abraham van der Velde on 6 December 1683 specified that there would be no common possession, each party would bring and keep his or her own assets. A testament of 18 May 1701 stipulated that Hendrick van Buyten's nephew Adriaen and his niece Maria would each get the usu-

fruct of a capital sum of 4,000 guilders. (Delft G.A., Orphan Chamber, *boedel* no. 265 VI.)

Household goods and chattel concerning both parties ("concernerende t' gemeen") on the strength of the disposition of the deceased.

In the front hall ("voorhuijs")
 A large ("groot stuck") painting by Vermeer
 a little piece ("stuckje") by Bramer
 a society piece ("geselschap") by Palamedes
 a little piece ("stuckje") by Palamedes
 a little piece by Bronckhorst
 a landscape with little cows
 two little pieces with company ("geselschap")
 a nicely painted landscape ("een aardig geschildert lantschapje")
 two fruit pieces
 one with little birds
 a piece of Moses
 one of Prince Willem young with flowers
 a fruit piece
 a moon shine ("maneschyntje")
 a little society piece
 a king's throne
 a ruined castle with sheep
 a company at play ("een spelent geselschapje")
 two little imitation flowers ("gefigureert blommetjes")
In the little room next to the hall
 3 little landscapes by Van Asch (before the bedstead)
 2 little pieces ("stuckjes") by Vermeer
 another 11 pieces large and small
In the back hall ("achtersaeltje")
 7 paintings and 3 on panel ("borretjes")
In the clothes attic ("kleersolder")
 2 boxes for paintings ("kassen tot schilderyen")

Among the books, a Testament in quarto, a Psalmbook, and the *Institution* by J. Calvin.

The sum of the common *boedel*'s effects comes to 24,829 gul. 13 st. 8 pen. (Delft G. A., Orphan Chamber, *boedel* no. 265 IX.)

443. 23 December 1703. Juffr. Aleijdis van Roosendael, daughter of age, living in Delft, amends an earlier testament [nonextant] by the following declaration. She asserts that "she has never been dedicated to the Roman Catholic church as a beguine ('klopje') or nun in any other name, become married ('getrout') or otherwise dedicated herself to the same church or that a priest has ever clothed her in a spiritual vestment by saying these or similar words. 'Receive this vestment of purity and keep it for eternity,' much less that, on that occasion, on her behalf, was a wedding feast ('bruyloft') given or wax candles lit, or that she made any vows ('beloften') to any priest belonging to an order or secular, that she wished to enter into the state of marriage [with Christ]." She further declares that "about fifty years ago, out of her own volition, without the least solemnity, she had put on a black robe of 'pour de soie' [peau de soie], and had then for ever after dressed in black in the same way as beguines do, without ever having dedicated herself as a beguine or ever having made vows to anyone else to this end." After this declaration Aleydis van Roosendael makes her testament. She bequeaths 100 guilders to her niece Juffr.

Anna van Dijck, the oldest daughter of Bartholomeus van Dijck, clerk of the State
Council in the Hague, 100 guilders to her niece Anna Maria van Roosendael,
daughter of the hon. Johannes van Roosendael, vice-rector of the Latin School in
Gouda, and 100 guilders to Johannes Vermeer, the little son of her, testatrix's,
nephew Johannes Vermeer the Elder, living in the house of his uncle Sr. Joannes
Cramer, merchant here. She names as universal heir Elisabeth Catharina Hospe-
rius, daughter of her niece Beatrix Vermeer, procreated by Johannes Christophorus
Hosperius, which Elisabeth Catharina Hosperius has been living since the age of
three years and eight months with the testatrix and has been brought up by her.
(Delft G. A., records of Notary Jan de Bries, cited in Van Peer 1975, p. 47a.)

444. 27 December 1705. Mr. Pieter de Bye, attorney before the Court of Holland, on
behalf of the children of the late Johannes Vermeer, as heirs of the late Juffr. Maria
Thins, their grandmother, empowers the heer Godefrydus Bulck, notary and rent-
master in Schoonhoven, to lease four morgen of land situated in or around Bon
Repas, formerly leased by Jacob Willemsz. de Vosch, and to obtain from Otto Hen-
dricksz. van Oosten 297 guilders 14 stuivers in back rents owed for eight morgen
of land situated in Bon Repas. The procuration was renewed on 14 December 1706
by Anna van der Goes, dowager of the late Mr. Pieter de Bye in virtually the same
terms. The name "Johannes van der Meer" was corrected to "Johannes Vermeer."
(The Hague G. A., records of Notary H. T. van Coesfelt, no. 978.)

445. 27 February 1706. The lord magistrates of Delft having examined the request of
Johan Cramer, on behalf of all the children and grandchildren of the late Jan Ver-
meer and Catharina Bolnes, seeking that someone should be authorized to repre-
sent the person of Jan Jansz. Vermeer the young, 18 to 19 years old, owing to the
absence of the latter's father, and to request, along with the other supplicants, from
the High and Mighty Lords, that authorization be given to dissolve the *fideicom-
missum* on a certain domain, nine and a half morgen situated in Bon Repos [*sic*],
and, after having obtained the same [authorization], to sell this domain and lands,
have authorized the aforesaid Johan Cramer, as by the present he is authorized and
qualified, to represent the person of Johan Jansz. Vermeer the young, in the absence
of the latter's father, and, along with the other supplicants, to request the dissolu-
tion of the fideicommissum on the aforesaid domain, as also to sell the same and,
from the proceeds, to pay the capital sums [mortgages] invested therein. (Delft
G. A., "Camerboeck der Stad Delft" 1698–1718, cited in Obreen 1881, 4: 300–
301.)

446. 20 March 1708. "Nicolaes van Aken, with the procuration of Hendrick Ter-
beeck van Coesvelt, prosecuting attorney ('solliciteur militair') here in The Hague,
as having the charge and procuration of Ignatius Vermeer, and also as guardian
over Franciscus Vermeer, appear in this capacity before the High Court of Holland
as plaintiff in the case that he is waging against Michiel Hanneman married to
Clementia Gaymans, as universal legatee of her brother Arent Gaymans and also
as possessor of the plaintiff's mortgage and defendant in this capacity." He asks
the defendant to pay the capital sum of 1,500 guilders with all the interests at 4
percent that have accrued since 12 July 1700, which debt arises from a mortgage
on a one-third share in a house, as more broadly described in the petition.

In his reply Lelhart van Vouw, attorney for Michiel Hanneman, husband of Cle-
mentia Gaymans, as defendant in the original case and plaintiff in the cross-suit
("eijscher in reconventie"), asserts that the plaintiff in the original case and defend-
ant in the cross-suit will establish that everything Clementia Gaymans did after her
brother's death was done with the authorization of the Court of The Hague. While
it is true that Arent Gaymans had issued a mortgage for 1,500 guilders on the house

located on the corner of the Spuij in behalf of the plaintiff as guardian over Franciscus and Ignatius Vermeer and 400 guilders in behalf of Justus van der Netten and that, with the authorization of the court, she had paid the interests on this sum to the plaintiff, in the meanwhile she had found out that the late Herman Gaijmans in his will of 27 July 1661 had named his three children out of the second bed ("nakinderen"), procreated with his second wife Christina Dalen, as heirs of the aforesaid house, which house they would be able to enjoy in freehold property upon access to their legal age or after becoming married, in such wise that after the death of each child in succession the house should revert to the next one in line, and hence that Arent Gaymans was not entitled to encumber the house with a mortgage or to pay interest thereon, so that such payments, done with the authorization of the court, were erroneous and abusive; hence the plaintiff is requested to return the same to the defendant in the name of his wife, as being the last one alive of the children of the second bed of Herman Gaijmans. In particular the appellant asks the defendant in the suit to pay 600 guilders, amounting to ten years interest on the capital sum, to Michel Hanneman in the name of his wife. The defendant in the cross-suit must also see to it that the mortgage deed for 1,500 guilders is annulled and made void.

In his "conclusion," Nicolaes van Aken points out that the attorney for the defendant had acknowledged in his plea that Arent Gaymans had passed a legal obligation before the alderman ("schepenenschultbrieff") for 1,500 guilders and thus encumbered the house, to the extent of the one-third share belonging to him, with this mortgage. Moreover the allegation was frivolous and untrue that the interest payments had been made only with the authorization of the court and that it had only now been discovered that Herman Gaymans, the father of Arent and Clementia Gaymans, had made such dispositions as were mentioned in the plea in the codicil to his testament. So in consideration of the fact that the above-said authorization had become null and void upon the death of Arent Gaymans, as also of the fact that the defendant and appellant in the cross-suit must for years have known about the codicil, he [the attorney for the defense in the cross-suit] rejects the claims made by the opposing attorney as being "inacceptable, impertinent, and irrelevant." He also requests that the authorization and the codicil be communicated to him.

In his conclusion and rebuttal the attorney for the defendant in the original suit and plaintiff in the cross-suit rejects the claims made by his opponent and reaffirms his own claims. He also refuses to communicate the authorization [of the court] and the codicil as being "premature." (The Hague A. R., 3ᵉ afdeeling, Hoge Raad, "Requesten," inv. no. 524 I, 1708.)

447. 27 June 1708. "Today . . . there appeared before me . . . notary . . ., in the presence of the undersigned witnesses, Hendrick Terbeeck van Coesvelt, prosecuting attorney ('solliciteur militair') here in The Hague, as having [received] charge and procuration from Ignatius Vermeer, which procuration was passed before the notary Jan Vermeer in Brugge [Bruges] on 9 February 1698, containing the clause of substitution, and also as guardian over Franciscus Vermeer; and the appearer in this capacity declared having substituted and empowered Nicolaes van Aken attorney before the High Court in Holland especially in the case as plaintiff ('impetrant') in r/a ['rau actie,' a suit brought on by the plaintiff bypassing certain preliminary hearings] and as defendant in the appeal ('reconventie') against Michiel Hanneman married to Clementia Gaymans defendant [in the lower court] and plaintiff before the aforesaid High Court in Holland," to defend the case and act in his

behalf in every respect. (The Hague G. A., records of Notary H. F. van Aken, fol. 129.)

448. 12 December 1713. Juffr. Maria Vermeer, Aleidis Vermeer, Geertruy Vermeer, Monsieur Otto van Hesselt in The Hague with the procuration of Ignatius Vermeer and Elisabeth Catharina Hosperius, and Jan Vermeer, for themselves and substituting themselves for Catharina Vermeer, all children and grandchildren and heirs of Johannes Vermeer and Catharina Bolones, husband and wife, having lived in the town of Delft, authorize Mr. Cornelius Franciscus de Bije attorney before the respective courts of justice here in The Hague to sell publicly at auction or sell privately ("onder de hant") on their behalf about eight morgen of feud land near Schoonhoven in the polder of Bon Repos [sic] kept in feud by the High and Mighty Lords of the States of Holland and West Friesland, to give a receipt for the sale, etc. The act is passed in The Hague before the witnesses Pieter Visser and Dirck Weest[?]. The signers are "Maria Vermor" [Vermeer], Aleydis Vermeer, Geertruijt van der Meer, and a cross in lieu of signature for Jan Vermeer. (The Hague G. A., records of Notary Hugo F. van Aken, cited in Van Peer 1959, p. 262.)

449. 24 June 1714. Jan Kraemer and Maria Vermeer, revoking previous testaments, name the survivor of them both sole and universal heir, with the provision that the survivor must support and bring up to their legal age or married state their child or children and give to any child or children who will have reached the age of 25 or become married the sum of 2,000 guilders, to be expended from the moneys that his mother's widow and sons of the heer Dominicus Kraemer owe him. The testator signed illegibly "because of his trembling hand." The testament was witnessed by Petrus Coel, notary, and Gerrit de Cijs. (Delft G. A., records of Notary P. Cool, no. 2478.)

450. 30 June 1714. Betrothal in Leyden of Jan Vermeer [III], born in Rotterdam, clothweaver, living in the Haarlemmerstraet and Elisabeth de Roo, born in Delft, living in the Koesteegh in Leyden. (Leyden G. A., Betrothal files, cited in Van Peer 1959, p. 622.)

451. 3 April 1719. Maria Theresa, daughter of Hugonis van der Velde and Catharina Cramers, is baptized in the Jesuit Church in Delft. The witnesses are Dominus Aegidius Cramer and Maria Cramers. (Delft G. A., Jesuit Station of the Cross, Baptism files.)

452. 25 June 1720. Johannes Vermeer, 32 years old, living in Leyden, is vested ("verlijd") with the domain of "Bon Repas" by presumption of his father's death, who has been for some 30 years outside the country, without any news being heard from him. (The Hague A. R., "Repertorium van der Lenen," cited in Obreen 1881, 4: 301–302.)

453. 19 June 1721. The domain of Bon Repas is vested ("verlijd") in Aart Coorvaar, 60 years old, living under Bon Repas, by transfer from the children of Vermeer. (The Hague A. R., cited in Obreen 1881, 4: 302.)

454. 1749. In this year Alida Vermeer, living in The Hague, sister of Maria Vermeer, died. (Gouda G. A., "Request boek" Oud Archief, 209 fol. 168, cited in Matthijs 1976, p. 48.)

APPENDIX C
GENEALOGICAL CHARTS

Chart No. 1 The Family Tree of Johannes Vermeer

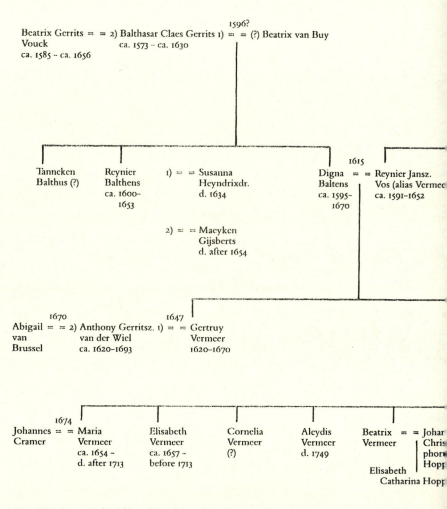

Note: This chart omits the children of Vermeer's uncles and aunts.

Y

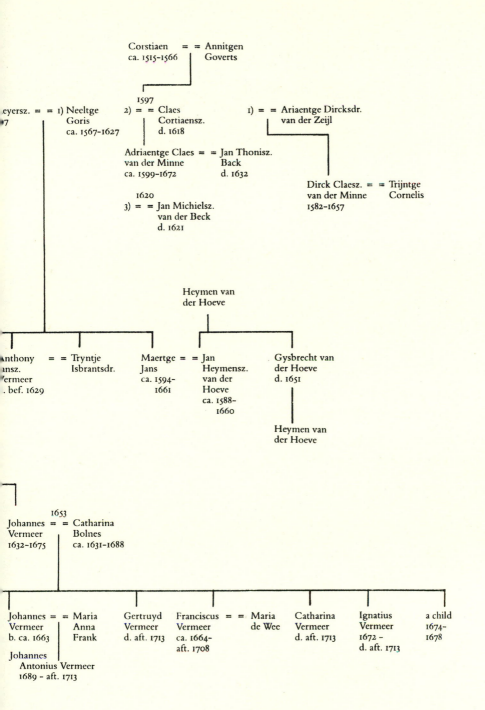

Corstiaen = = Annitgen
ca. 1515-1566 Goverts

1597
...eyersz. = = 1) Neeltge 2) = = Claes 1) = = Ariaentge Dircksdr.
...7 Goris Cortiaensz. van der Zeijl
 ca. 1567-1627 d. 1618

 Adriaentge Claes = = Jan Thonisz.
 van der Minne Back
 ca. 1599-1672 d. 1632

 Dirck Claesz. = = Trijntge
 van der Minne Cornelis
 1620 1582-1657
 3) = = Jan Michielsz.
 van der Beck
 d. 1621

 Heymen van
 der Hoeve

...nthony = = Tryntje Maertge = = Jan Gysbrecht van
...ansz. Isbrantsdr. Jans Heymensz. der Hoeve
...ermeer ca. 1594- van der d. 1651
. bef. 1629 1661 Hoeve
 ca. 1588-
 1660
 Heymen van
 der Hoeve

1653
Johannes = = Catharina
Vermeer Bolnes
1632-1675 ca. 1631-1688

Johannes = = Maria Gertruyd Franciscus = = Maria Catharina Ignatius a child
Vermeer Anna Vermeer Vermeer de Wee Vermeer Vermeer 1674-
b. ca. 1663 Frank d. aft. 1713 ca. 1664- d. aft. 1713 1672 - 1678
 aft. 1708 d. aft. 1713
Johannes
Antonius Vermeer
1689 - aft. 1713

Chart No. 2 The Family Tree of Catharina Bolnes

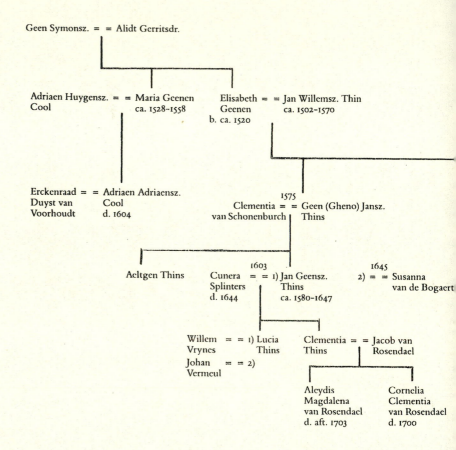

Geen Symonsz. = = Alidt Gerritsdr.

Adriaen Huygensz. = = Maria Geenen Elisabeth = = Jan Willemsz. Thin
Cool ca. 1528–1558 Geenen ca. 1502–1570
 b. ca. 1520

Erckenraad = = Adriaen Adriaensz. 1575
Duyst van Cool Clementia = = Geen (Gheno) Jansz.
Voorhoudt d. 1604 van Schonenburch Thins

 1603 1645
 Aeltgen Thins Cunera = = 1) Jan Geensz. 2) = = Susanna
 Splinters Thins van de Bogaert
 d. 1644 ca. 1580–1647

 Willem = = 1) Lucia Clementia = = Jacob van
 Vrynes Thins Thins Rosendael
 Johan = = 2)
 Vermeul

 Aleydis Cornelia
 Magdalena Clementia
 van Rosendael van Rosendael
 d. aft. 1703 d. 1700

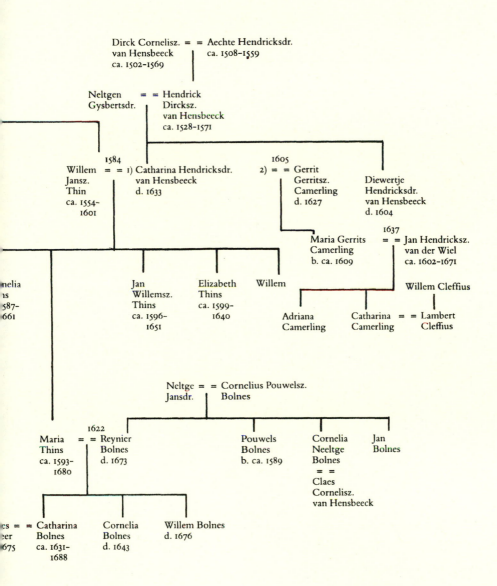

Dirck Cornelisz. = = Aechte Hendricksdr.
van Hensbeeck ca. 1508-1559
ca. 1502-1569

Neltgen = = Hendrick
Gysbertsdr. Dircksz.
 van Hensbeeck
 ca. 1528-1571

1584 1605
Willem = = 1) Catharina Hendricksdr. 2) = = Gerrit Diewertje
Jansz. van Hensbeeck Gerritsz. Hendricksdr.
Thin d. 1633 Camerling van Hensbeeck
ca. 1554- d. 1627 d. 1604
1601

 1637
 Maria Gerrits = = Jan Hendricksz.
 Camerling van der Wiel
nelia b. ca. 1609 ca. 1602-1671
1s
587- Jan Elizabeth Willem Willem Cleffius
661 Willemsz. Thins
 Thins ca. 1599-
 ca. 1596- 1640 Adriana Catharina = = Lambert
 1651 Camerling Camerling Cleffius

 Neltge = = Cornelius Pouwelsz.
 Jansdr. Bolnes

 1622
Maria = = Reynier Pouwels Cornelia Jan
Thins Bolnes Bolnes Neeltge Bolnes
ca. 1593- d. 1673 b. ca. 1589 Bolnes
1680 = =
 Claes
 Cornelisz.
 van Hensbeeck

es = = Catharina Cornelia Willem Bolnes
er Bolnes Bolnes d. 1676
675 ca. 1631- d. 1643
 1688

Chart No. 3 The Bloemaert-Vermeer Connection

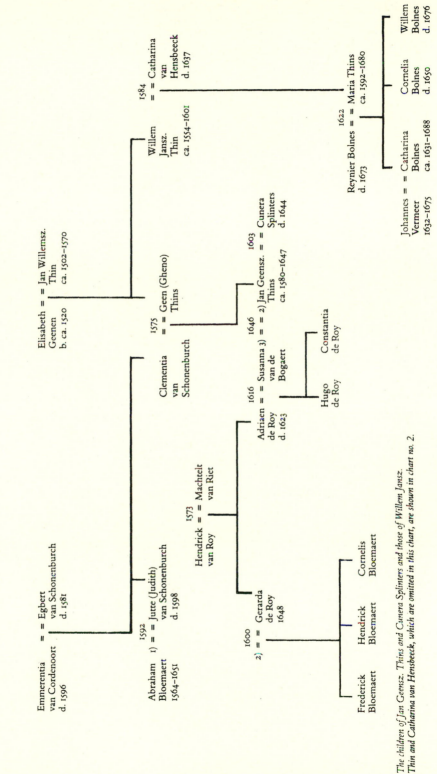

The children of Jan Geensz. Thins and Cunera Splinters and those of Willem Jansz.
Thin and Catharina van Hensbeeck, which are omitted in this chart, are shown in chart no. 2.

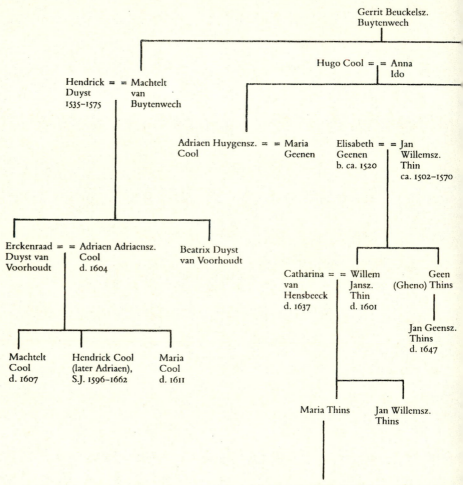

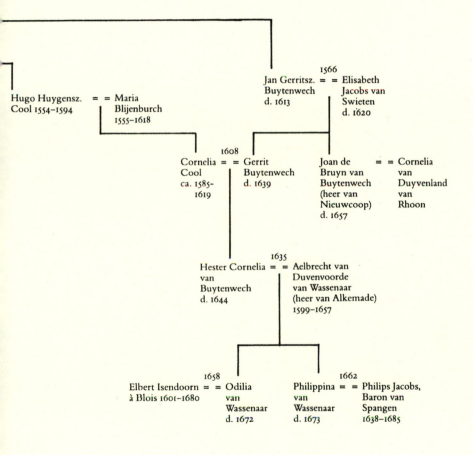

Hugo Huygensz.　=　=　Maria
Cool 1554–1594　　　Blijenburch
　　　　　　　　　　1555–1618

　　　　　　　　　　　　　　　　　　　　　　1566
　　　　　　　　　　　　　　　　Jan Gerritsz.　=　=　Elisabeth
　　　　　　　　　　　　　　　　Buytenwech　　　　Jacobs van
　　　　　　　　　　　　　　　　d. 1613　　　　　　Swieten
　　　　　　　　　　　　　　　　　　　　　　　　　d. 1620

　　　　　　　　　　　　1608
Cornelia　=　=　Gerrit　　　　Joan de　　　　=　=　Cornelia
Cool　　　　　Buytenwech　　Bruyn van　　　　　van
ca. 1585–　　d. 1639　　　　Buytenwech　　　　Duyvenland
1619　　　　　　　　　　　　(heer van　　　　　van
　　　　　　　　　　　　　　Nieuwcoop)　　　　Rhoon
　　　　　　　　　　　　　　d. 1657

　　　　　　　　　　　　1635
Hester Cornelia　=　=　Aelbrecht van
van　　　　　　　　　　Duvenvoorde
Buytenwech　　　　　　van Wassenaar
d. 1644　　　　　　　　(heer van Alkemade)
　　　　　　　　　　　　1599–1657

　　　　　　　1658　　　　　　　　　　　　1662
Elbert Isendoorn　=　=　Odilia　　Philippina　=　=　Philips Jacobs,
à Blois 1601–1680　　van　　　　　van　　　　　　Baron van
　　　　　　　　　　　Wassenaar　Wassenaar　　　Spangen
　　　　　　　　　　　d. 1672　　　d. 1673　　　　1638–1685

Note: Some family relationships omitted in this chart are covered in previous charts.

BIBLIOGRAPHY

MANUSCRIPT SOURCES

Amsterdam. Gemeente Archief

"Justitie boek," R. A. 293
"Kwijtscheldingen," no. 33
Notarial archives
"Schepen Kennissen," no. 14
"Secret confessie boek," R. A. 533

Breda. Gemeente Archief

Notarial archives

Delft. Gemeente Archief

"Begraafboeken van de Oude en Nieuwe Kerck," nos. 37, 40, 41
"Doopboek," no. 12
"Haardsteden register," 1600
"Huizenprotocol"
"Kerkelijk boek," no. 5
Notarial archives
"Poorter regyster," 1536–1649
"Register der Acten van Cautiën voor Schepenen van Delft"
"Stadsondertrouwboek," no. 124
"Trouwboeken"
"Verponding boek," 1620, 1632, 1638
Camer van Charitate, "Beste Opperste Kleed Boeken"
Camer van Charitate, "De deut op de gulden," no. 237
O.R.A., "Kamerboek der Stadt Delft," 1671–1684, 1698–1718
Orphan Chamber archives for South Holland ("Weeskamer archieven voor Suid Holland")

Gorinchem. Gemeente Archief

"Kohier van de verponding," no. 4140
Notarial archives
"Rechterlijk Archief"
"Reckeningen van de Thesaurier," 1611–1660

Gouda. Gemeente Archief

"Crimineel Vonnisboek," R. A. 177
"Hoofdgeld register," O. A. 2292
Notarial archives
"Requestboek," 1683–1695
"Stadt Tuychtboeck," no. 1637

Gouda. Archief van de Hervormde Gemeente

"Jaar rekeningen St. Jan"
"Sterftelijsten St. Janskerk," no. 25

Gouda. Orphan Chamber Archives

"Weesboeken"

Groningen. Gemeente Archief

"Rechterlijke archieven"

Haarlem. Gemeente Archief

Notarial archives

The Hague. Algemeen Rijksarchief

"Gedruckte resolutiën van de Staten van Holland en West Friesland"
Hof van Holland, "Civile sententiën," no. 751
Hof van Holland, "Interpositiën van de decreten by den Hove van Holland,"
1664–1675, Archief Q, no. 85
Hoge Raad van Holland en Zeeland, "Requesten," no. 524 I
Hoge Raad van Holland en Zeeland, "Sententiën," no. 80A
Leenkamer van Holland, "Repertorium der Lenen"

The Hague. Gemeente Archief

Notarial archives

Leyden. Gemeente Archief

Notarial archives

Rotterdam. Gemeente Archief

"Doopboeken"
Notarial archives

Schiedam. Gemeente Archief

"Trouwboeken"

Utrecht. Gemeente Archief

Notarial archives
"Transport registers"

Published Sources

Aillaud, G., A. Blankert, and J. M. Montias. *Vermeer*. Paris: Hazan, 1986.

Barbour, Violet. *Capitalism in Amsterdam in the 17th Century*. Ann Arbor: University of Michigan Press, 1963.

Baudelaire, Charles. *Les Fleurs du mal*. Poitiers: Librarie Fontenaux, 1949.

Berckel, H. E. van. "Priesters te Delft en Delfshaven 1646–1696." *Bijdragen voor de geschiedenis van het Bisdom van Haarlem* 25 (1900): 230–63.

Beresteyn, E. A. *Grafmonumenten en grafzerken in de Oude Kerk te Delft*. Assen: Van Gorcum en comp. N. V. uitgevers, 1938.

Blankert, Albert, with contributions by Rob Ruurs and Willem L. van de Watering. *Vermeer of Delft: Complete Edition of the Paintings*. Oxford: Phaidon, 1978.

Bleyswijck, Dirck van. *Beschryvinge der Stadt Delft*. 1667.

Boogaard-Bosch, A. C. "Een onbekende acte betreffende den vader van Jan Vermeer." *Nieuwe Rotterdamsche Courant* 25, 25 January 1939.

Boström, K. "Jan Vermeer and Cornelis van der Meulen." *Oud Holland* 66 (1951): 117–22.

Bouricius, L.G.N. "Vermeeriana." *Oud Holland* 42 (1925): 271–73.

Bredius, Abraham. "Iets over Johannes Vermeer." *Oud Holland* 3 (1885): 217–22.

———. "Nieuwe bijdragen over Johannes Vermeer." *Oud Holland* 28 (1910): 61–64.

———. "Italiaansche schilderyen in 1672 door Haagsche en Delftsche schilders beordeeld." *Oud Holland* 34 (1916): 88–93.

———. "Schilderyen uit den nalatenschap van den Delftschen Vermeer." *Oud Holland* 34 (1916): 160–61.

———. *Künstler-inventare: Urkunden zur Geschichte der Holländischen Kunst des XVI^ten, XVII^ten und XVIII^ten Jahrhunderts.* 7 vols. The Hague: Martinus Nijhoff, 1915–1921.

Brouwer, H. C. "De verdwenen kloosters uit de Delftse binnenstad." In *De stad Delft: Cultuur en maatschappij tot 1572*, pp. 54–59. Exhibition Catalogue. Delft: Stedelijk Museum Het Prinsenhof, 1979.

Coolhaas, W. P. et al. *Jan Pietersz. Coen: Bescheiden omtrent zijn bedrijf in Indië.* 7 vols. The Hague: Martinus Nijhoff, 1919–1953.

Cornelissen, J.D.M. *Romeinsche bronnen voor den kerkelijken toestand der Nederlanden onder de Apostolische Vicarissen 1592–1729.* (Rijksgeschiedkundige Publicatiën), no. 77, 2: 1. The Hague: Martinus Nijhoff, 1932.

Crena de Iongh, A. C. G. C. *van Santen's Lichte Wigger en Snappende Siitgen: Zeventiende-eeuwse gesprekken in Delfts dialect.* Assen: Van Gorcum, 1959.

Dillen, J. G. van. "Isaac Le Maire en de handel in actiën der Oost-Indische Compagnie." *Economisch-historisch Jaarboek* 16 (1930): 46–111.

Dogaer, H. G. "De inventaris van Diego Duarte." In *Jaarboek van het Koninklijk Museum voor Schone Kunsten*, pp. 195–221. Antwerp, 1971.

Droog, M.P.R. "De parochie Schipluiden na de Hervorming." *Bijdragen voor de geschiedenis van het Bidsom van Haarlem* 32 (1908): 235–60.

Dudok van Heel, S.A.C. "Honderdvijftig advertenties van kunstverkopingen uit veertig jaargangen van de *Amsterdamsche Courant* 1673–1711." *Jaarboek Amstelodamum* 67 (1980): 149–73.

———. " 'Het Schilderhuis' van Govert Flinck en de kunsthandel van Uylenburgh aan de Lauriersgracht te Amsterdam." *Jaarboek Amstelodamum* 74 (1982): 70–90.

———. "Waar waren de Amsterdamse Katholieken in de zomer van 1585? Enkele aantekeningen van het kohier van 1585." *Jaarboek Amstelodamum* 77 (1985): 4–53.

Emmens, J. A. "De schilderende Jupiter van Dosso Dossi." *Miscellanea I. Q. van Regteren Altena.* Amsterdam: Schelterme en Holkema, 1969. pp. 52–54.

Gaskell, Ivan. "Vermeer, Judgement, and Truth." *Burlington Magazine* 126, no. 978 (September 1984): 557–61.

Gelder, Jan van, and Ingrid Jost. *Jan de Bischop and His Icones and Paradigmata; Classical Antiquities and Italian Drawings for Artistic Instruction in Seventeenth-Century Holland.* Doornspijk: Davaco Publishers, 1985.

Ginzberg, Carlo. *The Cheese and the Worms: The Cosmos of a Sixteenth-Century Miller.* Baltimore: John Hopkins University Press, 1980.

Goudappel, C. D. "Ondertrouw en huwelijk van Jan Vermeer." *Delftse historische sprokkelingen*, pp. 20–26. Delft, 1977.

Gowing, Lawrence. *Vermeer.* New York: Icon Editions, Harper & Row, new edition, 1970.

Groot, Hugo de. *Inleydinge tot de Hollandsche Rechts-Geleerthey.* Amsterdam: J. Boon, 1738.

Gudlaugsson, S. J. *Gerard ter Borch.* 2 vols. The Hague: Martinus Nijhoff, 1959.

Harvard, Henri. *La céramique hollandaise: Histoire des faïences de Delft, Haarlem, Rotterdam, Arnhem, Utrecht, et des porcelaines de Weesp, Loosdrecht, Amsterdam et La Haye.* 2 vols. Amsterdam: Compagnie Générale d'Editions "Vivat," 1909.

Haverkamp-Begemann, Egbert. "Rembrandt as a Teacher." *Rembrandt after Three Hundred Years.* Exhibition Catalogue, Art Institute of Chicago, 1969.

Historiae societatis Jesus. Rome, 1750.

Hoeck, F. van. "De Jezuïeten-statie te Delft, 1592-1709–1771." *Haarlemsche bijdragen, Bouwstoffen voor de geschiedenis van het Bisdom van Haarlem* 6 (1948): 407–444.

Hoet, Gerard. *Catalogus of naamlyst van schilderyen met derselven pryzen,* vol. 1. The Hague, 1752.

Irenaeus, P. *Biografisch overzicht van de vroomheid in de Nederlandse Carmel.* Tiel: Drukkerij-uitgeverij Lannoo, 1950.

Jameson, Mrs. *Sacred and Legendary Art.* 2 vols. 2d edition. London: Longman, Green and Co., 1911.

Jaanus, H.J. *Hervormd Delft ten tijde Arent Cornelisz. 1573–1605.* Amsterdam: Nordemann's uitgevers maatschappij n.v., 1950.

Janszoon, Matthys Balen. *Beschryvinge der stadt Dordrecht.* Dordrecht: Simon onder den Linde, 1678.

Jongh, E. de. *Portretten van echt en trouw: Huwelijk en gezin in de Nederlandse kunst van de zeventiende eeuw.* Exhibition Catalogue, Frans Halsmuseum (Zwolle and Haarlem: Uitgeverij Waanders, 1986).

Jongh E. de, and P.J. Vinken. "Frans Hals als voortzetter van een emblematische traditie. Bij het huwelijksportret van Isaac Massa en Beatrix van der Laen." *Oud Holland* 76 (1961): 117–52.

Kitson, Michael C. "Florentine Baroque Art in New York." *Burlington Magazine* 111 (1969): 409–410.

Kort, J.C. "Repertorium op de lenen van de hofstede Arkel en Haastrecht." *Ons Voorgeslacht* 38 (1983): 161–92, 219–22.

Kotte, Wouter. "De katholieke tak van het Delftse geslacht Camerling." *Archief voor de geschiedenis van de Katholieke Kerk in Nederland* 2 (1964): 129–79.

Leeuwen, Simon van. *Het Rooms-Hollands Regt.,* 11 ed., Amsterdam, 1744.

Logan, Anne-Marie. *The "Cabinet" of the Brothers Gerard and Jan Reynst.* Amsterdam, Oxford, and New York: North-Holland Publishing Company, 1979.

Matthijs, C.J. *De takken van de dorre boom: Genealogie van de Goudsefamilie Van Hensbeeck.* Gouda: Rapide-Gouda, 1976.

Minne, A. van der. *Genealogie van de familie Van der Minne.* Utrecht: Familie uitgave, 1937.

Moes. E.W. "Een merkwaardige verzameling teekeningen." *Oud Holland* 3 (1895): 182–92.

Monconys, Balthazar de. *Journal de voyage de Monsieur de Monconys.* 2 vols. Lyon: H. Boissart et G. Remens, 1666.

Montias, John Michael. "New Documents on Vermeer and His Family." *Oud Holland* 91 (1977) : 267–87.

———. "Vermeer and His Milieu; Conclusion of an Archival Study." *Oud Holland* 94 (1980): 44–62.

———. *Artists and Artisans in Delft: A Socio-Economic Study of the Seventeenth Century.* Princeton: Princeton University Press, 1982.

———. "Cost and Value in 17th-Century Dutch Art." *Art History* 10 (1987).

Naumann, Otto. *Frans van Mieris the Elder (1635–1681)*. 2 vols. Doornspijk: Davaco Publishers, 1981.

Neurdenburg, Elisabeth. "Johannes Vermeer. Eenige opmerkingen naar aanleiding van de nieuwste studies over den Delftschen schilder." *Oud Holland* 59 (1942): 65–73.

———. "Nog enige opmerkingen over Johannes Vermeer van Delft." *Oud Holland* 66 (1951): 31–44.

Nieuw Nederlandsch Biografisch Woordenboek. P. C. Molhuysen, P. J. Block, and K. H. Kossman, eds. 10 vols. Leyden: A. W. Sijthoff, 1911–1937.

Obreen, F.D.O. *Archief voor Nederlandsche Kunstgeschiedenis.* 7 vols. Rotterdam: Van Hengel en Eeltjes (J. van Baalen en zonen), 1877–1890. Vol. 1, 1877; vol. 4, 1881.

Oldewelt, W.F. "De hoeffijserse schuld (1616–1681)." *Jaarboek Amstelodamum* 51 (1959): 43–45.

Parival, Jean de. *Les Délices de la Hollande.* Amsterdam: Chez Jean de Ravestein, 1669.

Peer, A.J.J.M. van. "Was Jan Vermeer Katholiek?" *Katholiek cultureel tijdschrift* 2 (1946): 469–70.

———. "Rondom Jan Vermeer: De kinderen van Vermeer." *Katholiek cultureel tijdschrift Streven*, new series, 4 (1951): 615–26.

———. "Drie collecties schilderyen van Jan Vermeer." *Oud Holland* 72 (1957): 92–103.

———. "Rondom Jan Vermeer van Delft." *Oud Holland* 74 (1959): 240–45.

———. "Jan Vermeer van Delft: Drie archiefvondsten." *Oud Holland* 83 (1968): 220–24.

———. "Een zeventiende-eeuwse familie geschiedenis." Typescript. Delft, ca. 1975.

Plomp, Michiel C. " 'Een Merkwaardige Verzameling Teekeningen' door Leonard Bramer." Doctoraal Hoofdvak Scriptie. Kunsthistorisch Institut der Rijksuniversiteit van Utrecht. 2 vols. 1983–1984.

Raa, F.J.G. ten, and F. de Baas. *Het staatsche leger 1568–1795.* 8 vols., vol. 4 (1625–1648). Breda: De Koninklijke Militaire Academie, 1918.

Relation en forme de journal du voyage et séjour que le Sérénissime et Très-Puissant Prince Charles II Roy de la Grande Bretagne etc. . . a fait en Hollande depuis le 21 Mai jusques au 2 Juin 1660. The Hague: Adriaen Vlack, 1660.

Resolutiën der Staten-Generaal. Rijksgeschiedkundige publicatiën, Grote serie, nieuwe reeks, part 4, 1619–1620. The Hague: Martinus Nijhoff, 1981.

Rogier, Jan. "De betekenis van de terugkeer van de Minderbroeders te Delft in 1709." *Archief voor de geschiedenis van de Katholieke Kerk in Nederland* 2 (1960): 169–205

Salomon, Nanette. "Vermeer and the Balance of Destiny." In *Essays in Northern European Art Presented to Egbert Haverkamp-Begemann.* Doornspijk: Davaco Publishers, 1983.

Schierbeek, Abraham. *Antoni van Leeuwenhoek: Zijn leven en zijn werken.* 2 vols. Lockem: De Tijdstroom, 1950–1951.

Schierbeek, Abraham, with Maria Roosenboom. *Measuring the Invisible World: The Life and Work of Antoni van Leeuwenhoek.* London: Abelard-Schuman, 1959.

Sluijter, Eric Jan. "De schilderkunst van c. 1570 tot c. 1650." In *De stad Delft: Cultuur en maatschappij van 1572 tot 1667.* 2 vols. Exhibition Catalogue. Delft: Stedelijk Museum Het Prinsenhof, 1981.

———. *De "heydensche fabulen" in de Noordnederlandse schilderkunst circa 1590–1670: Een proeve van beschrijving en interpretatie van schilderijen met verhal-*

ende onderwerpen uit de klassieke mythologie. The Hague: Quickservice Druk-
kerij Entschede, 1986.

Stolbach, Michael Hunt. "Exhibition Catalogue." Spencer A. Samuels Gallery, No-
vember-December 1984, New York.

Strauss, Walter L., and Marjon van der Meulen, with the assistance of S.A.C. Dudok
van Heel and P.J.M. de Baar. *The Rembrandt Documents.* New York: Abaris
Books, 1979.

Sutton, Peter C. *Pieter de Hooch: Complete Edition with a Catalogue Raisonné.* New
York: Phaidon Books, 1980.

Swillens, P.T.A. "R. K. Kunstenaars in de 17ᵉ eeuw." *Katholiek Cultureel Tijdschrift* 1
(1946): 416–19.

———. *Johannes Vermeer, Painter of Delft 1632–1675.* Utrecht and Brussels: Spec-
trum Publishers, 1950.

Visser, P. C. "Waar de beesten te markt komen." *Delftse Courant,* 10 April 1948.

Vries, Jan de. "Barges and Capitalism: Passenger Transportation in the Dutch Econ-
omy, 1631–1839." *Bijdragen,* Afdeling Agrarische Geschiedenis, Landbouwho-
geschool, Wageningen 21 (1978): 33–361.

Wagenaar, Jan. *Vaderlandsche Historie.* Amsterdam: Johannes Albert, 1793.

Walsh, John, Jr. "Vermeer." *Metropolitan Museum of Art Bulletin* 31 (1973).

Watering, Willem van de. "The Later Allegorical Paintings of Niclaas Berchem." Lon-
don, Leger Galleries, Exhibition of Old Master Paintings, 1981.

Welu, James A. "Vermeer: His Cartographic Sources." *Art Bulletin* 57 (1975): 529–
47.

———. "Vermeer's Astronomer: Observations on an Open Book." *Art Bulletin* 68
(1986): 263–67.

Wheelock, Arthur K., Jr. *Jan Vermeer.* New York: Harry N. Abrams, 1981.

———. "St, Praxedis: New Light on the Early Career of Vermeer." *Artibus et Histo-
riae* 7 (1986): 71–89.

Wheelock, Arthur K., Jr., and C. J. Kaldenbach. "Vermeer's *View of Delft* and His
Vision of Reality." *Artibus et Historiae* 3, no. 6 (1982): 9–35.

Wijsenbeek-Olthuis, T. *Achter de gevels van Delft: Bezit en bestaan van rijk en arm in
een periode van achteruitgang (1700–1800).* Hilversum: Verloren, 1987.

GENEALOGICAL PERIODICALS

Genealogische en Heraldische Bladen; Central Bureau van Genealogie, *Jaarboek;
Nederlandsche leeuw; Wapenheraut*

INDEX

Name Index

Hooch, Pieter de (painter), 71, 103–104,
132, 136, 136 n22, 152 n60, 153, 171–
72, 187, 199, 201, 230; *Interior Scene*,
151–52, Fig. 27
Hooch, Quyrinch Jansz. van der (mer-
chant), 278
Hoogenhouck (brewer), 223, 345
Hoogstraten, Samuel van (painter), 172,
188, 221–22, 340
Hooren, Nicolaes van, 331
Hoorendijk, Joost Lenertsz. van, 289
Hoorn, Claes Pietersz. van (ship steward),
295–96
Hopper, Edward (painter), xv
Hopprus (*also* Opperis *and* Oprust), Pieter
Corstiaensz.(leather merchant), 61, 72,
74, 288–90, 299, 303–304
Horenbecke (Horenbeeck), Daniel van
(merchant), 41
Horst, Lambrecht (Lambartus) van der
(Jonckheer), 176 n20, 177, 177 n23, 292
Horst, Niclaes van der, 79, 304
Horst, Reijer Lambertsz. van der, 177 n23
Hosperius, Elisabeth Catharina, 240, 242,
366, 368
Hosperius, Johannes Christophorus, 240,
366
Houck, Heindrick Jacobse van der (carpen-
ter), 318
Houck, Michiel van (glassmaker), 332
Houckgeest, Gerard (painter), 71, 136, 151
Houten, Adriaen Hendricksz. *See* Buyten,
Arien Hendricksz. van
Houve, Daniel van der (notary), 360
Houve, Jan Gerritsz. van der (faiencier),
318
Hugeli, Philippe, 181 n41
Hurcq, Franchois (attorney), 311
Huyberts, Eelken, 294
Huyberts, Herman, 362
Huyberts, Willemken, 294
Hu(y)brechts, Margareta (bookseller), 179,
326
Huycksloot, Cornelis Pietersz., 312
Huygen, Pieter, 41
Huygens, Constantin (statesman), 207–208
Huyssloot, Arij Pietersz., 328

IJsbrantsdr., Annitgen 303–304
IJsbrantsdr., Lysbeth, 303–304
IJssel, Cornelis Len(d)ertsz. (Lenderts) van
der, 45–46, 272–73, 277
Immenraedt, Michel-Angelo (painter), por-
trait of Odilia and Philippina Maria van
Wassenaer, 210, Fig. 55
Irenaeus, P., 181 n42

Isbrants (IJsbrants), Catharina (Tryntje),
15, 52, 174 n13, 270, 278, 282–284
Isbrantsdr., Duyffse, 269
Isbrantsz., Jacob. *See* Castijllije, Jacob Is-
brantsz. van
Isendoorn, Elbert van (à Blois), 210, 335
Isselsteyn, Adriaen (painter), 355

Jaanus, H. J., 4 n2, 5 n5
Jacobs, Crijntgen, 313
Jacobs, Emmerentia, 216, 337, 355–56
Jacobs, Geertge, 50–51, 279
Jacobs, Itge, 79–80, 304
Jacobs, Neeltge, 277
Jacobs, Pieternelletge, 285
Jacobsdr., Barber, 286
Jacobsdr., Grietge, 303
Jacobsz., Cornelis, 277
Jacobsz., Gelle, 269
Jacobsz., Henric, 276
Jacobsz., Jacob, 270, 277
Jacobsz., Jan, 59 n7
Jacobsz., Wouter, 284
Jallis, Cornelis 't, 121 n36
Jameson, Mrs., 141, 141 n38
Janbaes, Jan Jorisz. (brickbaker), 293
Jans, Aettgen, 289
Jans, Annetge, 175, 178 n30, 179, 326
Jans, Heijndricke, 282
Jans, Lysbeth, 291
Jans, Maertge (Maritge), 9, 13–14, 37, 52,
64–65, 174, 174 n12 and n13, 269–71,
276, 278, 282, 285–86, 301, 317
Jans, Maritge, 326
Jans, Trijntge, 313
Jansdr., Anna. *See* Jans, Annetge
Jansdr., Elisabeth, 319
Jansdr., Gerritge, 270
Jansdr., Neeltge, 59 n7
Jansdr., Sara, 292
Jansdr., Susanna, 290
Jansdr., Tryntgen, 311
Jansz., Abraham (tailor), 291
Jansz., Anthonis (baker), 61 n13
Jansz., Anthony. *See* Vermeer, Anthony
Jansz.
Jansz., Arent (brickbaker), 297
Jansz., Arien (workmaster). *See* Breda,
Adriaen Jansz.
Jansz., Cornelis (carpenter), 287
Jansz., Cornelis (organizer of lotteries), 44
Jansz., Cornelis (caffa worker). *See* Noor-
den, Cornelis Jansz. van
Jansz., Gerrit (framemaker). *See* Wiel, Ger-
rit Jansz. van der
Jansz., Ghysbrecht (butcher), 282

Rosendael, Jan Jacobsz. van (burgomaster), 108
Rosieren, Johannes van der. See Rogier, Jan
Rosmorle, Jacob Jacobsz., 305
Rossen, Aryen Maertensz. van, 218
Rossum, Pieter van, 286
Rota, Govert (notary), 134, 310–12
Roy, de (family), 110
Roy, Adriaen de, 110, 123–24, 296, 298
Roy (Roi), Constantia de, 297
Roy, Gerarda de, 110, 124
Roy (Roi), Hugo de, 297–98
Ruijven, Jan Dircsz. van, 246 n1
Ruijven, Jan Hermansz. van, 246, 246 n1, 248 n9
Ruijven, Johan (Jan) Claesz. van (notary), 247–49, 323
Ruijven, Magdalena Pieters van, 209 n23, 247 n8, 248 n14, 251–54, 256, 359–61. See also Pieters, Magdalena
Ruijven, Maria Claesdr. van, 248 n14, 249, 254
Ruijven, Maria Pieters van, 251 n22, 321, 323
Ruijven, Niclaes Pietersz. van (brewer), 246, 247 n6, 249
Ruijven, Pieter Claesz. van, xx, 134–35, 172, 205, 298 n23, 246–48, 247 n5, 250–54, 260–62, 321–31, 329, 332
Ruijven, Pieter Jansz. van (I), 246 n1
Ruijven, Pieter Jansz. van (II) (painter), 248 n2
Ruijven, Pieternella Claesdr. van, 247
Ruijven, Sara Claesdr. van, 249, 254, 323
Ruijven, Simon Pietersz. van, 251 n22
Ruijven, Trijntje Pieters van, 246 n1
Ruijven, Willem van (notary), 261
Rummelaer, Johan, 270
Ruselaer, Johan, 289
Ruselaers, Susanna, 289
Ruts, Jan Gerritsz. (goldsmith), 269
Rutten, Gijsbert, 92, 288, 290
Ruurs, Rob, xix, 117 n32, 156 n8, 299, 304, 336
Ryswijck, Aryen Willemsz. van, 281

Saftleven (Sachtleven), Cornelis (painter), 81–82, 310
Salomon, Nanette, 162 n22
Salomonsz., Symon (merchant), 41
Samuels, Adriaen Simonsz. (sculptor), 138, 161, 161 n20
Samuels, Simon Ariensz. (sculptor), 138 n24, 216, 337
Sandelingh, Arent (Jonckheer), 292
Sanen, Arent van (glassmaker), 317–18
Sanen, Aryen Gerritsz. van, 312

Sanen, Dirck Gerritsz. van, 312
Sanen, Gerrit Adriaensz. van, 312
Santen, Gerrit Cornelisz. van (playwright), 77, 134, 138, 138 n27
Santen, Heyndrick Engelsz. van (wainscotter), 295–96
Santen, Jacob van (notary), 297–98
Santen, Johan Cornelisz. van (captain), 76–77, 134, 300–301, 310–11, 319
Santen, Maria van, 246 n1
Santen, Pieter Jansz. van, 66
Sas, Hugo (silk merchant), 298
Schade, Johan (apothecary), 336, 354
Schade, Robbrecht (captain), 90–92, 293–94
Schagen Cornelis Leendertsz. van (merchant), 61 n14, 65, 307
Schepper, Hendrick de, 209, 334–35
Schierbeek, Abraham, 225 n27
Schilperoort, the widow, 313
Schimmel, Abraham (merchant), 41–42
Schimmel, Jacob (swordmaker), 41–42, 46, 275
Schinkel (painter), 319
Schinkel, Herman (printer), 5
Scholl, Johan Pietersz., 294–95
Schonenburch (family), 110
Schonenburch, Egbert van, 110
Schonenburch, Judith (Jutte), van, 110
Schoonderwoert, Dirck (notary), 292
Schoone, F.A.M., 310
Scho(o)nenburch, Clementia van, 110, 351
Schoonhoven, Adriaen, 298
Schoonhoven, Frederick, 304–305
Scho(o)ten, Floris van (painter), 306
Schou, Isaac Aryensz. (worker in white wood), 337–38
Schouten, Jan, 211, 337
Schrick, He(y)ndricz. Jansz. van der (sculptor), 161 n20
Segersz., Jan (sailor), 283
Serrot, Jasper (glassmaker), 332–33
Sijmonsz., Jan, 285
Silvercroon, Pieter Spierincx. See Spierincx, Pieter
Silvergieter, Cornelis (captain), 68 n40
Singe, Joris van, 328
Singel, Pieter Jansz. (merchant), 41–42
Sint Jans, Geertgen tot (painter), 306
Six (collection), 208
Slatius, Henricus (Reformed preacher), 35–36
Slingelan(d)t, Gerrit van, 294
Slingelant, Simon van, 74, 176 n20
Slo(o)ting, Willem Jansz. (merchant), 72, 291
Sluijter, E. J., 145, 145 n43 and n44

Vermeer, Jo(h)annes Reyniersz. (*cont.*)
198–99; receives bequest from Maria
Thins, 158; relationship to Balthasar
Gerrits, 33–34; represents Maria Thins,
157, 167, 209–12, 325–27, 336; repre-
sents his wife Catharina, 315–16, 334;
settles father-in-law's estate, 336–37; *St.
Praxedes*, 140–42, 146, Fig. 17; social
status, 134, 247 n4; studio of, 221, 341–
42; testament of, 213–14; value of his
paintings, 182–83; *View of Delft*, 187,
197, 200, 200 n89, 250, 255, 261, 265,
Fig. 34; "Visit to the Tomb," 139–41,
146, 181–82; witnesses act, 133–34,
175, 209–10, 308, 310, 318, 325–26,
335; *Woman Holding a Balance* (for-
merly *Woman Weighting Gold*), 162,
182, 191, 255–56, 261, Fig. 30; *Woman
in Blue Reading a Letter*, 162, 189 n69,
190, 192, 259 n51, 266, Fig. 29;
Woman Playing a Lute, 191, 217, 260,
260 n54, 265–66; *Woman with a Pearl
Necklace*, 184, 191, 256, 261, Fig. 43;
Woman with Two Men, 190, 261, Fig.
41; *Woman with a Wine Jug*, 190, 266,
Fig. 42; "Wrightsman Vermeer," *see
Portrait of a Girl*, supra
Vermeer, Maria Jansdr. (II), 243 n89
Vermeer, Maria Johannesdr. (I), 132, 154–
56, 158, 174, 196–97, 211, 214, 218,
225, 233–34, 237–39, 242–45, 311,
314, 336, 356–58, 361, 363, 368
Vermeer, Neeltge Anthonijsdr. (I), 52, 70,
270
Vermeer, Neltje Anthonijsdr. (II), 282
Vermeer, Pieter (beerworker), 299
Vermeer, Reynier Jansz. (alias Vos), 62, 79,
91–92, 244, 247 n4, 270, 276–82, 287,
309, 312, 318; art dealer, 76–77; bap-
tism of, 9; borrows money, 300–301,
310–11; caffa worker, 13, 54–58, 63,
67, 74, 83, 87, 105, 194, 225; character
of, 83–84, 105; collector of paintings,
56–57, 307; contacts with artists, 63,
69–71, 77–78, 81, 290, 294; debts of,
58, 68–69, 96, 102, 285, 289, 295, 300–
301, 307, 310, 314, 319; death of, 81,
96, 306–307; family background, 9–11;
flees after fight, 59–60; guarantees loan,
80–81, 305–306, 328; inherits from
Claes Corstiaensz., 48; innkeeper, 68–
69, 72–76, 203, 284, 288–89, 294–96,
299, 304–305; inventory of, 55–58,
221; leases inn, 60–61, 72; marriage, 14,
65; milieu 16, 37, 67–68, 140; musical
background, 11–12, 139; named Vos,

11, 61–62: portrait of, 56, 339; pur-
chases "Mechelen," 72–73; registers in
the Guild of St Luke, xvi–xvii, 63, 87,
285, 310; role in counterfeiting affair,
23, 28; social status, 65, 82, 134; stock
of paintings, 81; testament of, 69–70,
77; training as caffa worker, 13; travels,
62, 285; witnesses act, 60, 66, 81, 284,
286, 292, 295, 298, 303, 305
Verschoor, Maria, 146 n46
Verschoor, Willem (painter), 145–46 n46;
Cephalus and Procris, 145, Fig. 19
Verwey, Johannes (Father Wynants), 101
Vianen, Gysbrecht Jansz. van, 62, 285
Vignola, Giacomo (architect), 179
Vinck, Gerrart, 311
Vinken, P. J., 145 n43
Visscher, Floris (merchant), 250, 323
Visscher, Nicolaes (mapmaker), 189
Visser, Pieter, 368
Vlieger, Anthonij de (treasurer of Oud Be-
yerland), 335
Vlieger, Joris Jooster de (baker), 292
Vlieger, Maria Catrijna de, 238, 362
Vlieger, Simon de (painter), 172, 251–52,
254–55, 257, 360, 364
Vliet, Christian van (attorney), 226–27,
346–47
Vliet, Hendrick van (painter), 136, 140
Vliet, (Vlijet), Pieter Willemsz. van (mer-
chant), 72, 291
Vliet, Willem van (painter), 62
Vockestaert, Hendrick (town secretary),
348
Vogel, Janetge Jacobsdr., 190, 190 n71
Volland, Franchoijs, 64 n26, 282
Voocht, Leendert Pauwelsz., 308
Voorhou(d)t, Beatrix Duijst van, 111, 270,
293
Voorhoudt, Duijst van (family), 110, 246
n1
Voorhou(d)t, Erckenraad Duijst van, 114,
246 n1, 270
Vos, Jan de (workmaster), 76, 92, 295
Vos, Reynier Jansz. (brewery worker), 62.
See also Vermeer, Reynier Jansz.
Vosch, J. (notary), 350
Vosch, Jacob Willemsz. de, 366
Vosch, Josijntge de, 305
Vosmaer, Daniel (painter), 136, 200
Vosmaer, Jacob Woutersz. (painter), 78
Vosmaer, Nicolaes (painter), 136, 182
Vosmaer, Sasbout (Catholic priest), 179
Vouck, Beatrix Gerrits. *See* Gerrits, Beatrix
Vouck, Claes Gerritsz., 24, 87, 284
Vouck, Gerrit, 21, 284

Subject Index

ILLUSTRATIONS

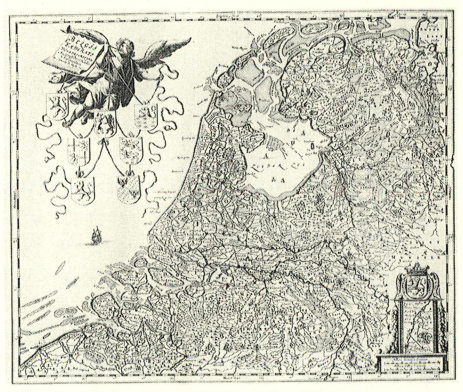

Fig. 1 Map of Holland. Amsterdam, Rijksmuseum

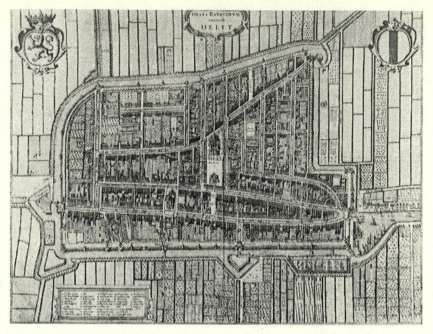

Fig. 2 Map of Delft, J. Blaeu, 1649. Delft, Gemeente Archief

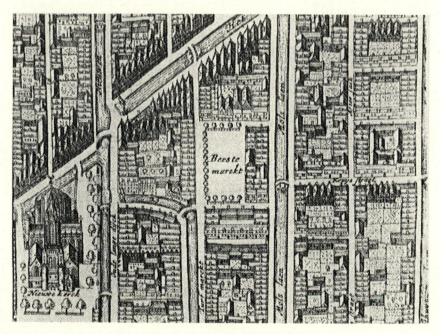

Fig. 3 The Cattle Market, detail of Fig. 2

Fig. 4 Jacob Delff, *Portrait
of the Notary W. de Langue
(with Daniel van der Brugge)*,
1648. London, Norbert Fishman
Collection (1939).
Photo: Iconographisch Bureau

Fig. 5 Balthasar van der Ast, *Still Life with Shells*.
Rotterdam, Museum Boymans-van Beuningen

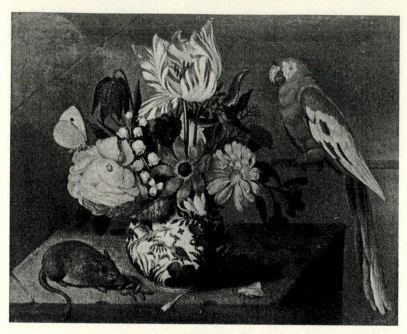

Fig. 6 Jan Baptista van Fornenburgh, *Vase of Flowers with Parrot*, 1629. Germany, private collection

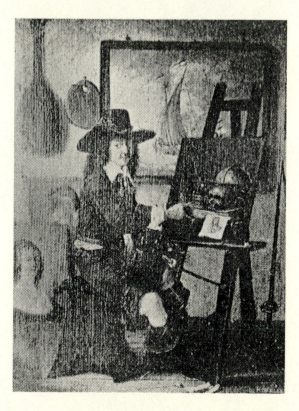

Fig. 7 Pieter Steenwijck, *Self-Portrait with Vanitas Still Life*. Formerly Ypres (Belgium), Musée (destroyed during World War I)

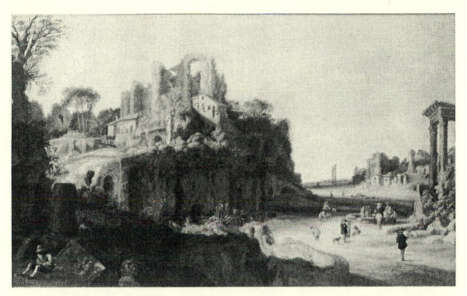

Fig. 8 Pieter Groenewegen, *Landscape with Ruins*. Amsterdam, Rijksmuseum

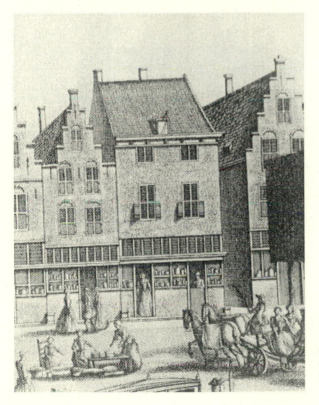

Fig. 9 J. Rademaker,
The Inn Mechelen, detail
of *View of Market Place*,
c. 1720. Delft,
Gemeente Archief

Fig. 11 Leonard Bramer, drawing after *The Fortune Teller* by Jan Lievens. West Berlin, Staatliche Museen Preussischer Kulturbesitz, Kupferstichkabinett

Fig. 10 Evert van Aelst, *A Still Life with Roses, Tulips, and Other Flowers*. Formerly London, art trade

Fig. 12 Gerard ter Borch, *The Unwelcome Messenger*. The Hague, Mauritshuis

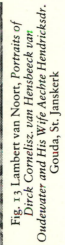

Fig. 13 Lambert van Noort, *Portraits of Dirck Cornelisz. van Hensbeeck van Oudewater and His Wife Aechte Hendricksdr.* Gouda, St. Janskerk

Fig. 14 J. Vermeer, *Christ in the House of Martha and Mary.*
Edinburgh, National Galleries of Scotland

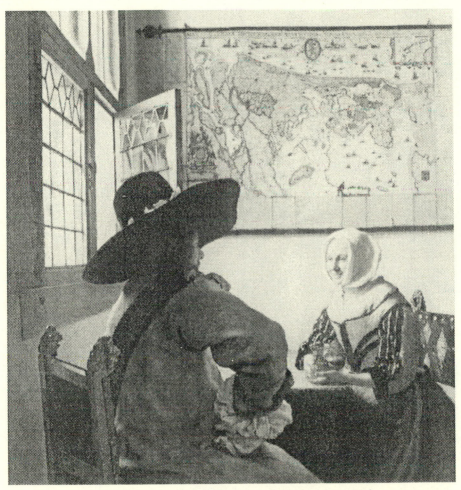

Fig. 15 J. Vermeer, *The Officer and the Laughing Girl*.
New York, copyright The Frick Collection

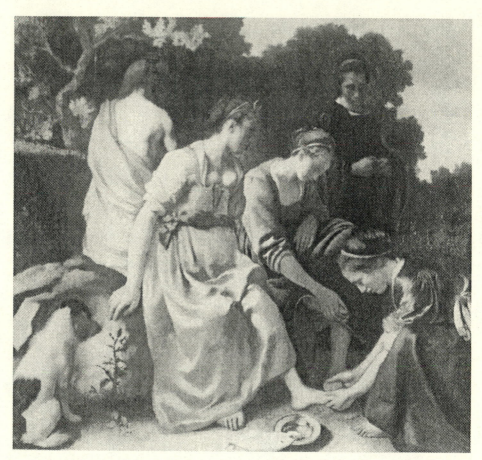

Fig. 16 J. Vermeer, *Diana and Her Companions*.
The Hague, Mauritshuis

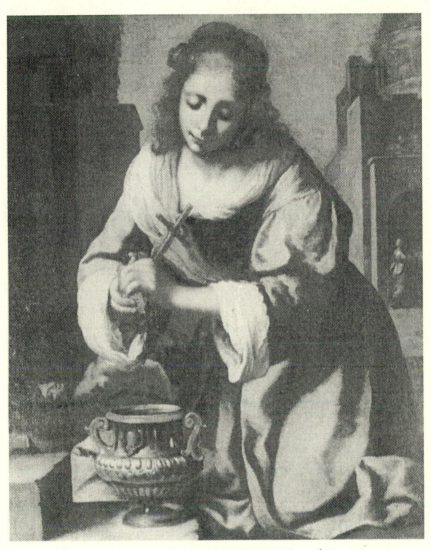

Fig. 17 J. Vermeer (attributed to), *St. Praxedes*.
New York, Spencer Samuels and Co.

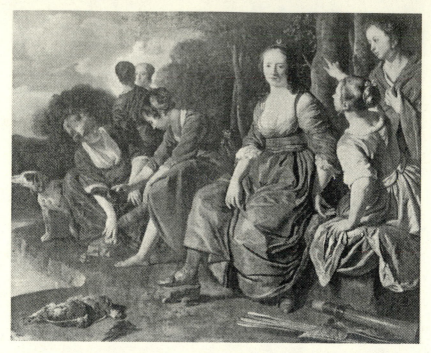

Fig. 18 Jacob van Loo, *Diana and Her Nymphs*. East Berlin,
Staatliche Museen zu Berlin, Gemäldegalerie

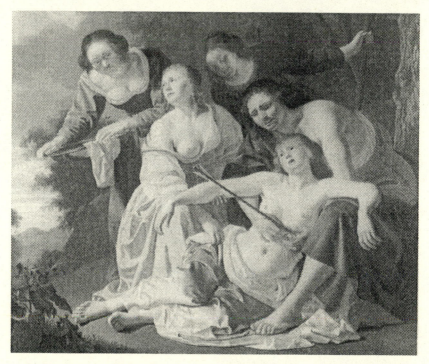

Fig. 19 Willem Verschoor, *Cephalus and Procris*, 1657.
Utrecht, Central Museum

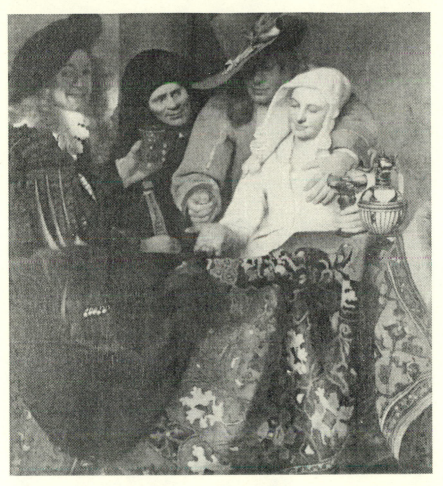

20

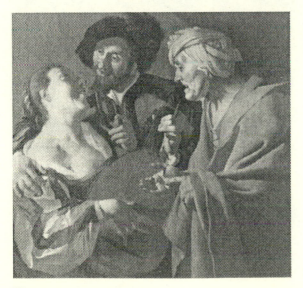

Fig. 20 J. Vermeer, *The Procuress*, 1656. Dresden, Staatliche Kunstsammlungen, Gemäldegalerie Alte Meister

Fig. 21 Dirck van Baburen, *The Procuress*. Boston, Museum of Fine Arts

21

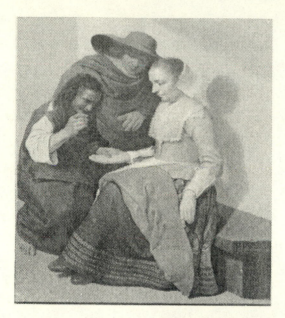

Fig. 22 Jacob van Velsen,
The Fortune Teller, 1631.
Paris, Musée du Louvre

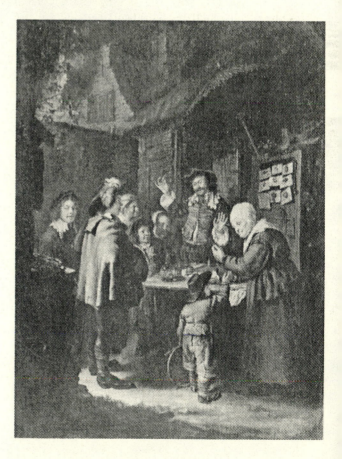

Fig. 23 Frans van Mieris,
The Charlatan, 1650–1655.
Florence, Uffizi

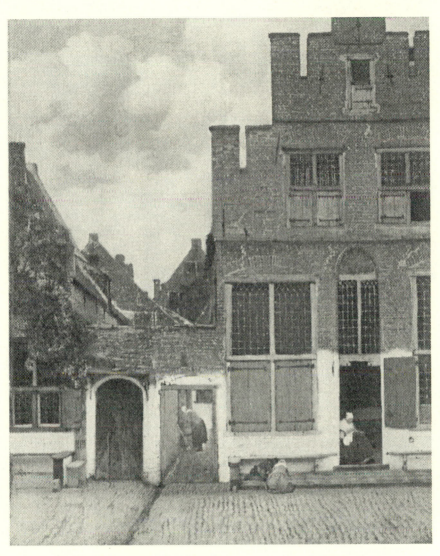

Fig. 24 J. Vermeer, *The Little Street*. Amsterdam, Rijksmuseum

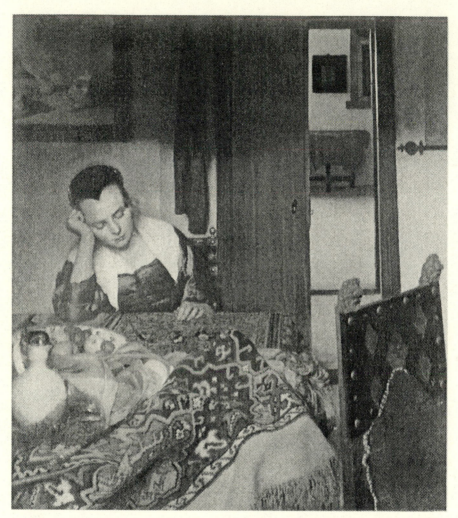

Fig. 25 J. Vermeer, *Girl Asleep at a Table*. New York, Metropolitan Museum of Art, bequest of Benjamin Altman, 1913

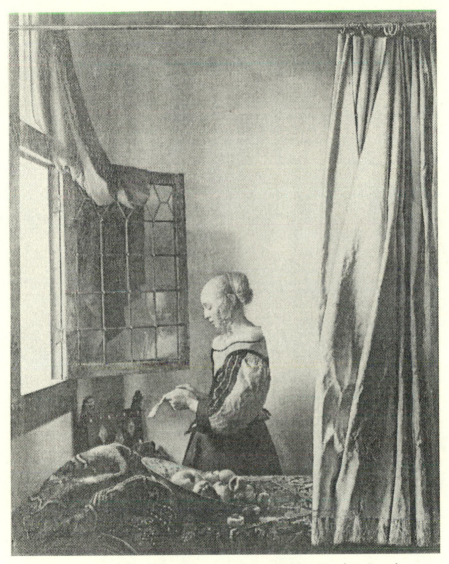

Fig. 26 J. Vermeer, *Girl Reading a Letter at an Open Window*. Dresden, Staatliche Kunstsammlungen, Gemäldegalerie Alte Meister

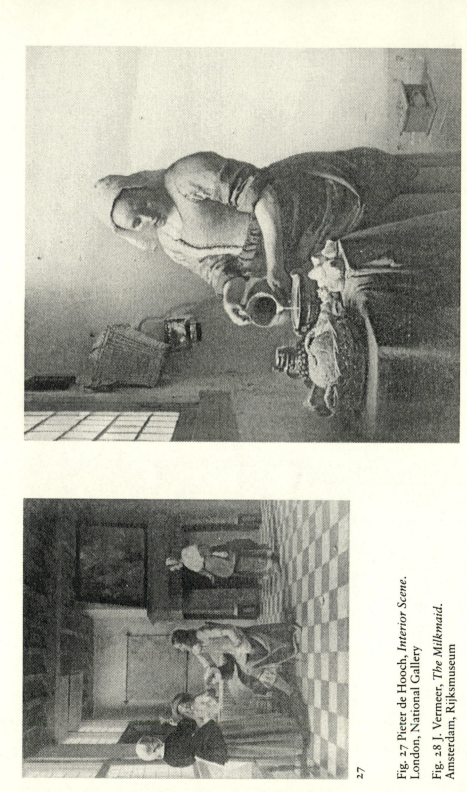

Fig. 27 Pieter de Hooch, *Interior Scene.*
London, National Gallery

Fig. 28 J. Vermeer, *The Milkmaid.*
Amsterdam, Rijksmuseum

27

28

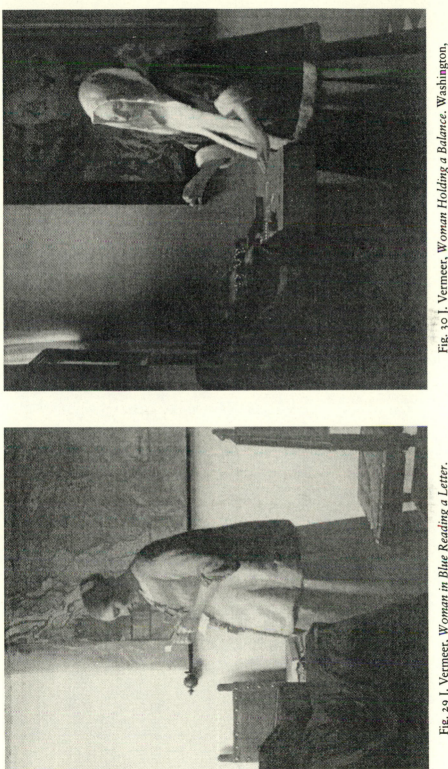

Fig. 29 J. Vermeer, *Woman in Blue Reading a Letter*.
Amsterdam, Rijksmuseum

Fig. 30 J. Vermeer, *Woman Holding a Balance*. Washington,
National Gallery of Art, Widener Collection

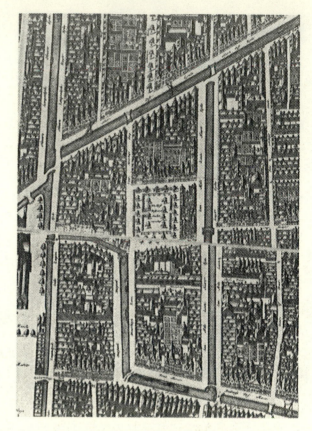

Fig. 31 Streets on the
South Side of the
New Church, detail, Caert
Figuratyf, 1675–1678.
Delft, Gemeente Archief

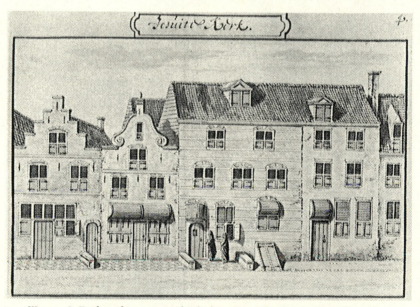

Fig. 32 J. Rademaker, pen and ink drawing, *The Jesuit Church on the
Oude Langendijck*. Delft, Gemeente Archief

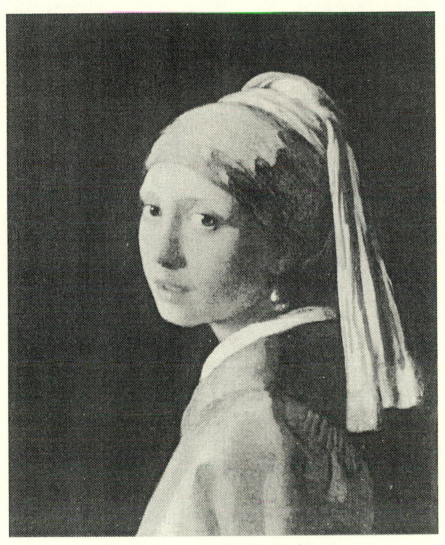

Fig. 33 J. Vermeer, *Girl with the Pearl Earring*.
The Hague, Mauritshuis

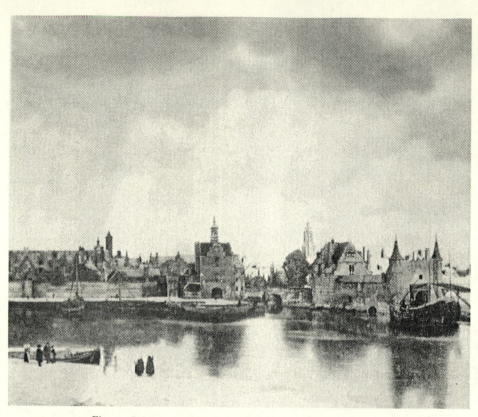

Fig. 34 J. Vermeer, *View of Delft*. The Hague, Mauritshuis

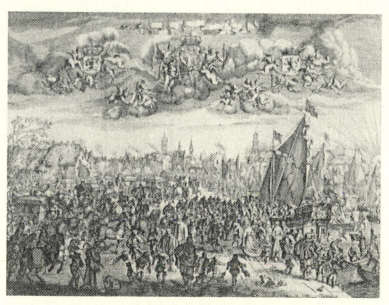

Fig. 35 David Phillippe (after N. van der Venne),
The Arrival in Delft of King Charles II of England, 1660.
Delft, Gemeente Archief

Fig. 37 J. Vermeer, *The Art of Painting.* Vienna, Kunsthistorisches Museum

Fig. 36 J. Vermeer, *The Concert.* Boston, Isabella Stewart Gardner Museum

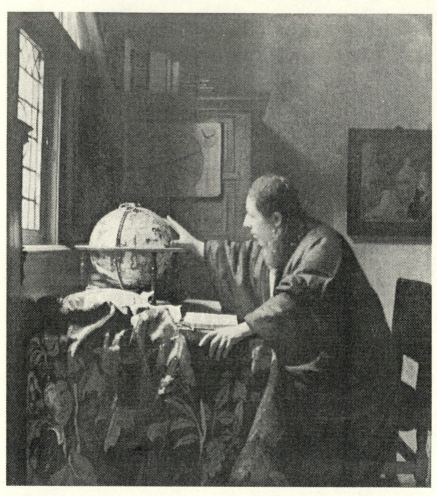

Fig. 38 J. Vermeer, *The Astronomer*. Paris, Musée du Louvre

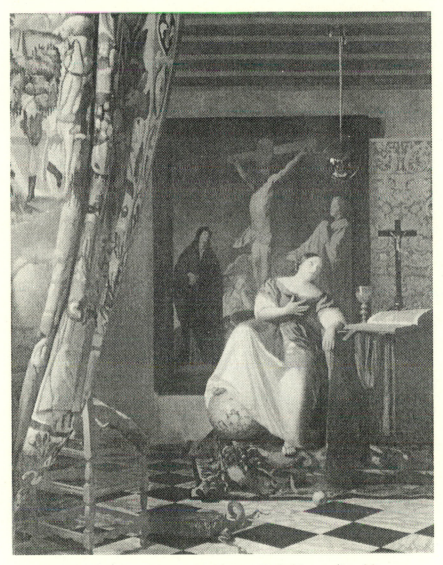

Fig. 39 J. Vermeer, *Allegory of Faith*. New York, Metropolitan Museum
of Art, Michael Friedsam Collection, 1931

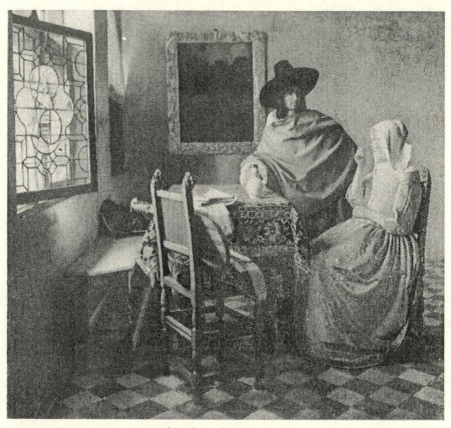

Fig. 40 J. Vermeer, *The Glass of Wine*. West Berlin, Staatliche Museen
Preussischer Kulturbesitz, Gemäldegalerie

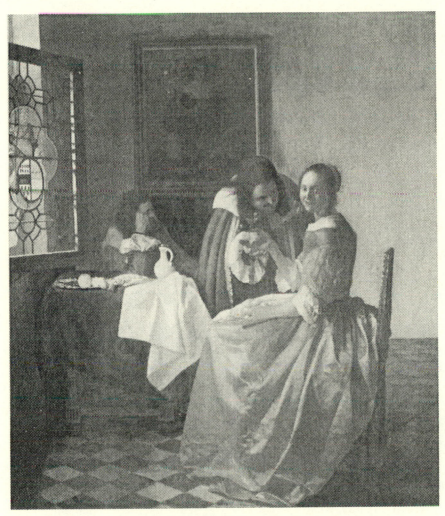

Fig. 41 J. Vermeer, *Woman with Two Men*. Braunschweig,
Herzog Anton Ulrich Museum

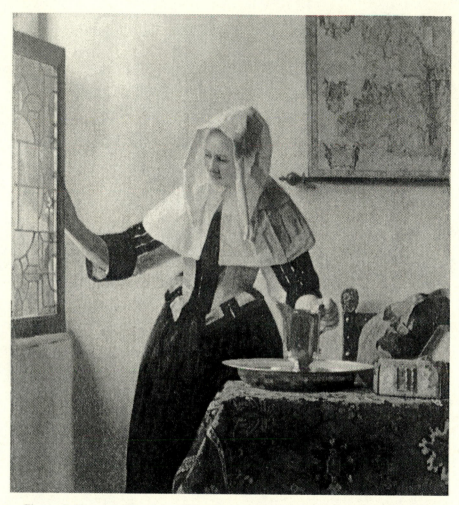

Fig. 42 J. Vermeer, *Woman with a Wine Jug*. New York, Metropolitan Museum of Art, gift of Henry G. Marquand, 1889

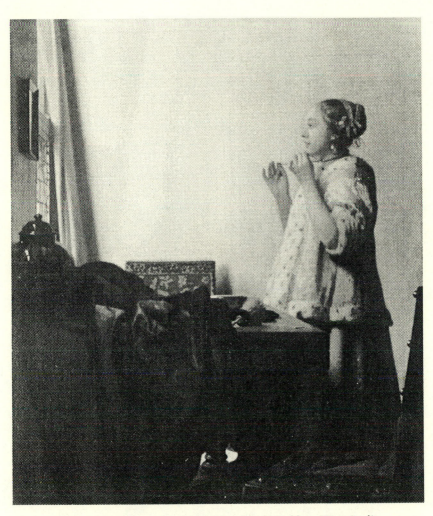

Fig. 43 J. Vermeer, *Woman with a Pearl Necklace*. West Berlin,
Staatliche Museen Preussischer Kulturbesitz, Gemäldegalerie

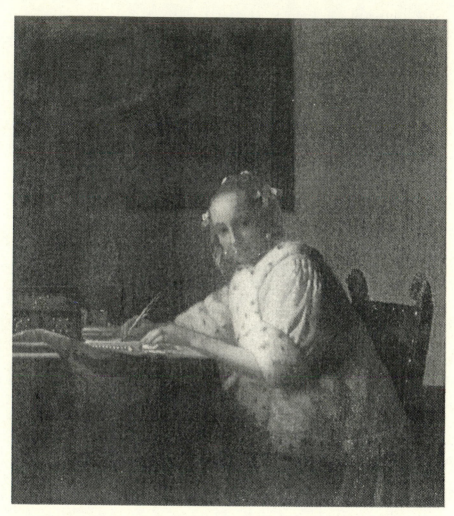

Fig. 44 J. Vermeer, *Lady Writing a Letter*. Washington, National Gallery of Art, gift of Harry Waldron Havemeyer and Horace Havemeyer, Jr., in memory of their father, Horace Havemeyer

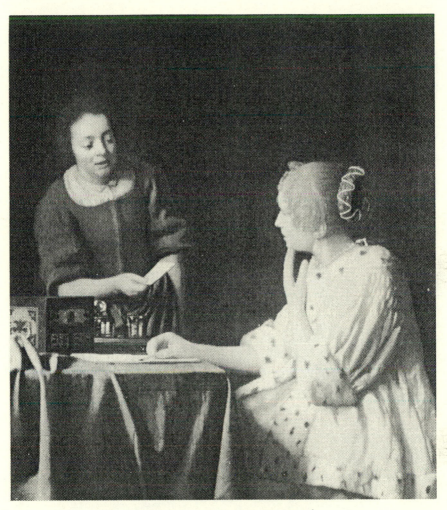

Fig. 45 J. Vermeer, *The Lady with a Maidservant.*
New York, copyright The Frick Collection

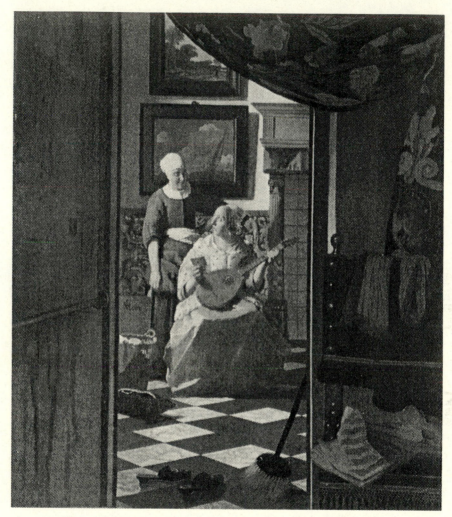

Fig. 46 J. Vermeer, *The Love Letter*. Amsterdam, Rijksmuseum

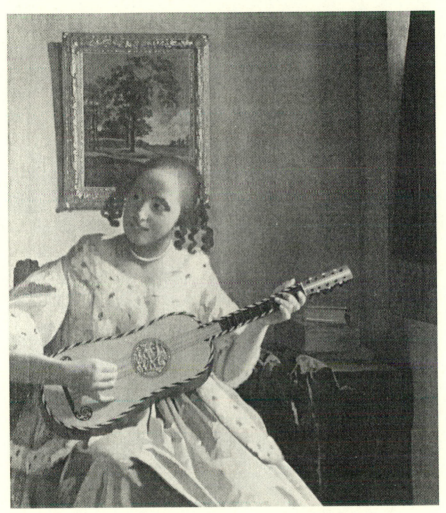

Fig. 47 J. Vermeer, *The Guitar Player*. Kenwood, English Heritage
as Trustees of the Iveagh Bequest

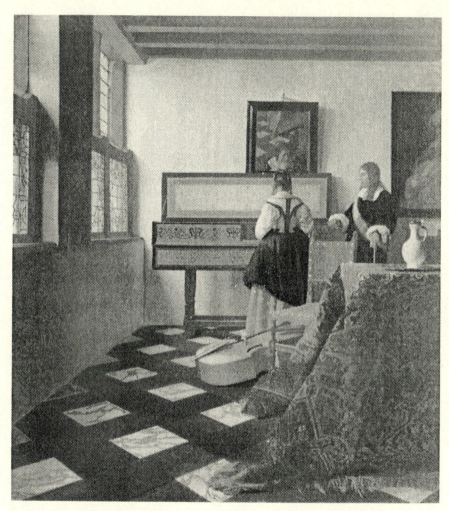

Fig. 48 J. Vermeer, *The Music Lesson*. London, Buckingham Palace, by permission of H. M. the Queen. Copyright reserved

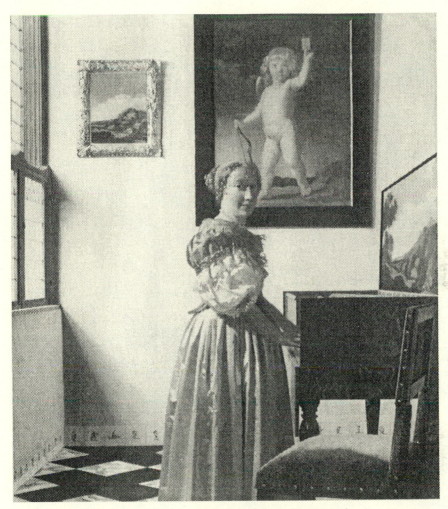

Fig. 49 J. Vermeer, *Lady Standing at the Virginals*.
London, National Gallery

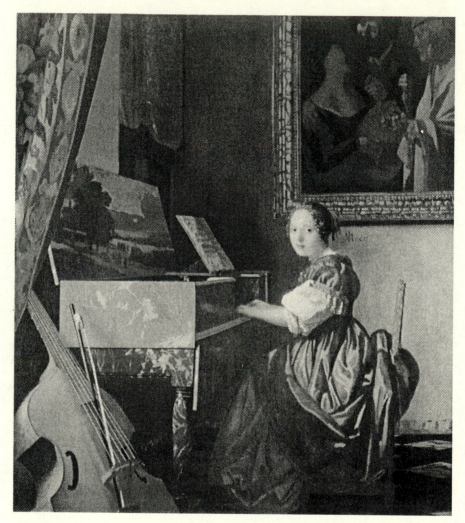

Fig. 50 J. Vermeer, *Lady Seated at the Virginals*.
London, National Gallery

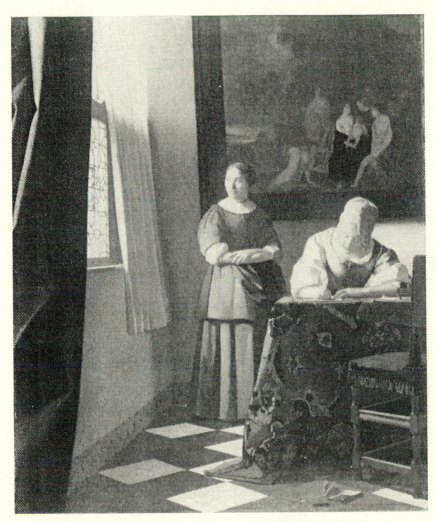

Fig. 51 J. Vermeer, *Lady Writing a Letter with Her Maid.*
Blessington, Ireland, Sir Alfred Beit

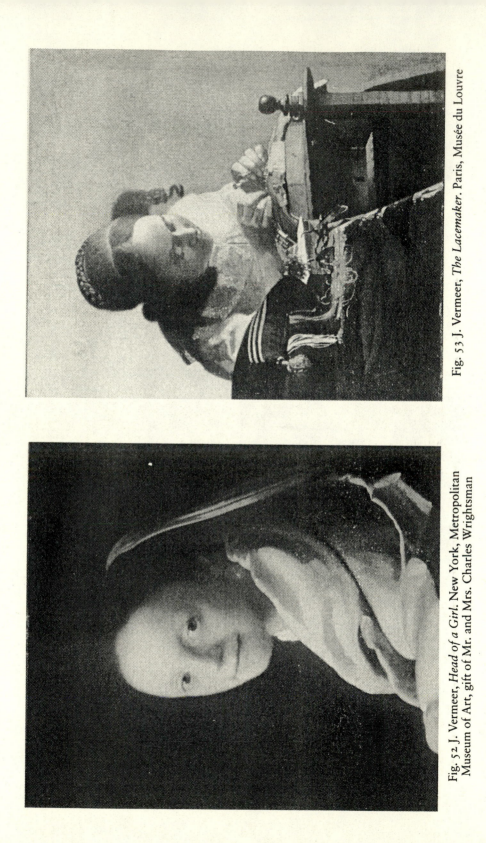

Fig. 53 J. Vermeer, *The Lacemaker*. Paris, Musée du Louvre

Fig. 52 J. Vermeer, *Head of a Girl*. New York, Metropolitan Museum of Art, gift of Mr. and Mrs. Charles Wrightsman

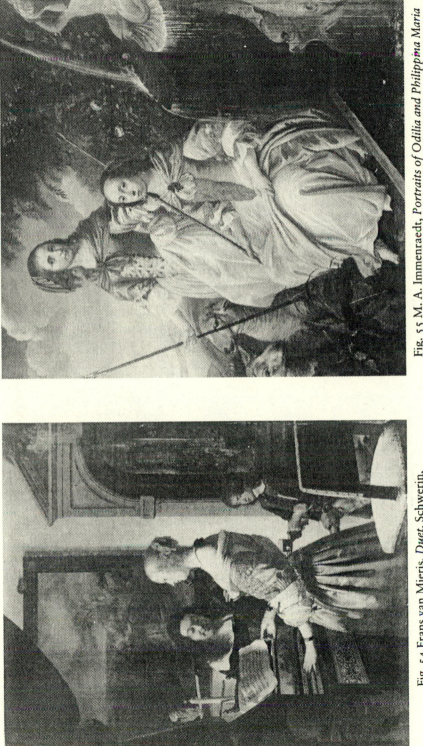

Fig. 55 M. A. Immenraedt, *Portraits of Odilia and Philippina Maria van Wassenaer*, 1661. The Hague, Gemeentemuseum

Fig. 54 Frans van Mieris, *Duet*. Schwerin, Staatliches Museum

Fig. 56 Emanuel de Witte,
*Interior of the New Church
in Delft with the Tomb of
Prince Willem of Orange*,
1653. Los Angeles, Collection
of Mr. and Mrs. Edward
William Carter. Photo:
Los Angeles County
Museum of Art

Fig. 57 Emanuel de Witte, *Interior of the Old Church in Amsterdam*.
Los Angeles, Collection of Mr. and Mrs. Edward William Carter.
Photo: Los Angeles County Museum of Art